© 2000 Benedikt Taschen Verlag GmbH Hohenzollernring 53, D–50672 Köln www.taschen.com

© 2000 for the works by Charles & Ray Eames:
Eames Office, Venice, CA, www.eamesoffice.com
© 2000 for the works by Jacques Adnet, Gunnar Aagaard
Andersen, Herman Bongard, Bernard Durussel, Danuta
Dybowska, Leonor Fini, Hugo Gehlin, Ann Greenwood,
Dieter Hinz, Erik S. Höglund, Jaruslak Junek, Lisa Larson,
Stig Lindberg, Tyra Lundgren, Jean Lurcat, Tom Möller,
Marcel Mortier, Jais Nielsen, Edvin Öhrström, Bengt Orup,
Arthur Percy, Sigurd Persson, Eric Ravilious, Axel Salto,
Zdzislaw Wroblewski: VG-Bild-Kunst, Bonn

Design: UNA (London) designers
Production: Martina Ciborowius, Cologne
Editorial coordination: Susanne Husemann, Cologne
© for the introduction: Charlotte and Peter Fiell, London
German translation by Uta Hoffmann, Cologne
French translation by Philippe Safavi, Paris

Printed in Italy ISBN 3-8228-6619-9

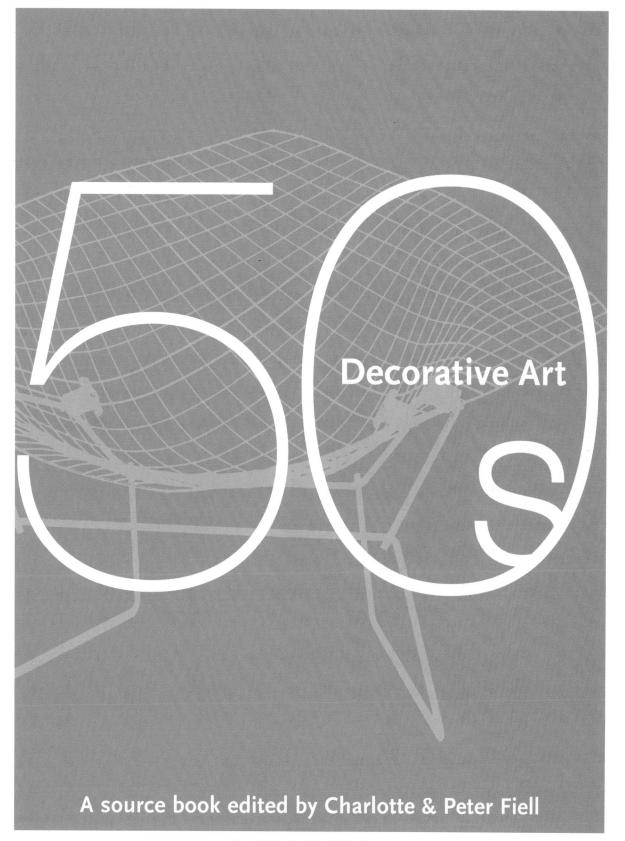

TASCHEN

KÖLN LONDON MADRID NEW YORK PARIS TOKYO

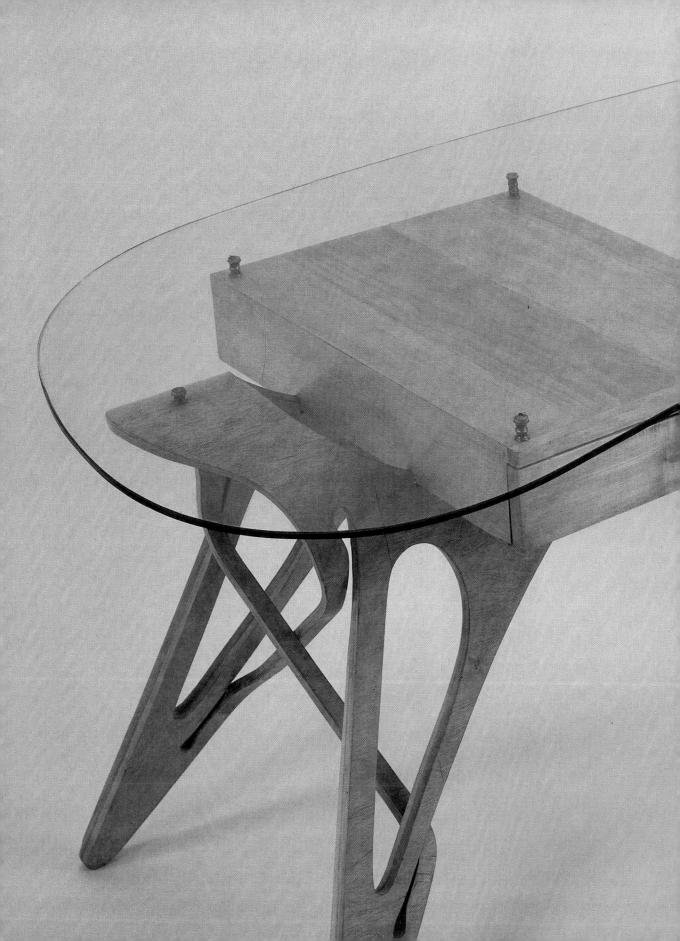

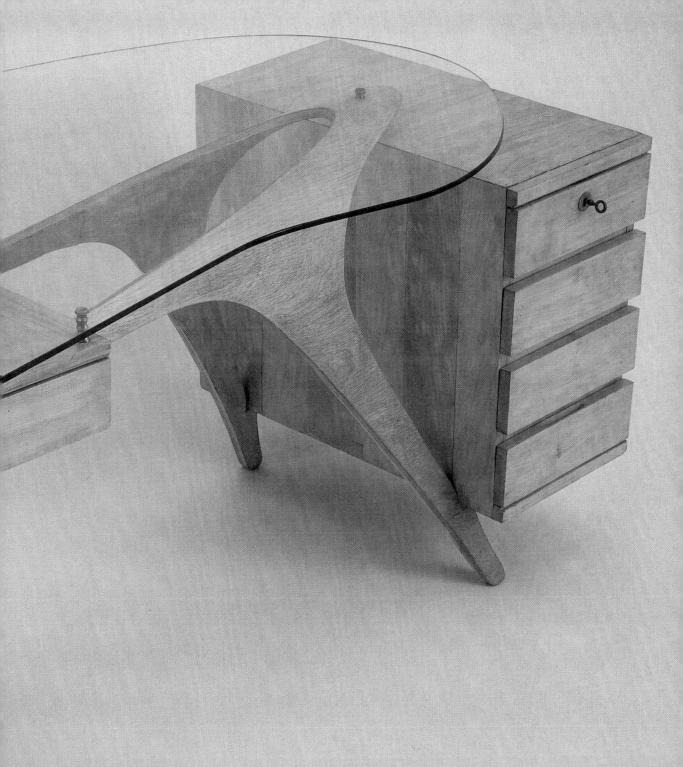

CONTENTS INHALT SOMMAIRE

preface Vorwort Préface	9
introduction Einleitung Introduction	13
houses and apartments Häuser und Apartments Maisons et appartements	26
interiors and furniture Interieurs und Möbel Intérieurs et mobilier	78
textiles and wallpapers Stoffe und Tapeten Textiles et papiers peints	266
glass Glas Verrerie	312
lighting Lampen Luminaires	382
silver and tableware Silber und Geschirr Argenterie et arts de la table	434
ceramics Keramik Céramiques	516
index Index	570

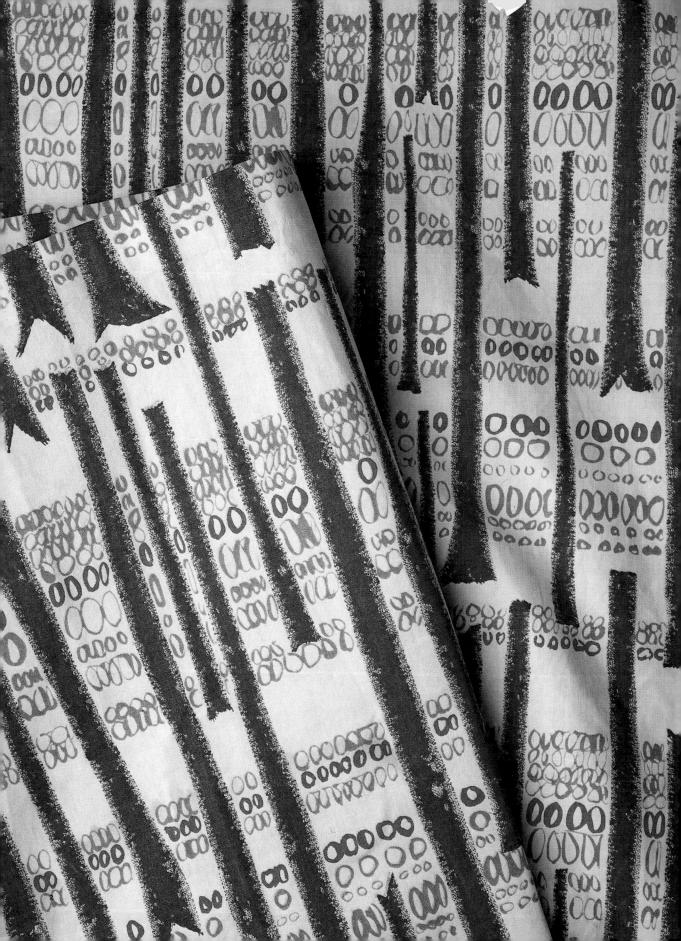

PREFACE

- 1. Carlo Mollino, Moulded and perforated plywood desk for Singer, 1950
- 2. Lucienne Day, Forest textile, c. 1955
- 3. Unknown designer, Lamp (European), 1950s
- 4. George Nelson, MAA chair for Herman Miller, 1958

The "Decorative Art" Yearbooks

The Studio Magazine was founded in Britain in 1893 and featured both the fine and the decorative arts. It initially promoted the work of progressive designers such as Charles Rennie Mackintosh and Charles Voysey to a wide audience both at home and abroad, and was especially influential in Continental Europe. Later, in 1906, The Studio began publishing the Decorative Art yearbook to "meet the needs of that ever-increasing section of the public who take interest in the application of art to the decoration and general equipment of their homes". This annual survey. which became increasingly international in its outlook, was dedicated to the latest currents in architecture, interiors, furniture, lighting, glassware, textiles, metalware and ceramics. From its outset, Decorative Art advanced the "New Art" that had been pioneered by William Morris and his followers, and attempted to exclude designs which showed any "excess in ornamentation and extreme eccentricities of form".

In the 1920s, *Decorative Art* began promoting Modernism and was in later years a prominent champion of "Good Design". Published from the 1950s onwards by Studio Vista, the yearbooks continued to provide a remarkable overview of each decade, featuring avant-garde and often experimental designs alongside more mainstream products. Increasing prominence was also lent to architecture

and interior design, and in the mid-1960s the title of the series was changed to *Decorative Art in Modern Interiors* to reflect this shift in emphasis. Eventually, in 1980, Studio Vista ceased publication of these unique annuals, and over the succeeding years volumes from the series became highly prized by collectors and dealers as excellent period reference sources.

The fascinating history of design traced by *Decorative Art* can now be accessed once again in this new series reprinted, in somewhat revised form, from the original yearbooks. In line with the layout of *Decorative Art*, the various disciplines are grouped separately, whereby great care has been taken in selecting the best and most interesting pages while ensuring that the corresponding dates have been given due prominence for ease of reference. It is hoped that these volumes of highlights from *Decorative Art* will at long last bring the yearbooks to a wider audience, who will find in them well-known favourites as well as fascinating and previously unknown designs.

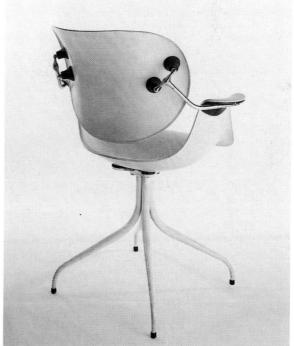

1950s · preface · 9

Die »Decorative Art« Jahrbücher

Die Zeitschrift The Studio Magazine wurde 1893 in England gegründet und war sowohl der Kunst als auch dem Kunsthandwerk gewidmet. In den Anfängen stellte sie einer breiten Öffentlichkeit in England und in Übersee die Arbeiten progressiver Designer wie Charles Rennie Mackintosh und Charles Voysey vor. Ihr Einfluss war groß und nahm auch auf dem europäischen Festland zu. 1906 begann The Studio zusätzlich mit der Herausgabe des Decorative Art Yearbook, um »den Bedürfnissen einer ständig wachsenden Öffentlichkeit gerecht zu werden, die sich zunehmend dafür interessierte, Kunst in die Dekoration und Ausstattung ihrer Wohnungen einzubeziehen.« Diese jährlichen Überblicke unterrichteten über die neuesten internationalen Tendenzen in der Architektur und Innenraumgestaltung, bei Möbeln, Lampen, Glas und Keramik, Metall und Textilien. Von Anfang an förderte Decorative Art die von William Morris und seinen Anhängern entwickelte »Neue Kunst« und versuchte. Entwürfe auszuschließen, die »in Mustern und Formen zu überladen und exzentrisch waren.«

In den zwanziger Jahren hatte sich *Decorative Art* für modernistische Strömungen eingesetzt und wurde in der Folgezeit zu einer prominenten Befürworterin des »guten Designs«. Die seit 1950 von englischen Verlag Studio Vista veröffentlichten Jahrbücher stellten für jedes Jahrzehnt ausgezeichnete Überblicke der vorherrschenden

avangardistischen und experimentellen Trends im Design einerseits und des bereits in der breiteren Öffentlichkeit etablierten Alltagsdesigns andererseits zusammen. Als Architektur und Interior Design Mitte der sechziger Jahre ständig an Bedeutung gewannen, wurde die Serie in *Decorative Art in Modern Interiors* umbenannt, um diesem Bedeutungswandel gerecht zu werden. Im Jahre 1981 stellte Studio Vista die Veröffentlichung dieser einzigartigen Jahrbücher ein. Sie wurden in den folgenden Jahren als wertvolle Sammelobjekte und hervorragende Nachschlagewerke hochgeschätzt.

Die faszinierende Geschichte des Designs, die *Decorative Art* dokumentierte, erscheint jetzt als leicht veränderter Nachdruck der originalen Jahrbücher. Dem ursprünglichen Layout von *Decorative Art* folgend, werden die einzelnen Disziplinen getrennt vorgestellt. Mit großer Sorgfalt wurden die besten und interessantesten Seiten ausgewählt. Die entsprechenden Jahreszahlen sind jeweils angegeben, um die zeitliche Einordung zu ermöglichen. Mit diesen Bänden soll einer breiten Leserschaft der Zugang zu den *Decorative Art* Jahrbüchern und seinen international berühmt gewordenen, aber auch den weniger bekannten und dennoch faszinierenden Entwürfen ermöglicht werden.

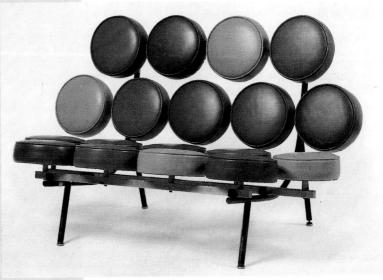

Les annuaires « Decorative Art »

Fondé en 1893 en Grande-Bretagne, The Studio Magazine traitait à la fois des beaux-arts et des arts décoratifs. Sa vocation première était de promouvoir le travail de créateurs qui innovaient, tels que Charles Rennie Mackintosh ou Charles Voysey, auprès d'un vaste public d'amateurs tant en Grande-Bretagne qu'à l'étranger, notamment en Europe où son influence était particulièrement forte. En 1906, The Studio lança The Decorative Art Yearbook, un annuaire destiné à répondre à «la demande de cette part toujours croissante du public qui s'intéresse à l'application de l'art à la décoration et à l'aménagement général de la maison». Ce rapport annuel, qui prit une ampleur de plus en plus internationale, était consacré aux dernières tendances en matière d'architecture, de décoration d'intérieur, de mobilier, de luminaires, de verrerie, de textiles, d'orfèvrerie et de céramique. D'emblée, Decorative Art mit en avant «l'Art nouveau » dont William Morris et ses disciples avaient posé les jalons, et tenta d'exclure tout style marqué par «une ornementation surchargée et des formes d'une excentricité excessive »

Dès les années 20, Decorative Art commença à promouvoir le modernisme, avant de se faire le chantre du «bon design». Publiés à partir des années 50 par Studio Vista, les annuaires continuèrent à présenter un remarquable panorama de chaque décennie, faisant se côtoyer les créations avant-gardistes et souvent expérimentales et les produits plus «grand public». Ses pages accordèrent également une part de plus en plus grande à l'architecture et à la décoration d'intérieur. Ce changement de politique éditoriale se refléta dans le nouveau titre adopté vers le milieu des années 60: Deçorative Art in Modern Interiors. En 1980, Studio Vista arrêta la parution de ces volumes uniques en leur genre qui, au fil des années qui suivirent, devinrent très recherchés par les collectionneurs et les marchands car ils constituaient d'excellents ouvrages de référence pour les objets d'époque.

Grâce à cette réédition sous une forme légèrement modifiée, la fascinante histoire du design retracée par *Decora*tive Art est de nouveau disponible. Conformément à la maquette originale des annuaires, les différentes disciplines sont présentées séparément, classées par date afin de faciliter les recherches. Les pages les plus belles et les plus intéressantes ont été sélectionnées avec un soin méticuleux et on ne peut qu'espérer que ces volumes feront connaître *Decorative Art* à un plus vaste public, qui y retrouvera des pièces de design devenues célèbres et en découvrira d'autres inconnues auparavant et tout aussi fascinantes.

Les années 50 · Préface · 11

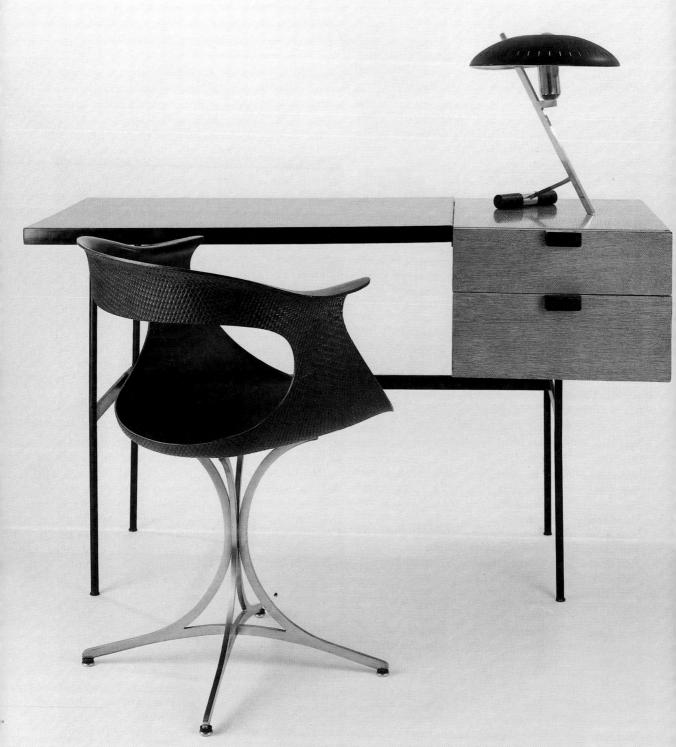

INTRODUCTION THE 1950s

7. Pierre Paulin, Wood, Metal and Formica Desk for Édition Thonet, 1956–1958; Erwin & Estelle Laverne, *Lotus* chair for Laverne International, 1958 and *Philips* metal table lamp, c. 1956 8. Arne Jacobsen, *Ant No.* 3100 chair for Fritz Hansen, 1951–1952

Homemaking and the American Dream

The 1950s were a period of renewal and optimism that saw post-war austerity gradually replaced by an unprecedented consumer boom. The turmoil of the previous decades gave way to peace and freedom in the West, while vast energies were spent on making much of the world a better place socially, politically, economically and materially. In the decorative arts, national characteristics so prevalent prior to the Second World War became almost obliterated by "constructive pacifism" and its pursuit of universalism and quality. Architecture and design benefited from new applications of wartime research, from anthropometrical data to state-of-the-art materials and methods of construction. New materials such as plastic laminates, fibreglass and latex foam quite literally shaped the look of the 1950s, while designers were inspired by a wide range of themes such as molecular chemistry, nuclear physics, science fiction, African art and abstract contemporary sculpture by such artists as Alexander Calder and Hans Arp. The spiky angular forms of the early 1950s gave way to more organic and biomorphic shapes as the decade progressed.

By the early 1950s, America had moved on from the despair and insecurity that had been associated with the Great Depression and began to experience a period of seeming abundance, driven by a new culture of consumerism. The prosperity of rich metropolitan areas, however, overshadowed the poverty still found in many rural communities and especially among the immigrant and ethnic populations. Designers and manufacturers appealed to consumers' growing aspirations by producing streamlined and forward-looking products that were the embodiment of the "American Dream". These objects of desire

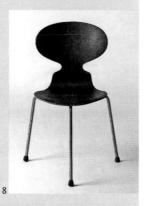

were the very antithesis of the "make do and mend" ethos of the 1930s and 1940s, often incorporating a built-in obsolescence which was intended to fuel consumption and, thereby, productivity and prosperity. In the United States, the vast majority of people aspired to a secure job (preferably in a large corporation), a house in a neatly kept suburb, a large family, a large car and an array of labour-saving appliances. The home became the very focus of the American Dream and manufacturers mercilessly targeted this new generation of "homemakers" and consumers.

In European countries such as Britain and Italy, postwar austerity was overcome by common-sense know-how and breathtaking inventiveness. As in America, the home had a special significance during the 1950s as a place of refuge from a world of rapidly advancing technologies, and also as a haven in which to forget the very real threat of nuclear war. In Britain, over 350 schools were provided with model flats for the teaching of "homecraft" to a new generation of homemakers. During the early 1950s, however, buildings, especially in Britain, remained subject to frustrating building regulations and restrictions, while prefabrication (a key to low-cost housing) existed for the most part in theory rather than in practice. It was not until the mid-1950s that Europeans began enjoying the housing boom that had already taken place in America. These new homes in turn required new furnishings, fuelling a revival in the decorative arts which was characterised by technical experimentation. Designers working in the spheres of glass and ceramics drew upon the latest metallurgy research to craft objects both more colourful and expressive in form. Textile designers incorporated newly-developed synthetic materials into their patterns, while silversmiths, especially in Denmark, created ground-breaking sensual organic forms.

New Housing and Ways of Living

On both sides of the Atlantic, the lower middle classes benefited from the large-scale development of smaller houses. Home-ownership rapidly became no longer the province of the rich. In America, Europe and Scandinavia, all of whom instituted post-war housing programmes, housing became widely regarded as a fundamental human right. In Europe, wartime bombing had effectively cleared many slum areas,

and from their ashes there now arose new, low-cost, state-aided housing that placed an emphasis on neighbourhood planning. Residential tower blocks, initially developed in Sweden, rapidly grew popular elsewhere too, while construction methods drew increasingly upon industrially manufactured components. Not surprisingly, the greatest advances in public sector housing were made in the most industrialised countries.

These new homes with their smaller living spaces required better planning and led to new ways of living that necessitated new furniture types, such as modular seating, room-dividers, storage walls and sofabeds, as well as new interior layouts, such as open-plan and split-level. Not every country embraced the new Modernism with equal fervour; France in particular remained torn between the old and the new. Gradually, however, the Modern aesthetic gained significant ground over what was termed the "period complex", and by the mid-century the "Contemporary" look was a recognisable and widely-embraced international style. The fact that mass production and mass distribution had reduced prices thereby allowed "contemporary furniture to come into its own".

Journals such as the *Decorative Art* yearbooks, which advocated natural finishes, pattern and texture in architecture, and light, flexibility and colour in interior design, were partly responsible for the mainstream acceptance of furnishings in the modern idiom. New magazines covering domestic issues and offering do-it-yourself tips also helped

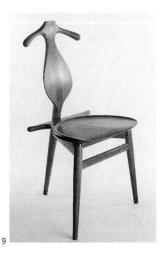

alter perceptions and tastes, as did trade fairs and exhibitions such as the annual and hugely popular Ideal Home Exhibition in London, which included an "ideal" three-bedroomed "People's House". Government-funded bodies such as the Council of Industrial Design and the Design & Industries Association also tirelessly promoted Modern design in Britain, while in America, the Museum of Modern Art in New York held exhibitions of "Good Design" from 1950 onwards.

The Contemporary Style

Ironically, the crusade launched by the progressive minority of design critics and museum curators proved all too successful, as Modern design exploded into a popular stylistic trend. The ascendancy of the Contemporary style – or "New Look", as Christian Dior had already termed it in 1947 - fuelled the search by some designers and manufacturers for novelty and gimmicks rather than practical design solutions, to such an extent that white goods were sometimes embellished with knobs and dials that served absolutely no practical purpose. Alarmed by this turn of events, Which? magazine was launched in 1957 by the Consumer's Association in Britain as an informative guide to the relative quality of consumer products. The rampant consumerism of the 1950s, however, remained unabated and offered fertile ground for the Pop culture of the following decade.

Although the 1950s cannot be regarded as a permissive period, seeds of anti-establishmentarianism were sown in it – from the rock'n'roll of Elvis Presley and the rebellious anti-heroes portrayed by James Dean and Marlon Brando, to Abstract Expressionism and the formation of CND (Campaign for Nuclear Disarmament). Television and jet travel were opening up new horizons, while satellites were heralding the age of global communications. The unprecedented affluence of the decade, which had been famously summed up by British Prime Minster Harold MacMillan as having "never had it so good", led to significantly higher standards of living by its close. The 1950s were an era of "dream cars, dream kitchens, dream houses" in which mass consumption was promoted as a social and economic necessity.

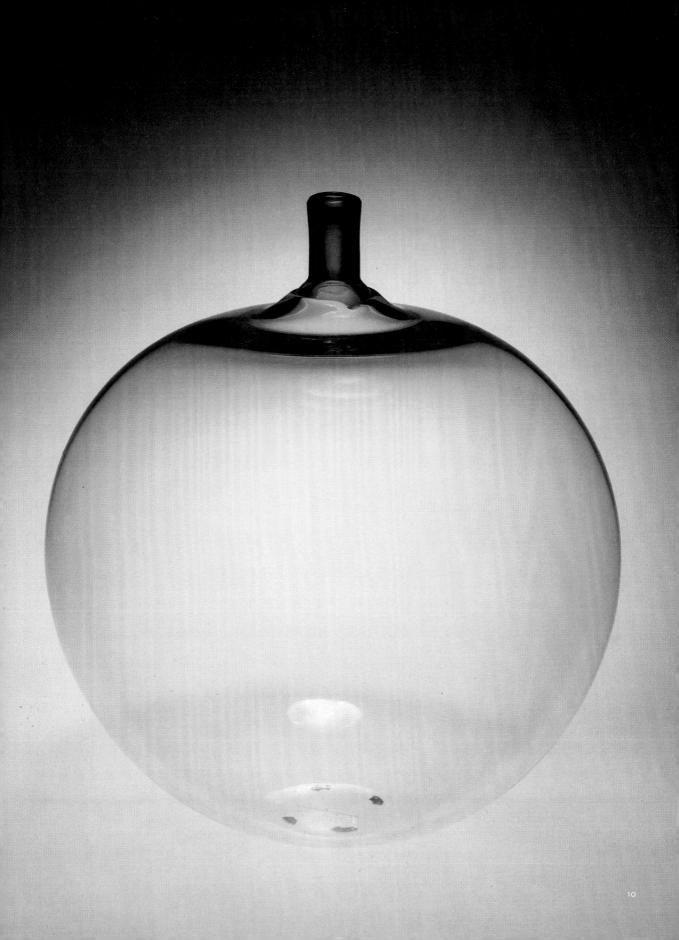

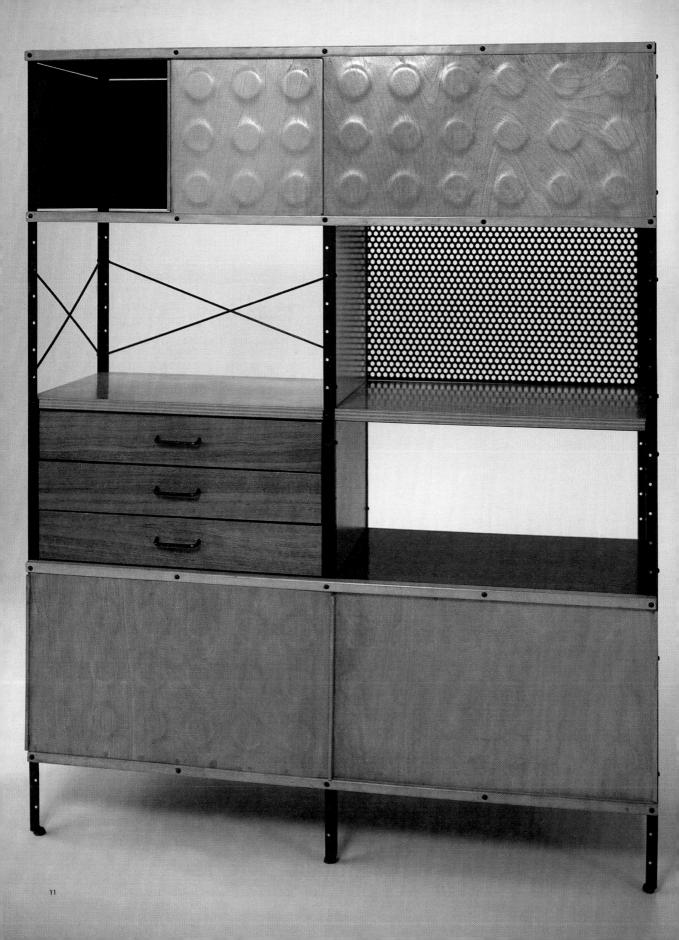

EINLEITUNG DIE FÜNFZIGER JAHRE

11. Charles & Ray Eames, ESU 400 (Eames Storage Units) for Herman Miller,

12. Charles & Ray Eames, PAW swivel chair for Herman Miller, 1950

Das schöne Heim und der »amerikanische Traum«

Nach den Entbehrungen des Krieges waren die fünfziger Jahre eine Zeit der Erneuerung und des internationalen Optimismus, mit der eine noch nie dagewesene Konsumwelle einsetzte. In den westlichen Ländern lösten Frieden und Freiheit die gewalttätigen Auseinandersetzungen der vorangegangenen Jahrzehnte ab. Mit enormen Anstrengungen wurde versucht, die sozialen, politischen, wirtschaftlichen und materiellen Grundlagen in der Welt zu stabilisieren und zu verbessern.

In den dekorativen Künsten nivellierten sich die noch vor dem Zweiten Weltkrieg so unterschiedlichen nationalen Positionen zu einem beinahe »konstruktiven Pazifismus«, in dem sich Universalismus und Qualitätsbewusstsein als maßgebende Werte durchsetzten. Architektur und Design profitierten von neuen Materialien und Konstruktionsmethoden aus der Kriegsforschung. Unter den neuen Materialien bestimmten besonders Kunststofflaminate. Fiberglas und Latexschaum den »Look« der fünfziger Jahre. Designer ließen sich aus vielen unterschiedlichen Quellen inspirieren – etwa der Molekularchemie und Nuklearphysik, von Science Fiction, afrikanischer Kunst und den abstrakten Skulpturen zeitgenössischer Künstler wie Alexander Calder und Hans Arp. Die spitzen, kantigen Formen der frühen fünfziger Jahre wurden später von mehr organischen und biomorphen Formen abgelöst.

In den frühen fünfziger Jahren ließen die USA die allgemeine Hoffnungslosigkeit und Unsicherheit der Großen

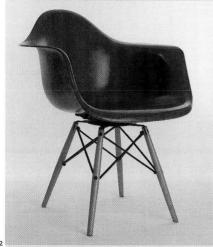

Depression hinter sich und brachen in eine Zeit scheinbar grenzenlosen Überflusses auf, die von den Bedürfnissen einer neuen Konsumkultur getragen wurde. Der ungeheure Wohlstand der Metropolen überschattete die noch immer erhebliche Armut in den ländlichen Gebieten und unter Immigranten und ethnischen Minderheiten. Gemeinsam versuchten Designer und Hersteller, die Gier der Konsumenten nach stromlinienförmigen und zukunftsorientierten Produkten, die den »amerikanischen Traum« repräsentierten, zu stimulieren. Diese Traumobjekte verkörperten das genaue Gegenteil der Kultur der Improvisation und Sparsamkeit, welche die dreißiger und vierziger Jahre charakterisiert hatte, denn sie hatten eine sogenannten »beabsichtigte Veralterung des Modernen« eingebaut, die den Konsum steigern und dadurch Produktivität und Wirtschaftswachstum sichern sollte. In den Vereinigten Staaten träumten die Menschen von einem sicheren Job (vorzugsweise in der Großindustrie), einem eigenen Haus in einem sauberen Vorort, einer großen Familie, einem großen Auto und einem Heer arbeitserleichternder Haushaltsgeräte. Das Haus stand im Zentrum des »American Dream«, und die neue Generation von »Hausfrauen« und Konsumenten wurde zur Zielscheibe der erbarmungslosen Vermarktungsstrategien von Industrie und Handel.

In Europa überwanden Länder wie z.B. Großbritannien und Italien das Elend der Nachkriegszeit mit gesundem Menschenverstand und einer geradezu atemberaubenden Kreativität. Wie in den USA hatte das Heim auch in Europa eine zentrale Funktion als Zufluchtsstätte vor einer Welt. die zunehmend vom schnellen technischen Fortschritt bestimmt war – ein Ort, an dem man die während des Kalten Krieges sehr reale Bedrohung durch einen atomaren Krieg vergessen konnte. In Großbritannien wurden für mehr als 350 Schulen Modellwohnungen zur Verfügung gestellt, in denen eine neue Generation von Hausfrauen in der Kunst der »Hauswirtschaft und Wohnungsgestaltung« unterrichtet wurde. In den frühen fünfziger Jahren war Bauen in Großbritannien noch immer durch frustrierende Baubestimmungen und -restriktionen eingeschränkt. Fertigbauweise, der Schlüssel zu verbilligtem Wohnungsbau, existierte zwar in der Theorie, war aber noch nicht überall in der Praxis verwirklicht. Erst in der zweiten Hälfte der fünfziger Jahre setzte auch in Europa ein Bauboom ein, der in den USA schon längst stattgefunden hatte. Die für die

neuen Wohnungen benötigten Einrichtungen leiteten eine Wiederbelebung in den dekorativen Künsten ein, die durch technisches Experimentieren gekennzeichnet war. Insbesondere Designer von Glas und Keramik experimentierten mit den neuesten Forschungen der Metallurgie, um zu expressiveren Farben und Formen vorzustoßen. Textildesigner begannen, neue synthetische Materialien in ihre Muster zu integrieren, und Goldschmiede, besonders dänische, schufen bahnbrechende organisch fließende Formen.

Neues Wohnen und neue Lebensstile

Auf beiden Seiten des Atlantiks profitierten besonders die unteren Mittelschichten von dem Aufschwung im Wohnungsbau. Privater Hausbesitz nahm zu und war nun nicht mehr nur ein Privileg der Reichen. In den USA, Europa und besonders in den skandinavischen Ländern wurden in der Nachkriegszeit staatliche Wohnungsbauprogramme entwickelt und das Recht auf eine Behausung zu einem fundamentalen Grundrecht des Menschen erhoben. In Europa hatten die Bomben während des Krieges Städte und Slums zerstört, und auf den Trümmern waren mit staat-

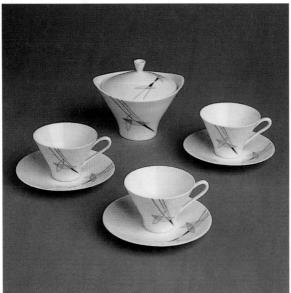

lichen Mitteln finanzierte, neue preiswerte Wohnsiedlungen entstanden. Durch die Anwendung von Konstruktionsmethoden mit seriengefertigten industriellen Baukomponenten setzten sich in den Städten allmählich auch mehrstöckige Wohntürme – ursprünglich in Schweden entwickelt – überall durch. Es war also kein Zufall, dass sich der staatliche Wohnungsbau am stärksten in den Industriestaaten entwickelte.

Die Einrichtung der neuen Wohnungen, die weniger Wohnfläche hatten, erforderte eine bessere Planung und führte zu neuen Lebensstilen, für die zweckmäßige Möbelformen - aus Kastenelementen zusammengesetzte Sitzgelegenheiten, Raumteiler, Schrankwände und Sofabetten - ebenso typisch waren wie neue Grundrissgestaltungen für offenere Wohnformen oder Zwischenstockwerke. Nicht alle Länder assimilierten den neuen Modernismus mit gleicher Begeisterung. Insbesondere Frankreich schwankte lange zwischen dem Alten und dem Neuen. Nach und nach setzte sich aber die moderne Ästhetik gegen die sogenannten »Stilmöbel« durch, und um die Jahrhundertmitte wurde dieser »zeitgenössische« Look als internationaler Stil überall akzeptiert. Massenproduktion und Massendistribution hatten das ihre getan und den »zeitgenössischen Möbeln« über sinkende Preise zum endgültigen Durchbruch verholfen.

Zeitschriften wie die Decorative Art Jahrbücher, die als Befürworter von materialgerechter Verarbeitung sowie von natürlichen Mustern und Texturen in der Architektur und zukunftsweisenden Konzepten flexibiler, heller und farbiger Innenraumgestaltungen eingetreten waren, trugen wesentlich zu einer breiten Akzeptanz moderner Wohnformen und Raumausstattungen bei. Die zahlreichen neuen Wohnzeitschriften und Do-It-Yourself-Bücher, die Möbelmessen und -ausstellungen, allen voran die jährlich stattfindende und äusserst populäre »Ideal Home Exhibition« in London, die ein »Modellhaus« mit drei Schlafräumen vorstellte, bewirkten, dass sich Sensibilität und Geschmack änderten. Auch staatliche Institutionen wie das Council of Industrial Design und die Design & Industries Association kämpften unermüdlich für zeitgenössisches Formempfinden in Großbritannien, und in den USA organisierte das Museum of Modern Art in New York schon seit 1950 Ausstellungen zu dem Thema »gutes Design«.

13

- 14. Poul Henningsen, PH6 lamp for Louis Poulsen, probably early 1950s (contemporary reissue based on earlier unrealized design)
- 15. Verner Panton, Cone chairs for Plus-Linje, 1958
- 16. Nils Landberg, Tulpan (Tulip) glasses for Orrefors, 1956
- 17. Erwin & Estelle Laverne, Champagne chair for Laverne International, 1957

Der zeitgenössische Stil

Ironischerweise war der ursprünglich von einer fortschrittlichen Minderheit von Designkritikern und Museumskuratoren begonnene Kreuzzug für »gutes Design« so erfolgreich, dass es als stilistischer Trend immer populärer wurde. Die allgemeine Akzeptanz des »zeitgenössischen Stils« – oder »New Look«, wie ihn Christian Dior schon 1947 genannt hatte – führte dazu, daß Designer und Hersteller sich mehr auf die Suche nach Novitäten und Schnickschnack als auf funktionale Designlösungen spezialisierten; etwa in dem sie weiße Möbel mit Knöpfen und Scheiben verzierten, die absolut keine praktische Funktion hatten. In Reaktion auf diese alarmierende Wende wurde in Großbritannien 1957 von der Consumer's Association zum Schutz der Verbraucher die Zeitschrift Which? als Informationsorgan zum Oualitätsvergleich von Gebrauchswaren ins Leben gerufen. Aber das hemmungslose Konsumverhalten der Verbraucher blieb davon unberührt und bereitete der Pop-Kultur der folgenden Jahrzehnte einen fruchtbaren Boden.

Obwohl man die fünfziger Jahre kaum als eine Zeit unbegrenzter Freizügigkeit bezeichnen kann, wurden damals

schon die Weichen für das spätere anti-autoritäre Verhalten gestellt – vom Rock'n'Roll eines Elvis Presley und rebellierenden Anti-Helden, verkörpert durch James Dean und Marlon Brando, bis zum Abstrakten Expressionismus und der Gründung antinuklearer Bewegungen. Fernsehen und Flugreisen öffneten neue Horizonte und Satelliten leiteten schließlich das Zeitalter globaler Kommunikation ein. Der unübertroffene Überfluss dieses Jahrzehnts, den der ehemalige Premierminister Harold MacMillan treffend mit den Worten »wir hatten es nie so gut« charakterisierte, resultierte am Ende des Jahrzehnts in einem allgemein höheren Lebensstandard. Die fünfziger Jahre waren die Ära der »Traumautos, Traumküchen, Traumhäuser«, in der Massenkonsum zu einer sozialen und wirtschaftlichen Notwendigkeit wurde.

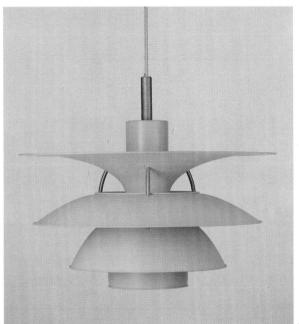

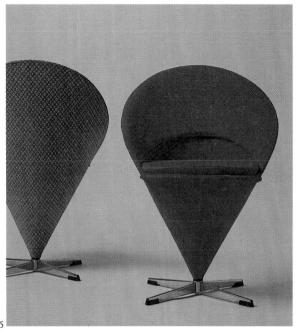

1

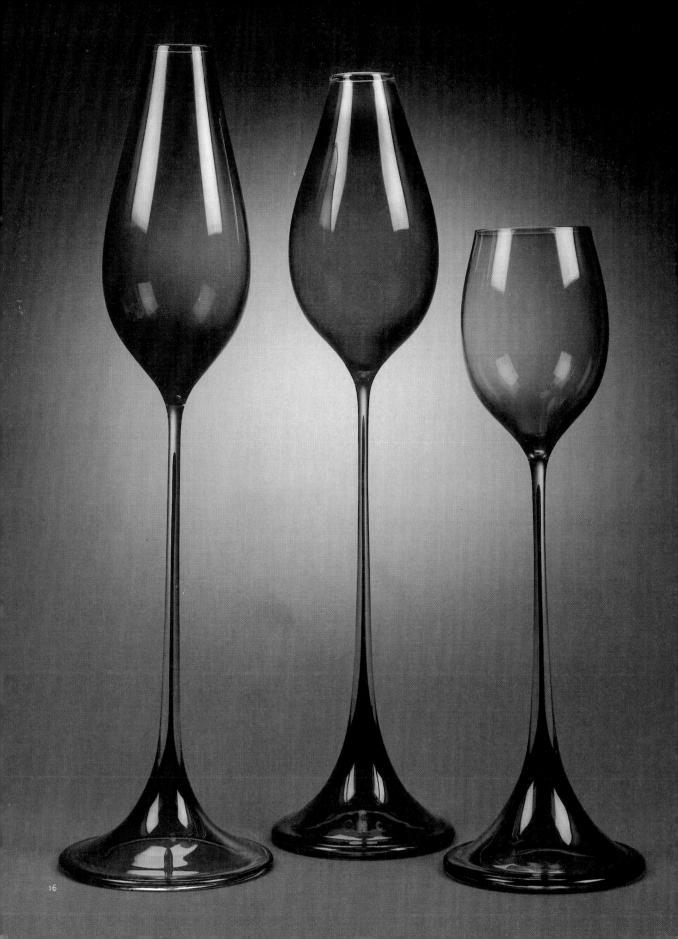

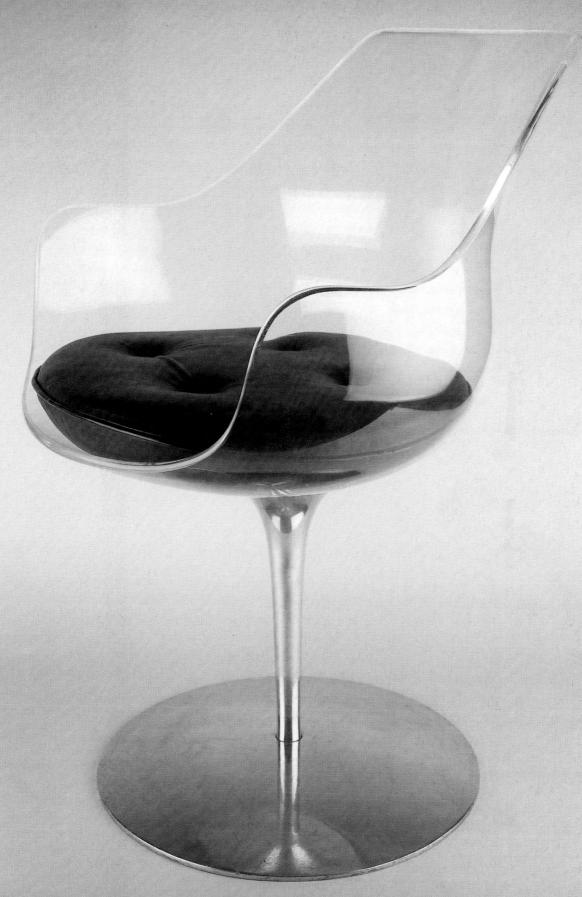

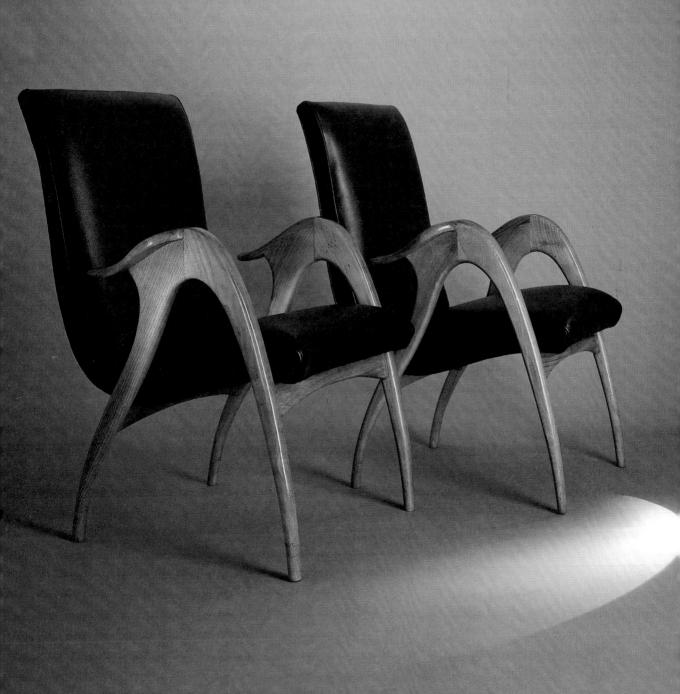

INTRODUCTION LES ANNÉES 50

- 18. Unknown designer, Leather & Walnut chairs for Malatesta & Mason,
- 19. Piero Fornasetti, Canisters for Fornasetti, c. 1955
- 20. Arne Jacobsen, AJ (Visor) floor lamp for Louis Poulsen, c. 1956

Monter son ménage avec le rêve américain

Les années 50 correspondirent à une période de renouveau et d'optimisme, l'austérité de l'après-guerre s'effaçant progressivement devant un essor de la consommation sans précédent. En Occident, le tumulte des décennies antérieures céda la place à la paix et à la liberté, tandis qu'on dépensait une énergie considérable à faire du monde un endroit plus vivable socialement, politiquement, économiquement et matériellement. Dans le domaine des arts décoratifs, les caractéristiques nationales, très marquées avant la Seconde Guerre mondiale, furent pratiquement annihilées par le «pacifisme constructif» dans sa quête universaliste de la qualité. L'architecture et le design bénéficièrent des nouvelles applications développées par la recherche militaire, des données anthropométriques ainsi que des matériaux et méthodes de construction de pointe. Les nouvelles matières telles que les plastiques laminés, la fibre de verre et la mousse de latex conditionnèrent le look des années 50. Les designers puisaient leur inspiration dans des sources aussi diverses que la chimie moléculaire, la physique nucléaire, la science-fiction, l'art africain ou la sculpture abstraite contemporaine telle que la pratiquaient des artistes comme Alexander Calder ou Hans Arp. Les formes angulaires et hérissées du début de la décennie cédèrent peu à peu le pas à des silhouettes plus organiques et biomorphiques.

Au début des années 50, l'Amérique s'était enfin débarrassée de l'atmosphère d'angoisse et d'insécurité associée à la Grande Dépression et entamait une période d'apparente abondance qu'alimentait la nouvelle culture du consumérisme. Toutefois, la prospérité des riches métropoles cachait la misère qui affligeait encore de nombreuses communautés rurales ainsi que les populations d'immigrants et les minorités ethniques. Les designers et les fabricants entretenaient les aspirations grandissantes des consommateurs en produisant des objets aux lignes épurées et tournés vers l'avenir qui incarnaient le « rêve américain ». Ces objets de désir étaient l'antithèse même de la mentalité de « débrouille et bricolage » des années 30 et 40. Ils étaient souvent conçus de sorte à devenir rapidement obsolètes afin de pousser à la consommation et, donc, d'entretenir la productivité et la prospérité. Aux Etats-Unis, la grande majorité des gens aspirait à un emploi stable (de préférence dans une grande entreprise), à une maison dans une banlieue bien entretenue, à une famille nombreuse, à une grosse voiture et à tout un éventail d'appareils mé-

nagers limitant les corvées domestiques. La maison devint le centre même du «rêve américain», et les industriels ciblaient sans merci cette nouvelle génération de ménages et de consommateurs.

Dans des pays européens tels que la Grande-Bretagne et l'Italie, l'austérité d'après-guerre fut surmontée par un savoir-faire reposant sur le bon sens et par une créativité époustouflante. Comme en Amérique, la maison occupa un rôle particulièrement important tout au long des années 50. Elle constituait un refuge où l'on se sentait à l'abri d'un monde où les technologies progressaient rapidement et où l'on pouvait oublier la menace bien réelle d'une guerre nucléaire. En Grande-Bretagne, plus de 350 écoles furent équipées d'appartements modèles où l'on enseignait comment tenir sa maison à une nouvelle génération de futures femmes d'intérieur. Cependant, au début des années 50, le secteur du bâtiment, surtout en Grande-Bretagne, était encore soumis à des régulations et des restrictions frustrantes. Le préfabriqué (la solution pour un logement bon marché) existait plus en théorie qu'en pratique. Il fallut attendre le milieu de la décennie pour que les Européens commencent à connaître le grand essor de l'immobilier qui s'était déjà produit aux Etats-Unis. Tous ces nouveaux logements nécessitaient de nouveaux ameublements, ce qui suscita un regain des arts décoratifs caractérisé par l'expérimentation technique. Les créateurs travaillant dans le domaine de la verrerie et de la céramique se

tournèrent vers les récentes recherches en métallurgie pour façonner des objets plus colorés et plus expressifs. Les stylistes du textile intégrèrent de nouvelles matières synthétiques à leurs tissus. Les orfèvres, notamment au Danemark, inventèrent des formes organiques sensuelles révolutionnaires.

Nouveaux logements, nouveaux modes de vie

Des deux côtés de l'Atlantique, la petite bourgeoisie bénéficia de la construction à grande échelle de petites maisons. Devenir propriétaire de son logement n'était plus l'apanage des riches. En Amérique, en Europe et en Scandinavie, où l'on avait instauré des programmes de logements d'aprèsguerre, l'accession à la propriété fut bientôt considérée comme un droit fondamental. En Europe, les bombardements avaient détruit de nombreux quartiers insalubres. Des cendres de ces derniers surgirent de nouveaux logements bon marché, subventionnés par l'Etat, et mettant l'accent sur l'urbanisation des quartiers. Les tours d'habitation, qui firent d'abord leur apparition en Suède, devinrent rapidement populaires dans les autres pays tandis que les méthodes de construction reposaient de plus en plus sur des composants fabriqués industriellement. Naturellement, les plus grandes avancées dans le domaine des habitations financées par le secteur public se produisirent dans les pays les plus industrialisés.

22

Ces nouveaux logements plus petits nécessitaient une meilleure organisation de l'espace. Cela entraîna l'apparition de nouveaux modes de vie qui requéraient de nouveaux types de meubles tels que des sièges modulaires, des cloisons amovibles, des placards encastrés, des canapés convertibles, ainsi que de nouveaux plans, tels que des espaces ouverts ou sur plusieurs niveaux. Ce modernisme ne fut pas accueilli partout avec la même ferveur. La France, notamment, resta déchirée entre le moderne et l'ancien. Toutefois, l'esthétique moderne gagna progressivement du terrain sur ce qu'on appelait le «complexe d'époque» et, vers le milieu du siècle, le « style contemporain » était devenu un style international très répandu et immédiatement reconnaissable. En faisant baisser les prix des produits, la production et la distribution de masse lui avaient permis de «s'imposer».

Les magazines, tels que les annuaires de *Decorative Art*, qui prônaient les finitions naturelles, les motifs et la structure en architecture, ainsi que la lumière, la flexibilité et la couleur dans la décoration d'intérieur, étaient en partie responsables de l'acceptation générale d'un langage moderne en matière d'ameublement. Les nouveaux magazines qui proposaient des thèmes de la vie domestique et des idées à réaliser soi-même ont aussi contribué au changement des perceptions et des goûts. C'est aussi le cas des salons et expositions, comme par exemple la très populaire Ideal Home Exhibition annuelle de Londres, qui exposa une

maison «idéale» à trois chambres. Les organisations financées par le gouvernement, telles que le Council of Industrial Design et la Design & Industries Association, ne cessaient de préconiser le design moderne en Grande-Bretagne. Pendant ce temps, aux Etats-Unis, le Musée d'Art Moderne de New York organisait des expositions de «bon design» dès 1950.

Le style contemporain

Ironiquement, la croisade lancée par la minorité progressiste des critiques de design et des conservateurs de musée fut dépassée par son succès: le design moderne explosa et devint une tendance stylistique populaire. L'ascendance du style «contemporain», ou du «New Look» comme Christian Dior l'avait déjà baptisé dès 1947, incita certains designers et fabricants à rechercher la nouveauté et l'anecdotique à tout prix plutôt que des solutions pratiques, au point que de gros appareils électroménagers étaient parfois embellis de poignées ou de cadrans qui ne servaient strictement à rien. Alarmée par cette nouvelle tournure, l'Association Britannique de Consommateurs lança en 1957 le magazine Which? pour informer les lecteurs sur la qualité relative des produits de consommation. Néanmoins, le consumérisme galopant des années 50 continua sur sa lancée, préparant le terrain à la culture pop de la décennie à venir.

Bien que l'on ne puisse vraiment considérer les années 50 comme une décennie permissive, elles semèrent les graines de la contestation de l'ordre établi, du rock and roll d'Elvis Presley et des antihéros rebelles incarnés par James Dean et Marlon Brando, à l'expressionnisme abstrait et à la formation de la C. N. D. (Campagne pour le Désarmement Nucléaire). La télévision et les transports aériens ouvrirent de nouveaux horizons, alors que les premiers satellites annonçaient déjà l'ère de la communication planétaire. La prospérité sans précédent de la décennie, parfaitement résumée par la célèbre réplique du Premier ministre britannique Harold MacMillan - «On n'a jamais été aussi riche» -, déboucha sur une hausse significative du niveau de vie. Les années 50 furent l'époque des « voitures de rêve, cuisines de rêve et maisons de rêve», durant laquelle la consommation de masse fut promue au rang de nécessité sociale et économique.

houses and apartments | Häuser und Apartments | Maisons et appartements

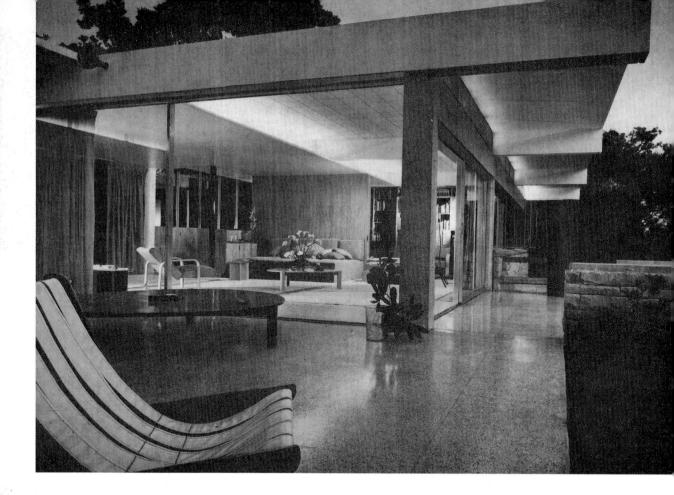

The house of Mr and Mrs Warren Tremaine, in Santa Barbara, has a structural solidity, deriving from reinforced concrete, and is enriched by the detachment of roof slab from the frontal girders. Each lintel girder has a uniform span of sixteen feet of the continuous lower openings, comprising doors, windows and sliding plate-glass fronts framed in anodized aluminium. Between girders and roof extends a tier of swingin windows which, when open, form a glass shelf. Continuous fluorescent tube lighting illuminates the ceiling. Ventilation takes place at ceiling height, where it is most effective.

Exterior and interior borderline is obliterated by a system of radiant floor heating extending to outer terraces. Living areas, covered and roofless terraces are combined in one flowing space, extending on the one hand to a roof deck of panoramic view and on the other to an underground gallery of graphic exhibits leading to a plateglazed pool and play porch equipped with its own cooking facilities.

HOUSE AT SANTA BARBARA

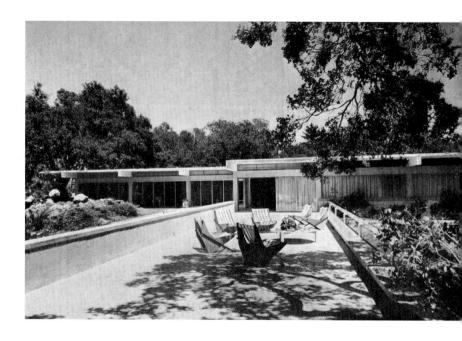

Despite such a conception of the private house, no suggestion of freakishness r novelty has been permitted in its design. Architect: Richard J. Neutra.

PPOSITE, TOP: Looking from the radiantly heated dining terrace into the living

uarters whose sliding glass walls have been pushed aside. All furniture was esigned by the architect.

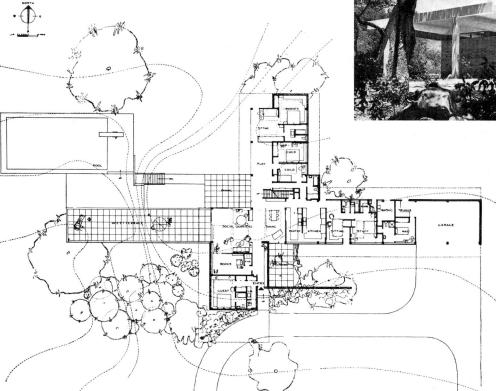

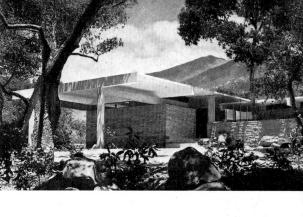

The terrazzo-paved ocean terrace, radiantly heated, extends west of the social quarters to a view of the ocean at its end. (Photos: Julius Shulman).

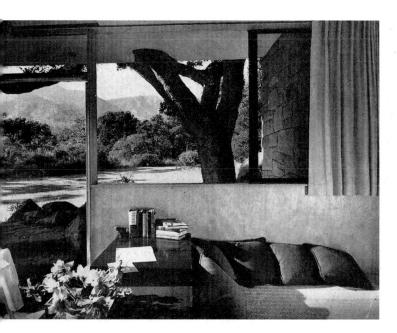

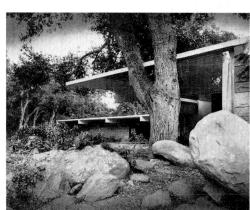

TOP: The roof slab cantilevers at the end of the house at Santa Barbara, California. ABOVE: A view from the north where old oak trees and rock outcroppings limit the building site. LEFT: The owner's private sitting-room. Note the cutting of the overhang to preserve the tree.

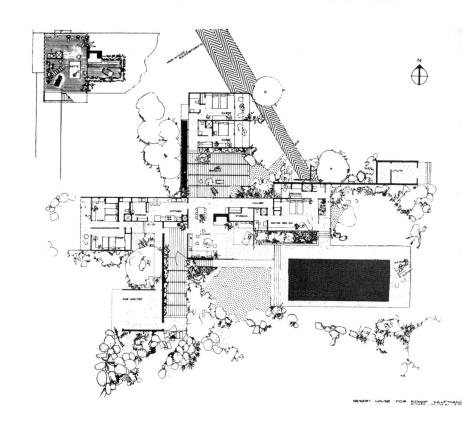

A HOUSE IN THE
COLORADO DESERT

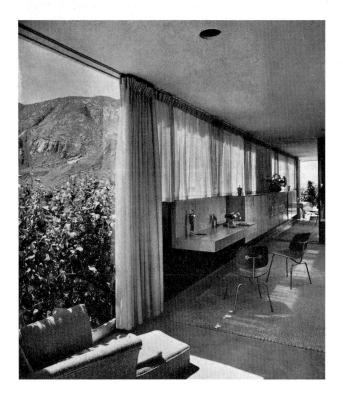

This four-courter house, designed by Richard J. Neutra, has Utah stormasonry walls sandwiched to structural cores to take horizontal and eartly quake strains, and is sited to be sheltered from north winds. All exterior walls have mica-glaze Cemelith finish. LEFT: Part of the master suite showing the wall-hung storage furniture of birch and the continuous curtain

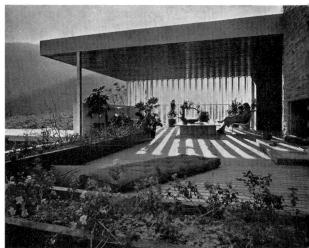

 $\mathbf{30} \cdot \text{houses}$ and apartments $\cdot\,1950\text{--}51$

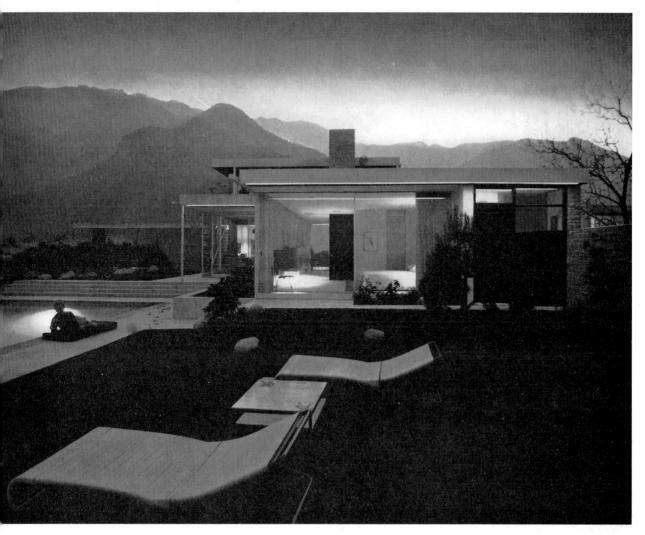

f light canary yellow. Opposite, RIGHT: A view of the outdoor-indoor ving-room with its vertical aluminium blinds, protecting against wind, in and sandstorm when closed. Opened, they allow air movement on hot ays and give a view of the mountains beyond. ABOVE: A view in late iternoon, looking towards the master bedroom across the lawn patio.

BELOW, LEFT: The bedroom wing from the swimming pool, and RIGHT: a view from the south over the oasis plantation. Large natural boulders give privacy to the entrance. The garage wall was made without mortar joints in softly coloured stratified Utah stone. (Photos: Julius Shulman).

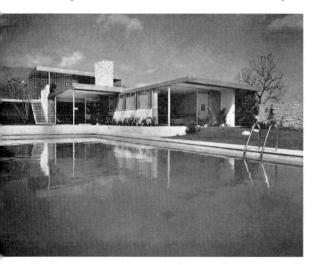

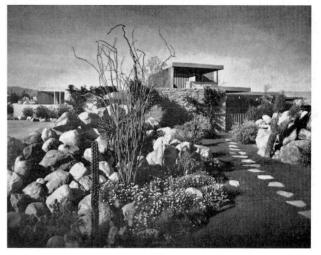

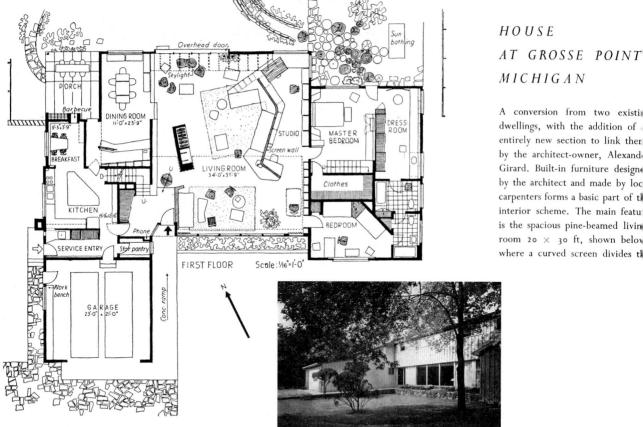

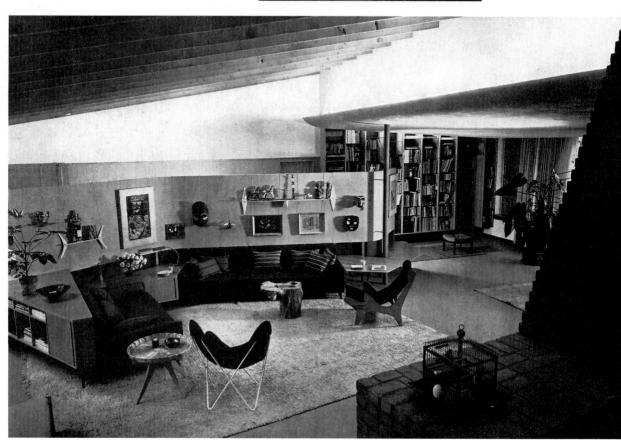

tudio from the living area. The walls are blacktained fir-plywood, with grey concrete floor, old cathode indirect lighting, natural rugs and ark brown sofas with red and yellow cushions. he natural orange brick fireplace in the same oom is seen here. Note the variations in eiling and the rise to the dining area. A antilevered staircase (BELOW) in the masteredroom leads to the children's room above, XTREME RIGHT: Another view of the master edroom. The bedspread is orange, the carpet and-coloured.

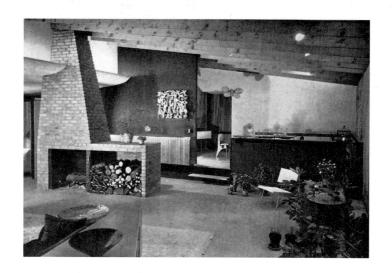

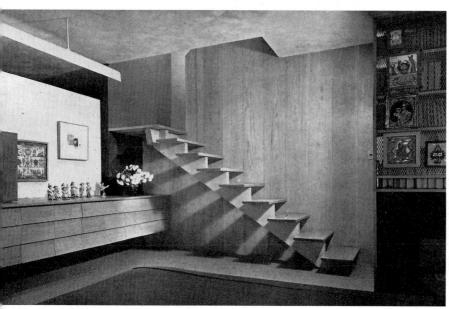

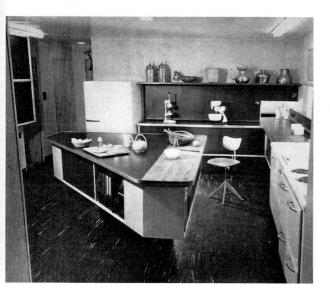

ABOVE: A counter with black linoleum top and white enamelled front, standing on pipe legs can be used as a food bar or as a serving surface in the dining-room. Tables in foreground of solid cherry-wood. LEFT: The kitchen with its three-way island table covered with black linoleum, fitted with a maple cutting board and designed for convenience from all angles of working. (Astleford photos).

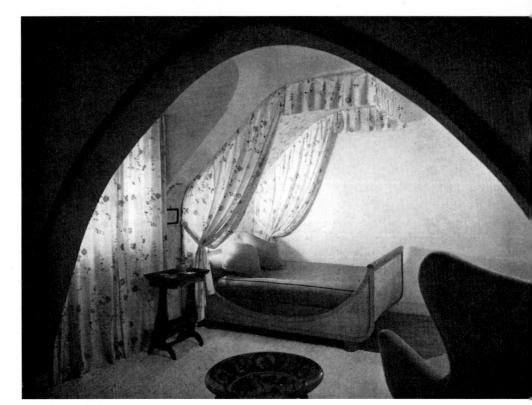

RIGHT AND BELOW: Two views of a small top storey apartment in Paris furnished with antique and modern pieces, the latter in natural oak and cane. The curtains and bed draperies are straw-coloured chintz patterned in mauve and carmine.

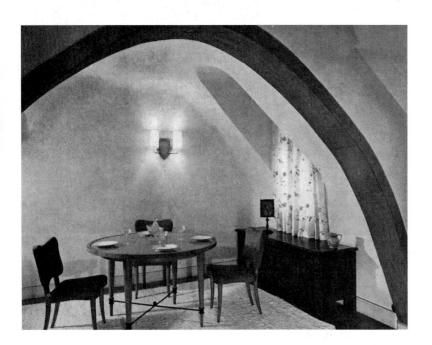

THE PARISIAN APARTMENT

BELOW: Recessed shelving, the beading painted in tête de nègre, is a feature in this French lounge. Ivor walls form a background to the rust-coloured curtain and upholstery in tête de nègre. (Collaborator: Jacque Levy-Ravier)

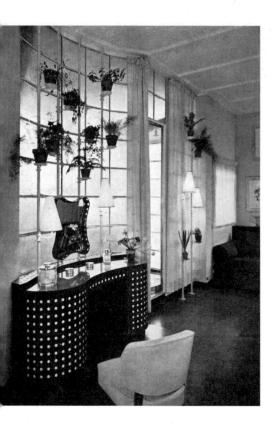

LOW: This French living-room has a red brick fireplace and een coverings to the large settee and chairs. A pleasant splash colour is given by the orange lacquered base of the floor lamp. LEFT: Metal dressing-table lacquered royal blue with perforations showing the ivory lacquered wood beneath. White poles support the lighting and the plant holders.

BELOW: The other end of the bedroom shown on the left, with similarly perforated book shelving. The divan covering is royal blue.

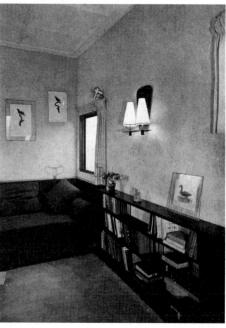

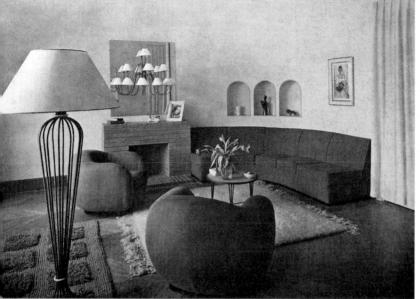

The decorative schemes on these two pages are by Jean Royère (france).

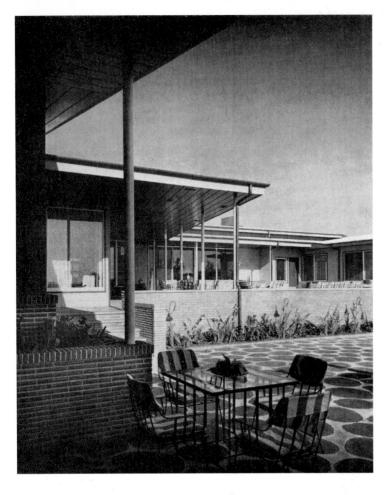

The residence of Mr and Mrs Charles P. McGaha. LEFT Looking towards the living room. Exterior finish redwood siding painted blue. Special planting areas have been retained and framed by split brick and lighted for night effects by wrought iron crook-staff bells. Below A pool-side view of the house and its terrace made are dwood blocks set in cement. Black wrought iron furniture on terrace with cushions and backs covered in recewite and blue striped sail cloth.

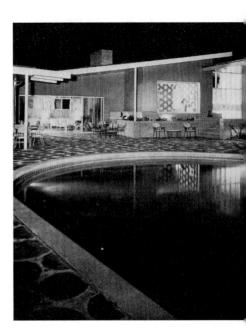

WICHITA FALLS - TEXAS

ABOVE: The entrance gate is radio-controlled by walkie-talkie units at the gate and in the house. RIGHT: The St Charles kitchen containing steel cabinets lacquered light blue; Hotpoint garbage disposal and dishwasher; and built-in electric range and oven by Thermador. The floor is blue and white rubber tile.

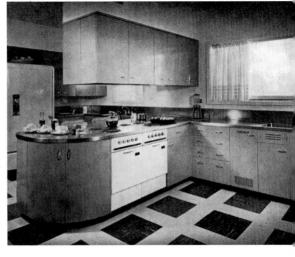

The daughters' dressing-room furnished in a scheme of green and red lacquer, and a mirrored wall which gives an impression of size. Chairs covered in quilted chintz, one in red, the other in green.

BELOW: The games room with chairs and sofa upholstered in unborn calfskin, and draperies hand-painted with the motif of the Katchina dolls made by the Hopi Indians. Poker table covered with russet leather and fitted with individual drawers for players' poker chips. The free shape rug and ceiling are in strawberry ice-cream colour.

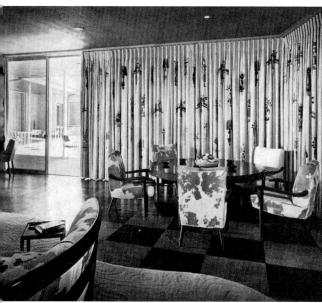

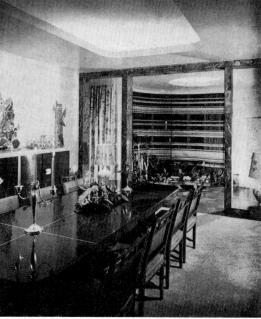

ABOVE: The dining-room has a blue lacquer table with blue plastic top, and the blue lacquer chairs are covered in rose-copper leather. The buffet, also in blue lacquer, has a cork top. The carpet is sea-green. Through the archway is the flower room, with a hand-woven reed screen to the window.

GHT: In Mrs McGaha's dressing room the alls are deep aquamarine, the carpet is ey-green, and the split reed screens equered red, handwoven with threads of ack, white and gold. The dressing table it is lacquered the same colour as the alls and contains a built-in sewing achine which can be raised to table level. th chairs are of solid Lucite covered in ilted Italian silk printed in Switzerland th blue, yellow, red and beige preminating. Interiors designed by Paul szlo. Executed by Laszlo Inc (USA).

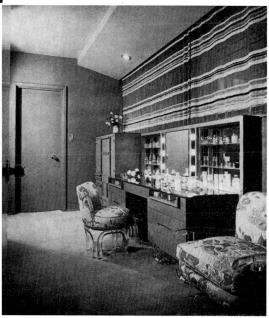

Dr Treweek's redwood house overlooking the lake is one of a pair designed by the same architect whose aim was to merge the house harmoniously into the natural surroundings of eucalyptus trees. CENTRE: A view along the flagstone-paved terrace to the kitchen door.

BOTTOM: The living-room, which occupies a

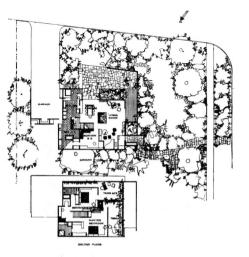

LOS ANGELES, CALIFORNIA

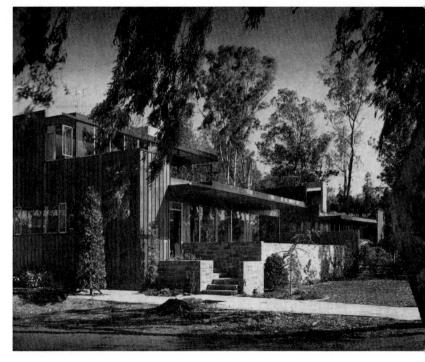

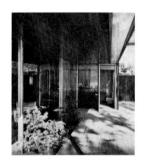

large area of the lower floor, has a free standing fireplace in narrow grey flagstone. Behind it is the dining area. A bay towards the north windows comprises the music area, and contains the piano, radio, gramophone, books and television. Below: The built-in dressing table, made of birch, has a mirrored fold-down lid, and is fitted with a brown Formica top on the outside. The wall panelling is of light bleached birch, fitted with mirror on one side. Architect: Richard J. Neutra (USA).

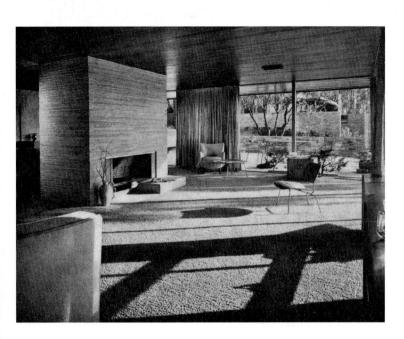

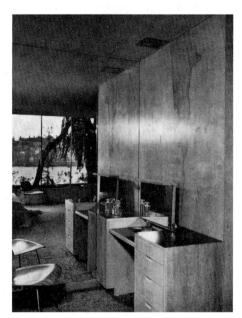

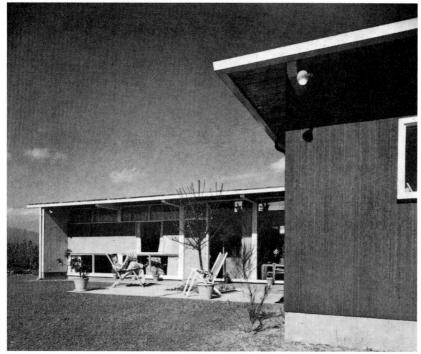

This British Columbian home makes use of the many building timbers available in Canada in its exterior and interior. The wall to the left is of striated plywood yellow-greyed off, with a horizontal spandrel to the studio wall of 1 in. by 6 in. cedar V-joint painted dark grey green. All posts, beams and window frames are white, and the door greyed-off cobalt blue.

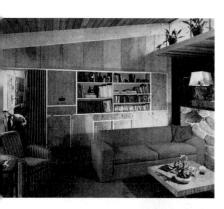

The three interiors are all of the same room. The fireplace is of rough split granite boulders in soft colours varying between grey, pink, green and rust, with white cement joints. Wall fitments and panelling of Western birch plywood with white fir framing to the shelving. In the left-hand picture is seen the 'Modernfold door' (grey-green fabric on a concertina steel frame) which leads to the studio.

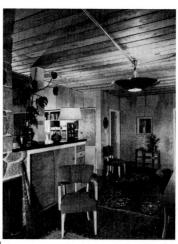

view from the fireplace. he wall on the left is overed with burlap glued to bugh plywood and painted ey pink, and the door is ush plywood. A mushroom-loured broadloom carpet overs the plywood floor. rchitects: Gardiner & hornton, MRAIC, ARIBA CANADA).

hoto: Graham Warrington)

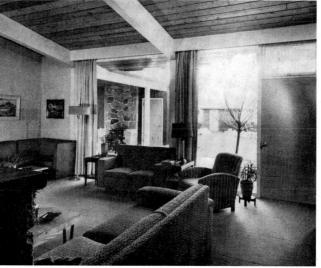

VANCOUVER, BRITISH COLUMBIA

Photos below and right: Courtesy of Architectural Review

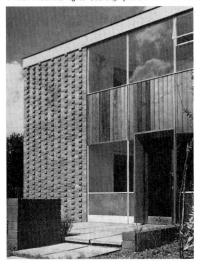

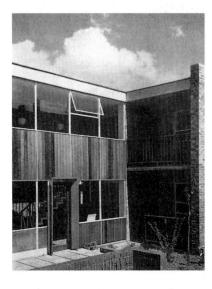

FLATS AT TWICKENHAM

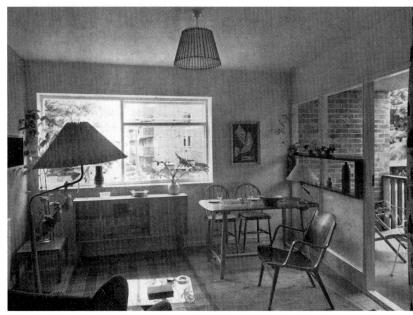

The exterior of the block of six flats known as 'Box Corner', Twickenham, Middlesex, is of pleasant-looking golden brown brick, with pattern of projecting red brick, and panels of oiled cedar boarding assuming a natural unevenness of colour. The balconies also have cedar balustrades. In general, the paintwork is white with turquoise blue reveals to the main door architrave. Internally, the staircase balustrade between floors is metal painted pale grey with polished mahogany capping, and the brick wall is golden brown, dark stained headers making a formal pattern. The stairs and passage flooring is of blue and pale grey rubber tiles. In each flat the living-room is divided from the balcony by a glazed screen (the upper part clear, the lower translucent) in painted softwood with a shelf unit in polished hardwood. The first floor flat illustrated has contemporary furnishings from Dunns of Bromley. Architects: Eric Lyons FRIBA and G. Paulson Townsend LRIBA (GB)

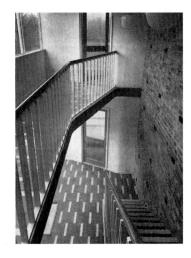

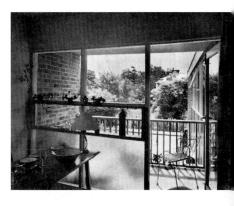

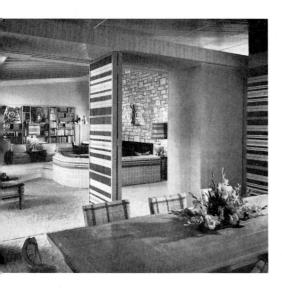

HOUSE AT BEVERLY HILLS

and Mrs William Perleberg have a large livingm, in their Californian home, divided from the ing-area by handwoven reed screens. It is nished in soft tones of beige and grey with ents of red and brown. The upholstered pieces in beige plaid with a brown stripe; the dining irs and table in bleached walnut. TOP RIGHT: Perleberg Junior's room with built-in teleon, radio and bookshelves, and striped chintz the upholstery and draperies. BELOW LEFT: e master bedroom with a raised fireplace of vertine marble and sliding doors below giving iew of the garden. In front of it, a glass-topped te on Lucite base. The quilted bedspread is of e silk matching the rose carpet, and the sofa is juilted red and white silk handprinted. BELOW HT: Washbasins, in the dressing-room/bathm fitted to a centre partition, form an island h access from either side. The ceiling has t-ray, infra-red and daylight lamps. A further stration is shown on page 38. House and eriors designed by Paul Laszlo (USA)

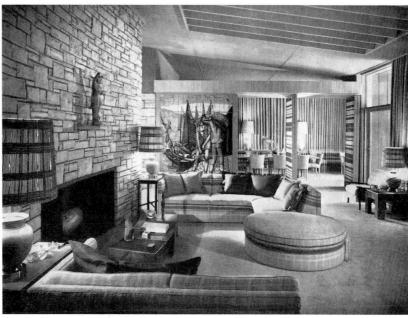

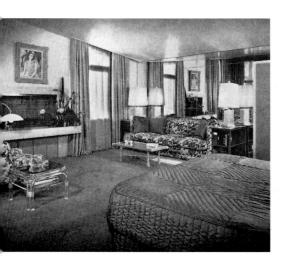

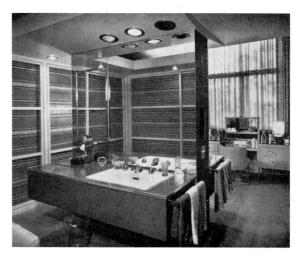

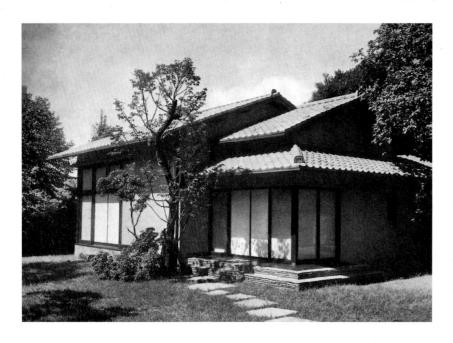

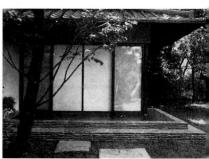

A STUDIO HOUSE IN JAPAN

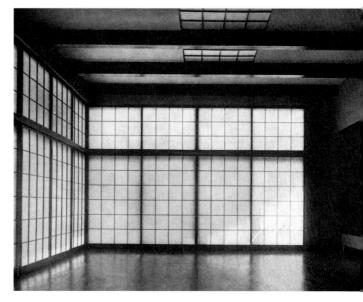

Although this is a new house (and it appears modern enough to Western eyes nevertheless follows traditional Japanese principles in domestic architecture; princip which take into account the need for standardized features employed in such a man as to give variety in unity. It was built for Mr Ryuzaburo Umehara to the designs Professor Isoya Yoshida. The austerity of the interior appointments may amon to starkness in comparison with Western ideas, but the rooms are not bare. I design, as in all Japanese houses, makes a virtue of economy, giving pleasure in quiet refinement, clean lines and absence of furniture as well as in its relation to garden of which it forms a part. The exterior of the house is painted light yelle the wooden uprights dark brown with Japanese tiling on the roof, and green rock pla forming the terrace. In the studio (ABOVE) the clay wall is dull red, and there sliding doors which push back to the right-hand wall. The platform in the alco (LEFT) is lacquered dark brown with pillars of keyaki and vertical wooden upriglacquered vermilion.

A NEW YORK APARTMENT

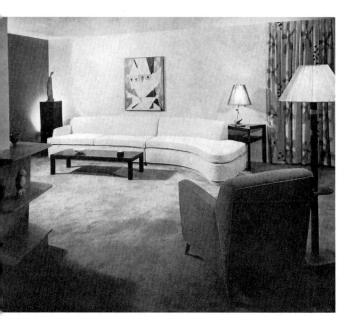

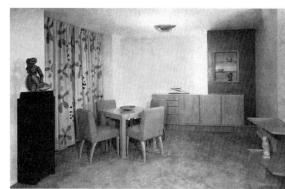

ne large living-room in this City apartment is dominated by the two-piece sofa, -ft long, designed especially for television viewing, covered in hand-woven white enille shot with gold. A black lacquered angle table, low coffee table, and a inting by Hans Moller complete the group. Facing the sofa is the television binet, its 24-inch screen concealed by slide-in doors. The bookshelves architecrally connect living-room to dining alcove and are in platinum walnut. The armair is covered in coral fabric. Living-room walls are grey with a purple section the left of the couch. In the dining alcove, the grey walls again have a purple ction to the right of the buffet and coral coverings to the platinum walnut chairs. ne wood sculpture by Milton Hebald stands on a black lacquer pedestal flanked by ind-printed curtains on grey and silver ground by Donelda Fazakas. The two nall illustrations (RIGHT) show the bleached mahogany chests in the bedroom, the ntre drawer section of which is fitted for jewellery and similar items; and a close-up ew of the black lacquered table seen in the top illustration with its lamp on a ulptured wood base and reed shade designed and made by James L. McCreery. the master bedroom the bedhead and bedspread are of light blue satin, the rmer framed in hand-sculptured bleached mahogany, the same wood being used the side tables and chests. On this floor is a gold-coloured carpet, blue, beige d gold being repeated in the sheer gauze draperies and grass cloth on the walls. esigners and makers: Wor-De-Klee Inc. (USA)

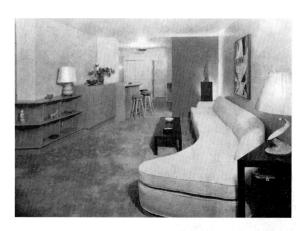

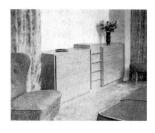

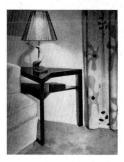

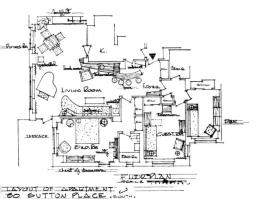

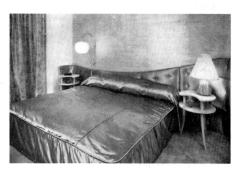

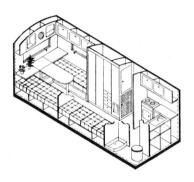

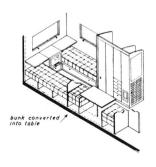

A HOUSE ON WHEELS

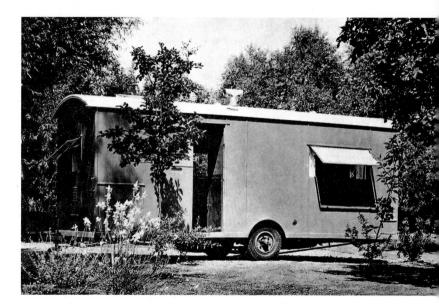

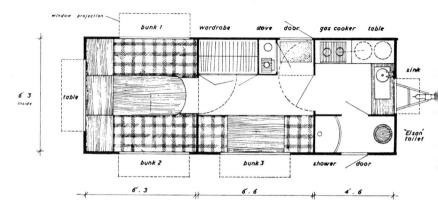

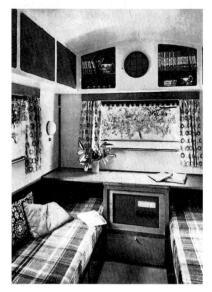

This trailer was designed as a home for two, with a third bunk when required. Its over-all size wa limited by regulations and weight for towing by a 20-h.p. car: the kitchen was placed forward becaus its heavier equipment would make the trailer tail-heavy if placed at the rear. Outside walls painted fla pale grey, roof silver painted, window frames bright chromium with green and white sunblinds, an red and white curtains. Carpet is pale grey, with yellow, green and white bunk covers over rubbe mattresses. Kitchen has white walls and cupboards, grey linoleum, zinc and teak table tops. Ligh either from the 12-volt car battery or from the butane-gas cylinders used for cooking and heating Architects: Tayler & Green FFRIBA Makers: Bertram Hutchings Caravans Ltd (GB)

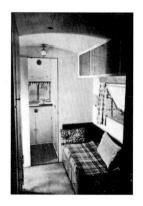

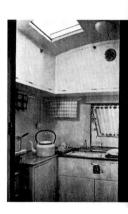

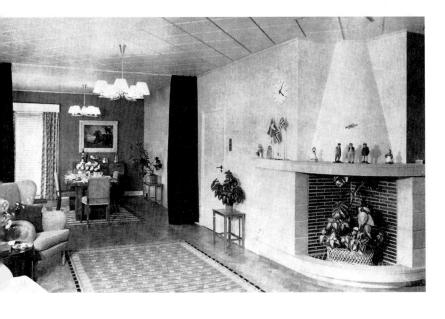

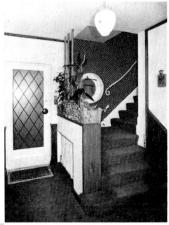

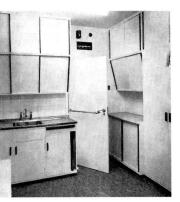

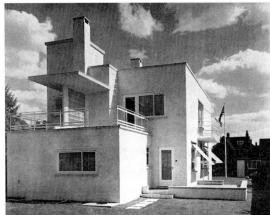

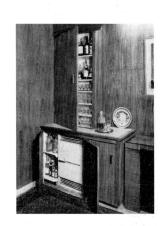

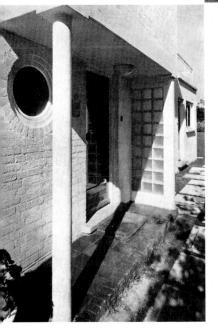

A HOUSE IN NORFOLK

'Varmland', in the East Anglian city of Norwich, replaces a bomb-destroyed house. Built of rustic Fletton bricks sprayed with *Snowcem*, it embraces both structurally and in the interior details many Scandinavian features, from the corner fireplace in the living-room to the Swedish rugs and Danish light fittings. The front porch has a glass brick screen, a circular window, and the name of the house in a coloured coat-of-arms plaque. The rear elevation shows another glass brick screen on the first floor, and the sun terraces. Internally, the entrance hall is carpeted in cherry red, the door panel is of acid burnt glass with Swedish handles, and the wallpapers (John Line & Sons Ltd) are blue and white with a star motif. The L-shaped living-dining room has beech parquet flooring with Swedish rugs predominantly blue in colour, the decorations are in grey and geranium red, and the fabrics are blue, white and red. In the kitchen, the cupboards have been recessed over the working surfaces which are faced with Formica: the cabinets have sliding doors of Masonite, white enamel finish. The small illustration shows an Australian walnut cocktail cabinet with built-in Electrolux refrigerator. Designer: Paymond King. Executive architect: Thomas F. Trower friba (GB)

OTHAM, KENT

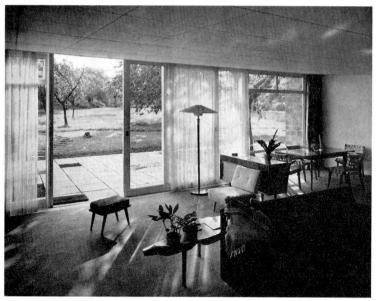

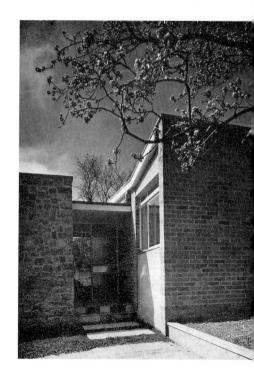

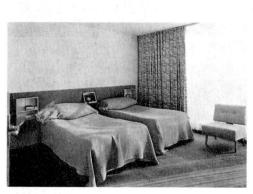

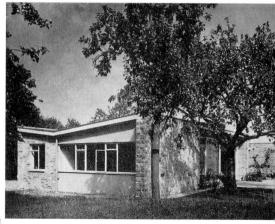

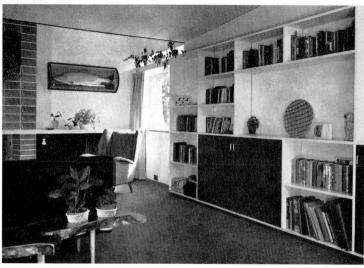

This house, set on a sloping orchard site of about one acre, and designed for the architect's own use, is of Kentish Ragstone multicolour bricks and blocks rendered with a pale blue-grey cement: interior walls are white. All large panes of glass are in Insulite double-glazing, and the living-room (top left) has full-height glass, the sliding door running on a rubber-covered track. Floors are of solid concrete with embedded wire radiant heating, covered with gunmetal fitted carpet. The contemporary upholstered furniture, by Hille of London and Dunn's of Bromley, is in black, pale yellow and warm grey fabrics. The bedroom scheme is in pale blue with a specially designed upholstery and sycamore bedhead. Another view of the living-room is shown at lower left: the shelving and walls are white, with macassar ebony and mahogany fronts to the cupboards. This bookcase, the bedhead, low yew tables and mahogany dining chairs were made to the architect's own designs by F. W. Clifford Ltd. Architect: Brian Peake, FRIBA (GB)

'UNBRIDGE WELLS, KENT

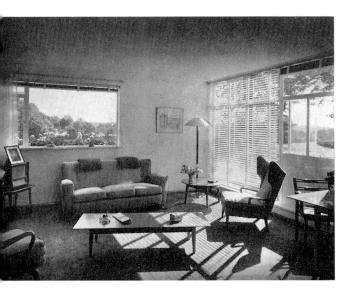

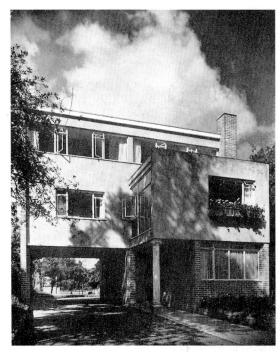

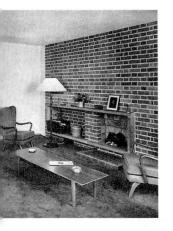

Designing a doctor's house presents special problems since it is desirable that the accommodation necessary for the practice should be separate from the living quarters.

The ground floor in this housebuilt for Dr and Mrs Oswald-Smith on a site only 40 feet wide-is occupied almost entirely by the doctor's consulting rooms, but includes garage space for two cars. Above is a projecting living-room, facing south. The interior (top, left) has an olivegreen fitted carpet, white walls and white venetian blinds to a ceilingheight window. It is furnished in natural mahogany with upholstery in a warm grey/beige fabric. The tiled fireplace (left) is built into a background wall of grey, white-pointed brick, the extended surround forming a frame for a niche. RIGHT: Natural mahogany stairway with bamboo screen and grey brick wall. Bottom right: Dividing the livingroom from staircase lobby is a fitted 'sideboard' in natural mahogany with panels of pale blue Warerite and reeded glass; a service hatch is included. The two bedrooms (one of which is illustrated bottom left) are on the top floor, and have fitted cupboards and built-in dressing tables. The exterior (top, right) is finished in grey, white-pointed brick with infilling panels rendered in pale grey cement. Window frames are painted white, the front door pale yellow. Architect: Brian Peake, FRIBA (GB)

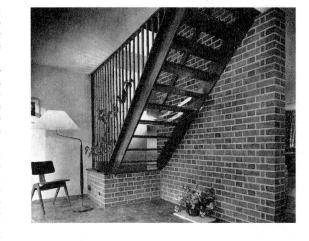

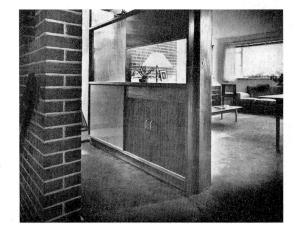

Designed by Mr Leslie Gooday, ARIBA, for his own use, this house at Sheen was built to a floor area of only 1,245 square feet within which are accommodated three bedrooms, living room, studio, bathroom, dressingroom, hall, kitchen, utility room and garage. RIGHT: Exterior of Uxbridge flint bricks with 15° pitch copper roof on timber trusses. BELOW: Lounge and raised dining area. The insulated ceiling slopes up from the fireplace to about 12 feet with the dining area ceiling at a lower level. Window wall is of Pirana pine in grooved 4-inch strips. BOTTOM, CENTRE and RIGHT: Corridor dressing-room, equipped with dressing table, wash basin and fitted wardrobe, and brick-walled kitchen with cantilevered table. Furnishings are in House & Garden colours and David Whitehead fabrics (GB) Courtesy 'The Architect & Building News'. Photos: J. R. D. Heming

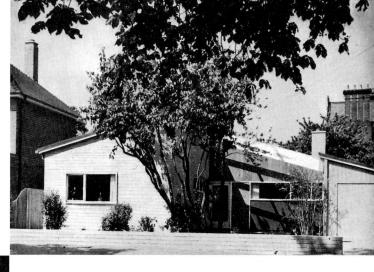

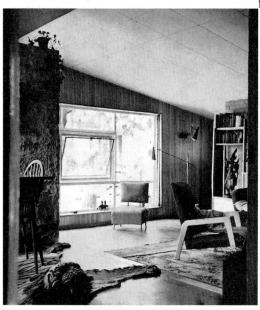

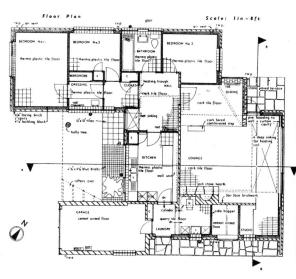

SHEEN, LONDON, SW14

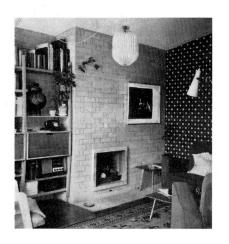

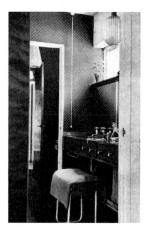

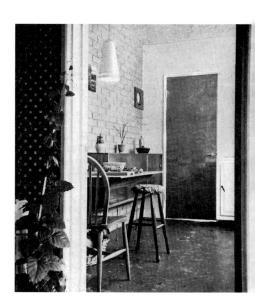

BEVERLY HILLS, CALIF.

Mr Neutra's sound principles of designing a house to the 'biology of the landscape' and to the 'biology of the humans who are here to cast anchor' are embodied in the home illustrated on this page. The problem involved was mainly to fit the house to a very steep hillside and to provide some level outdoor sitting areas. An outdoor patio was one of the stated requirements and a balcony facing west was developed in addition.

The house hugs the hillside and is reached by a gently sloping path ending in a flight of steps up to the wide entrance porch. A trellis on which growing vines are trained affords interest and shade to the entrance. The living-room faces south-west overlooking a canyon on one side and, on the other, opening directly, through wide glass doors which slide apart, on to the spacious patio. This device visually enlarges the living-room space and enables meals to be taken outdoors, if desired, with the minimum of inconvenience. Beyond the patio a terraced garden planted with shrubs and bushes leads the eye up the hillside. At the fireplace end of the room are metal-covered cupboards for wood storage, and a record cabinet and record shelves are ranged under the windows. Architect: Richard J. Neutra, FAIA (USA)

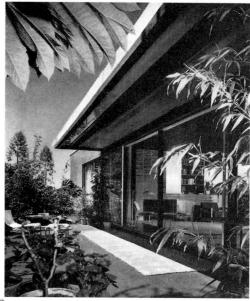

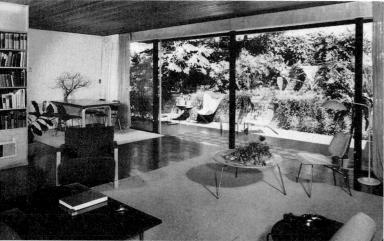

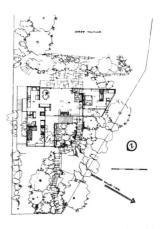

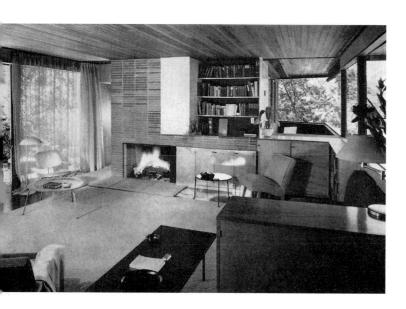

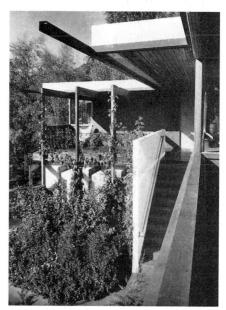

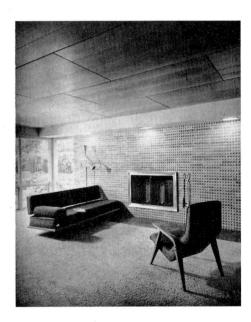

In this Canadian home built for Mr and Mrs L. J. Lefohn, the living-room brick fireplace wall of a novel design is thrown into relief by lights inset in the Luan mahogany-panelled ceiling. Couch and chair, also of Luan mahogany, are upholstered in a grey rough fabric with a light rust geometric design. RIGHT (Top): Diningroom. Walls are light cocoa, ceiling grey; mahogany furniture with bleached oak contrasting surfaces; chair coverings cotton Celanese in a soft yellow shade. CENTRE: Hall table of 3-inch armourplate glass on driftwood grey tree stump with flat lacquer finish. Light fitting of spun aluminium on Luan mahogany stem. Coral pink partition wall, grey carpet. BELOW (Right): Recreation room panelled and furnished in bleached Philippine mahogany, upholstery in tan and chartreuse. White tiled floor, streaked beige, with copper dividing strips; draperies in off-tones of floor colours. Tempera mural (shown below), painted by the architect, based on Nootka Indian art. The house was designed and furnished by Robert R. McKee, B.Arch, MRAIC. Furniture makers: Segal's Studio, Ridgewood Studios Ltd and the Progressive Manufacturing Co (CANADA)

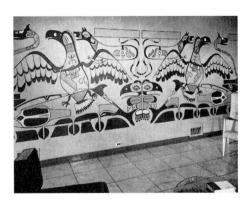

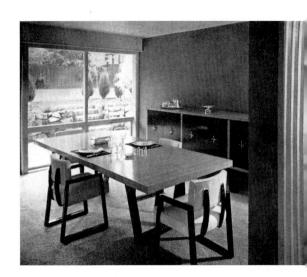

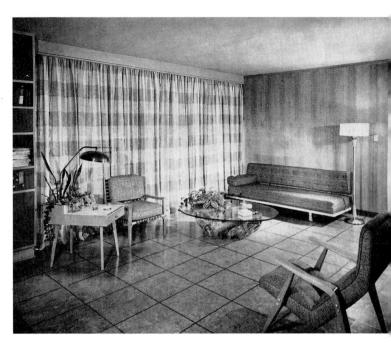

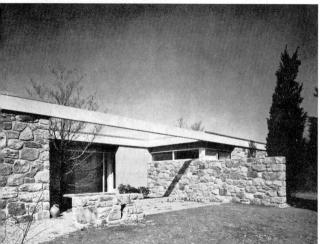

NEW CANAAN, CONN.

A house in Connecticut planned with an integral continuity between interior and exterior. The bluestone flagged court is repeated in bluestone flooring throughout, sliding windows replace doors; ceilings are natural cypress. An unpainted asbestos cement board facia gives unity to the exterior (left). The desk (centre) is of painted wood with Marlite sliding panels to bookshelf. Kitchen: Teak counters, other surfaces white. Dining-room: Teak table, foreground wall blue, background yellow. Grey Marlite sliding panels open onto the Living-room with its white-painted brick fireplace against a blue wall. The Travertine-topped table, leather lounge chairs on black frames and grey tweed-covered Knoll couch suggest a masculine atmosphere. House and furniture designed by Marcel Breuer, A1A (USA)

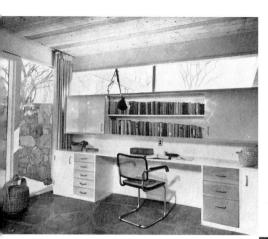

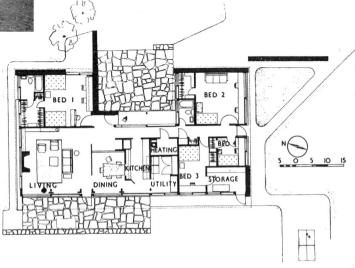

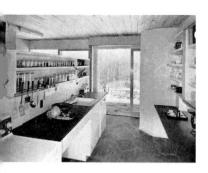

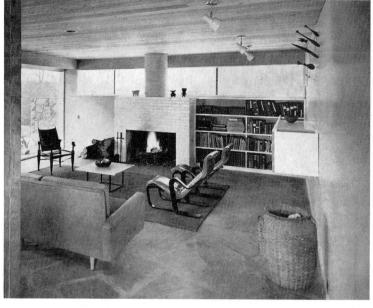

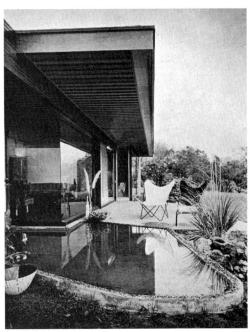

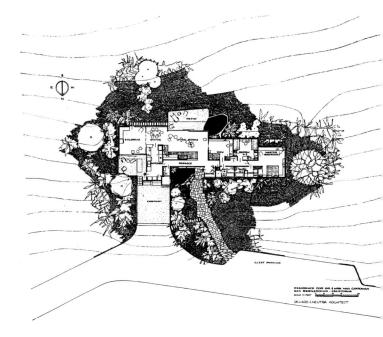

SAN BERNARDINO - CALIFORNIA

This house was designed for Dr and Mrs Max Goodman and their two young sons, and is built on a height overlooking the town towards the south. It occupies not more than 2700 sq. feet, but by planning the living room, den, dining bay and solarium as one visual unit, a sensation of uninterrupted space is created; this is further emphasised by the corrugated light pine ceiling continuing, through glass partitions underneath, onto the roof overhang, where it is reflected in a strategically placed pool. The livingroom is carpeted in moss green, curtains are brick. BELOW is the children's playroom and/or solarium, which has a built-in television set fitted with a birch covering door, a birch-panelled wall, Vinylite cork floor covering, and a wall seat upholstered in white plastic. Architect: Richard J. Neutra, FAIA (USA)

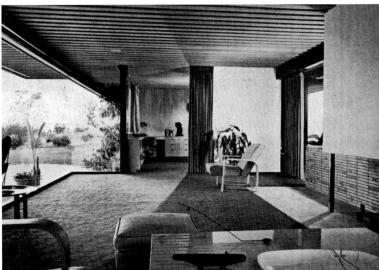

52 · houses and apartments · 1955-56

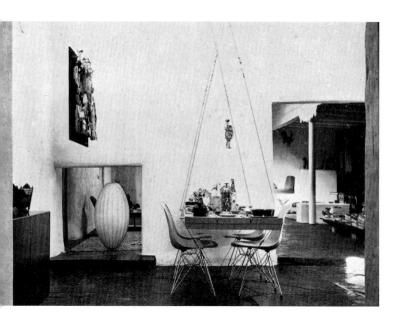

SANTA FE - NEW MEXICO

This house was remodelled, restored and added to by the designer to serve as a home for his family, as an office and as a workshop. Previously it was of three different periods, the oldest dating back over two hundred years. It is a good example of a successful partnership between old and new styles: for instance, the twentieth-century fibre glass plastic chairs, by Charles Eames, do not look at all incongruous in a setting of adobe and pumice white-plastered walls hung with folk carvings, and native red stone flooring. The pine dining table is suspended from ceiling and floor by steel and nylon cables. Opposite it is a mural (shown bottom) executed by the architect in brilliant casein colours. The living-room is all white with bright colour accents such as the fireplace seat upholstered in magenta and orange Peruvian wool fabrics. In the kitchen is an impressive perforated masonite pine-framed utensil rack. Architect: Alexander Girard, AIA (USA)

(Photos: Charles Eames)

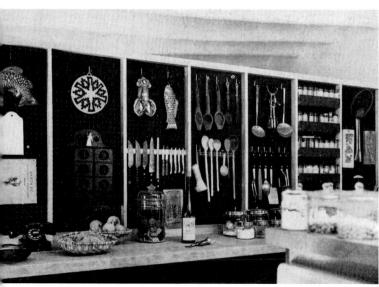

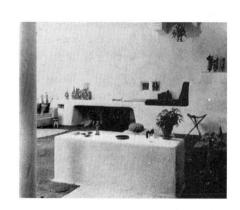

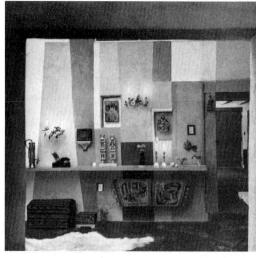

MARTINEZ - ARGENTINA

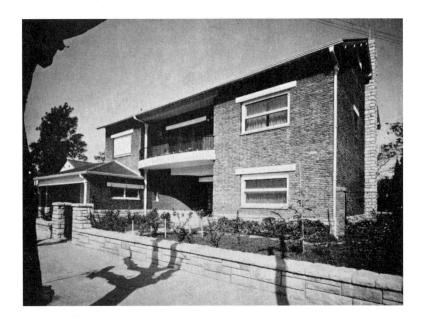

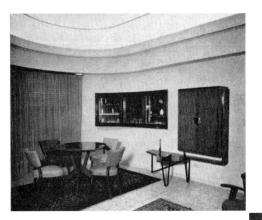

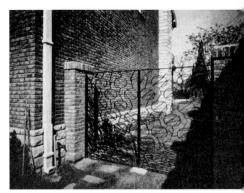

The houses illustrated on this and the opposite pagare built in the environs of Buenos Aires, and both at designed to give protection against, and to obtain the maximum benefit from, the hot climate of the Argenting. The home of Mr Francisco Hirsch is built of brick with a wide overhanging roof and a recessed porch and loggia. Each window is fitted with sun blinds which at rolled up under neat white panels when not in us. The chimney and the low garden wall are of Mar delay Plata stone; the decorative wrought-iron gate we designed by Mrs. Hirsch.

A winding stairway in shades of green terrazzo leas off the main hall, which has yellow walls and a vaulte roof in blue; background linen draperies are brick re The sitting-room (below and far left) has grey ar yellow walls and is furnished in natural peterebi woo with chairs upholstered in Nile green and yellow linenthe sofa in grey, yellow, and black cotton tweed. The last two colours are repeated in the shades of the adjustable floor lamp beside it. Floor and hearth are green terrazzo; the latter is framed in black palissand and rests on a dark peterebi base, extended on eith side as an ornamental shelf. By the window are tw wall cabinets. The first contains objets d'art; the secon (which forms a continuous unit with the small tab below it) is a fitted bar with sliding doors and interi lighting. Furniture and fittings are by Adams sR lighting by Ilum, sc. Architect: Federico Werm (ARGENTINA)

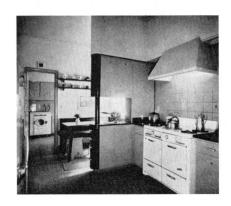

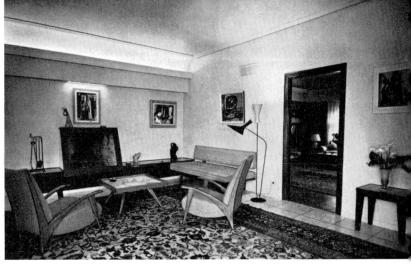

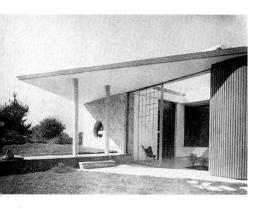

SAN ISIDRO - ARGENTINA

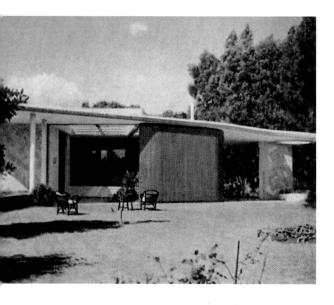

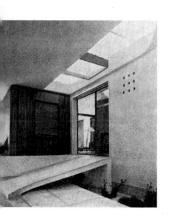

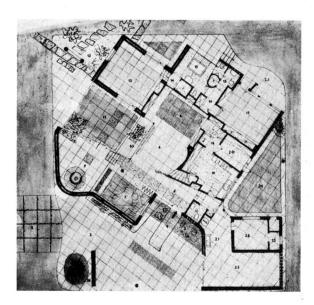

Built in the centre of a 'V' shaped site, the house faces north, (equivalent to a southern aspect in the northern hemisphere). The square plan of the roof and floor gives a parallel frontage to the street, while the main rooms are orientated at an angle of 37° to obtain the greatest value from the sun; co-ordination is achieved by cuttings in the roof line. Exceptionally wide eaves protect the walls from the summer heat. Basically, the floor area, both inside and out, consists of 3×3 foot squares of polished terrazzo, serving as a pattern for the distribution of the walls, while oak, marble, linoleum and other materials emphasise the special character of individual areas.

At left is the central patio which has a sliding roof of double iron plate with sun shutters opening in any direction. The main living-room, with slatted cedarwood wall, lies immediately behind it. Exterior walls are in a variety of finishes, and a glass mosaic by the painter Carybé decorates the entrance. Below, *left to right*: Entrance bridge spanning an ornamental fish pond; bedroom window wall with fitted mosquito frames; corner of the living-room—fireplace in cement and refracted brick. Designed by architect Martin Eisler for Mr. Alfred Silbermann (ARGENTINA)

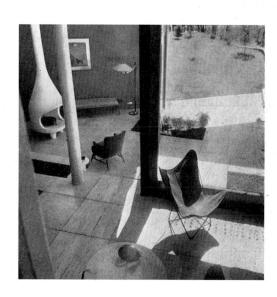

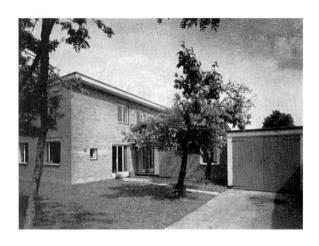

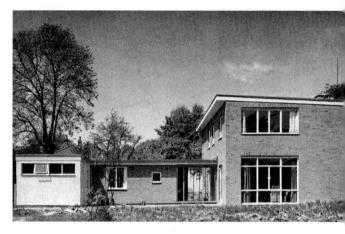

SYDENHAM - LONDON, S.E.26

This five-bedroom house was designed by the architect for his own use. It is situated off a quiet road in one of the London suburbs, and has an enclosed garden with fruit trees. Living and sleeping accommodation are in the two-storey block, and a hall, cloakroom and study in the single storey, which runs at right angles to the former with a double garage at the end. Excluding the garage, the total area occupied is 1500 square feet. The two-storey block has 11-inch cavity walls of buff facing brick, and the single storey is in 9-inch brickwork, colour washed in blue and in white.

On the ground floor is a combined living-dining room with french windows opening onto paved terraces on the south side. The kitchen opens directly off the dining recess and has direct access to it via a hatch inset in a wood-panelled wall. Other walls are in fairfaced brickwork or are distempered in light colours, the surface area being broken up with small niches. Flooring is concrete on hardcore finished with Marley tiles. The lower flight of the staircase, which rises directly from the tiled hearth, has precast reinforced concrete treads cantilevered from the adjoining wall with a metal handrail painted white; the upper flight is in polished hardwood. Heating is provided by a Weatherfoil unit housed beneath the stairs; supplementary warmth in the living area is radiated from a new type of pressed metal free-standing open fire. designed in America, which is seen in the illustration at right. Architect: Edward D. Mills, FRIBA (GB) (Courtesy: The Architect) (Photos: Colin Westwood)

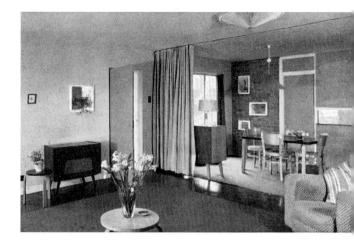

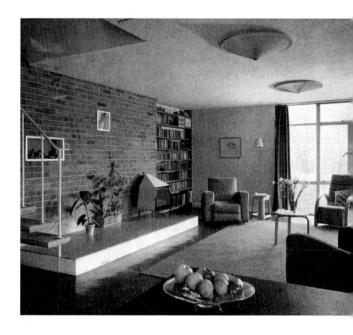

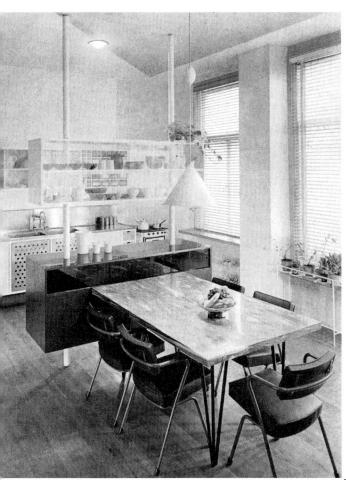

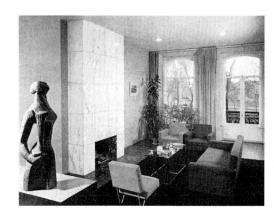

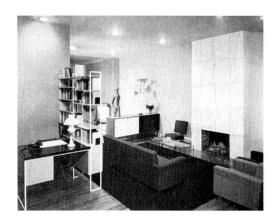

An eighty-year old house in Amsterdam was converted and furnished by the designer for his own use. Above is the kitchen-dining area which, together with lounge-study and hall, occupies the ground floor. The whole space is planned as one unit with flooring of warm brown Java teak; shelving or cabinets and ceiling colour change define the limits of each area. Here, for instance, a black plastic-topped storage cabinet, supporting a white-painted shelf fitment with sliding glass panels, divides off the kitchen. The doors facing the kitchen are painted red and white, and on the dining side are three sliding panels giving easy access to the interior. The dining table top of Silesian marble rests on black-enamelled steel legs. Chair frames are in grey-enamelled steel, with washable plastic upholstery in a darker tone.

In the lounge the ceiling height fireplace of Calacatta marble flanked by grey painted walls, rises from a black Belgian stone hearth. Upholstery is in dark brown and in blue; draperies are yellow Velours d'Utrecht, carpet black. Dividing off the hall is a cabinet with black and white sliding glass doors on which stands a sculpture The Political Prisoner by Ben Guntenaar. Knock-down adjustable bookshelves on white-enamelled steel frames divide lounge from study, and include a built-in radio.

The kitchen has three stainless steel sinks, above which is a storage unit with glass drawers and glass-fronted cupboards. All gas, electricity and water piping is hidden behind yellow white *Eternit* enamelled panels which are screwed onto a removable framework. A powerful ventilator removes all cooking odours. Architect: J. Penraat, GKF, KIO (HOLLAND)

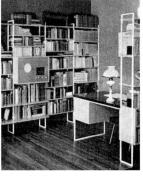

AMSTERDAM
- HOLLAND

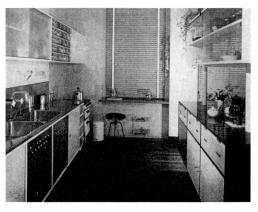

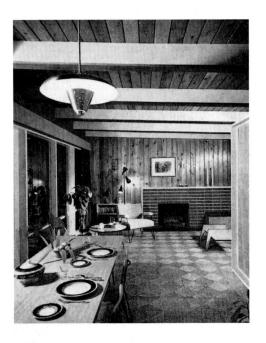

VANCOUVER - CANADA

In Canada timber is a readily available and widely used building material: it is also very well suited to the climatic conditions of the country. Another great advantage is that Canadian cedar, used in its natural state, makes a perfectly satisfactory wall finish; thus a considerable saving can automatically be effected by its use.

The house illustrated here is a low cost one. To keep his structure economical and easy to build, the architect used post-and-beam construction and building materials cut to standard sizes. The main framework is of posts spaced at 4-foot intervals. Beams connect the tops of the posts and support the roof planks, which are extended to form a wide protective overhang.

The whole of the living area is planned as a single unit. A semi-transparent framed screen—somewhat reminiscent of Japanese sliding screens—divides off the dining end. It stands clear of the floor and thus does not destroy the unity of the interior, which is furnished in an alternating scheme of light and dark finishes. Architect: A. King, MRAIC (CANADA)

The trend which divides interiors into areas rather than rooms, and therefore tends to dispense with any particular division, is often thought to be unsuitable to cold or variable climates. In fact it is a trend which is growing throughout the world and is found in high latitudes as well as those in equatorial zones. It would appear that a low density of population, rather than an amenable climate, induces a favourable attitude toward open plan housing and intelligent methods of heating.

It is difficult to see the connection between the partitioning plan of a house and the number of people living within a given area of territory, although the external proportions and number of floors will obviously be influenced by population density. Nevertheless, countries such as Canada, the United States, South America, the Scandinavian group, Australia—all with comparatively widely dispersed populations—have given a lead in the design of houses in which the internal volume is utilised to the utmost, opened out and kept warm instead of being closed off into chilly rectangular boxes.

In densely populated countries like Britain, where little plots of land are jealously fenced off against neighbours, the idea of seclusion invades, unnecessarily, the interior of the house itself and imposes its own very severe restrictions on liberal interior design. Such a way of thinking is usually supported by localised and inadequate heating arrangements, which make the small room, with all its inconveniences, the only possible way to keep warm in winter.

In the review of houses which follows, the examples from larger countries, it will be noticed, reveal a habitually freer and more open design, an appreciation of the esthetic values of building materials and textures, and a greater awareness of the physical proportions and structural surfaces of the house itself.

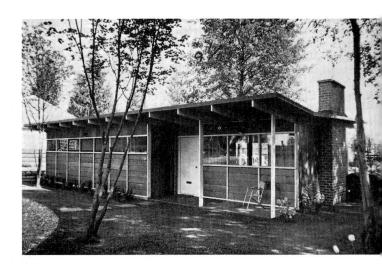

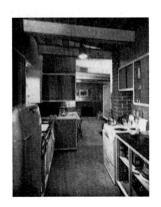

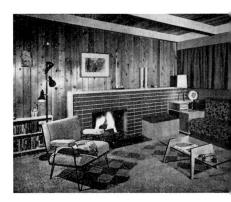

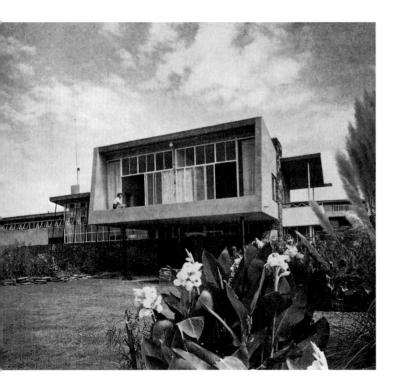

PRETORIA—SOUTH AFRICA

An artesian borehole, a beautiful view over distant hills, indigenous trees, and a river with a series of dams are the setting for this house, situated in a lovely valley about 10½ miles west of Pretoria

It was built by the architect for his own use and is christened 'Hakahana', meaning 'quick', because he and his wife had to act speedily to get a roof over their heads and to establish a farm. The rear block—a tubular steel structure with non-loadbearing walls—was completed within a month, and was their temporary home: it now houses guestrooms, studio/games room, and garage.

In designing the main house, the readily available (continued below)

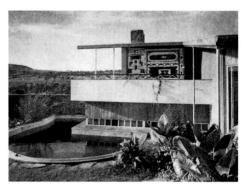

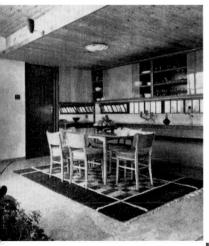

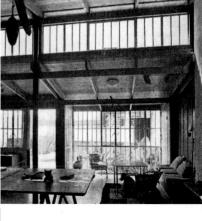

water supply played an important part—
'we wanted to see it all the time, to hear it running'. This desire materialised into a swimming pool at two levels abutting directly onto the living room, which has a picture window at water level. This creates a sense of coolness in summer; in winter the concrete-hooded fireplace and slate walls retain the heat and keep the room cosy. Opposite is a bar with steps leading up to the dining room. The bedrooms, raised high above ground level, jut out from the house and command a magnificent view

Exterior walls are plastered grey; a mural by a native woman of the Mapoch tribe decorates one wall. Architect: H. W. E. Stauch, MIA (SOUTH AFRICA)

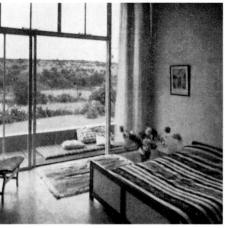

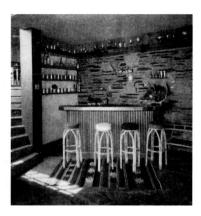

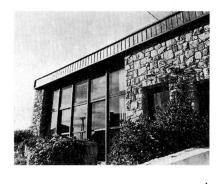

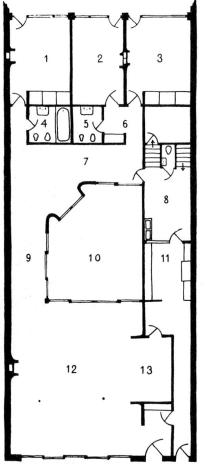

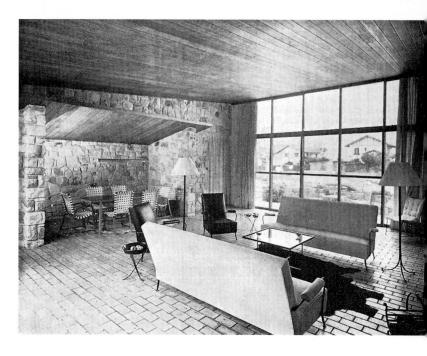

MAR DEL PLATA – ARGENTINA

This is a seaside home in a fashionable summer resort or the shores of the Atlantic. It is built on a long, narrow plot with a garden at one end, and a central patio—glass-walled on three sides (No. 10 on plan). A gallery (9) links the living-room (12/13) with the library (7) and bedrooms (1/2/3); the kitchen and service quarters (11/8) lie behind the patio.

The house is built of local grey stone and red brick. The front entrance (top left) gives direct access to the large living-dining room, which is paved in red brick and has a cedarwood ceiling. A wide window, framed within lemon curtains, has sliding panels opening onto a small terrace, and another, opposite, leads onto the patio. The living area is furnished in black wrought iron, with sofas upholstered in a natural handwoven fabric, armchairs in black leather, the floor rug is a black cowhide.

The use of local stone for the dining recess (other walls chalk white) gives it a separate individuality, further emphasised by the lower level unstained wooden ceiling. Dining table and chairs are veneered mahogany.

At left is a corner of the gallery and (below) one of the bedrooms in a cool green-and-white colour scheme; the bedhead unit is in walnut. All three bedrooms have direct access to the garden. Architect: Walter Loos (ARGENTINA)

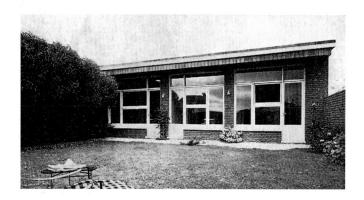

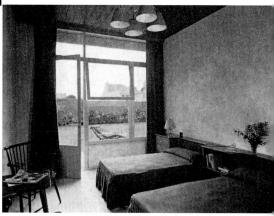

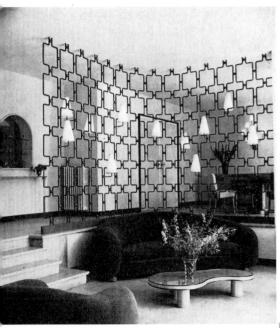

ST. NAZAIRE - FRANCE

Illustrated on this page is a country home on the coast of Brittany. The garden looks down on to the estuary of the Loire and commands a fine view across the open water and out to sea. The house itself—a long, low-built structure with a tiled sloping roof and gable windows to the upper floor—faces this view. French windows give direct access from the living-room to the garden. There is also a summer dining-room, the whole front of which can be thrown open to the garden terrace, and here one can sit on long summer evenings enjoying the constantly changing pattern of the river traffic.

A corner of the living-room is shown at left. The settee and armchair are upholstered in velvet, and the low table in the foreground is in thick plywood with a straw marquetry patterned surface under glass. The dining end of this room is at a slightly higher level and is separated from the main area by a gold-studded black wrought-iron screen, carrying light fittings at varying heights on both sides. (Other details in wrought-iron include the main door grille and flanking lamp posts, and the staircase balustrade.) Dining table and chairs are in light oak with black, grey and yellow plastic covers to chairs.

The summer dining-room is furnished in bleached cane, which makes an effective contrast to the red-tiled floor and walls. The light fittings, two of which are shown flanking the beige-hooded brick fireplace, are also backed by bleached cane mounts.

The bedroom curtains in sky blue, green and violet and door panels of the same fabric are designed by Paule Marrot. All other fittings and furniture are designed by the architect, Jean Royère (FRANCE)

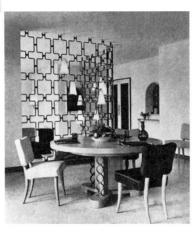

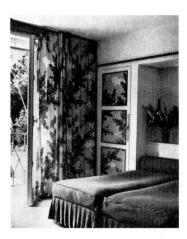

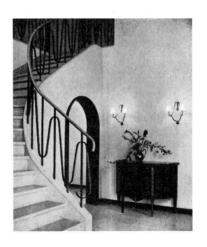

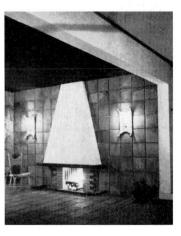

SYDNEY—AUSTRALIA

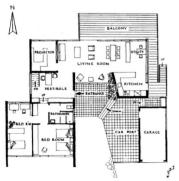

This home, shared by himself and his parents, was planned by a young Australian architect while still at Sydney university. It is built on a steep slope overlooking Botany Bay, and has an openplan central section, containing living, dining, kitchen and utility areas, with bedrooms and garage in side wings. By this arrangement the living room has the winter sun and, with ceiling-height windows along two sides, commands a magnificent view. On the lower ground level is a self-contained unit used for dancing or games, or as a guest room.

The exterior of the house is white; interior decoration and furnishings (selected by the architect) are in a varied but carefully blended choice of colours; ceilings hardwood, on Oregon pine beams. Below: Bookshelves and storage cupboards in the vestibule. Below Right: Dining table, backed by film projection screen and loudspeaker disguised as a free-standing cupboard and room divider. Architect: Ross Thorne (AUSTRALIA)

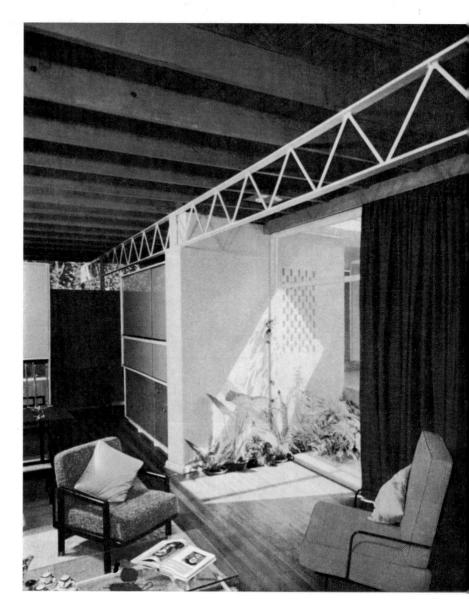

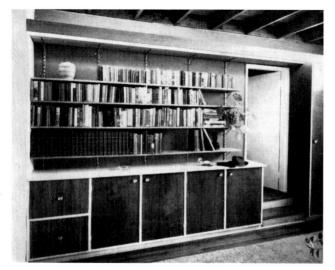

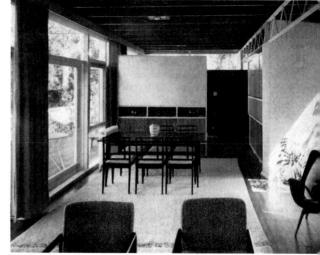

ORCO VALLEY—CALIFORNIA

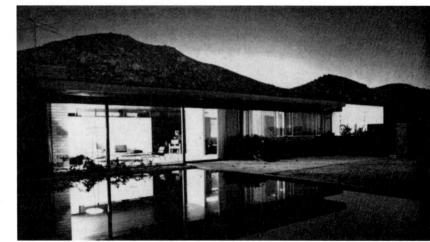

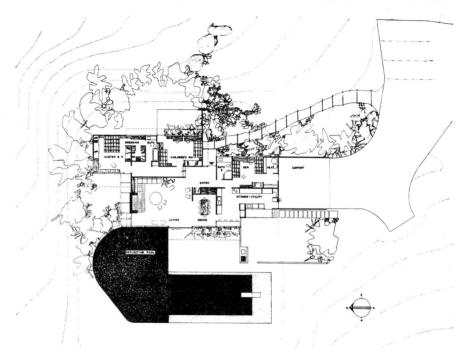

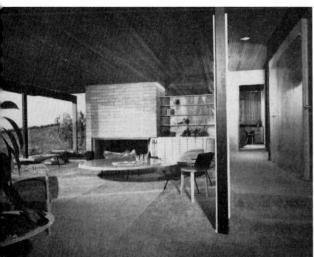

A winding drive up a mountain side leads to this house—the home of a busy country doctor and his wife and two teenage boys. The surrounding landscape is arid and desert-like; not, perhaps, an ideal site, yet possessing its own rugged beauty of outline and individual interest.

The long, low, wood-frame house is planned to 'fit the biology of the landscape'. Exterior walls are plastered, interior birch-panelled, with a redwood ceiling linking living, dining and kitchen areas. One wall of the living room is in glass, and immediately in front of this is a large pool carrying the interior image outside so that house and surroundings become one. It also engenders a cool and restful atmosphere, which is fostered by the choice of grey and charcoal for furnishings and upholstery in the living room. A more colourful note is introduced at the dining'end, with blond birch table and chairs, and upholstery and match-stick curtains in light green. A small bar counter (top left) linking kitchen and dining corner is used for breakfast and light meals.

Radiant heat coils are embedded in the concrete flooring, and there is a large grey stone fireplace in the living room for additional warmth in winter. Architect: Richard J. Neutra, FAIA (USA)

HIORTEKÆR - DENMARK

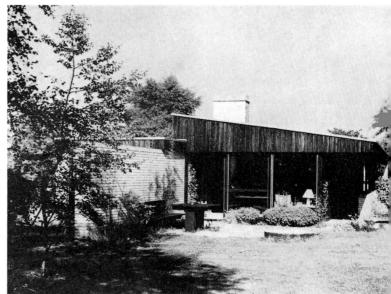

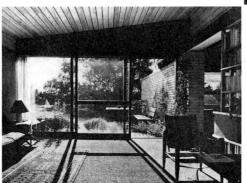

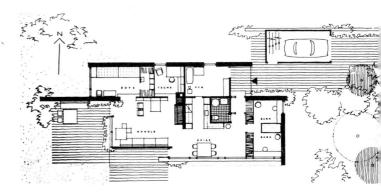

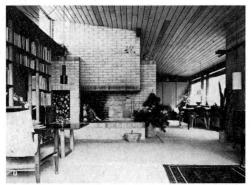

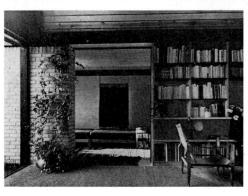

'One of the most difficult tasks facing an architect is the designing and building his own house', says Mr. Udsen, whose home this is on the outskirts of Copenhage And indeed it requires perhaps even more self-discipline than when working the requirements of others.

The site, about half-an-acre in extent, is a fairly wooded one, and as it was desir to have an informal 'easy to keep' house, an open plan was decided on with t kitchen in direct contact with the whole living area and with the children's room.

The house is built of Bloustrød bricks on a wood frame construction with weatherboard facing just below the roof line. Flooring is cement painted wi Zellaphen and carpeted with fibre runners except in the kitchen. Here a consurface has been applied, which is comfortable to walk on and easy to keep clear The ceiling is in natural boarding, doors and cabinet work in oil-finished Oreg pine.

Instead of the closed-in stove, traditional on the Continent, there is a cent raised hearth, large enough to take a log fire, with a brick chimney piece extendito the ceiling and containing a built-in niche for wood storage. This feature for the main interior division, with bookshelves acting as other partition 'walls'. Interfurnishings are simple, with low-slung canvas chairs and couches, and bright coloured patterned floor rugs.

The parent's bedroom, facing west, leads directly off the living room and meant on occasion to serve as an extension to it. The outer dividing wall is on tinued outside, and an indoor climbing plant placed at the corner carries the e out to the garden. The children's room is placed at the other end of the living roof for 'a long distance from the children's to the parents' bedroom is of great advanta when the children are above the baby age'.

Nokatene pipes cemented into the floor provide a comfortable and economic ty of heating. Architect: Bertel Udsen, MAA (DENMARK)

his house, by its open plan and built-in miture, aims at a feeling of space within relatively small area. It stands on a rner site and is bordered on three sides pines, Swedish conifers and silver birch. erge windows creating 'picture areas' of es and sky link these surroundings with e interior and ensure that the house forms

integral part of the site.

The hall is paved in heather-colour tarry tiles, the whole living area in wood ocks, with furniture and fittings in teak. ghting, placed at strategic points, iphasises individual areas within the en plan, and a visual link between upper d ground floor is provided both internally d externally by the white metal staircase. Lime-yellow in varying proportions cording to the mood required is used as e main colour link. It provides: a welcome the porch and hall; with orange/red, ack and white, a lively dining scheme; a eerful kitchen, with lime-yellow ceiling d door, white walls, black/white plasticed floor, black/green and white serving tch, orange/red door to drying cupboard, intwork of wood units in wisteria and nite, and working surfaces in grey/white rmica. In the living room it is used for

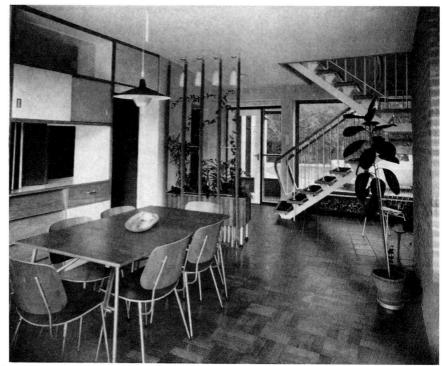

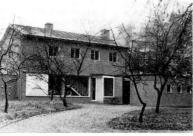

KIDDERMINSTER -WORCESTERSHIRE

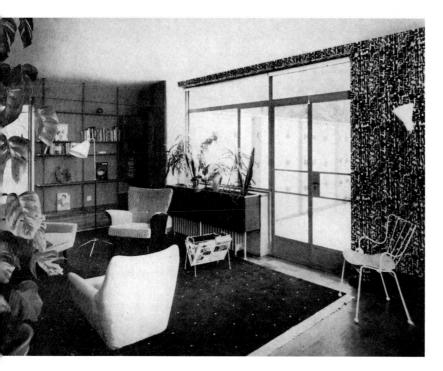

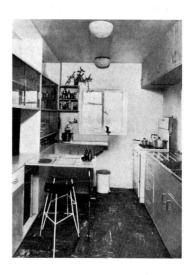

window curtains and upholstery, creating a sunny effect against grey/green paintwork and wall areas, and pine-black carpet. Bedrooms and guest room are in quieter tones, but lime-yellow continues as an accent in curtains and wallpaper.

Skirting and other radiators fed by a solid fuel boiler supply an efficient central heating system. For focal interest there is a coal fireplace in the living area at knee height with a quarry tile hearth forming a continuous seat round two walls.

Interior decorations are by the owner, Mrs. Leonard Griffin. Architects: S. N. Cooke & Partners, FF/RIBA (GB)

SYDNEY - AUSTRALIA

This house, designed by the architect for his own use, is on Point Piper, a headland overlooking Sydney harbour. Because of space restrictions and the steep slope, it is built on three levels with a seven-foot drop between each, the main living area being centrally placed.

A striking feature is the imaginative use of colour throughout, commencing with the garden facade in white framing, deep turquoise eaves, and black terrazzo-paved terrace. In the dining room the warm tones of the red-upholstered teak furniture make an effective contrast to the white checkerboard storage wall with up-and-down sliding doors; strip panelling above is in Queensland maple. Accenting the pleasure of good food and wine is a background vista of sea and sky reflected in a sunken pool in turquoise/blue/lavender mosaic tiles at the terrace end.

Lounge and dining room interconnect, and the whole area $(43\frac{1}{2}$ feet) is carpeted in a soft pinky-grey. Panelling in warm brown maple contrasts with the bleached silvery maple finish of the gallery and recessed bookcase wall; opposite is a 17-foot window wall giving a clear view of the harbour. The bedroom is in muted shades of grey, white and black, highlighted with deep gold bedspread and vivid turquoise ceiling. The bathroom in pink, with grey-patterned Italian tiling. has neat overhead storage shelves. Architect: L. McDonald Downie (AUSTRALIA)

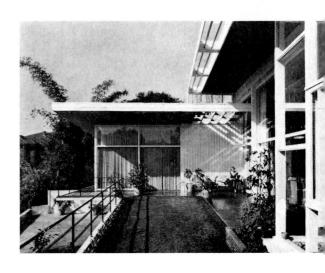

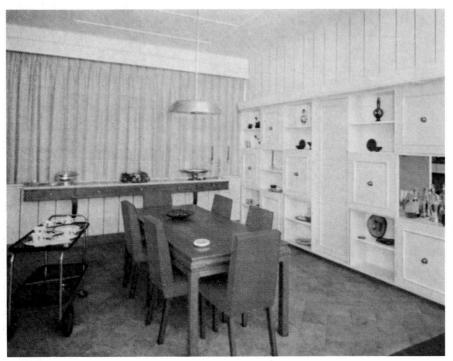

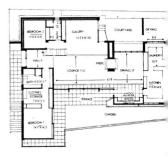

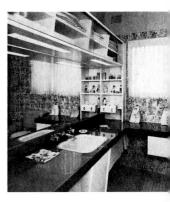

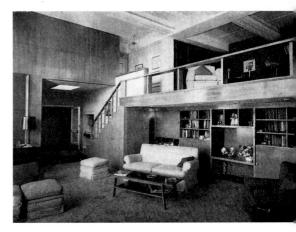

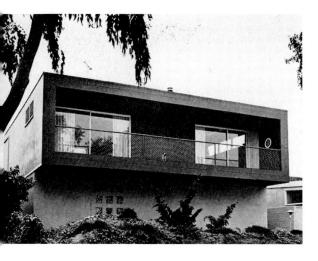

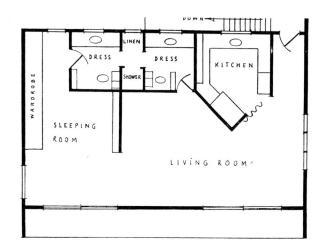

DRONA DEL MAR – ALIFORNIA

has always been my theory that architecture I interior design are influenced more by the nomic conditions existing in a country than aesthetic thinking: this house is an outstand; example' states the architect, who planned primarily as an 'easy-to-run' seashore home Mr and Mrs Ray Melin, and to accomdate family or other visitors at weekends.

It was therefore designed as two separate f-contained units. The main living area, on upper level, is reached by an exterior stair-y of heavy oak treads housed in logs. It asists virtually of one large room, divided by ling panels, with the kitchen separated by a reen-curtain.

een-curtain.
Interior walls are celadon green, ceiling ite-washed board; the linoleum floor covergin a woven pattern of white, grey, and arcoal, is stain and dirt resistant. Upholstery likewise in soil-resistant vinyl 'breathable ugahyde'; the bridge table chairs in split ne on an iron frame are a practical design for shore living. In addition to central heating, whole area is warmed by an open, pivoting eplace in baked enamel.

In the kitchen, efficient planning includes aging refrigerator and freezing units, while -conditioning removes cooking odours and rmits the closely related kitchen-living area. chitect: H. W. Grieve, AID (USA)

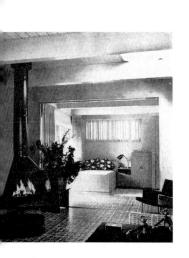

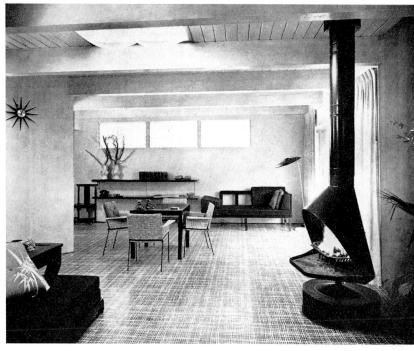

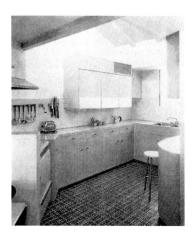

PACIFIC COAST – CALIFORNIA

The design of this house with its feeling of 'expanding into outer space' is the result of careful planning by the architect to overcome the limitations of a somewhat restricted and precipitous site. It had the advantage, however, of a panoramic view reaching southward to the waters and horizon of the Pacific coast. To enjoy this, the main living quarters are raised above ground level; at the same time, a strip of clerestory windows and transparent 'bubble' openings inserted below the level of the cantilevered roof, open up the interior to the wooded mountainside. Complete integration of the house with its surroundings is thus achieved, and the space limitations of the site successfully overcome.

Built on a stainless steel-clad framework, the long, stretched house is reflected in a swimming pool at the south-east end, where, as part of the planning consideration, provision was made for accommodating holiday visits from four married sons of the owners, Mr and Mrs Joseph Staller.

Illustrated on the right is the glass-walled south facade overlooking the wide coastal landscape down to the sea. The sloping two inch-plank insulated roof, supported on laminated beams and timber frame, projects well out to afford protection from the hot

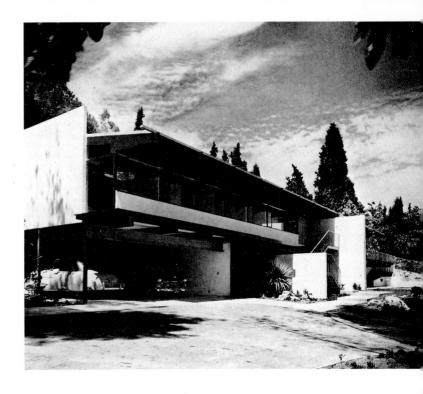

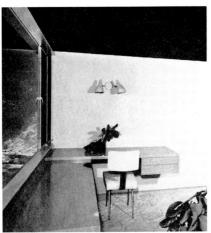

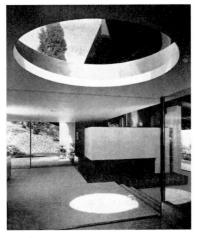

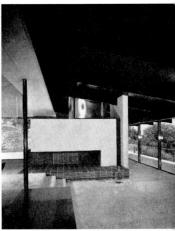

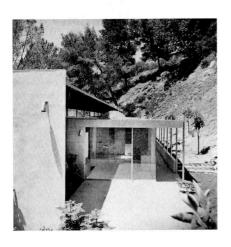

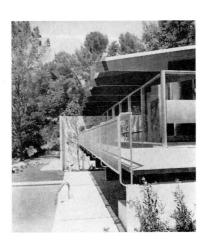

Californian sun. The master bedrooms a situated to the west of the entry stair and ant room; downstairs are two secondary bedroom connecting with the pool-porch. A corner of ou of the bedrooms with built-in fittings designe by the architect, is shown above, left.

Screened by the central white spur wall, the living area and den, separated by a double fir place, lie at the eastern end, and open with wis sliding doors and glazed openings onto spacious balcony terrace over the pool. Sever steps up and hillward is the deck of the dining area and breakfast room with a sliding glapartition in between. At the far end sliding glass doors open onto a small courtyard. A deep texture fitted carpet covers the whole floarea. The fireplace in white Texas shellston has a pivotal position in the centre of the living space which seems to expand laterally to touter world. Architect: Richard J. Neuts FAIA (USA)

XURY FLAT - NEW YORK

is open plan setting was entirely redesigned from a ventional 5½-room apartment by an architect who ceives rooms as vistas not contained by the resnts of four walls, but rather as a continuous effect h distant horizons; a play of lights, shapes and dows; a contrast in colours, textures and surfaces. At the entrance, a dropped illuminated ceiling, rheo-

ically controlled for desired lighting effects, estabes a welcoming and serene atmosphere.

pace for musical interests and books, seating for h formal and informal entertainment, a well-stocked and 'wine cellar' were some of the requirements to met. To create the necessary space, bookcases conling desk and storage space were floated between ıms; a fitted bar, interior lit, and accessible to both ng and dining areas, built into the entrance hall; and arge area created and redesigned into a modern ng room and antique drawing room separated by an minated dividing screen. A large geometric pattern idwoven carpet spanning this area brings unity to h rooms. Though furnished in entirely different les, they have common elements in teak panelling I draperies of handwoven Siamese silk. To save ce, radio and record equipment are housed in a tting wall cabinet in oiled-teak designed by the hitect, as are the sculptured settee and chair; se are upholstered in Dreyfuss fabrics. Dining niture is in high-polished dark cherrywood with saic inlay. Colour schemes inter-relate, the colours iging from browns to muted rusts, putty and sand

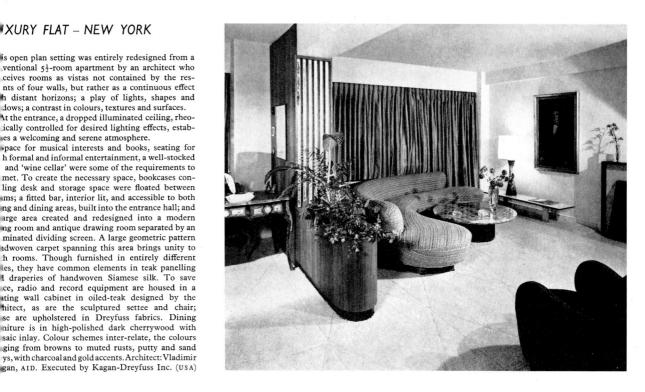

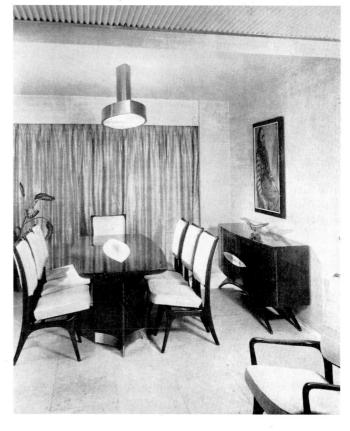

HAMPSTEAD - LONDON

THE problems facing an architect are many: not least, as in this case, of 'infiltrating' a house of modern design into an old-established high class residential area. It is built on land formerly used as tennis courts, with only a 60-foot frontage onto a road containing houses of mixed character but which, in the eyes of the local authorities, formed an architectural unit not to be disturbed.

The occupants are a widow and teenage daughter, and in addition to the main living area there are four bedrooms, two bathrooms, and a study. The house is placed at right-angles to the road, so that all rooms (except the study) face south to a rural and well-wooded aspect; there is thus no sense of being overlooked by the adjacent houses. Exterior walls are faced in local red brick and yellow London stocks, with double-glazed Insulite units framed in white-painted timber forming a window wall on the south side.

Illustrated below is the well-chosen colour scheme of the living/

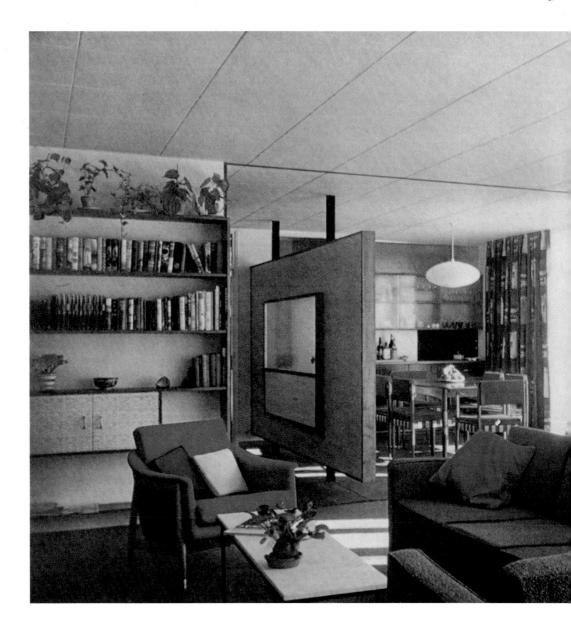

dining/hall area, planned as one visual unit carpeted throughout in gunmetal grey, with the ceiling in Unitex softboard panelling. A semi-solid partition with inset cupboards screens the dining area from the inner hall, and a sliding panel provides privacy from the living room if desired. At the far end is a two-way fitting with direct access to the kitchen, where the equipment is grouped into separate areas for cooking, laundry, and breakfast; the main colour scheme is grey and yellow.

The bedrooms look out to the south-west through ceiling-height

The bedrooms look out to the south-west through ceiling-height windows and are provided with built-in cupboards and dressing table with a large wall mirror. In the bathrooms, windows at ceiling level ensure privacy and good light; the mosaic-tile surround is in blue/white or yellow/white. Heating is by a thermostatically-controlled system embedded in the floors. Furnishing and interior decoration are by the architect, Brian Peake, FRIBA, MSIA (GB)

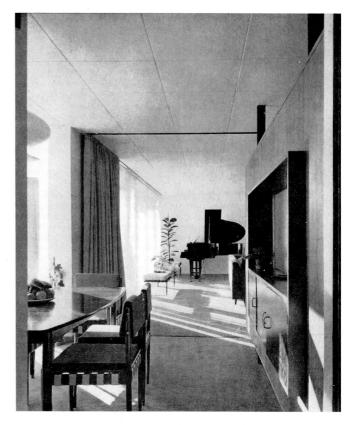

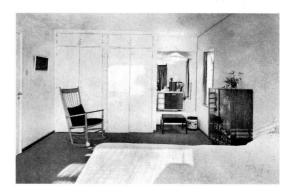

AMSTERDAM - HOLLAND

THIS flat is in a new glass-fronted block built on the banks of the Amstel in the heart of old Amsterdam. It is occupied by a leading Dutch furniture designer and interior decorator, and is furnished in a style reflecting his lively appreciation of the aesthetics of industrial design. With a fresh, simple colour scheme, he has created a home in which he can both work and live: to use his own expression 'a liveable sphere.'

The large studio/living room is divided by a metal folding door faced in ivory plastic; the whole room can thus be used when receiving clients, or the studio end can be shut off for working. A dark blue fitted wool carpet covers the entire floor area; this balances the light-toned colour scheme with walls papered in Japanese grasscloth, white paintwork, and door panels in red, olive green, or lemon yellow. The dining group is in teak, the silvergrey upholstered suite in brass and teak combined. Adjoining the limestone fireplace is a brass-edged hanging bookshelf, lined in white plastic with top surface in red.

The kitchen, just glimpsed through the open door, has a black colovinyl floor, blue-tiled walls, white-lacquered cupboards, and working surfaces faced in red Formica.

Architects Bart van Kasteel and J. A. Landman; the flat is furnished and decorated by A. A. Patijn (HOLLAND)

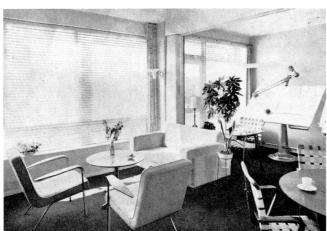

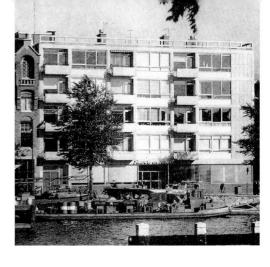

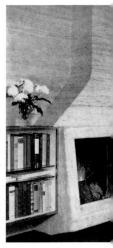

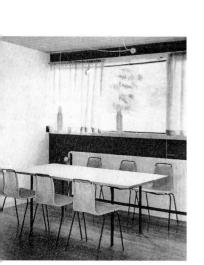

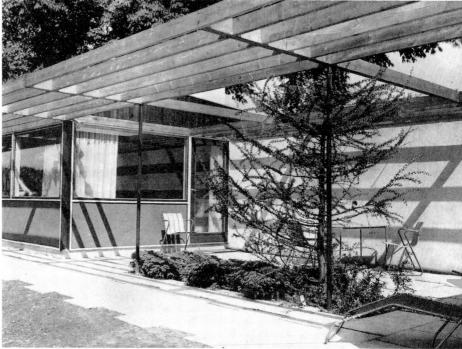

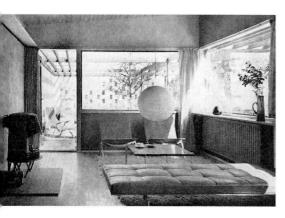

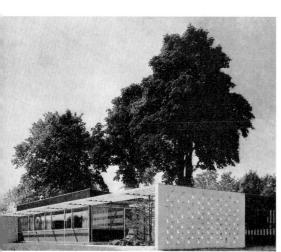

SØLLERØD KRAT - DENMARK

THIS house is one of several designs submitted by various architects for the planned development of a rural area with three-bedroom family houses of simple construction. It is a very successful design, since it is not only visually pleasing from the outside, but is well-planned inside for family living, with the rooms all grouped around and opening into a common dining-hall.

It is built mainly of cement-rendered lightweight concrete, but the whole wall area on the south side surrounding two bedrooms and the long, oblong living room is a glass and steel-frame construction with the window base faced in asbestos cement, painted blue. Forming a visual extension to the living room, is a sheltered walled terrace with a pergola-like timber roof which extends out over the window wall and links the two ends of the house; this is in plain, untreated pine, in contrast with the dark solignumtreated centre roof panelling. Behind the terrace is a carport.

The interior is simply furnished with metal frame furniture designed by Poul Kjærholm, and made by E. Kold Christensen. Both floor and ceiling are boarded in natural pine. Thermostatically-controlled radiators placed under the windows maintain an even temperature throughout. Architects: Henrik Iversen and Harald Plums (DENMARK)

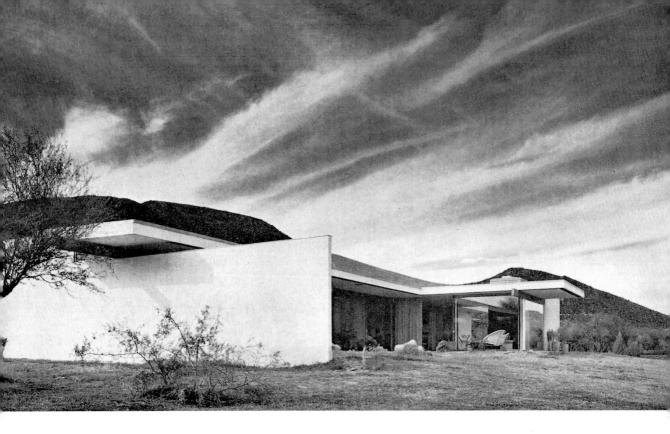

SHOSHONE - CALIFORNIA

This house, set against the backdrop of a black volcanic mountain which underlines the simple geometric form of its roof line, is situated on the edge of the Nevada desert. The owner is the supervisor of Indio County in the adjoining State of California.

The surroundings are dramatic: nearby lies the famous death valley, nearly 300 feet below sea level, and Mount Whitney, the highest mountain in America, rising to 14,495 feet. The house is designed to 'coalesce' with this landscape: side wings stretch out into the desert, and the 30-foot long living-dining room, together with the adjoining glass-walled sunroom, opens out through sliding doors to a sheltered terrace overlooking a golf course and the mountains beyond. Built-in fittings keep the floor space uncluttered, increasing the sense of continuity with the exterior. Alongside, sharing the view, are three bedrooms, two of which, with built-in shelves and desk, are used as study/bedrooms by the teenage son and daughter of the family. These rooms face east, and are shaded from the heat and glare by the deep overhang of the roof. Below: Night view of the interior. In the background is the long verandah entrance, off which is a guest room with its own walled patio. Architect: Richard J. Neutra, FAIA (USA)

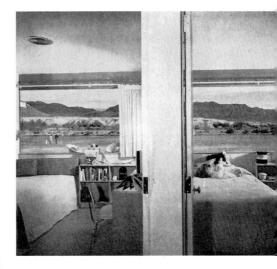

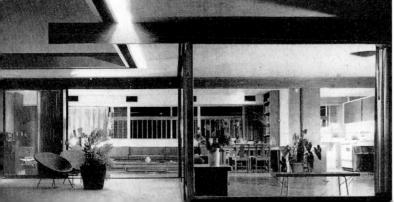

ELSINKI - FINLAND

The rural setting of this block of two-storey terraced flats makes it difficult to realise that they lie within a twenty-nute bus journey from the heart of a capital city. They are it built on the shores of the Finnish Gulf amidst the beautiful hipelago surrounding Helsinki. Though the block is a modern kel-steel frame and concrete construction, it yet retains some-ng of a traditional character in the white-painted fascia extending ng the top.

ng the top.

There are in all seven three-bedroom flats, divided from one ther by a buttress wall, and each having its own private beach. ove is the main living area: this comprises a combined sittinging room and kitchen, which can be separated from one another sliding panels or curtains, with a central built-in wardrobe fitting iding off the bathroom and dressing room. The central heating tem is contained in the floor, and the teak-framed wide window la has three thicknesses of glass for insulation against the cold winter.

At ground level, with direct access to a small terrace, are the una' (Finnish steam bath), a small dressing room and study, re room, and garage.

oldness of construction, a sound feeling for material and an anised simplicity in the interior furnishing, combine to produce atmosphere of serenity and repose in keeping with the exterior roundings. Architect: Viljo Rewell (FINLAND)

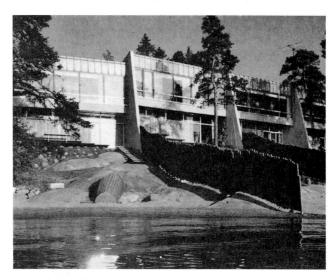

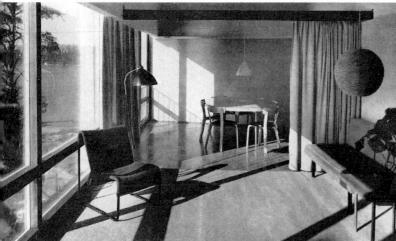

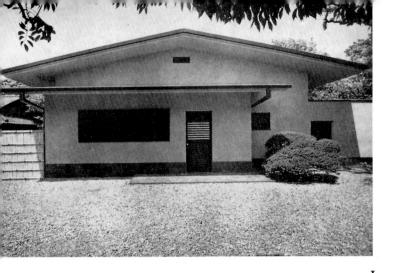

Basic to the architectural tradition of Japan are the simplicity of form and proportion based on a module of 2:1, and expressed most obviously in the *tatami* (wadded mats).

In this tradition is the home of Ryuzaburo Umehara, a major artist. The architect designed it to provide a setting with a feeling of open space, and reflecting colours which would conjure up the spirit of Kyoto, Peking and Paris—towns of which the artist had special memories.

The fifteen rooms are laid out on a big, simple plan with posts and beams in stained lauan, and bone-white ceilings.

- I Front entrance, with threshold paved in aqueous rock which is continued into the entrance hall and parlour linking the garden to the interior. Exterior walls, stucco; fittings, steel sash; interior walls, beige brush-finish.
- 2 The salon, opening directly onto the garden, has pale blue brush-finish walls, red-lacquered shelf, and zelkova-boarded floor.
- 3, 4 Entrance hall and parlour.
- 5, 6 Intercommunicating ten-mat rooms with sliding screens and a transome grille in cypress, lacquered dark brown. In 6 can be seen the tokonoma, a traditional recess for the display of a special work of art. Beside it is the tokowaki, also traditional, a built-in cupboard with sliding doors. Architect: Isoya Yoshida, Academy of Arts (JAPAN)

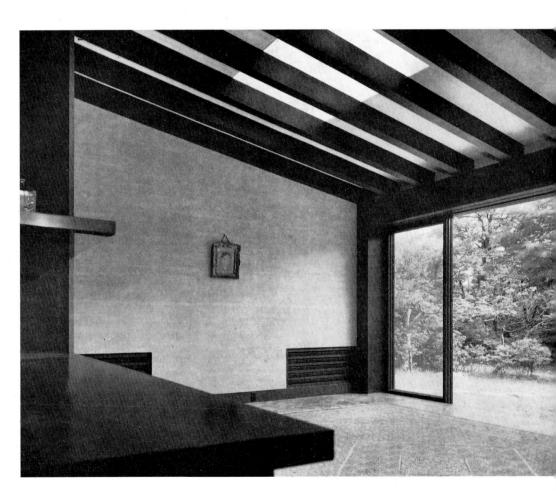

2

TOKIO - JAPAN

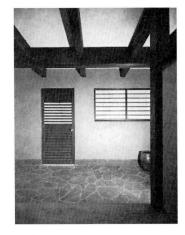

3

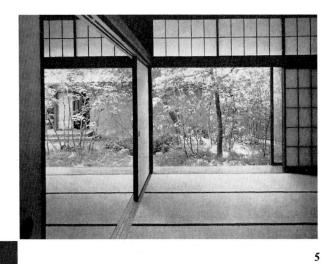

4

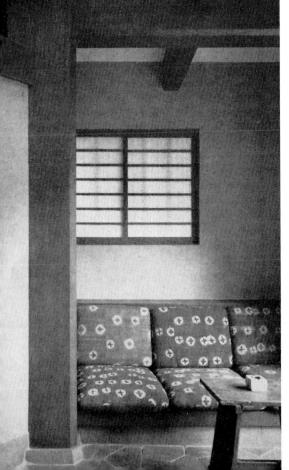

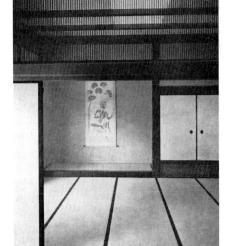

6

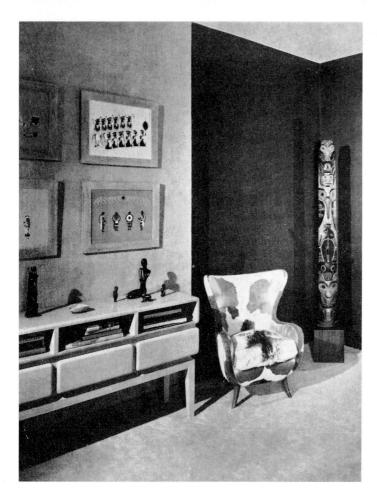

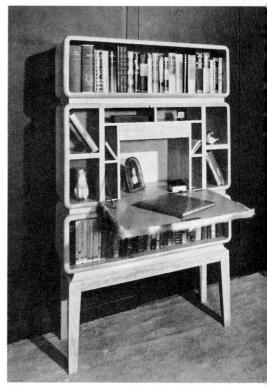

Furniture in solid oak, with the chair and drop front of the collined bookcase and writing desk covered in calfskin, design by Catherine Speyer and made by Rena Rosenthal Inc.

Built-in wall cabinet in natural mahogany comprising desk unit, radio and phonograph unit, loud-speaker, and record storage, designed by Felix Augenfeld. The handles are aluminium, as also are the tubular legs, which are fitted with an invisible screw device for adjusting height. Benches and chairs are upholstered in yellow leather, and the floor covered in silver-grey broadloom.

(Photo: Ben Schnall).

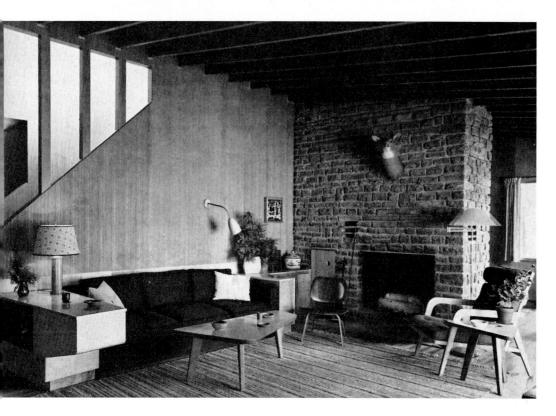

ing-room designed by Alexander Girard, showing the natural stone fireplace.

• furniture is in birch against walls of pine.

• upholstered in dark brown fabric, with the armchair in orange.

• leford photo).

Mahogany bar cabinet designed by Felix Augenfeld, with sliding doors, partly covered in white leather and partly of perforated aluminium sheet. Legs and knobs of aluminium. Counter top and back wall of travertine. (Photo: Ben Schnall).

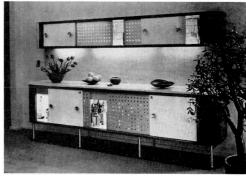

Living-room furniture designed by George Nelson and made by Herman Miller Furniture Company. Black-and-white rug on the floor by V'Soske Inc.

LEFT: Living-room furniture designed and made by Jens Risom. Silk drapery designed by Alexander Girard. (Polish folk sculpture lent by the Polish Embassy.)

82 · interiors and furniture · 1950-51

POSITE: Sitting-room in the house of Mrs Herman Kiaer modernized by William Platt, architect, decorated by Joseph Mullen. The pine panelling makes an unusual background for the modern inting by David Pack but harmonizes pleasantly with the general colour scheme. The recessed okshelves and console table below were also designed by Joseph Mullen. (Courtesy: Town and Country).

nall dining-room in a New York penthouse apartment designed by Felix Augenfeld using Herman ller furniture combined with custom-made pieces. The storage unit is of primavera with a red quer front. On the right are hanging rubber foam cushions covered with red and white print. ulti-coloured print forms the draperies against the black and grey marbleized rubber tile flooring. hoto: Ben Schnall).

ABOVE—LEFT: Intruder wing chair upholstered in fawn tapestry from the 'Helios' range. CENTRE: Sabu covered in 'Ormiston' printed linen designed by Marion Mahler and made by Donald Bros Ltd.

RIGHT: Cavalier upholstered in rust wool tapestry supplied by Heal's Wholesale and Export Ltd. All three chairs designed by Howard B. Keith, MSIA and made by H. K. Furniture Ltd. Available in both birch or beech with

light, medium or dark finish to woodwork. (Photos: John Gay). BELOW: Sitting-room furniture designed by Laurence A. J. Rowley and made by The Rowley Gallery. The curved bookcase is in English sycamore, polished ivory colour: it has drawers on the other side, thus making a desk. Cabinet in the background also in sycamore, designed to accommodate music and gramophone records. Lamp standard of bamboo enriched with gilt leaf.

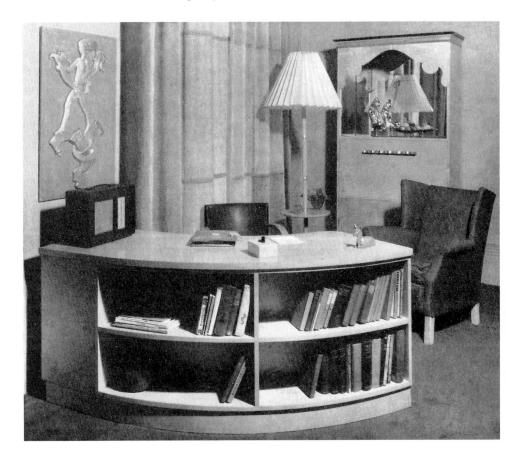

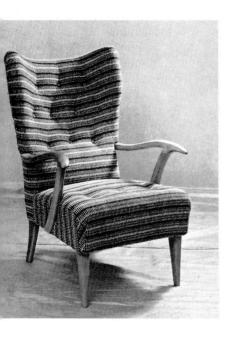

Occasional chair in Honduras mahogany designed and made by S. A. Lord, of the High Wycombe School of Art. Woodwork finished in natural colour. Covering of wool tapestry made in the School.

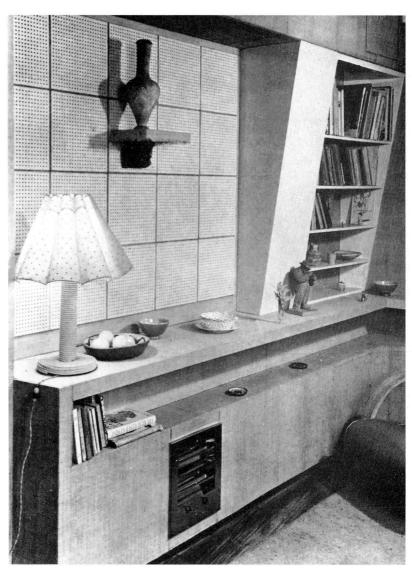

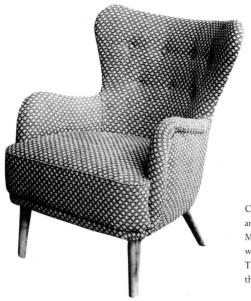

Sitting-room at Hyde Park Corner, London,
designed by A. V. Pilley, FRIBA,
and executed by A. Francis & Co Ltd.
Walls and fitment covered with natural raffia cloth,
panel wall of untreated acoustic Celotex tiles.
Bookshelves painted gloss white and battleship grey.
Chair upholstery Indian red against a light cream
lambs' wool carpet on the plywood parquet floor.
(Photo: John Furley Lewis).

Chair designed by Ernest Race, FSIA, and produced by Ernest Race Ltd.

Made on an electrically welded steel rod frame with vertical coil springing and rubberized hair stuffing. The legs are of polished beech, the covering is blue and white cotton tapestry.

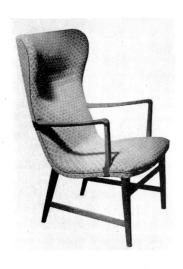

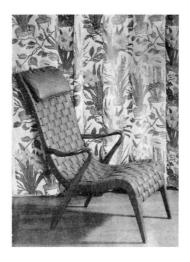

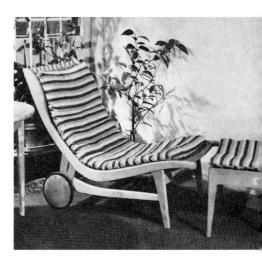

BELOW: Corner of a sitting-room designed by Oskar Riedel.
The upholstered corner fitment can be converted
into an emergency bed by the placing of an additional line of stools.
Cupboard mounted above the stove is
designed to house china and is accessible from both sides.

Chimney breast is supported by two iron columns and an iron frame the fireplace being faced with Delft tiles on right and left. (Photo: Courtesy of *Die Kunst und Das Schöne Heim*)

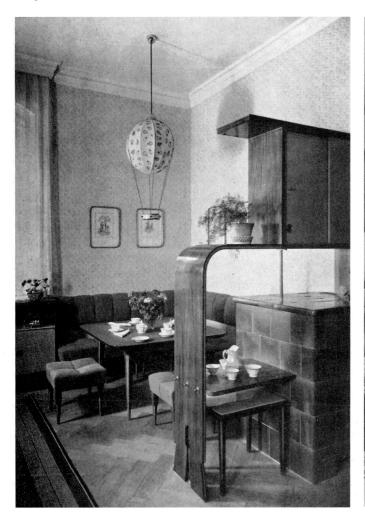

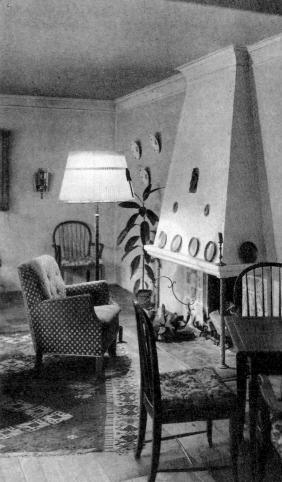

TREME LEFT: Lounge chair in natural-coloured ahogany, covered with grey and green hand-woven oric, designed by Harbo Sølvsten and made the firm of Harbo Sølvsten.

FT CENTRE: Chair with interlaced leather covering, signed by Axel Larsson and made by Svenska 5belfabrikerna.

rtain, The Lilies, designed by Elsa Gullberg and de by AB Elsa Gullberg Textilier och Inredning. FT: Trolley chair and stool in birch, designed Carl Johan Boman and made by O. Y. Boman AB. Ind-woven covering in green, yellow and white, signed by Lea Wehmanen-Tennberg.

GHT: Chairs in beech,

signed and made by Fritz Hansens Eftfl, vered with hand-printed 'Graucob' textiles.

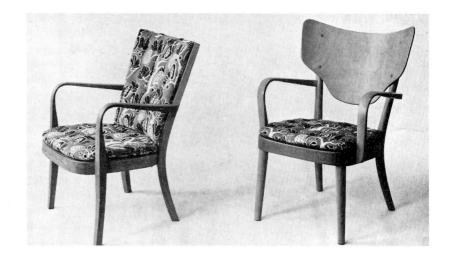

ting-room designed by Eduard von der Lippe, owing the fireplace opening framed in brass surrounded by blue and white Delft tiles pped with red marble. Plain sand-coloured walls contrast with e multi-coloured carpets and textiles.

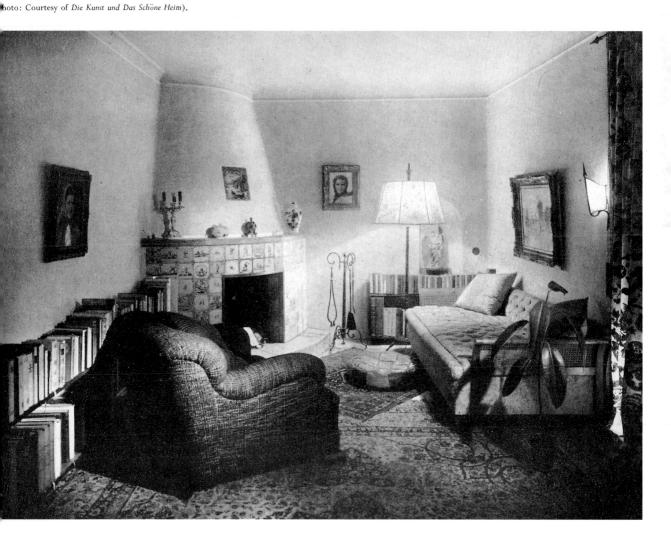

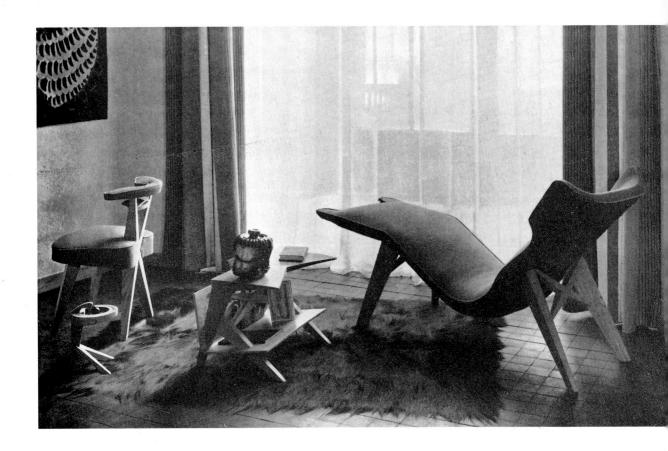

Living-room designed by Bernard Durussel showing a smoking chair, and ash and pipe tray on the left, a low table for books or magazines (see also illustration below, left), and a chair designed for restfulness, all in natural oak.

Curtains (above) in blue cotton with white and dark blue stripes designed by Bauret: (below) by René Maule Chairs upholstered in blue wool fabric.

The walls are white, the flooring black tiles covered with a black apeskin rug. RIGHT: Tubular armature chair with natural heavy oak seat and back designed by Bernard Durussel.

88 · interiors and furniture · 1950-51

Cupboard in polished ash, with Havana leather doors, ornamented with gilt studs.

BELOW: Lady's writing table in polished ash and chair upholstered in pale yellow. All designed by Jean Royère. Curtain in background is of multicoloured chintz.

able and chairs in polished ash, designed by Jean Royère.
he table has a green opaline top
d the chairs are covered in green fabric.
ackground curtain, plum coloured with a twisted rope design.
ELOW: Sideboard designed by André Renou and Jean-Pierre Genisset
d made by La Crémaillère, mounted on a base of
ansparent glass and covered in natural parchment. The handles are of
ope fixed to the drawers with brass studs. Picture by Suzanne Fontan.

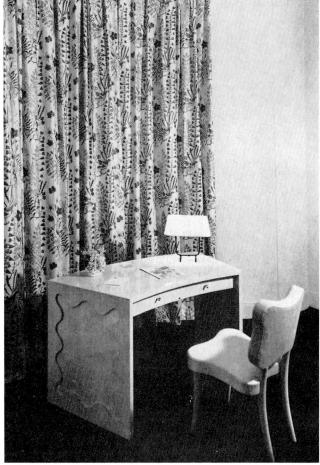

1950–51 \cdot interiors and furniture \cdot 89

Suggestion for a bedroom, furnished in the contemporary manner, by Hugh Casson.

It lays emphasis on the colour value to be derived from suitable choice of a mixture of textiles for curtains, bedspreads and chair covers in a room of small dimensions.

Reproduced by courtesy of Morton Sundour Fabrics Ltd.

OPPOSITE PAGE: Dwarf wardrobe, dressing table and chair, the latter covered in printed linen, part of a bedroom suite in waxed walnut, waxed oak or waxed mahogany, designed by Christopher Heal, MSIA, and made by Heal & Son Ltd.

BELOW, LEFT: Bedroom in the Corrientes style by Comte SA

The two-tiered bed and all the furniture is in native South American woods, left in their natural colours.

BELOW, RIGHT: Bedroom furniture designed by Professor Karl Nothhelfer and made by Holig-Homogenholzwerke. Bed and cupboard designed to fit into a sloping wall section.

Under the window is a combined work-table and chest. (Courtesy: Die Kunst und Das Schöne Heim).

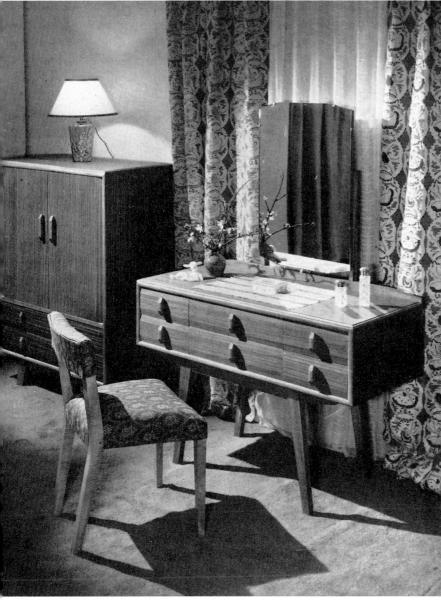

Bedroom scheme in birch and pine designed by Alexander Girard. The bedhead is covered in green grass cloth: the bedspread of bright yellow. Black linoleum top to the writing desk and bed-

side table. (Astleford photo).

Bedside trolley on wheels, designed by Edward H. Pinto and made by Compactom Ltd. Framework is old gold anodized aluminium inlaid with Santa Vera. Flaps and lower tray of laminated plastic, veneered with buff linette Formica.

BELOW: Dressing table in sycamore with green hide covered and padded centre designed by C. Addison and made by Thomas Justice & Sons Ltd.

AT BOTTOM: Bedside table in painted wood with wax polished finish designed by Laurence A. J. Rowley and made by The Rowley Gallery Ltd. The triangular shape and ball castors enable the table to be placed in any convenient position. Top section is a useful hinged flap. Electric lamp, made to swivel, is controlled by a miniature press switch. Shade of pleated nylon enclosed at bottom to counteract glare.

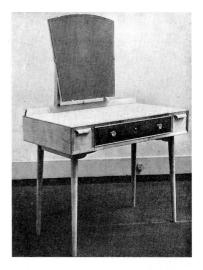

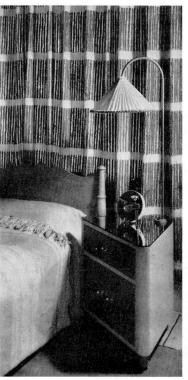

1950-51 · interiors and furniture · 91

- I and 2. Unad writing-dressing table in blackbean with English cherrywood front; the chair in beech. Unad sideboard and table with hand-made coffee table in beech and dining chair all designed by The Story Design Group (Ian Henderson, Director of Design) and made by Story & Co. Ltd. Simplon settee and Intruder chair made by H. K. Furniture Ltd.
- 3. Mahogany rail-back settee with Dunlopillo seat covered in Scottish tweed by Wilson & Glenny Ltd, and table with Formica top made by A. H. McIntosh & Co. Ltd. Chair made by John McGregor & Sons Ltd, of formed plywood with tweed upholstered seat. All three pieces designed by Dennis Lennon, MC, ARIBA. Handmade rug by the Highland Home Industries Ltd. (Courtesy: Scottish Furniture Manufacturers Ltd.)
- 4. Settee with back and seat of pressed aluminium upholstered in foam-rubber and covered in Scottish tweed by Wilson & Glenny Ltd, designed by Dennis Lennon, MC, ARIBA, and made by John McGregor & Sons Ltd. (Courtesy: Scottish Furniture Manufacturers Ltd.)

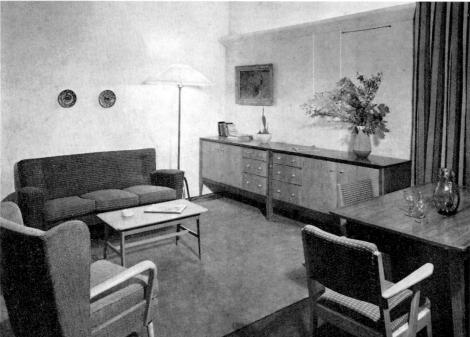

6. Unit chairs which, placed together, form a seat made by John McGregor & Sons Ltd, and covered in Old Glamis fabric by Donald Bros Ltd. Coffee table with mahogany legs and a lip of mahogany round the veneered sycamore top made by A. H. McIntosh & Co. Ltd. Bookcase in mahogany lined with sycamore made by Andrew Thomson & Sons Ltd. All designed by Jacques Groag, Dipl.Ing. Arch, FSIA. (Courtesy: Scottish Furniture Manufacturers Ltd.)

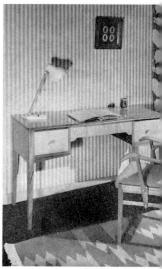

5. Radiogram, low for us from an armchair or moun able on high legs designe by Neville Ward, B Arc ARIBA, MSIA, and Fran Austin, MSIA, and made II Wylie & Lochhead Ltd.

(Scottish Furniture Manufacturers Ltd

OPPOSITE: Interior furnished I Liberty & Co. Ltd. Wall des in natural birch made by Firmar Ltd. Windsor armchair i birch made by The Furnitur Industries Ltd. Upholstere chair designed by Howar Keith, MSIA, and made b H. K. Furniture Ltd. Tray-to table in Chilean rauli and birc by Ronald Harford & Henr Long. Skane wing chair wit striped covering by Trimwe Products Ltd. Lamp by Merchant Adventurers Ltd.

(Colour photo: Peter Luling.
Courtesy: Good Housekeeping.)

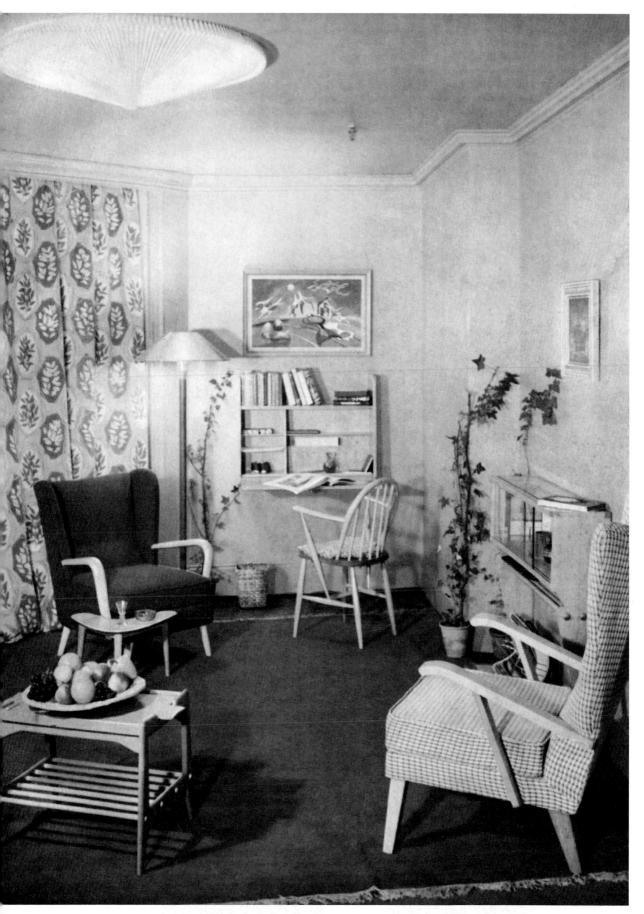

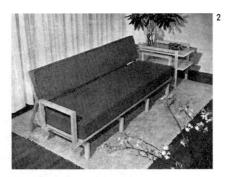

- Chest with drawers in Australian cedar framed in silver ash on a myrtle stand designed and made by S. Krimper (Collection of the National Gallery of Victoria).
- 2. Couch, 7 ft. long, in walnut and primavera with 6-in. mattress-type foam-rubber cushion to seat, both back and seat cushions removable and zippered; and matching table of two shelves hung from wooden frames all designed by Joseph Salerno and made by Corvilla Furniture Inc.
- Writing desk, settee and nesting tables in Queensland blackbean, designed and made by S. Krimper. Cushions covered in linen: Indian rug on the floor.

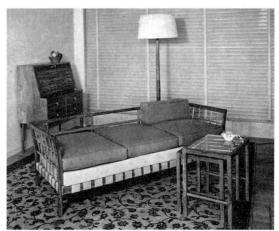

4. Dining-room furnished by Dunn's of Bromley. Bookcase-cupboard unit and dining table in oak designed by Geoffrey Dunn. Table chair by Geoffrey Dunn and E. Clinch, MSIA. Small table in chestnut by A. B. Reynolds. Two upholstered chairs designed by Howard Keith, MSIA, and made by H. K. Furniture Ltd. Textile designed by F. H. K. Henrion, FSIA, and produced by A. & J. Finch Ltd.

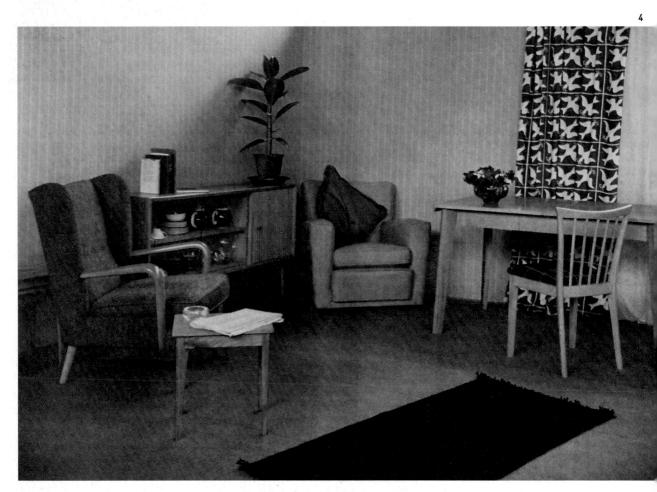

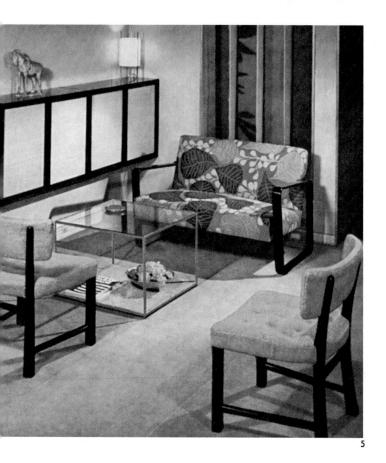

- 5. Living-room group designed by Edward J. Wormley and made by Dunbar Furniture Manufacturing Co. Settee of moulded laminated plywood with a covering of Swiss printed linen, and mahogany chairs covered in hand-woven metallic cloth by Dorothy Liebes. Cabinet of mahogany with pandanus cloth panels, and glass table combined with metal and Finnish birch birl.
- Occasional chairs in natural oak of even height to fitted table, and wrought-iron floor lamp designed by J. H. Tabraham and made by D. S. Vorster & Co. (Pty) Ltd.

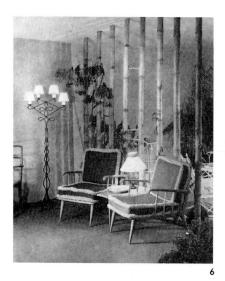

- Mahogany and maple table with engraved plate-glass top designed by P. Döhler and made by P. Döhler Workshops.
- 8. Living-room designed by Paul T. Frankl Associates. Table of 4-in. bleached cork on a plywood frame, settee covered in hand-loomed silk by Maria Kipp with cushions in Morton Sundour's Red Rowena. Lamp bases of split bamboo matting and shades wound with white cotton cord. White textured wool carpet on the floor.

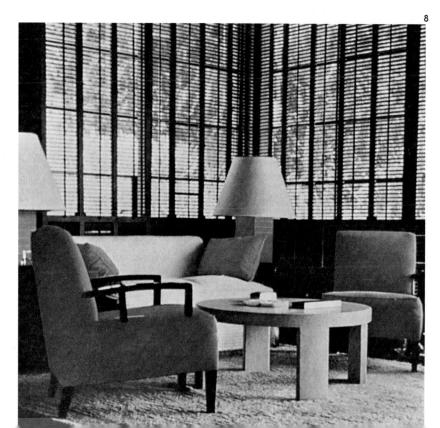

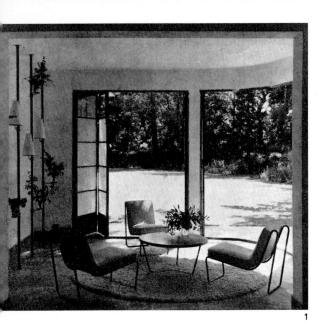

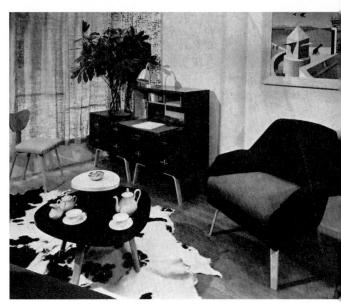

- Garden room designed by Jean Royère with green lacquered furnit upholstered in woven raffia. The circular rug is of white wool.
- Interior designed by Allan Gould and executed by Functional Furnit Manufacturers.
- Low coffee table on a base of macassar ebony with plate-glass top and undershelf for magazines designed and made by Bernard Durussel. Comics by G. Jouve.
- Living-room furnished in oak by Jean Royère with the chair and secovered in plain green fabric. Curtains are white with the motif in viand grey.
- Suite in maple and teak upholstered in blue hand-made woollen fab with grey seats, designed by Finn Juhl and made by Søren Willads Mobelfabrik A/S.

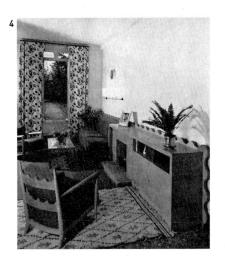

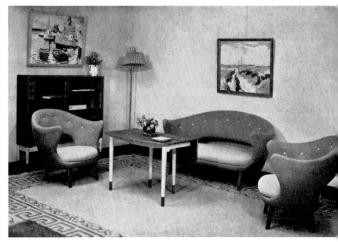

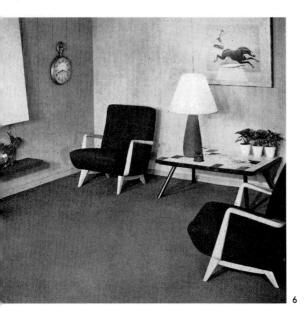

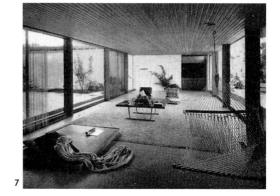

- Living-room designed by Donald Deskey Associates for the Bigelow-Sanford Carpet Co., as a setting for their 'permaset process' carpeting.
- Recreation room designed by Twitchell & Rudolph and built by Associated Builders Inc. Sliding glass walls with fish net curtains. (Photo: Ezra Stoller.)
- Furniture in ash with table legs of forged iron designed by Jean Royère. Chair coverings in red cotton with the motif in yellow and grey. Window seat upholstered in green cotton fabric.
- Fireplace faced with old tiles and surrounded with travertine; glass-topped table
 on iron frame, and chairs in beige fabric designed by Jacques Dumond. Tapestry
 above fireplace by Jean Lurçat.
- 10 and 11. Living-dining-room in the Frank Mitchell home designed by Semmens-Simpson and built by Pike & White Construction. Chesterfield and two chairs upholstered in turquoise fabric with a white leaf motif. Black lacquer dining table with white shag rug below and white covering to dining chairs.

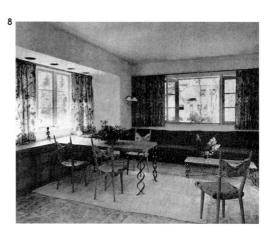

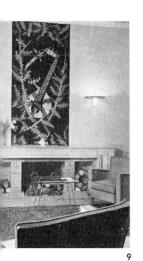

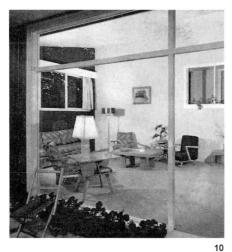

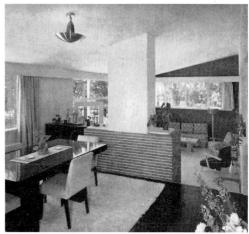

- 1. Unad furniture in blackbean and cherrywood, and Hepple dining chairs designed by The Story Design Group (Ian Henderson, Director of Design) and made by Story & Co. Ltd. Fern Leaf chintz curtains in brown, plum, green, grey and white. Lamp with green glass base and Le Klint shade.
- 2. Sideboard and table designed by Booth & Ledeboer F and ARIBA, and chairs designed by W. H. Russell, FSIA, all made by Gordon Russell Ltd. Sideboard doors of narrow reeded boards with handles of Bombay rosewood. Table reducible in length by removal of centre panel, which can be stored on runners fixed between the rails.

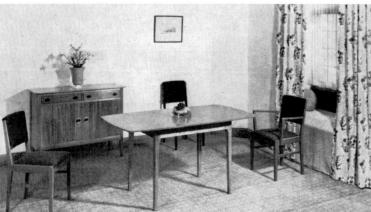

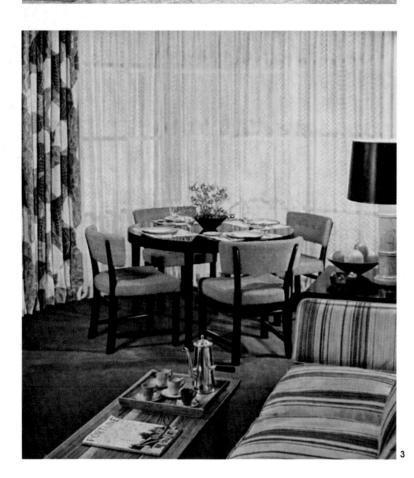

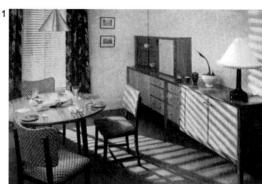

- 3. Dining group by The Dunbar Furniture Manufactur Co., with mahogany dining table (extendable by insertion of an aproned leaf) and chairs covered hand-woven metallic fabric by Dorothy Liet 'Long John' in foreground is of sap-striped waln and the settee is covered in striped textured dama Swiss printed linen curtains.
- 4. Mrs. Chiyo Uno's Western-style living-room design by Professor T. Satow with wax-polished cesideboard and sen-wood tables and chairs made Ginza-kensetsu Co. Ltd. Walls covered with p yellow basho cloth; white ceiling; cherry parq flooring, wax-polished; and dark blue Pers pattern carpet.

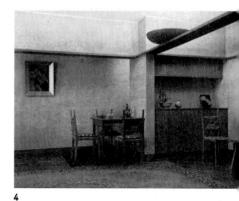

 Dining table and chairs in walnut and primav designed by Joseph Salerno and made by Corv Furniture Inc. The zipper-covered foam-rubber ch cushions rest on sailcloth slings laced to the fram

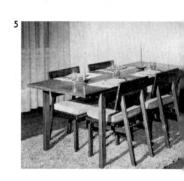

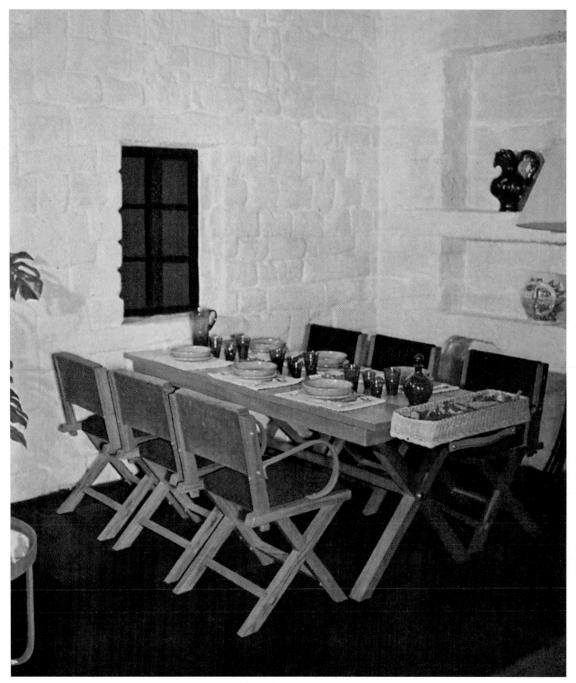

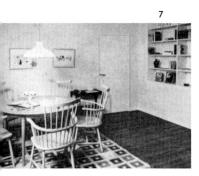

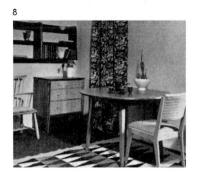

- 6. Country dining-room designed by Jacques Adnet and executed by Cie des Arts Français with furniture in elm, and simple pottery and glassware to suit the scheme. (Colour photo: Alec Murtay.)
- Table, chairs and built-in bookcase-cupboard in polished beech designed by Nils Enström and made by A B Ferd. Lundquist & Co. Hand-woven carpet by Ingrid Hellman-Knafve.
- 8. Blackbean and cherrywood *Unad* furniture designed by The Story Design Group (Ian Henderson, Director of Design) and made by Story & Co. Ltd.

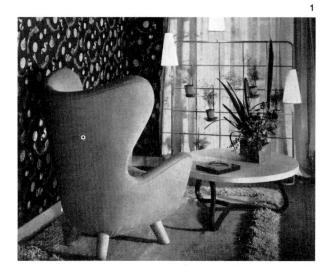

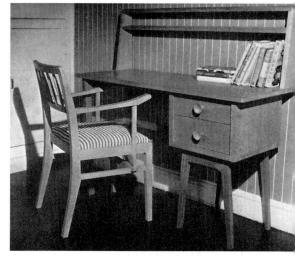

- 1. Armchair covered with grey felt and table of forged iron with natural coloured top designed by Jean Royère. Wallpaper painted by Leonor Fini.
- 2. Mahogany writing table and oak chair, designed by Peter Brunn and made by Peter Brunn Workshops.
- 3. Table top with pressed leaves under plate-glass designed by Martin Eisler.
- 4. Oak writing table, chair and carpet designed by Jacques Dumond.
- 5. Oak coffee table with two nesting tables designed by Catherine Speyer and made by Rena Rosenthal Inc. Large table has sea twill under glass top.
- 6. Coffee table of plate-glass, walnut and Italian twine designed by Martin Freedgood and made by Bernhard & Hayes Inc.
- 7. Pearwood table by Paul T. Frankl Associates for Johnson Furniture Co.
- 8. Nest of tables, rauli legs and frames, tops of sapele mahogany, brass feet. Designed for The British Leather Federation by Hulme Chadwick, ARCA, and made by Frank W. Clifford Ltd.
- 9. Glass-topped cocktail table with walnut legs pierced with brass shafts designed by T. H. Robsjohn-Gibbings. Made by The Widdicomb Furniture Co.
- 10. Mahogany coffee table with tiled top designed by Vladimir Kagan and made by Kagan Woodcraft Inc.

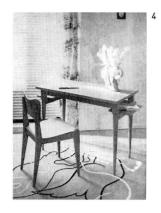

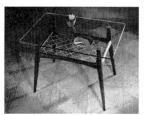

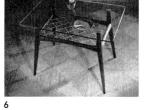

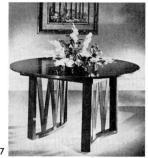

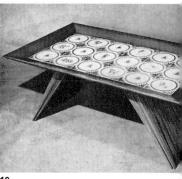

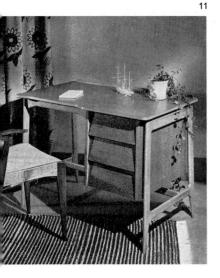

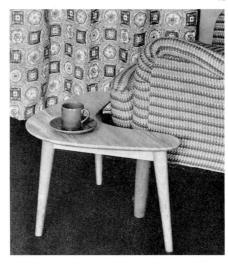

- 11. Writing table and chair in Australian silky oak and Chilean rauli designed and made by Ronald Harford and Henry Long for Heal & Son Ltd. The chair has small arms to allow easy movement of the body.
- 12. Boomerang table available in oak, walnut or mahogany, 12 in. high, designed by A. M. Lewis, MS1A, and made by Liberty & Co. Ltd.
- Magazine table in bleached cork on wooden frame designed by Paul T. Frankl for Johnson Furniture Co.

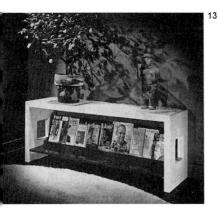

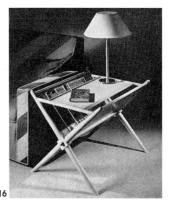

- 14. Magazine tree with walnut shelves and birch trunk, available also in mahogany, designed by Edward J. Wormley and made by Dunbar Furniture Manufacturing Co.
- 15. Magazine rack with plate-glass dividers designed by Ernst Payer and made by Harvey G. Stief Inc.
- 16. Magazine rack in sorrel walnut designed by T. H. Robsjohn-Gibbings. Made by The Widdicomb Furniture Co.
- 17. Nested tables with sap-striped walnut tops on mahogany bases (available in sets of three or four tables) designed by Edward J. Wormley and made by Dunbar Furniture Manufacturing Co.
- 18. Hand-painted tiled-top coffee table of oak, natural pickled finish, designed by Vladimir Kagan and made by Kagan Woodcraft Inc., for Kagan-Dreyfuss Inc. The tiles are treated to resist heat and liquor marks.
- 19. Oak drop-leaf table, natural pickled finish, designed by Vladimir Kagan and made by Kagan Woodcraft Inc., for Kagan-Dreyfuss Inc. Candlestick and lamp also designed by Vladimir Kagan.
- Free form coffee table designed by Arthur A. Klepper, and made by Wor-De-Klee Inc. Available in oak, mahogany, walnut or birch.

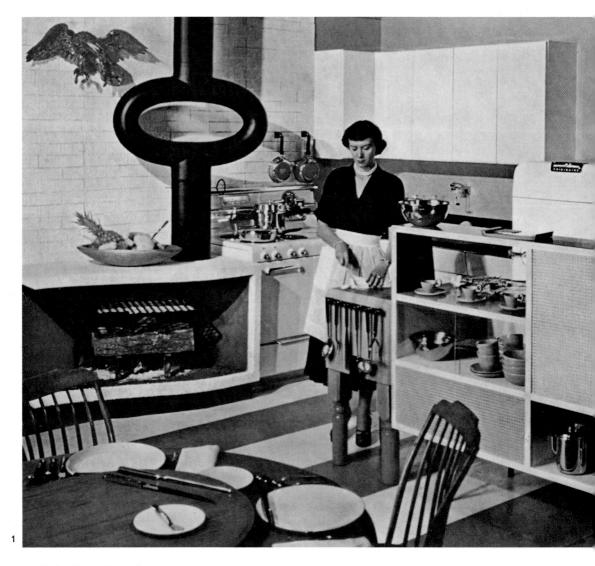

1. Kitchen designed by William T. Snaith of Raymond Loewy Associates with Frigidaire, double-oven range, American kitchen cabinets and Goodyear Wingfoot Vinyl flooring, all Loewy-designed. Fireplace made by Peter de Guard. (Photo: George Karger, Pix Inc. Courtesy: FLAIR.)

2. Snack bar or kitchenette designed by Cecil & Presbury Inc., and made by Sylvania Electric Products Inc., providing a spacious counter, shelving, grille and small refrigerator behind the coral leather cupboard doors. Paintwork also in coral.

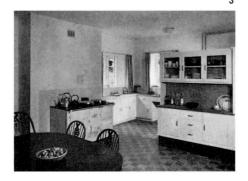

3. Dining-kitchen designed by Booth & Ledeboer F and ARIBA, and made by Wooldridge & Simpson Ltd. Off-white painted fittings and African mahogany bench tops. Wall tiling pale cream, eggshell finish. Equipped with Aga cooker and stainless steel sink. (Photo: John Maltby.)

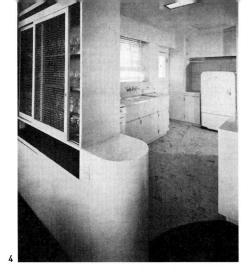

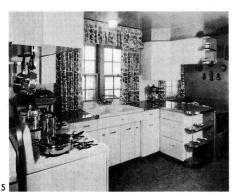

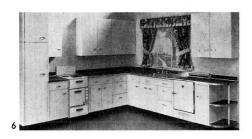

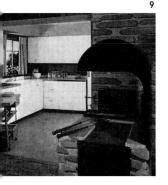

7. Kitchen scheme designed and carried out by Sylvania Electric Products Inc. Walls light blue; curtains grey, red and white; shelf covering light grey; mottled blue and white floor; and Admiral electric cooker.

8 and 9. Kitchen schemes designed by The General Electric Home Bureau, using cookers, refrigerators and other units made by The General Electric Company. Indoor-outdoor kitchen (left) has an outside fireplace for charcoal broiling.

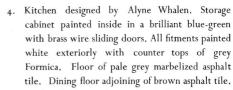

- Kitchen built round a Kitchen Pride sink made by The Crane Company, with a built-in breakfast nook on the far right and a utility room (not shown) on the left.
- Zintec steel cabinets, bonderized and stove enamelled cream, and stainless steel sink, with the steel
 counter tops covered with Formica in a kitchen
 designed by Ezee Kitchens Ltd.

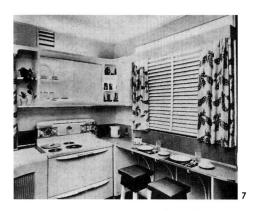

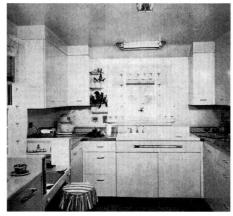

_

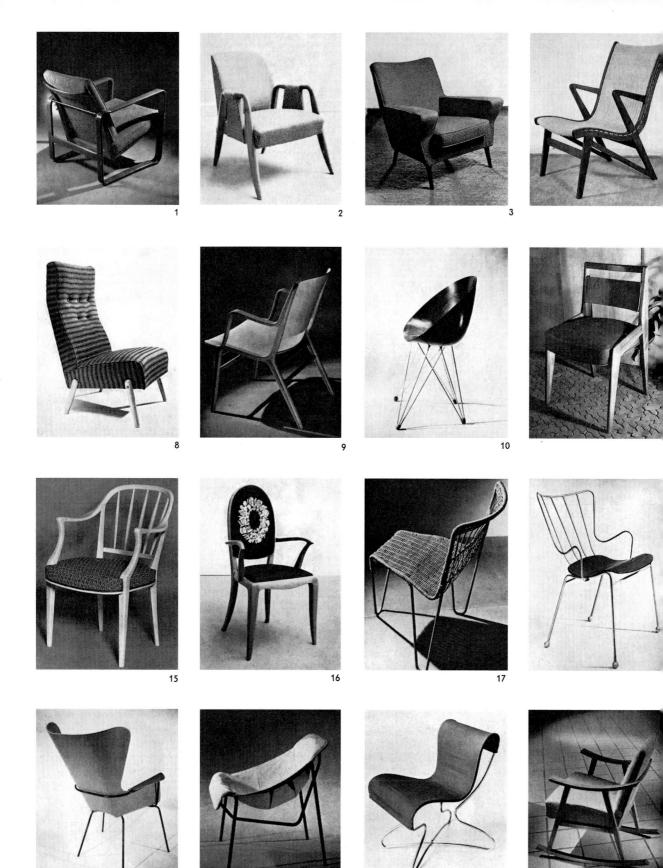

104 · interiors and furniture · 1951–52

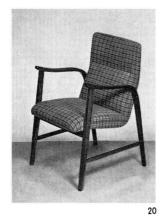

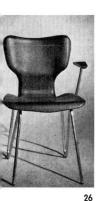

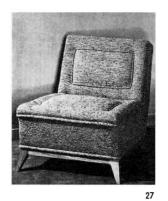

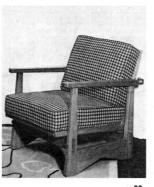

1. Cane back, wooden frame. Dunbar Furniture Manufacturing Co. 2. Natural Makore mahogany. Designer: T. R. L. Robertson. Makers: A. H. McIntosh & Co. Ltd. 3. Stuffover. Designers: Neville Ward, BArch., ARIBA, MSIA, and Frank Austin, MSIA. Makers: H. & A. G. Alexander & Co. Ltd. 4. Teak and cane. Designers: Aage Windeleffand David Birnbaum. Maker: Axel I. Sørensen. 5. Upholstery, webbing straps. A. F. Styne, AID, for Advance Design Inc. 6. Maple, tweed upholstery. Designer: Paul T. Frankl for Johnson Furniture Co. 7. Teak. Designers: Aage Windeleff and David Birnbaum for Axel I. Sørensen. 8. Steel, beech and Dunlopillo. Ernest Race Ltd. 9. Ax chair, laminated beech and solid wood. Designers: Peter Hvidt and O. Molgaard Nielsen. Makers: Fritz Hansens Eftfl. 10. Moulded plastic on tubular frame. Robert Nickel (Institute of Design, Chicago). 11. Natural walnut, striped grey cotton velvet. Bernard Durussel. 12. English walnut and dark green goatskin. Designer: Edward Barnsley. Made by Charles Bray. 13. Lacquered birch designed by Nils Enström. AB Ferd. Lundquist & Co. 14. Beech and plywood. Designer: Borge Mogensen for The Danish Co-operative Wholesale Society. 15. Lacquered birch. Designer: Bertil Fridhagen for Svenska Möbelfabrikerna, Bodafors. 16. Natural Makore mahogany, foam-rubber back. Designer: T. R. L. Robertson for A. H. McIntosh & Co. Ltd. Covering by Arthur H. Lee & Sons Ltd. 17. Lacquered steel frame, plaited cane, by R. Guys. 18. Antelope. Welded steel and plywood. Makers: Ernest Race Ltd. 19. Elm with white-painted back and woollen cover. Designer: Carl-Johan Boman for O/Y Boman AB. 20. Elm or beech, and check wool. Designer: Axel Larsson for Svenska Möbelfabrikerna, Bodafors. 21. Pink beech, cane and blue-grey leather. Designer: W. H. Russell, FSIA, for Gordon Russell Ltd. 22. Fibreboard on tubular frame. Designers: Joan Robinson and William Geer (Institute of Design, Chicago). 23. Metal frame, canvas seat. Designers: Nathan Lerner and Group (Institute of Design, Chicago). 24. Plated steel tubing and zippered fabric. Designermaker: Eva Zeisel. 25. Birch, sorrel finish. Designer: T. H. Robsjohn-Gibbings for The Widdicomb Furniture Co. 26. Moulded plastic, tubular frame, adjustable. Designer: Arpad Augusztiny (Institute of Design, Chicago). 27. Walnut, muslin cover, foam-rubber. John Ossian for John Scalia Inc. 28. Oak frame, metal-sprung

cushions, by Renan de La Godelinais.

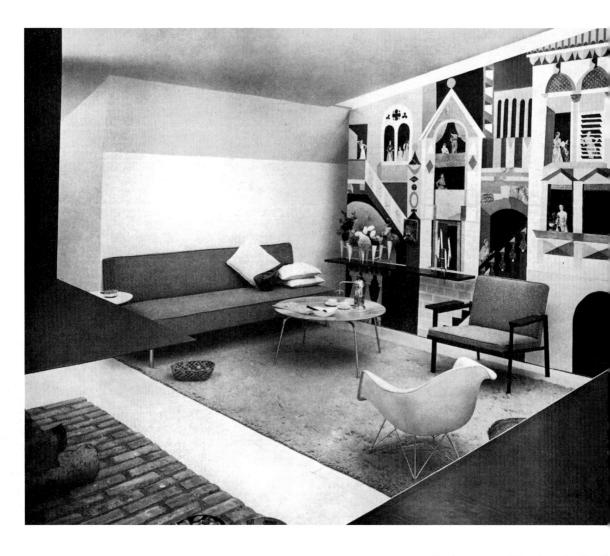

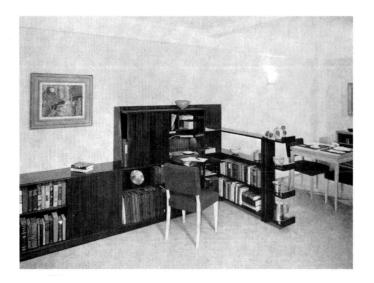

Mural in papier collé by Alexander Girard.

AIA. Sofa and arm chair designed by George Nelson and covered in grey fabric by Moss-Rose. Plastic shell chair and moulded ash plywood coffee tables designed by Charles Eames. Furniture Makers: Herman Miller Furniture Corporation. Gold coloured heavy wool pile rug by V'Soske, Floor covered in black and white Vinyl cork by Dodge Vinyl Corporation (USA).

Cabinet bookcase with wing divider in dark mahogany (or any other wood to order). Light mahogany chair with covering of brown textured fabric. Designer: Irina A. Klepper. Makers: Wor-De-Klee Inc (USA).

106 · interiors and furniture · 1952-53

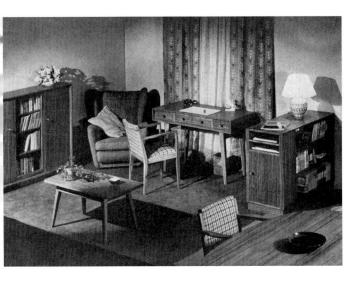

Queensland walnut bookcase, writing table, occasional table and screen bookcase designed by A. Greenwood, MSIA. Small chairs designed by A. J. Milne, MSIA. Makers: Heal & Son Ltd. Curtains of Heal's *Spring Harvest* printed linen. Easy chair by H. K. Furniture Ltd (GB).

Below: Dining-living room divided by a bamboo screen arranged by Frederick Manning. Natural oak sideboard, oak shelf and 'flying' bookcase, and two one-arm chairs of light oak (together forming a settee) (BRITISH); oak dining table and chairs (SWEDISH); and a natural elm bureau (DANISH). From Bowman Bros Ltd (GB).

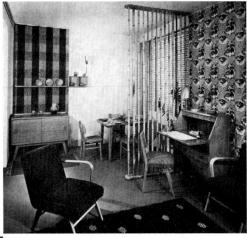

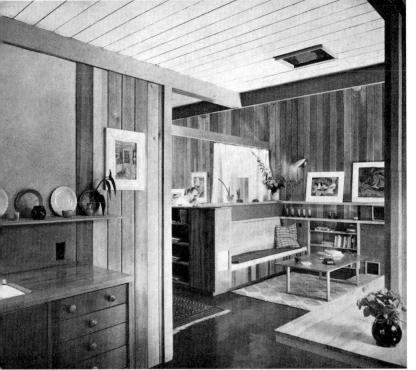

Living-room and a corner of the studio in the North Vancouver home of Mr and Mrs Bruno Bobak, furnished by the owner. Of post and beam construction, with red cedar walls and a white ceiling. Birch furniture with a cedar base to the sink unit and terracotta linoleum to floor. Posts and beams painted grey. Designer: Douglas Shadbolt (CANADA). (Photo: Peter Varley)

OPPOSITE: Natural ash coffee table ward-in. plate glass top. Designer: Dovan Sliedregt. Makers: M. A. Ouwe & Co (HOLLAND).

Coffee table with ¾-in. glass top on a light grey mahogany base. Available also in dark mahogany and in oak, walnut and birch, light or dark finishes. Designer: Irina A. Klepper. Makers: Wor-De-Klee Inc (usa).

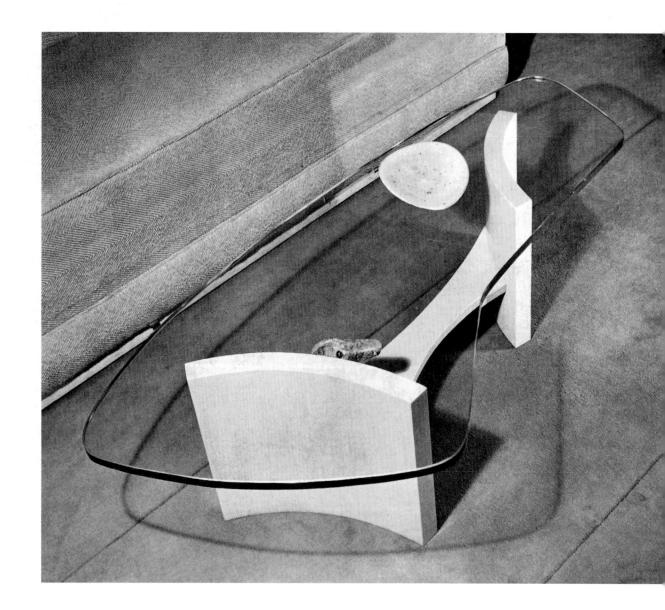

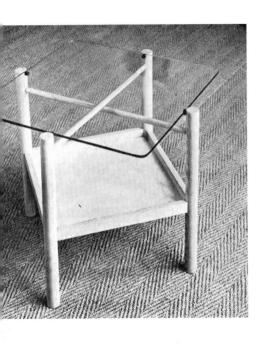

Metal and glass coffee table of 1-in. thick plate glass 42-in. by 18-in. supported on highly polished brass frame. Designer: Brice of Auerbach Associates. Makers: Charak Furniture Co Inc (USA).

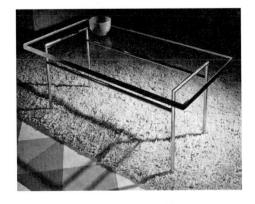

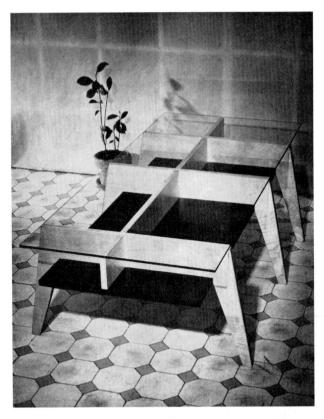

Coffee table, prototype (not yet in production) made in 3-in. plywood with glass top and ebonized undershelf. Designer and maker: Jacques de Tonnancour (CANADA).

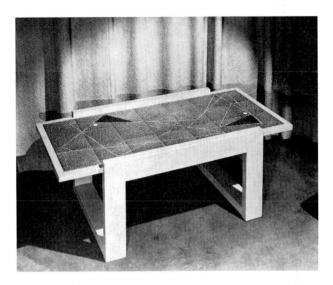

Light grey mahogany occasional table inset with tiles of rough textured ceramic by Key-Oberg. Available also in dark mahogany, oak, walnut or birch, in light or dark finishes, with tiles to blend. Designer: Arthur Klepper. Makers: Wor-De-Klee Inc (USA).

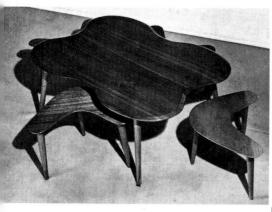

Occasional table with metal plant container, laminated top of Japanese tamu on beech underframe. Designer: K. McAvoy. Makers: Liberty & Co Ltd (GB).

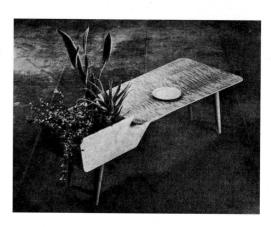

Nimbus coffee table with four fitting 'boomerangs', available in oak, mahogany or walnut. Designers: A. M. Lewis and K. McAvoy. Makers: Liberty & Co Ltd (GB).

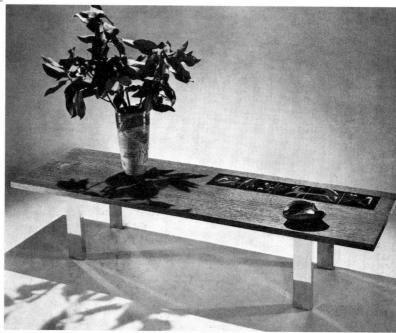

BELOW: Octopus coffee table in mahogany and sycamore, natural waxed finish. Designer: Peter Brunn. Makers: Peter Brunn Workshop (GB). (Photo: John Fry)

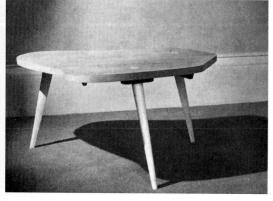

Coffee table in brushed oak on polished bronze legs, inset with five hand-painted ceramic tiles which act as coasters for glasses. Designer: Vladimir Kagan. Makers: Kagan-Dreyfuss Inc (USA).

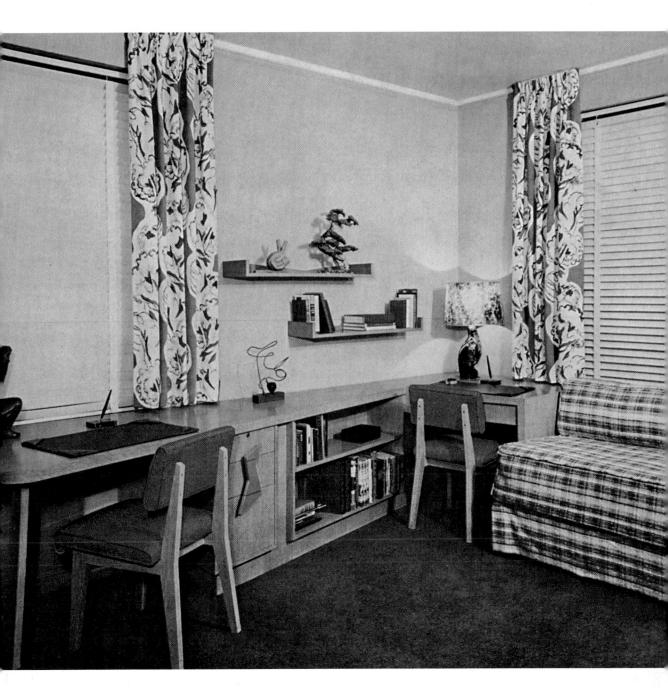

Corner of a room for two boys with a bleached oak desk fitment and sofa beds (the room contains two, separated by a table) covered in plaid cotton and rayon Greeff fabric. Heavy cotton draperies with *Trees* design by Dan Cooper. Knoll *Prestini* covering to chairs, cotton and rayon in red and oatmeal. The wooden sculpture on left by Walter Midener: free form wire, stone, wooden and ceramic sculptures by Anita Weschler. Furniture designer: Irina A. Klepper. Makers: Wor-De-Klee Inc (USA).

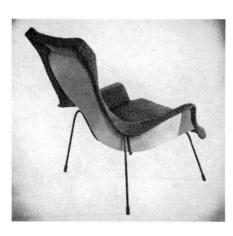

Easy chair, spring stuffed loose seat cushion, covered in green tapestry. Designer: A. J. Milne, MSIA. Makers: Heal & Son Ltd (GB).

Sectional chairs, frames of birch stained to any required colour, cotton print covered in rose, mustard and black on white ground. Designers and makers: Advance Design Inc (USA).

LEFT: Chair mounted on steel rod base held in position by four bolts, sl moulded in fibrenyle plastic with latex foam headrest and seat cushion, cove in brown pile fabric with the outside back in contrasting material. Design Dennis Young, ARCA, MSIA. Makers: Design London Educational Industrial Ltd (GB).

Mahogany occasional table with chessboard inlay, made by A. H. McInte & Co. Ltd; and chairs made by Steadfast & Co Ltd, upholstered in tartan plused made by Wilson & Glenny Ltd, all designed by Jacques Groag, Ding.Arch, FSIA. Thistle decanter and glasses made by Edinburgh & Le Flint Glassworks Ltd. Rugs by Highland Home Industries Ltd (GB). (Courtesy: Scottish Furniture Manufacturers Ltd)

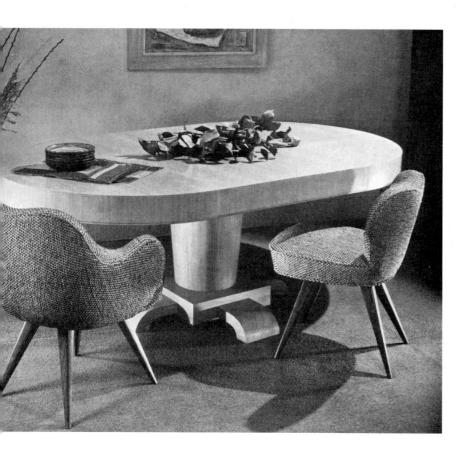

Extension dining table (shown extended) of korina, and walnut chairs covered in black, grey and white handwoven fabric. Designer: Vladimir Kagan. Makers: Kagan-Dreyfuss Inc (USA).

Occasional chair, birch frame, covered in gold and ivory on brown ground weavecraft. Designer: Bill Evans. Makers: Advance Design Inc (usa).

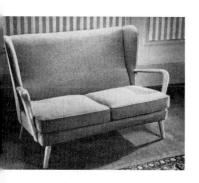

uder settee with arms and legs of beech or ch polished to sycamore, walnut or mahoy, covered in pinky-beige wool and cotton estry designed by Marianne Straub. Furnia designer: Howard B. Keith, MSIA. cers: H. K. Furniture Ltd (GB).

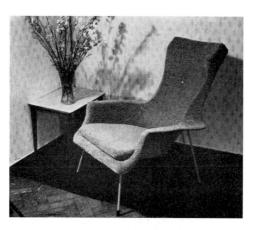

Front view of the chair shown opposite, top left. The steel legs are stove enamelled in light blue and have rubber pad toes. Designer: Dennis Young, ARCA, MSIA. Makers: Design London Educational and Industrial Ltd (GB).

Chair on walnut legs covered in ivory textured fabric with cushions of red oriental silk. Designer: Donald Cameron. Makers: Rena Rosenthal Inc (USA).

BELOW: A living-room in Stockholm furnished by Emilio Del Junco (CUBA) with Swedish and American pieces. The book shelving is adjustable on metal wall guides.

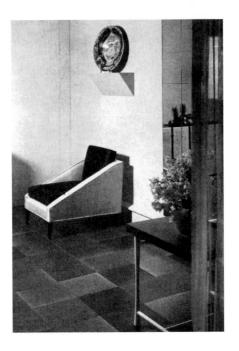

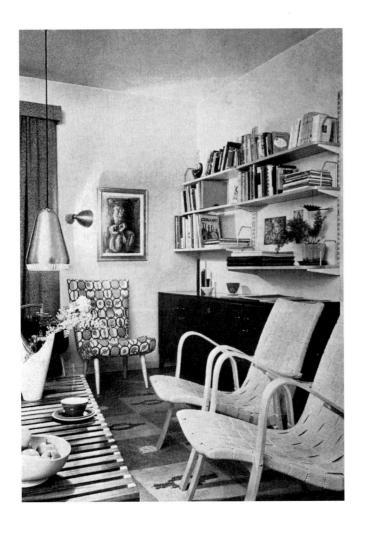

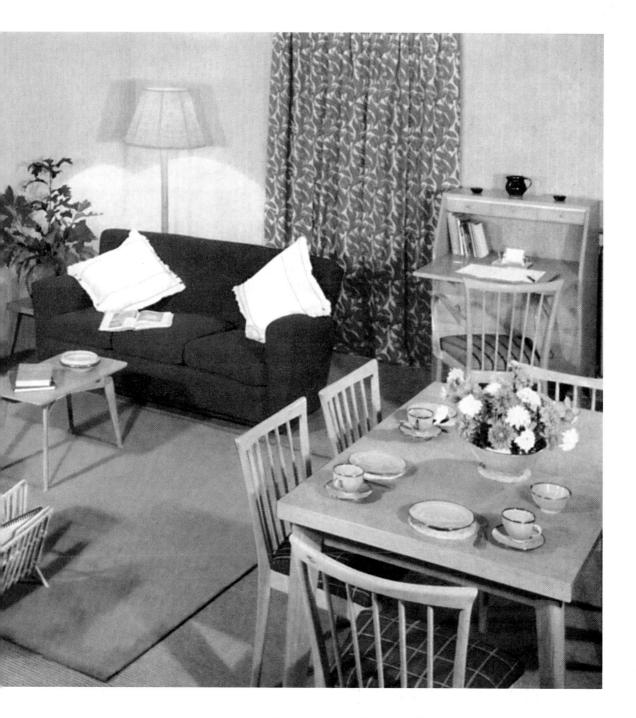

Living-dining room arranged by Dunn's of Bromley with a Simplon settee and easy chair (Designer: Howard B. Keith, MSIA. Makers: H. K. Furniture Ltd); Freydun dining table available in oak or mahogany (Designer: Geoffrey Dunn); Freydun dining chairs in beech or mahogany (Designer: E. L. Clinch, MSIA); Occasional table in oak or mahogany (Designer: Jacques Groag, Dipl. Ing. Arch, FSIA); and cane canterbury (Designer: Geoffrey Dunn) (GB).

(Courtesy: Good Housekeeping)

Siesta in deep textured corn yellow tapestry made by Tibor Ltd. Designer: Howard B. Keith, MSIA. Makers: H. K. Furniture Ltd (GB).

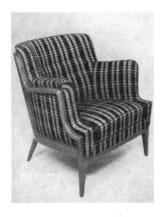

Beech frame, upholstered in cloth made by Richard Johnson. Designer: Bertil Fridhagen. Makers: Svenska Möbelfabrikerna (SWEDEN).

Stelvio in black and grey Welsh wool tapestry. Designer: Howard B. Keith, MSIA. Makers: H. K. Furniture Ltd (GB).

Birch frame covered in blue, and white striped woollen fab Designer: Carl-Johan Bom Makers: O Y Boman AB (FINLAN

White birch, clear cellulosed. Mustard yellow upholstery. Detachable legs. Designer: A. V. Pilley, friba. Makers: C. Jay Cole & F. A. Cole Ltd (GB).

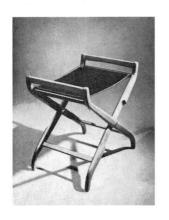

Futura. Collapsible stool of red beech with plastic web seat. Makers: AB Nordiska Kompaniet (SWEDEN).

'Knock-down' chair in bleached birch upholstered in dark blue wool. Designer: Dirk van Sliedregt. Makers: Jonkers Meubelfabriek (HOLLAND).

Oak frame with loose cushion s Available also with loose ba Designer: Steve Tourre. Mak Mueller Furniture Co (USA).

Mahogany frame, covered in Tabergs Yllefabrik. Designer: Svante Skogh. Makers: AB Svenska Möbelfabrikerna (SWEDEN).

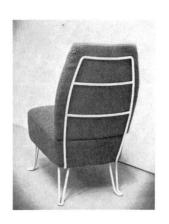

White lacquered iron frame, with hairlock stuffing and handwoven covering. Designer: Nils Enström. Makers: AB Ferd. Lundquist & Co (SWEDEN).

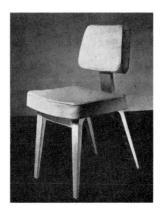

Honduras mahogany and Canadian birch moulded laminated sections, lemon yellow whipcord cover. Designers: Jane Drew and Maxwell Fry, FFRIBA with Neil Morris. Makers: Morris of Glasgow (GB).

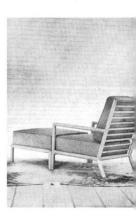

Sorrel-finish walnut chair ottoman, foam-rubber uphols covered with beige linen. signer: T. H. Robsjohn-Gibb Makers: The Widdicomb Furni Company (USA).

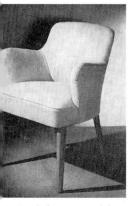

es. Beech legs, oatmeal linen ring. Designers: Geoffrey n and Mollie Benham. Makers: n's of Bromley (GB).

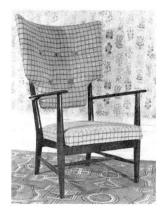

Mahogany frame, moulded plywood back and foam-rubber seat, covered in horse blanket tweed. Designers: Norman A. P. Whicheloe and Nigel Walters. Makers: Primavera (GB).

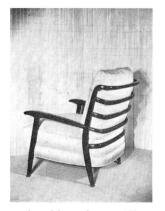

Hardwood frame, lacquered black. Fixed seat, loose back. Covering of light green textured silk. Designer: Paul Laszlo. Makers: Laszlo Inc (USA).

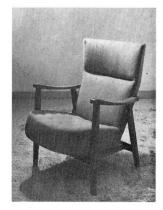

Elm frame upholstered in blue woollen fabric. Designer: Olof Ottelin. Makers: O Y Stockmann AB (FINLAND).

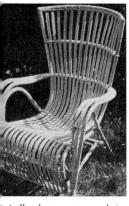

trically - bent rattan chair. gner: Dirk van Sliedregt. ers: Gebr. Jonkers (HOLLAND).

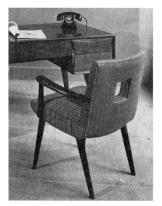

Walnut legs and arms, upholstered in green and gold damask. Designer: Erno Fabry. Makers: Fabry Associates Inc (USA).

Natural beech or birch. Makers: AB Nordiska Kompaniet. Designed by their Design Department (SWEDEN).

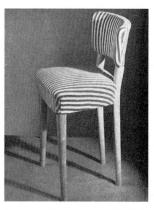

Sycamore frame, seat and back in coral and ivory Regency stripe velvet. Designer: Roff Marsh, FRIBA, AMTPI. Makers: D. Burkle & Son Ltd (GB).

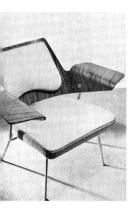

and arms of pre-formed plyd, steel frame, back and seat of rubber covered in lime yelfabric. Designer: Robin Day A. Makers: S. Hille & Co (GB).

White birch, clear cellulosed, seat and back webbed and padded. Mustard yellow upholstery. Detachable legs. Designer: A. V. Pilley, friba. Makers: C. Jay Cole & F. A. Cole Ltd (GB).

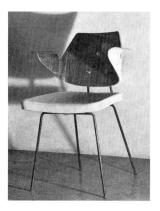

Steel underframe with leathercovered sponge rubber seat, moulded plywood back and arms. Designer: Robin Day, ARCA. Makers: S. Hille & Co Ltd (GB).

Plywood seat, mahogany underframe, covered in Scottish tweed. Designer: Dennis Lennon, MC, ARIBA. Makers: John McGregor & Sons Ltd, for Scottish Furniture Manufacturers Ltd (GB).

LEFT: Chairs covered in red and blue repp, and aperitif table, all in w cherrywood. The table has a space between the glass top and the for magazines or papers, and a container for plants or flowers at one Walls veneered in natural Swedish pine, floor covered in slate linoleum and a white long pile wool carpet. Interior decorator: Ben Durussel (FRANCE).

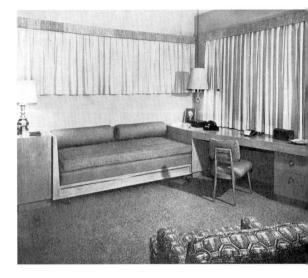

RIGHT: Man's room furnished in pickled oak, the bed mounted on large rubber castors to facilitate movement; bed cover of brown and beige tweed; curtains of natural silk shantung with valance of Puerto Rican fibre hand-woven by Geraldine Funk; carpet beige and olive tweed mixture; chair covered with quilted chintz, olive green, brown and beige. Designer: William Pahlmann (USA).

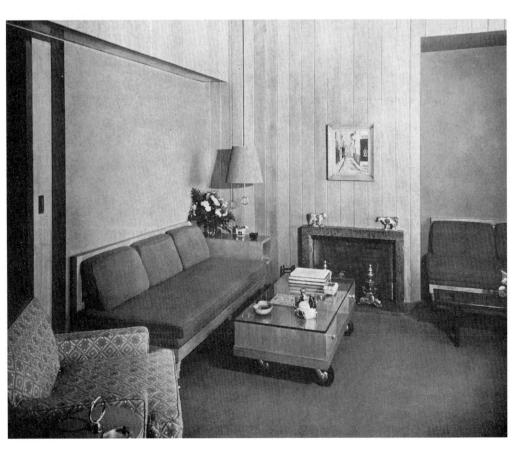

Sofa beds with natural backs (which collapse make three-quarter bed) covered in olive gr coral and brown tw Coffee table with glass two drawers and a ce magazine space, mountee brass large and castors. Chair covered quilted glazed chintz olive-green and beige coral ground. Lime g shaded reed light on ce pulley. Designer: Wil Pahlmann (usa).

ing-room with 7 ft. 6 in. sofa bed and holstered lounge chair, both of foam rubber struction. The metal frame cocktail table a glass top and base of Finnish birch burl. signer: Edward Wormley. Makers: Dunbar initure Corporation (USA).

Low: Living-room furniture, fabrics and pet designed by William Pahlmann. If the table of walnut with burl top. Sofawered with hand-woven Peruvian linen Rio ande design; white silk gauze curtain inted with Still Trees design, both made by humacher Fabrics. Roll reed blind tondow of natural coloured yarn with gold copper Lurex woven by Grace Ritchie arke Studio. Furniture makers: Grand pids Bookcase & Chair Co (usa).

GHT: Work table with four drawers and a litting locker, and sewing chair both in ht mahogany. Designer: Olof Östberg. akers: The Swedish Homecraft Association WEDEN).

(Courtesy: The Swedish International Press Bureau)

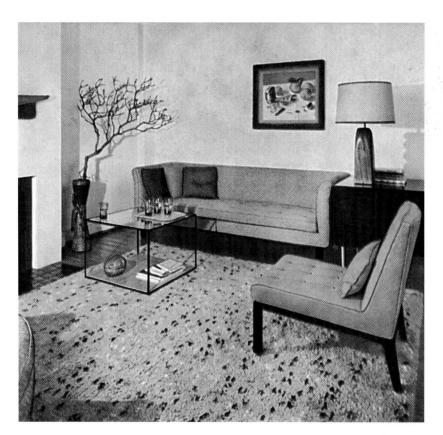

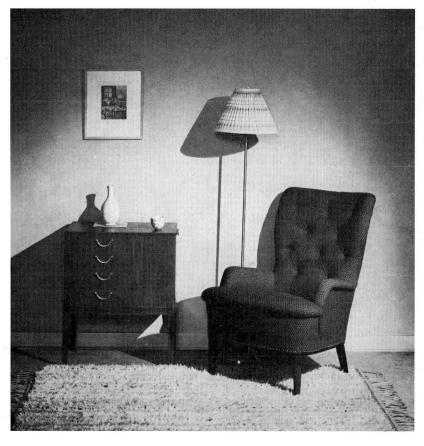

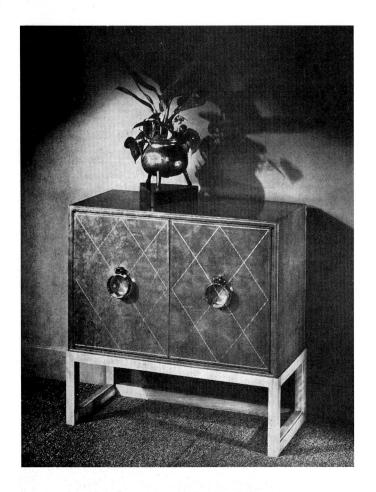

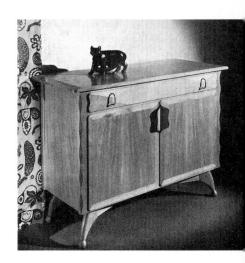

Sideboard of Jugoslavian beech, the long drawer will compartment fitted for cutlery. Designer: A. J. Milr MSIA. Makers: Heal & Son Ltd. Curtain of Matuprinted linen. Designer: Roger Nicholson (GB).

LEFT: Commode covered in topgrain hand-tool leather on a bleached mahogany base. Hand-wroug brass ring handles. Makers: Charak Furniture Co I (USA).

BELOW: Sideboard in mahogany and rosewood, the doc decorated with incised lines showing the light colour-veneer below. Handles of brass. Designers: Booth Ledeboer, F & ARIBA. Makers: Gordon Russell L (GB).

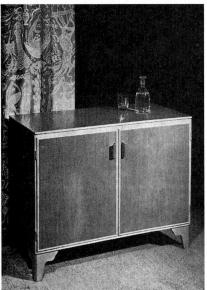

Triva cabinet in mahogany and birch with moulded handles and fitted with two adjustable shelves or sliding trays on each side. Designer: Elias Svedberg. Makers: A B Nordiska Kompaniet (SWEDEN).

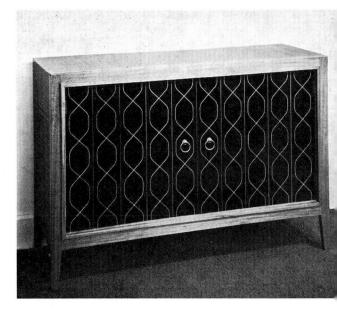

nber-toned mahogany chest, the drawers and door enings formed by a grooved wooden overlay which ms part of the design and acts as decoration. signer: Harvey Probber. Makers: Harvey Probber (USA).

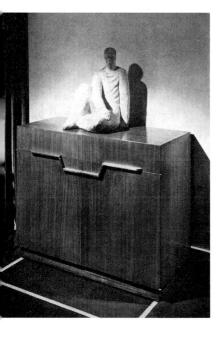

Four-door cabinet in dark walnut with panels of bleached Hungarian ash. Designer: Donald Cameron. Makers: Rena Rosenthal Inc (usa).

rural pickled oak tambourpred double chest, 8 ft. 6in. g. Designer: Vladimir gan. Makers: Kaganeyfuss Inc. Lamp, plate, lpture and painting also m Kagan-Dreyfuss (usa).

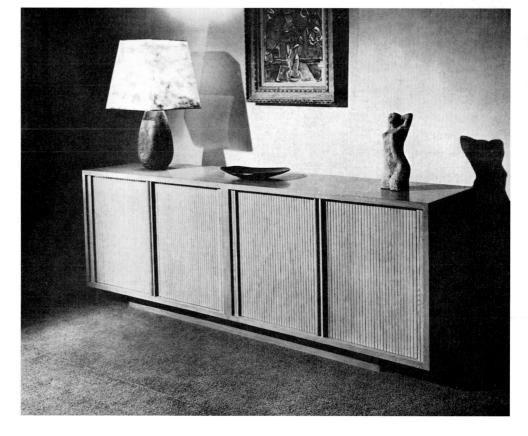

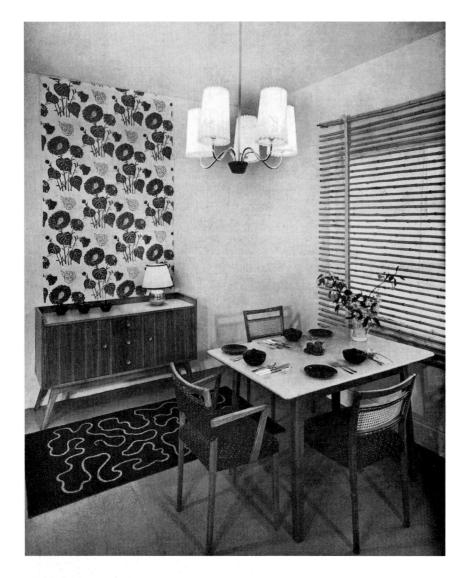

Pencil-striped walnut suite, the table and sideboard tops faced with heatproof and washable Warerite; chairs with cane or tapestry backs to match seats; *Ormiston* linen on wall designed by Marion Mahler and made by Donald Bros Ltd. Furniture designer: E. L. Clinch, MSIA. Makers: Bowman Bros Ltd (GB).

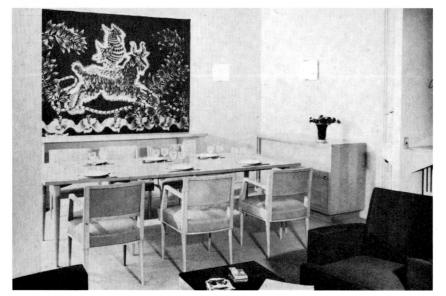

ABOVE: Birch table, top clear cellulosed, with legs of aerofoil section (detachable for transport) fixed to the table frame with coach screws. Designer: A. V. Pilley, FRIBA. Makers: Walter F. Baker Ltd (GB). Chairs from the Continental factories of Thonet Bros Ltd.

LEFT: Dining table, chairs and sideboard in polished ash, chair coverings of natural morocco. Tapestry on rear wall by Jean Lurçat. Table in foreground of ash with black slate top. Easy chairs covered in dark green velvet. Designer: Jacques Dumond. Makers: Ets Gazel et Cie (FRANCE).

EOVE: Dining table and chairs in natural mahogany with brass feet. esigner: Dennis Lennon, MC, ARIBA. Makers: Joseph Johnstone d for Scottish Furniture Manufacturers Ltd (GB).

ELOW: Hand-made Queensland walnut furniture, the chairs with uffed seats and backs covered in fawn hide and the cupboards lined ith sycamore. Curtains of *Chrysanthemum* printed linen designed by lichael O'Connell. Furniture designer: A. Greenwood, MSIA. Lakers: Heal & Son Ltd (GB).

BELOW: Extending dining table, sideboard and side table in oak. Designers: Booth & Ledeboer, F & ARIBA. Makers: W. Rowntree & Sons Ltd. Beech chairs with loose seats covered in cotton tapestry. Designer: E. L. Clinch, MSIA. Makers: Goodearl Bros Ltd (GB).

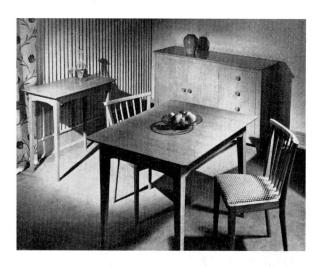

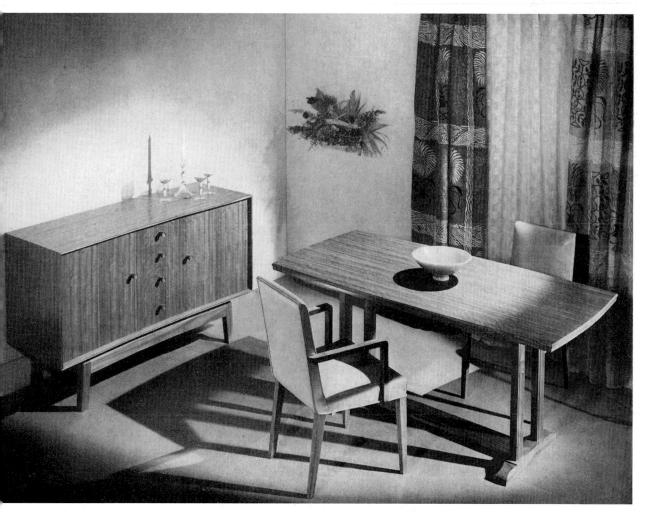

RIGHT: Bookcase with sliding glass doors; bureau with mirror fitted to top drawer if desired; and folding table, all in oak. Table available also in walnut. Makers: D. Meredew Ltd (GB)

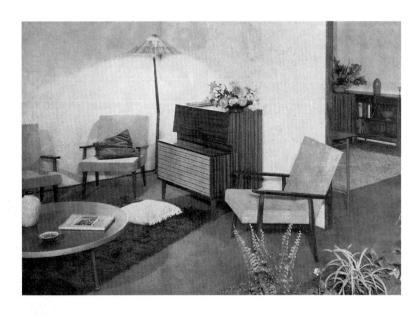

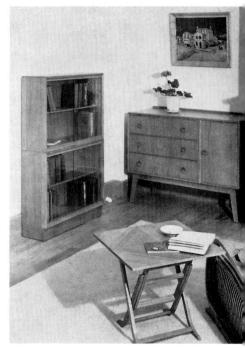

ABOVE: Radiogram and chairs in sapele mahogany, and light oak table on grey steel legs with terra-cotta linoleum top. Chair upholstery of Dunlopillo foam rubber covered in yellow wool and mohair mixture. Designers: J. H. Tabraham (radiogram) and D. S. Vorster (chairs and table). Makers: D. S. Vorster & Co (Pty) Ltd (SOUTH AFRICA)

Television - radio - phonograph-record album cabinet, usable as one fitment or as separate units, in cordovan or blonde finish mahogany with perforated coloured masonite sliding doors to television and record cabinets. The drapery is Laverne's *Maze*, white satin with the design in black. Designer: F. B. Arthur. Makers: F. B. Arthur Modern Interiors (USA)

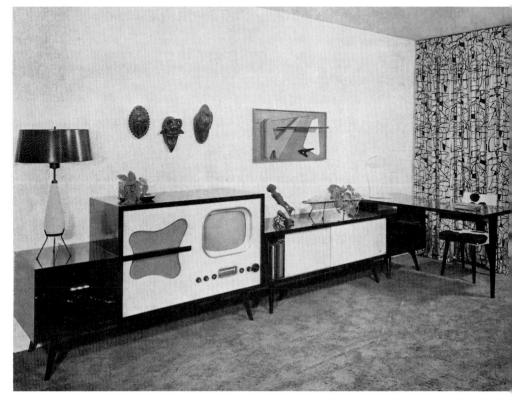

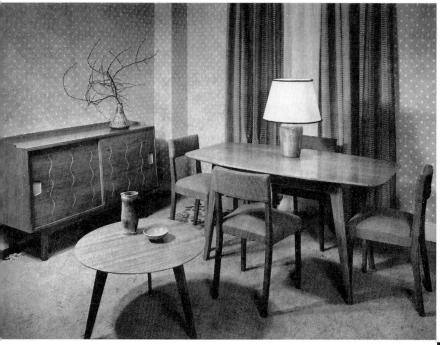

Chelsfield dining-suite in Pal Dao walnut with elm doors to sideboard and Caton fabric in red or olive-green on chairs. Coffee table available in natural oak, walnut or mahogany. Designer: Ian Audsley MSIA. Makers: G. W. Evans Ltd (GB)

RIGHT: Storage cabinets of Douglas fir plywood. Designer: Fred Brodie MRAIC. *Rushtex* and steel-framed chairs designed by Robin Bush and Earle A. Morrison. Makers: Earle A. Morrison Ltd (CANADA).

BELOW: Combination sideboard and cocktail cabinet in mahogany, sliding doors of Brazilian rosewood, top of black plastic, inside of swing door white lacquer, mixing surface and back of Cipollino marble, and chromium legs. Designer: Felix Augenfeld (USA)

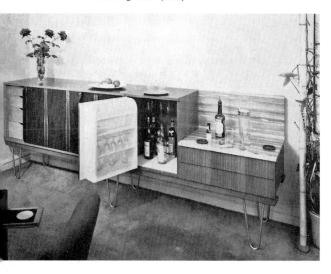

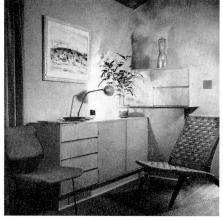

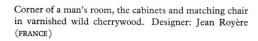

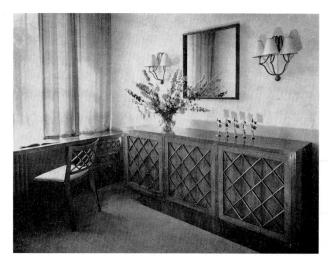

Free-form Regency coffee table yew, with brass ferrules. Design and makers: Charak Furniture Copany (USA)

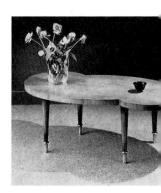

Mahogany table, natural cellulo finish. Designer: Dennis Young, AR MSIA. Makers: Design (Lond Educational & Industrial Ltd (GE

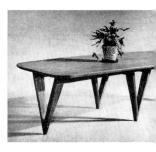

Patio with Mesa table, strapped sofa covered in *Bark* linen, side chair in *Strata* linen, and curved cocktail couch in linen tweed. Designer: T. H. Robsjohn-Gibbings. Makers: The Widdicomb Furniture Company. Courtesy: The Marble Institute of America (USA)

Mesa table in walnut, Sienna finish. Designer: T. H. Robsjohn-Gibbings. Makers: The Widdicomb Furniture Company (USA)

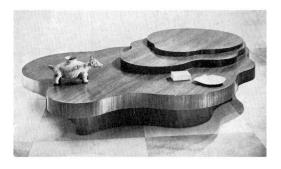

Coffee table with ¼-inch glass top o sculptured walnut, oak or mahogi base. Designer: Vladimir Kag Makers: Kagan-Dreyfuss Inc (USA

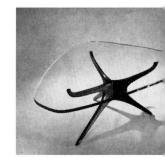

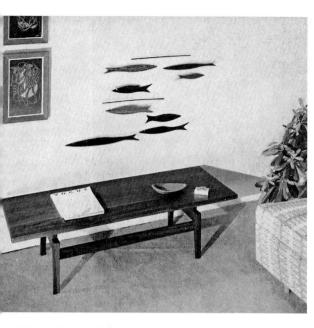

w table in walnut or birch, 54 inches long, available also with Micarta in yellow, grey or green, convertible into a bench by the addition of a inch reversible foam rubber pad. Designer: Jens Risom. Makers: Jens om Design Inc (USA)

r-shaped table made of cork veneered to a wood base. Designer: Paul Frankl. Makers: Johnson Furniture Company (USA)

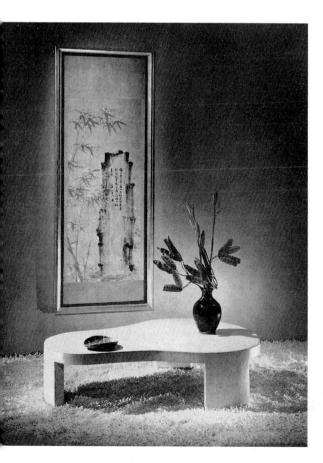

Cedar and beech coffee table, 4 ft long, 1 ft 6 inches wide and 1 ft 3 inches high. Designer and maker: Martin Grierson (GB)

Plant table in African mahogany (available also in walnut or beech) with plastic plant tray. Top slides over plant tray to make a plain table if required. Designer: T. Gibbs. Makers: Primavera (GB)

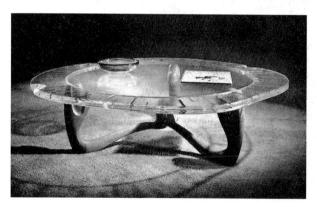

Coffee table, sculptured base of natural walnut and free-shaped Lucite top, the outer edge frosted with an irregular pattern of colour. Designer: Paul Laszlo. Sculpture: F. F. Kern. Makers: Laszlo Inc (USA)

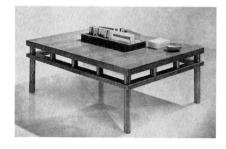

Walnut cocktail table with centre recess for magazines. Designer: T. H. Robsjohn-Gibbings. Makers: The Widdicomb Furniture Co (USA)

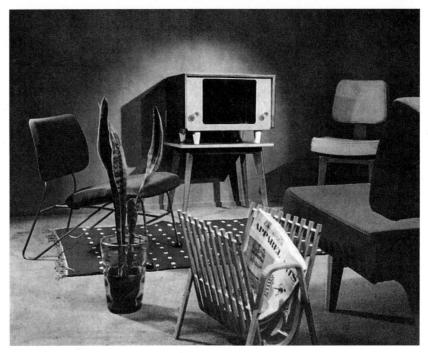

Television set in macassar ebony with *Sycamore Q* front; *Esbac* chair (LEFT) with moulded plywood seat and back on quarter-inch mild steel frame, foam rubber cushioning; I.C.A. chair (RIGHT BACKGROUND) and two-seated chair on laminated frames with foam rubber upholstery; magazine rack in mahogany and birch laminations. Designer: Neil Morris (I.C.A. chair in conjunction with Jane Drew and Maxwell Fry, FFRIBA). Makers: Morris of Glasgow (GB)

Walnut chairs covered in black and white calfskin, walnut cocktail table with black *Trolonit* top, brass-edged, and built-in walnut settee covered in handwoven woollen fabric. Designer: Paul G. R. Baumgarten. Maker: P. Döhler (GERMANY)

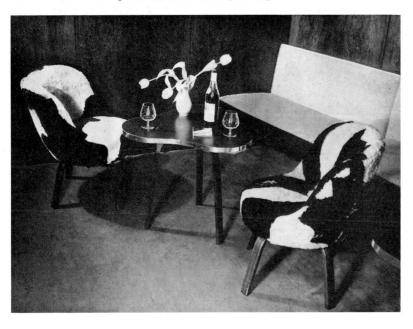

HT: Combination chest-bureau in k, walnut or mahogany on beech base h matching chair. Designer: Børge gensen. Makers: Søborg Møbelrik (DENMARK)

ow: Living-room with walls of ilippine mahogany, cane panelled ors and red tile floor, radiant heated. e long bench under the window has netal frame and slate top painted rtreuse, the same colour being reted in the Micarta top of the table. as covered in printed linen, easy irs in white linen, curtains of printed gauze. All upholstered and modern niture (except the two iron and rush irs) by William Pahlmann Associates: (USA)

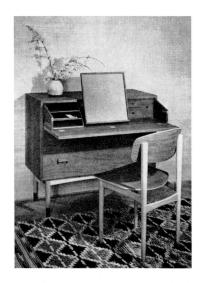

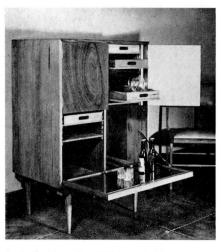

Cocktail cabinet of petiribi fronted with walnut, the serving shelf faced with Formica. The inner shelves have handles at both ends and can be used as trays. Makers: A.I.M. (ARGENTINA)

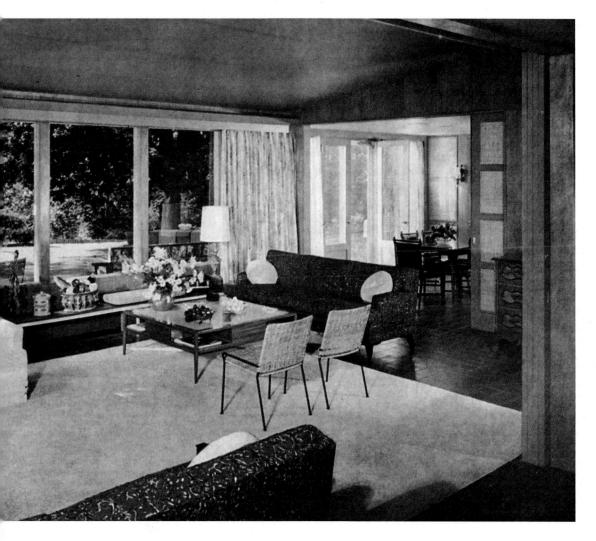

Walnut cabinet faced with a paper map of London. Designer: Josef Frank. Makers: Svenskt Tenn (SWEDEN)

LEFT: Cocktail cabinet in guatambú with black plastic covered doors. Designer: Jacobo Glenzer. Makers: Jacobo Glenzer and Isidoro Kurchan (ARGENTINA)

BELOW: Waxed oak chest with polished brass handles. Designer: René Jean Caillette (FRANCE)

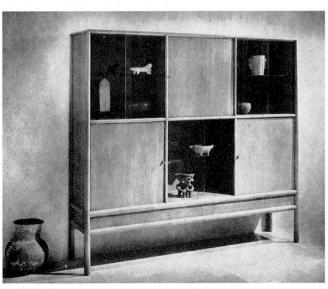

Cabinet in walnut and birch with sliding glass doors. Designer: T. H. Robsjohn-Gibbings. Makers: The Widdicomb Furniture Company (USA)

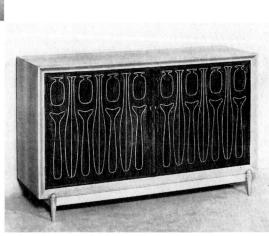

Beech sideboard with routed decoration on the Indian laurel door panels. Designer: Kelvin McAvoy, exclusively for Liberty & Co. Ltd (GB)

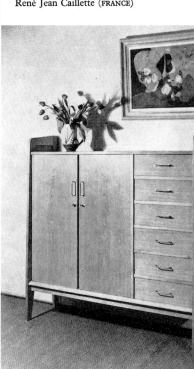

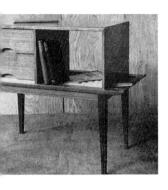

LEFT: Cabinet in Honduras mahogany and English beech, finished in the natural colours of the woods. Designer and maker: Arthur Edwards of the High Wycombe College of Further Education (GB)

French walnut cabinet with burr maple drawer fronts, natural colour with satin lacquer finish. Designer: T. R. L. Robertson DA. Makers: A. H. McIntosh & Co. Ltd (GB)

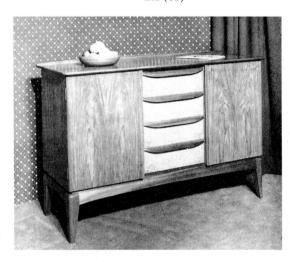

LEFT: Cabinet in smoked oak, mahogany and beech, or teak and beech, oil-finished. Designer: Poul M. Volther. Makers: Fællesforeningen for Danmarks Brugsforeninger Møbler (DENMARK)

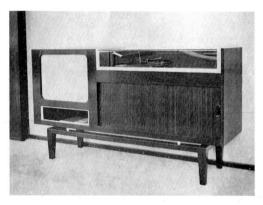

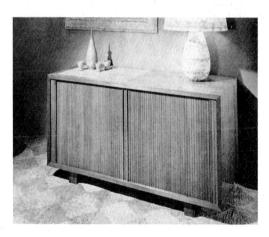

TOP: Multi-purpose units in natural oak—television set, record cabinet, linen storage chest and cocktail bar with built-in lighting. Designers and makers: Kim Hoffmann & Stephen Heidrich (USA)

CENTRE: Radiogram in wengé, coffee brown with thin light brown stripes, and a glass top fitted into a copper frame. Tambour front to lower cupboard. Designer: Dirk van Sliedregt. Makers: H. H. de Klerk & Zoon (HOLLAND)

BOTTOM: Combination bar-television cabinet in walnut with pull-out bar unit behind the tambour fronts. Black Formica base to bar section, and marble inlay on top left-hand for additional mixing space. Designer: Vladimir Kagan. Makers: Kagan-Dreyfuss Inc (USA)

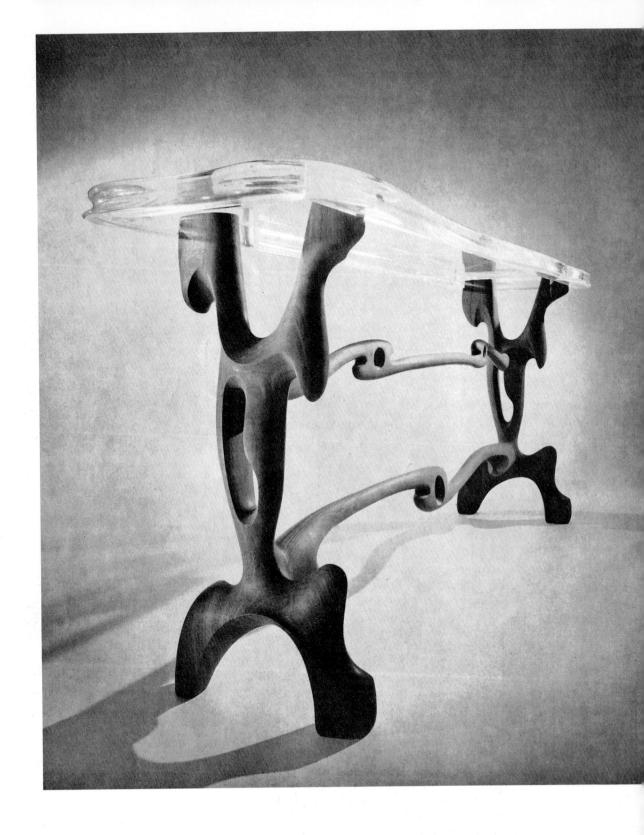

Wall table with free-form clear Lucite top on base of sculptured we natural finish. Designer: Paul Laszlo. Sculpture: F. F. Kern. Ma Laszlo Inc (USA)

op-leaf table, elm or mahogany top birch underframe. Designers: AB rdiska Kompaniet Design Studios. kers: AB Nordiska Kompaniet

Stacking tables, beech frames with plywood tops surfaced in plastic of different colours, or in various wood veneers. Designer: Robin Day, ARCA. Makers: S. Hille & Co. Ltd (GB)

Occasional table in oak, mahogany or straightgrained walnut with moulded plywood top. Designer: Ewart Myer. Makers: Horatio Myer & Co. Ltd (GB)

ass-topped table, 36 inches diameter, I-inch thick polished plate-glass pported on *Armourplate* fins bedded o a hardwood base. Designer: Sven rrnfeldt, LRIBA. Makers: Pilkington os Ltd (GB)

Waxed Japanese oak table with glass top on tri-foil column fitted into an oak plinth. Designer and maker: H. W. Grieve (USA)

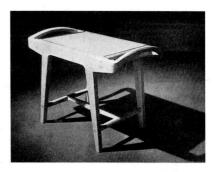

Natural waxed-finished oak tray table with cork top edged walnut. Designer: Peter Brunn, MSIA. Makers: Peter Brunn Workshops (GB)

Children's work table with a shelf for satchels, etc. The working surfaces are topped with Formica in the Linette range of colours. Designer: Pierre Leconte (FRANCE)

LEFT: Warerite surface incorporating a photographic design veneered on to a laminated wood base, finished with black Warerite edgeveneer, polished mahogany frame and brass ferrules. Designer: Richard Levin, MSIA. Makers: F. W. Clifford Ltd (GB)

ABOVE: Woman's desk incorporating a desk lamp, and matching chair in natural oak and cane. Designer: Jean Royère (FRANCE)

RIGHT: Laminated beech stacking chair on steel plastic-covered legs fitted with rubber toes. Designer: Arne Jacobsen. Makers: Fritz Hansens Eftfl (DENMARK)

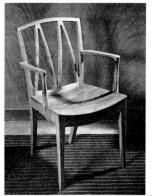

BELOW: Folding laminated blonde by plywood chair on §-in tubular steel painted black and fitted with grey rulfeet. Designer: Russel Wright. Mal Shwayder. From Modernage Furni Corporation (USA)

Chair in a combination of cherrywood elm. Designer: David W. Pye. Ma

R. Lenthall (GB)

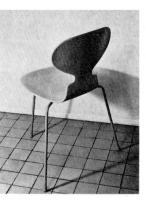

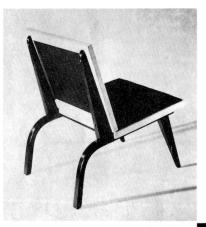

Lounge chair in natural red oak and black lacquer, supplied with seat and back insets of cane, natural oak wythe, or in muslin for covering with fabric. Designer: Edward D. Stone. Makers: Fulbright Industries (USA)

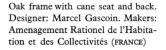

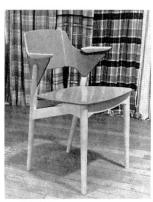

LEFT: Armchair with frame and arm-pads of ash, formed plywood seat and back cellulosed celadon green. Designer: J. A. Williams, while a student at the Royal College of Art (GB)

BELOW: Natural cane-backed chair with fixed padded seat, in birch stained blonde, black, cordovan or mahogany. Designer: E. J. Brussel. Makers: Advance Design Inc (USA)

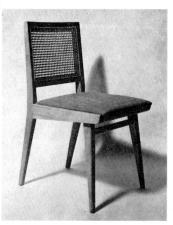

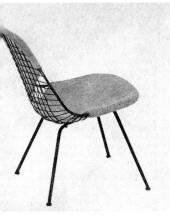

re shell on black metal legs, fitted th removable two-piece or single shion in leather or fabric. Designer: arles Eames. Makers: Herman Miller erniture Company (USA)

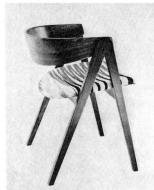

BELOW: Reclining chair in natural ash.
Designer: Dipl-lng Arch SchneiderEsleben. Makers: Gebrüder Thonet
A.G. (GERMANY)

Knock-down chair in birch with No-sag springs in seat and back. Covering of machine-woven fabric with piped edges and buttoned back. Designers: Nordiska Kompaniet Design Studios. Makers: A.B. Nordiska Kompaniet (SWEDEN)

RIGHT: Dining chair on oak, walnut or mahogany legs with hair, spring and foam rubber cushioning and covering of brown, white and beige hand-woven fabric. Chair designer: Vladimir Kagan. Fabric designer: Hugo Dreyfuss. Makers: Kagan-Dreyfuss Inc (USA)

LEFT: Oak frame, 36-inch high back, seat covered in brown, white and beige handwoven fabric. Available also in walnut and mahogany. Chair designer: Vladimir Kagan. Fabric designer: Hugo Dreyfuss. Makers: Kagan-Dreyfuss Inc (USA)

BELOW: Woodpecker chair with vertical coil springs to seat and foam rubber 'swell' to back, on legs of polished beech. Designer: Ernest Race FSIA. Makers: Ernest Race Ltd (GB)

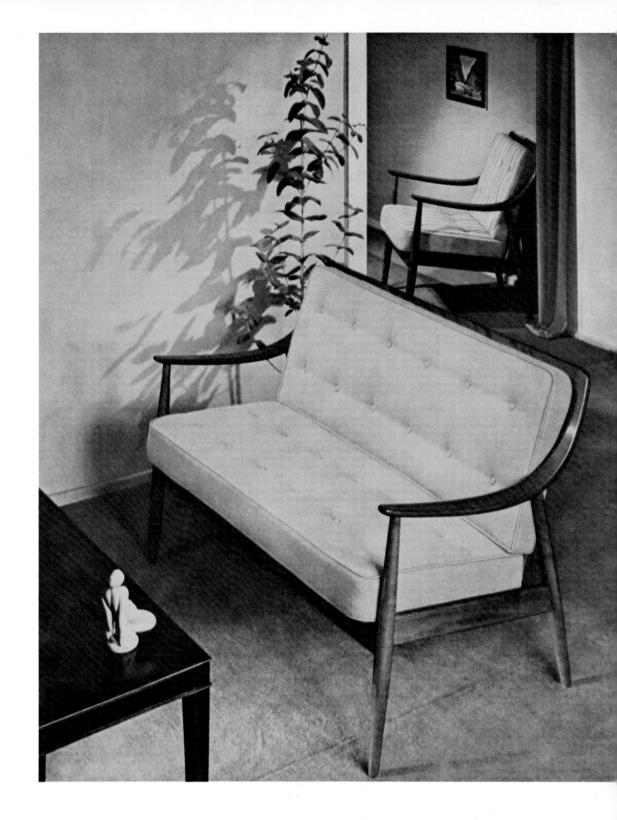

Settee and arm-chair in Royal Danish beech, finished in mahogany, walnu natural colour, the settee covered in gold-coloured woollen fabric and the c in similar striped material. Designers: Peter Hvidt and O. Mølgard-Niel Makers: France & Daverkosen (DENMARK)

Demountable chair, floor lamp with twoway adjustable light, and low table with two asymmetric shelves. Designer: René Jean Caillette (FRANCE)

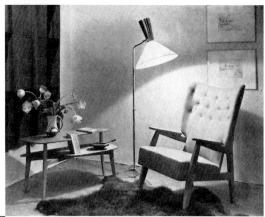

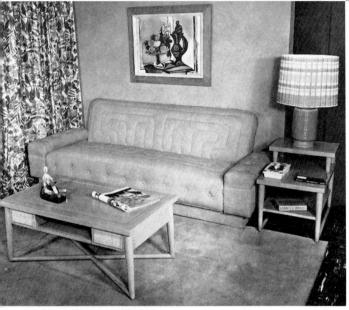

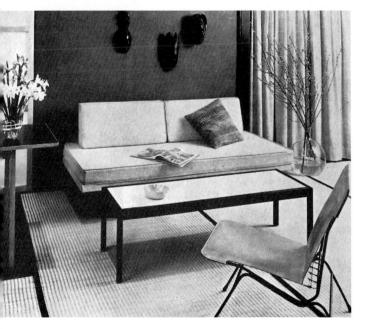

Day-bed on walnut base covered in natural jute and linen fabric. Coffee table of walnut inset with white Micarta. Steel chair with natural saddle leather seat. Designer: Allan Gould. Makers: Allan Gould Designs Inc (USA)

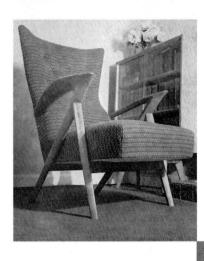

Occasional chair in natural cherrywood, handsprung with hair stuffing, covered in nigger brown wool tapestry checked in red and white. Designer and maker: F. W. Boyd of High Wycombe College of Further Education (GB)

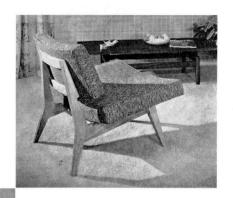

Large, low armless chair, show-woof frame of walnut or birch, with four rubber seat and back. Designer: Je Risom. Makers: Jens Risom Design In (USA)

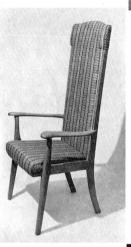

Birch frame, Sienna finish, foam rubber upholstered seat and loose back cushion. Designer: T. H. Robsjohn-Gibbings. Makers: The Widdicomb Furniture Company (USA)

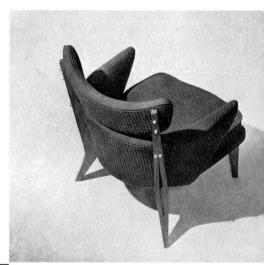

Chair in English oak with foam rubber upholstery covered in a striped and floral printed duck. Designer: P. Yabsley MSIA. Maker: P. Yabsley with the assistance of D. Wellstead (GB)

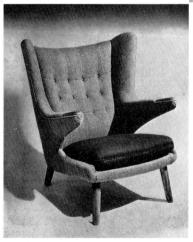

Show-wood frame of agba, natural cellu losed finish, upholstered in green an red lined fabric over Latex foar cushioning. Designer and make Dennis Young ARCA MSIA for Th British Rubber Development Boar (GB)

Upholstered chair with arm-tips of teak, covered in beige fabric with a green cushion. Designer: Hans J. Wegner. Maker: A. P. Stolen (DENMARK)

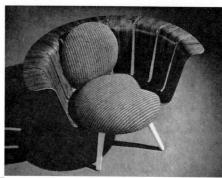

Chair constructed of a series of 'S' bends of formed plywood riveted to make a curved back. Legs of stove-enamelled aluminium. Seat and cushion of foam rubber. Designer: Ernest Race FSIA. Makers: Ernest Race Ltd (GB)

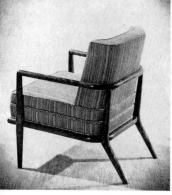

Birch frame, Sienna finish, with blue Strata linen covering over foam rubber. Designer: T. H. Robsjohn-Gibbings. Makers: The Widdicomb Furniture Company (USA)

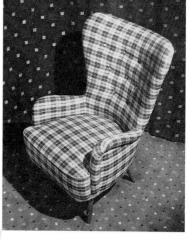

Esprit chair, beech frame in natural, walnut or mahogany finishes, outside back and platform covered in similar fabric to front but in reverse colours. Tension-sprung back and seat with 'high crown' rubber foam seat cushion. Designer: Howard B. Keith MSIA. Makers: H. K. Furniture Ltd (GB)

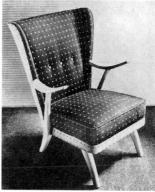

Wing chair, welded steel rod frame, legs of turned beech, seat with vertical coil springing and back stuffed with rubberized hair. Designer: Ernest Race FSIA. Makers: Ernest Race Ltd (GB)

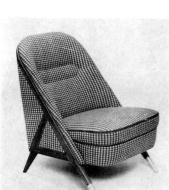

Upholstered chair on teak frame, upholstered in red and white fabric. Feet tipped with brass. Designer: Bertil Fridhagen. Makers: Svenska Möbelfabrikerna, Bodafors (SWEDEN)

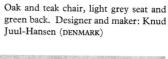

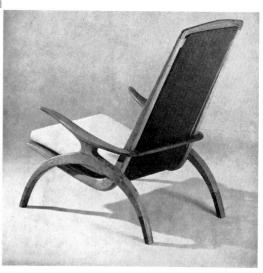

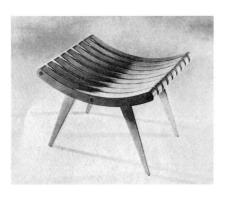

Stool formed of sections of solid red oak bent into a series of ribs. Available also in black lacquer. Designer: Edward D. Stone. Makers: Fulbright Industries (USA)

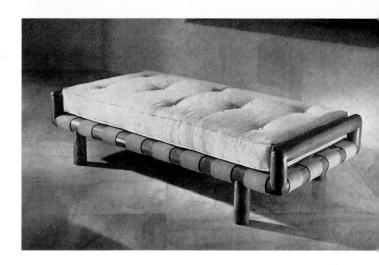

Strapped birch sofa, Sienna finish, with foam rubber mattress covered in linen tweed. Designer: T. H. Robsjohn-Gibbings. Makers: The Widdicomb Furniture Company (USA)

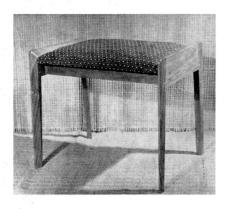

American walnut stool with seat upholstered in fabric designed by Marianne Straub. Designer: Peter Brunn MSIA. Makers: Peter Brunn Workshops (GB)

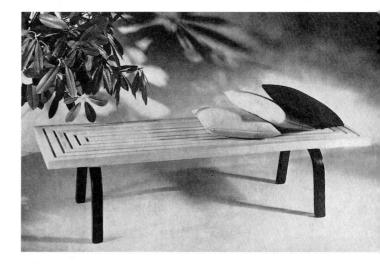

ABOVE: Bench of slatted red Arkansan oak, 62 in long, on black lacquered legs. Designer: Edward D. Stone. Makers: Fulbright Industries (USA)

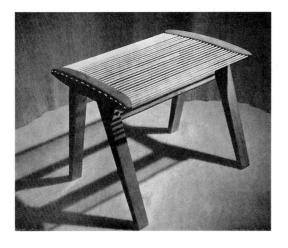

Stool made of vivaró (a native Argentinian wood) with coloured stringing. Makers: A.I.M. (ARGENTINA)

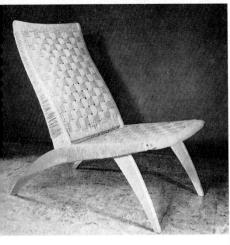

Electrically-bent rattan chair. Designer: Dirk van Sliedregt. Makers: Gebr. Jonkers (HOLLAND)

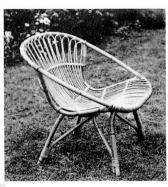

casional chair with Rushtex seat and ck, on oak or walnut frame. Designer: rle A. Morrison. Makers: Earle A. Moron Ltd (CANADA) *Photo: A. David Rogers*

LOW: Natural mahogany terrace chair th rush seat and back. Designer: Dennis nnon Mc. ARIBA. Makers: Scottish rniture Manufacturers Ltd (GB)

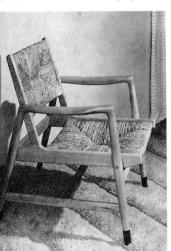

LEFT: Black-lacquered European beech with seat and back of woven Hong Kong grass. Designer: Harold Bartos. German-made for Modernage Furniture Corporation (USA)

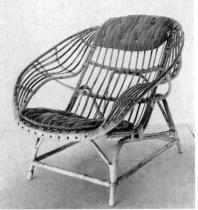

Rattan chair with green and white linen cushions. Designer: Olavi Hanninen. Makers: O/Y Stockmann AB (FINLAND)

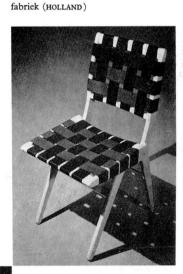

'Knock-down' chair, plywood frame

with laced cotton webbing seat and back

in yellow, red or black. Designer: Dirk

van Sliedregt. Makers: N. V. Utrecht-

sche Machinale Stoel- en Meubel-

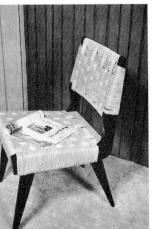

Ash-framed chair strung with rope. Designer: Poul Kjærholm. Makers: Fritz Hansens Eftfl (DENMARK)

Settee and easy chair on mahogany frame, upholstered in yellow over 'Epeda' springs: the Dunlopillo cushions are covered in a fine yellow check on black ground fabric. Designer: Svante Skogh. Makers: Ernst Hjertqvist & Co. (SWEDEN)

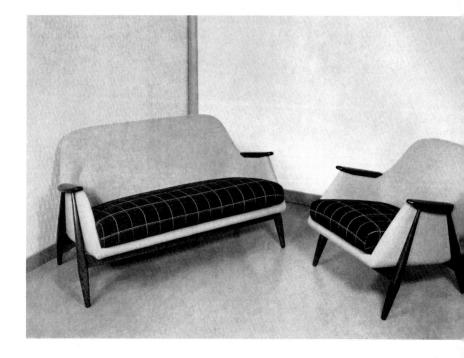

BELOW: Settee and armchair from the *Hilleplan* range covered in a variety of exclusive fabrics with foam rubber cushions on hand-sprung bases. The centre table is of Derbyshire fossil stone on a laminated timber frame. Designer: Robin Day, ARCA, FSIA. Makers: Hille of London Ltd (GB)

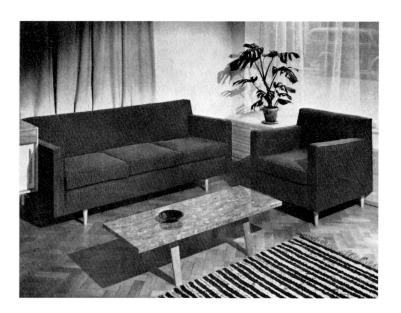

BELOW: Pandora settee covered in contrasting woolle fabrics; outside oatmeal, inner back and cushions grey at white spot. Tension-sprung back upholstered over rubbe ized hair. Deep foam rubber cushions. Designer: Howar B. Keith, MSIA. Makers: H. K. Furniture Ltd (GB)

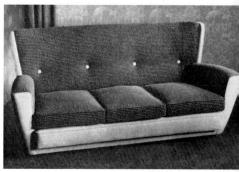

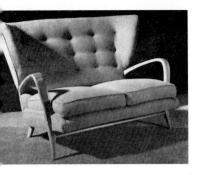

hon settee with beech frame, hand-sprung k and tension-sprung seat. Pocket spring rior cushion. Covered in Tibor or Whitehead ics. Designer: A. J. Milne, MSIA. Makers: Horace Holme Ltd (GB)

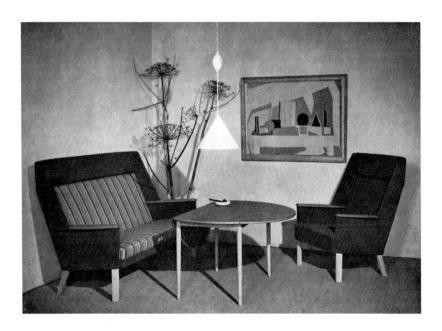

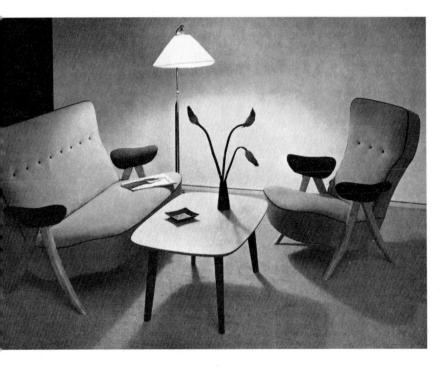

ABOVE: Three pieces shown at the Dansk Kunsthåndværks Forårsudstilling 1953. The settee and chair have foam rubber cushioning and were designed by Folke Pålsson and Erik Ole Jørgensen. Teak table with beech surface finish designed by Poul M. Volther. Makers: Fællesforeningen for Danmarks Brugsforeninger Møbler (DENMARK)

Settee and chair in natural cherrywood, upholstered in *Gent*, a moss-textured hand-woven woollen fabric, main colour corn, arms and piping anthracite. Table surfaced Formica with cherry legs lacquered black. Designer: Th. Ruth. Makers: Wagemans & van Tuinen NV (HOLLAND)

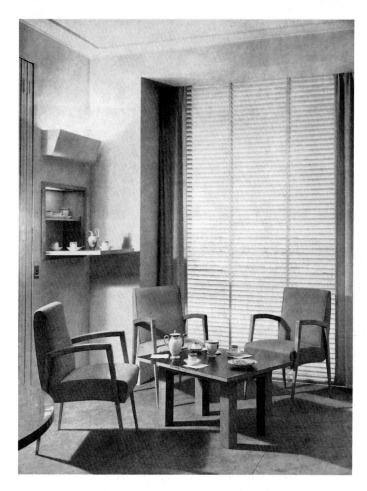

ABOVE: Corner of a salon. Low folding table of polished pearwood with black Formica surface. Chairs, also of pearwood, are upholstered in yellow satin de laine. Walls are light grey. Designer: Jacques Dumond (FRANCE)

BELOW: Interior with pine slatted ceiling and oak-faced firepl canopy. Settee and chair covered in green-and-yellow-strig fabric. Handmade rug with yellow and off-white design deep red ground. Interior designer: Frederick Manning. Finiture and furnishings by Bowman Bros Ltd (GB)

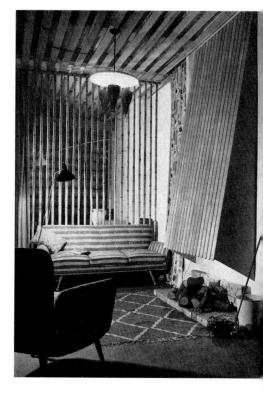

Informal arrangement for a study-cum-sitting room. Sets (upholstered in rib-cord), writing table and magazine/boo holder are harmoniously designed in natural birch. Gre carpeting, light grey walls and red-lacquered triangular occisional table add colour. Chairs are Swedish. Design A. A. Patijn. Makers: Meubelfabriek Swanborn (HOLLAND)

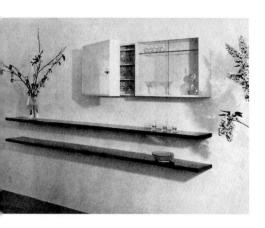

Cocktail wall cabinet in painted whitewood set against a wall distempered light grey. The two-metre long shelves are of palissander; floor is dark grey. Designer: William Penaat. Makers: Metz & Co. (HOLLAND)

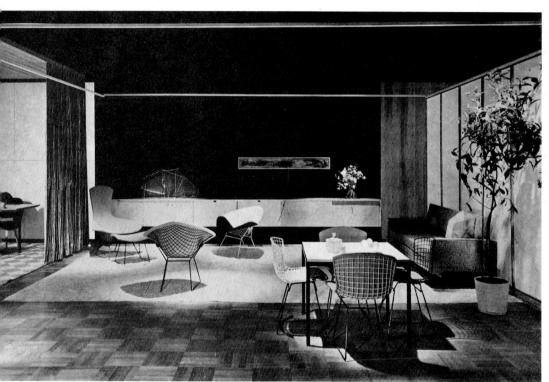

Living-room furnished with *Bertoia* form-wire chairs on rod frames finished black oxide, white vinyl or white enamel. The dining chairs are contour shaped with canvas or foam rubber seat pads in tangerine, black, lemon or turquoise; the pivoting diamond-shaped lounge chairs also have removable foam rubber cushioning covered in Prestini cotton fabrics in five colours. The high-back chair (*far left*) and ottoman (*right*) are designed for deep comfort with black oxide seat contour and base cushioned with foam rubber. Designers: Florence Knoll and Knoll Planning Unit. Makers: Knoll Associates Inc. (USA)

Piano in mahogany with satin-finish brass lyre, ferrules and tops to the legs. The slender tapered legs are not entirely straight: they curve in accordance with the classical precedent of entasis. Designer: Walter Dorwin Teague Associates. Makers: Steinway & Sons Inc. (USA). (Entasis—the slight swelling outline given to the shaft of a column to correct apparent concavity.)

Free-standing triple-sectional cupboard with shelves. Total height 6 feet 10\(\frac{3}{4}\) inches, the cupboards each measuring 27\(\frac{1}{2}\) inches wide by 15\(\frac{3}{4}\) inches deep. Top, sides and door handle of centre cupboard are teak; front and back panels and frame are lacquered black. Designer: David Rosén, N.K. Design Studio. Makers A/B Nordiska Kompaniet (SWEDEN)

BELOW: Armchair on bentwood frame with leather seat. Table legs are also bentwood with teak or jacaranda top. Designer: Yngve Ekström. Makers: ESE-Möbler (SWEDEN)

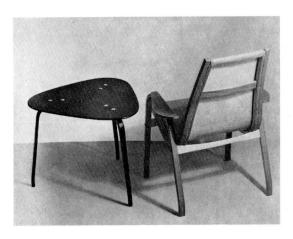

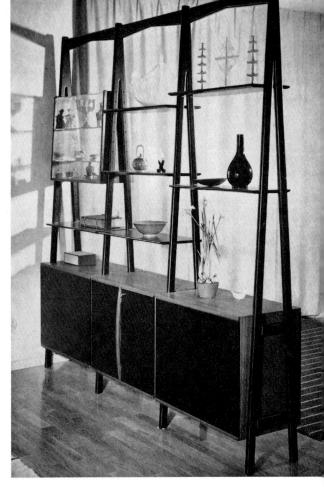

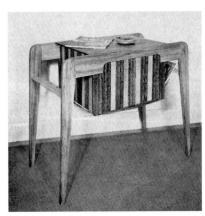

Occasional table in brown and pollard oak with corded magazine racks. The flap of the centre cupboard lifts and slides under the top. Designer and maker: H. J. Perkins (GB). RIGHT: Hand-made desk and chair in mahogany. Chair back and Dunlopillo seat covered in a Primavera fabric. Desk designer: A. J. Stiff, chair by A. Noble. Makers: Primavera (London) Ltd (GB)

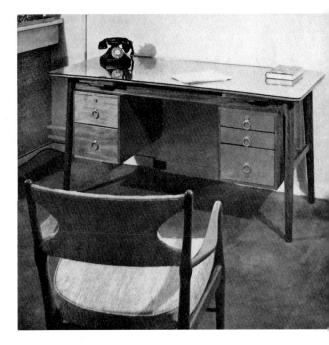

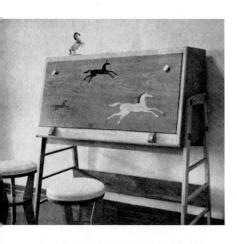

Drop-front cocktail cabinet of Burma teak on ladder mount, the front veneered in Ceylon satinwood with inlay motif in flowered satinwood, ebony and tamarind. Designer: J. Jonklaas, MSIA. Makers: The Decorators & Furnishers Ltd (CEYLON)

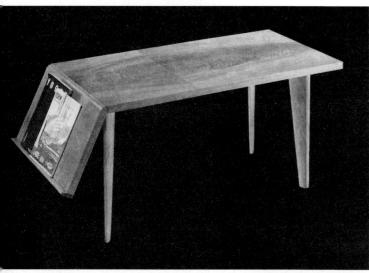

ABOVE: Wire magazine holder, 8-gauge frame with 12-gauge circles. spray-painted in a variety of colours. Designer: John Crichton. Maker: Tom Beer (NEW ZEALAND). LEFT: Drop-side table in plane, 22 inches wide by 3 feet long extended. Designer: Marianne Boman. Makers: 0/Y Boman AB (FINLAND)

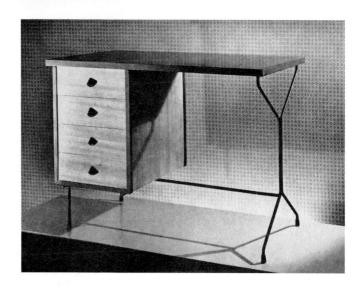

LEFT: Free-standing bookshelves of teak with cherrywood shelves and deep base drawer. Designed and made by Knud Juul-Hansen (DENMARK)

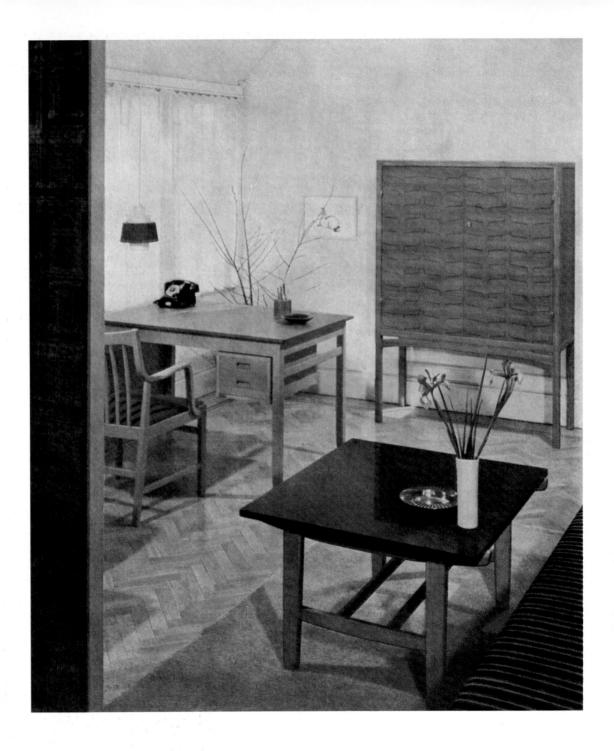

Cabinet in teak with carved decoration on the doors. The writing table has a teak top on grey-lacquered legs. The black granite top of the occasional table in the foreground is supported on oiled pinewood legs. Designers: Sven Engström and Gunnar Myrstrand. Makers: A/B Skaraborgs Möbelindustri (SWEDEN)

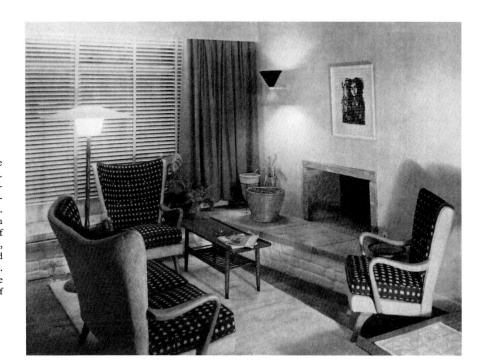

iving-room in the extendible house uilt by Simms Sons & Cooke Ltd. rchitect: W. M. Carter, ARIBA. Off-hite Indian rug, flame textured curin fabric, and light grey wallpaper. In atural mahogany. Outside backs of ettee and chairs in light grey fabric, eats and inside backs in dark brown and rey; natural mahogany legs and arms. Designer: Robert Mabon. All furniture and fittings supplied by Dunn's of romley (GB)

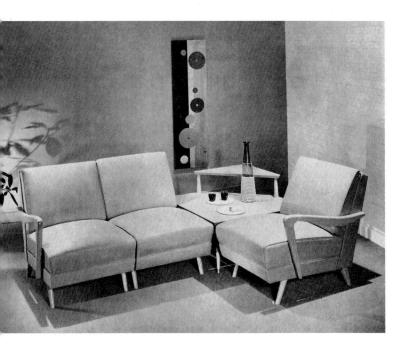

BELOW: Teak and cherrywood reading desk, chair and writing table with glass-topped extension. Chair designed by Erik Buck; desk and table designed and made by Knud Juul-Hansen (DENMARK)

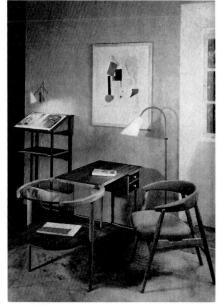

NBOVE: Three-piece sectional settee and corner table in oak, finished a butternut tone. Upholstery of 'knubette' (Respirovinyl) plastic in red, lime, emerald green or grey. Designers and makers: T. Baumritter & Co. Inc. (USA)

RIGHT AND BELOW: Walnut-topped cocktail tables on polished brass legs. Designer: T. H. Robsjohn-Gibbings. Makers: The Widdicomb Furniture Company (USA)

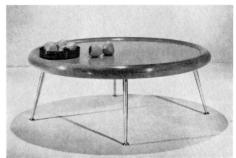

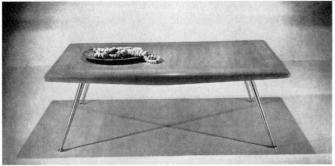

BELOW: White birch sideboard with dark mahogany doors and birch-framed electric clock. Wall brackets are copper. Sideboard designer: S. Asscher. Maker: Asscher Interiors (HOLLAND).

BELOW: Settee, designed by Lea Nevalinna, of white painted birch covered with a black-and-white-striped handwoven fabric. Tables, designed by Eila Meiling, have natural teak tops on black painted metal legs. Adjustable metal frame lamp-stand designed by Eero Paatela. Furniture makers: Te-MA (FINLAND). BELOW (Right): Glass-topped stone-shaped coffee-table with cutout recess for ash-tray or vase. Supports are double cones of rosewood, waisted, with a solid cast brass stretcher. Designer: Edward Wormley. Makers: Dunbar Furniture Corporation (USA)

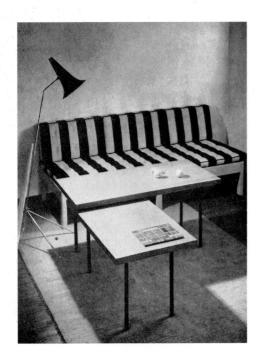

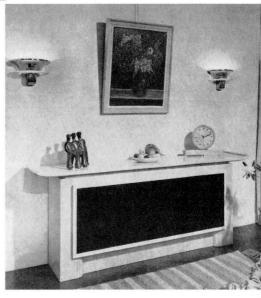

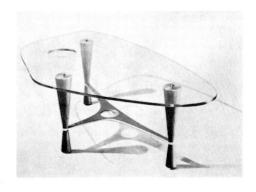

Living-room of Vancouver apartment designed and decorated for his own use by Mario Prizek. Walls and ceiling in various tones of sandalwood brown; deep terra-cotta asphalt tiled floors with black tiled borders. Carpet in oyster white. Settee covered in deep brown heavily textured flax fabric, and chair in the same material in chartreuse. Draperies are of wine grown jersey. Table lamps have mahogany bases with copper base caps and deep tangerine corduroy shades

Furniture designers:

Morrison-Bush Associates Ltd (CANADA). (Photo: Graham Warrington)

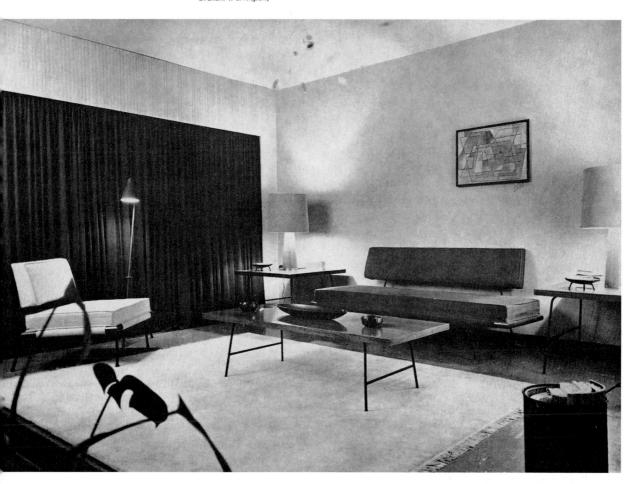

Small three-drawer chest (20\subseteq inches high) with birch or walnut top and welded angle frame on legs of chrome-plated steel. Side panels in neutral or brightly coloured combination. Designer: Charles Eames. Makers: Herman Miller Furniture Co (USA)

Black wrought-iron hanging wall mirror with opaque white glass pivoting shelves, overall 25 inches high by 14 inches wide, 8-inch deep shelves. Designer: Paul Mc-Cobb. Makers: Bryce Originals (USA)

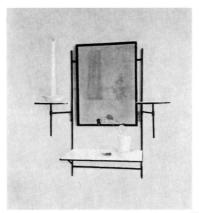

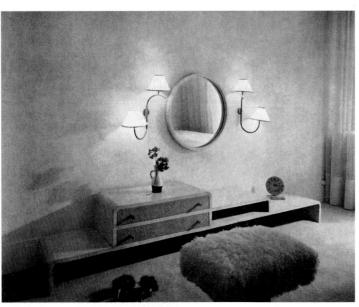

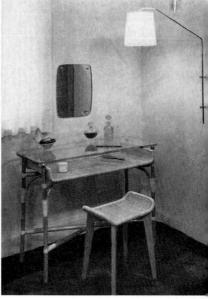

Glass-topped dressing table of Manilla rattan, with under shelf and stool seat executed in pulp wrapping cane. Designer: René Jean Caillette. Make Chevallier (FRANCE)

ABOVE: Low, three-tier dressing table in varnished sycamore, the drawers being faced with rose embossed fabric. Stool covered in white fur. Gilded metal light brackets. Designer: Jean Royère (FRANCE)

RIGHT: Bedroom scheme with bedcover and matching curtains of Vantona Starlight design, available in Tudor rose, jade green, royal blue or autumn gold. Makers: Vantona Textiles Ltd. Esprit chair in cherry red wool tapestry. Designer: Howard Keith, MSIA. Makers: H. K. Furniture Ltd (GB)

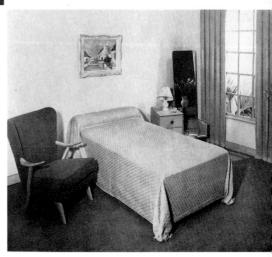

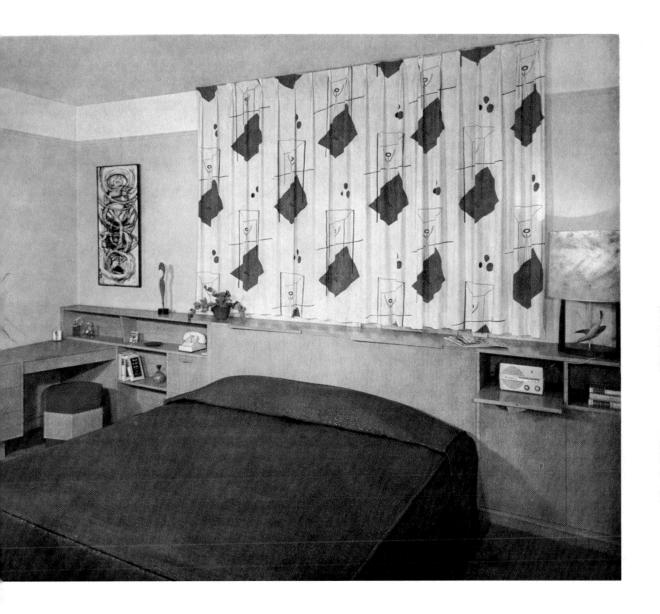

A bedroom in a New York apartment, designed also is a retreat for the non-television addict. Well-chosen materials, colours and finishes have created a pleasing, uncluttered interior within a restricted space of 14 feet by 14 feet. The light oak headboard extends from wall to wall; storage chest, cupboards, shelving and even reading lamps are built into it, thus providing ample surface space. Walls and carpet are a warm light grey; the bedspread is in a brown and gold heavy woven fabric with bright accents of coral and brown in the drapery to tone. Designed and furnished by Wor-De-Klee Inc. (USA)

Double-sided nursery toy unit on wheels in multi-ply with ivory enamel finish and black plastic handles. Shut down lids, pull-down side flaps and drawer opening on both sides give easy access to a child. Designed and made by A. J. Eves, BA (GB)

(Photo: Marchant)

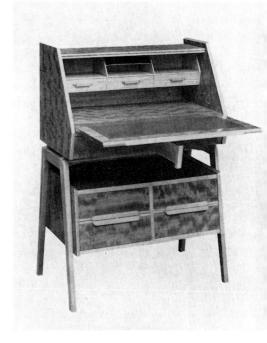

Radiogram cabinet in Burma teak, the front veneered with Ceylon satinwood and mahogany. Designer: T. Jonklaas, MSIA. Makers: The Decorators & Furnishers Ltd (CEYLON)

RIGHT: Corner cupboard in waxed oak with cane-panelled doors. Designer: Jean Royère (FRANCE)

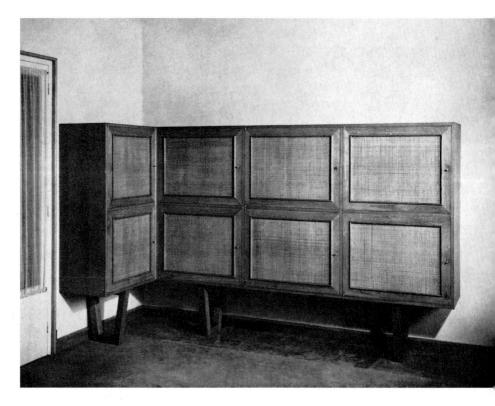

Work-table in walnut, consisting of self-contained table and sewing box lined with English plane. Designer and maker: Kenneth D. Lampard (GB)

Small cabinet in cherrywood with flat polished brass circular key plate and brass-tipped hinges. Designer: B. Helweg-Möller. Maker: Jacob Kjær (DENMARK)

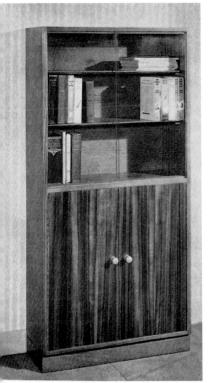

LEFT: Combined bookcase and cupboard in African walnut; laminated cupboard doors veneered in Queensland walnut with sycamore handles and sliding glass panels to top section. Designer: Neil Morris Makers: H. Morris & (
(GB)

Chest with leather-bound metal frame, front veneered acajou. Copper handles are also bound with leather. Designer: Jacques Adnet. Makers: Compagnie des Arts Français s/A (FRANCE)

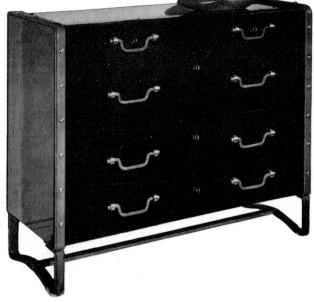

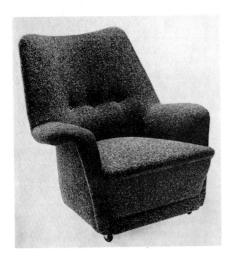

LEFT: Easy chair with wide arms and sloping back. Welded steel rod frame mounted on ball-bearing castors with hard rubber wheels, upholstered in grey tweed. Designer: Ernest Race, RDI, FSIA. Makers: Ernest Race Ltd (GB)

RIGHT: Ditzel easy chairs on smoked oak frames with exteriors covered in a dark brown woollen fabric and interiors lined a natural shade. Designers: Nanna and Jørgen Ditzel. Makers: A. P. Stolen (DENMARK)

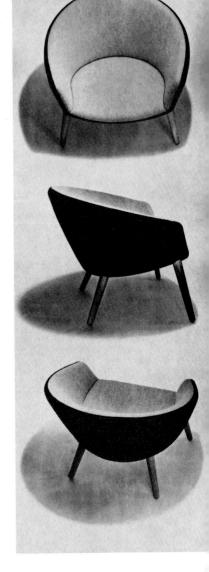

RIGHT: Chair on metal frame finished black. The moulded seat and back are padded with foam rubber and are covered in a strong, hard-wearing fabric. Designer: Hans-Harald Molander, N.K. Design Studio. Makers: A/B Nordiska Kompaniet (SWEDEN)

BELOW: 'Knock-down' chair for assembly with six screws, the moulded seat finished blue on beech legs. Designer: Yngve Ekström. Makers: A/B Södra Snickeri- & Möbelfabriken (SWEDEN)

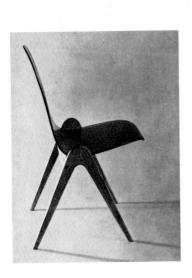

BELOW: Sunlite contour lounge chair with aluminium alloy tube frame and removable nylon covering in royal blue, green, red or gold. Designer: Julien Hebert. Maker: Siegmund Werner Ltd (CANADA)

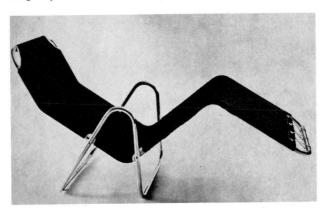

(Photo: Michel Brault)

The Ditzel chair of woven wicker on a sturdy mahogany frame. Designers: Nanna and Jørgen Ditzel. Maker: L. Pontoppidan (DENMARK). From Dunbar Furniture Corporation (USA)

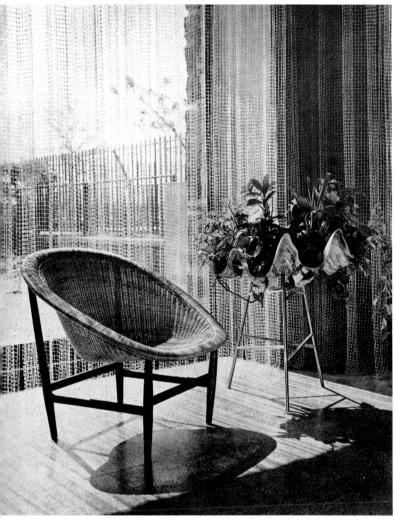

Moulded chair finished mahogany on iron legs sprayed white plastic; the latter are designed so as to be secured to the seat by one screw only. Designer: Yngve Ekström. Makers: A/B Södra Snickeri- & Möbelfabriken (SWEDEN)

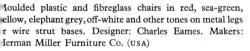

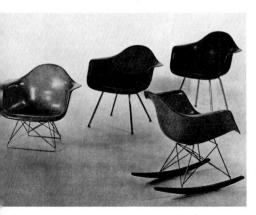

The Bombay chair of heavy woven rattan with spar varnish finish, frame of black wrought iron. Designer: John Risley. Makers: Ficks-Reed Company (USA)

Settee upholstered in yellow and grey check cotton over Latex foam cushioning. Legs of natural polished beech. Designer: Ernest Race, RDI, FSIA. Makers: Ernest Race Ltd (GB)

RIGHT: Prototype chair with curved ladder back and seat upholstered in foam rubber. Designer: Poul M. Volther. Makers: Fællesforeningen for Danmarks Brugsforeninger Møbler (DENMARK)

LEFT: Cradle-shaped lounge chair with beech legs, upholstered in fawn corduroy velvet with cushion and studs in red corduroy. Designed by Kelvin McAvoy for Liberty & Co. Ltd (GB)

BELOW: Natural petiribi table and chair covered in natural linen with hand-painted design in green on a light brown ground; alternative colourings white and yellow on black ground. Textile designer: Margot Portela Parker. Furniture designers and makers: Adams, SRL (ARGENTINA)

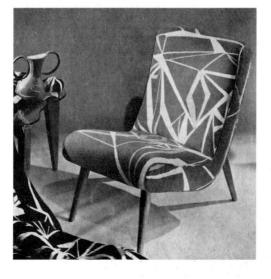

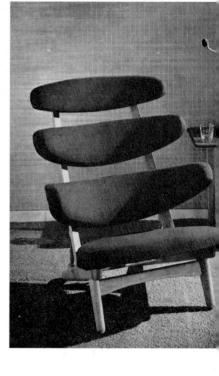

BELOW: Oak chair with moulded backrest of laminated beech faced with Pacific walnut. Designer: David Fowler, MSIA. Makers: D. Meredew Ltd (GB)

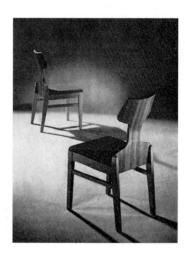

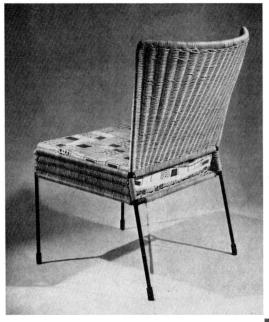

ABOVE: Strong yet light chair with laminated frame of maple or walnut, seat and back white corded nylon. Designer: Jacques S. Gullion. Maker: Modernart (CANADA) (Photo: Capital Press

ABOVE: Black metal-framed natural cane chair with inset Dunlopillo cushion; the cushion cover is removable. Designer: Dennis Lennon, MC, ARIBA (GB)

BELOW: Occasional chair covered in *Lucerna* handwoven fabrics in a variety of colours. The back is supported on a resilient laminated spine. Designer: Robin Day, ARCA, FSIA. Makers: Hille of London Ltd (GB)

ABOVE: Nesting Kangaroo rocker and low table of welded steel rod enamelled white and graphite. Table top of natural teak. Designer: Ernest Race, RDI, FSIA. Makers: Ernest Race Ltd (GB)

LEFT: Slat-backed chair from the Hilleplan range with mahogany frame on beech legs. Seat and back cushions are reversible, the seat cushion being supported on tension springs. Designer: Robin Day, ARCA, FSIA. Makers: Hille of London Ltd (GB)

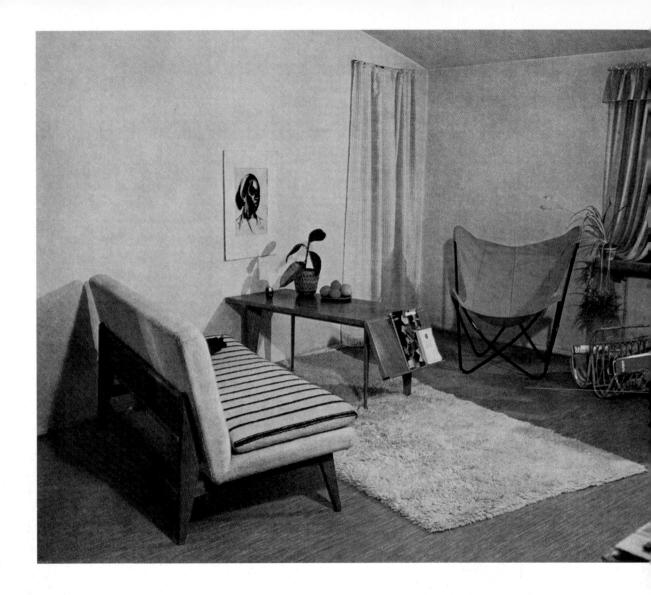

Corner of a Finnish living-room. Settee covered in white woollen fabric with loose cushion in brown and white; occasional table in plane with hinged magazine rack; black metal-frame chair with orange-brown fabric cover. Designer: Marianne Boman. Makers: O/Y Boman AB (FINLAND)

RIGHT: 'Long-Tom' stool in beech (length 40 inches), with seat covered in Heal's *Fitzroy* fabric. Designers: Le Grest & Co. (GB). The sycamore table illustrated is designed by David Joel Ltd, for Heal's of London (GB)

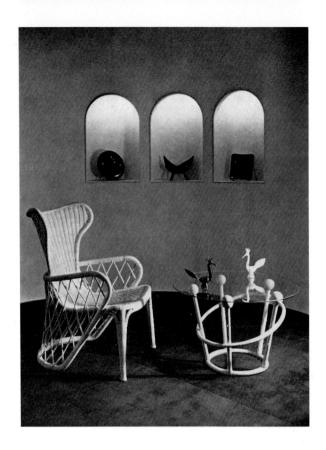

White rattan wing chair with open diamond pattern back support and arms. The matching rattan ring-base table has a glass top supported on five knobbed legs enclosed within a circular hoop. Designer: Jean Royère. Maker: Jean-Paul Gauberti (FRANCE)

Glass shelving 2 feet 3 inches long by 7 inches wide on oak, ash or acajou supports. Designer: René Jean Caillette (FRANCE)

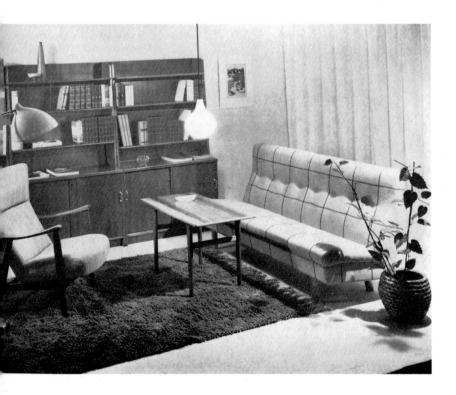

Living-room furnished in mahogany with extendible combined bookcase and cupboard units lining one wall. Settee and armchair covered in handwoven fabrics. Standard lamp of brass with grey painted metal shade and ceiling lamp of white opalescent glass designed by Lisa Johansson-Pape. Furniture designer: Olof Ottelin. Maker: O/Y Stockmann AB (FINLAND)

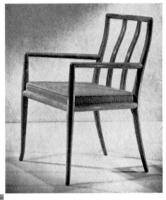

LEFT: Walnut dining chair with foam rubber upholstered seat covered in linen. Designer: T. H. Robsjohn-Gibbings. Makers: The Widdicomb Furniture Co. (USA)

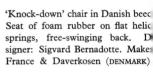

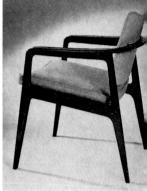

LEFT: Dining chair in Honduras mahogany, with seat and back covered in a redspotted white woollen fabric. Designer: A. A. Patijn. Makers: Meubelfabriek Zijlstra (HOLLAND)

LEFT: Dux armchair on bee frame finished teak. Seat and be are covered in Danish Plyds fabriblack warp with yellow weft, wheadrest in grey rep. Design Alf Svensson. Makers: Ljui Industrier AB (SWEDEN)

RIGHT: Python armchair with beech frame, hand-sprung back and tension-sprung seat; pocket spring interior cushion. Covered in Tibor or Whitehead fabrics. Designer: A. J. Milne, MSIA. Makers: E. Horace Holme Ltd (GB)

Red beech chair with plaited rattan back: seat covered in a black-and-yellow check fabric. Designer: S. I. R. Bertil Fridhagen. Makers: A/B Svenska Möbelfabrikerna (SWEDEN)

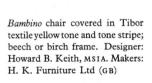

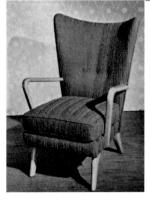

Armchair in Yugoslavian beech. Tapestry covered coil-sprung seat and rubberized hair back. Designer and maker: Roger Harcourt, High Wycombe College of Further Education (GB)

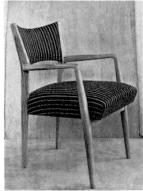

The Milford fireside chair from the Ardale range combines a polished sycamore frame with deep sprung upholstery and foam-rubber fillings, covered in attractive woollen tapestries. Designer: Laurence A. Reason. Makers: A. Reason & Sons Ltd (GB)

LEFT: Chair on birch frame finished mahogany, black, light grey and other colours. 'No-sag' sprung seat and back, seat padded foam rubber. Designer: Bengt Ruda. Makers: A/B Nordiska Kompaniet (SWEDEN)

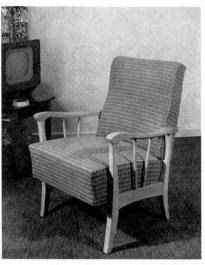

Armchair in beech with yew arms, pholstered in grey moquette with Latex foam cushion seat on ension springs. Designer and naker: Peter Hayward, of the High Wycombe College of Furher Education (GB)

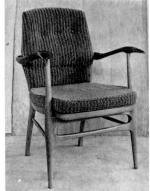

RIGHT: Dining chair of natural red beech. Seat covered linen with a handprinted leaf design in black on brown ground by Britt - Marie Arppe. Designer: Lea Nevalinna. Makers: TE-MA (FINLAND)

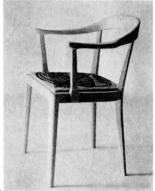

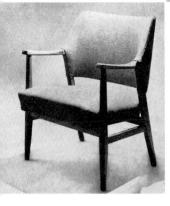

LEFT: Birch armchair with seat and back covered in a grey-green handwoven fabric. Designer: Stig Sallamaa, Makers: 0/Y Stockmann AB (FINLAND)

RIGHT: Stacking armchair with red beech frame; seat and back covered with a black close-weave fabric over foam rubber. Designer: Axel Larsson. Maker: A/B Svenska Möbelfabrikerna Bodafors (SWEDEN)

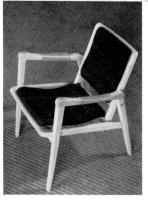

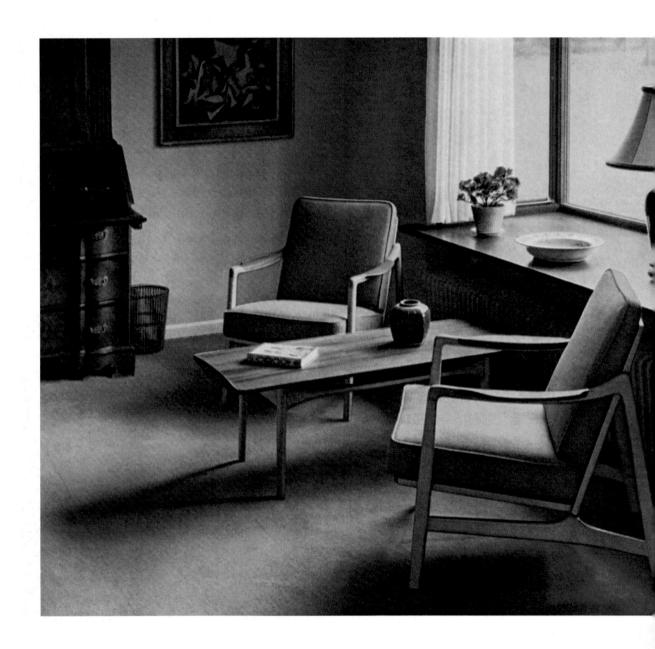

Danish interior in which period and modern furniture are successfully blended. Table and chairs are in Royal Danish beech, with flattened arm rests and table top in walnut or mahogany finishes. Designed and made by: France & Daverkosen (DENMARK)

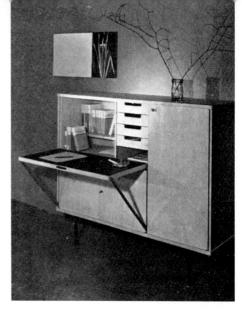

Waxed white ash writing bureau on black steel legs. It is equipped with plenty of cupboard, drawer and shelf space, and the writing surface to the fall is faced with black linoleum. Designed and made by René Jean Caillette (FRANCE)

Vriting desk and chair in ash and valnut; the drawer fronts are shaped o form full-width handles. An enarged drawing makes a decorative ackground panel. Designed by Geneviève Pons for 'La Maîtrise', Galeries Lafayette (FRANCE)

Feak study or dining table on brass egs, top surfaced with black Form-ca. Blue webbing is used for the seat and back of the matching teak chairs. Draperies are champagne with blue, yellow and brown motifs. Designer: A. A. Patijn. Makers: Meubelfabriek Zijlstra (HOLLAND)

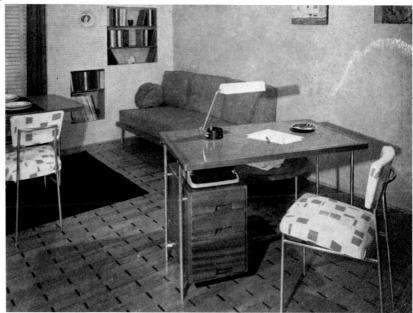

Writing desk in natural acajou on copper-finished metal demountable base. Space for a typewriter is neatly provided by lowering the drawer unit. Chairs are upholstered in washable *Acella* plastic. The settee converts to a bed, to which the small circular table visible beneath the desk forms the headpiece. Designer: Gautier-Delaye. Makers: Vergnères Fils (FRANCE)

Polished beech sectional settee, and armchair, tension-sprung seat and back and spring-filled tapestry cushions. Designer: R. A. Long. Table by A. J. Milne, MSIA, Skittles rug by Ronald Grierson. For: Heal's of London (GB)

Beech settee with teak-stained legs, upholstered in hairlock and covered in a black, grey and white striped woollen fabric with ends in a darker colour. Designers: Ejner Larsen and A. Bender Madsen. Makers: Fritz Hansens Eftfl (DENMARK)

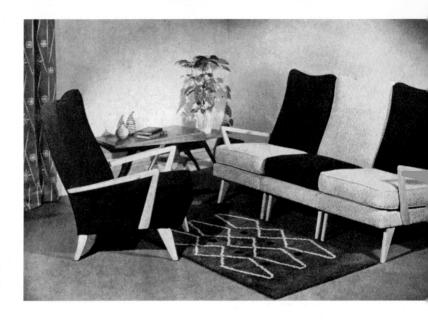

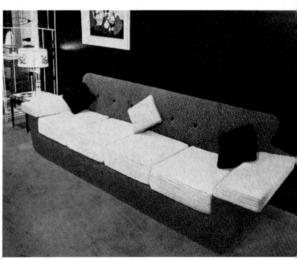

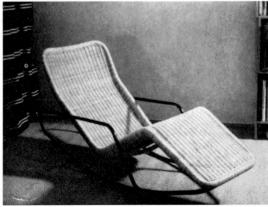

Settee in grey 'astrakan'-type fabric, buttoned in black. Cushion arms covered in Tibor deep-textured Berkeley fabric in lemon you Overall size 8 feet 6 inches by 2 feet 2 inches. Designed by Kelvin Mc for Liberty & Company Ltd (GB)

Rocking chair on wrought-iron frame lacquered black. The continuous, seat and leg-rest is in natural rattan. Designer: Dirk Sliedregt. Makers: Gebr. Jonkers (HOLLAND)

Lightweight armchair in English beech; tension sprung seat and back and Latex foam cushion covered in grey/off-white tapestry with cherry pipings. Designer: F. G. Clark. Makers: George Clark (Bristol) Ltd (GB)

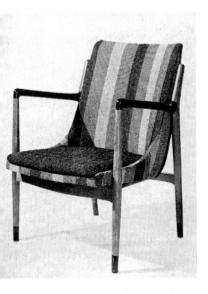

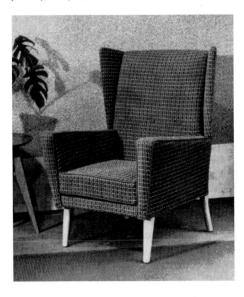

PVE: Beech armchair with walnut nrests and leg tips. Tension rung seat, upholstered in yellow/ ck panama-weave wool over foam ber. Designers: Poul Elnegaard pair), Aagaard Andersen (fabric). akers: Unika-Væv (DENMARK)

Texaloom cane chair in pale grey with foam rubber loose cushion covered in black/ white Helico texturedrape designed by Tibor Reich, FSIA (GB)

POSITE: Light armchair on ash me with bucket seat upholstered a dark wool fabric. Designer: erre Guariche (FRANCE)

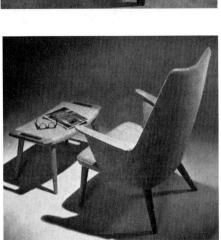

Chair upholstered in grey wool fabric over hair with loose sprung cushion in contrasting stripes of yellow, grey and dark brown; legs and arm tips of teak. Designer: Kurt Olsen. Makers: A. Andersen & Bohm (DENMARK)

PPOSITE: Scania. Beech frame, dark reen wool upholstery, foam rubber ashions. Striped seat cushion rests n tension sprung base. Designer: If Svensson. Makers: Madrassabriken Dux AB (SWEDEN) Matching stool and chair in fumed oak upholstered in a grey woollen fabric. The chair has a detachable head-rest (not shown) and foam rubber padded seat. Designer: Hans J. Wegner. Makers: A. P. Stolen (DENMARK)

Easy chair with Latex foam padded armrests and cushioning, and tension-sprung seat and back. Medium oak or beech frame with walnut veneer. Designed and made by Greaves & Thomas Ltd (GB)

Wicker armchair on steel frame, lacquered black. Designed by H. Baliero for OAM (ARGENTINA)

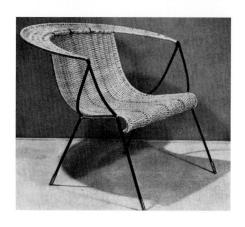

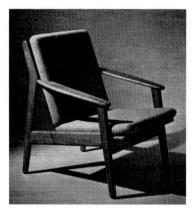

Easy chair in fumed oak, oil finished, with loose foam rubber back and seat cushions on *Telax*-rubber bands. Designer: Poul M. Volther. Makers: Fællesforeningen for Danmarks Brugsforeninger Møbler (DENMARK)

Bentwood dining chair in oak. The padded seat and back are covered in brownand-white checked wool. Designer: D. S. Vorster & Co. (Pty) Ltd (s. AFRICA)

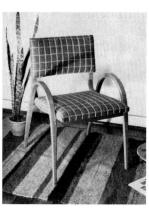

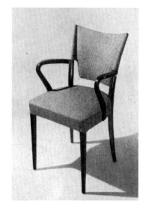

Cherrywood dining chair with armrests carved to give a firm hand grip. Upholstered in blue wool over foam rubber. Designer: A. A. Patijn. Makers: Meubelfabriek Zijlstra (HOLLAND)

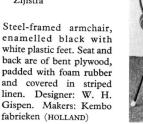

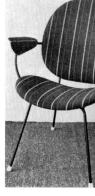

BELOW: Low armchair in walnut, upholstered in moquette in red, grey, mustard, black, green or fawn. Designer: Neil Morris. Makers: Morris of Glasgow (GB)

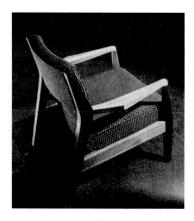

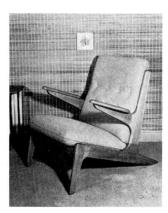

Adam. Low armchair in oak or beech. The hairlock-padded cushions are covered in wool fabrics in a variety of colours. Designer: Kurt Østervig. Makers: Jason Furniture Factories (DENMARK)

Shelved-back armchair upholstered in black-andyellow wool fabric; legs and armtips are of teak. Designer: Kurt Olsen. Makers: A. Andersen & Bohm (DENMARK)

Chair designed for tropical use constructed entirely of bent cane with soft cane bindings. Designed and made by Jean Royère in collaboration with Paul Gauberti (FRANCE)

Low chair in acajou with sprung seat and back upholstered in grey handwoven fabric. From the Formule range of sectional furniture designed by H. Kempkes Jr. Makers: Kempkes' Meubelfabrieken, NV (HOLLAND)

Walnut armchair, upholstered in a printed linen fabric over foam rubber upholstery. Designer: T. H. Robsjohn-Gibbings. Makers: The Widdicomb Furniture Company (USA)

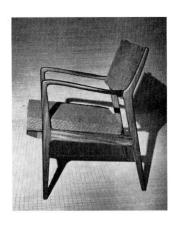

LEFT: Armchair in walnut or teak with loose foam rubber cushions covered in a green close-weave wool fabric. Designer: Karl Erik Ekselius. Makers: A/B J.O. Carlsson(SWEDEN)

RIGHT: Walnut Contour chair, natural finish, upholstered hair and foam rubber covered in natural-and-black linen mixture weave by Hugo Dreyfuss. Chair designed byVladimir Kagan. Makers: Kagan-Dreyfuss Inc. (USA)

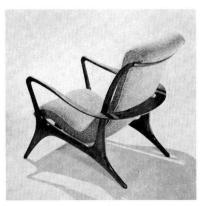

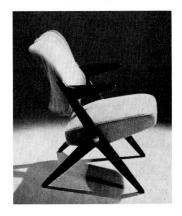

Armchair of polished birch stained black, with pivoting or fixed back, deep foam rubber cushioning and No-sag springs in the seat. Designer: Bengt Ruda. Makers: A/B Nordiska Kompaniet (SWEDEN)

RIGHT: Bock chair on beech frame with birch legs stained black. Black saddlegirth and cotton-covered rubber cushion. Designer: Yngve Ekström Makers: ESE-Möbler (SWEDEN)

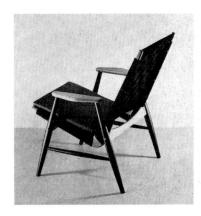

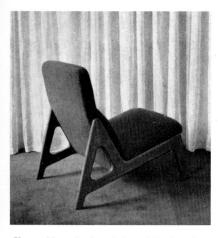

Kurt. Natural oak, upholstered Epeda springs and hairlock under Unica Væv fabrics. Designer: Kurt Østervig. Makers: Jason Furniture Factories (DENMARK)

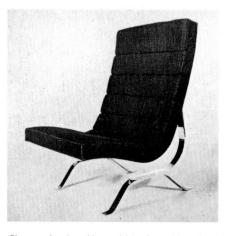

Chrome plated steel base with horizontal 'cartridge' foam-rubber upholstery covered in fabrics to individual choice. Designer: George Nelson. Makers: Herman Miller Furniture Company (USA)

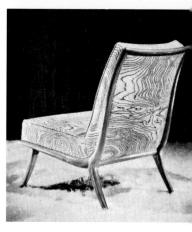

Walnut frame upholstered in a print linen fabric over foam rubber. Designe T. H. Robsjohn-Gibbings. Makers: T Widdicomb Furniture Company (USA)

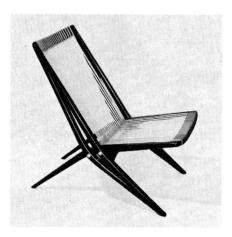

Beech frame, stained black, with white plastic corded seat and back. Designer: Bertil Fridhagen. Makers: AB Svenska Möbelfabrikerna, Bodafors (SWEDEN)

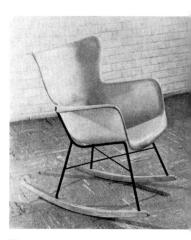

Fibreglass plastic seat, black wrought-in frame on hardwood rocker base, honey to finish. Designer: Lawrence Peabody. Make Selig of Leominster (USA)

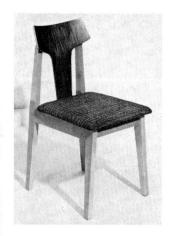

White beech frame, walnut faced beech back; seat covered Tibor fabrics. Designers: Meredew Design Group. Makers: D. Meredew Ltd(GB)

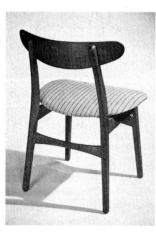

Fumed oak frame, hairlock seat, greybrown wool fabric corver. Designer: Hans J. Wegner. Makers: Carl Hansen & Son Møbelfabrik (DENMARK)

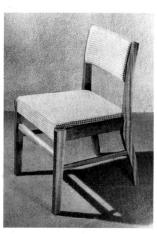

Walnut, oak or mahogany frame; moquette upholstery over foam rubber. Designer: Neil Morris. Makers: Morris of Glasgow (GB)

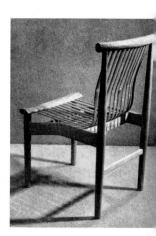

Waxed Japanese ash frame, lam ated bamboo seat. Designed by Isa Kenmochi and Akira Shinjo, Industi Arts Institute, Tokyo (JAPAN)

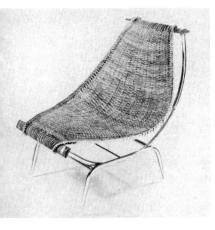

zy Bowl garden chair on gold anodized aluminium me. The detachable rattan cradle seat is on nylon arings and automatically adjusts to the sitter's ight. Designer: James C. Witty. Makers: The oy Sunshade Co. (USA)

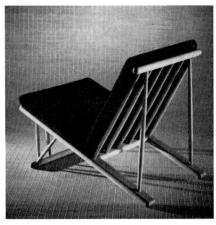

Occasional chair in natural beech with *Telax*-rubber banded seat and foam rubber cushions covered in fabrics to individual choice. Designer: Poul M. Volther. Makers: Fællesforeningen for Danmarks Brugsforeninger Møbler (DENMARK)

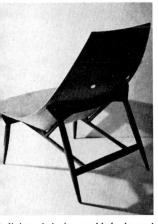

clining chair in moulded plywood, lulose finished, with mahogany legs d frame. Designed and made by artin Grierson (GB)

Wrought-iron garden chair lacquered orange, with white knobs; the seat is in perforated tôle. Designed and made by Jean Royère (FRANCE)

Occasional chair of English walnut, with woven piping cord seat. Designed and made by J. Y. Johnstone at the Royal College of Art (GB)

Forté laminated chair, walnut, mahogany, elm or oak veneer. Latex foam cushion. Designers and makers: E. Khan & Co. Ltd (Tecta Division) (GB)

'olding chair on black-lacquered tuular steel frame. The detachable anvas seat and back is made in several olours. Designer: Olof Pira. Makers: B Nordisk Kompaniet (SWEDEN)

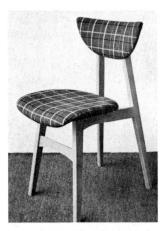

Birch dining chair with bent plywood seat and back rest covered in grey-green checked linen over foam rubber. Designer. W. H. Gispen. Maker: Kembo fabrieken (HOLLAND)

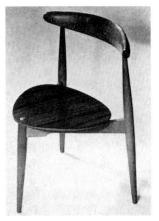

Stackable three-legged dining chair in beech or smoked oak with teak seat. Designer: Hans J. Wegner (DENMARK). For Woolland Bros. Ltd (GB)

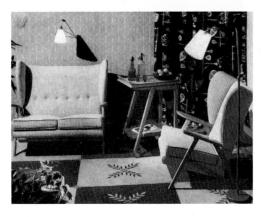

Button-back wing settee and chair with flattened arm rests. The matching trolley has a fitted tray top. Designed and made by J. H. Hunt & Co. (Yatton) Ltd (GB)

Living-room with floor of *Accotile* cork. Makers: Armstrong Cork Co. Ltd. (GB). Upholstered chairs designed by Howard Keith; beech ebonised stacking chairs and natural beech table with black Warerite top by Robin Day. Draperies at left are *Macrahanish* hand-printed cotton designed by Robert Stewart; at right *Philodendron* hand-printed linen by Helen Close. For Liberty & Co. Ltd (GB)

Settee, table and chair of Honduras mahogany with loose sprung cushions upholstered in yellow wool fabric, with yellow-and-white striped seat and back facings. Curtains are off-white, carpet silver-grey. The light fitting is brass. Designer: A. A. Patijn. Makers: Meubelfabriek Zijlstra (HOLLAND)

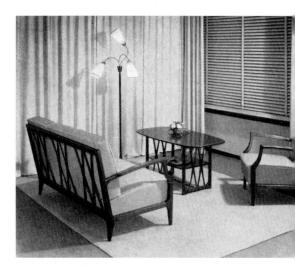

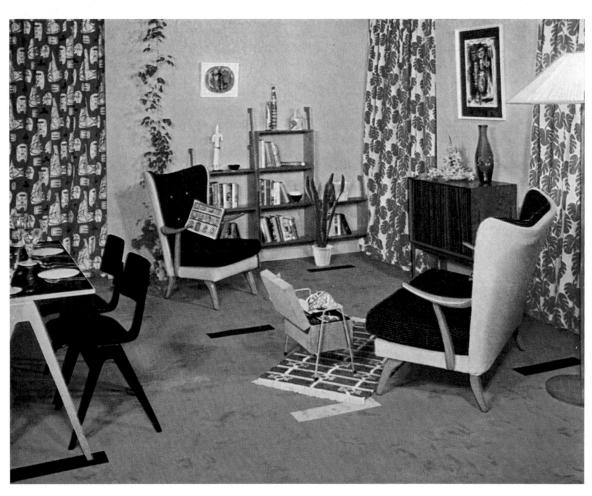

Chairs in deep texture fabrics *Henley* white, and *Hong Kong* flame with grey-and-white motifs. Curtain *Cymbeline* in persimmon shot Lurex gold thread. Designer: Tibor Reich, FSIA. Makers: Tibor Ltd. Table by S. Hille & Co. Ltd. Chairs by H. K. Furniture Ltd(GB)

Dux chairs upholstered in Tranås wool and rayon fabrics. Svedje wool and hair carpet on pure linen warp. Makers: Tabergs Yllefabriks AB (SWEDEN)

Oiled teak table on black enamelled steel base. Designer: Pian Haggstrom. *Sab* teak chair, designed by Carin Bryggman; white wool seat cover handwoven by O/Y Metsovaara A/B. *Figaro* settee (see page 40). For TE-MA (FINLAND)

BELOW: Swedish rocker, scrubbed pine; mahogany table wax finished; Isokon long chair in walnut and birch, upholstered Latex foam and lemon yellow tweed. Wall fitments of pine, natural waxed outside, cellulosed inside, on steel rod supports with turned beech finials. Designer Dennis Young ARCA, MSIA. Table and fittings made by Design London Ltd (GB) (Photo: A. Lammer)

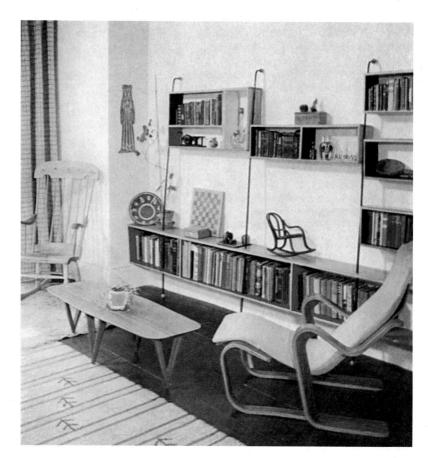

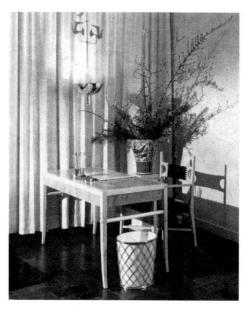

Bleached maple desk with natural ash top and sides, and maple chair upholstered in red leather. Polished brass pendant. Designer: Tommi Parzinger. Makers: Parzinger Originals Inc. (USA)

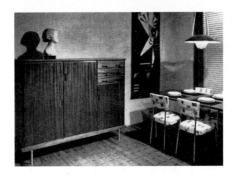

The copper-finished steel demountable framework of this dining group enables it to be easily packed. Table top and sideboard are in natural acajou; finger-holds are incorporated in the main body of the sideboard front, giving a smooth finish. Chairs are upholstered in washable *Acella* plastic. Designer: Gautier-Delaye. Makers: Vergnères Fils (FRANCE)

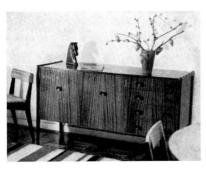

Four-foot sideboard in solid agba with walnut veneer on sliding doors; drop-leaf table, and slatted back chairs with tapestry seats. Designer: Herbert E. Gibbs. Makers: Herbert E. Gibbs Ltd (GB)

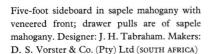

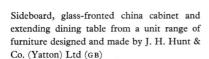

Beech dining group. The sideboard has an ash-lined fall front and the cupboard below is fitted with three shelves and a cutlery drawer. Exterior is veneered teak to match the shaped table top. The beech chairs have tapestry-covered stuffed seats and backs. Window draperies are *Coppice*, a cotton print designed by Mary White. Furniture designed by A. J. Milne, MSIA, for Heal's of London (GB)

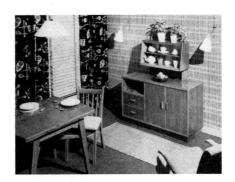

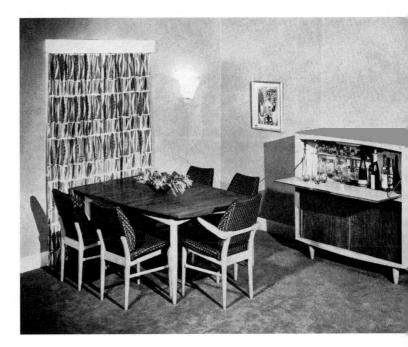

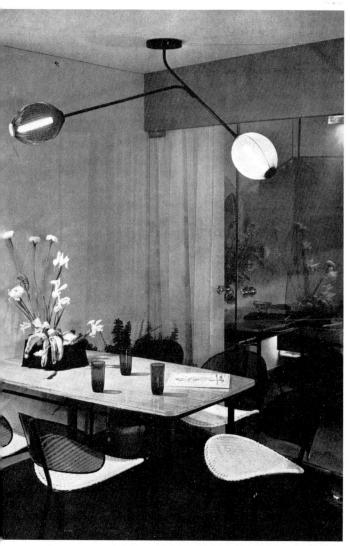

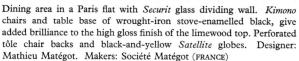

Freba sideboard, comprising two cabinets with sliding doors of fibre and glass and a drawer unit, supported on steel tripod legs. Made in various woods, length 9 feet. Designer: Alfred Altherr, Arch. BSA. Makers: K. H. Frei (SWITZERLAND) (Photo: Hans Finsler)

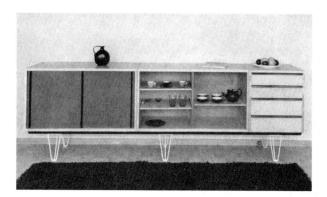

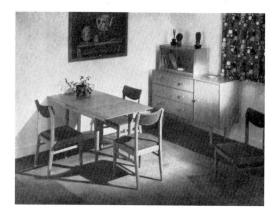

Dining-room furnished in white birch with upholstery of Sweet Corn, Mesh or Safari Tibor fabrics. The table is extendible and on top of the sideboard is a small movable glass-fronted bookcase. Designers: Meredew Design Group. Makers: D. Meredew Ltd (GB)

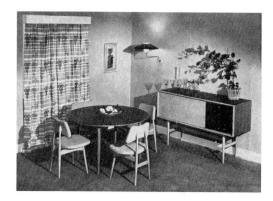

Hand-made beech furniture with teak veneers. Chairs are upholstered in various fabrics over foam rubber. Designed by Nigel Walters, MSIA for Heal's of London (GB).

BELOW: Light oak bridge table with transparent glass surface; chair seats upholstered in plain green cotton. Designed and made by Jean Royère (FRANCE)

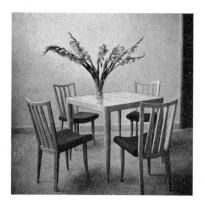

Solid hardwood sideboard on sycamore base, door panels veneered walnut, incised decoration. Designed and made by Bath Cabinet Makers Ltd (GB), (Photo: Goran Billing). FAR RIGHT: Cocktail cabinet with handdecorated tiled drop front by Boris Chatman. Designed by Daisy Stricker for Rena Rosenthal Inc. (USA). BELOW: Windsor Bergère suite in beech, natural waxed finish, and elm and beech occasional table. The chair has an extra deep seat fitted with foam rubber cushion, with a feather-down filled back cushion. The tension sprung settee is similarly upholstered. Coverings are in a selected range of contemporary fabrics. Designer: L. R. Ercolani. Makers, Furniture Industries Ltd (GB)

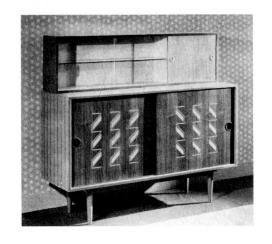

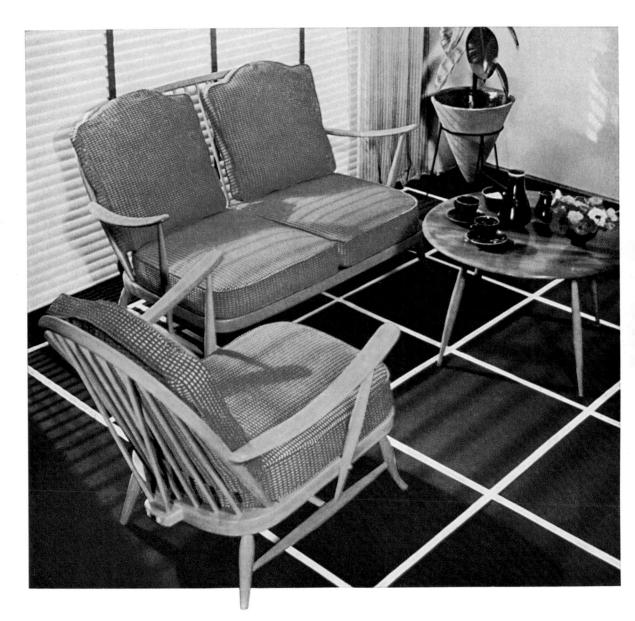

View across the dining-room into the kitchen in the designer's own house in Tokyo. There are no dividing walls; instead the rooms can be closed off or thrown open to one another by means of sliding partitions running on grooved tracks inset in the flooring. Furniture & furnishings designed by Hiroshi Ohchi and made by the Fuse Manufacturing Co. Architect: Nobutoshi Satoh (JAPAN)

LEFT: Three-tier swivel trolley in perforated tôle lacquered black-and-white, centre platform ash lacquered yellow. Designer: Mathieu Matégot. Makers: Société Matégot (FRANCE). CENTRE: Drop-front cocktail trolley in beech and mahogany or sycamore with ebonised finish; the swivel top is inlaid with cream Formica. Designer: A. M. Lewis, MSIA, for Liberty & Co. Ltd (GB). RIGHT: Beech drop-leaf trolley with teak shelves. The top, inlaid with black Formica, is extendible to 3 feet. Designer: Yngve Ekström. Makers, Källemo Möbelfabrik AB (SWEDEN)

Occasional table on black wrought-iron legs with marble top and wicker magazine shelf. Designer: Maurizio Tempestini. Makers: John B. Salterini Co. Inc. (USA) Window draperies are *Electra*, a denim fabric on which the design is 'engraved' by a new printing process; a choice of six colours is available. Designers and makers, Titus Blatter & Co. (USA)

Glass-topped black wrought-iron table and chairs from the *Riviera* collection. The slip seats to the chairs are covered in sailcloth dyed a light orange, styled melon. Designer: Maurizio Tempestini. Makers: John B. Salterini Co. Inc. (USA)

Limewood table on wrought-iron legs stove-enled black. The highly polished top contrasts the black matt Formica surface of the drawer Kimono chair on wrought-iron frame with tôle and rattan seat. The wall mirror is also framrattan. Designer: Mathieu Matégot. Makers: Se Matégot (FRANCE)

Teak or mahogany small table, 22 inches high, extending hinged top. The two leaves fold over another, measuring 26×20½ inches when closed 26×41 inches fully extended. Designers: Engström and Gunnar Myrstrand. Makers: A/B S borgs Möbelindustri (SWEDEN)

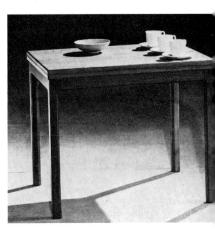

ate-leg table. The legs slide in radial grooves and are braced r strength and rigidity. Each pivots on a single radius arm out one of the four points in the central unit, thus dispensing ith the normal bars and pivots at base. Designed and made v J. Y Johnstone, Des. RCA, at the Royal College of Art (GB)

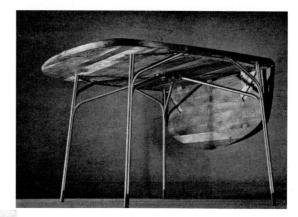

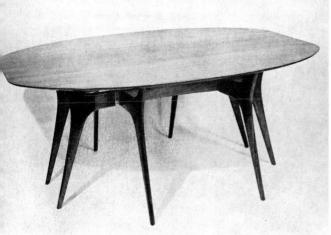

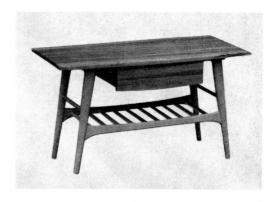

val drop-leaf table in birch, oak, walnut, mahogany, korina or errywood. Four legs swing out to support the extended wes, which increase the width from 1 foot 6 inches to 3 feet inches; length 5 feet 6 inches. Designer: Vladimir Kagan akers: Kagan-Dreyfuss Inc. (USA)

wo-tier coffee table with a top of unusual design 2 feet 5 inches ng. This and the shelf are veneered with oak, mahogany or ripey walnut in natural finishes. Designer: Ewart Myer. akers: Horatio Myer & Co. Ltd (GB)

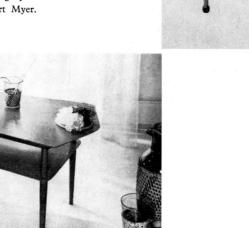

TOP: Occasional table in Australian walnut with underhung drawer. The top is 3 feet 4 inches long, the stretchers forming a magazine rack. Designed and made by James Herbert. ABOVE: Dining table in oak inlaid Indian laurel, with Indian laurel feet. The top is 4 feet long, extending by tambour action to 6 feet. Designed and made by J. R. Varrall. Both are students at the L.C.C. Technical College for the Furnishing Trades (GB)

Living-room furnished in natural mahogany, the bedroom in ash and light blue Formica, with a white cord dividing screen. A sense of unity is achieved by the use of black for the panel above the bed, the cushionto the long bench, and Formica facings to cabinet. Armchairs have deep Latex foam cushioning and are upholstered in dark and light shades of blue and green; dining chairs are in red. The glass-topped small metal table stands on a golden yellow rug. Furniture made by Garfagni and Castellaneta. Bedroom mural in tones of grey by R. Fumeron. Interior de signed by Ramos (FRANCE)

While allowing for considerable freedom in the expression of de and refinements, the trend of modern furnishing is towards a cerdiscipline both of shape and in the manner of siting. A proceetidying up, which started in the kitchen, is now finding its around the house. It is partly an æsthetic exercise in spatial metry, but it is also (and more important from the practical of view) the result of endeavouring to make homes easier to run more convenient to live in.

Because the practical and æsthetic aims are therefore of a p tive and purposeful nature, the keynote of what is still clumsil ferred to as 'contemporary design' is a solid one that should en more than an ephemeral existence if logically pursued.

Furniture is the functional basis of domestic comfort within shelter, heat and light-providing architectural framework. It sign is as much a science as an art and if the purity and simplicity form emerging from proper scientific study exhibits a tendency ward starkness, any such starkness is better countered in the less f tional aspects of furnishing, manifest in wallpapers, textile patter carpets and other items giving freer rein to expression in coand pattern, than by injudicious departure from well-tried for

The rooms and furniture illustrated in this section show m interpretations within this broad theme and are loosely class according to types of room and varieties of furniture within renised categories. The representation is typical of modern tho and reveals the current trends of the world's leading designers.

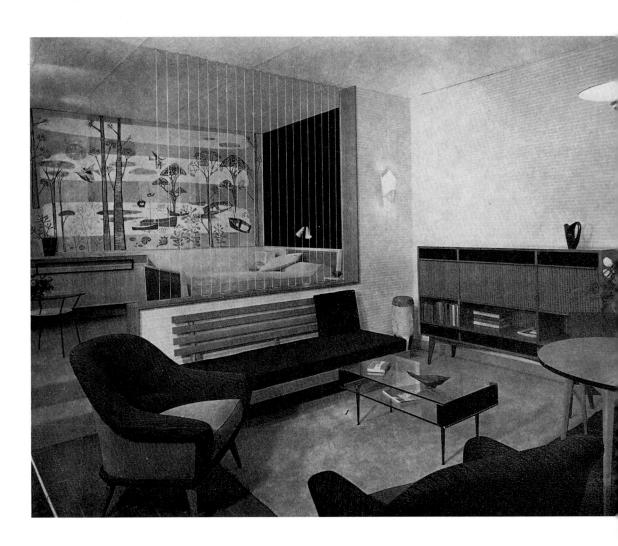

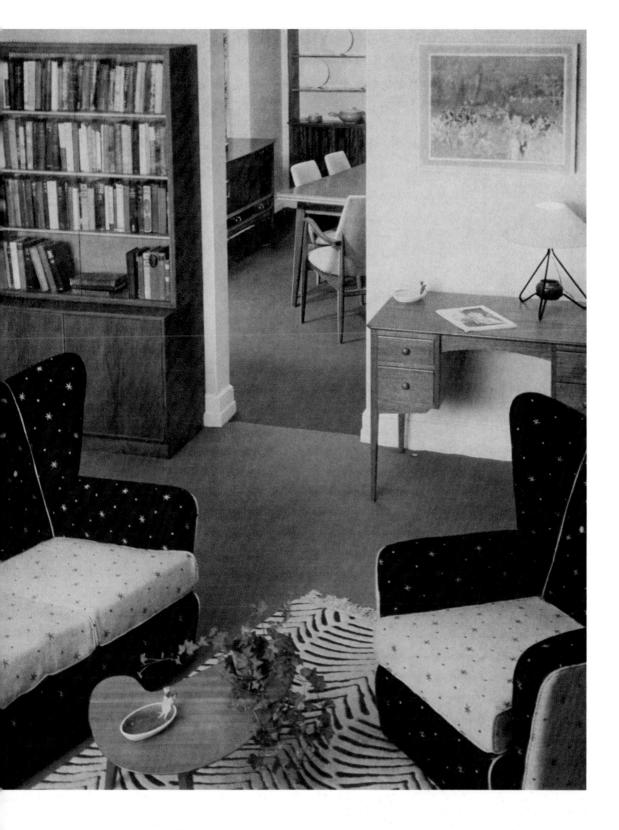

ookcase faced with teak; small palette table and writing desk in natural maogany finish. The deep sprung settee and chair are upholstered in a tapestry reave. In the inner room, the dining group is veneered in mahogany and rose-ood. Interior furnished by Harrods of London (GB)

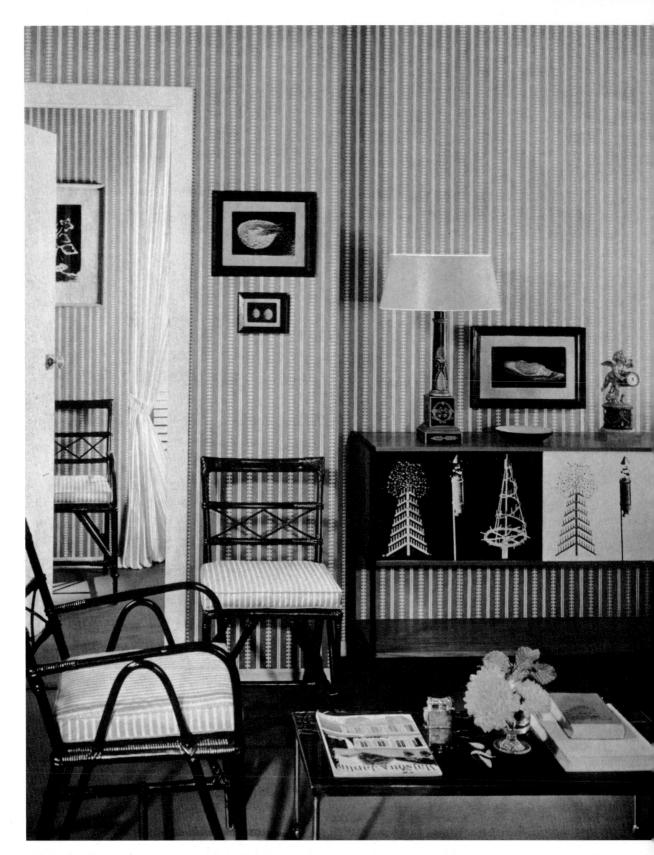

A basic two-colour scheme relieved by touches of yellow. Wallpaper from the Crown range of the Wall Paper Manufacturers Ltd; its simplicity heightens the effect of the dark toned furnishing. Coffee table and mahogany sideboard are designed by Terence Conran. Interior furnished by Peter Jones Ltd (GB)

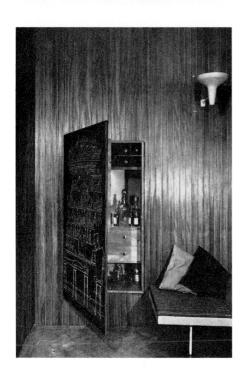

Cocktail cabinet (replacing original doorway) inset in a slatted mahogany living-room wall. Photostat enlargement of a Steinberg drawing mounted on the door makes a decorative panel when it is closed. The bench seat is in birch. Designer: Ian Bradbery, MSIA. Makers: Modular Displays Ltd (GB)

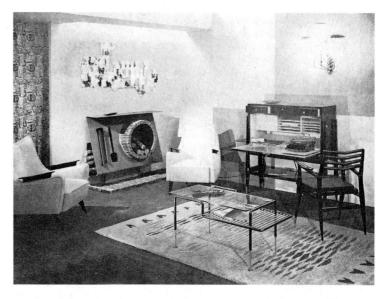

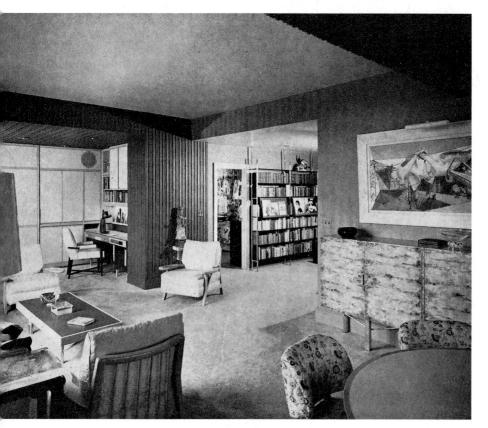

ABOVE: Furniture in black and green Beka lacquer finish, desk interior sycamore. The typewriter folds back inside; raised writing shelf is in green glass. Walls are light grey, with yellow-green panel over desk; carpet greygreen; armchairs upholstered in yellow. Tile hearth, chimney encased in tôle frame. Interior designed and executed by Raphaël (FRANCE)

Open plan interior with dividing walls in a herring-bone plastic wallpaper, and in dark wood panelling. Bleached walnut, teak and lacquer furniture; carpet beige. Built-in television set, radio and tape recorder in wall fitment at left of desk

Designed by Paul László and executed by László Inc. (USA)

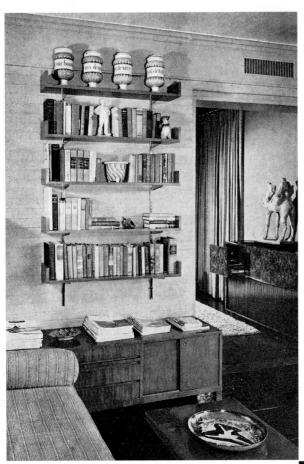

BELOW: Bleached walnut combination unit incorporating fitted bar, radio and recording equipment, writing desk and book storage; built-in lighting in canopy and bar make it entirely self-contained. Designer: Hans N. Wormann. Makers: F. Bauerschmidt & Son (USA)

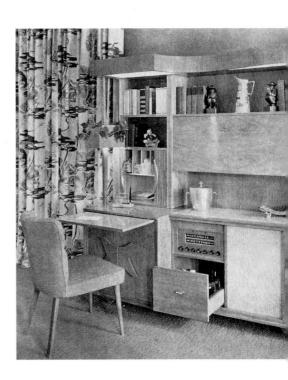

ABOVE: Walnut shelf unit on brass supports nailed into brick wall. Beneath is a custom made walnut cabinet, and at right a unit housing radio, amplifier and record player in the top half with storage space below; top is a burl walnut. Designed and made by William Pahlmann Associates Inc. (USA)

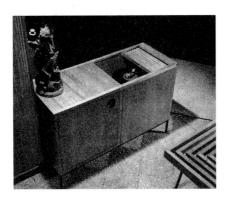

ABOVE: Gramophone and record cabinet, 3 feet wide, in Heart Rimu wood mounted on black iron base. The roll-back top gives easy access to the record player. Designer: John Crichton (NEW ZEALAND). RIGHT: Wall unit incorporating a built-in television, radio and tape recorder. When not in use it is completely hidden behind folding doors

Designer: Paul László. Made by László

Inc. (USA).

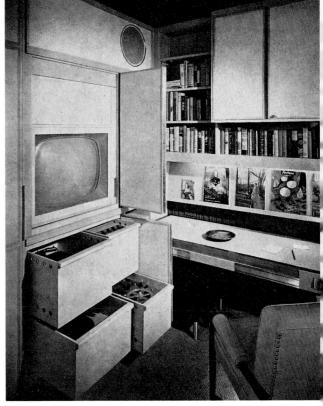

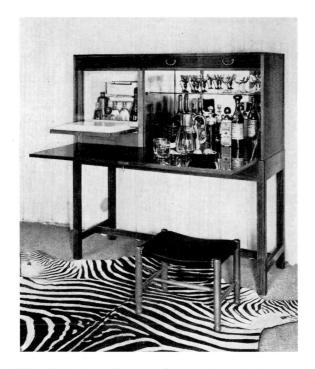

BELOW: A colourful floor laid with *Accoflex* vinyl asbestos marbled and plain black tiles; many designs and colours are available. Makers: Armstrong Cork Co. Ltd. The coffee tables on polished steel frames with slate/mahogany tops and brass fittings are designed and made by Michael Wickham. Chairs are by Buoyant Upholstery Co. Ltd (GB) (*Photo: Michael Wickham*)

Bar in walnut, 4 feet 4 inches high, fitted with refrigerator and interior lighting. The fall is surfaced with black arborite stain resistant plastic. Matching stool has a green leather-covered seat. Designer: Josef Frank. Makers: Svenskt Tenn AB (SWEDEN)

Beech sideboard, mansonia veneer, with routed front and three drawers. One-third fitted shelf enclosed by door, two-thirds by fall front. Height 4 feet. Designed by H. E. Long, MSIA. For Heal's of London (GB)

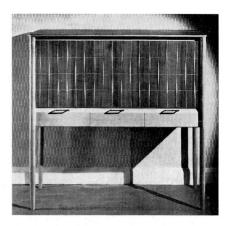

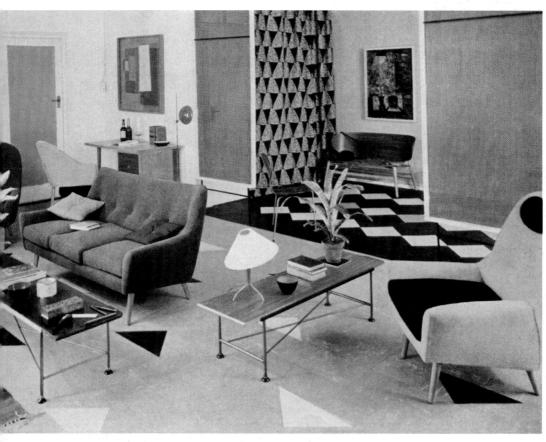

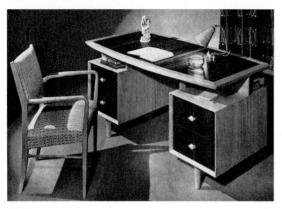

Hardwood desk veneered in rosewood and mahogany with ample storage space beneath the raised top. It is also available in walnut. Designer: Christopher Heal, FSIA. Makers: Heal's of London (GB)

ABOVE: Bureau made in nutwood or cherrywood w maple surface to writing shelf. Pearwood chair u holstered in yellow plastic. Designers and make Möbelfabrik Gebrüder Rohrer GmbH (GERMANY)

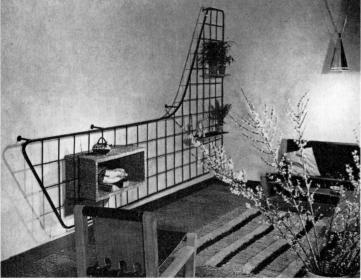

Scored brick fireplace framed within black wrought-iron screen, with hook-on shelves for plants or books. Slung seat and back to chair and settee are in a black plastic fabric. Designer and maker: Jean Royère (FRANCE)

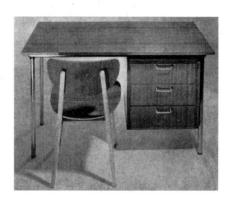

Knock-down desk and chair in natural teak. Designer: C. Braakman. Makers: NV Utrechtsche Machinale Stoel-en Meubelfabriek UMS (HOLLAND)

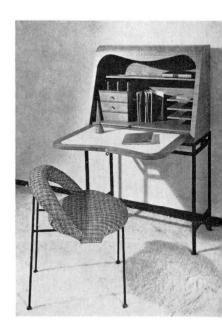

ABOVE: Oak bureau on black wrought-iron fram natural parchment surface to fall. Wrought-ire chair upholstered in black-and-white cotton chec Desk designed by Jean Royère; chair by Jean-Pa Gauberti (FRANCE)

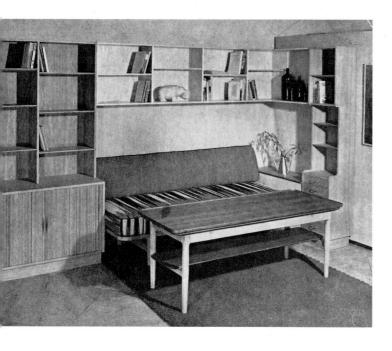

Continuous wall unit in smoked oak and pine. The same woods are used for extending table and divan, which has interior sprung back rest and seat upholstered in Unika-væv fabrics in plain grey and *Icicle* grey, white and black. Designer and maker: Knud Juul-Hansen (DENMARK)

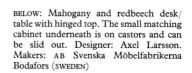

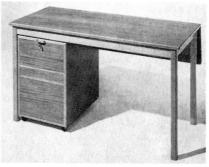

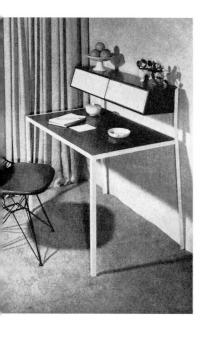

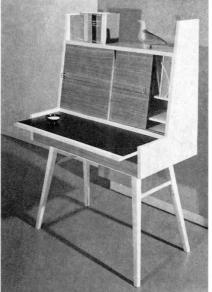

BELOW: Drawing table for home use on white-lacquered steel frame, 2 feet 8 inches high. Fitted with two drawers and a side tray, and concealed lighting in the lid. Designer and maker: Jacques Dumond (FRANCE)

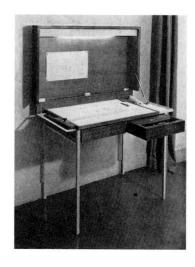

Writing desk on white-enamelled steel frame, rosewood top, with micarta box for papers. Charles Eames steel wire chair upholstered in Naugahyde. Desk designed by George Nelson. For Herman Miller Furniture Co. (USA)

ABOVE: Cherrywood writing desk, matt finish, with black plastic surface to pull-out writing shelf. The sides are extended to form a bookshelf; front sliding panels are in walnut. Designers and makers: Möbelfabrik Wilhelm Renz KG (GERMANY)

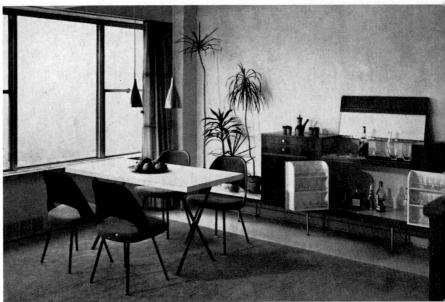

BELOW: Storage unit in African walnut on black angle iron frame. Top cabinet has sliding glass doors; lower doors are faced with washable eighteenth-century photostated engravings. Designer: Terence Conran. Makers: Conran Furniture (GB)

ABOVE: Custom-designed walnut bar and sideboard unit on polished blegs, with marble plant shelf. The dining table is by the Herman M Furniture Company, and the chairs by Knoll Associates. Yellow carpet white rubber flooring. Interior designed by architect Felix Augenfeld (U(Photo: Alexandre Georges)

RIGHT: A setting illustrating the advantages of an overall planned schem furniture design. All the pieces shown are from the G-Plan range in a loak finish; the chairs are upholstered in wool fabric shot with Lurex met thread. Designers and makers: E. Gomme Ltd (GB) (Photo: Anthony Des Vogue Studios)

BELOW: Waxed elm dining group from the Windsor range. Seats of ch and the two 'love seats' are especially shaped for comfort; the curved by and rails are in beech. Designer: L. R. Ercolani. Makers: Furniture Indust Ltd (GB)

BELOW: Cooker-trolley in walnut, linseed finish, fitted with double-plate electric cooker and compartments for utensils and ingredients. Designers: Kim Hoffmann and Stephen Heidrich (USA)

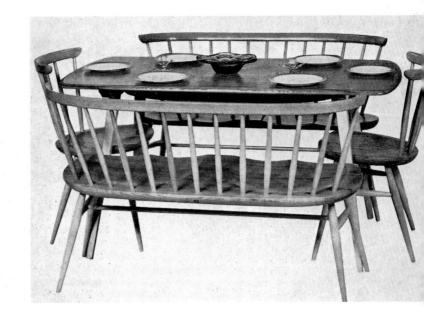

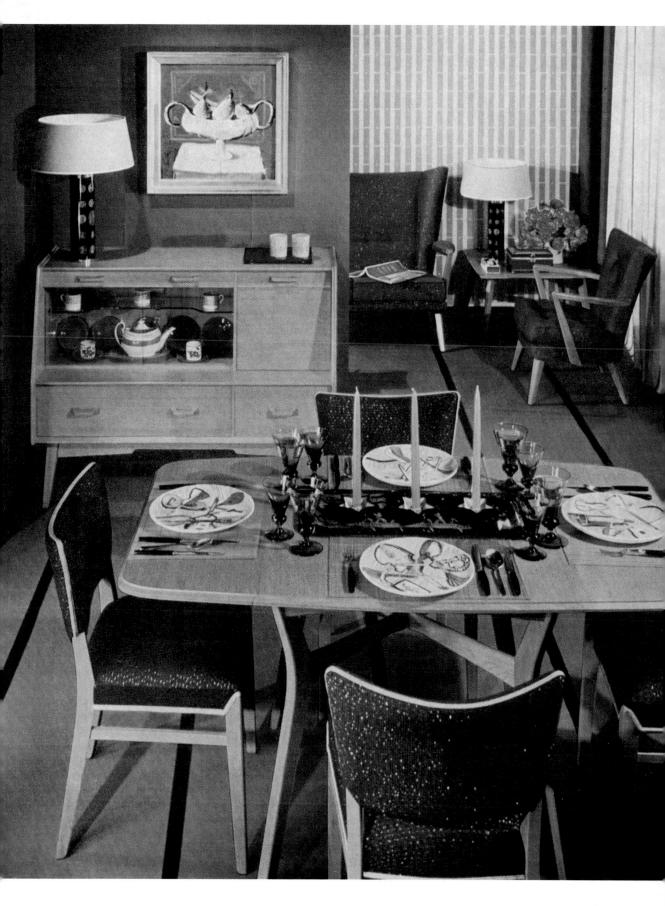

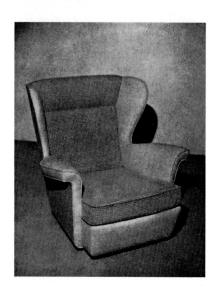

LEFT: Pavone moulded foam rubber seat cushion and Hairlok preformed back upholstered in a two-tone colour scheme. A matching settee is also made. Designer: Howard B. Keith, MSIA. Makers: H.K. Furniture Ltd (GB)

RIGHT: Formell in beech; elm, mahogany, walnut, jacaranda or teak finish. Upholstered Dux springs and foam rubber with wool fabric cover. Designer: Alf Svensson. Makers: Ljungs Industrier AB (SWEDEN)

BELOW: Palmir tension sprung chair with moulded Hairlok back; Lintafoam cushion. A matching settee is also made; both are available in a wide range of covering fabrics. Designer: Howard B. Keith, MSIA. Makers: H.K. Furniture Ltd (GB)

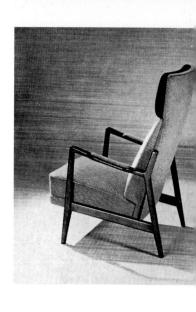

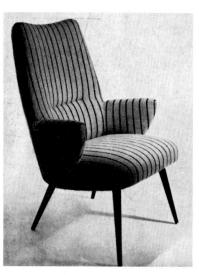

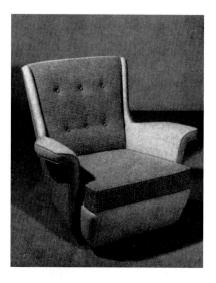

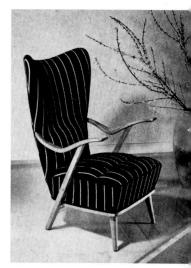

ABOVE: Natural cherrywood armchair from Casala range. Foam rubber padding w black/white wool fabric cover. Designer: Hinz. Makers: Carl Sasse KG (GERMANY)

LEFT: Moulded plywood chair on steel le enamelled black. Seat padded foam rubb back rubberised hair, upholstered mohair we tweed. Ten different colours are availab Designer: Earle A. Morrison. Makers: Rot Bush Associates Ltd (CANADA)

T: Sark on hardwood frame upholstered erised hair. Cover is in natural and black tford deep texture Tibor fabric. Latex cushion. Designer: Ronald E. Long, Makers: R. S. Stevens Ltd (GB)

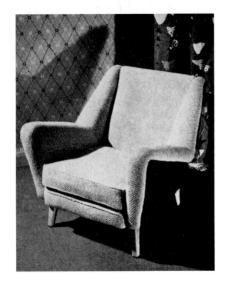

BELOW: Balmoral on hardwood frame. Rubberised hair upholstery with deep texture fabric cover in contrasting colours. Latex foam cushion. Designer: Ronald E. Long, MSIA. Makers: R. S. Stevens Ltd (GB)

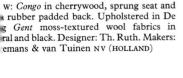

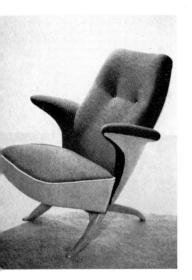

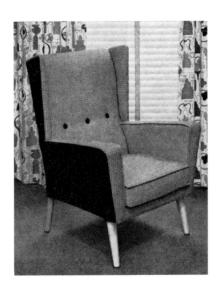

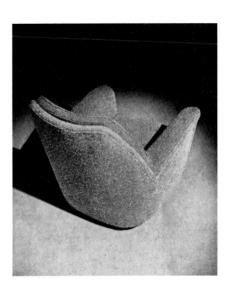

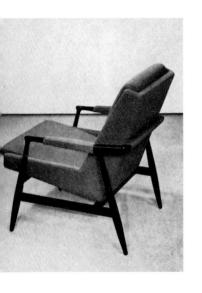

ABOVE: Wing chair on beech frame, natural finish; tension sprung seat and back, Latex foam cushion. Inside covered tomato tapestry, outside black mohair. Designer: F. G. Clark. Makers: George Clark (Bristol) Ltd (GB)

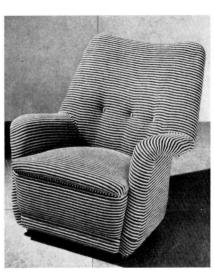

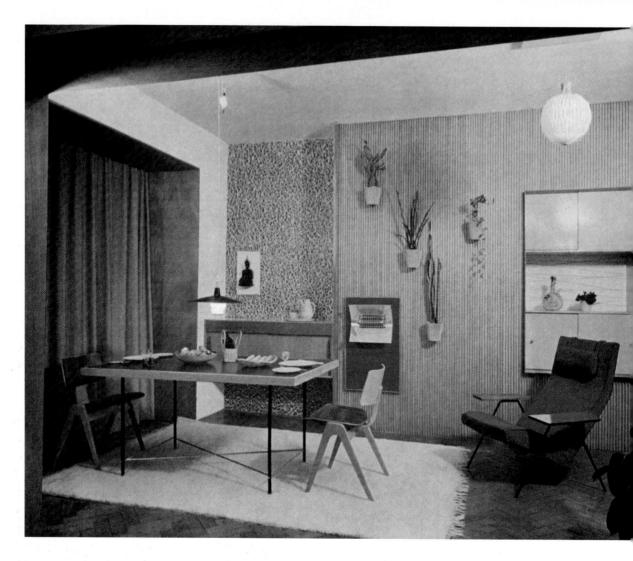

White walls and ceiling and mahogany linings to doors and windows give light and warmth to this dining-room in a converted basement flat. A birch-slatted wall conceals the original fireplace; the old recesses hold (Right) a storage fitment framed in mahogany and (Left) a sideboard backed by a photographic texture panel. Chairs and sideboard are by Hille of London. Lino-topped dining table, edged birch, with matt black metal tube legs and chrome metal cross brace designed by Ian Bradbery and Derek Newton; bent brass chrome-plated electric fire reflector by Anthony Mann, MSIA. Interior designed by Ian Bradbery, MSIA. Executed by Modular Displays Ltd (GB)

RIGHT: Chatsworth solid beech trolley, medium or natural finish; trays are surfaced with washable Vynide or with selected oak veneers. Makers: Compactom Ltd (GB)

FAR RIGHT: Polished brass tea wagon, shelves of heat-resistant black Arborite. Designer: Josef Frank. Makers: Svenskt Tenn AB (SWEDEN)

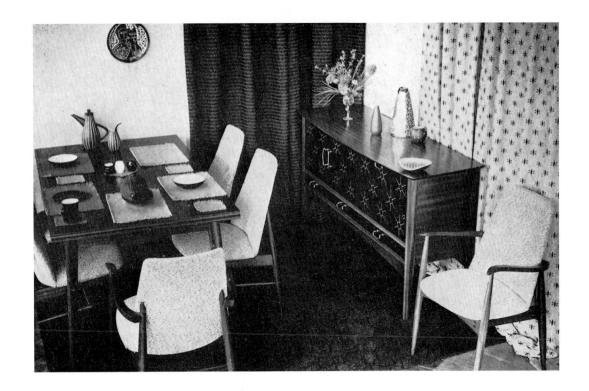

Laurel dining group, chairs upholstered natural Stratford texture fabric; draperies Olive-shot-Lurex Berkeley and black and white Helico; deep cherry 'Marble' Banbury carpet. Tigoware ceramics and fabrics designed by Tibor Reich, FSIA. Furniture made by W. G. Evans & Sons Ltd; fabrics by Tibor Ltd; Tigoware by Joseph Bourne & Son Ltd (GB) (Photo: Studio Kordes)

RIGHT: Laundry-kitchen panelled in fir plywood, grey washable finish. Ceiling of painted fir beams with exposed hemlock plank floor above. Ceramic plaques by Hugh Jones, bowl by Claude Vermette. Designer: Philip F. Goodfellow, MRAIC (CANADA)

BELOW Left: Cherrywood trolley; top tray revolves and is surfaced with stain-resistant red plastic. Designers and makers: Möbelfabrik Wilhelm Renz kg (Germany). Right: Red and white kitchen. Working surfaces in dark green plastic, doors faced Tavanit plastic. Black-and-white Cerabati tiled floor. Designed and executed by Janette Laverrière (FRANCE)

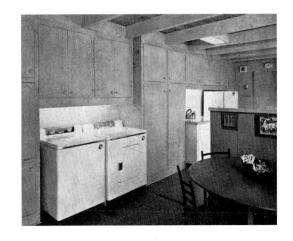

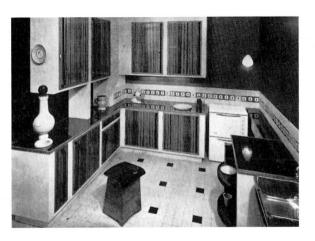

RIGHT: Bambino child's chair on ebonised birch frame; foam rubber padded seat and back covered in light grey knubby wool fabric. Designer: Ilmari Lappalainen. Makers: Askon Tehtaat O/Y (FINLAND)

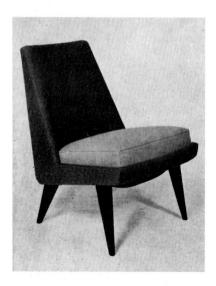

ABOVE: Moulded chair on ebonised beech legs. Upholstered in turquoise blue wool fabric with cushion in grey. Designer: Alf Nilsson. Makers: AB Knolls Eftr (SWEDEN). BELOW: La Martingala Metallic tube frame, upholstered foam rubber on resilient webbing. Removable cotton, wool, or lastex cover. Designer: M. Zanuso. Makers: Ar-flex S.pA (ITALY)

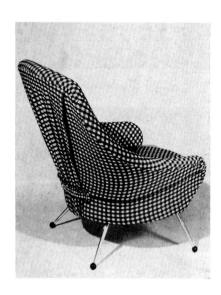

RIGHT: Stroma on hardwood frame. Rubberised hair upholstery with deep texture fabric cover in contrasting colours; Latex foam cushions. A matching settee is also made. Designer: Ronald E. Long, MSIA. Makers: R. S. Stevens Ltd (GB)

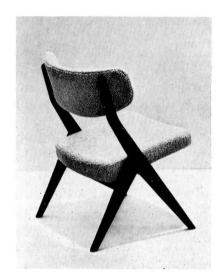

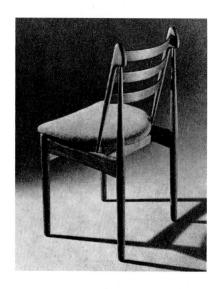

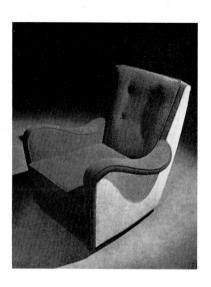

BELOW: Alderney on beech frame. Upholss rubberised hair and covered in a wide rang fabrics in contrasting colours. Designer: Re E. Long, MSIA. Makers: R. S. Stevens Ltd

LEFT: Fumed oak dining chair, oil finish. Frubber padded seat with wool fabric of Designer: Paul M. Volther. Makers: Faforeningen for Danmarks Brugsforeni Møbler (DENMARK). RIGHT: Laminated be chair, lacquered black, on nickel finished rod frame, rubber feet. Also made in tearosewood. Designer: Arne Jacobsen. Mal Fritz Hansens Eft. A/S (DENMARK)

ABOVE: Slung seat on walnut, ash or mahog legs; laminated arms. Upholstered firm elaslats and foam rubber with custom-made vor cotton covering. Brass fittings. Desig G. F. Frattini. Makers: Figli di Amedeo Cas (ITALY)

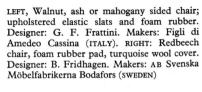

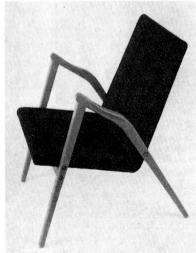

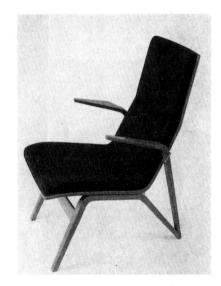

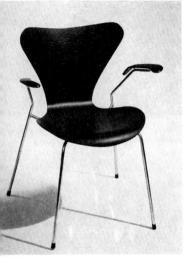

ABOVE: Redbeech chair with shaped arm rests. Slung seat upholstered foam rubber and black tweed. Designer: Axel Larsson. Makers: AB Svenska Möbelfabrikerna Bodafors (swedden). RIGHT: Beech chair; sprung seat; covered plain red and red/white wool fabric. Designer: G. Eberle. Makers: Gebrüder Thonet AG (GERMANY). BELOW: Albaro Plywood seat on metal tubular frame, foam rubber cushion. Designer: G. Pulitzer. Makers: Ar-flex s.pA (ITALY)

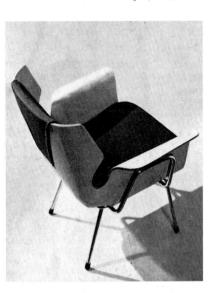

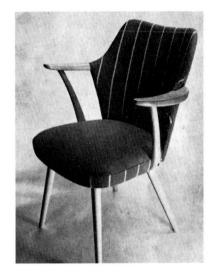

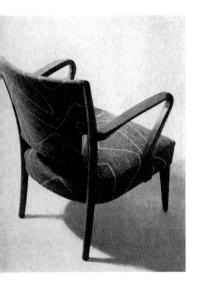

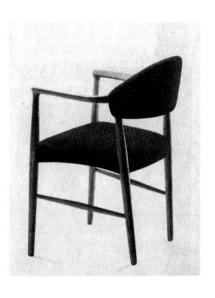

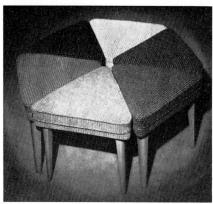

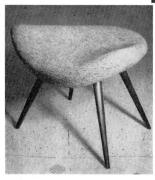

ABOVE: Beech stools, upholstered foam rubber and covered in a wide range of fabrics. Designer: Howard B. Keith, MSIA. Makers: H. K. Furniture Ltd (GB)

RIGHT: *Thema* beech frame chairs. Seat cushions and backs padded foam rubber with red check wool fabric covers. Designer: Yngve Ekström. Makers: ESE Möbler AB (SWEDEN)

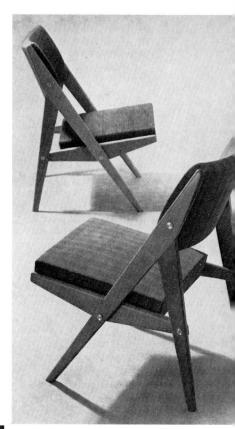

ABOVE: Stool with shaped seat, padded foam rubber, on black-lacquered cherrywood legs. Designer: Christav Paleske. Makers: Wörrlein Werkstätten (GERMANY)

RIGHT: Magistrate stool on beech legs, polished natural, walnut or mahogany finish; top upholstered foam rubber. Designer: Howard B. Keith, MSIA. For Heal's of London (GB)

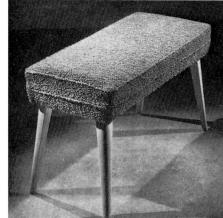

LEFT: Light beech Casala stool. Seat upholstered black and yellow wool fabric. Designer: D. Hinz. Makers: Carl Sasse KG (GERMANY)

RIGHT: Beech Vanson dining chair. Seat upholstered in Latex foam, back in rubberised hair, covered in a pale sage green Sanderson fabric. Designer: Peter Hayward, MSIA. Makers: W. G. Evans & Sons Ltd (GB) (Photo: C.o.I.D.)

SHT: Columbus beech frame; moulded seat uptstered wool fabric and foam rubber padding. signer: Hartmut Lohmeyer (GERMANY) Makers: ungs Industrier A/B (SWEDEN)

Low: Easy chair with pre-formed aluminium it on steel legs; upholstered foam rubber. Dener: James A. Howell (USA). Makers: Galleria obili d'Arte (ITALY)

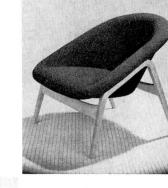

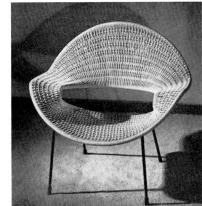

ABOVE: Steel frame stove-enamelled black; seat of plastic-covered cord. Designed and made by F. Watkins at the Royal College of Art (GB)

BELOW: Dining chair on steel legs with laminated plywood back. Foam rubber seat cushion is covered in black/white plastic, the back in black plastic. Designer: E. Harlis. Makers: Gebrüder Thonet AG (GERMANY)

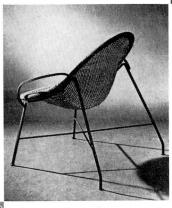

ABOVE: Java chair on black iron frame designed to fit woven cane bucket seat. Designer: John Crichton. Frame made by Steelex (NEW ZEALAND)

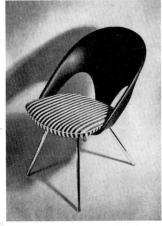

Moesch high-backed woven cane armchair on black iron frame. Makers: Rohrmöbelfabrik W. Jenny AG (SWITZERLAND)

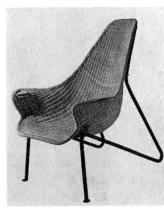

BOVE: Beech dining chairs, plywood backs, from the Casala range. The foam rubber seat cushions are faced with Acella washable lastic. Designer: D. Hinz. Makers: Carl Sasse KG (GERMANY)

Waxed elm glass-fronted bookcase; interior lined felt and fitted with Securit glass shelves. Armchair on black-lacquered metal frame is upholstered in bright red wool fabric over Latex foam. Carpet is grey, rug burnt Sienna. Furniture designed and made by René Jean Caillette (FRANCE)

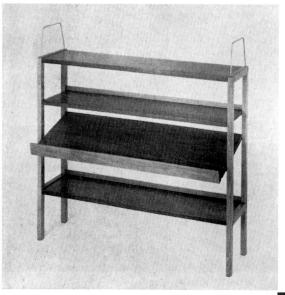

ABOVE: Knock-down bookshelves in red beech and mahogany. Designer: Carl-Axel Acking. Makers. AB Svenska Möbelfabrikerna Bodafors (SWEDEN)

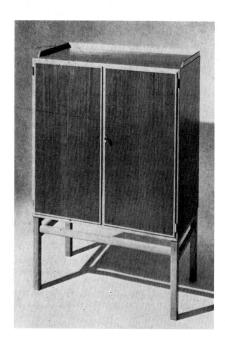

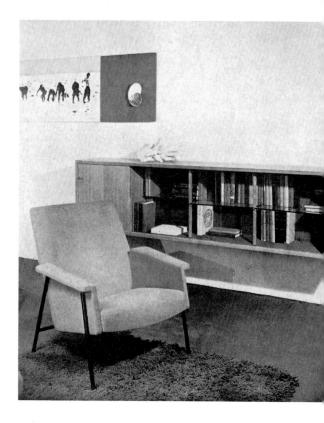

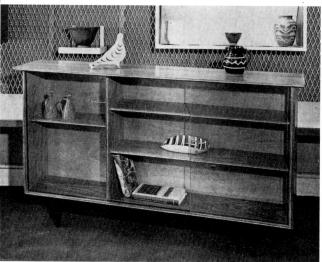

ABOVE: Bookcase in black bean and ebonised sycamore, with adjustable shelves. Length 5 feet. Designer: Eric G. Clements, Des. RCA, MSIA. Maker: H. A. Lock (GB) (Courtesy: Miss A. Jones)

LEFT: Unit cupboard in mahogany and redbeech. Designer: Axel Larsson. Makers: AB Svenska Möbelfabrikerna Bodafors (SWEDEN)

HT AND BELOW: Mahogany disy/cocktail cabinet designed as a iding unit, with Vynide-covered and sliding doors to cocktail side. 1 supports inlaid Indian laurel. signed and made by James Herbert the L.C.C. Technical College the Furnishing Trades (GB)

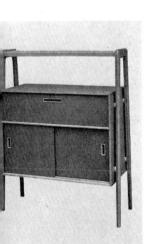

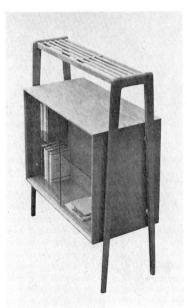

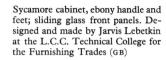

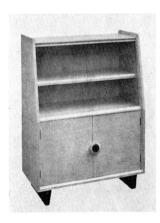

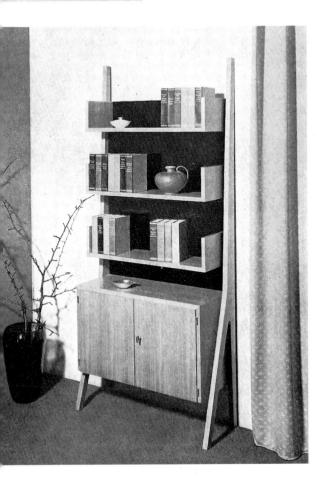

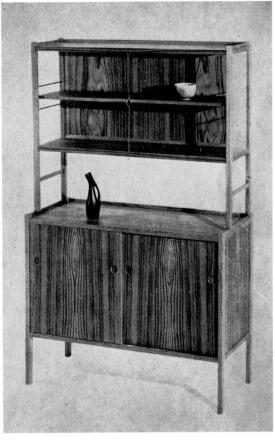

ABOVE: Kontrast cabinet in matt-polished teak, display shelves enclosed within sliding glass doors. Designer: Yngve Ekström. Makers: Källemo Möbelfabrik AB (SWEDEN). LEFT: Bookshelf and cupboard combination in cherrywood, 4 feet 4 inches high, with black backing to shelves. Designers and makers: Möbelfabrik Wilhelm Renz KG (GERMANY)

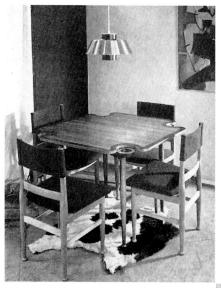

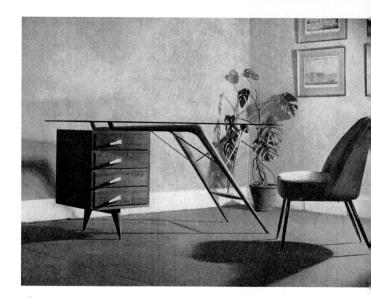

Mahogany desk with armour-plated glass top; supports and drawer handles are polished brass. Designed by Cherna Schotz. The chair, upholstered in velvet ov Latex foam, with brass-turned legs is an Italian design by Carlo Pagani. For Pe Jones, London (GB) (Photo: John Lewis & Co. Ltd)

ABOVE: Bridge table in nutwood, with chairs in smoked oak. Designed and made by Knud Juul-Hansen (DENMARK)

Table for use between two armchairs forming quarter-circle seating. Stove-enamelled base enclosed in polished brass band, Micarta top edged brass. Designers: Kim Hoffmann and Stephen Heidrich. Makers: Ironmasters (USA)

Small maple table on brass-tipped legs, with lacquered top. Designers and makers: A. Hainke, GmbH (GERMANY)

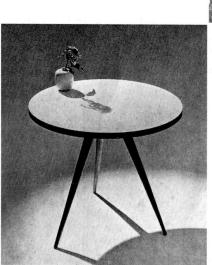

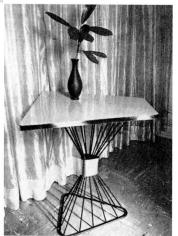

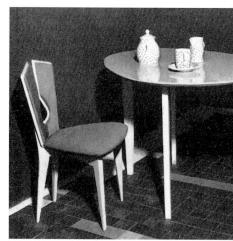

ABOVE: Ash coffee table and chair; Tavas plastic top to table, chair upholstered brig green cotton fabric. From a range design and made by Janette Laverrière (FRANCE

LEFT: Card table in teak designed by Fin Juhl. Made by Niels Vodder (DENMARK)

FAR LEFT: Dining table on waxed elm base, elliptical smoked glass top, 5 feet 7 inches in length. Designed and made by René Jean Caillette (FRANCE). LEFT: Teakwood dining table designed by K. E. Ekselius. Made by AB J. O. Carlsson (SWEDEN)

ABOVE: Knock-down coffee table in oiled teak. Length 4 feet 11 inches. Designer: Kurt Olsen. Makers: A. Andersen & Bohm (DENMARK)

BELOW: Beech occasional table, 4 feet $2\frac{1}{2}$ inches long. Top edged cherrywood with black Resopal plastic surface; also made with ivory surface. Designer: Satink. Makers: Wörrlein Werkstätten (GERMANY)

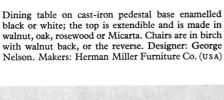

BELOW: Small cherrywood table and (right) dining table in beech with top surfaced in ivory Resopal plastic, cherrywood edge. Designers and makers: Wörrlein Werkstätten (GERMANY)

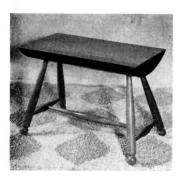

Small table on splayed legs carved in solid walnut. Designer: Josef Frank. Makers: Svenskt Tenn AB (SWEDEN)

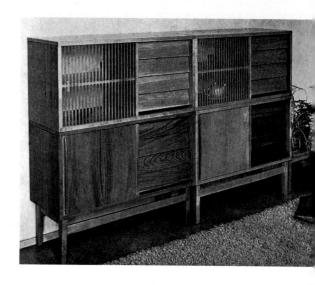

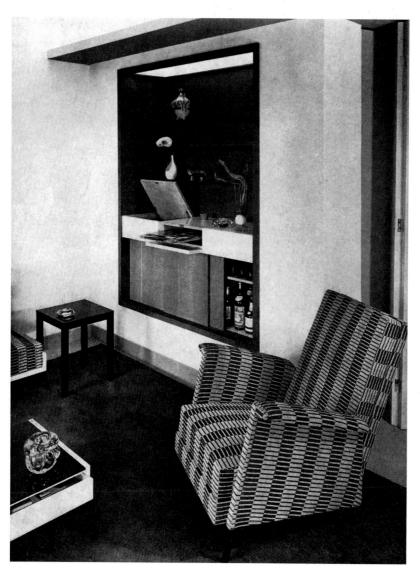

ABOVE: Cabinets made in elm or twith sliding doors, recessed dr fronts, and striped glass sliding r to display section. Designer: Il Lappalainen. Makers: Askoo/y(FINL

LEFT: A space-saving fitted wall with built-in lighting strip. The share glass, record player and restorage unit are lacquered white, below is a green felt-lined bar sliding oak doors. Furniture and holstery are in black and white, cared. Interior designed and execute Jacques Dumond (FRANCE)

BELOW: Occasional table in solid with top edged in brass. Desig Vladimir Kagan AID. Makers: Ka Dreyfuss Inc. (USA)

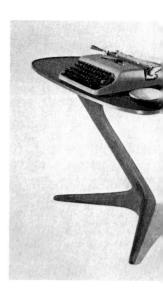

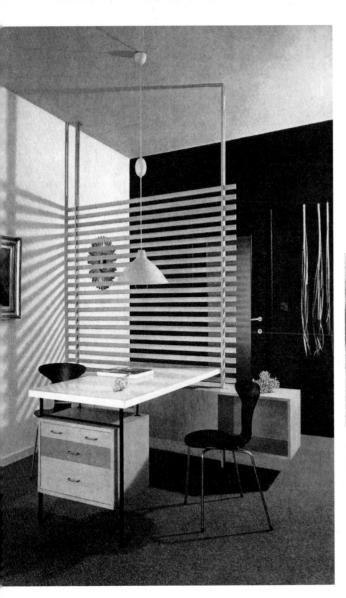

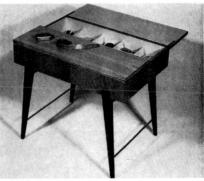

Cherrywood sewing table on black-stained supporting frame. Designer: Satink. Makers: Wörrlein Werkstätten (GERMANY)

OVE: Living-room with combined table, bookshelf and een unit in ash. End supports are black metal, and the le is surfaced in white Formica. The black-lacquered tal chairs are Danish, designed by Arne Jacobsen. erior designed by Jul De Roover. Unit made by L. ttiens-Lierre (BELGIUM)

levision/writing/storage fitment composed of *Vanson* its in mahogany and rosewood (alternative finish hogany or walnut) mounted on plastic covered steel s with adjustable feet in brass or plastic; top cases have ling doors in clear or figured glass. The television set a Pye model designed by Robin Day, FSIA. The units d chair (made in mahogany or walnut) are designed by ter Hayward, MSIA. Makers: W. G. Evans Ltd (GB)

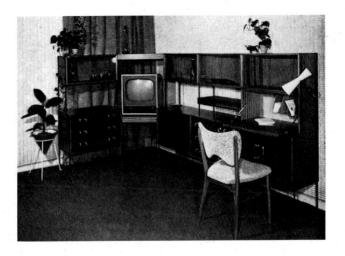

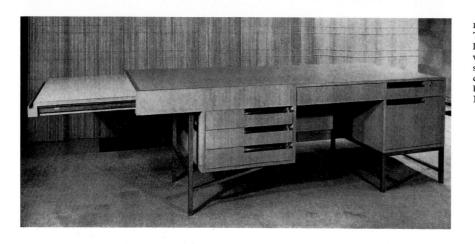

LEFT: Bleached walnut writing de The 7-foot top is faced with be leather and the 3-foot extension shelf white micarta. The underframe is solid brass, dull chrome finish; drawer handles are Plexiglass. Desigr by Paul László AID. Makers: Lász Inc. (USA)

White oak sideboard with drop front wine cupboard and sliding glass doors to china cabinet, which is fitted with a half shelf. From the 'Golden Key' range of furniture designed and made by Palatial Ltd (GB)

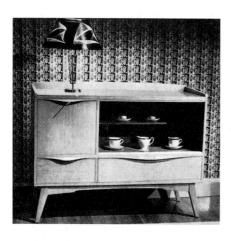

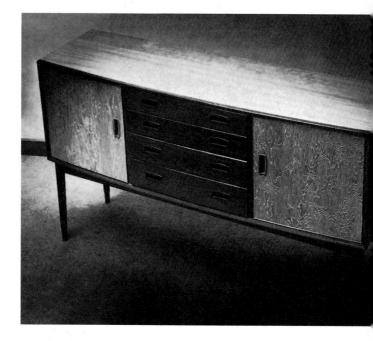

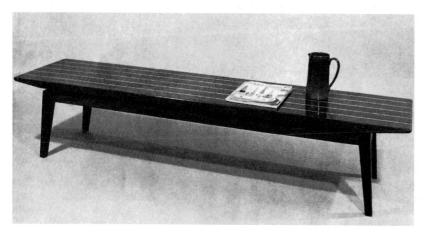

ABOVE: Pine sideboard, 5 feet long, lipped front edge with teak; drawer fronts and fin grips are also teak, and the doors are sa blasted pine. Designed and made by J. Houghton, at the Royal College of Art (GB)

Cocktail table in oak, afrormosia, mahogan walnut. The inlaid top is 6 feet long. I signer: Sigrün Bülow-Hube. Makers: Works (CANADA)

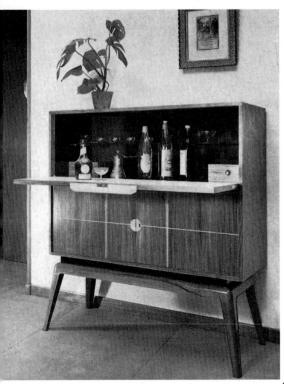

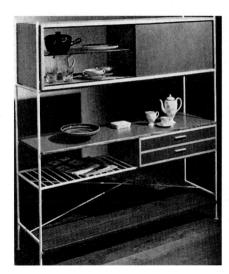

Room divider on white-painted tubular steel frame. The bottom shelf is in solid mahogany, with upper shelf, cabinet and drawers in hardwood faced with Formica or Warerite. Designed and made by Kandya Ltd (GB)

VE: Cocktail cabinet in bleached walnut, interior polished k, with top of flap surfaced in silver-grey Formica. wer fronts are veneered cherrywood with sycamore in-Designer: F. M. Gross, FSIA, FRSA. Makers: Beck & litzer (Contracts) Ltd (GB)

ow: Hilleplan 'Junior' desk with mahogany pedestal inet, front veneered ash or rosewood; also available with d drawers. The desk top is surfaced in black or grey leum. Designed by Robin Day, ARCA, FSIA. For Hille London Ltd (GB)

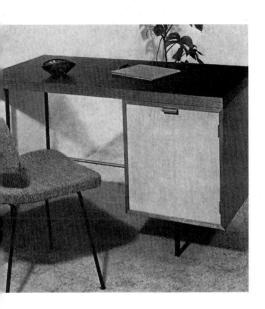

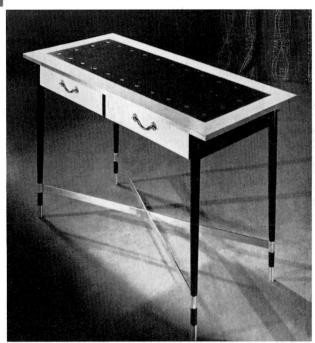

Hand-made side table with top in plastic laminate, inlaid skiver centre and brass edge; ebonised underframe and legs, with brass stretchers and toes. The drawer fronts are painted white. Designed by H. Stephenson, MSIA. For Heal's of London (GB)

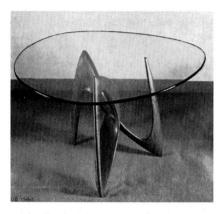

Occasional table on hand-carved polished walnut base, with thick, brilliant crystal top measuring 2 feet 4 inches across. Designers and makers: Fontana Arte (ITALY)

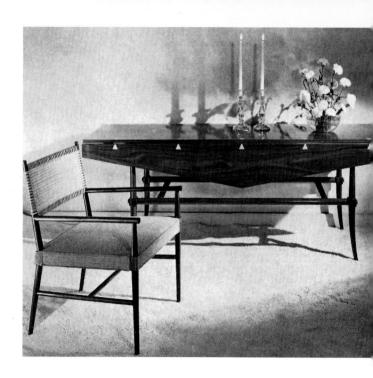

ABOVE: Walnut drop leaf table with ina' butterfly inlay. The top 6½ feet and over 3 feet at widest point wher open. Designer: Tommi Parz Makers: Parzinger Originals Inc. (U

LEFT: Plastic-topped table and charsteel legs; the chairs are in diff colours. Designer: W. Frey, Swb. M. Stella-Werke AG (SWITZERLAND)

Occasional table, with incorporated a zine rack, in walnut, oil finish. Des Vladimir Kagan, AID. Makers: K Dreyfuss Inc. (USA)

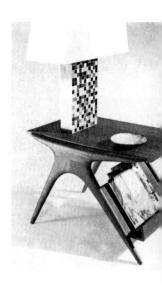

ABOVE: Small mahogany table; the top is inlaid with maple. Designed and made by Oskar Riedel (AUSTRIA)

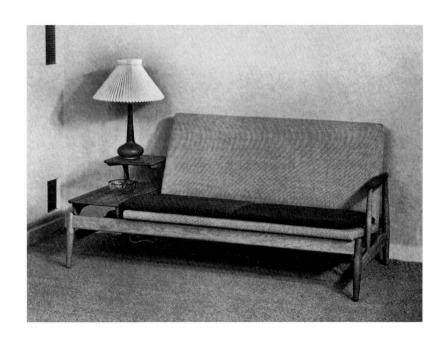

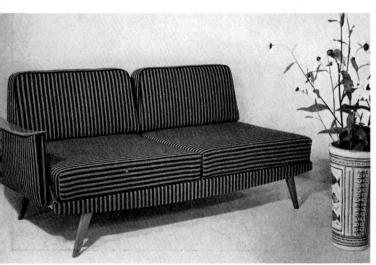

ABOVE: Oak settee with shelf unit in teak. Upholstery No-sag springs, light grey wool fabric cover, black cushions. Designer: Hans Olsen. Makers: Hovedstadens Møbel- og Madrasfabrik (DENMARK). LEFT: Convertible settee in cherrywood; the arm rest swings down level with the base to form a bed. Back cushions upholstered coconut fibre, seat cushions feathers and foam rubber. Designers and makers: Wörrlein Werkstätten (GERMANY)

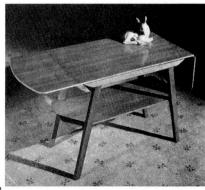

ABOVE: Occasional table in striped walnut or natural oak veneers. The flap ends are supported on automatic self-locking steel brackets. Designer: D. W. Munckton. Makers: Yatton Furniture Ltd (GB)

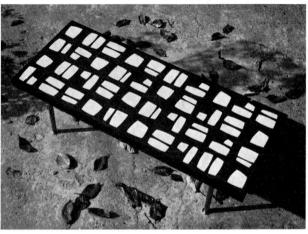

White glaze on matt black tiled top with edge of ebonised wood; polished brass legs. Designer: Brian Hubbard. Makers: Chelsea Pottery (GB)

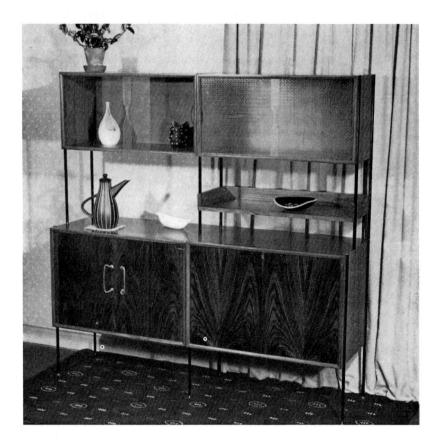

ABOVE: Vanson unit assembled as a sideboard, using a cupboard, wine cabinet and display cases in mahogany and rosewood mounted on plastic covered steel legs with adjustable feet in brass or plastic; alternative finishes are mahogany or walnut. Designer: Peter Hayward, MSIA. Makers: W. G. Evans & Sons Ltd (GB)

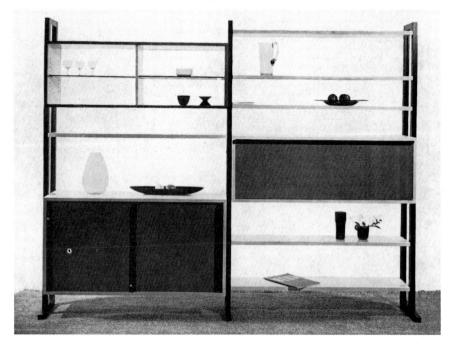

The 'Penguin' wall bookshelf it oak, for small format books, ments. Designer: Frank Heig RCA, MSIA. Makers: Beaver & Ltd (GB)

LEFT: Wall unit with shelves and in maple. The left-hand designed to hold records or fol has sliding doors in red or ot colours; the cabinet on the rig pull-down writing shelf. I Alfred Altherr, SWB. Makers Frei and Richard Münch (SWITZ

I cabinet in mahogany with doors and vers veneered in ash; the slatted rack w is in cherrywood. Interior trays are d with plastic, handles brass. Deed and made by Roger Fitton, at the h Wycombe College of Further Educa-(GB)

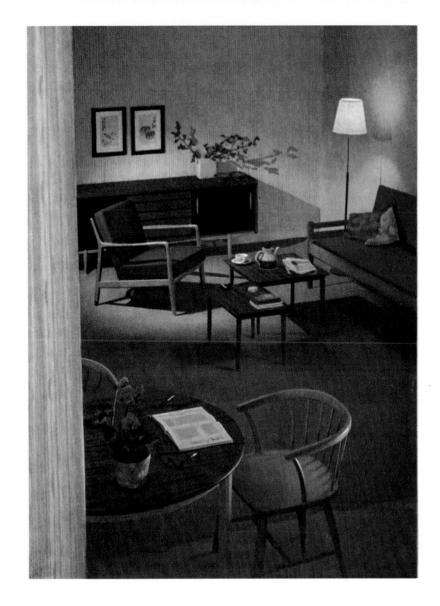

ectional wall magazine racks (1, 2 or 3 ctions) of half-inch lacquered cane hung 1 simple plaster hooks or brass wood rews. Designers and makers: Standishaylor (Designs) Ltd (GB)

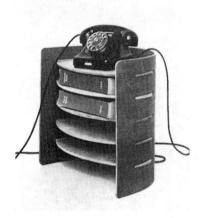

Interior furnished in natural and lacquered teak, with beech occasional chair. Dining table and chairs are designed by Erik Fryklund. Makers: AB Hagafors Stolfabrik; nesting tables Kombinett by Alf Svensson. Makers: Tingströms Möbelfabriks AB; chair with loose cushions USA 143, by Folke Ohlsson. Makers: Ljungs Industri AB; settee College designed and made by Erik Berglund, Uno Swalén, Eilas; Trio cabinet with sliding doors and centre drawer section by AB Hugo Troeds Industrier (SWEDEN) (Courtesy: FORM' Magazine)

Telephone table in laminated beech. Designed by Kristian Vedel, Makers: Torben Ørskov & Co. (DENMARK)

Breakfast table and stools on white-enamelled metal legs, brass tipped. The table top is black micarta; seat cushions upholstered in yellow and white striped linen over foam rubber. The small six-fold Chinese screen is in gold, white and black. Designer: Tommi Parzinger. Makers: Parzinger Originals Inc. (USA)

BELOW: Twin occasional tables with slatted oak tops mounted on black iron underframe. Designer: John Crichton. Maker: J. Shaw (NEW ZEALAND)

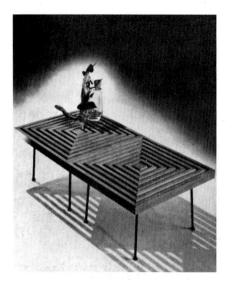

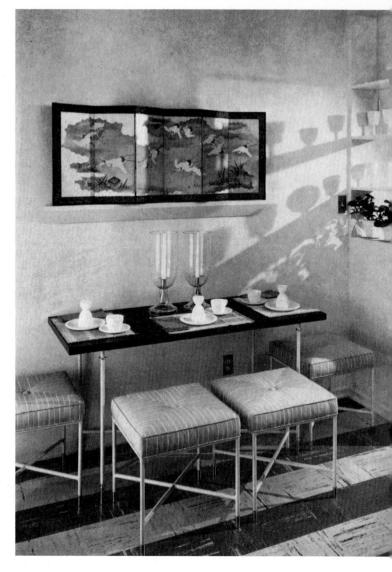

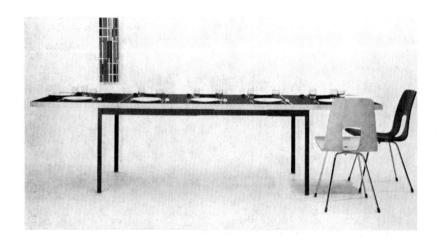

LEFT: Pull-out dining table on steel base, whardwood top surfaced in linoleum. Designed Fred Ruf, SWB. The plywood chairs on lacque metal legs are by Hans Bellmann, SWB. Make Wohnbedarf AG (SWITZERLAND)

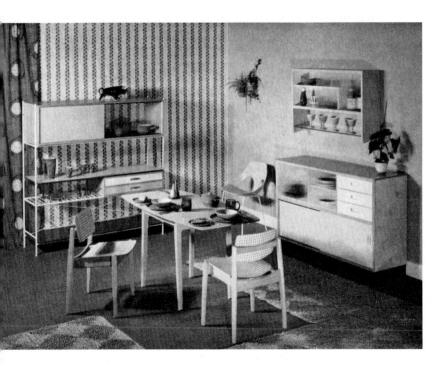

Drop-flap dining table with top faced greyand-white check Formica or Warerite, and matching chairs; contrasting gay colours are used for the fronts, tops and shelves of the cabinet and white metal-frame room divider. Designers and makers: Kandya Ltd (GB)

HT: Mahogany sideboard with sliding doors; interior fitted two wers and shelf. Designer: Robert Heritage, Des.RCA, MSIA. Makers: W. Evans Ltd (GB). BELOW RIGHT: Occasional table in afrormosia, finish. The brass-tipped legs are ebonised black. Designed and made A. Younger Ltd (GB). BELOW: Dining group in ash, with chair seats backs in nylon cane. The table top folds over, and the articulated al base enables it to serve also as a console. Designer and maker: xime Old (FRANCE)

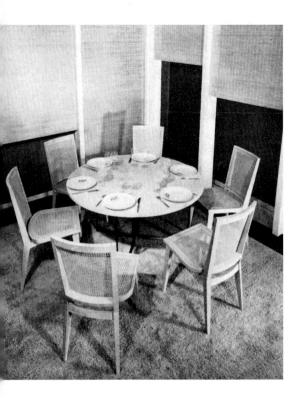

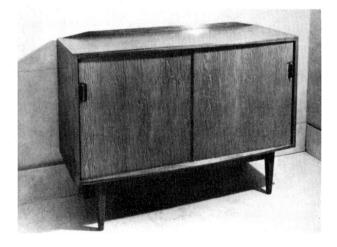

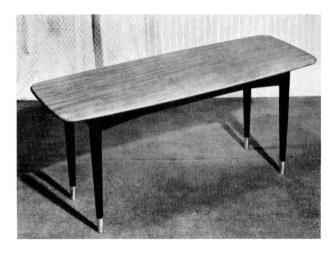

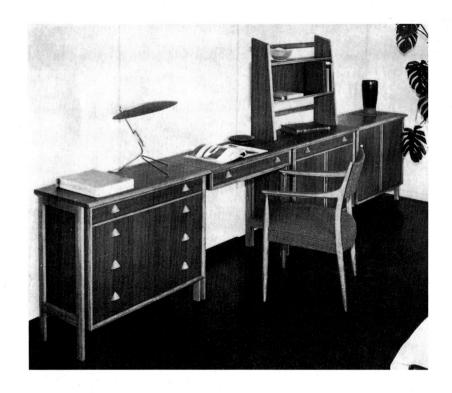

LEFT: Chest of drawers, writing table, cabinets and bookshelf designed as unit pieces for combined or separate arrangement. They are made in oil-finished teak with edges and legs in oak. The chair is inoak. Designer: Svante Skogh. Makers: AB Seffle Möbelfabrik (SWEDEN)

BELOW: An attractive colour scheme, with chairs upholstered in *Shaftesbury* deep-texture turquoise fabric; curtains in *Cymbeline* texture drape interwoven with Lurex. The fabrics and 'marble' carpet are designed by Tibor Reich, FSIA. Fabrics made by Tibor Ltd, and carpet by Ian C. Steele & Co. Ltd. The television set is a Pye model; furniture by H. K. Furniture Co. Ltd (GB)

BELOW: Living-room furnished in acajou, with desk top surfaced in black Formica; the bookshelves slot into the end supports and can be varied in height. A light grey 'marbled' linoleum covers the floor. Designer: Jul De Roover. Furniture made by De Bruyn Frères (BELGIUM)

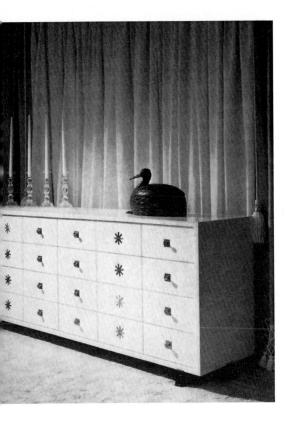

ABOVE: Eight-drawer double chest on dark mahogany base. It is lacquered in custom colours—here shown in white with gold bronze hardware. Designer: Tommi Parzinger. Makers: Parzinger Originals Inc. (USA)

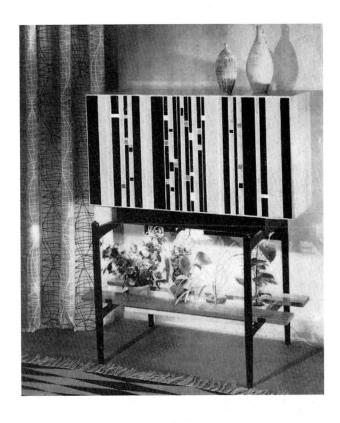

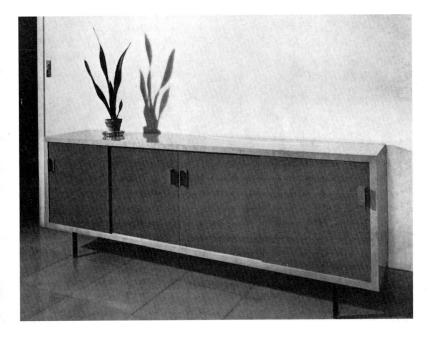

ABOVE: Cocktail cabinet on ebonised underframe fitted with a plant shelf and built-in fluorescent lighting. The front can be a frame for embroidery, painting, or other work of art. Designer: Ernst Pollak, MSIA. For Heal's of London (GB)

Cabinet in ash, natural gloss finish, supported on black-enamelled iron legs. The sliding doors are lacquered grey. Designed and made by Jacques Dumond (FRANCE)

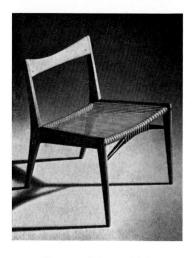

ABOVE: Cherrywood frame with boomerang-shaped rosewood stretchers. Designed and made by J. A. Scott, student at the Royal College of Art (GB)

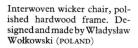

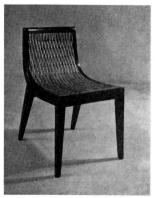

BELOW: Folding chair on black-lacquered iron frame; plaited rattan seat and back with armrests of oiled teak. Designer: Arne Nilsson. Makers: Hans-Agne Jakobsson AB (SWEDEN)

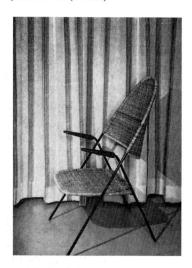

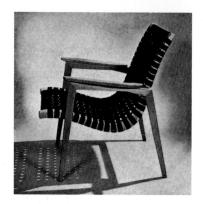

TOP: Easy chair in oak, afrormosia, mahogany or walnut; coloured webbing. Designer: Reinhold Koller. Makers: Aka Works (CANADA). ABOVE: Rubber-banded oak folding chair, rubbed oil finish; brass fittings. Designed and made by John Ravillious, student at the High Wycombe College of Further Education (GB)

LEFT: Plaited soft wicker chair on hardwood base. RIGHT: Bent cane corded chair. Both are designed and made by Władysław Wołkowski (POLAND)

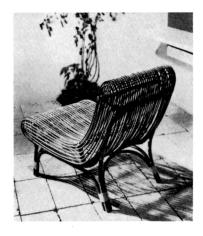

ABOVE LEFT: Bucket chair on nickel-finished steel rod base; upholstered foam rubber with wool fabric cover. Designers: Nanna and Jørgen Ditzel. Makers: Fritz Hansens Eft a/s (DENMARK). RIGHT: Garden chair in nut brown plasticised cane with natural cane bindings. Designed and made by Janine Abraham (FRANCE)

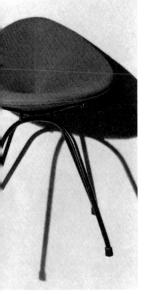

ABOVE: Cocktail stool on black metal base, tipped rubber. Steelrimmed preformed seat upholstered foam rubber with green wool fabric cover. Designer: Italo Meroni. Made by Giulio Meroni (ITALY)

BELOW LEFT: Low chair of white oxidised aluminium on chromium base. Designed and made by Janine Abraham (FRANCE). RIGHT: Garden chair with stove-enamelled tubular steel frame and Terylene cord infilling. Designed and made by Hans Jensen, at the Royal College of Art (GB)

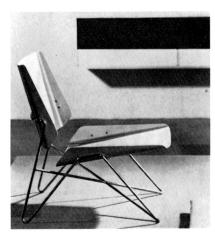

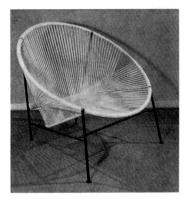

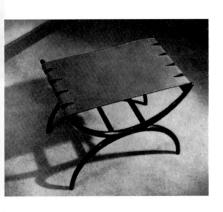

LEFT: Dressing-table stool in rosewood, with seat of saddle-stitched cowhide. Designed and made by J. R. Houghton, student at the Royal College of Art (GB). RIGHT: Moulded fibre-glass chair in a wide range of pigmented colours on stove-enamelled tubular steel legs; loose foam-rubber cushion. Designer: Aidron Duckworth. Makers: Kandya Ltd (GB)

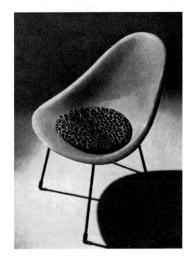

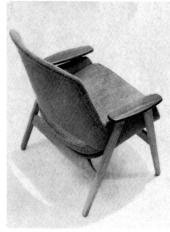

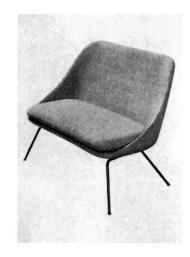

BELOW: Birch armchair with sprung seat and deep foam-rubber cushioning; upholstered green wool fabric. Designer: Olof Ottelin. Makers: O/Y Stockmann AB (FINLAND)

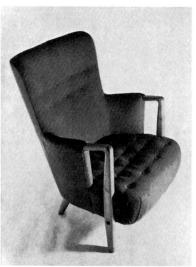

ABOVE Left: Padded chair on birch frame, loose foam-rubber cushion, wool fabric cover. I signer: Olof Ottelin. Makers: O/Y Stockmann AB (FINLAND); Right: Sitwell-sofa of upholster 'Stracolite' on steel legs. Designer: Hans Bellmann, SWB. Makers: Strässle Söhne & Compa (SWIZERLAND). BELOW Left: Covered hardwood chair, latex foam cushions; underframe eboni beech. Designers: Students Bernard Gay and B. A. North, L.C.C. College for the Furnish Trades (GB); Right: Maori hardwood frame, latex seat cushion on Rotex rubber webbing; bupholstered rubberised hair, large range of covering fabrics. Designer: Ronald E. Long, Ms. Makers: R. S. Stevens Ltd (GB)

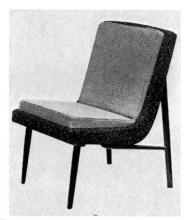

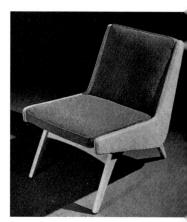

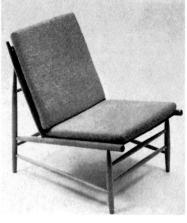

LEFT: Birch low chair with loose foam-rubber cushions covered in wool fabric. Designer: Olli Borg. Makers: Asko o/Y (FINLAND)

RIGHT: Sumburst in beech, with a wide fan back of tapering ginger-finished spokes, sprung seat. The loose foamrubber cushions are covered in Danish wool fabrics. Designed by Paul M. Volther (DENMARK), for Berge-Norman Inc. (USA)

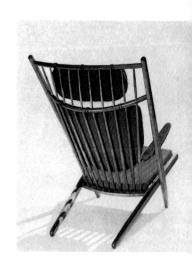

RIGHT: White beech stacking chair with padded seat; the back panel is in a natural or coloured finish. Designers and makers: Kandya Ltd (GB)

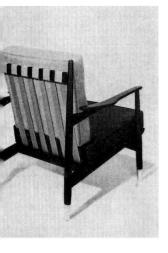

DVE: Beech armchair lacquered black, th brass-tipped legs; leather-banded t and back. The loose foam-rubber hions are covered in ribbed wool ric. Designer: Jos. De Mey. akers: 'Luxus' (BELGIUM)

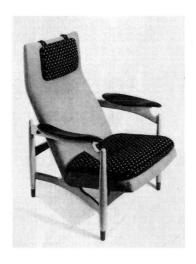

Beech armchair with teak arm-rests and feet. Upholstered grey-green wool fabric over Moltoprène on No-sag springs, with foam cushions in black-and-gold. Designer: Jos. De Mey. Makers: Van Den Berghe-Pauvers (BELGIUM)

RIGHT: Garden chair on steel frame lacquered black with laminated seat in ash or teak. Designers: Nanna and Jørgen Ditzel. Makers: Møbelfabriken Kolds Savværk

A/S (DENMARK)

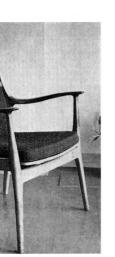

DVE: Yew frame with preformed seat d back in ash. The latex foam seat and ck cushions are covered in forest-green estry. Designed and made by David venport, student at the High Wycombe llege of Further Education (GB)

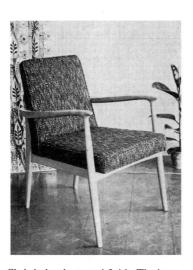

Chair in beech, natural finish. The loose foam-rubber cushions covered in deep texture wool fabric are supported on rubber webbing. Designed and made by John Strange, at the High Wycombe College of Further Education (GB)

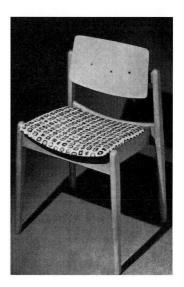

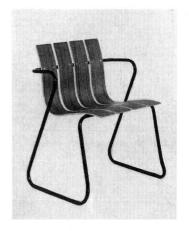

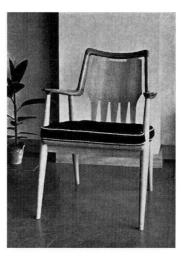

Beech and walnut frame, back of preformed ash ply. Frame seat with rubber webbing supporting latex cushions covered in black moquette. Designed and made by Colin Gibson, High Wycombe College of Further Education (GB)

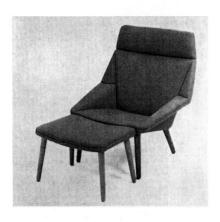

LEFT: Matching chair and stool in teak, padded foam rubber, with wool fabric cover. Designers: Nanna and Jørgen Ditzel. Makers: Søren Willadsens Møbelfabrik (DENMARK)

RIGHT: Square-built armchair upholstered in textured cotton over foam rubber on rubber webbing; ebonised beech legs. Designed by Edson Crafts, James A. and Marie Howell. Makers: Selig Manufacturing Co. (USA)

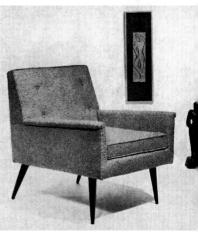

BELOW: Tubular steel frame, tip rubber; deep-textured wool fa cover over foam rubber. Desig Christa von Paleske. Makers: Wörn Werkstätten (GERMANY).

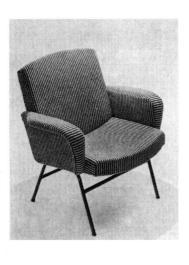

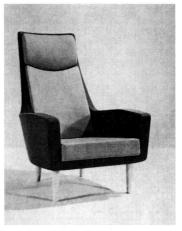

ABOVE LEFT: Armchair on black-lacquered steel base, upholstered in thick ribbed black-and-white wool fabric over foam rubber. Designer: Olli Borg. Makers: Asko o/Y (FINLAND). RIGHT: Model for wood frame construction on waxed beech legs; upholstery Aeropreen foam plastic on Pirelli rubber webbing, with removable cushions. Designed and made by Martin Grierson, LSIA. BELOW: Sculptured chair and ottoman on ebonised beech legs, with deep foam-rubber cushioning on springs; grey textured wool fabric cover. Designed by Edson Crafts, James A. and Marie Howell. Makers: Selig Manufacturing Co. (USA)

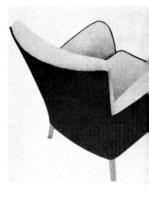

ABOVE: Beech tension-sprung tub with latex foam cushion and in upholstered in off-white tweed, ex in black mohair. Designer: F. G. (Makers: George Clark (Bristol) (GB)

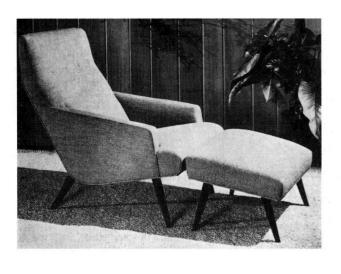

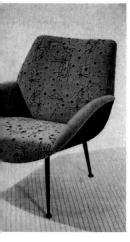

/E: Laminated beech chair on k iron legs. Upholstered foam eer and De Ploeg Rapallo and to wool fabrics. Designer: Th. l. Makers: Wagemans & Van een NV (HOLLAND)

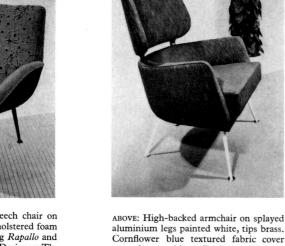

ABOVE: High-backed armchair on splayed aluminium legs painted white, tips brass. Cornflower blue textured fabric cover over foam rubber. Designer: Norman Fox MacGregor. Makers: Valley Upholstery Corporation (USA)

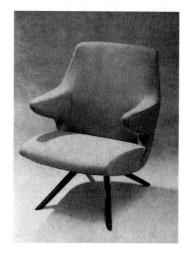

Easy chair on metal legs lacquered in graphite grey or white. No-sag springs in seat and back; seat and arms padded foam rubber, back padded fibre. Designer: Bengt Ruda. Makers: Nordiska Kompaniet A/B (SWEDEN)

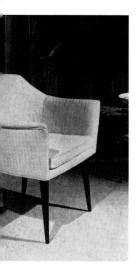

E: Armchair on ebonised h legs; upholstered foam rubover rubber webbing, with n covering fabric. Designed Edson Crafts, James A. and ie Howell. Makers: Selig ufacturing Co. (USA)

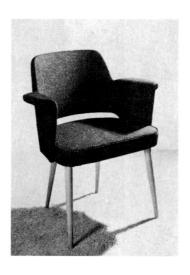

LEFT: Stafford amply-proportioned dining chair on beech or mahogany legs, upholstered latex foam over Pirelli rubber webbing. Designer: Robin Day, ARCA, FS1A. Makers: Hille of London (GB)

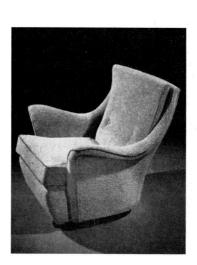

BELOW: Braemar on hardwood frame. Rubberised hair upholstery, with deep texture fabric cover in contrasting colours; latex foam seat cushion. Designer: Ronald E. Long. Makers: R. S. Stevens Ltd (GB)

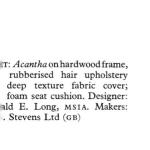

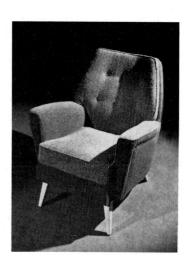

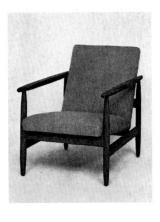

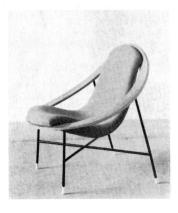

LEFT: Oak frame; seat and back upholstered in wool fabric over foam rubber. Designer: Ejvind A. Johansson. Makers: Fællesforeningen for Danmarks Brugsforeninger (DENMARK). RIGHT: Ring frame of laminated ash, or walnut/mahogany, natural finish, with suspended foam-rubber cushioned seat; stove-enamelled rubbertipped iron base. Designer: Parisi. Makers: Figli di Amedeo Cassina (ITALY)

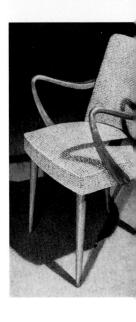

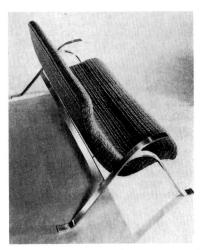

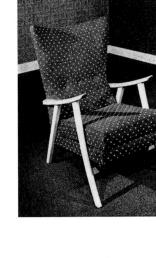

ABOVE: Desk or dining ch with solid mahogany ar and legs. The latex padd seat is upholstered in bla and white textured moquet Designer: Ronald E. Lon MSIA. Makers: R. S. Steve Ltd (GB)

holstered in tapestry or une moquette; tension sprung s with latex cushion, spru and padded back. Design and makers: Yatton Furnitt Ltd (GB)

LEFT: Beech frame, natuoak or walnut finish. U

ABOVE: Stainless steel frame; seat upholstered in deep texture Luxuratex, designed by Hugo Dreyfuss, over hair and foam rubber. Sofa designed by Vladimir Kagan, AID. Makers: Kagan-Dreyfuss Inc. (USA)

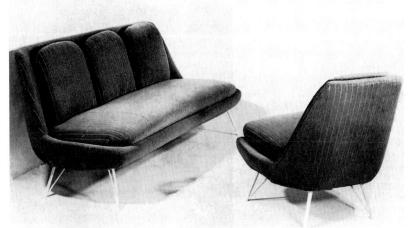

Beech sofa and chair on white-enamelled steel legs. Upholstered rubberised hair, with springs and foam-rubber padding to loose seat and back cushions. Designers and makers: Wörrlein Werkstätten (GERMANY)

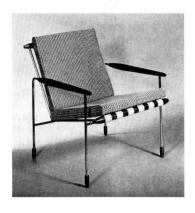

Easy chair on copper-plated rolled-steel frame, with walnut or birch turnings banded in copper or brass. Reversible foam-padded cushions. Designer: Robert Kaiser. Makers: Primavera (CANADA)

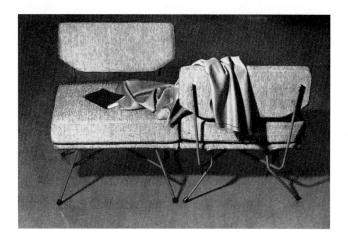

Elettra chair-settee combination on lacquered tubular metal frame with rubber-tipped ends. The foam-rubber sprung cushions have detachable covers. Designers: Belgiojoso-Peressutti-Rogers. Makers: Ar-flex (ITALY)

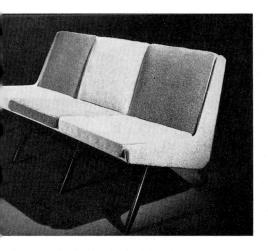

ori settee on ebonised beech legs. Back upholstered rubberised r; seat, 'Rotex' rubber webbing, with latex cushions in consting colours. Designer: Ronald E. Long, MSIA. Makers: R. S. vens Ltd (GB)

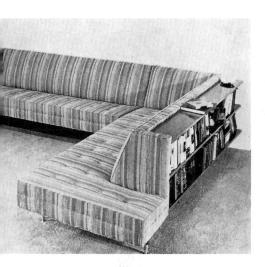

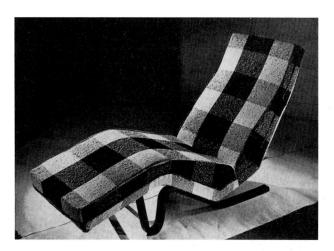

ABOVE: Chaise longue on ebonised laminated plywood (or natural beech) frame; upholstered latex foam on Pirelli webbing with cotton/rayon deeptexture cover. Designer: A. J. Milne, FSIA. For Heal's of London (GB). LEFT: Sectional settee designed as a room divider with built-in walnut bookshelves to right arm; sprung seat and deep air-foam upholstery under strié fabric cover. Designer: Norman Fox MacGregor. Makers: Valley Upholstery Corporation (USA). BELOW: Mahogany frame; seat and back padded foam rubber on No-sag springs, steel-blue wool cover. Designer: Jos. de Mey. Makers: Van Den Berghe-Pauvers (BELGIUM)

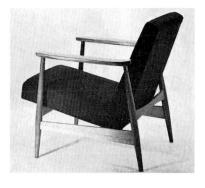

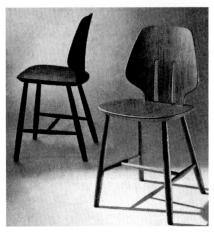

ABOVE: Dining chairs in natural or ebonised beech, or smoked oak; laminated seat and back. Designer: Ejvind A. Johansson. Makers: F. D. B. Møbler (DENMARK)

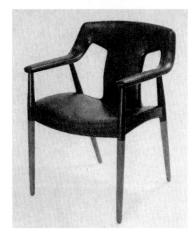

ABOVE: Teak armchair upholstered in black oxhide. Designed by A. Bender-Madsen and Ejner Larsen. Made by L. Pontoppidan (DENMARK)

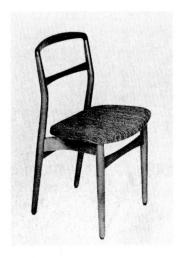

ABOVE: Laminated beech-frame bedroom chair with 'coat-hanger' back; foam rubberpadded seat, handwoven wool fabric cover. Designed and made by Sven Staaf and Lars Olson, SIR (SWEDEN)

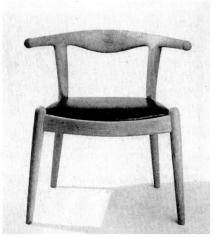

ABOVE: Broad frame natural oak chair with padded seat upholstered in black leather. Designer: Hans J. Wegner. Made by Johannes Hansen (DENMARK)

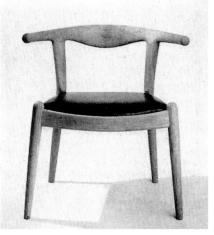

ABOVE: Windsor armchair in na beech, wax finish; latex foam cus with detachable cover. Designer: I Ercolani. Makers: Furniture Indus Ltd (GB)

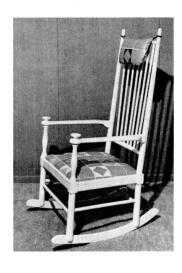

RIGHT: White hardwood rocking chair with padded seat cushion and head-rest. Designed by Karl-Axel Adolfson. For Gösta Westerberg Möbel AB (SWEDEN). FAR RIGHT: Moulded fibreglass seat on polished steel tapered legs. Available in yellow, black, turquoise, or deep blue, with wool-covered foam rubber cushion. Designed and made by Kay Kørbing (DENMARK)

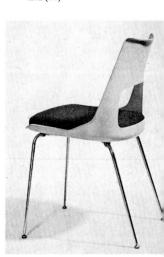

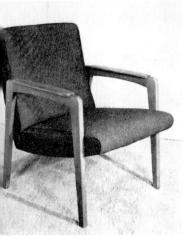

E: Red beech frame, teak armrests, mahogany, anda or ebonised finish; No-sag springs in seat back. Designer: Bengt Ruda. Makers: AB Nora Kompaniet (SWEDEN)

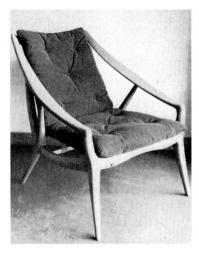

ABOVE: Oregon pine frame with corduroy kapok-stuffed cushions on rubber webbing. Designed and made by John Tucker, High Wycombe College of Further Education (GB)

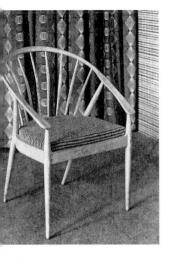

TE: Steam-bent ash frame, loose foam er cushion on tension springs. Designed made by John and James Herbert and E. ker, L.C.C. Technical College for the hishing Trades (GB)

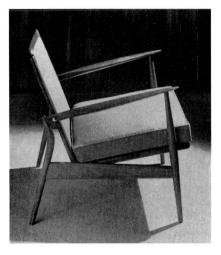

ABOVE: Walnut, saddle, or nubian finish hardwood frame with 'spear-head' armrests of African inspiration. Cane back, foam rubber seat cushion with zippered cover. Made in Denmark for Selig of Leominster (USA)

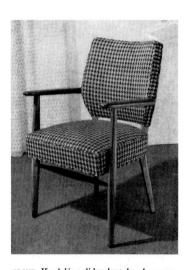

ABOVE: Kendal in solid walnut, hand-sprung seat, and padded back with rubberised-hair filling; wool tapestry cover. Designer: Laurence A. Reason. Makers: A. Reason & Sons Ltd (GB)

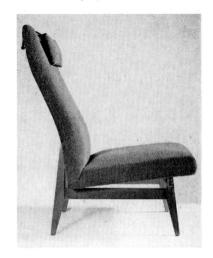

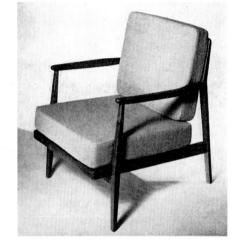

IT: High-back sewing chair in the beech. Upholstered foam rubber Pirelli webbing with wool fabric ring; the head cushion is adjust-. Designed and made by D. Mere-Ltd (GB). FAR RIGHT: Oiled walnut the with hand-woven wool fabric ris on loose foam rubber cushions. igner: Reinhold Koller. Made by Works (CANADA)

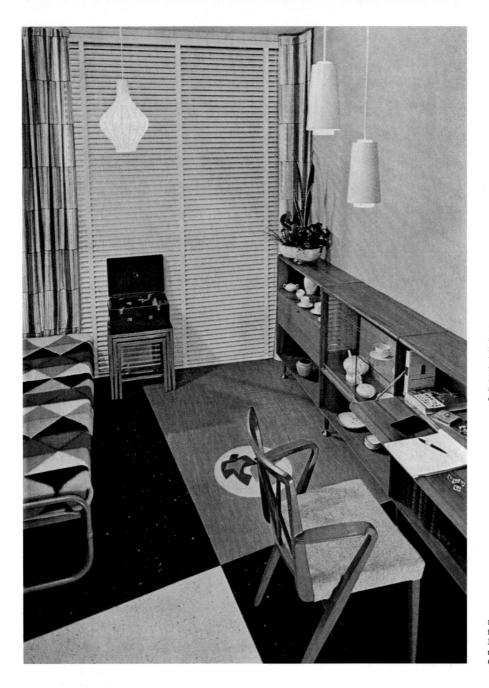

LEFT: Girl's study/bedroom in a li and fresh-looking colour scheme. furnished with 'poly-Z' link-units walnut, built up as a continuous fitting with matching chair. The in linoleum floor covering is both prac and decorative. Interior designed executed by A. A. Patijn (HOLLAND)

BELOW: Writing table in figured to framing in ash; drawer fronts face-Formica with brass pulls. Designed made by Roger Fitton, High Wyco. College of Further Education (GB)

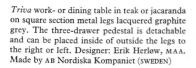

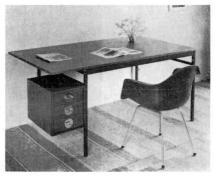

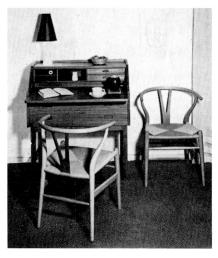

ABOVE: Secretaire in teak, designed and made by Gösta Westerberg Möbel AB (SWEDEN). The oak chairs with woven fibre seats are designed by Hans J. Wegner. Makers: Carl Hansen & Son (DENMARK)

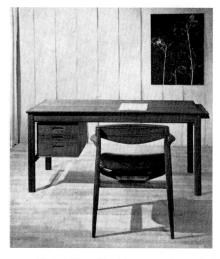

ABOVE: Teak writing table with top extensions on ball bearings; the drawers are detachable, and can also be placed at right. Designers: Tove and Edv. Kindt-Larsen. Made by Gustav Bertelsen & Co. (DENMARK)

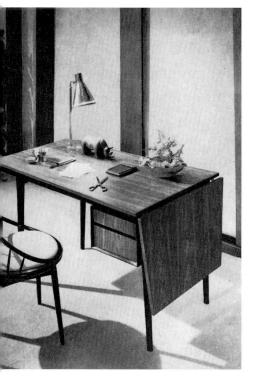

ABOVE: Drop-leaf writing desk in rosewood with oiled teak veneer; underframe and spindle-back chair in nubian (as shown), or in walnut or saddle finish. With leaf extended, the top measures 5 feet 8 inches. Made in Denmark. For Selig of Leominster (USA)

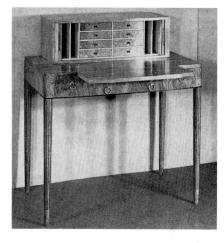

ABOVE: Writing table in English walnut and amboyna, inlaid with ebony; top cabinet fitted with a tambour shutter and pull-out top. Designed and made by Barry Warner, Leicester College of Art (GB)

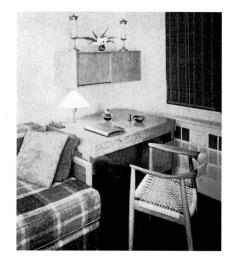

RIGHT: Corner of study, with writing desk, wall cabinet and chair in figured oak. Designed and made by Wor-de-Klee, Inc. (USA)

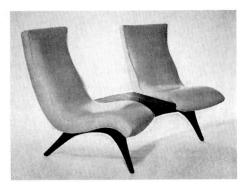

ABOVE: Contour two-seater, upholstered in white cowhide, with connecting shelf and base in walnut, oil finish. Designer: Vladimir Kagan, AID. Made by Kagan-Dreyfuss Inc. (USA)

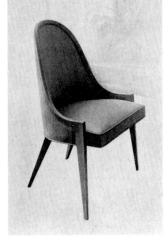

ABOVE: Occasional chair upholstered in powder blue silk; the frame is mahogany with an 'antique white' finish. Designer: Harvey Probber. Made by Harvey Probber, Inc. (USA)

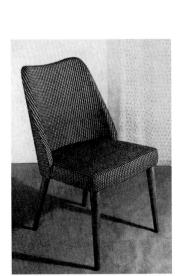

ABOVE: Kirby dining chair. Hardwood frame, upholstered wool tapestry over plastic foam on Pirelli webbing. Designer: Laurence A. Reason. Makers: A. Reason & Sons Ltd (GB)

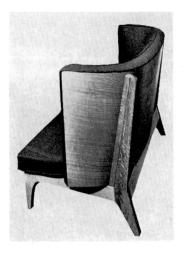

Oak settle designed to seat three for television viewing. The curved back, padded with rubberised hair, and loose Dunlopillo seat cushion are covered in Tibor *Tiara* fabric. Designed and made by Edward Baly (GB)

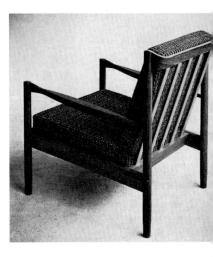

ABOVE: Rosewood armchair with loose seat and cushions of foam rubber covered in wool tapestry. signed and made by O. Tybulewicz at the Royal Colle Art (GB)

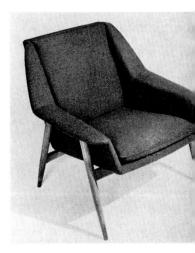

ABOVE: Menton on yew underframe. Sprung pre-fc seat with wool fabric upholstery over 'Parkertex' padded back and loose seat cushion. Designemade by Parker-Knoll Ltd (GB)

VE: Triton tension-sprung beech frame armr, natural or ebonised finish, or in walnut or ogany. Fitted with loose seat cushion in afoam rubber and upholstered in a wide e of covering fabrics over Lintafelt padding. igner: Howard B. Keith, MSIA. Made by C. Furniture Ltd (GB)

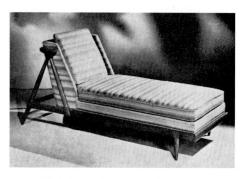

ABOVE: Chaise-longue in pecan wood, warm emberglow finish, with coil-sprung seat and foam rubber cushions; fitted muslin cover. Designed and made by Tomlinson (USA)

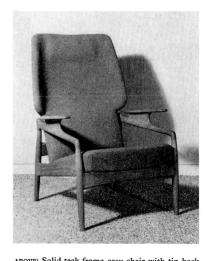

ABOVE: Solid teak frame easy chair with tip-back adjusting to the sitter's weight. Designed and made by Advance Design, Inc. (USA)

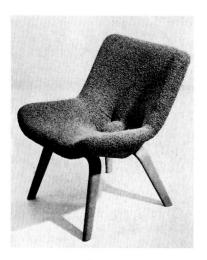

ABOVE: Foam rubber on pre-formed shape, covered handwoven wool fabric; beech legs. Designed by Hiort af Ornäs (FINLAND). For Gösta Westerberg Möbel AB (SWEDEN)

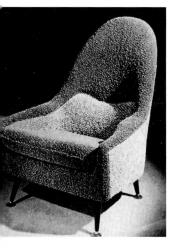

VE: Low armchair from a suite in a two-tone p texture wool fabric over rubber webbing I deep plastic foam padding, with foam rubseat cushion dove-tailed into the back. The nised beech legs are fitted with brass feres. Designed by A. J. Milne, FSIA. For al's of London (GB)

LEFT: Armchair with long Dunlopillocushioned seat; pale polished beech legs. Upholstered in black-and-white tweed, or in alternative colours; also made in hide. Designer: Michael Inchbald, MSIA, FRSA. Madé by Michael Inchbald Ltd (GB)

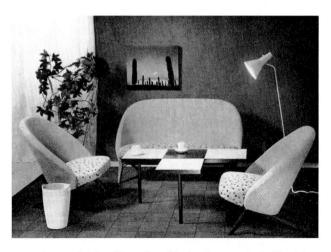

ABOVE: Settee and chairs with pre-formed back and seat on ebonised beech legs. The seat is upholstered in De Ploeg grey/black *Chicago* fabric over 'Epeda' springs; the back in grey *Livorno* over foam rubber. Designer: Th. Ruth. Made by Wagemans & Van Tuinen, NV (HOLLAND)

ABOVE: Teak open-unit bookcase for 'Pen small format books, back faced in Formi a variety of colours. Designed and mad Barry Warner, Leicester College of Art

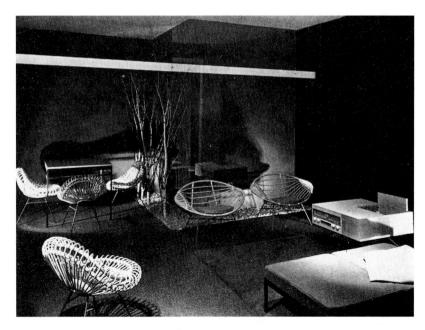

ABOVE: Cane chairs on tubular iron legs, lacquered black, with seat cushions in latex foam; ash box-table on black iron legs mounted on castors houses radio, records and record player; the interior is lined in orange Feutrine, the top surfaced in white Formica. The dining table top, surfaced in grey Formica, extends to 5 feet 6 inches; its base, and that of the studio couch, is of square section iron, lacquered black. Interior designed and executed by Janine Abraham (FRANCE)

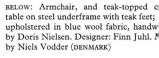

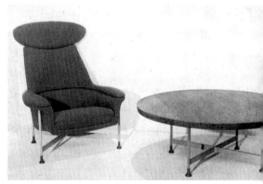

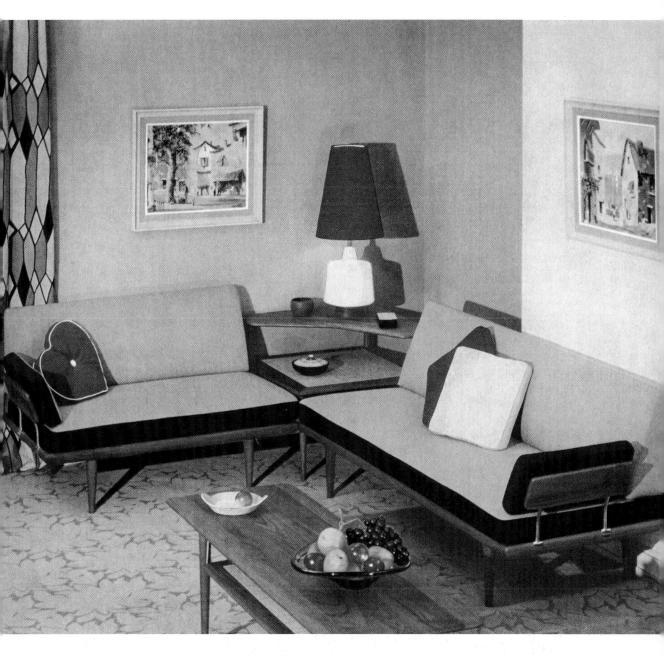

Danish oiled-teak furniture in a setting reflecting the warm tones of the wood, and enlivened by brilliant touches of scarlet. The 'bumper' settees have oose, sprung seat and back cushions, and the armrests can be placed at either end; they are thus adaptable to a variety of seating arrangements. Interior designed and furnished by Harrods of London (GB)

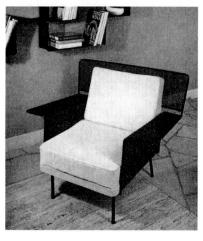

ABOVE: Stretched perforated-metal armchair, lacquered black, on black iron frame; Dunlopillo seat and back cushions. Designed and made by Société Matégot (FRANCE)

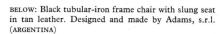

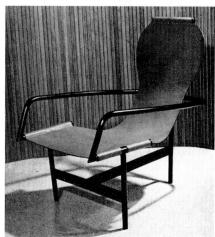

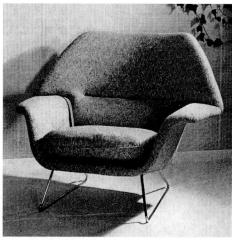

ABOVE: H-W-H chair of generous proportions. Wool fabric covering over preformed Latex foam padded seat and tapered cushion; chrome metal underframe. Designed by Robin Day, ARCA, FSIA. For Hille of London (GB)

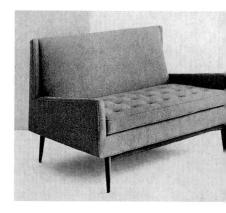

ABOVE: Loveseat covered in close-woven finely tex fabric over foam-padded frame, with loose foam rubbe cushion on flat springs; walnut base. Designers: Jam and Marie Howell. Makers: Design Previews Inc. (US.

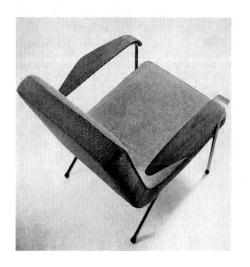

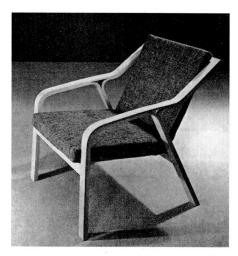

FAR LEFT: Tubular steel frame free-swinging back and shaped armrests. Upholstered rough-te wool fabric over Latex foam. signed and made by A. A. J. (HOLLAND). LEFT: Laminated frame, cotton-covered metal suspension, and loose Latex cushions with zippered covers signed by P. Guariche, M. M. and J. A. Motte. Made by Steiner (FRANCE)

IT: Laminated beech chair (legs exed in thirty-eight layers). Also made solid teak seat and teak finish to legs. gner: Arne Jacobsen, MAA. Made "ritz Hansens Eft A/S (DENMARK)

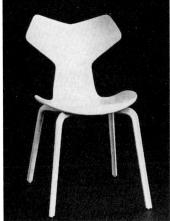

w: Laminated birch seat and back;
birch underframe with walnut
h. Designed and made by M.
mentowska, at the Warsaw Institute
ndustrial Design (POLAND)

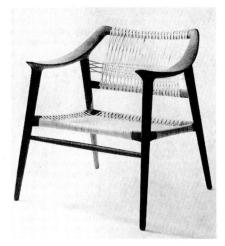

ABOVE: Teak frame armchair, woven wicker seat and back. Designed and made by Rastad og Relling (NORWAY)

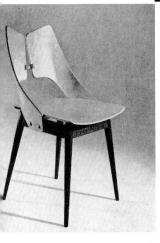

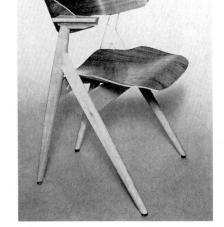

ABOVE: Imperial Contemporary chair in yellow birch; solid birch legs, moulded seat and back with walnut veneer, or other finish. Designer: Jan Kuypers, ACID. Made by the Imperial Furniture Mfg. Co. Ltd (CANADA)

ABOVE: Pearwood dining chair, bright black ebony veneer; seat cushion covered in grey fabric handwoven by Hélène Henry. Chair designed and made by Max Ingrand (FRANCE)

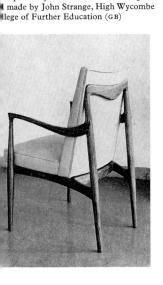

ow: Rosewood dining chair, 'handle'

k of preformed ply or framed up; beige

e upholstery over foam rubber. Designed

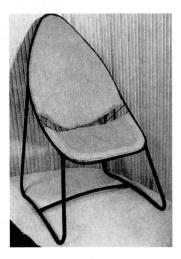

LEFT: Tubular-iron frame chair, stoveenamelled black, iron mesh seat and Latex foam cushions with removable linen covers. Designed and made by M. Baugniet (BELGIUM) RIGHT: Coffee table in walnut, mahogany, or oak, oil finish. The tray leaf is faced with Formica material; with ends extended, top measures 6 feet 8 inches. Designer: K. Stonor Poulsen. Made by Scandia Furniture Reg'd (CANADA)

BELOW: Beech table and 'knock-down' chairs, transparent lacquer finish. The table top is in hardboard with Hornitex or Resopal surface; the chair seats, upholstered in Moltopren with washable plastic covering, are easily removable for cleaning. Designed and made by Josef Theisen, OHG (GERMANY)

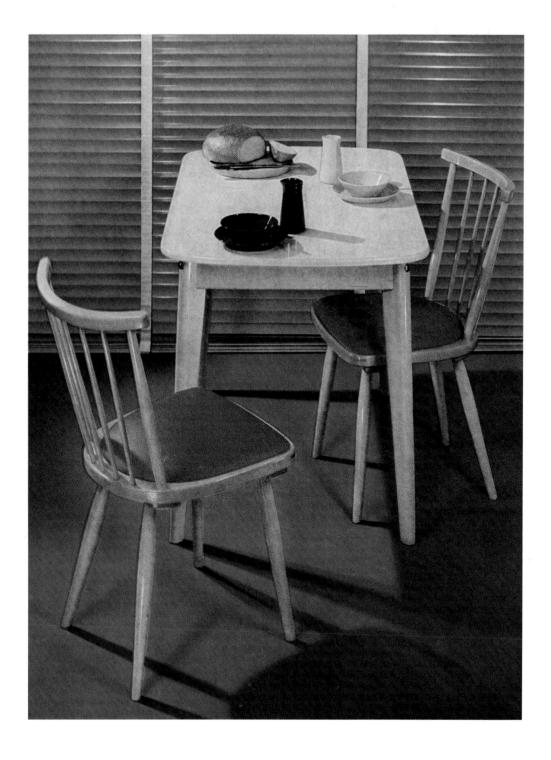

ABOVE: Oak frame settee with rubberwebbing seat and detachable metal legs; the Latex foam cushions are reversible. Designer: Herbert Yates. Made by Herbert Yates Group Ltd (GB)

LEFT: Armchair on oil finish walnut base; 'No-sag' springs and Latex foam upholstery with striped wool fabric cover in blues, greens, and purples. Designers: James A. & Marie Howell. Made by Design Previews Inc. (USA)

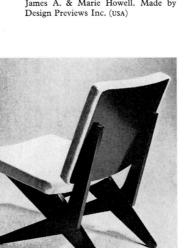

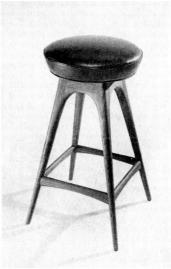

ABOVE: Oiled teak bar stool on sculptured legs; sprung cushion upholstered in black leather. Designer: Vladimir Kagan, AID. Made by Kagan-Dreyfuss, Inc. (USA)

ABOVE: Black-lacquered birch chair with reversible foam rubber cushions covered in plain wool fabric. Designer: Grunsven. Made by NV Ums-Pastoe (HOL-LAND). BELOW: Convertible armchair/bed with fold-down back and slide-out base. Walnut finish birch frame, red/black wool repp covers over sprung cushions and base. Designed and made by M. Chomentowska, Warsaw Institute of Industrial Design (POLAND)

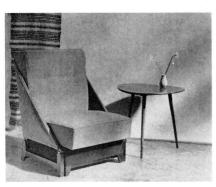

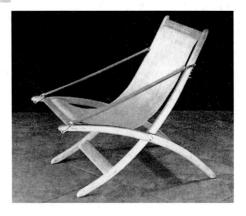

ABOVE: Folding chair in oak with canvas seat and adjustable leather straps. Designer: Professor Ole Wanscher. Handmade by A. J. Iversen (DENMARK)

RIGHT: Teak cabinet with brass hinges, and matching five-drawer chest of the same height. Width of cabinet: 4 feet 6 inches. Designer: Børge Mogensen. Made by P. Lauritsen & Son (DENMARK)

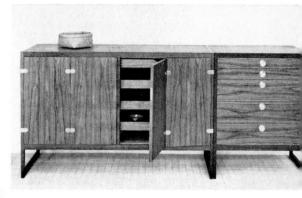

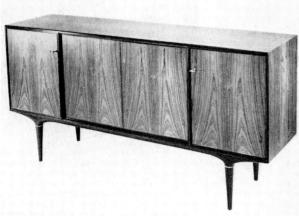

ABOVE: Cortina Rio-jacaranda cabinet, plastic lacquer finish; base and front framing in dark-stained beech. Designer: Svante Skogh, SIR. Made by Seffle Möbelfabrik AB (SWEDEN)

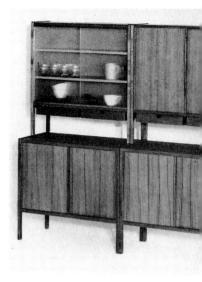

ABOVE: Combination cabinets in teak an beech from the *Librett* multiple-unit series signer: Bertil Fridhagen, STR. Made bl Svenska Möbelfabrikerna (SWEDEN)

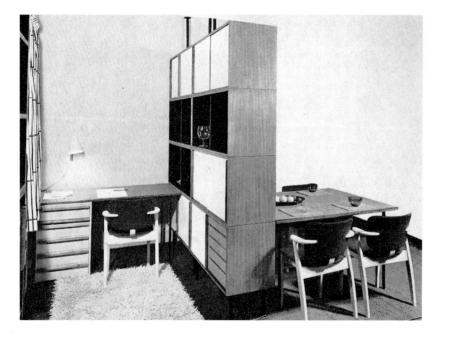

LEFT: Sectional cupboard unit in oiled te black tubular metal frame, with sliding do white and black hardboard; teak desk and d table. Designer: Lea Nevanlinna. The c in white-painted birch with padded seat back covered in black wool fabric, are by I Tapiovaara. For TE-MA O/Y (FINLAND)

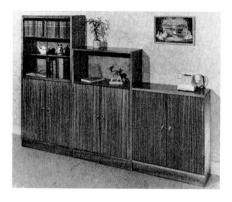

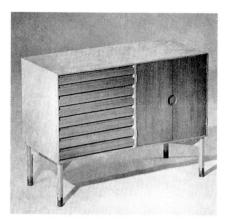

ABOVE: Unit cabinet in oak; drawers, and doors of cupboard section faced in teak. Designer: Åage Herman Olsen. Made by Thysen Nielsen (DENMARK)

LEFT: Bookcase units in oak, mahogany, or walnut; dark, medium and natural finishes. Designer: Neil Morris. Made by Morris of Glasgow (GB)

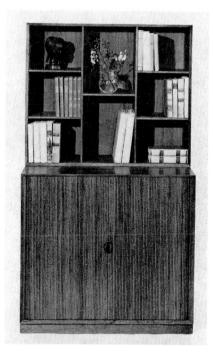

ABOVE: Bookcase in teak, part of a unit series. Designers: Peter Hvidt and O. Mølgaard Nielsen. Made by Søborg Møbelfabrik A/S (DENMARK)

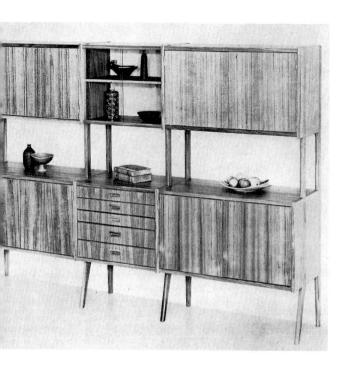

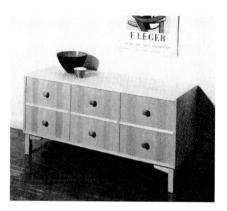

ABOVE: Six-drawer cabinet in pine. Designed by T. Kempe. Made by Waggeryd AB. For Gösta Westerberg Möbel AB (SWEDEN)

LEFT: Teak combination unit with movable cabinets and shelves designed for variable arrangement. Made by AB Skaraborgs Möbelindustri (SWEDEN)

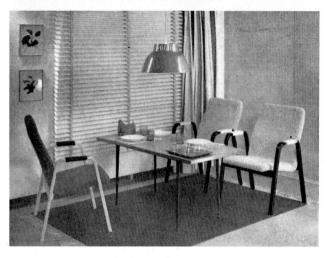

ABOVE: Columna laminated birch dining chairs, lacquered black or other colours; contrast upholstery over foam rubber. Designer: Ilmari Lappalainen. Made by Asko O/Y (FINLAND)

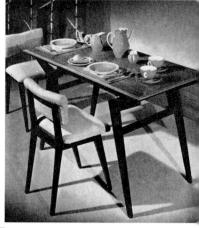

ABOVE: Two-height table, dining or occasional; tops mahogany, walnut or veneers; legs and underframe rosew or beech finish. Matching chairs upholst in a wide variety of covering fab Designed by Christopher Heal, FSIA. Heal's of London (GB)

RIGHT: Walnut finish dining suite on bl lacquered legs; chairs upholstered in T Henley fabric. On the right a matof Librenza unit, and sprung settee and a chair with Latex foam cushions. Desig and made by E. Gomme Ltd (GB)

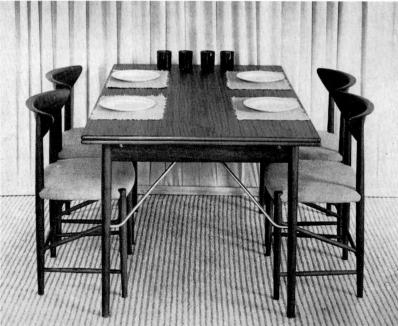

ABOVE: Dining group in teak. The under leaf of the table pushes out on pivoting rods, extending the top to 7 feet 10 inches. Designers: Peter Hvidt and O. Mølgaard Nielsen. Made by Søborg Møbelfabrik (DENMARK)

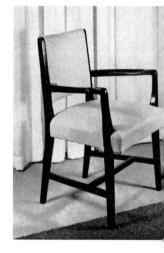

RIGHT: Dining chair in mahogany or other hard wood, ebonised or natural finish. Webbed and sprung seat covered in a wide choice of fabrics, or upholstered in leather. Designed and made by Trollopes of London (GB)

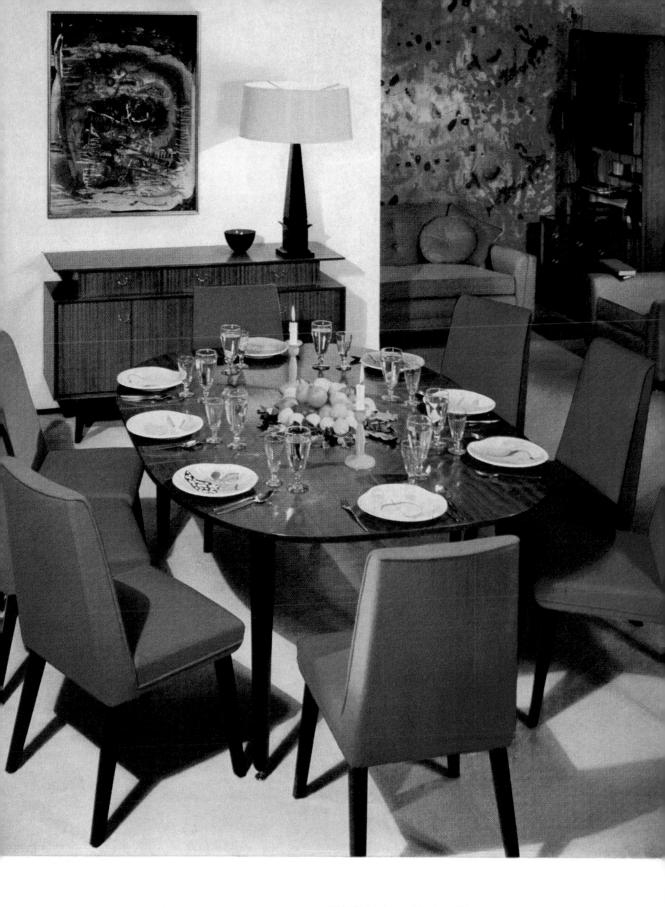

RIGHT: Teak plant table with interchangeable decorated tile top and space for alternative types of plant container. Designed and made by Bernard North and Michael Butterworth, L.C.C. Technical College for the Furnishing Trades (GB)

LEFT: Birch table and laminated chairs, light and dark finish, on steel tube legs. Designer: Hans Bellman. Made by AG Möbelfabrik Horgen-Glarus (SWITZERLAND)

RIGHT: Nesting tables on beech legs, rosewood or ebony top with heat-resistant finish. Designed and made by Edward Baly (GB)

BELOW: Egg-shaped occasional table in oak, walnut or teak. Designed and made by D. Meredew Ltd (GB)

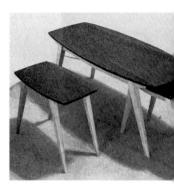

ABOVE: Coffee table, grey and white tiled top set in a mahogany frame; black hardwood base. Designer: John Crichton. Made by R. H. Saunderson (NEW ZEALAND)

ABOVE: Prototype model of work- or dirtable in ash, top stained black, with bittings. The legs are adjustable to five diffeheights, or fold flat for storage. Designed Arne Karlsen (DENMARK)

LEFT: Birch table, coloured linen unders. The height can be lowered by swinging the over to the longer arm of the axis, with be shelf reversed to right. Designed and made M. Chomentowska, Warsaw Institute of Inctrial Design (POLAND)

ABOVE: Occasional table, tray top in oil-finished teak or American walnut on black-lacquered tapered legs. Designed by Fritz Hansens Eft. A/S. For Raymor (USA)

RIGHT: Glass-topped occasional table with woven cane shelf; carved base in teak, palissander, or other woods. Designed by Tove and Edv. Kindt-Larsen. Made by Gustav Bertelsen & Co. (DENMARK)

below: Teak dining table, legs smoked oak; top extends to $3\frac{1}{4}$ yards. Designer: Hans J. Wegner. Made by Andr. Tuck (DENMARK)

HT: Glass-topped coffee table on walnut, birch, or mahogany legs; iron, is, or copper stretchers. Designer: Robert Kaiser. Made by Primavera NADA). BELOW: Occasional table on carved peteribi base, double glass top. igned and made by Adams, s.r.l. (ARGENTINA)

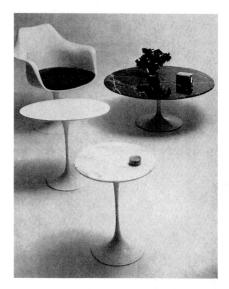

ABOVE: Pedestal tables, metal base, white, grey, or charcoal fused-on colour; white plastic laminate, walnut veneer, or marble top. Moulded plastic/fibreglass chair on cast aluminium base in correlated colours. Designed and made by Knoll Associates, Inc. (USA)

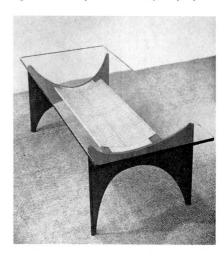

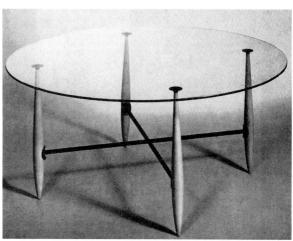

LEFT: Chest-of-drawers in cherrywood. The pivoting brass bow handles are partially plastic covered and fit into a routed recess in the drawer fronts. Designed and made by M. S. Wason at the Royal College of Art (GB)

BELOW: Bedstead in smoked oak with boxed-in sprung mattress; rail ends. Designer Hans J. Wegner. Made by Ry Møbler (DENMARK)

ABOVE: G-plan chest-of-drawers in natural oak, front lacquered Chinese white, with brass pulls. The adjustable brass feet to the black-lacquered base enable its height to be varied. Designed and made by E. Gomme Ltd (GB)

BELOW: Pedestal dressing table in mahogany; drawer fronts veneered fiddle ash with white china knobs. The right wing of the triple mirror is on a separate swivel for close make-up. Designed by Robert Heritage, MSIA. For Heal's of London (GB)

ABOVE: Poudreuse with twin adjustable mirrors and pivoting plastic-faced cosmetic trays. Handmade in solid niove and olive ash veneers; satin brass metalwork. Designer: Nigel Walters, MS1A. For Heal's of London (GB)

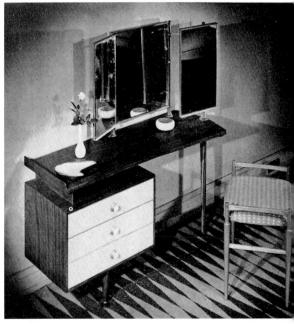

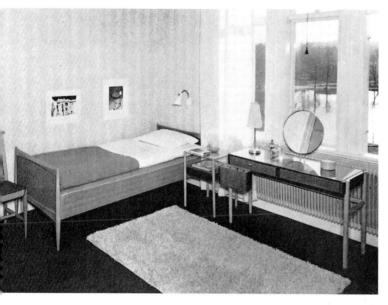

ABOVE: Combined dressing table and chest-of-drawers in teak and rosewood; brass pulls, interior lined sycamore; top fitted with movable trays and pull-out shelf. Designed and made by Barry Warner, Leicester College of Art (GB)

ABOVE: Red beech *Bodabed* with deep spring mattress, ends panelled in Galon vinyl plastic; teak and red beech glass-topped bedside table and dressing table with pivoting cosmetic compartment; red beech 'hanger-back' chair. Designer: Bertil Fridhagen, SIR. Makers: AB Svenska Möbelfabrikerna (SWEDEN)

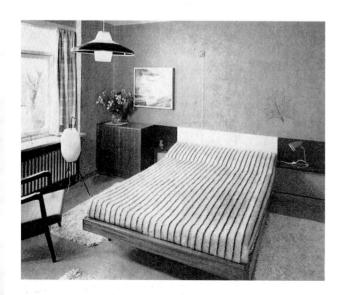

ABOVE: Bedroom furnished in acajou sapele, bedhead in light grey leather and black Formica, with matching bedcover. End wall dark violet; beige linoleum and 'thumbletweed' light grey rugs cover the floor; armchair upholstered in yellow. Designer: Jos. de Mey. Furniture made by Van Den Berghe-Pauvers (BEIGIUM)

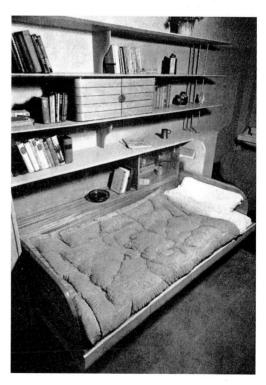

ABOVE: Bed-sitting room with space-saving folding bed unit in pale green Japanese lacquer. It swings up to the level of the first bookshelf when closed, thus becoming part of the wall fitment. Bookshelves are in pearwood on brass rod supports. Designed and made by F. M. Gross, FSIA, FRSA (GB)

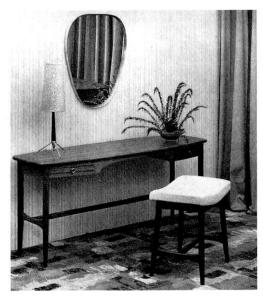

Dressing table and stool in sapele; the stool has a fitted foam rubber cushion. Designer: J. H. Tabraham. Made by D. S. Vorster & Co. (Pty) Ltd (SOUTH AFRICA)

BELOW: Cabinet-made dining table and sideboard in solid mahogany, clear cellulose lacquer finish, dulled and waxed. The sideboard is 5 feet 9 inches wide and has end cupboards fitted with adjustable shelves. The doors are made of small matched V-jointed panels, flush-mounted with the drawer fronts. The middle rail forms both drawer pull and cupboard handle. Designed and made by Robin Nance (GB)

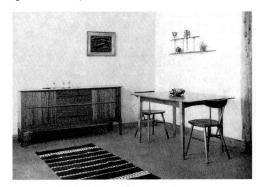

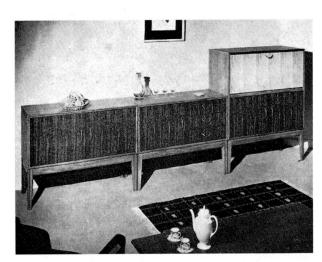

Cabinets in teak solid and veneer, doors and drawers veneered Indian laurel. The end cabinet, fitted either as a bureau or for cocktails, has a fall-front veneered Prima Vera; top surfaces in heat-resistant clear lacquer finish; handles in stainless steel. Designer: W. H. Russell, FSIA. Makers: Gordon Russell Ltd (GB)

Hallway with curved sapele staircase rising between whiteplastered and sapele-panelled walls; the treads are faced black lino and edged in aluminium. The light-beech chairs are upholstered in grey-green fabric over foam cushioning. Designer: Jos. De Mey. Executed by Van den Berghe-Pauvers (Belgium)

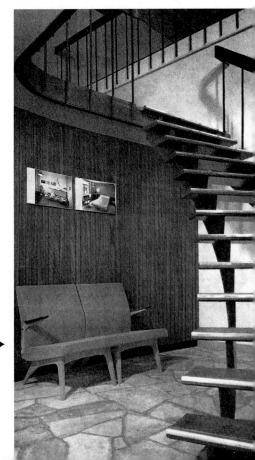

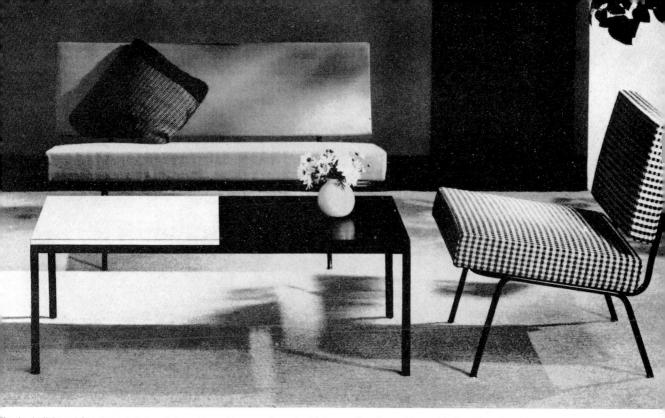

Steel-tube light-weight settee and chair, upholstered in a wide range of covering fabrics over deep foam-rubber cushioning. The coffee table, designed in proportion, is on a Tee-section steel frame with laminated plastic, teak or walnut veneered top. Designer: Florence Knoll. Made by Knoll International Ltd (USA/GB)

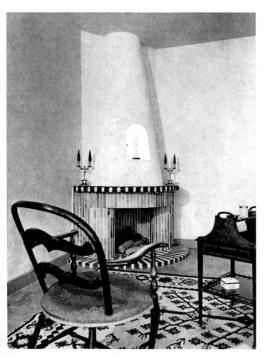

Corner fireplace in multicolour brick with curved hearth and mantelshelf in $t\hat{e}te$ -de- $n\hat{e}gre$ and white brick. Designed and executed by Jean Royère and Yves de Parcevaux (FRANCE)

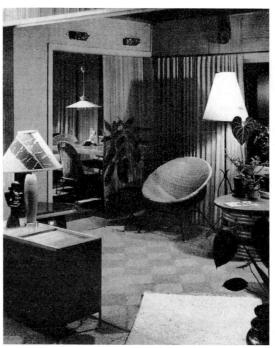

A restful sunroom with walls of treated Weltex wood and peacockblue Japanese strawcloth; seagrass/rattan woven curtains; teak and cane furniture. Designer: John Crichton (NEW ZEALAND)

- I Lounge group in solid teak: table model No. 531, and chair No. 137 with foam padded seat and back rest upholstered in Thai silk; a wide range of covering fabrics is available. Designer: Finn Juhl, m.a.a. Makers: France & Son A/S (DENMARK)
- 2 Lounge group No. 115 from the Artifort range: foam-pad laminated shell on hardwood legs, with white cotton felt metaflex spring-unit cushion, upholstered in Rapallo Stalakite wool covering fabrics. Designer: Theo R Makers: Wagemans & Van Tuinen NV (HOLLAND)

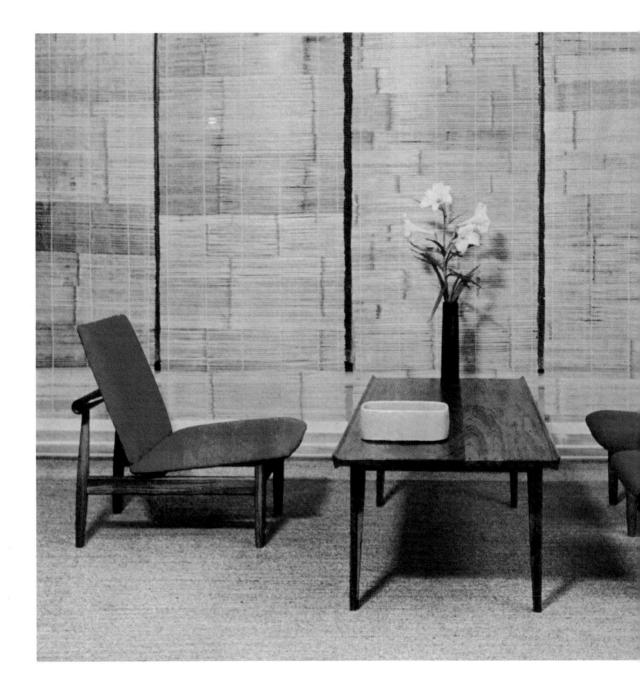

3 Built-in lounge bar in polished brass decorated with panel prints of botanical subjects in colours chosen to match the colour scheme of the room. Interior designed and executed by Ets. Vanderborght Freres SA (BELGIUM)

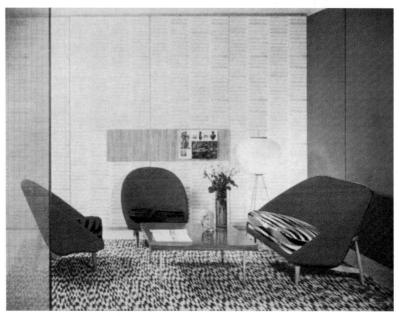

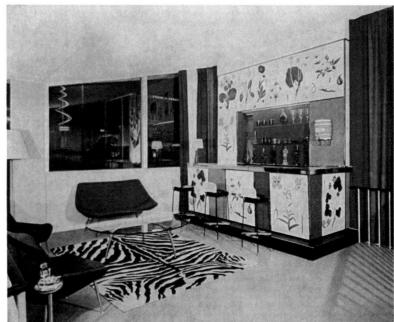

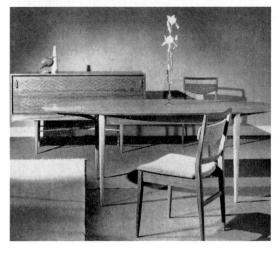

Dining group in mahogany with muninga veneers. The table top extends to 6 feet 8 inches, with the leaves folding back under the top when not in use. The side-board has flush-closing sliding doors with brass handles; interior fitted two drawers in addition to storage space. Designer: Robert Heritage, MSIA. Made by Heal's of London (GB)

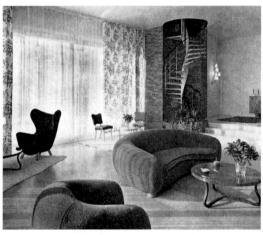

Living-room of a country house near Paris. White Comblanchien stone floor, walls cream-painted and multicolour brickwork. The curved settee and chair are upholstered in red plush velvet, wing chair in black; low tables are marble-topped on black wrought-iron base. The spiral stair is in white-lacquered metal with unpolished glass treads; window curtains white, patterned in tones of green.

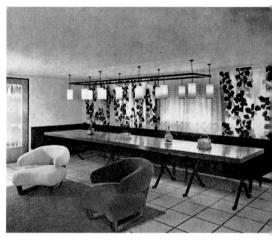

Basement room in the same house, furnished for shooting particle White ceramic-tile floor quartered in nigger-black; white chin curtains with a two-tone green design by Paule Marrot; black wrough iron table surfaced in red Formica. Chairs in yellow and in taupe ribbo velvet; carpet garnet-red. Architect: A. Bernard. Furniture a fittings by Jean Royère (FRANCE)

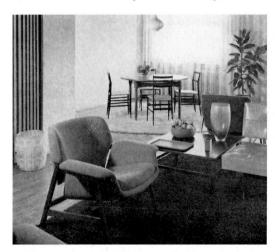

Living-room with dining corner. Low-slung foam-padded armchair on walnut frame; low walnut table with reversible top (one side faced black matt Formica); dining table in Mansonia walnut. Designer: Gianfranco Frattini. The ebony finish dining chairs are by Gio Ponti. Furniture made by Figli di Amedeo Cassina (ITALY)

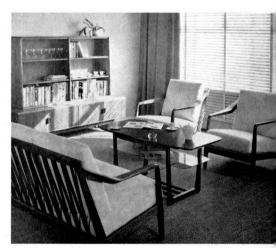

Living room furnished in walnut with loose well-padded foam-rubb cushions to settee and armchairs; these are fitted with removab covers. The low coffee table has a glass undershelf for magazine Designer: A. A. Patijn. Furniture made by Meubelfabriek Zijlst (HOLLAND)

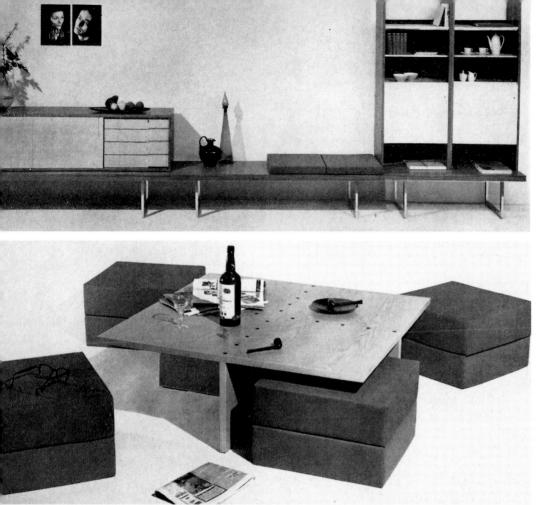

Group of bench units in nutwood on chrome steel base, with ashfronted matching chest and bookshelves. Designed and made by Wörrlein Werkstätten (GERMANY)

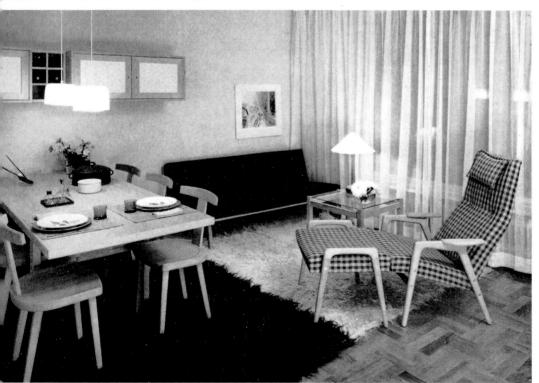

Low table, 3 feet 4 inches square in teak, rosewood or ash with ebony dowels; hassocks upholstered in nylon foam with removable cotton covers. Designed for TV or informal entertaining by Axel Thygesen. Made by Interna (DENMARK)

Living room furnished in oak: the dining table and chairs are designed by Olavi Hänninen, sofa and glass-topped table by Hiort af Ornäs (FIN-LAND); the lounge chair and stool are by Yngve Ekström of Sweden. The wall cabinets with plaited-cane fronts are designed by Evy Westerberg-Levander. For Gösta Westerberg AB (SWEDEN)

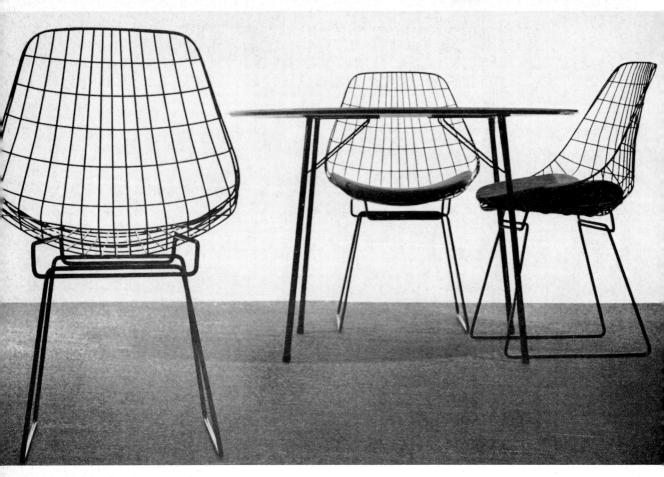

ABOVE: Wire and steel rod basket chairs, white or black fin cushions in moulded rubberised hair and foam plastic. Desig by Braakman & Dekker. Made by NV Ums-Pastoe (HOLLAND)

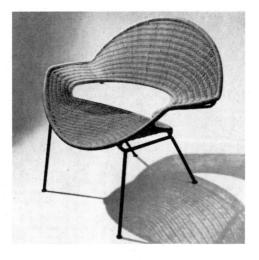

■ College chair on black metal frame with woven cane elliptical and back. Designed by Frank Watkins. Made by Finmar Ltd (

Cabinet made chair in teak; nylon cord seat, back, and armre Designed by H. Vestergaard Jensen. Made by Peder Peder (DENMARK)

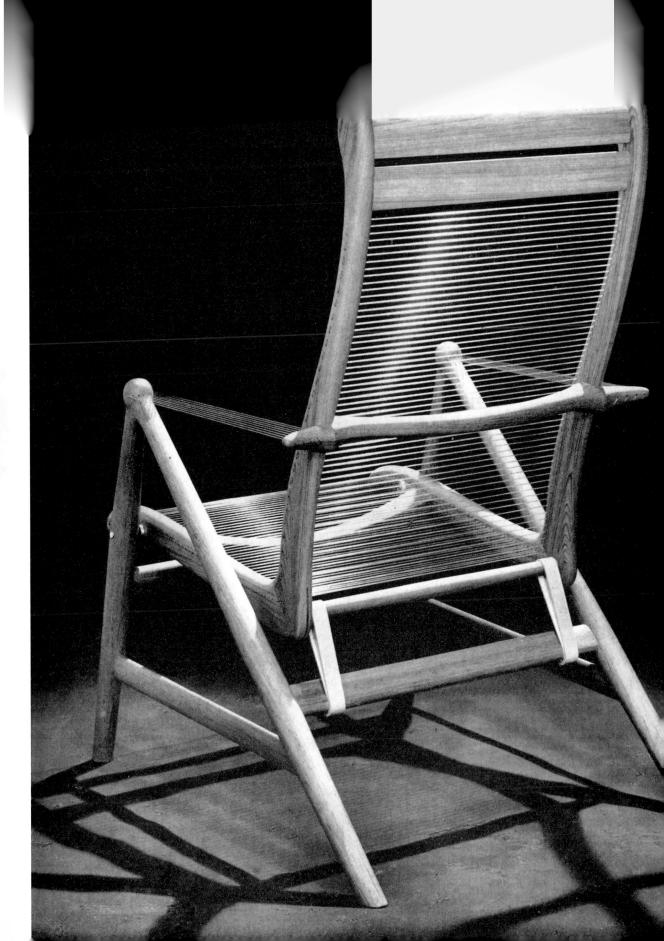

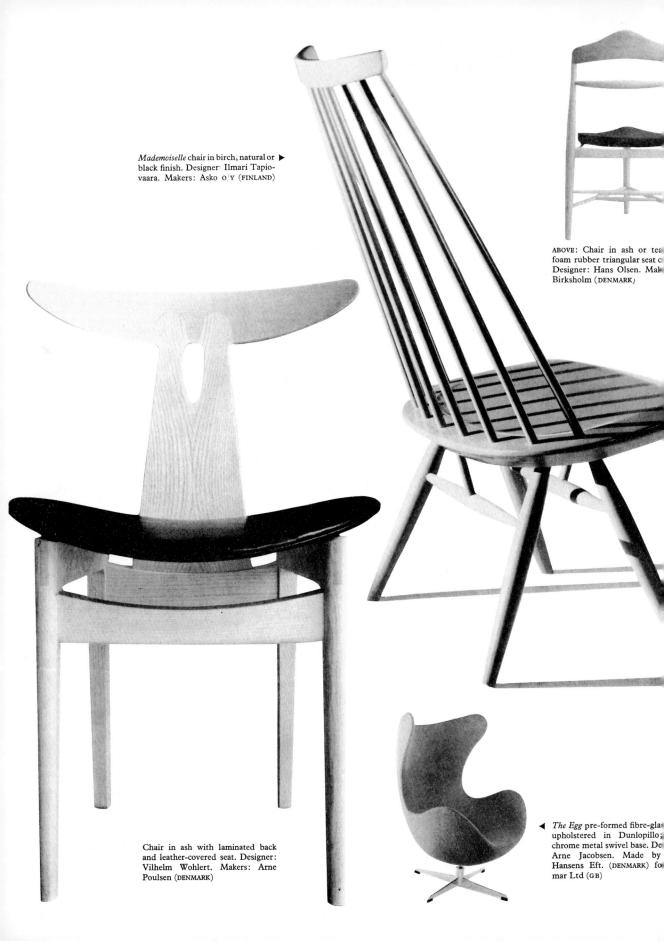

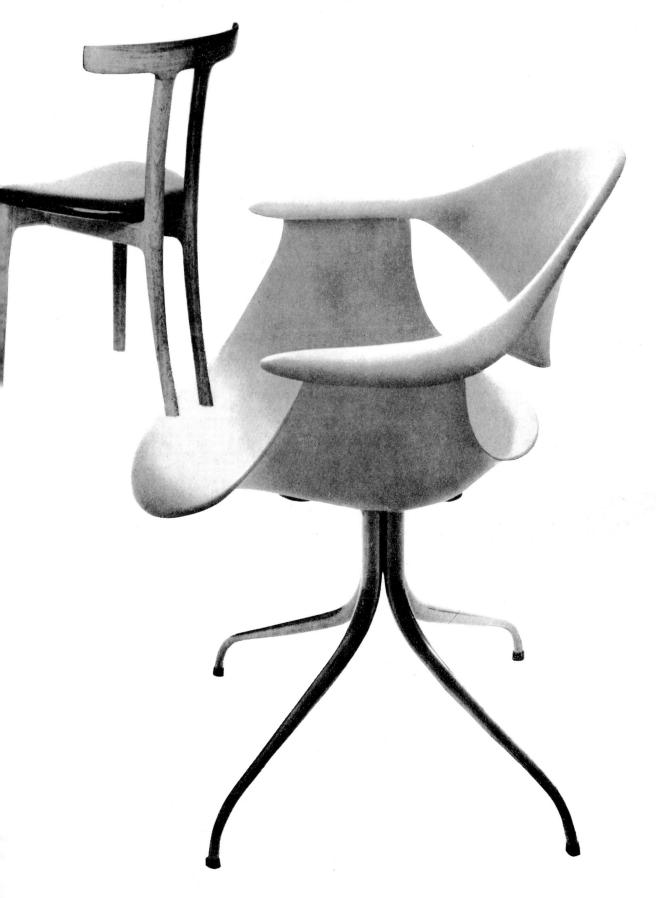

RIGHT: Beech armchair upholstered in latex foam and plastic foam. Designed and made by Brian Dollemore, High Wycombe College of Further Education (GB)

FAR RIGHT: Beech chair with moulded seat and back rest. Designed and made by Zdizisław Wrøblewski, Warsaw Institute of Industrial Design (POLAND)

RIGHT: Steel-tube chair, up-holstered in dark grey and yellow wool fabrics over foam rubber. Designed by R. & E. Gooværts-Kruithof. Made by S. A. Gobert (BELGIUM)

FAR RIGHT: Armchair in beech, legs tipped teak; preformed seat, upholstered foam rubber and wool covering fabric, with loose foam cushion. Designer: Björn Engö. Made by Möre Stolfabrik A/S (NORWAY)

RIGHT: Side chair, angle-section steel frame, foam rubber seat and back cushions. Designer: C. S. Noxon. Made by Metalsmiths Co. Ltd (CANADA)

FAR RIGHT: Chair made in birch or teak, clear resin finish; with moulded plywood back; hairlock seat cushion. Designed by members of the Tokyo Industrial Arts Institute (JAPAN)

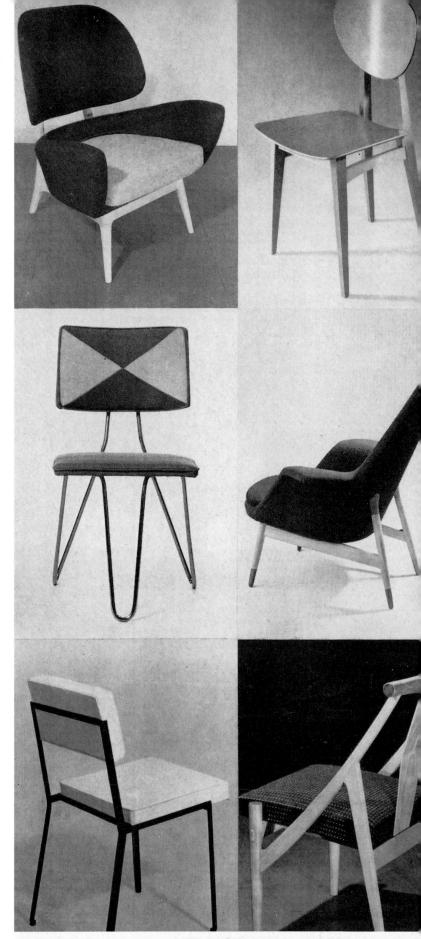

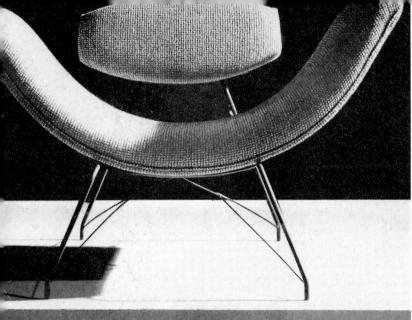

Reversible chair, iron-tube and wire frame construction; up-holstered in hand-woven fabric over foam rubber. Designer: Martin Eisler. Makers: Forma (ITALY/BRAZIL)

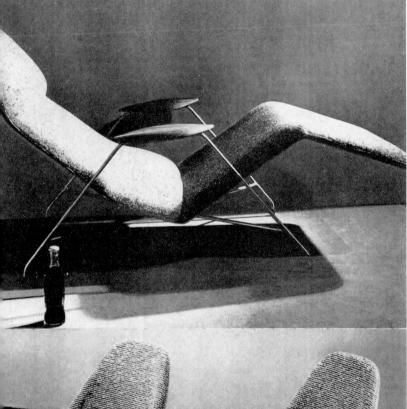

Tube-iron and wire frame easy chair with carved wood arm-rests; upholstered in handwoven fabrics over foam rubber. Designer: Carlo Hauner. Makers: Forma (ITALY/BRAZIL)

Side chair, steel-tube frame, upholstered foam rubber and tweed covering fabric; an alternative model has arm-rests in cherrywood. Designed and made by Wörrlein-Werkstätten (GERMANY)

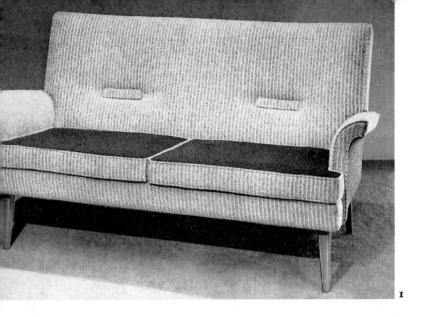

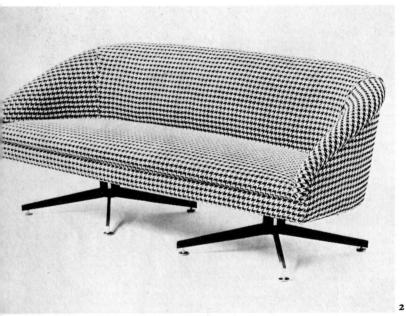

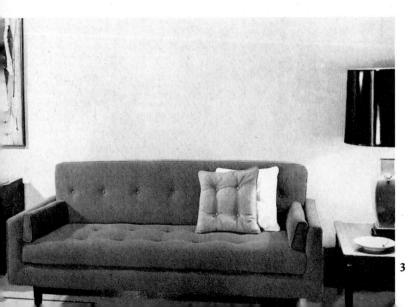

Side chair. Fibreglass shell, upholstered Dunlopillo; metal underframe, finished eggshell black or satin chrome. Made by Conran & Company Ltd (GB)

Armchair in teak with laminated arm rests; foampadded seat and back. Designer: Finn Juhl, m.a.a. Made by Bovirke (DENMARK)

- Tuan beech frame settee; back upholstered preformed rubberised hair on springs, seat tension-sprung with foam rubber cushions. Available in a wide range of covering fabrics and in three sizes. Designer: Howard B. Keith. Makers: H. K. Furniture Ltd (GB)
- 2 Six-foot wide ash frame settee; upholstered foam rubber with 'no-sag' springs in back, and hair and coil-sprung seat; satin aluminium dual base with stainless steel adjustable glide feet. Designer: Ward Bennett. Makers: Lehigh Furniture Corporation (USA)
- 3 G-plan three-seater setee on black-lacquered legs with brass feet. Hardwood shell upholstered in wool fabric over foam rubber; foam rubber sprung seat cushion, and fitted elbow rests. Made by E. Gomme Ltd (GB)

Cane frame chair with woven cane base and deep seat; foam rubber cushion. Designed by Erik Andersen and Palle Petersen. Made by Bovirke (DENMARK)

BELOW: Liege cherrywood daybed, reversible cushions upholstered foam rubber on feather base with yellow, blue and red wool fabric covers. Made by Wörrlein Werkstätten (GERMANY)

Large Eve foam padded plastic shell chair on red-beech legs; 'no-sag' springs in seat. Designer: Kerstin Hörlin-Holmqvist. Makers; AB Nordiska Kompaniet (SWEDEN)

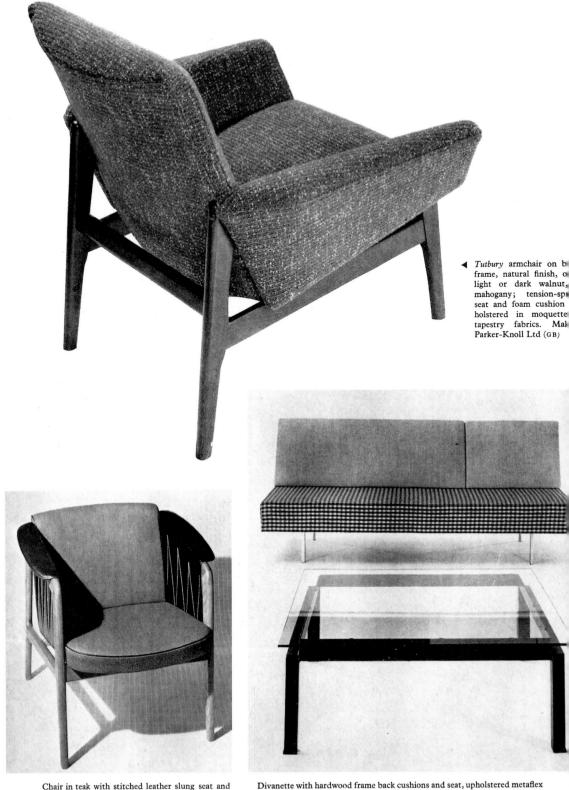

Chair in teak with stitched leather slung seat and foam-padded seat and back cushions. Designer: Björn Engö. Makers: Möre Stolfabrik A/S (NORWAY)

Divanette with nardwood frame back cushions and seat, uphoistered metaliex spring-unit, white cottonfelt and foam rubber with De Ploeg Bolivia covering fabrics; oval chrome metal tube legs with plastic caps. Designed by Theo Ruth and Kho Liang Ie; the latter also designed the glass-topped black-lacquered metal table. Made by Wagemans & van Tuinen NV (HOLLAND)

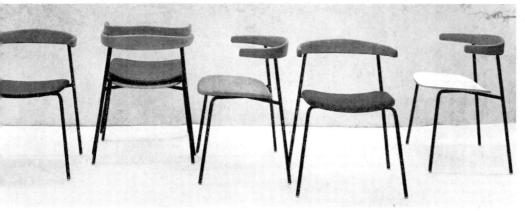

Dining, or stacking chair. Steel tube frame, stove-enamelled black; steamshaped beech back; pre-formed plywood seat veneered teak or laminated plastic, or fabric covered over Dunlopillo. Designed and made by Conran & Company Ltd (GB)

RIGHT: Flat-steel frame chair, upholstered in wool fabric over deep foam rubber cushioning. Designer: W. H. Gispen. Made by Kembo Meubelfabrieken NV (HOLLAND)

BOTTOM RIGHT: Teak chair with woven cane seat and back. Designed by Peter Hvidt and O. Mølgaard-Nielsen, m.a.a. Makers: Søborg Møbelfabrik A/S (DENMARK)

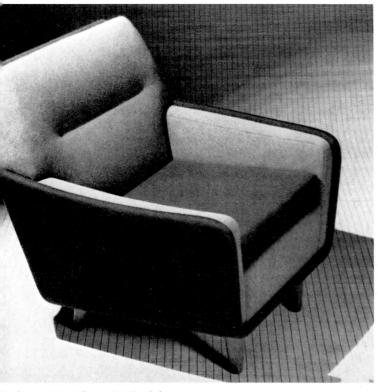

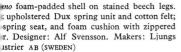

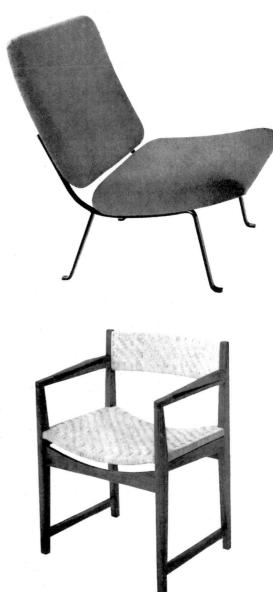

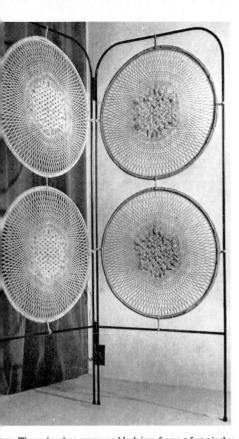

ve: Woven bamboo screen on black iron frame 2 feet 5 inches n. Designed and made by Mosuke Yoshitake (JAPAN)

aged screen on oiled walnut frame, 6 feet 6 inches high; adwoven panels in natural bamboo, and orange, blue and tan ns. Designed and made by James and Marie Howell (USA)

nging screen composed of traditional forms in 6-mm acrylic stic, and 2-mm polished brass and black iron, with engraved coration. Designed and made by Yasuhiro Hiramatsu (JAPAN)

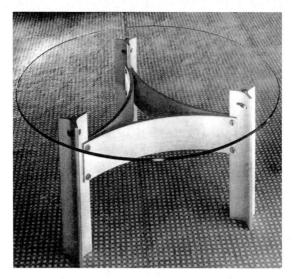

Glass-topped occasional table on laminated wood base.
Designed and made by Gautier-Delaye (FRANCE)

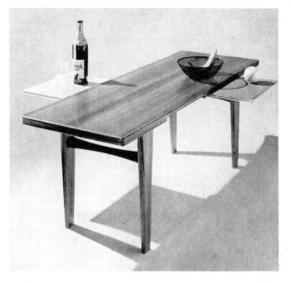

Cocktail/coffee table in walnut, medium or dark finish, or in oiled teak; the pull-out shelves are surfaced in green and ivory Resopal. Designed and made by Wilhelm Renz kG (GERMANY)

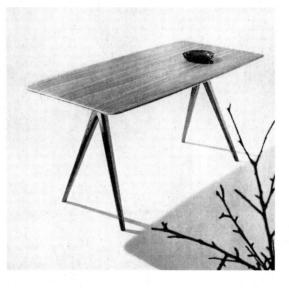

Knock-down coffee table in Burma teak, oiled finish. Designed and made by Wilhelm Renz KG (GERMANY)

BELOW: Teak occasional table; the top is reversible and faced with plastic on one side. Designer: C. Braakman. Makers N. V. Ums-Pastoe (HOLLAND)

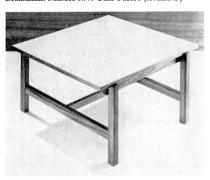

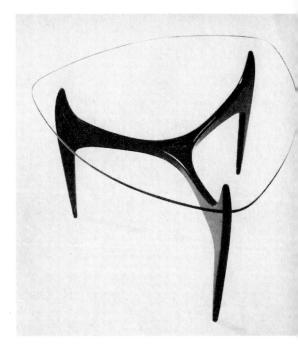

ABOVE: Occasional table on black-lacquered sculptured hardwood base plate glass top. Designer: Jos. De Mey. Makers: 'Luxus' (BELGIUM)

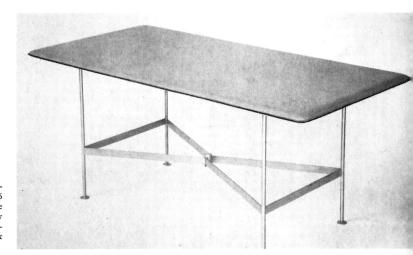

Occasional table with saddlestitched coachhide top 36 inches long; underframe polished brass. Designed by J. Jaraczewska and E. Ihnatowicz. Makers: W. J. Mars & Co. Ltd (GB)

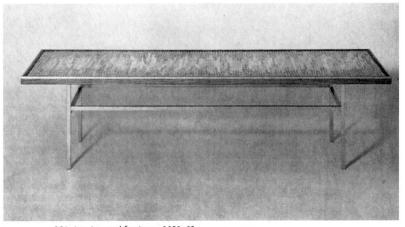

264 · interiors and furniture · 1959-60

▼ Teak frame coffee table mosaic-inlaid top, 5 feet or or with solid teak or certile top; the legs and tririn in brass or aluminium, signed and made by the Furniture Co, Ltd (CAN/

Teach Teach

Teach

Teach

Teach

Teach

Teach

Teach

Teach

Teach

Teach

Teach

Teach

Teach

Teach

Teach

Teach

Teach

Teach

Teach

Teach

Teach

Teach

Teach

Teach

Teach

Teach

Teach

Teach

Teach

Teach

Teach

Teach

Teach

Teach

Teach

Teach

Teach

Teach

Teach

Teach

Teach

Teach

Teach

Teach

Teach

Teach

Teach

Teach

Teach

Teach

Teach

Teach

Teach

Teach

Teach

Teach

Teach

Teach

Teach

Teach

Teach

Teach

Teach

Teach

Teach

Teach

Teach

Teach

Teach

Teach

Teach

Teach

Teach

Teach

Teach

Teach

Teach

Teach

Teach

Teach

Teach

Teach

Teach

Teach

Teach

Teach

Teach

Teach

Teach

Teach

Teach

Teach

Teach

Teach

Teach

Teach

Teach

Teach

Teach

Teach

Teach

Teach

Teach

Teach

Teach

Teach

Teach

Teach

Teach

Teach

Teach

Teach

Teach

Teach

Teach

Teach

Teach

Teach

Teach

Teach

Teach

Teach

Teach

Teach

Teach

Teach

Teach

Teach

Teach

Teach

Teach

Teach

Teach

Teach

Teach

Teach

Teach

Teach

Teach

Teach

Teach

Teach

Teach

Teach

Teach

Teach

Teach

Teach

Teach

Teach

Teach

Teach

Teach

Teach

Teach

Teach

Teach

Teach

Teach

Teach

Teach

Teach

Teach

Teach

Teach

Teach

Teach

Teach

Teach

Teach

Teach

Teach

Teach

Teach

Teach

Teach

Teach

Teach

Teach

Teach

Teach

Teach

Teach

Teach

Teach

Teach

Teach

Teach

Teach

Teach

Teach

Teach

Teach

Teach

Teach

Teach

Teach

Teach

Teach

Teach

Teach

Teach

Teach

Teach

Teach

Teach

Teach

Teach

Teach

Teach

Teach

Teach

Teach

Teach

Teach

Teach

Teach

Teach

Teach

Teach

Teach

Teach

Teach

Teach

Teach

Teach

Teach

Teach

Teach

Teach

Teach

Teach

Teach

Teach

Teach

Teach

Teach

Teach

Teach

Teach

Teach

Teach

Teach

Teach

Teach

Teach

Teach

Teach

Teach

Teach

Teach

Teach

Teach

Teach

Teach

Teach

Teach

Teach

Teach

Teach

Teach

Teach

Teach

Teach

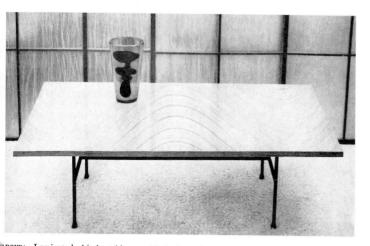

BOVE: Laminated birch table on black iron legs. Designer: Tapio Wirkkala. Makers: Asko O/Y (FINLAND)

ABOVE: Occasional table, slatted sapele top on metal tube base lacquered grey. Designed and made by Eric Lemesre (BELGIUM)

ove: Lamp table in black iron, containing a perforated tal drum fitted with a coral fibreglass diffuser decorated th a pressed butterfly and leaves; plate glass top. Dener: John Crichton. Makers: P. Pausma (NEW ZEALAND)

Coffee table in Burma teak with yellow laminated-plastic elliptical top. Designed and made by Barry Warner, Leicester College of Art (GB)

Knock-down occasional table in 'keyaki' wood with clear lacquer finish; the legs are affixed to the top with forked bolts in a dull black finish. Designed by members of the Tokyo Industrial Arts Institute. Made by Fuji Jidosha Co. Ltd (JAPAN)

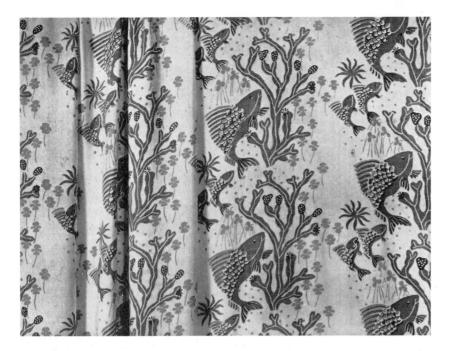

LEFT: Aquarium. Hand-printed curtain designed by Edna Martin and produced by Mölnlycke Väfveri AB.

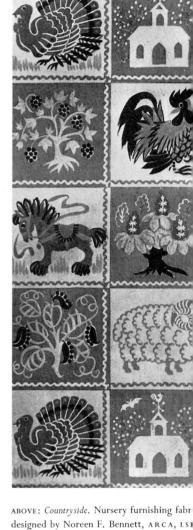

ABOVE: Countryside. Nursery furnishing fabr designed by Noreen F. Bennett, ARCA, LSI in yellow, grey, pink, sage and crimson on blue and white squares.

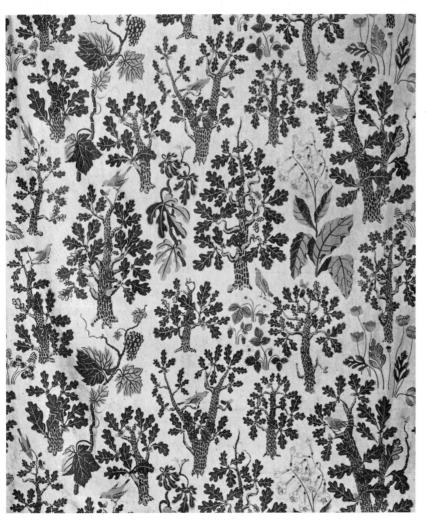

LEFT: Printed linen in green, yellow and browdesigned by Josef Frank and produced by Svensk Tenn.

esque. Hand-print on grey linen, gned by Maud Fredin-Fredholm and made by d Fredin-Fredholm Textilier AB. burs: ultramarine, sea-green and green-grey. Vine. Hand-printed curtain in alternate light and dark stripes designed by Edna Martin and produced by Mölnlycke Väfveri AB

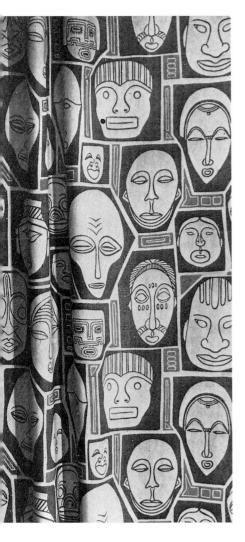

n planning.
d-print designed by Susan Gröndal.
produced by Licium.
ours: deep yellow,
or red on white ground.

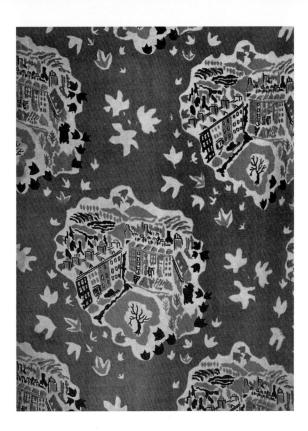

ABOVE: London Square. Screen-printed linen in three colours on white, designed by Mary Oliver and produced by Donald Bros Ltd.

Available in combinations of scarlet, olive and celadon; yellow, dark and light grey; turquoise, dark and light grey; dusty pink, mushroom and chocolate.

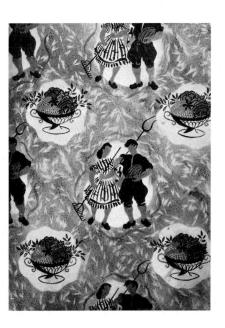

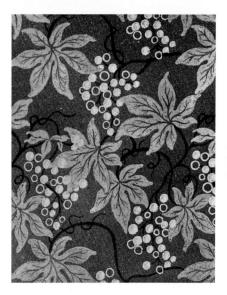

go-inch hand-prillinen, produced W. Foxton Ltd, available in maize, green an maize, rust and or gold, green a

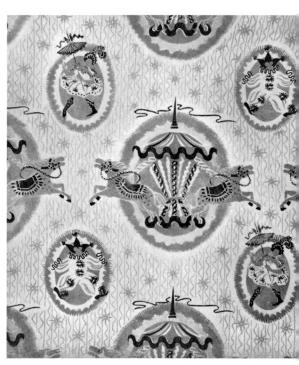

ABOVE: Screen-printed linen or rayon in lime green, grey, pink, black and bright red on white. LEFT: Linen in green, chartreuse, dark red and pink on grey and white textured background. Two nursery fabrics designed by Noreen F. Bennett, ARCA, LSIA, and made by Donald Bros Ltd.

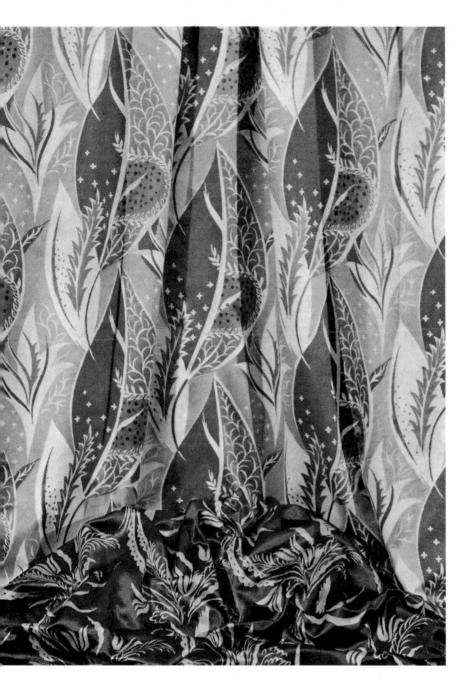

Furnishing fabrics designed by Margaret Simeon. Background: four-colour screenprinted satin, produced by John Lewis & Co Ltd. Foreground: single-colour screenprinted satin, printed by Allan Walton Textiles.

BELOW, LEFT: Espalier. Handprinted curtain in natural colours on a white ground designed by Edna Martin and made by Mölnlycke Väfveri AB and RIGHT, Scan. Silkscreen fabric in various colour contrasts designed and produced by Ben Rose Handprinted Textiles.

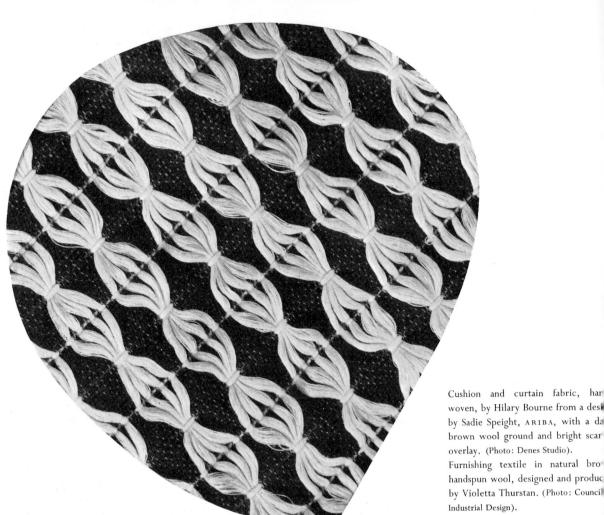

Upholstery fabric of yellow and white cotton gimp, with two tones of grey linen and white viscose gimp, designed by Grace Best and Doreen Jackson and made by G. Pritchard.

Hand-woven curtain in cream cotton bouclé, with broad stripes of brick red and narrow stripes of gold cotton, and, BELOW: Hand-woven woollen furnishing materials with regular thick horizontal stripes of self material (left) silver grey, (right) bottle green, all designed by Erna Cohn and Lucie Arnheim and made by Lucerna Handweavers.

RIGHT: Hand-woven curtain and furnishing fabrics, designed by Maud Fredin-Fredholm and made by Maud Fredin-Fredholm Textiler AB. Top and lower: warp cotton, weft wool. Right: warp and weft of worsted wool.

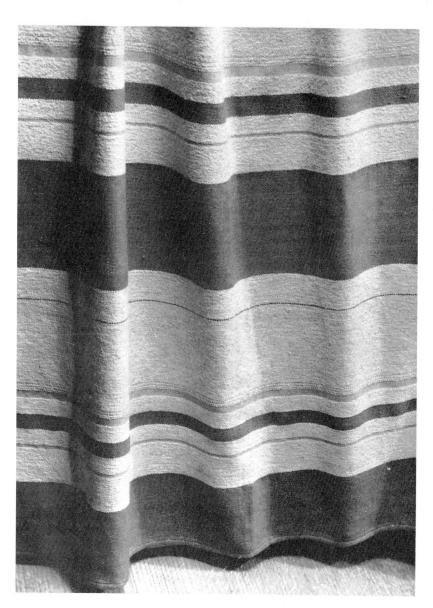

- Anacreon. Printed linen designed by Josef Frank and produced by Svenskt Tenn. White background with the motif in blue, green, red and yellow.
- Perring Print. 50-in. cotton, the design in dark blue on a buff ground, designed and handprinted by Mary Oliver for the exclusive use of William Perring & Co. Ltd.
- Eden. Printed linen and rayon, available with blue or green background, designed by Stig Lindberg and made by A B Nordiska Kompaniet.

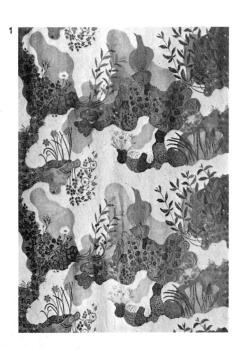

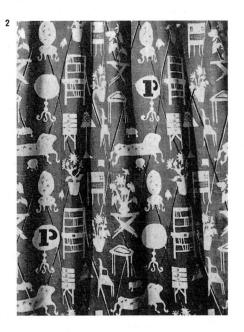

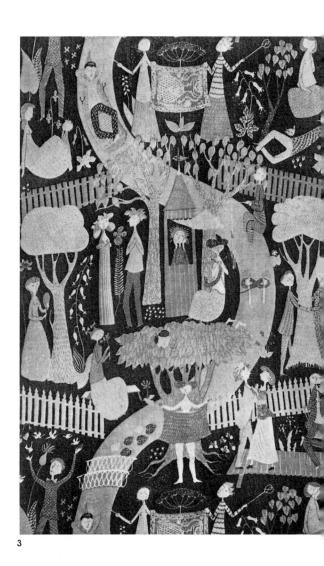

OPPOSITE: Assortment. Printed linen designed by Stig Linberg and produced by A B Nordiska Kompaniet. Av able in blue, grey-green or yellow-green.

- 48-in. furnishing linen designed for Liberty & Co. Ltd, by Victoria Norrington. Hand-printed in yellow and grey; various greens; grey and brown; brick, fawn and turquoise; or rose, grey and turquoise, all on a natural ground.
- Indian Primitive. Cotton fabric in yellow and green; blue and tan; red and grey; and coral and brown, designed and made by Ben Rose Handprinted Textiles.

 Pottery. Printed cotton and rayon in blue, green, red or yellow designed by Stig Lindberg and produced by A B Nordiska Kompaniet.

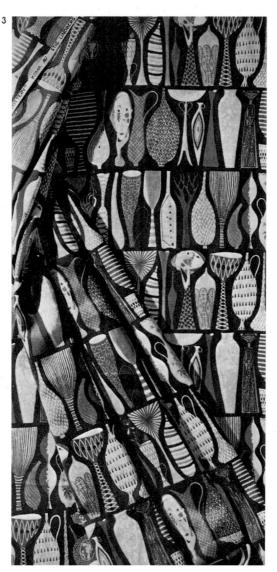

4. 48-in. furnishing linen designed by Geo Willis for Liberty & Co. Ltd. Ha printed in wine, yellow and fawn; r fawn and brown; yellow and oran green, blue and red; or light blue, d blue and green, all on a natural ground

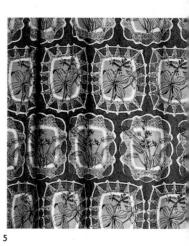

 Elysian. 50-in. screen-print on hea cotton, six colour schemes available, 6 signed by Lucienne Day, FSIA, and ma by Edinburgh Weavers.

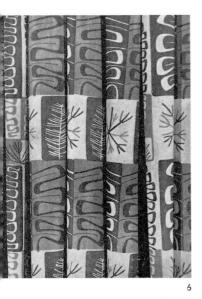

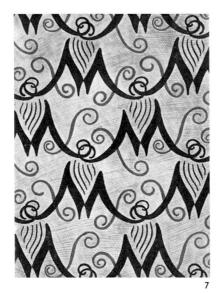

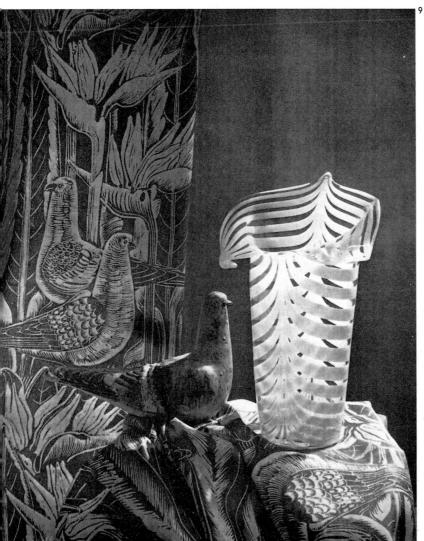

- Jamaica. Spun rayon and cotton in red and grey; mulberry and tan; or green and orange.
 Designed and produced by Ben Rose Handprinted Textiles.
- 50-in. hand-print on rayon and cotton dobby satin produced by W. Foxton Ltd. Colours: green and gold; red and fawn; brown and gold; and rust and green all with touches of nigger brown on cream ground.
- Cuneiforms. 64-in. loomed haircloth in orange and brown designed by Ruth Adler and hand-printed by Edward C. Schnee.

- Printed linen available in black or red; earthenware dove made by Gustavsbergs Fabriker A B; and vase in clear and white crystal made at Paolo Venini's Glassworks, Murano.
- Printed linen in red or dark green.
 All designed by Tyra Lundgren for A B Nordiska Kompaniet.

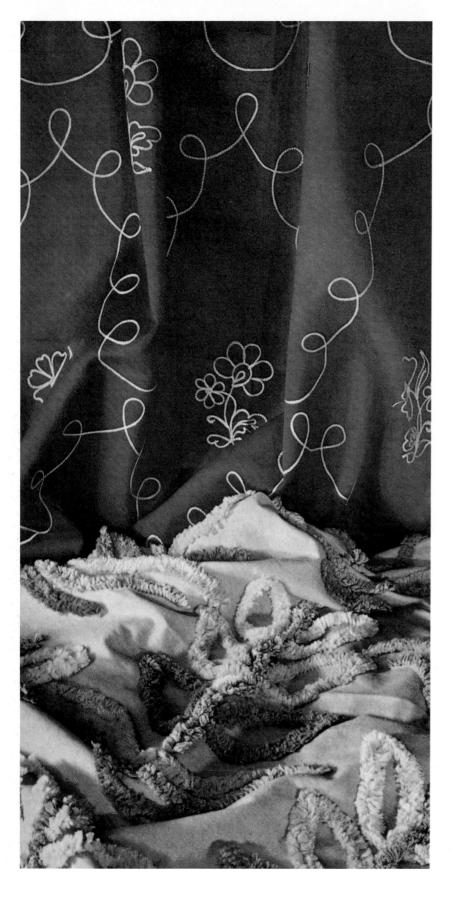

- 1. Background: 50-in. embro dered satin available in brow or green satin with whi chain stitch, and in whi satin with green or red st ching. Foreground: 48-ii candlewick, natural grou with the candlewick desi in a choice of two, three a four colour schemes. Bo are Rosebank fabrics produc by Turnbull & Stockdale Le
- Astral. Cotton, rayon a mohair hand-printed cas ment fabric designed Mrs. John S. Bolley and ma by Goodall Fabrics Inc.

- 6. Eroica. 50-in. acetate as gimp cotton brocade in range of eleven two-colour tone-on-tone effects. Desig ed by Frank R. Gibson, MSI and produced by Morton Su dour Fabrics Ltd.
- 7. Allegro. 50-in. screen print heavy cotton, available three colour schemes, c signed by Humphrey Spende MSIA, and produced Edinburgh Weavers.

- 3. Buttons and Bows. 50-in. Everglaze chintz designed by Duncan Grant and produced by George Henderson Textiles Ltd. Colours: apple green and blue with maroon stripe; pink and blue with indigo stripe; orange and blue with green stripe; and grey and yellow with cerise stripe.
- Horsemen. Beige linen with motif in pale blue, dark blue and terra-cotta, designed by Noreen Bennett, ARCA, for L. D. Ziegler.

 Oats. 36-in. printed rayon or 50-in. linen, white ground with motif in colour to suit individual requirements, designed and printed by Winning Read.

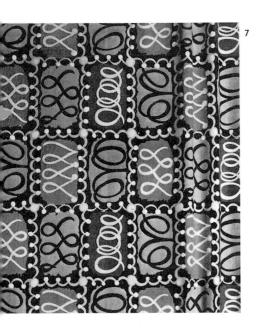

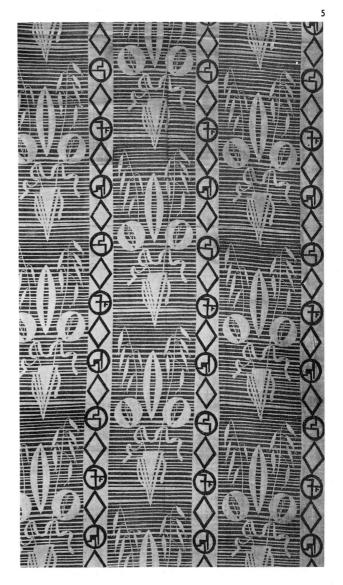

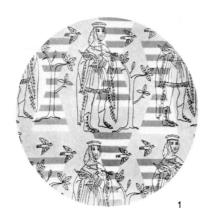

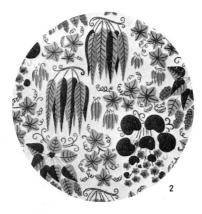

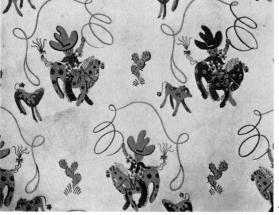

- Hunter. Hand-printed cotton and mohair fabric with a linen-like texture in beige, grey, flamingo and blue, designed by Ivan Bartlett and produced by Goodall Fabrics Inc.
- 51-in. cotton or spun rayon crêpe in six colours on a white or cream ground, designed by Märta Maria Dahlén and produced by Molnlycke Vafveri A B.
- Maya Fresco. Hand-printed cotton and mohair fabric, in light blue, spruce, gold, tan and grey. Designed by Jean and Hellen Gazagnaire and produced by Goodall Fabrics Inc.

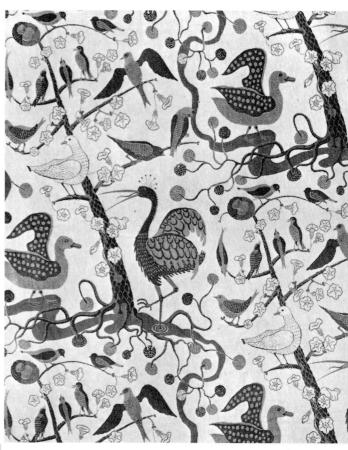

- 4. Texas. 50-in. printed linen cloth designed by Marjorie Young and produced by Donald Bros Ltd. A choice of five attractive colour schemes on a white background.
- 50-in. printed linen in green, brown and red on white ground, designed by Josef Frank and produced by Svenskt Tenn.

- Print and Imprint. Hand-print on Angora satin, in grey, bright navy, lilac, ruby and dark brown, designed by Ivan Bartlett and produced by Goodall Fabrics Inc.
- Birds in Trees. Spun rayon designed by Mary Oliver and screen-printed in four colours by Silfa Fabriksaktiebolag.
- Arcady. 50-in. screen-print on heavy cotton designed by Hans Tisdall and produced by Edinburgh Weavers. Bright chintz colours on white or pale pink, and in soft shades of blue or green on white.

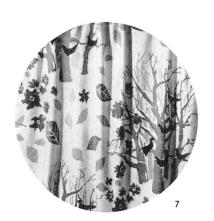

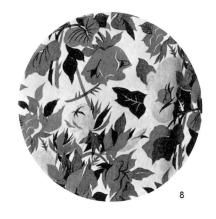

- Daphne. 50-in. printed rayon, cotton satin or permanent glaze chintz, available in pink, peach, pale lime, sea-green, blue or beige. Designed by Frank R. Gibson, MSIA, and produced by Morton Sundour Fabrics Ltd.
- 10. Trees. Hand-screened spun rayon designed by Edward J. Wormley and produced by Schiffer Prints Division of the Mil-Art Company Ltd. Colours: celadon green and bark brown on grey; light and bark brown on sand; bluegreen and moss-green on natural.

- Egyptian Fantasy. Designer: Peter Shuttleworth. Producers: The Wall Paper Manufacturers Ltd. Decorations in pink, green, grey, maize and terra-cotta on white or black ground.
- Sea Horses. Designer: Bruce Hollingsworth. Producers: John Line & Sons Ltd. Available on white or blue ground.

- Cheerio. Designer: Lawrenc Gussin. Producers: Wall Trend Inc. Handprinted in chartreuse white and black on Chinese red Available also on Stylon wall can vas.
- Designer: R. H. Callwood. Producers: The Wall Paper Manufacturers Ltd. Blue-grey, greet or white grounds with flower and leaves in grey, turquoise red, yellow, green and white.

 Producers: Arthur Sanderson & Sons Ltd. Off-white design on blue, oyster, green and apricot satinette grounds.

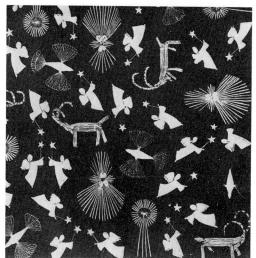

6. Swedish Homecrafts. Designer:
Marianne Fisker. Producer:
Ernst Dahl. Background green
with decorations in white and
yellow.

Designer: Margaret Simeon.
 Producers: Lightbown Aspinall
 branch of The Wall Paper
 Manufacturers Ltd. Motif in
 white on pale grey ground.

 Blue Oranges. Designer: Mellville Cross. Producers: Inez Croom Inc. Hand-printed by silk screen in green, blue or white.

 Designer: Philip Pompa, Producers: John Line & Sons Ltd. Available in a range of colourings. Birds in the Reeds. Hand-printed linen and cotton mixture in grey and green; beige and green; blue and brown; brown and yellow; beige and grey; or yellow and grey. Designer: Kristin Ingelög. Makers: Mölnlycke Väfveri AB (SWEDEN).

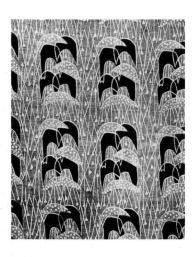

Wig-line-theme. Warp of cotton, weft of spun rayon, in green, brown and grey, or grey-green, yellow and red. Designer: Carl-Arne Breger. Makers: Mölnlycke Väfveri AB (SWEDEN).

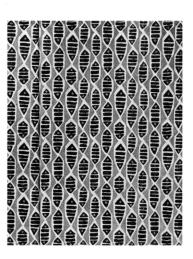

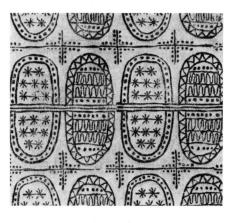

The Runestones. Linen with the motif brown or grey, Designer: Dagmar Hall Makers: Saléns (SWEDEN).

BELOW: Ellesmere (left). 50-inch screeprinted linen, also in sky-blue/sagreen; crimson/stone; pale blue/nar Designer: Eryl Rice. Astrid (backgroung 50-inch screen-printed linen, also ground shades of yellow, blue, greemushroom, elephant and chestnut. It signer: Marian Mahler. Both made Donald Bros Ltd. Pottery cocked designed and made by Dorothy Brende From Annette Handcrafts of Britain (GIII)

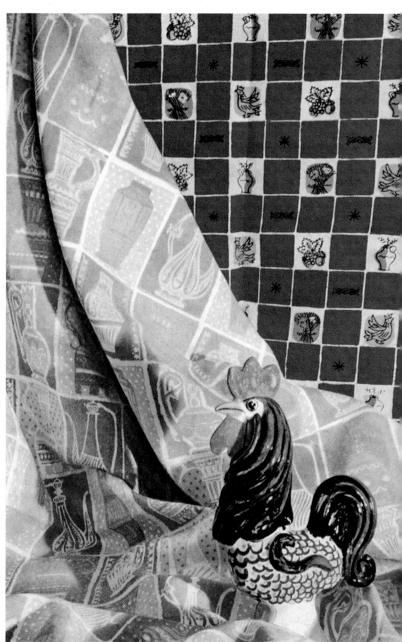

HT: Orlando. 50-inch rayon in lime green and grey. Deer and printer: Winning Read

).

ow: 48-inch Jacquard woven vy long staple spun rayon, Graffurnishing fabric, white abstract res on lime green ground or in er colours to order. Designer: Jueline Groag, MSIA. Makers: ico Printers Association Ltd

stles. Warp of cotton, weft of n rayon, in green, yellow and ite, and other colour schemes. signer: Else Marie Thorkildsen VEDEN).

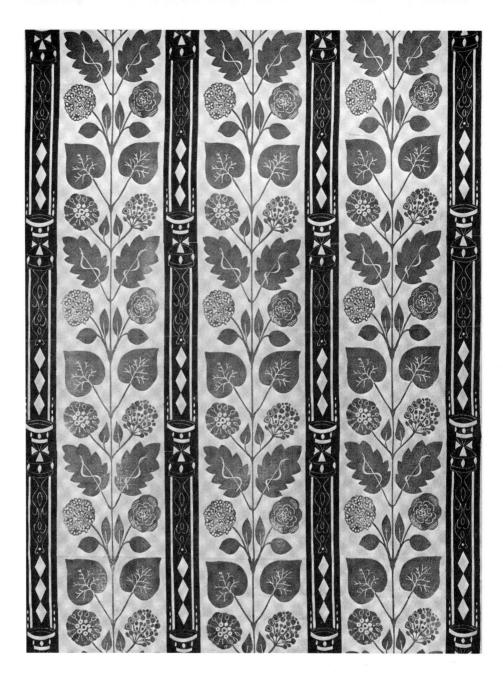

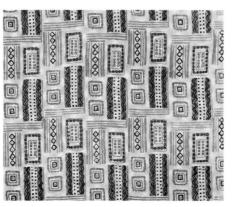

Indian Summer. White cotton with design in blue, carmine and yellow-green. Designer: Dagmar Haller. Maker: Eric Ewers (SWEDEN).

Vibrations. 48-inch satinweave in mulberry and bronze-green, raspberry and jade blue, or stone grey and rock tan. Designers and makers: Ben Rose Handprinted Textiles (USA).

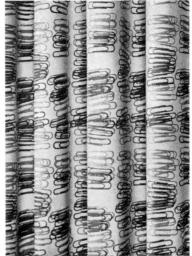

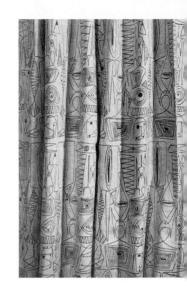

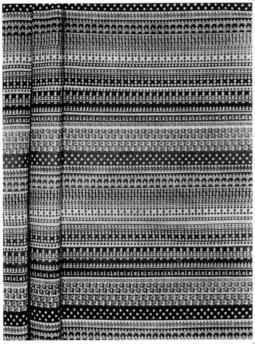

LEFT: Si and No (Typewriter characters). All-cotton warp sateen in chartreuse and brown on white; copper and brown on beige; two-tone grey on natural; and green and slate on natural. Designer: Bernard Rudofsky. Makers: Schiffer Prints Division of Mil-Art Co Inc (USA).

White rayon with design in yellow, orange, blue, grey and black. Designed and printed by J. Craig (GB).

FT: Wireworks. Bleached pure linen nd-printed in one colour to order. esigner: Ruth Adler. Makers: Adlerhnee Associates (USA).

By the Horn. Linen and cotton mixture in green, grey, yellow and brown on white, or green, blue, grey and yellow on paler yellow ground. Designer: Timo Sarpaneva. Makers: Mölnlycke Väfveri AB (SWEDEN).

Fruit Delight, 48-inch linen handprinted in five different colour schemes on a natural ground. Designer: Robert A. Stewart. Makers: Liberty & Co Ltd (GB).

r: Sticks and Stones. Bleached pure n hand-printed in two colours to er. Designer: Ruth Adler. Makers: er-Schnee Associates (USA).

Arches. Handprint on linen and cotton mixture in grey, brown and yellow, or red, blue and grey. Designers: Lars-Erik Falk. Makers: Mölnlycke Väfveri AB (SWEDEN).

BELOW: 48-inch Coconada cloth with wool content jacquard cross stripe, available in four different colour combinations. Design based on Windsor Castle with Elizabethan flowers and figures. Producers: W. Foxton Ltd (GB)

BELOW: 48-inch two-colour screenprint on fibro basket-weave cloth, available in cherry and stone or forest and gold. Designer: Roger Nicholson. Makers: David Whitehead Ltd (GB)

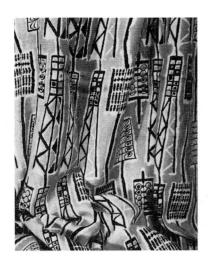

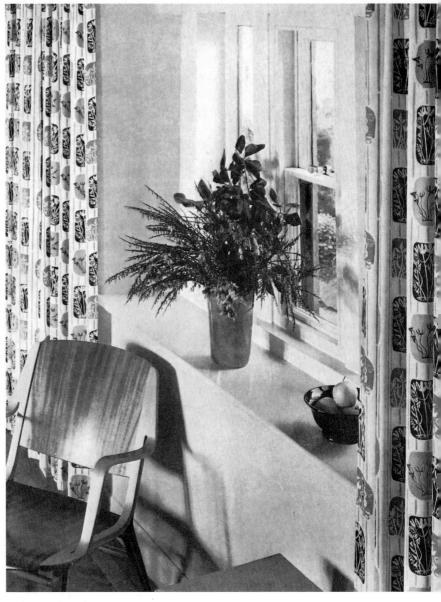

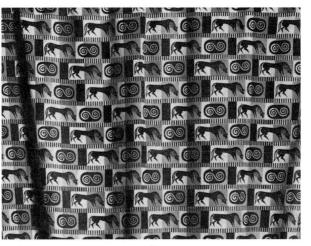

ABOVE: Curtains of 48-in machine print on spun ray available in chocolate, blue, gold; olive, salmon, beige; cerise, indigo, grey. Design Marion Mahler. Makers: Daw Whitehead Ltd (GB)

LEFT: Altamira. 50-inch scre print in five colourings on cre cotton. Designer: Christ Clegg. Makers: Edinbus Weavers (GB)

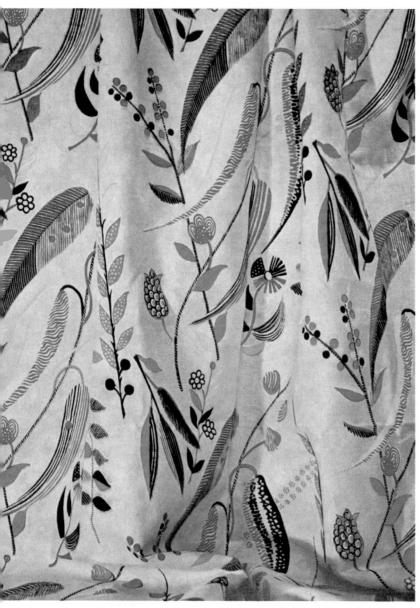

BELOW: Background: 50-inch fabric, cotton warp and wool weft, in eight different colours. Makers: Old Bleach Furnishing Fabrics (N. Ireland). Foreground: 48-inch screen-printed cotton, dark eggshell green with the motif in black and white. Designer: Terence Conran. Makers: David Whitehead Ltd (GB)

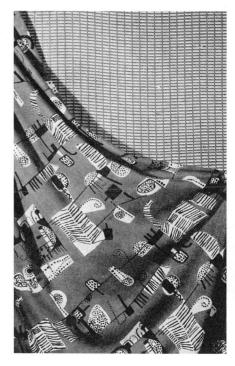

White cotton printed with yellow stripe and dark grey motif. Designer and printer: Robin Thomas. Producers: Mill House Fabric Printers (Penzance) Ltd (GB)

VE: 50-inch cotton twill or 1 in colours shown and in -green, yellow and black 1 natural ground. A Rosefabric. Makers: Turn-& Stockdale Ltd (GB)

nch machine-print on n rayon, available in st, black, turquoise and on; gun-metal, flame, land black; brown, black, l and lime; or madder, k, turquoise and lime, igner: Jacqueline Groag A. Makers: David Whitel Ltd (GB)

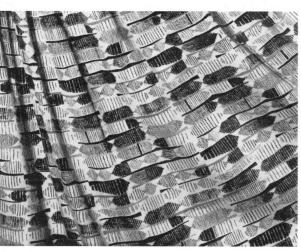

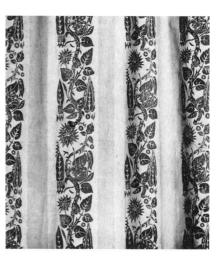

The Siamese Ballet. Hand-screened fabric in grey and red, black and turquoise, brown and orange, or green and black, all on natural ground. Designer: Edward Daly Brown. Makers: Schiffer Prints Division, Mil-Art Co. Inc (USA)

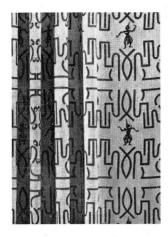

RIGHT: 48-inch textured cotton screen-print. Designer: Terence Conran. Makers: David Whitehead Ltd. Extreme right: Foreshore. 50-inch printed cotton. Designer: Lucienne Day ARCA. Makers: Edinburgh Weavers. Earthenware dish by Joan Motley (GB)

BELOW (Left): Acres. 50-inch screenprint on crêpe cotton in five colourings. Designer: Lucienne Day ARCA. Makers: Edinburgh Weavers. Centre: 50-inch screen-print in black and rust on fawn tinted cotton sateen. Designer: Barbara Pile. Makers: David Whitehead Ltd. Right: 48-inch screen-print in black on four contrasting grounds or in red on white. Designer: Terence Conran. Makers: David Whitehead Ltd (GB)

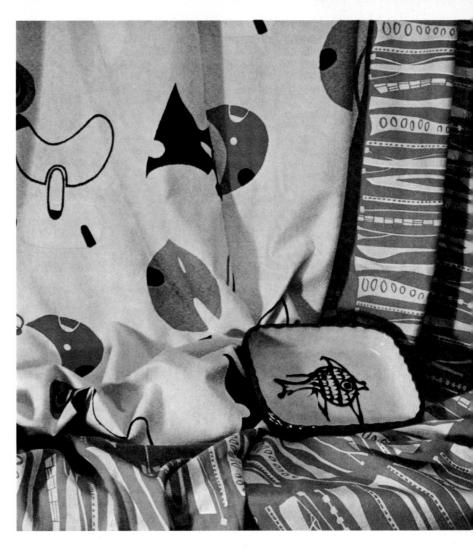

Trapez. 50-inch linen or cotton sa white and four contrasting colours. signer: Arne Jacobsen. Makers: Gre Textiles (DENMARK)

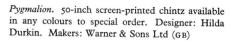

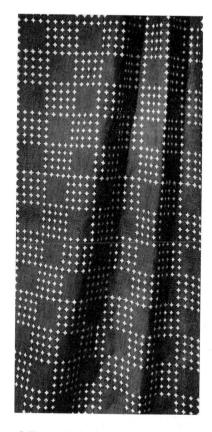

odcuts. 50-inch screen-printed linen in separate colour schemes. Designer: via Priestley. Makers: Liberty & Co. (GB)

ow: All Square. 50-inch heavy white ton block-printed in grey-blue, chest-, mustard and black. Designed and nted by Ronald Grierson MSIA (GB)

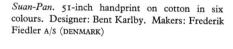

BELOW: Mosaic. Handprint in two colours on bleached linen. Designer: Bent Karlby. Makers: Frederik Fiedler A/S (DENMARK)

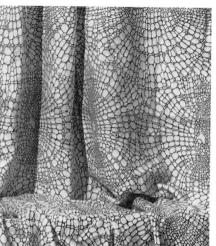

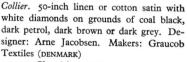

BELOW: Chanticleer. 36-inch sateen nursery print in scarlet, ochre and prune on pale grey. Designer and printer: Meriel Tower (GB)

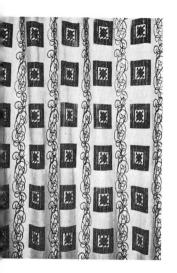

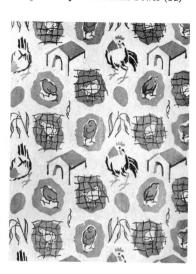

Termidor cotton velour in black, three shades of yellow, and white. Designer: Astrid Sampe. Makers: A/B Nordiska Kompaniet (SWEDEN)

Graphica 48-inch printed cotton with design in black on white, yellow, orange or khaki grounds. Designer: Lucienne Day, ARCA. For Heal's of London (GB)

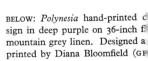

Central Park South. 50-inch white raysilk with silk-screen printed design in colours to special order. Designer: Ruth Adler. Makers: Adler-Schnee Associates (USA)

neycomb screen-printed design in cado, mustard or mocha on 50-h basket weave linen. Designer: el Dean. Makers: Schiffer Prints vision, Mil-Art Co. Inc. (USA)

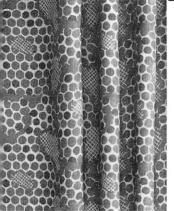

History of Shapes. Historical tapestry specially designed for Imperial Chemical Industries Ltd, . . . typical shapes throughout the ages from the first axe to the space ship. The tapestry is unique as it has been hand Jacquard woven and hand-screen printed, the fabric being constructed from pure silk and Ardil (protein fibre), and interwoven with non-tarnishing metallic threads. Although the fabric has all the deep texture qualities it is quite light and it has a soft and gentle drape. The repeat is 50 inches. Designer: Tibor Reich, FSIA. Makers: Tibor Ltd (GB)

BELOW: 50-inch screen prints on rough textured cotton. *Masts* (*Left*) designed by Hans Tisdall and (*Right*) *Banderole* designed by Humphrey Spender. Makers: Edinburgh Weavers (GB)

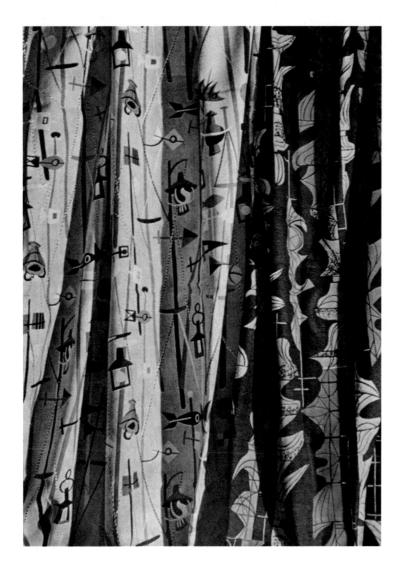

Arabesque. Linear design on medium weight linen. Co combinations rust and warm grey, deep yellow and g light and dark grey. Designers and makers: Ben (USA)

BELOW (*Left*): 48-inch printed cotton in mauve/grey/gl brown/pink/mushroom; green/blue/grey; orange/yel blue; grey/brown/lime. Designer: Mary White. (*Ra Trio*. 48-inch roller printed cotton. The design in boand-white on chartreuse, orange, grey, green and ye grounds. Designer: Lucienne Day, ARCA. For Head London (GB)

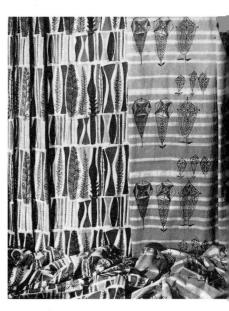

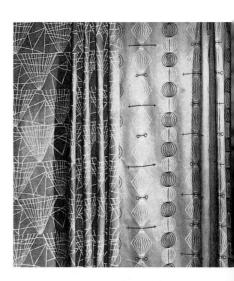

ABOVE (Left): Delta. 48-inch printed cotton, the design white on grey, red, lime or green grounds. Design Walter Kramer. (Right): Spinners. 48-inch printed cowith design in white and black on terra-cotta, olive-gared, grey and chartreuse grounds. Designer: Now Warren. For Heal's of London (GB)

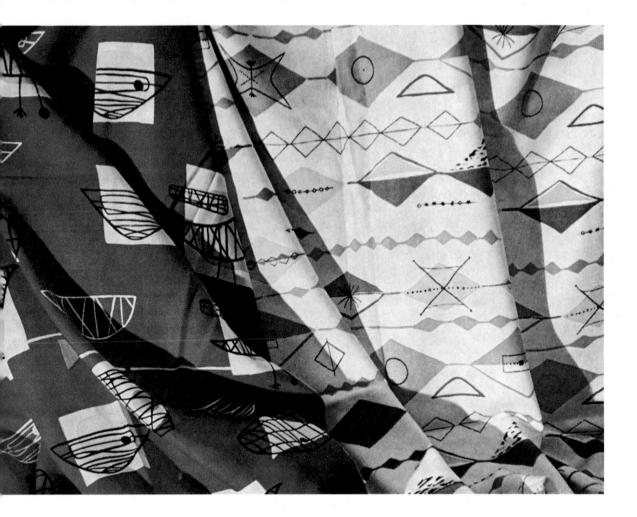

vE (Left): 48-inch spun rayon. Also available in inder, fawn and green. (Right): 48-inch spun on with design as shown or in green/yellow/grey lime green/turquoise/mushroom on off-white und. Designer: Marion Mahler. Makers: David itehead Ltd (GB)

ow (Left): Rush and Reed and (Right): Manx. inch rayon, cotton and linen in colourings to cial order. Designer: Karen Bulow. Makers: nadian Homespuns Reg'd (CANADA)

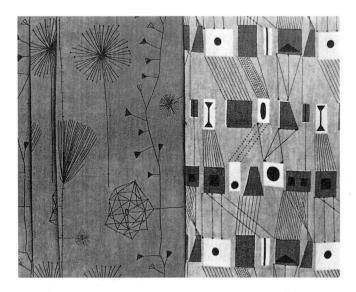

ABOVE (Left): Dandelion Clocks. 48-inch printed rayon with design in black on yellow, grey, turquoise and cerise grounds. (Right): Rig. 48-inch printed cotton in brown/turquoise; grey/red; mushroom/olive; forest green/lime. Designer: Lucienne Day, ARCA. For Heal's of London (GB)

RIGHT: Spiney Pines. Hand-screen print on 50-inch cotton Dreamspun; coral, lemon, and other grounds. Repeat 29 inches. Designed by Ruth Adler for Adler-Schnee Associates (USA). BELOW: Cotton screen-print in mustard, white, black, turquoise on greygreen, and other colourings. Designer: Jacqueline Groag, FSIA. Makers: Haworth's Fabrics Ltd (GB)

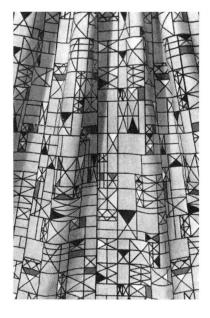

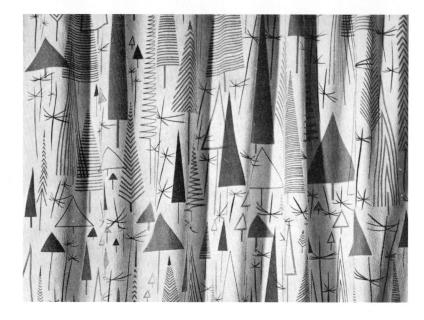

RIGHT: 50-inch Rosebank cotton print. Designer: Irene Browning. Makers: Turnbull & Stockdale Ltd (GB). FAR RIGHT: 48-inch thick cotton screen-print, as shown, and in scarlet/grey and pink/grey. Designer: Margaret Simeon. Makers: Sixten & Cassey Ltd (GB)

BELOW: 50-inch textured cotton screen-print in red, green and black on a grey rope ground. Designer: Philip Stockford, FRSA. Makers: Turnbull & Stockdale Ltd (GB). BELOW, RIGHT: Strings and Things. Screen-print on cotton Dreamspun or nubbin fabrics. Chartreuse, orange, and other grounds. Designed by Ruth Adler for Adler-Schnee Associates (USA)

AND BOTTOM: 48-inch all-cotton chine-printed jacquard texture rics; each is available in five erent colour combinations. Dener: J. Hill. Makers: Tootal adhurst Lee Co. Ltd (GB). FOREDUND: Helico texturedrape, a inch upholstery fabric with cotton reerized warp and textured gimp t. Designer: Tibor Reich, FSIA. kers: Tibor Ltd (GB)

age Church. 48-inch printed on or satin, with design in black yellow or white; or white line on nge, khaki, blueberry or sean grounds. Designer: Hilda rkin. For Heal's of London (GB)

umn 48-inch cotton printed in colours on a plain ground; six ur combinations are available. igner: Frits Wichard. Makers: Ploeg, Bergeyk (HOLLAND)

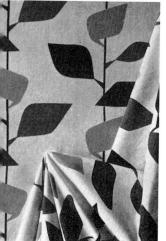

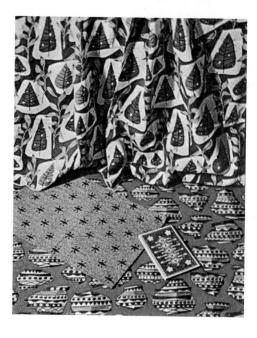

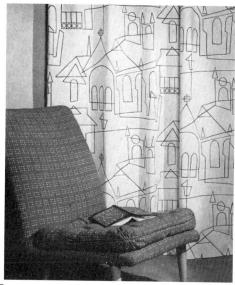

Guêpe (Wasp). 52-inch cotton flockprint in two colours. Designed by Kunstgewerbe-schule, Zürich. Made by Wohntextil AG (SWITZERLAND) (Photo: Hans Finsler)

48-inch machine-printed rayon fabrics. That shown at left is also available in tomato red, pale green, tan and wine; the other in vermilion, light green and burgundy. Both are designed by Marion Mahler for D. Whitehead Ltd (GB)

Nature Abstraite. 52-inch cotton-sateen with design printed in blue on grey, red, green and yellow grounds. Designed by Kunstgewerbe-schule, Zürich. Made by Wohntextil AG (SWITZERLAND).

(Photo: Hans Finsler)

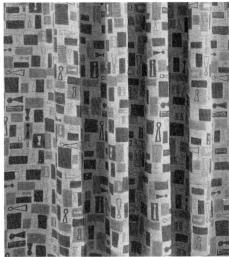

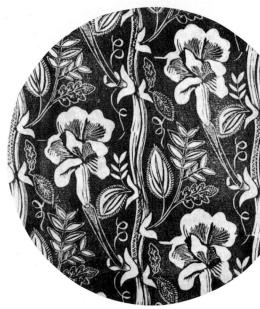

Zotis. One colour design on plain satin ground, in crimson and ivory or deep blue and mushroom. Designed and printed by Winning Read (GB)

LEFT: Cosmos. Pale grey hand-

LEFT: Cosmos. Pale grey handprinted Splendoline fabric. Circles in elephant-grey, golden yellow and white; dots in bright green-blue and terra-cotta. Designer: Gudrun Orrghen-Lundgren. Makers: A/B Olssons Textilfabriker (SWEDEN)

BELOW: Kaleidoscope. 48-inch Fortisan poplin or chintz multicolour print on light grey ground. Repeat 24-inch. Designer: Alexander Girard, AIA. For Herman Miller Furniture Co. (USA)

48-inch heavy spun rayon with machine-printed design in green, gold or blue predominating colours. Designer: Jacqueline Groag, FSIA. Makers: D. Whitehead Ltd (GB)

Scherzot. Splendoline fabric hand-printed in three colours. The leaves are in bright and medium grey, with markings and irregular lines leading into the leaves in dark grey. Designer: Gudrun Orrghen-Lundgren. Makers: A/B Olssons Textilfabriker (SWEDEN)

Fruit Cup. 50-inch cotton screen-printed to order in the customer's own choice of colours. Designers: Libert Dessins (FRANCE). For Warner & Sons Ltd (GB)

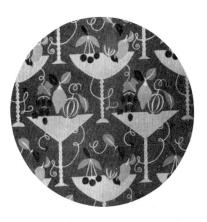

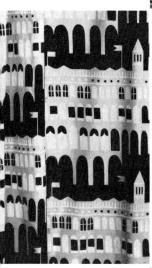

Colonnade. 50-inch screen print on heavy cotton crepe, in red, rust, green or mauve colourings. Repeat 19½ inches. Designer: Hilda Durkin. Makers: Edinburgh Weavers (GB)

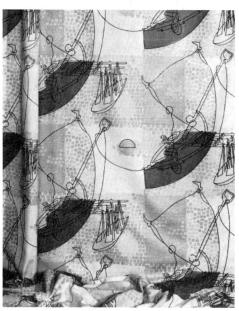

Scrub Oak. 48-inch screenprinted cotton, ratiné linen, or antique satin, produced in a choice of twenty-six colour combinations. Designer: John Brook. Makers: J. & J. Brook Associates (CANADA)

Arab Dhow. 50-inch screen print on heavy cotton crepe in gold plum and sage: sky blue, primrose and leaf green; grey, blue and yellow; blue, grey, red and gold. Repeat 26½ inches. Designer: Hilda Durkin. Makers: Edinburgh Weavers (GB)

Since furnishing textiles are not subjected to the same kind of use as wearable fabrics, there is a difference in scope for design, weave and material which strongly favours the furnishing textile designer. His latitude is such that he can, if he wishes, look upon his medium as a painter does his canvas, but, in addition to its being a vehicle for applied design, there are inherent potentialities of texture and weave as pattern sources in the material itself.

The vocabulary with which designers are thus provided, although extended from time to time by the introduction of new techniques and synthetic yarns, has been available for a very long time. Courage in exploiting its possibilities, however, has not always been in evidence and is in fact inclined to fluctuate. At the present time it is particularly encouraging to observe that some of the more conservative textile firms have begun to allow a lighter and more adventurous note to pervade their work. The decorative and yielding qualities of their furnishing fabrics counter the hard geometry of a modern interior.

This section is not intended as a summary of total output, but as being representative of the forward trends in design that are likely to have an influence on future production, or that have themselves grown from similar influences in the past. It demonstrates that there exists a wholesome and enterprising regard for the decorative potentialities of the modern idiom.

TOP: 48-inch roller-printed cotton fabrics in colours shown and in three other combinations. Designers and makers: Tootal Broadhurst Lee Co. Ltd (GB)

CENTRE (left): Screen-print on 36-inch textured cotton. Designed and hand-printed by Alison Hurd (GB). (Right) 48-inch textured gimp weave interwoven with gold Lurex. Also available in yellow, bright red, kingfisher blue and other colours, all with gold Lurex and black. Designers and makers: W. Foxton Ltd (GB)

BOTTOM (*left*): 50-inch spun rayon, as shown, and in other colourings. Designer: Robert Shaw. Makers: The Old Bleach Linen Co. Ltd (NORTHERN IRELAND). (*Right*) 48-inch vat printed cotton; also made in other colour combinations on fawn and turquoise blue grounds. Designers and makers: W. Foxton Ltd (GB)

ABOVE: 48-inch cotton print in black/white and alpine rose on grey; also available in white/blue/turquoise on vermilion ground, and other colourings. Designed by Jacqueline Groag, FSIA. For John Lewis & Co. Ltd (GB)

ABOVE RIGHT: Trapeze handprint on linen, batiste, or fibreglass fabrics 48-inches wide. Colours are gunmetal/dove; mustard/persimmon; chamois/ochre; bitter green/emerald, all on white ground with black horizontal line overprint. Designers and makers: Laverne Inc. (USA)

RIGHT: Construction two-colour print on 50-inch bleached linen in custom colours. Designed by Ruth Adler. Made by Adler-Schnee Associates (USA)

BELOW: Daystar handprint on batiste, linen, cotton, or fibreglass fabrics 48-inches wide. In silver and aqua, sandalwood and brown, red and black, all on white ground. Designers and makers: Laverne Inc. (USA)

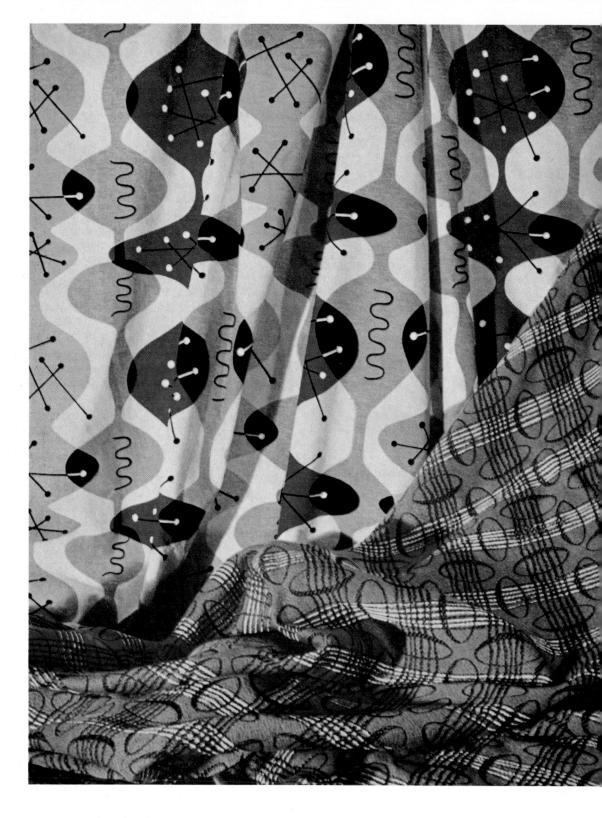

BACKGROUND: 50-inch Rosebank machine-print on crêpe cotton. It is available in five different colour combinations. Designer: W. Hertzberger. Makers: Turnbull & Stockdale Ltd (GB). FOREGROUND: 50-inch spun rayon woven fabric, as shown, and in other colourings. Designer: Robert Shaw. Makers: The Old Bleach Linen Co. Ltd (NORTHERN IRELAND)

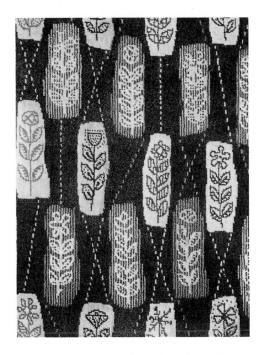

OVE: Carmyle Wilton wool carpeting, 27 inches wide, on jute and cotton e; multi-colour pattern on charcoal or wine ground. Makers: James mpleton & Co. Ltd (GB)

OW: Surte handwoven Gobelin tapestry in grey, black, and dark red. 5 feet. Designer: Ann-Mari Forsberg. Made by Märta Måås-Fjetterström (SWEDEN)

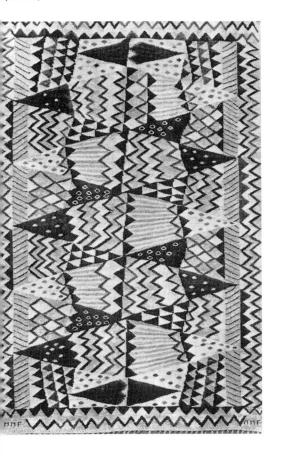

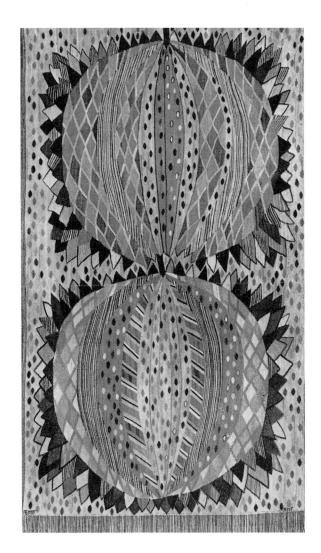

Above: The Melon handwoven Gobelin tapestry in yellow and green. 6 feet $7\frac{1}{2}$ inches \times 4 feet $2\frac{1}{2}$ inches. Designer: Ann-Mari Forsberg. Made by Märta Måås-Fjetterström ab (sweden)

BELOW: Wild Ducks handwoven linen tapestry in natural, black-and-white. Designed and made by Dora Jung (FINLAND)

BELOW: Roller printed cotton rep. Alternate leaves in shaded grey tones and in deep turquoise, with dividing lines in two grey tones. Designer: Gudrun Orrghen-Lundgren. Makers: Borås Wäfveri A/B (SWEDEN)

ABOVE: Astrid 50-inch hand-screen printed cotton on grey, orange, green, sapphire, or w grounds. Repeat 24 inches. Designer: J. Johnson. Makers: Morton Sundour Fabrics Ltd (GB)

RIGHT AND FAR RIGHT: Foliation two-colour hand-print, and Blockweave four-colour hand-print on 48-inch linen, cotton and rayon, or cotton sheer fabrics in a choice of thirty standard colours. Designer: Micheline Knaff. Makers: J. & J. Brook Ltd (CANADA)

w: Clarrisa four-colour hand-print on quality on. White bleached ground, large squares in grey screen, rectangles deep blue, smaller res almond green, leaves plum colour with the re reprint in deep blue. The pattern is imised, the lines uneven and irregular to give it Designed and printed by Gudrun Orrghendgren (SWEDEN)

DW: Tattoo 50-inch hand-printed linen in //blue, tan/orange; or in plain orange or blue. igner: Astrid Sampe. Makers: A/B Nordiska npaniet Textile Workshop (SWEDEN)

LEFT: Stim hand-print on quality Splendolin fabric. Abstract fish shapes grouped alternately in green-blue, and medium blue/yellow green colourings with veining and outlines in black. Designer: Gudrun Orrghen-Lundgren (SWEDEN). Makers: Sandvika Vaeveri A/S (NORWAY)

BELOW: 48-inch roller print on textured cotton. It is also available in five other colour combinations on grey, red, yellow, buff, and black grounds. Designers and makers: David Whitehead Ltd (GB)

LEFT: Bric-a-Brac hand-screen print on 48-inch textured cotton. Other grounds are grey, blue, lilac, topaz, jade green. Designer: Walter Krauer. Makers: Morton Sundour Fabrics Ltd (GB). RIGHT: Cryptography hand-print on heavy quality all cotton Arc-en-Ciel fabric, 52 inches wide. Designer: Sergio d'Angelo Reggiori. Makers: Manifattura JSA (ITALY)

BELOW: Blended textile/wallpaper designs: (Left) Venezia cotton mural drape of shaded diamonds on bands of grey, black and brick. Designed by Tibor Reich, FSIA. Made by Tibor Ltd (GB); (right) Intaglio, a Palladio wallpaper of shadowed stippled squares in blue with lilac on white. Designed by Roger Nicholson. Made by The Wall Paper Manufacturers Ltd (GB) (Photo: Copyright Manchester Cotton Board)

BELOW: 48-inch textured cotton with sty flower print in cornflower blue, yellow, red, t and green on white plaques against grey gro and in other colourings. Designer: Elsie St Makers: Turnbull & Stockdale Ltd (GB)

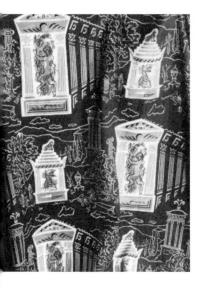

VE: Corinne 50-inch textured cotton print in on/grey/black/white on red ground; and in other colour combinations. Designers and ers: Morton Sundour Fabrics Ltd (GB)

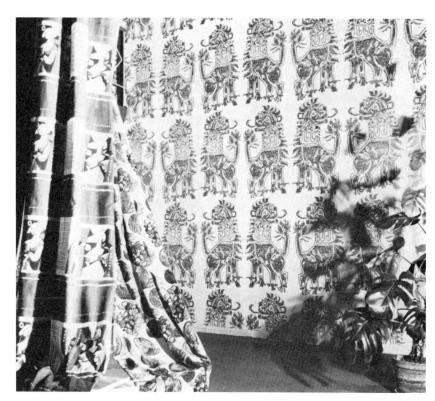

ABOVE: Sicilian Lion large-scale Palladio wallpaper in gold on white or black ground. Designer: Roger Nicholson. Makers: The Wall Paper Manufacturers Ltd (GB). In the foreground are hand-printed cotton fabrics Saraband designed by Robert McGowan for Edinburgh Weavers and Cassata, a huge-scale fruit print designed by Betty Middleton-Stanford for Liberty & Co. Ltd (GB) (Photo: Copyright Manchester Cotton Board)

LEFT: Sticks hand-print on heavy quality all-cotton Flamenco fabric, 52 inches wide. Designer: Gio Ponti. Makers: Manifattura JSA (ITALY). The enamel plate and bowl shown with it are designed and made by Edward Winter (USA) (Bowl by courtesy S. W. Vickery, Esq.)

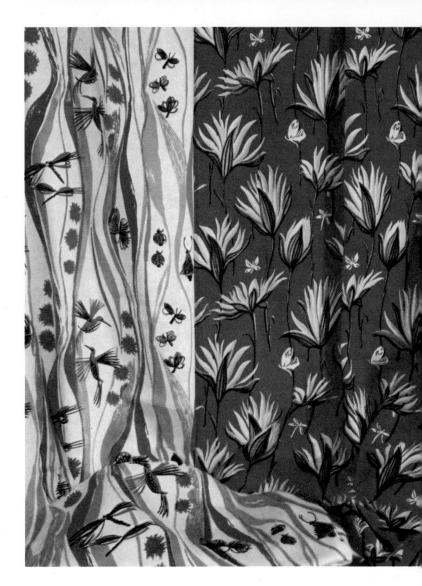

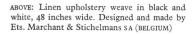

ABOVE LEFT: Summer Meadow screen-pri 48-inch satin rayon, with patented or resistant finish. Four different colour comtions are available. Designed and mad Tootal Broadhurst Lee Co. Ltd (GB). ARIGHT: Lotus five-colour print on textured ton, 48 inches wide. Other ground colour moss green, light blue, and light and dark Designed and made by Morton Sur Fabrics Ltd (GB)

RIGHT: Kite Tails four-colour print in charcoal, orange, fuschia, and ochre on heavy cream linen, 50 inches wide. Also printed on Fortisan silk; colour choice may be custom ordered. Designer: Gere Kavanaugh. Made by Isabel Scott Fabrics Corp. (USA)

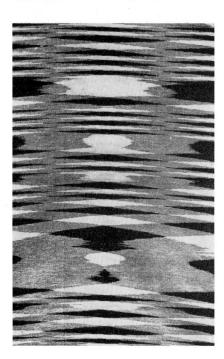

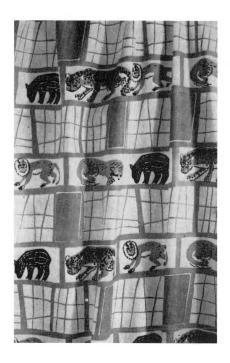

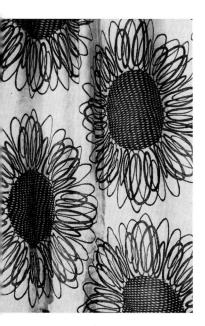

ABOVE LEFT: *Icicle* upholstery fabric, dip-yarn two-colour weave in yellow, orange, red, purple, blue, turquoise, green, all with black. Designed and made by Unika-Væv (DENMARK). ABOVE RIGHT: 36-inch cotton or flax fabric block-printed in Veronese green, cobalt, and black on white ground. Designed for nursery use by D. Dybowska. Printed at the Warsaw Institute of Industrial Design (POLAND)

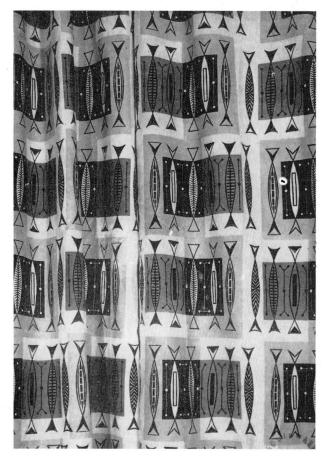

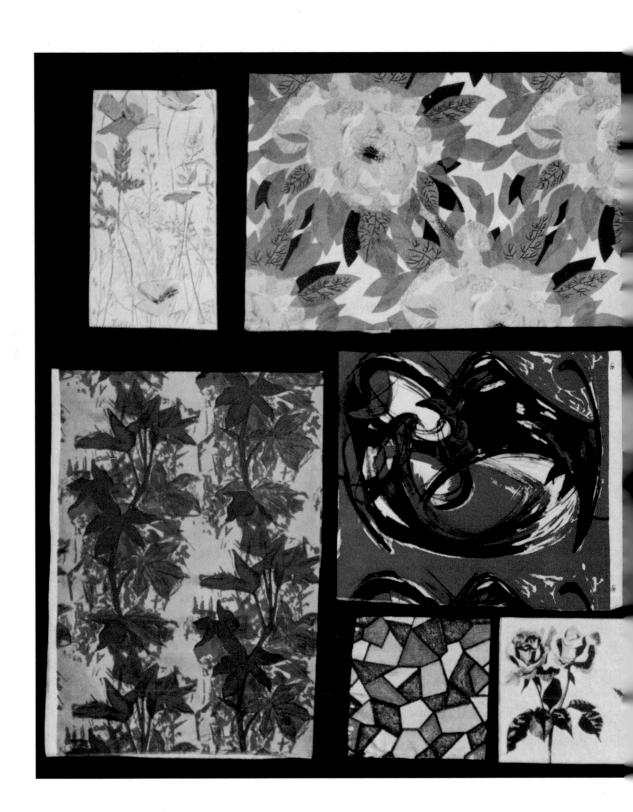

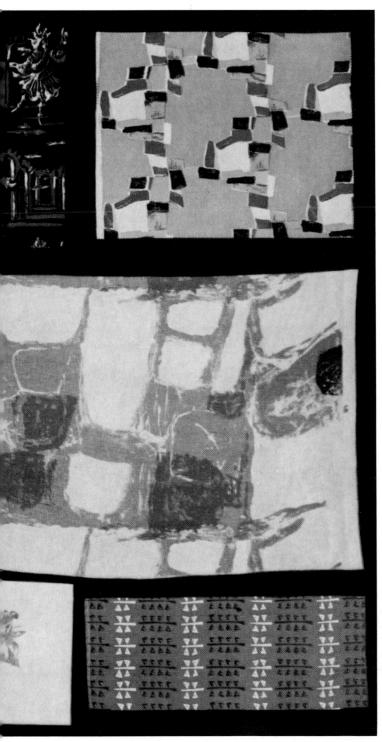

- I Californian Poppy screen-print on fine cotton 48 inches wide; repeat 24 inches. Also with blue or pink flowers, and on black, red, fawn, or grey/blue grounds. Made by David Whitehead Fabrics Ltd (GB)
- 2 Rosa screen-print on fine cotton, 50 inches wide. Designed by Marina Hoffer, MSIA. Made by Warner & Sons Ltd (GB)
- 3 Ballet Nègre screen-printed rayon-satin, 48 inches wide; available in three colourways. Designed by Desville of Paris. Made by Tootal Broadhurst Lee Co. (GB)
- 4 Screen-printed fine waffle-textured cotton, 48 inches wide; available in six colourways. Made by David Whitehead Fabrics Ltd (GB)
- 5 Tropical Leaves screen-printed cotton satin, 48 inches wide; available in five colourways. Designed by Helen Dalby. Made by Morton Sundour Fabrics Ltd (GB)
- 6 Matador screen-print on cotton satin, 48 inches wide; pattern repeat 19½ inches. Designed by Anthony Harrison. Made by Edinburgh Weavers (GB)
- 7 Skara Brae screen-print on heavy cotton-tweed curtain fabric; pattern repeat 21½ inches. Designed by William Scott. Made by Edinburgh Weavers (GB)
- 8 Non-shrink, non-stretch glass fibre curtain fabric, 46 inches wide, with a stained-glass effect screen-printed design. Made by Vetrona Fabrics Ltd (GB)
- 9 Kensington screen-printed Everglaze chintz, 50 inches wide; in seven colourways. Made by Donald Brothers Ltd (GB)
- to Dogstooth machine-print on textured cotton, 50 inches wide. Designed by Ronnie Thomas. Made by Turnbull & Stockdale Ltd (GB)

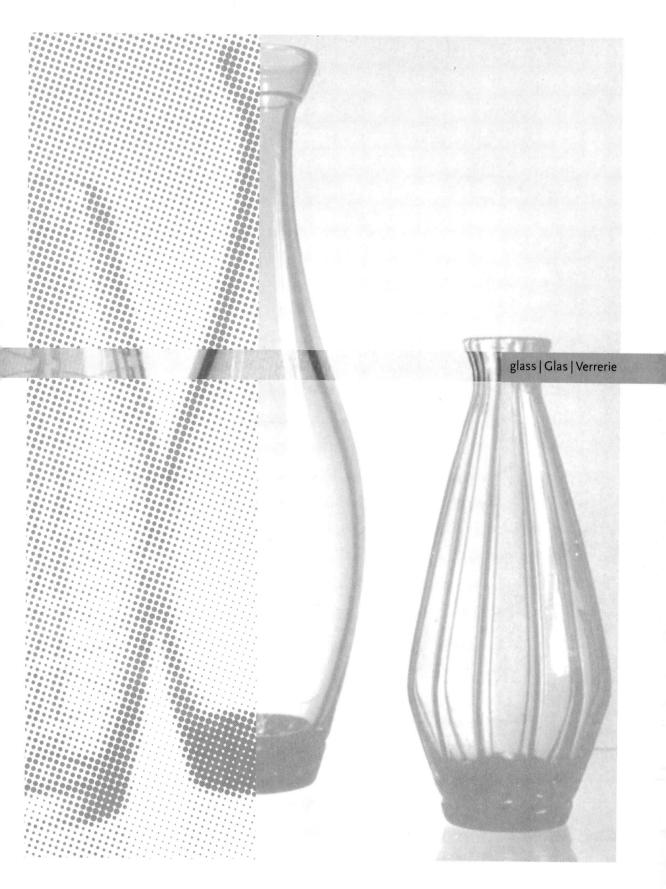

Ash bowl in amber glass designed by Lucrecia Moyano and made by Rigolleau Crystal Works SA

Hand-made oval vase (a unique piece) of clear lead crystal, inner wall fused with crackled metal oxide, designed by A. D. Copier and made by N. V. Nederlandsche Glasfabriek Leerdam.

BELOW and OPPOSITE: Glassware designed by Mrs Gunnel Nyman, made by Notsjo Glasbruk AB: clear-glass cream jug and sugar by vase with an outer section of clear glass and an inner section of either clyellow or lilac glass. EXTREME RIGHT: Vase of clear glass. All with mouter section of clear glass.

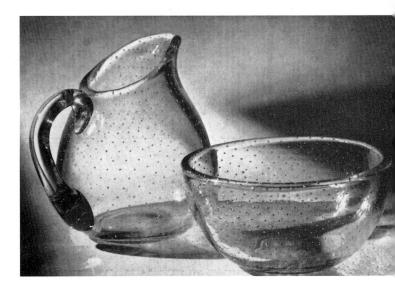

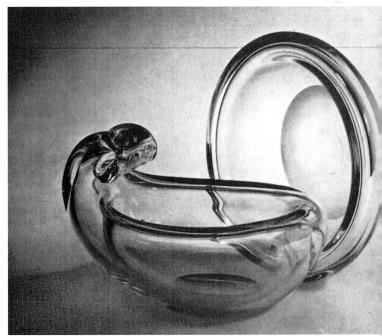

Double-walled glass bowls designed by Hugo Gehlin and made by Gullaskrufs Glasswork (The space between the two thicknesses of glass produces an interesting result.)

LEFT: Selena bowl with Moonstone lustre designed by Sven Palmquist and made by AB Orrefors Glasbruk.

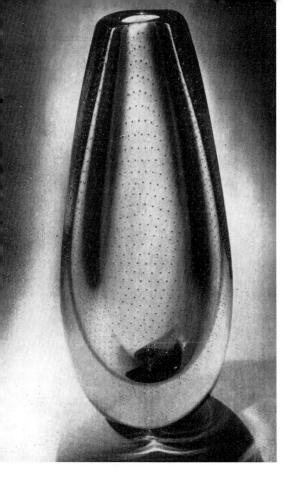

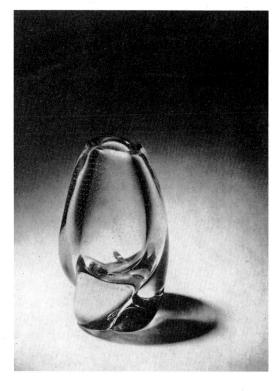

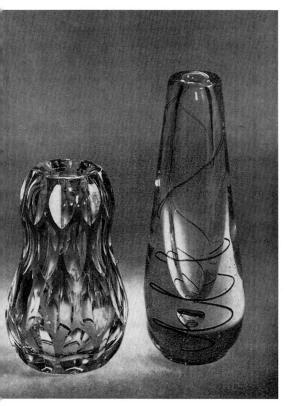

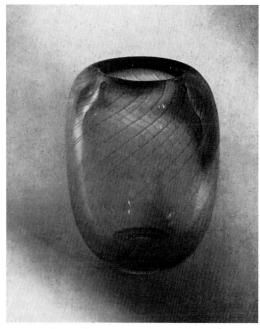

ABOVE: Vase in clear glass with smoke stripes, designed by Mrs Gunnel Nyman and made by Notsjo Glasbruk AB. LEFT: Coloured cut glass vase and vase with inlaid thread, designed by Elis Bergh and made by Kosta Glasbruk.

LEFT: Vases and bowl of thin lead crystal designed by Nils Landberg and made by AB Orrefors Glasbruk.

BELOW: Coloured decorative glassware in Ariel technique designed by Edvin Ohrström and made by AB Orrefors Glasbruk.

The design on the plate is in light blue on a clear crystal ground.

BELOW: Clear lead-crystal goblet engraved with ibex designed by A. D. Copier and made by N. V. Nederlandsche Glasfabriek Leerdam.

BELOW, CENTRE:

The Ariel vase, designed by Don Wier and made by Steuben Glass Inc., in clear hand-fashioned crystal with laid-on decoration.

The Shakespearean theme was engraved by copper wheel.

BELOW, RIGHT: Cut crystal oval bowl and matching candlesticks—the latter have removable lids which enable them to be used also for fruit or flowers—designed by G. L. de Snellman-Jaderholm and made by Riihimaki Glassworks.

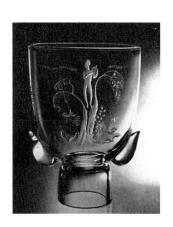

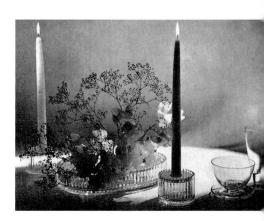

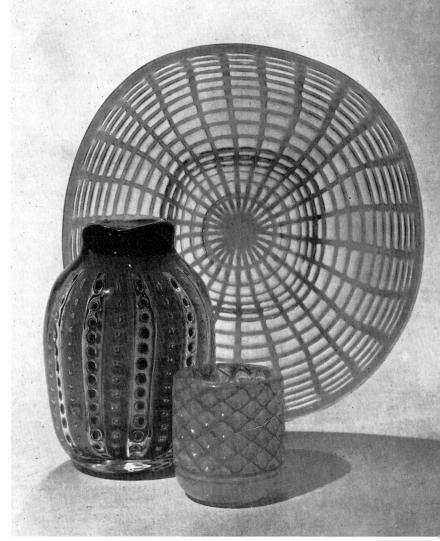

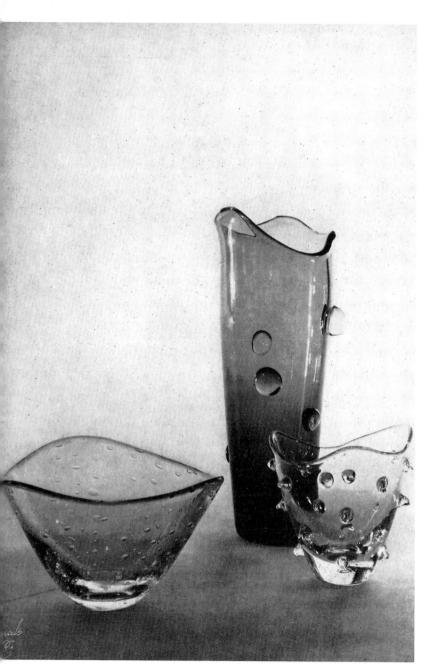

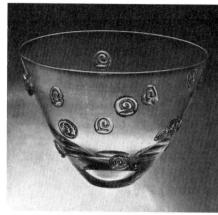

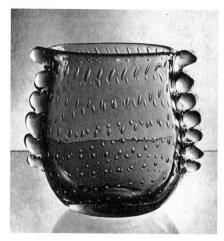

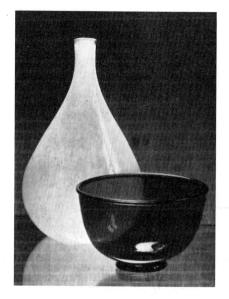

ft: Crystal bubble-glass bowl. Centre and right: Vase and bowl in soda glass, designed by Per Lütken and made by Holmegaards Glassworks A/S. th bowls are of white glass: vase is of coloured glass with clear glass 'knobs'. 3HT, TOP: Bowl of clear crystal with applied prunt decoration: umeter 3½ in. Hand-fashioned by Steuben Glass Inc. and designed in their Design Department. NTRE: Centrepiece in bubble glass, designed by Lucrecia Moyano d made by Rigolleau Crystal Works SA

d made by AB Orrefors Glasbruk.

- Slanting ashtray in heavy crystal, diameter 6½ in., designed and made by Steuben Glass.
- 10-in. lead crystal fruit dish, decorated with lightly cut lines forming an effective background to the heavily cut star motif, designed by Irene Stevens, ARCA, and made by Thomas Webb & Corbett Ltd.
- Engraved crystal bowl designed by Åse Voss Schrader and made by Studio Schrader.
- Heavy crystal engraved vase designed by Herman Bongard and made by Hadelands Glasverk.

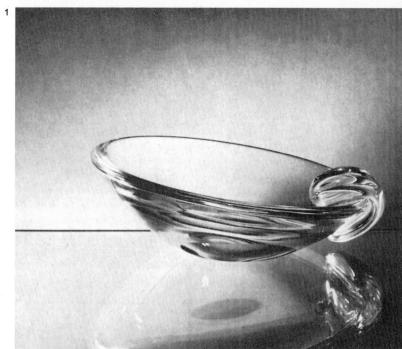

2

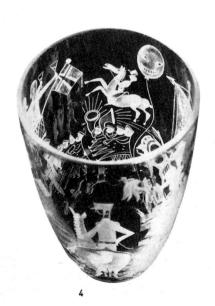

3

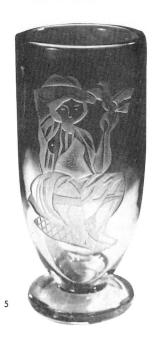

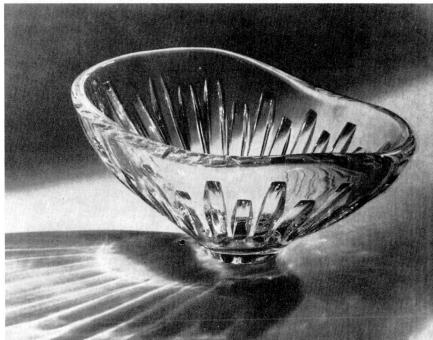

- 5. Heavy crystal vase made by Hadelands Glasverk.
- Cut glass crystal bowl designed by Arttu Brummer and made by Riihimaki Glassworks.
- Clear oven-proof glass mixing bowl with ringed fluting which
 acts both as measuring gradation and decoration, designed and
 made by The British Heat Resisting Glass Co. Ltd.
- Engraved crystal vase designed by Åse Voss Schrader and made by Studio Schrader.
- Vase and bowls in Graal technique, sepia and clear crystal, designed by Edward Hald and made by A B Orrefors Glasbruk.

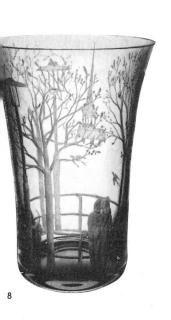

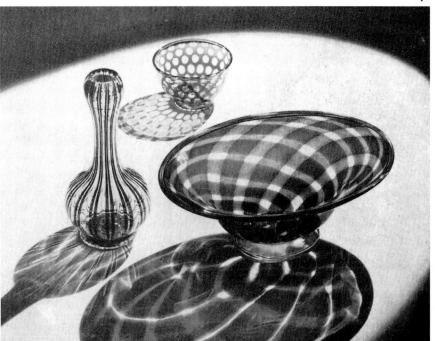

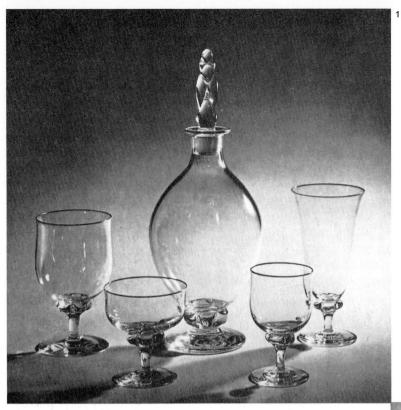

- Cut glass wine glasses and decanter made by Hadelands Glasverk.
- Lead crystal water set with decorative claw handle on jug, available in flint, amber, sapphire and sea green. Designed by W. J. Wilson, MSIA, and made by James Powell & Sons (Whitefriars) Ltd.

- Emerald green bubble glass water jug and tumbler, sherry decanter and glass, designed by G. L. de Snellman-Jaderholm and made by Riihimaki Glassworks.
- 4. Lamp-blown decanter and liqueur glass with opaque white embedded stripes designed by Fritz Lampl and made by Orplid Glass Ltd.

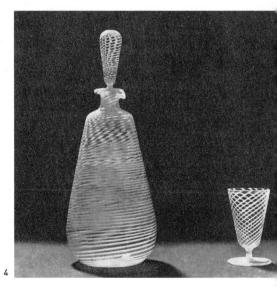

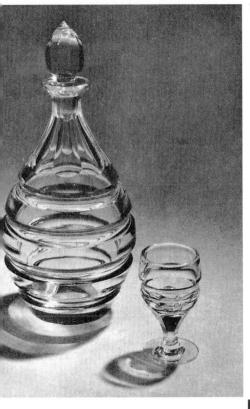

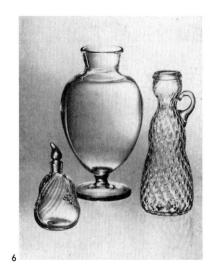

- Lead crystal sherry decanter and glass with deeply cut rings designed by Irene Stevens, ARCA, and made by Thomas Webb & Corbett Ltd.
- Perfume bottle and two vases designed by Edvin Ohrström and made by Sandviks Glasbruk.

Hand-blown whisky and cocktail glasses of clear soda glass with applied spiral decoration designed by Per Lütken and made by Holmegaards Glasværk A/S.

Glassware designed by Sven Palmqvist and made by AB Orrefors Glasbruk.

LEFT: Ravenna bowl, dark blue with brown and red decoration. RIGHT: Small Kraka bowl in light opal blue with 'net' design. BACKGROUND: Moonstone-coloured Selena vase.

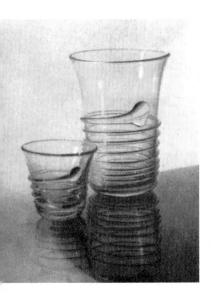

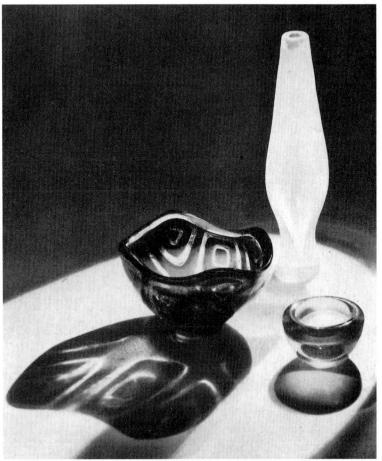

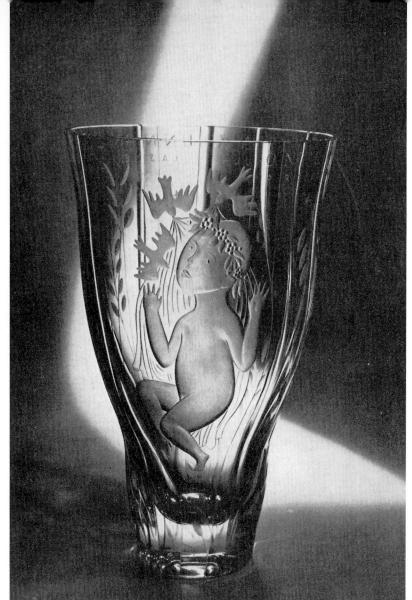

 Clear oven-proof glass gravy boat and pll traditional early Georgian design interple a modern material, designed and made British Heat Resisting Glass Co. Ltd.

- Engraved white crystal vase designed by Helena Tynell and made by Riihimaki Glassworks.
- 3. Hand-fashioned flat-sided clear crystal fish, height 3 in., designed and made by Steuben Glass.

nved English flint crystal tankard, ned by J. Granville Barker, ARCA, nade especially for Liberty & Co. Ltd.

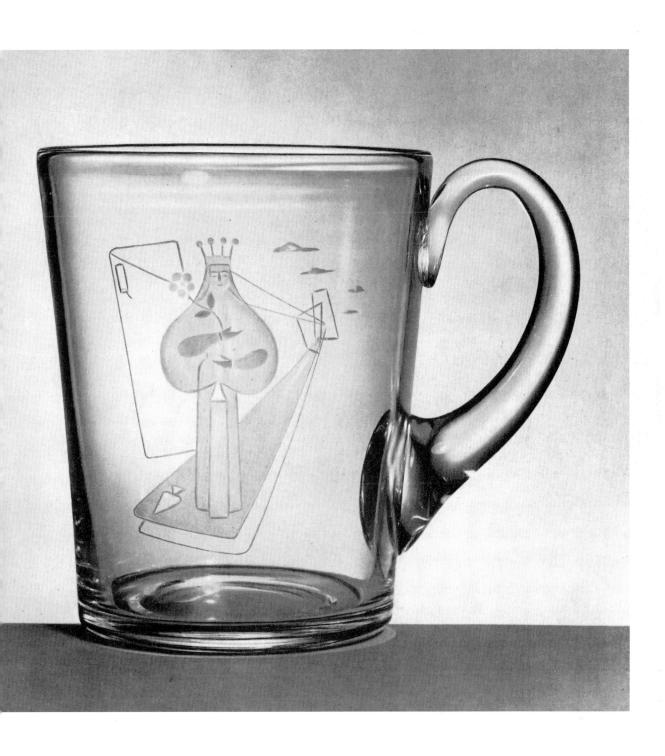

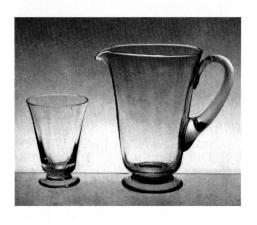

Lead crystal glass water set available in flint and amber, or flint with a ruby foot. Designer: W. J. Wilson, MSIA. Makers: James Powell & Sons (White-friars) Ltd (GB).

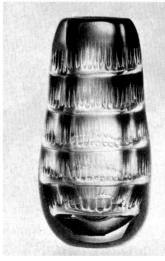

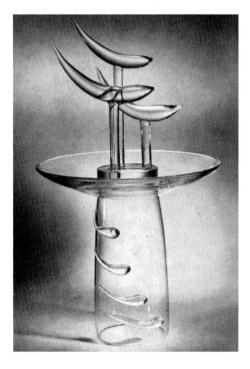

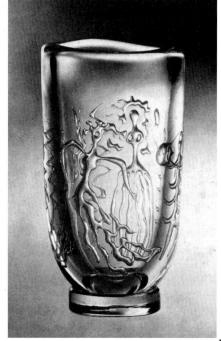

ABOVE: Northern Lights. Ariel vase in sombre purple, the design formed by the introduction of air into the wall of the glass. Designer: Edvin Öhrström. Makers: AB Orrefors Glasbruk (SWEDEN).

Glass fountain with symbolic figures, part seal, part bird, rising above the bowl on a wave-decorated pedestal. Designers and makers: Steuben Glass (usa).

Neckan's Dance. Ariel vase in clear crystal, the design formed by the introduction of air into the wall of the glass. Designer: Edvin Öhrström. Makers: AB Orrefors Glasbruk (SWEDEN).

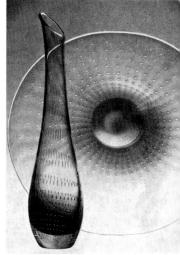

RIGHT: Ruby red crystal vase and turquoise blue plate. Designer: Vicke Lindstrand. Makers: AB Kosta Glasbruk (sweden).

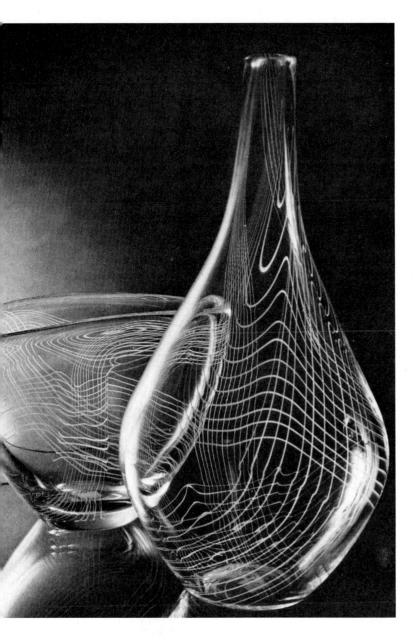

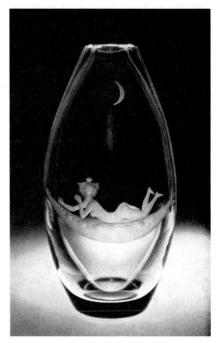

ABOVE: The Princess on the Pea (motif based on Hans Christian Andersen's fairy tale). Copper wheel engraving. Designer: Ingeborg Lundin. Makers: AB Orrefors Glasbruk (SWEDEN).

LEFT: White threads. Crystal bowl and vase with white glass threads. Designer: Vicke Lindstrand. Makers: AB Kosta Glasbruk (SWEDEN).

BELOW: Boot design tumblers with silk-screened decoration based on raffia or fibre boots. Designers and makers: Corning Glass Works (USA).

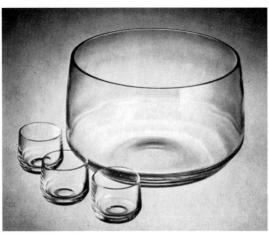

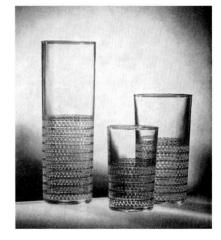

crystal punch, flower or owl with glasses to match. ners and makers: Tiffin nasters (U.S. Glass Co).

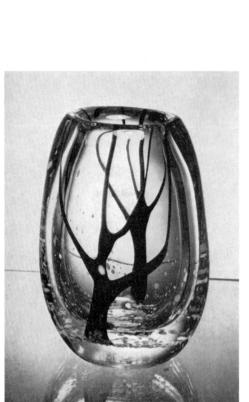

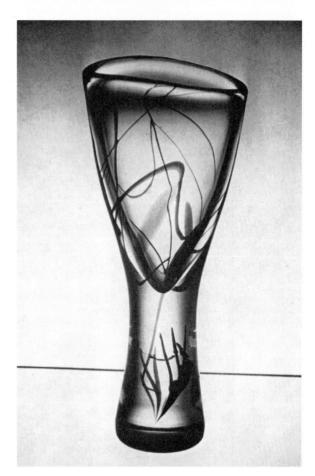

OPPOSITE: Ravenna bowls. Designer: Sven Palm Makers: AB Orrefors Glasbruk (SWEDEN).

ABOVE: Autumn. Crystal vase with multi-coloured decoration. ABOVE RIGHT: Abstracts. Clear crystal with black, blue and green inner decoration. RIGHT: Coral. Crystal with white inner decoration. All designed by Vicke Lindstrand. Makers: AB Kosta Glasbruk (SWEDEN).

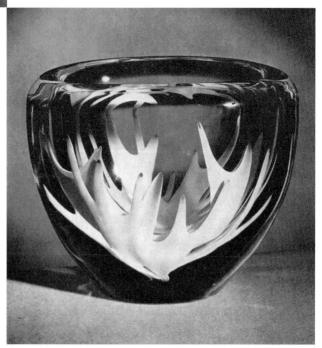

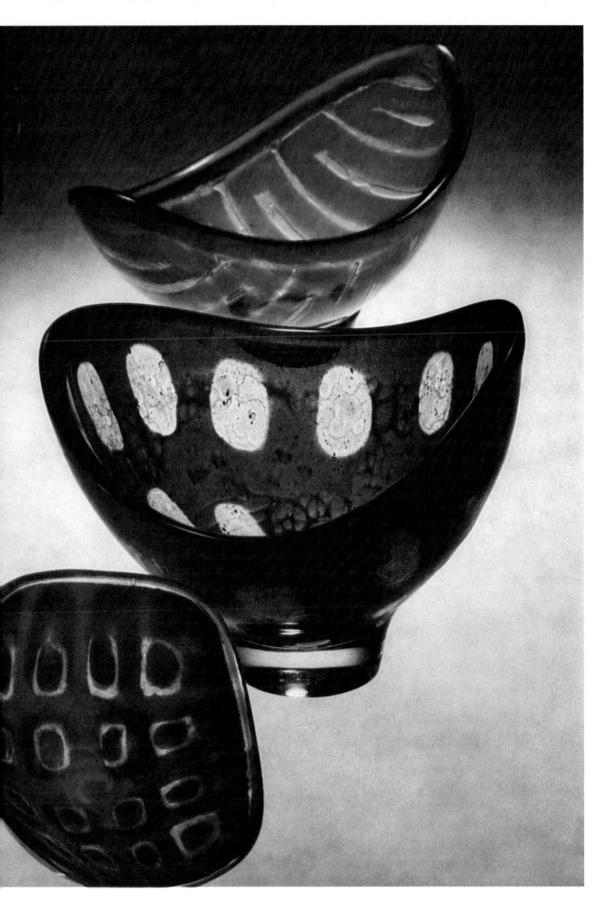

Crystal bowl with polychrome decoration on the inside. Designer: Vicke Lindstrand. Makers: AB Kosta Glasbruk (SWEDEN)

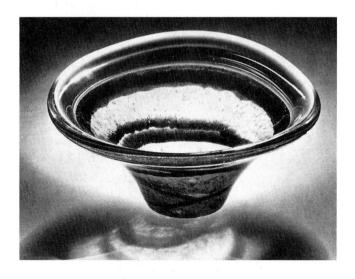

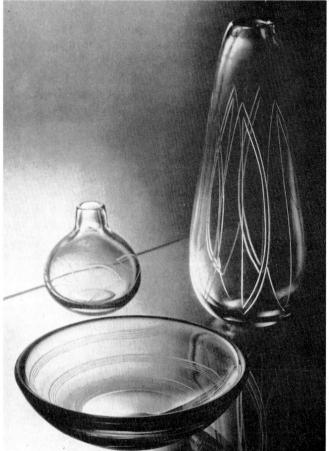

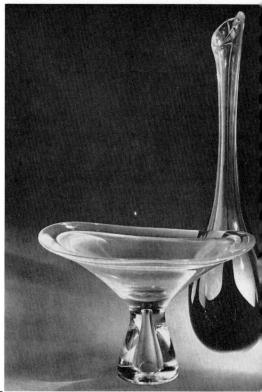

Cased crystal bowl with moon-codecoration, and bottle-shaped vasedark blue inner decoration. Des Vicke Lindstrand. Makers: AB Glasbruk (SWEDEN)

LEFT: Glass decorated in intaglio tech Designer: Monica Bratt. Makers: Rei Glasbruk for AB Nordiska Kom (SWEDEN)

BELOW: Engraved crystal vase. Des Ingeborg Lundin. Makers: AB On Glasbruk (SWEDEN)

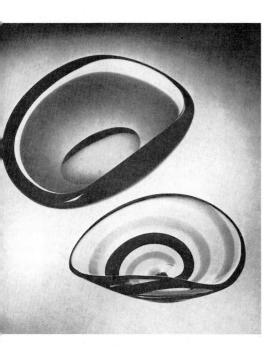

Crystal bowls with coloured decoration, one with ruby lining, the other with bands of blue, green and black. Designer: Vicke Lindstrand. Makers: AB Kosta Glasbruk (SWEDEN)

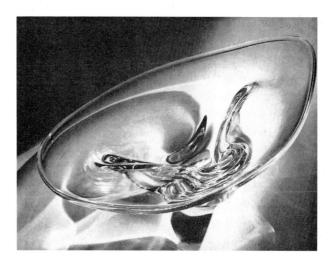

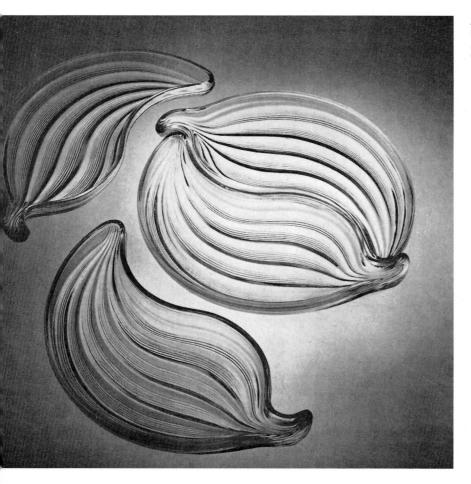

ABOVE: Clear crystal fruit bowl. Designer: Per Lütken. Makers: Holmegaards Glasværk A/S (DENMARK)

Hors d'oeuvres dishes, usable singly or interlocked. Designer: Nils Landberg. Makers: AB Orrefors Glasbruk (SWEDEN)

Unica pieces, clear crystal with opalescent treatment in blue and white. Designer: F. Meydam. Makers: NV Nederlandsche Glasfabriek 'Leerdam' (HOLLAND)

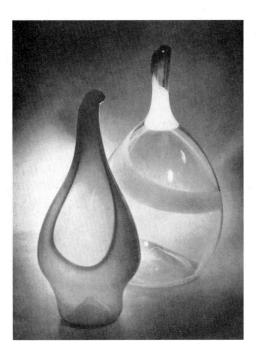

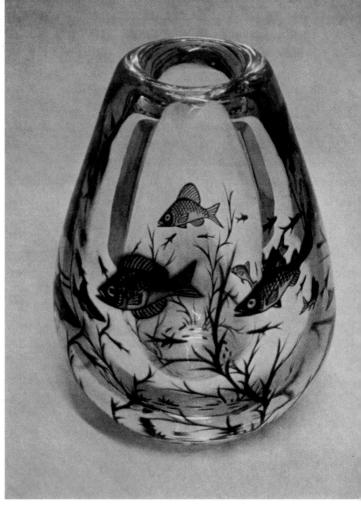

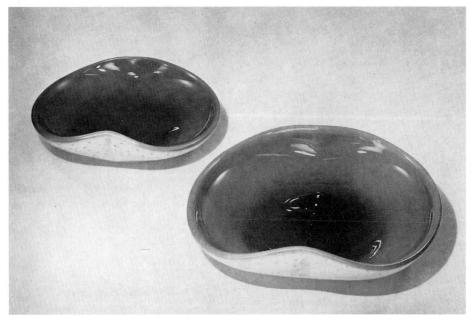

ABOVE: Crystal bowl in the technique. Designer: Edward Makers: AB Orrefors Glasbru (SW

Glass bowls lined with jade, or grey with bubbles in the crystal underside. Makers: I son Glass Works (USA)

r crystal vase, cut and polished. Designer: F. Meydam.
'ers: NV Nederlandsche Glasfabriek 'Leerdam'

"LAND)

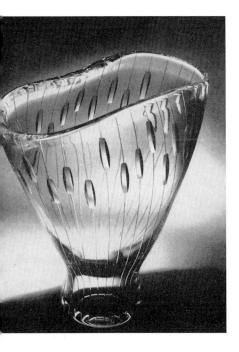

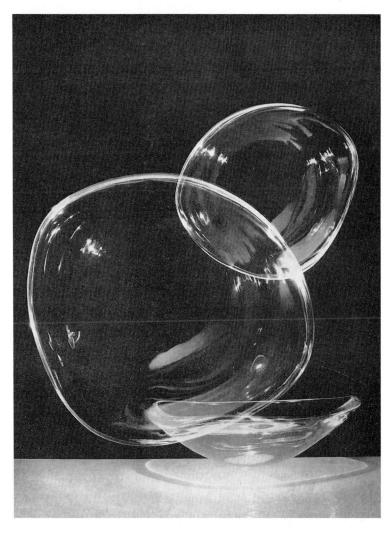

ABOVE: Bowls of white crystal. Designer: Tapio Wirkkala. Makers: Karhula-Iittala Glassworks (FINLAND)

Bowl of clear red crystal with bubble decoration. Designer: Lucrecia Moyano. Makers: Cristalerias Rigolleau sa

(ARGENTINA)

RIGHT: Vase and ashtrays in clear crystal. Designer: Per Lütken. Makers: Holmegaards Glasværk A/S (DENMARK)

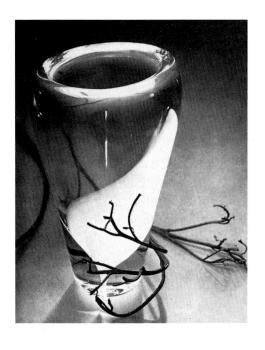

ABOVE: Thick crystal vase with opalcoloured decoration applied on the inside. Designer: Vicke Lindstrand. Makers: AB Kosta Glasbruk (SWEDEN)

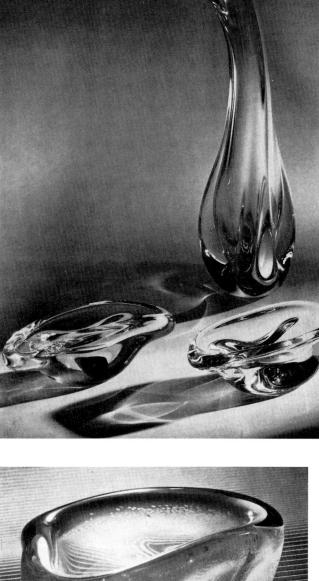

Unica bowl, clear crystal with white opal and light blue decoration, mounted on a wooden base. Designer: A. D. Copier. Makers: NV Nederlandsche Glasfabriek 'Leerdam' (HOLLAND)

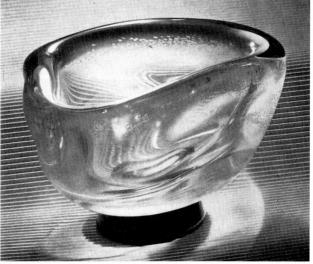

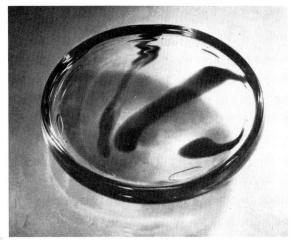

OW: Crystal bowl with opal-coloured coil if. Designer: Lucrecia Moyano. Makers: stalerias Rigolleau sa (ARGENTINA)

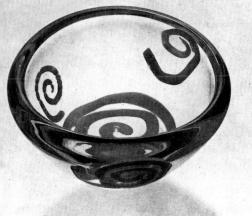

ABOVE: Clear crystal bowl decorated with free-drawn black lines and bubbles. Designer: Lucrecia Moyano. Makers: Cristalerias Rigolleau sA (ARGENTINA)

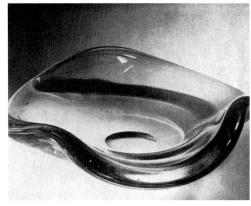

ABOVE: Unica bowl of clear crystal with opalescent treatment in blue. Designer: A. D. Copier. Makers: NV Nederlandsche Glasfabriek 'Leerdam' (HOLLAND)

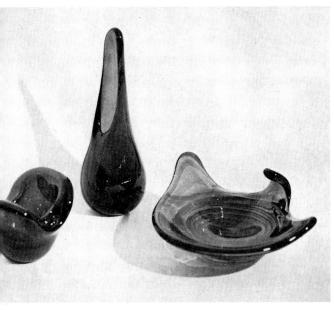

Blue soda-glass vases and bowl. Designer: Per Lütken. Makers: Holmegaards Glasværk a/s (DENMARK)

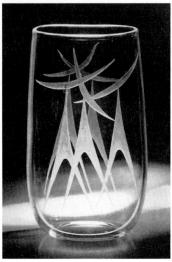

Engraved clear crystal vase. Designer: John Selbing. Makers: AB Orrefors Glasbruk (SWEDEN)

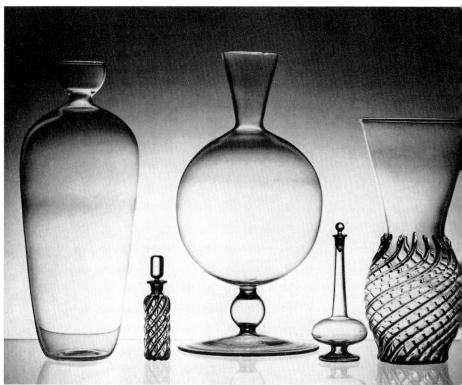

Blown crystal vases and scent bottles. Designer: Fritz Lampl. Makers: Orplid Glass Ltd (GB)

RIGHT: Clear crystal trinket jar. Designed and made by Tiffin Glassmasters (USA)

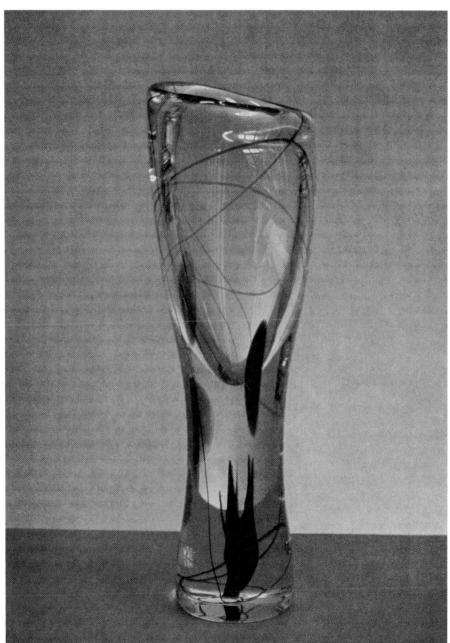

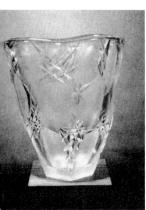

Hand-made crystal vase with colour incorporated in the body of the glass. Designer: Vicke Lindstrand. Makers: Kosta Glasbruk AB (SWEDEN)

LEFT: Cut-glass crystal flower vase. Designer: Jyunshiro Satoh. Makers: Kagami Crystal Glassworks (JAPAN)

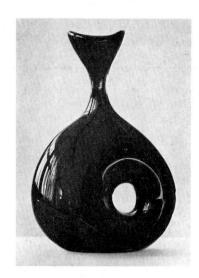

The shape of glass is revealed in its hilights as much as by its contours. Piero the mass of the lower body creates highlights which add interest to the shand further emphasize its intrinsic liquid quality

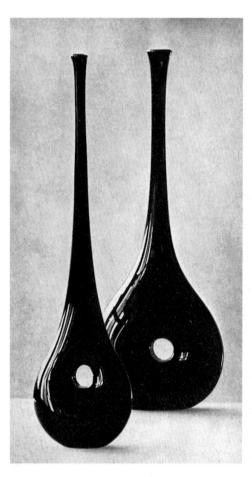

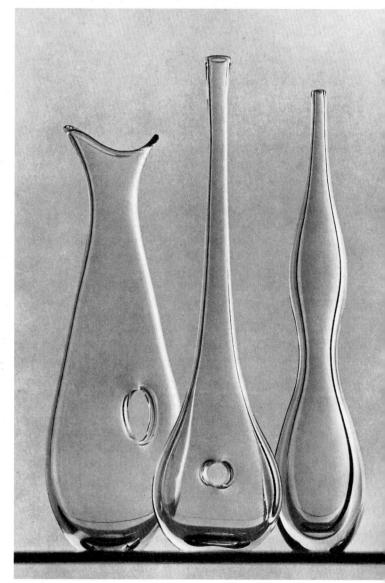

Vase Forms in black and clear glass. Designer: Vicke Lindstrand. Makers: AB Kosta Glasbruk (SWEDEN)

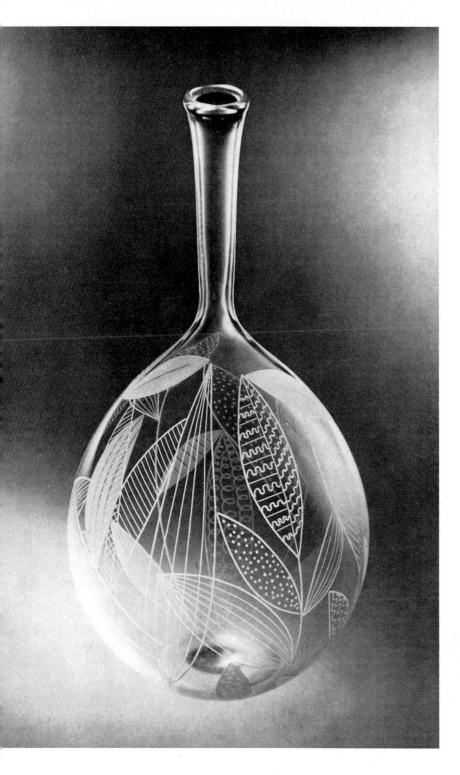

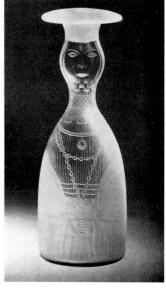

ABOVE: Engraved vase in clear crystal. Designer: Nils Landberg. Makers: AB Orrefors Glasbruk (SWEDEN). RIGHT: Crystal engraved liqueur bottle. Designer: Edward Hald. Makers: AB Orrefors Glasbruk (SWEDEN)

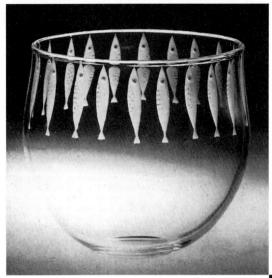

Engraved clear crystal bowl. Designer: Ingeborg Lundin. Makers: AB Orrefors Glasbruk (SWEDEN)

BELOW: Crystal flower vase engraved with figures of saints. Designer: Vicke Lindstrand. Makers: AB Kosta Glasbruk (SWEDEN)

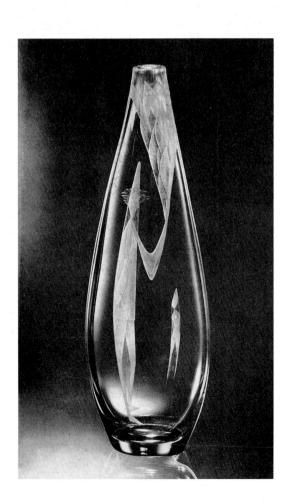

Engraved clear crystal vase. Designer: Sven Palmqvist. Makers: AB Orrefors Glasbruk (SWEDEN)

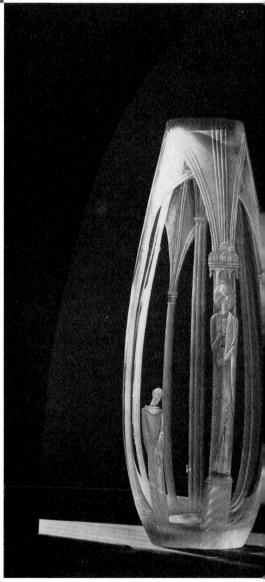

ABOVE: Cut crystal bowl. Designer: Tapio Wirkkala. Makers: Iittala Glassworks (FIN-LAND). RIGHT: Glass bowl in pastel colours, the shape derived from a floating lace handkerchief. From Liberty & Co. Ltd. Designer and maker: Paolo Venini of Murano (ITALY)

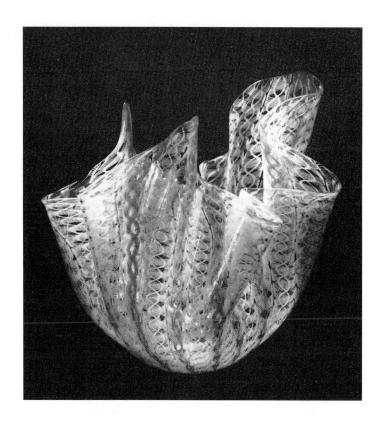

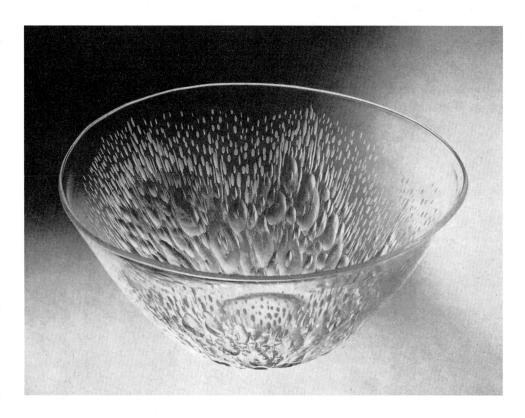

Clear crystal bowl engraved with a 'splash' motif ascending from the base. Designer: Edvin Öhrström. Makers: AB Orrefors Glasbruk (SWEDEN)

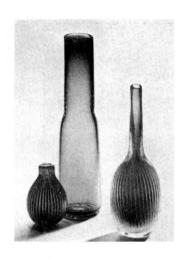

Ariel blown glass vases, two with exterior decoration of air-filled clear crystal streaks. The tallest is 13 inches high. Designer: Edvin Öhrström. Makers: AB Orrefors Glasbruk (SWEDEN)

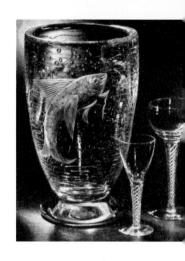

Engraved crystal vase, 12 inches high, sherry and hock glasses with air-f twisted stems. Designers and mal Stuart & Sons Ltd (GB)

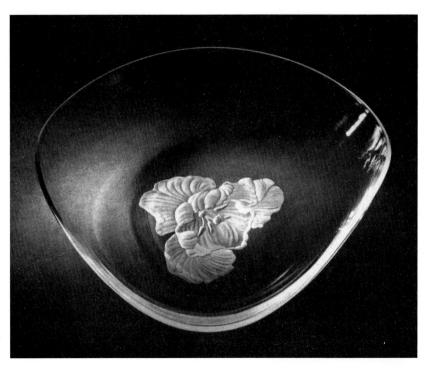

Tulip Bowl. Shallow, three-sided bowl of clear crystal sheared to a curving line around the rim and engraved with a tulip. Width 1114 inches. Designer: Don Wier. Makers: Steuben Glass (USA)

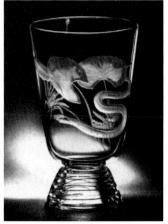

Clear crystal vase, 12 inches high, with Snake and Frogs engraving designed by John Nash, RA, for Steuben Glass (USA)

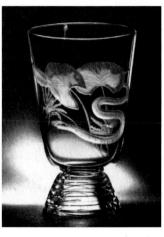

Wood Anemone. Blown clear crystal sha plate, 13½ inches diameter, engraved copper wheel with a design specially cre by wood engraver Reynolds Stone Steuben Glass (USA)

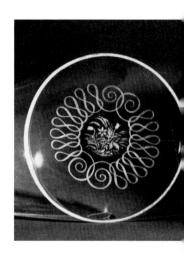

r crystal carafe and drinking glasses with aved linear design. The carafe measures ches at the base and, with a glass on top, inches high. Designer: Edvin Öhrström. kers: AB Orrefors Glasbruk (SWEDEN)

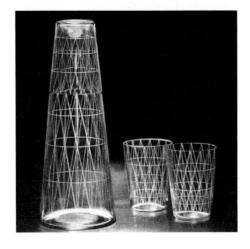

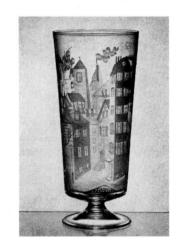

Engraved vase of clear crystal, 11\frac{1}{4} inches high. Designer: Nils Landberg. Makers: AB Orrefors Glasbruk (SWEDEN)

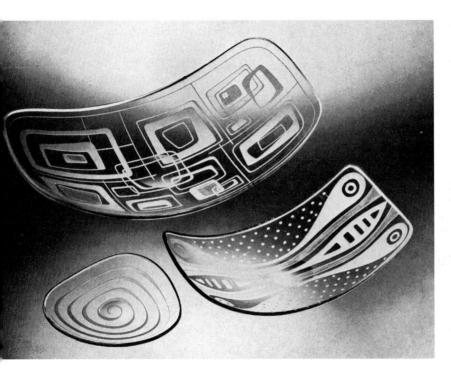

Clear crystal blown glass vase, 8½ inches high, with engraved decoration. Designer: Bengt Orup. Makers: AB Johansfors Glasbruk (SWEDEN)

ar crystal blown glass dishes with engraved oration. The largest is 11 inches by 4 hes, the smallest $2\frac{1}{2}$ inches in diameter. signer: Nils Landberg. Makers: AB Orres Glasbruk (SWEDEN)

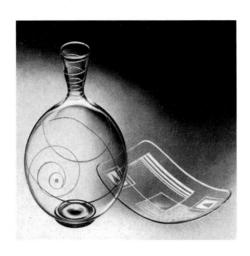

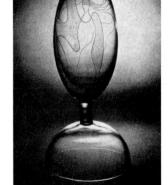

ar crystal blown glass vase 103 inches high, l dish with engraved linear design. Deter: Nils Landberg. Makers: AB Orrefors sbruk (SWEDEN)

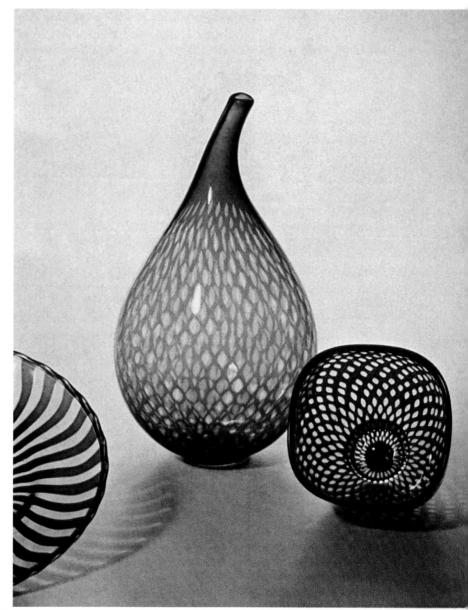

Orystal vase, about 12 inches high, and bowls in the *Graal* technique. Designer: Edward Hald. Makers: AB Orrefors Glasbruk (SWEDEN)

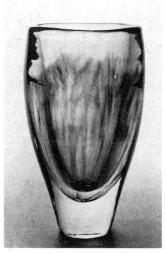

LEFT: Steel-grey crystal vase, 6 inches high, on clear crystal base. Designer: Edvin Öhrström. RIGHT: Clear crystal bowl, engraved decoration giving an under-water effect of floating shapes; diameter 7 inches. Designer: Ingeborg Lundin. Makers: AB Orrefors Glasbruk (SWEDEN)

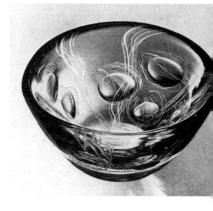

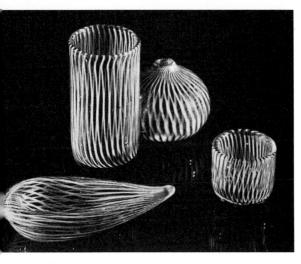

ran glass. Vase, 6 inches high; bowls $4\frac{3}{4}$ and $3\frac{1}{4}$ inches high; and mental dish. Designer: Nanny Still. Makers: Riihimaki Glassworks CAND). BELOW: Hand blown clear crystal vases and bowl. The taller is $12\frac{1}{2}$ inches high, the bowl $8\frac{1}{4}$ inches wide on a 3-inch base. igner Nils Landberg. Makers: AB Orrefors Glasbruk (SWEDEN)

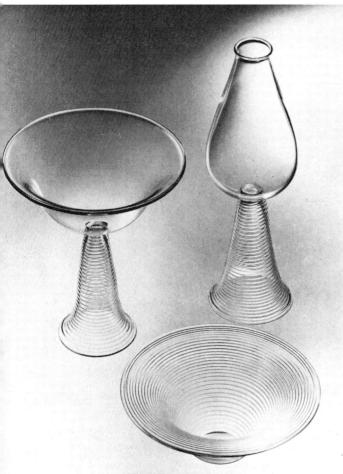

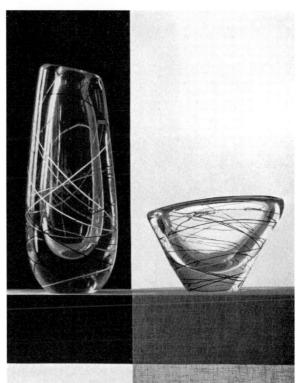

Clear crystal vase and bowl with spun thread decoration in black, white and red. Height of vase 10³4 inches, diameter of bowl 6 inches. Designer: Vicke Lindstrand. Makers: AB Kosta Glasbruk (SWEDEN)

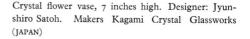

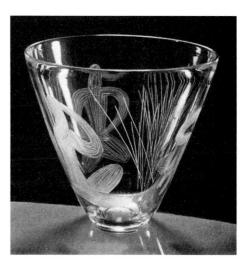

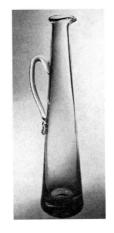

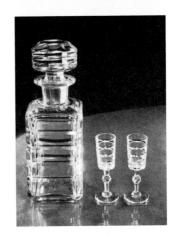

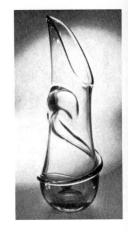

Oil, vinegar and mustard bottles in coloured or clear crystal glass. Designer: R. Stennett-Willson, MSIA. Made for J. Wuidart & Co. Ltd (GB). RIGHT: Blown glass flower jug, $9\frac{3}{4}$ inches high. Designer: Arthur Percy. Makers: Gullaskrufs Glasbruks AB (SWEDEN)

Cut crystal decanter and wine glasses. Designer: Jyunshiro Satoh. Makers: Kagami Crystal Glassworks (JAPAN). RIGHT: Blown glass vase, 14½ inches high, with applied swirl decoration. Designer: Hugo Gehlin. Makers: Gullaskrufs Glasbruks AB (SWEDEN)

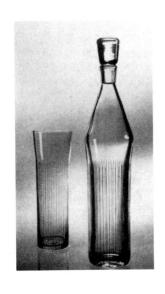

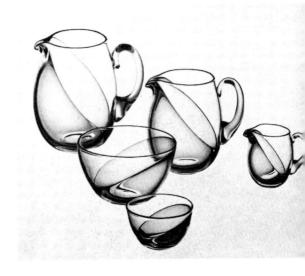

Cone-shaped decanter with a wide, steady base and diagonally cut teardrop stopper. Capacity 36 fluid ounces. Designers and makers: Steuben Glass (USA). FAR RIGHT: Heavy crystal jug and vase. Designer: Timo Sarpaneva. Makers: Karhula-Iittala Glassworks (FINLAND)

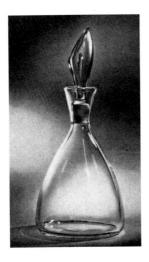

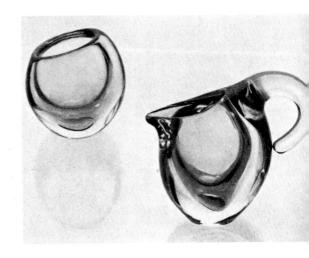

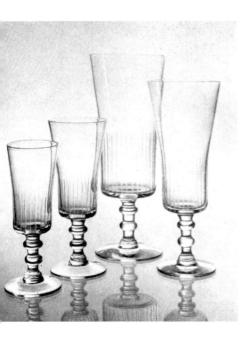

Glasses from the *Frances* wine service made in clear crystal and in two colours. Designer: R. Stennett-Willson, MSIA. Made for J. Wuidart & Co. Ltd (GB)

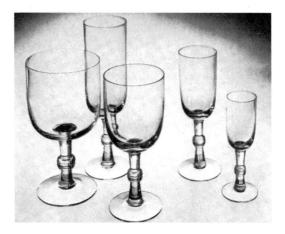

ove: Engraved clear crystal wine glasses from the Chevalier vice. Designer: Bengt Orup. Makers AB Johansfors asbruk (SWEDEN). BELOW: Crystal champagne glass with graved bamboo design. Designer: Jyunshiro Satoh. akers: Kagami Crystal Glassworks (JAPAN)

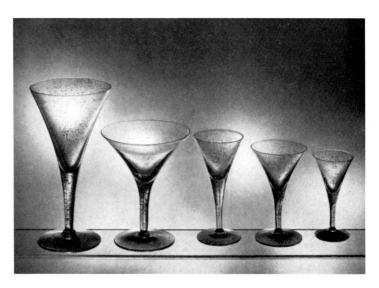

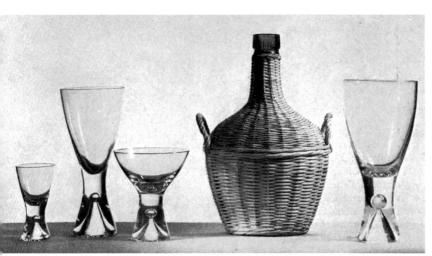

Crystal wine glasses decorated gold or palladium. Designers and makers: Imperial Glass Corporation (USA)

Wicker-covered wine pitcher, and crystal glasses with ball and cone air cavity in base. Designer: Tapio Wirkkala. Makers: Karhula-Iittala Glassworks (FINLAND)

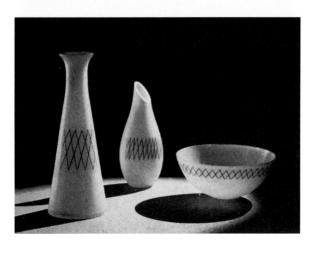

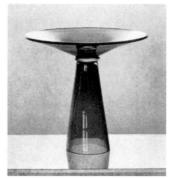

Blown crystal compote in ca charcoal glass. Base 8 inches hil bowl 8½ inches wide. Design Carl E. Erickson. Make Erickson Glassworks (USA)

White opaque crystal vases and bowl, black decoration. Designer: Paul Kedelv. Makers: AB Flygsfors Glasbruk (SWEDEN)

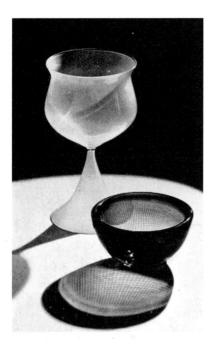

White crystal vase, 9 inches high, and etched bowl. Designer: Sven Palmqvist. Makers: AB Orrefors Glasbruk (SWEDEN)

Clear crystal vases decorated with spirals of black glass. Heights range from 8½ inches to to 18½ inches. Designer: Nils Landberg. Makers: AB Orrefors Glasbruk (SWEDEN)

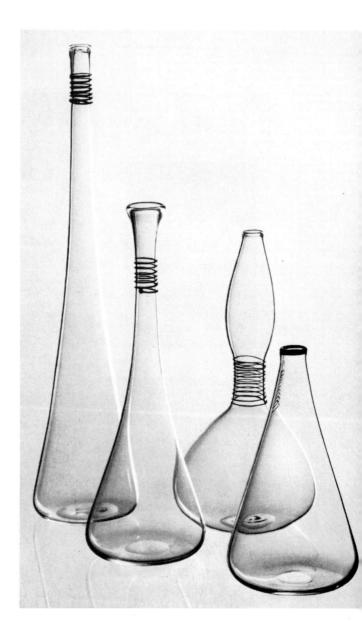

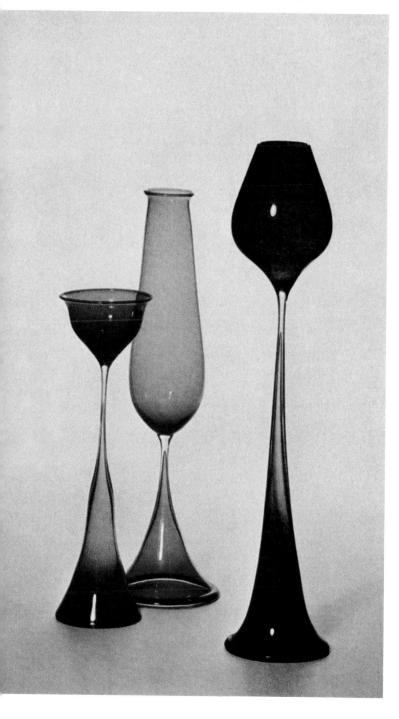

Vases in coloured crystal in sizes ranging from about 12 inches tall. Designer: Nils Landberg. Makers: AB Orrefors Glasbruk (SWEDEN)

Clear crystal vase, 11 inches high, with white thread decoration; it is also made with the thread design in black. Designer: Vicke Lindstrand. Makers: AB Kosta Glasbruk (SWEDEN)

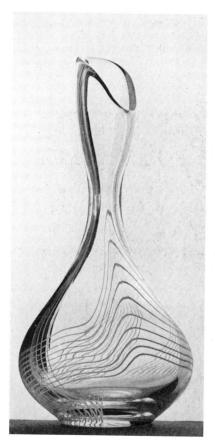

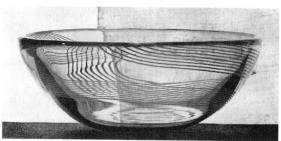

Clear crystal bowl, diameter 7‡ inches, also with black or white thread decoration. Designer: Vicke Lindstrand. Makers: AB Kosta Glasbruk (SWEDEN)

The treatment of glass assumes decorative qualities on account of shape, colour, opacity, texture, dimpling and bubbling, apart from whether or not it carries any applied surface cutting or etching. The growing tendency to appreciate glass as a fluid form, rather than as a mere vehicle for applied decoration, has resulted in many interesting technical developments which have sought to embody expressive design forms within the glass itself and to exploit the effects of internal refraction and surface reflection with great effect. The net result, as is well exemplified, has been to emphasise the natural beauty of the material, regardless of whether its raison d'être leans toward the purely decorative or the strictly functional.

When surface decoration is applied, as in the examples shown on these first pages, it has often been done in a manner which either brings life, and sometimes comedy, to a rather ordinary shape, or which lends emphasis and 'body' to a shape which stands to gain in quality from such treatment.

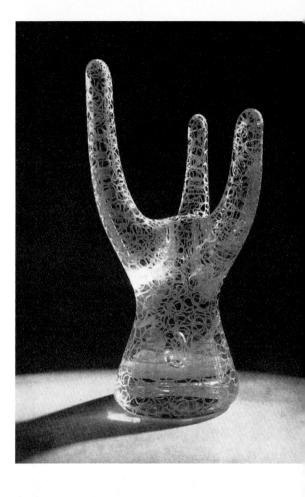

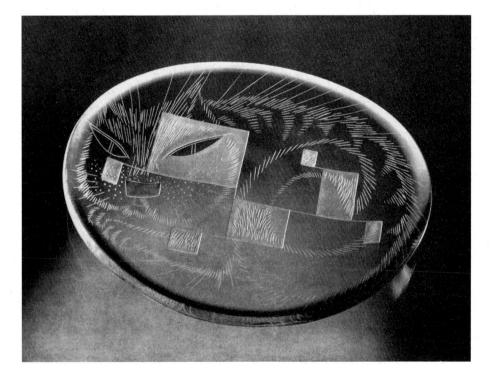

ABOVE: Vegetal form crystal sculture about 7 inches high. Design Bengt Orup. Makers: AB Johansfe Glasbruk (SWEDEN). LEFT: Hello Cengraved crystal plate, 11½ inch diameter. Shape designed by Hele Tynell; engraving by Th. Kap Makers: Riihimaki Glassworks (Fland)

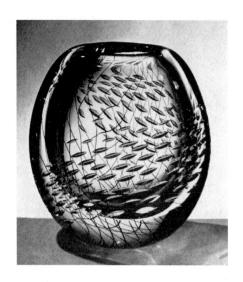

ABOVE: Atlantis Clear crystal vase, cut decoration fish on a background of black nets embodied in the glass. Designer: Vicke Lindstrand. Makers: AB Kosta Glasbruk (SWEDEN). RIGHT: Crystal flower bowl with a graduated bubble pattern, and ashtray with painted design in red and black. Designer: Lucrecia Moyano. Makers: Cristalerias Rigolleau (ARGENTINA). BELOW: Clear crystal bowls with engraved exterior decoration; 10½, 6½ and 4¼ inches in diameter. Designer: John-Orwar Lake. Makers: Ekenäs Glasbruk AB (SWEDEN)

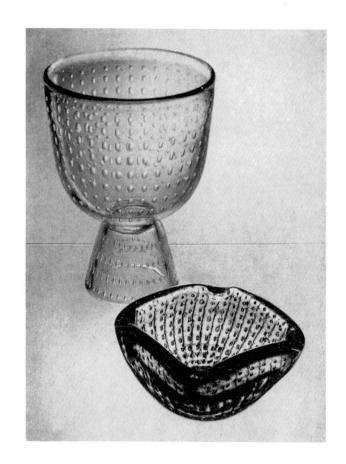

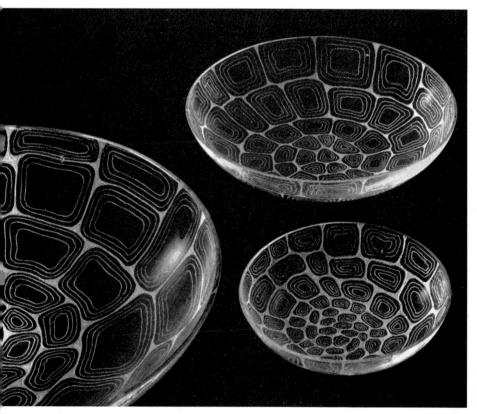

ABOVE: Crystal vase decorated in the Ariel technique. Designer: Edvin Öhström. Makers: AB Orrefors Glasbruk (SWEDEN)

Crystal vases in clear green, bluish and deep violet colourings. Designer: Kaj Franck. Makers: O/Y Wärtsiläconcern AB Notsjö Glassworks (FIN-LAND)

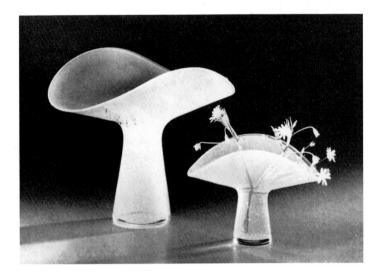

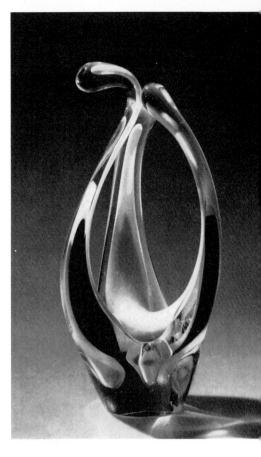

ABOVE: White crystal vases, $7\frac{1}{2}$ and $5\frac{1}{2}$ inches high. Designer: Sven Palmquist. Makers: AB Orrefors Glasbruk (SWEDEN)

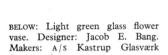

ABOVE: Thin-walled 'muslin' glass vase and compote. Colours: champagne, lustre, or clear crystal. Designer: Liskova. Makers: Moser Glassworks (czechoslo-VAKIA)

ABOVE: Fantasia crystal table decoration from the multi-color Coquille series. Makers: AB Flygsfors Glasbruk (SWEDEN)

BELOW: Deep pedestal bowl in clear crystal on cone-shape base ornamented by elliptical crystal forms. Designers an makers: Steuben Glass (USA)

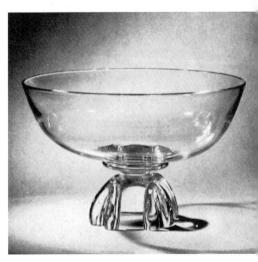

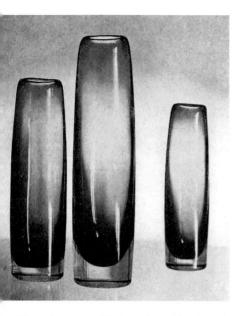

VE: Two-colour vases: blue/crystal, amethyst/crystal; low/white opalescent crystal. 6, 7, and 9 inches high, signer: Arthur Percy. Makers: Gullaskrufs Glasbruks (SWEDEN)

ow: Abstract form in high-polished crystal, Designer: chel Daum. Makers: Daum Cristallerie de Nancy

ANCE)

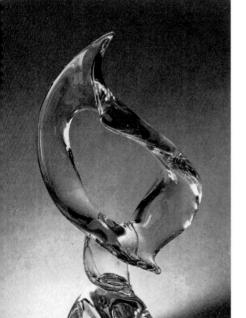

BELOW: Matching vase and bowl of Venetian glass, in tones of lilac and green with concentric pattern in yellow. Designer: Flavio Poli. Makers: Seguso, s.r.l. (ITALY)

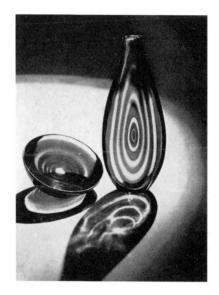

ABOVE: *Unica* crystal vases; orange, blue and yellow colourings. 10, 9½ and 14 inches high. Designer: F. Meydam. Makers: NV Koninklijke Nederlandsche Glasfabriek Leerdam (HOLLAND)

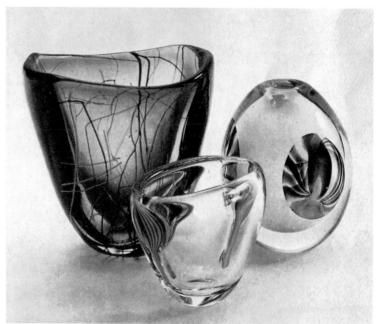

ABOVE: Serica vases, 5, 3 and 4½ inches high. Lined vase at left is in blue crystal; centre, clear with coloured opal; right, white opal with three coloured eyes. Designer: Iep Valkema. Makers: NV Koninklijke Nederlandsche Glasfabriek Leerdam (HOLLAND)

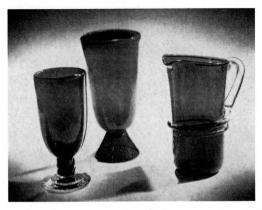

ABOVE: Vases and jug in ruby and clear crystal glass. Designed by R. Stennett-Willson, MSIA. For J. Wuidart & Co. Ltd (GB). RIGHT: Venetian blown glass pitcher; applied frontal decoration in bright colours. Height 17½ inches. Designer: Dino Martens. Makers: Vetreria Aureliano Toso (ITALY)

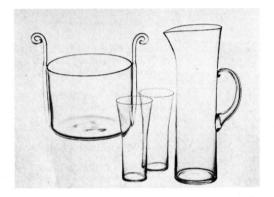

ABOVE: Clear crystal water set and bowl. Designer: Ingeborg Lundin. Makers: AB Orrefors Glasbruk (SWEDEN). BELOW RIGHT: Wheat-ear wine service and decanter in clear cut crystal. Designer: Irene Stevens, ARCA. Makers: Webb Corbett Ltd (GB). BELOW: Coloured glass tumblers, and decanters with applied decoration. Designer: Kjell Blomberg. Makers: Gullaskrufs Glasbruks AB (SWEDEN)

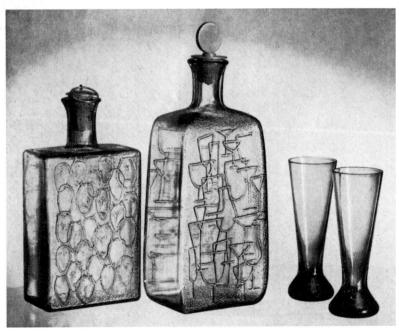

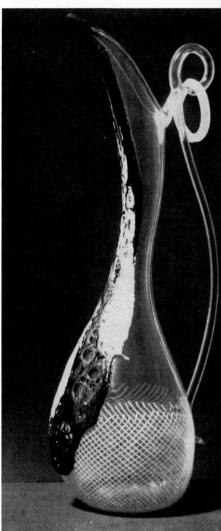

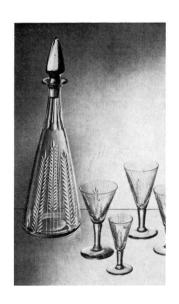

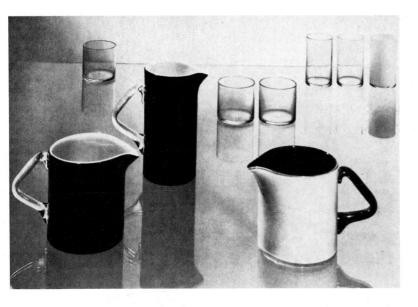

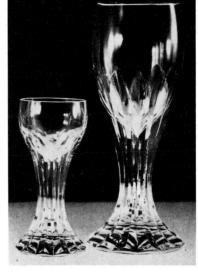

ABOVE: Vendôme wine service in cut crystal. Designer: Georges Chevalier. Makers: Cie. des Cristalleries de Baccarat (FRANCE)

ABOVE: Blown glass tumblers and black and white opaque glass jugs. Designer: Nanny Still. Makers: Riihimaki Glassworks (FINLAND)

RIGHT: Water jug and stackable tumblers in clear and coloured glass. Designer: Saara Hopea. Makers: 0/Y Wärtsilä-concern AB Notsjö Glassworks (FINLAND)

BELOW: Crystal bowl decorated in the *Graal* technique; clear crystal wine service. Designer: Edward Hald. Makers: AB Orrefors Glasbruk (SWEDEN)

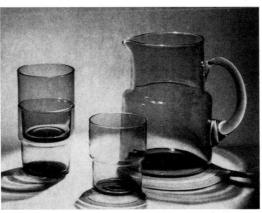

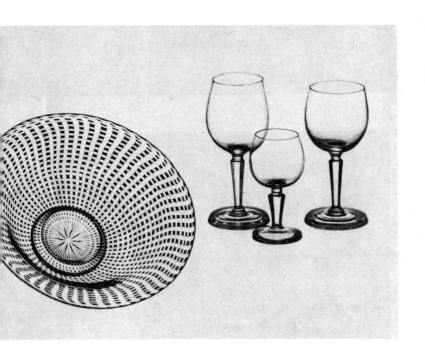

ABOVE: Venetian glass pitcher with black and white Zanfirico decoration. Height 19½ inches. Designer: Dino Martens. Makers: Vetreria Aureliano Toso (ITALY)

Crystal vase and bowls; colour decoration embodied in the glass by the *Kraka* and *Ravenna* techniques. Designer: Sven Palmquist. Makers: AB Orrefors Glasbruk (SWEDEN)

ABOVE: Clear crystal jug, one of a series representing bird shapes; colour accents on details. Designer: Lucrecia Moyano. Makers: Cristalerias Rigolleau (ARGENTINA)

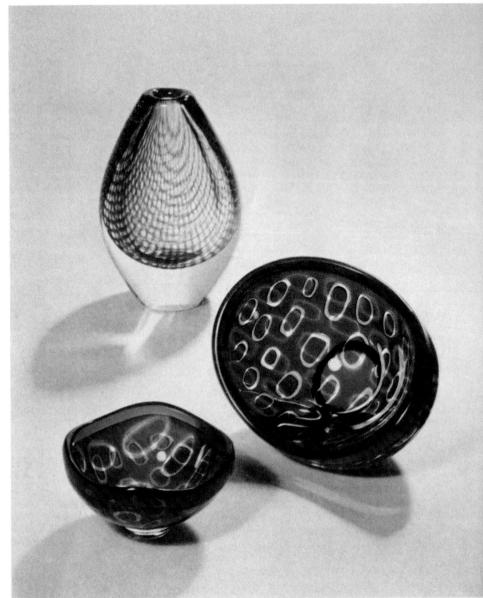

FAR LEFT: Palma clear crywine service. Designer: Valkema. Makers: NV Konlikje Nederlandsche Glabriek Leerdam (HOLLA LEFT: Fruit dish and bowsmoked crystal glass. Desig Monica Bratt. Makers: Imyre Glasbruk AB (SWEDEN

GHT: Set of table glasses in clear crystal on coloured base. ssigner: Helena Tynell. Makers: Riihimaki Glassworks NLAND)

Low: Clear crystal Kardinal wine service. Designer: ngt Orup. Makers: AB Johansfors Glasbruk (SWEDEN)

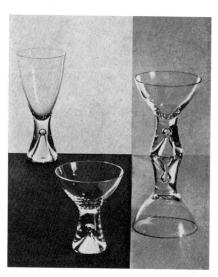

ABOVE: Clear crystal wine service on heavy crystal base. Designer: Tapio Wirkkala. Makers: Karhula-Iittala Glassworks (FINLAND)

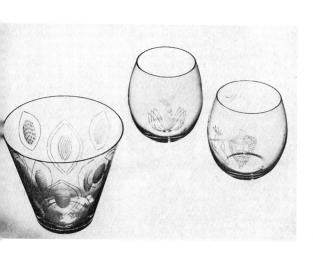

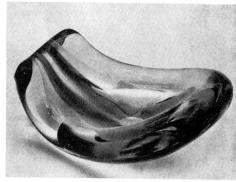

ABOVE: Unica bowl in light violet crystal with opal centre. Designer: A. D. Copier. Makers: NV Koninklijke Nederlandsche Glasfabriek Leerdam (HOLLAND). LEFT: Clear crystal engraved glasses. Designer: Hilkka Liisa Ahola. Makers: 0/Y Wärtsilä-concern AB Notsjö Glassworks (FINLAND)

The creation of decorative new designs in glass continues to challenge, as it always has, the imagination skill of designers, chemists, glass-blowers and moulders. With virtually no change in the equipment used, vations on established techniques are under constant development and each year new forms emerge to make contribution to the collective history of the art, perhaps after prolonged experiment and many disappointment.

There appears to be a growing interest in the possibilities of pattern, texture and colour fused into the be of the glass itself in many of the decorative pieces produced, particularly in Italy. Sometimes this achieve opacity akin to that of ceramic ware; other times ribbons of opaque or translucent colour trace patterns of under the surface of clear or tinted glass, attaining decorative effects which harmonise with the forms to we they are applied.

The cost of the raw material being relatively insignificant, freedom can be exercised in the amount of gused and the pieces illustrated vary from delicate thin-walled vessels to heavy, massive forms with lentice properties which supplement the reflections of their polished surfaces.

Whatever the form of decoration applied, glass remains a fusible material and most of the outstand designers and craftsmen working in this medium preserve its basic characteristics in the pieces they prod The hard, incised decoration which did much to destroy the intrinsic beauty of glass, although still practiby some of the traditional factories, has largely given way to much freer and more appropriate decorate treatments.

Sculpture in crystal in Ariel, Graal, and other techniques. Designer: Edvin Öhrström. Makers: AB Orrefors Glasbruk (SWEDEN)

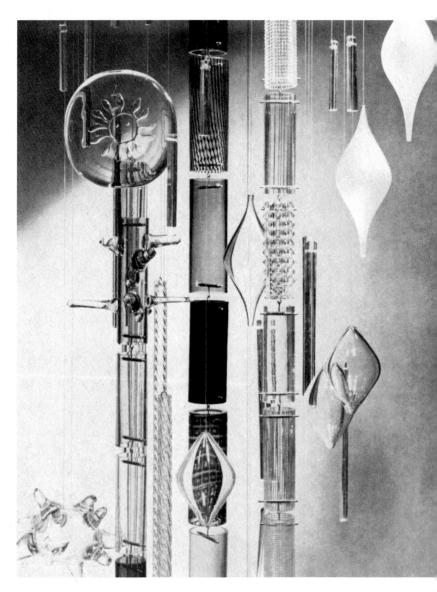

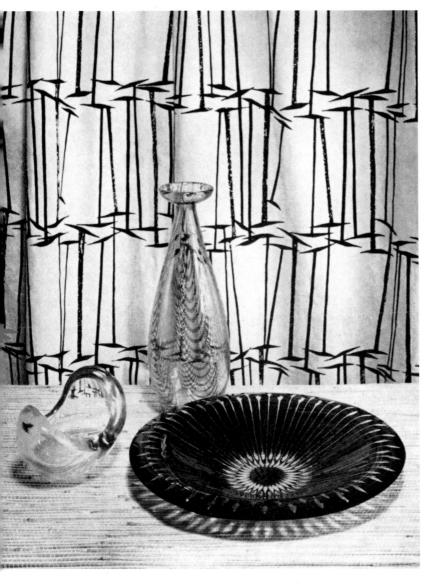

LEFT: Glassware by student designers. Clear crystal bowl by Ian Gordon, Edinburgh College of Art; red-flashed bowl with cut and engraved decoration by Charles Richards, Royal College of Art; vase with festooned thread decoration by M. Harris, Stourbridge College for Further Education (GB) (Courtesy: Glass Manufacturers' Federation)

BELOW: Free form, 24 inches high, in clear, high-polished crystal. Designer: Michel Daum. Makers: Daum Cristallerie de Nancy (FRANCE)

VE: Bent red-flashed glass bowl with engraved oration. Designer and maker: Geoffrey Baxter, s.RCA, Royal College of Art (GB)

HT: Heavy crystal bowl, 8 inches diameter, orated yellow lustre. Designer: Stanislav bensky. Makers: Zelezny Brod Glassworks ECHOSLOVAKIA)

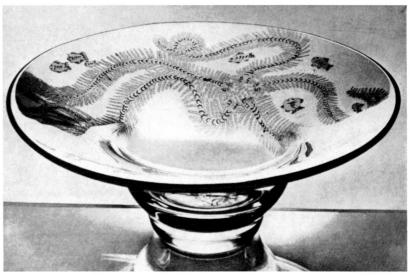

BELOW: Thick crystal vase with sandblasted decoration. Designer: Victor Berndt. Makers: AB Flygsfors Glasbruk (SWEDEN)

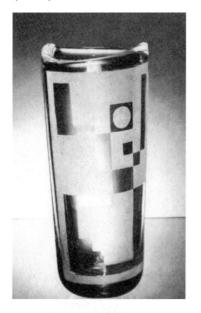

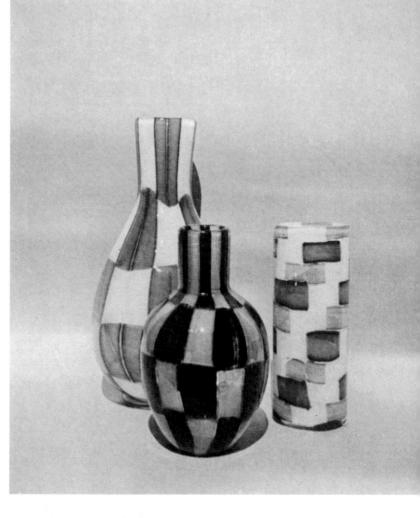

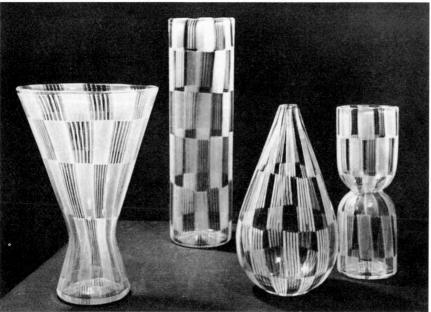

ABOVE AND LEFT: Hand-made Pevases, between 10 and 15 inches made up of small pieces of colc Venetian spun glass blown together; opaque and transparent effects are ob able in this technique. Designer: E Barovier. Makers: Barovier & (ITALY)

ABOVE: Shizuku ('dripping') glass boocrystal infused in a hand-made clastone cast, producing a raindrop surface pattern and diffused reflect $8 \times 5\frac{1}{2}$ inches. Designer: Masal Awashima. Makers: Awashima Glass Ltd (JAPAN)

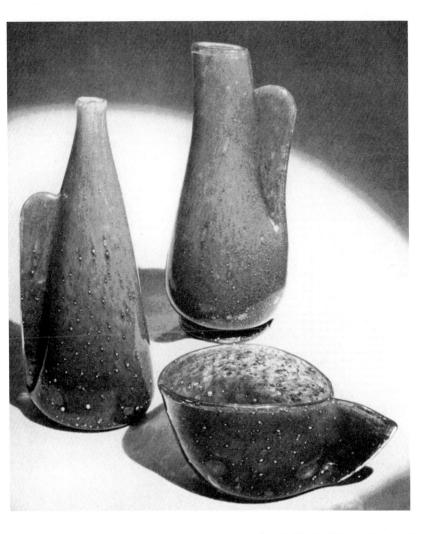

BELOW: Shizuku ('dripping') glass goblet of clay-infused crystal on clear crystal base. $6\frac{1}{2}$ inches. Designer: Masakichi Awashima. Makers: Awashima Glass Co. Ltd (JAPAN)

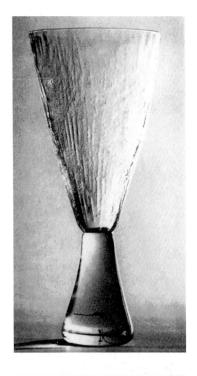

ABOVE: Cobalt blue bubble-glass bowl and vases; 10 and 12 inches. Designer: Ercole Barovier. Makers: Barovier & Toso (ITALY). BELOW: Crystal bowls (largest 19½ inches) decorated by the artist Dubé; black aluminium base. Makers: Fontana Arte (ITALY)

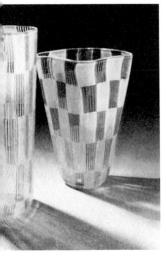

ABOVE: Spun Venetian glass handmade Pezzati vases in various colourings; 8 and 11 inches. Designer: Ercole Barovier. Makers: Barovier & Toso (ITALY)

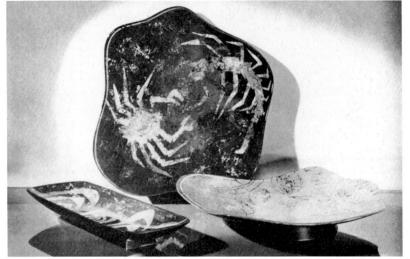

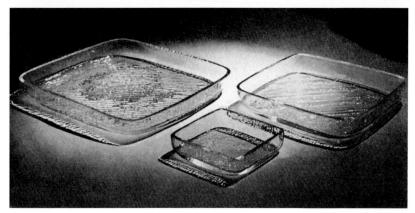

LEFT: Shizuku ('dripping') glass trays of cr The 'raindrop' surface pattern is produce first infusing the crystal in a hand-made or stone cast. Designer: Masakichi Awas' Makers: Awashima Glass Co. Ltd (JAPA)

BELOW: Clear crystal jug and vases. 10, 8 and 9¼ inches high. Designer: Masakichi Awashima. Makers: Awashima Glass Co. Ltd (JAPAN)

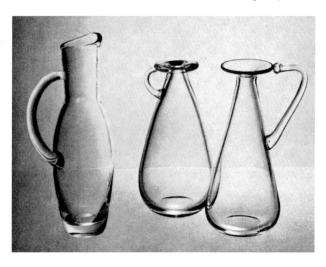

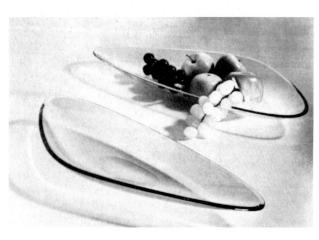

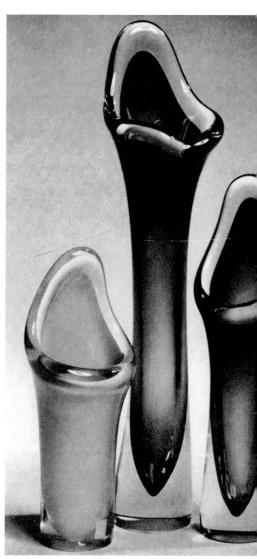

ABOVE: Harlequin heavy crystal vases cased in blue, green, lila other colours. 5\frac{1}{2}, 11\frac{1}{2} and 7\frac{1}{2} inches high. Designer: Paul Ke Makers: Reijmyre G'asbruk AB (SWEDEN). LEFT: Free form bow transparent coloured crystal, applied base. Lengths, 11 an inches. Designers and makers: Fontana Arte (ITALY)

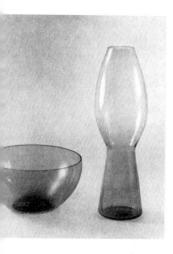

ABOVE: Emerald green bowl (7 inches diameter) and vase (9\frac{3}{4} inches high) designed by Jacob E. Bang. Makers: A/S Kastrup Glasværk (DENMARK)

RIGHT: Crystal vases with (left) sandblasted decoration; (centre) purple base, amethyst neck; (right) vertical green threads, black base. Designed and made respectively by students Charles Richards, Robert Welch, and Jane Webster at the Royal College of Art (GB)

BELOW: Two-colour crystal plates in blue/grey, violet/grey, green/grey or greenish tones. Designer: Timo Sarpaneva. Makers: Karhula-Iittala Glassworks (FINLAND)

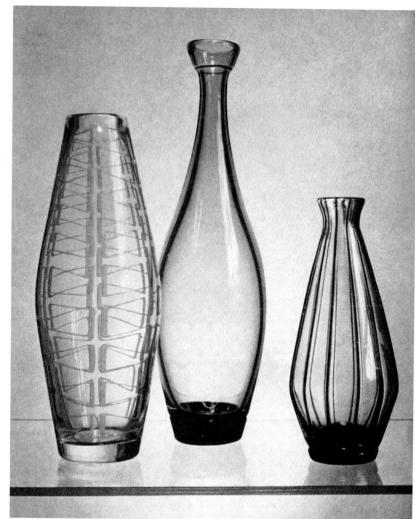

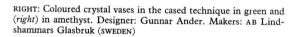

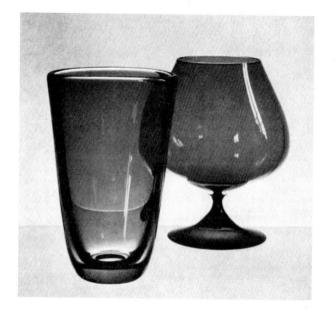

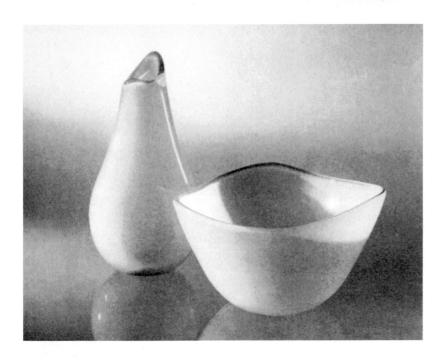

ABOVE: Cut crystal ashtrays, with centres in violet and in dark green glass. $4\frac{3}{4}$ and $5\frac{3}{4}$ in diameter. Designer: Saara Hopea. Makers: Wärtsila-concern AB Notsjö Glassworks (FINL

LEFT: Vase and bowl in opaque grey cry Designer: Bengt Orup, Makers: AB Johan Glasbruk (SWEDEN)

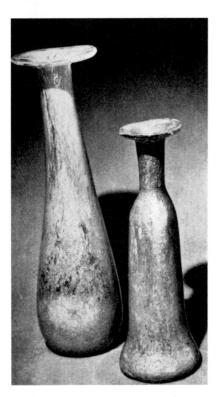

ABOVE: Aborigeni free form hand-made vases in amber Venetian glass. Designer: Ercole Barovier. Makers: Barovier & Toso (ITALY)

RIGHT: Spun coloured glass vases, resembling ceramic ware, with applied decoration. 11 and 19 inches high. Designer: Angelo Barovier. Makers: Barovier & Toso (ITALY)

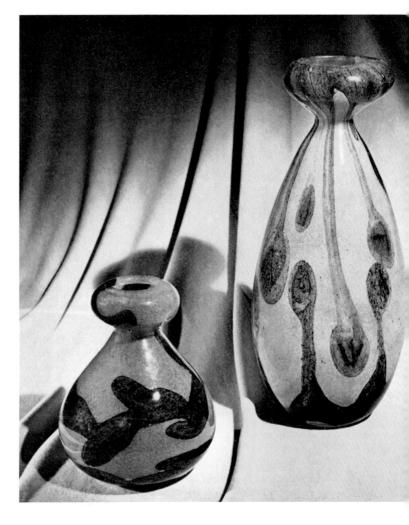

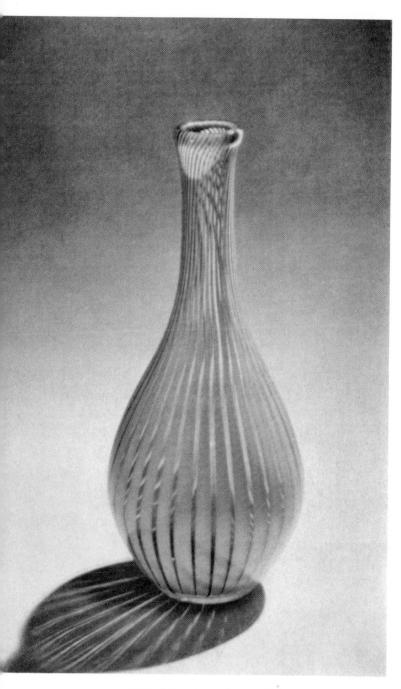

ABOVE: Coloured crystal vase with etched graduated bands. Designer: Oysten Sandnes. Makers: Norsk Glassverk A/S (NORWAY)

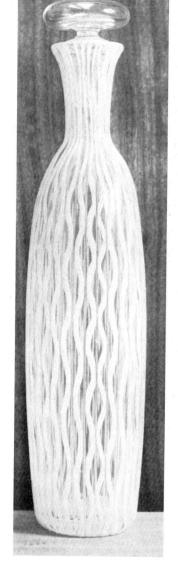

RIGHT: Venetian milk-white spun glass bottle. Height 14 inches. Designers and makers: Venini Glassworks (ITALY)

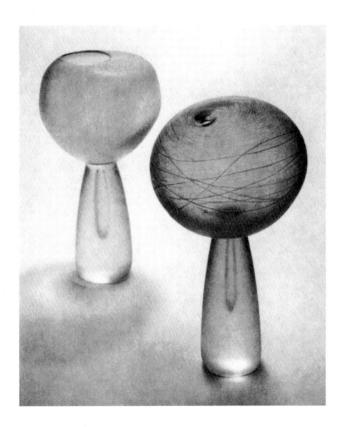

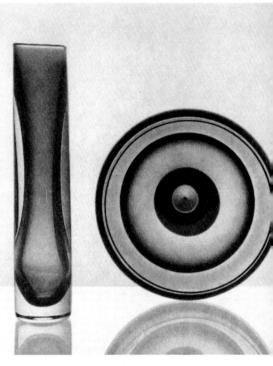

ABOVE: Coloured unique pieces encased in clear crystal. Vase yellow, in red and green; 10 and 9 inches. Designer: F. Meydam. Maker Koninklijke Nederlandsche Glasfabriek 'Leerdam' (HOLLAND)

Below: Pale blue vases encased in heavy crystal; $7\frac{1}{2}$, 5 and 11 inches Designer: Vicke Lindstrand. Makers: AB Kosta Glasbruk (SWEDEN)

ABOVE: Clear crystal vases, 7 inches high; etched decoration. Designer: W. Heesen. Makers: NV Koninklijke Nederlandsche Glasfabriek 'Leerdam' (HOLLAND)

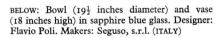

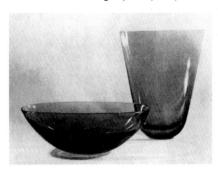

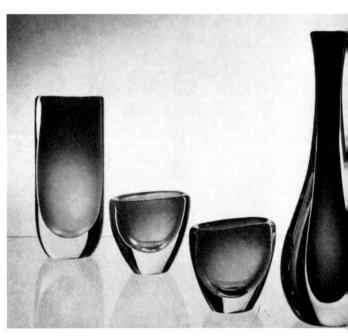

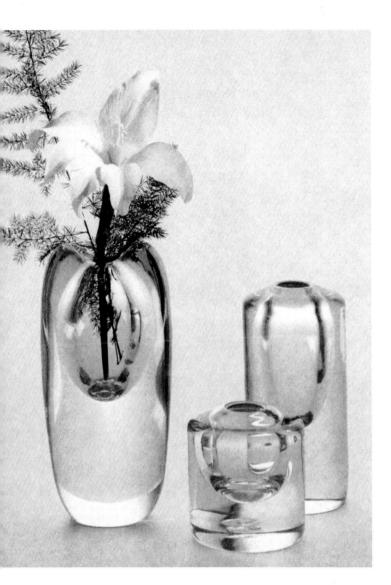

LEFT: Flower vases in clear crystal with inner holder suspended in the body of the glass. 4\frac{3}{4}, 2 and 3\frac{3}{4} inches high. Designer: F. Meydam. Makers: NV Koninklijke Nederlandsche Glasfabriek 'Leerdam' (HOLLAND)

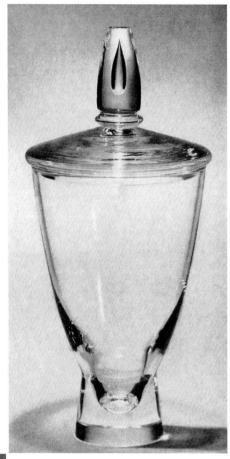

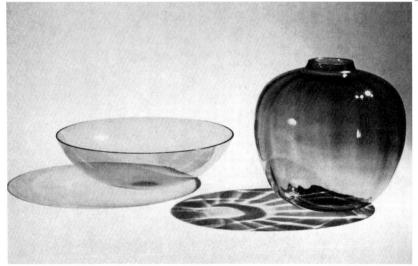

ABOVE: Classic urn with solid crystal base and teardrop finial. Height 12 inches. Designers and makers: Steuben Glass (USA). LEFT: Vase (6½ inches high) and bowl (8¾ inches diameter) in emeraldgreen glass. Designer: Jacob E. Bang. Makers: A/S Kastrup Glasværk (DENMARK)

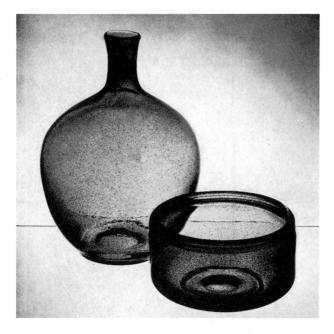

ABOVE: Coloured and clear crystal vase shapes. Designer: John Selbing. Mac A B Orrefors Glasbruk (SWEDEN)

LEFT: Carafe and bowl in green soda glass. Designer: Erik Höglund. Made by J Bruks ab (Sweden)

BELOW: Coloured crystal vase forms—orange, light green and blue. Desi, Viktor Berndt. Made by AB Flygsfors Glasbruk (SWEDEN)

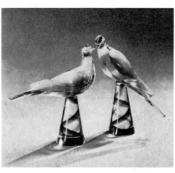

Tourterelles in solid crystal on clear crystal base with coloured spiral. 8 inches high. Designer: Marc Lalique. Made by Verreries de R. Lalique (FRANCE)

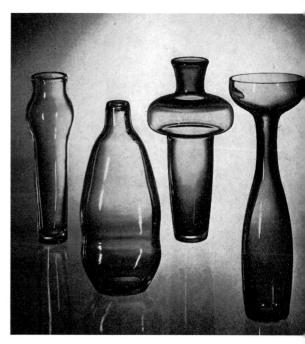

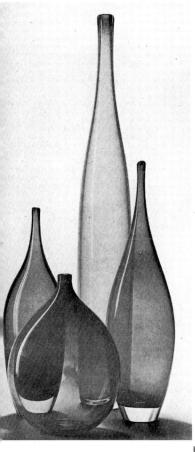

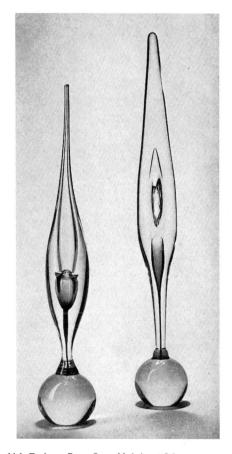

ABOVE LEFT: Ring vase in clear crystal. 24 inches high. Designer: Bengt Orup. Made by AB Johansfors Glasbruk (Sweden). Above right: Abstract forms in clear crystal or with colour suspended in the body; about 14 inches high. Designer: A. D. Copier. Made by NV Koninklijke Nederlandsche Glasfabriek 'Leerdam' (Holland). Below: Vase shapes in crystal. Designer: Edvin Øhrström. Made by AB Orrefors Glasbruk (Sweden)

E: Unica thin-walled vase shapes in clear tal with colour suspended in the body. 12 inches high. Designer: F. Meydam. e by NV Koninklijke Nederlandsche fabriek 'Leerdam' (HOLLAND)

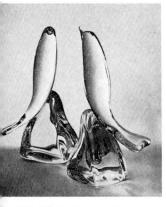

VE: Hirondelles in clear crystal on heavy stal base. 8 inches high. Designer: Michel um. Made by Daum Cristallerie de Nancy NCE)

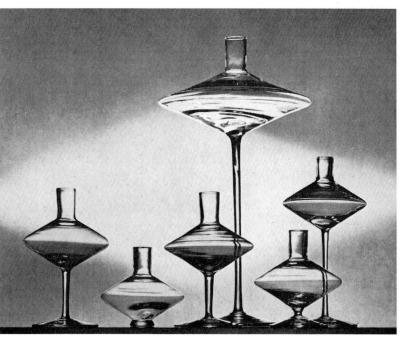

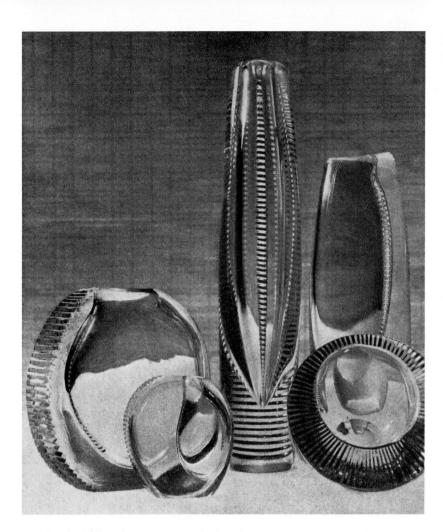

LEFT: Vases from the series Contrast by Asymmetry transparent crystal with cutting on one side reflec in the whole piece. Designer: Vicke Lindstrand. M by AB Kosta Glasbruk (SWEDEN)

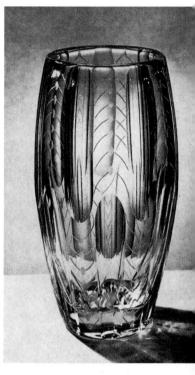

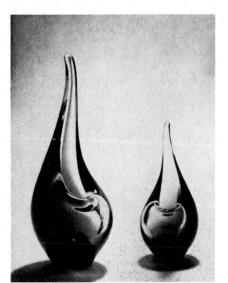

ABOVE: 'Flame' vases in pine-green encased in clear crystal, 6 and 9 inches high. Designer: Per Lütken. Made by Holmegaards Glasværk A/S (DENMARK)

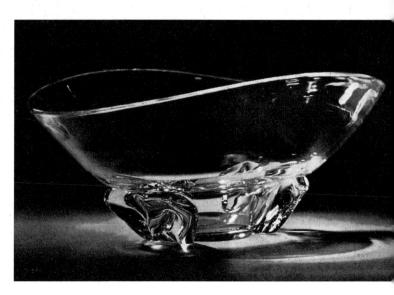

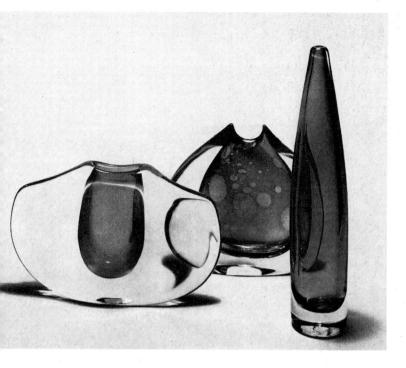

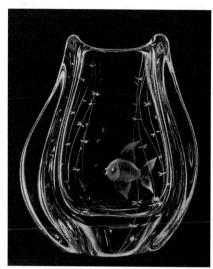

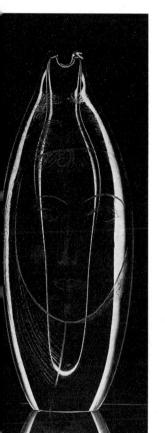

ABOVE LEFT: Unica vases in clear crystal with colour suspended in the body of the glass. 5, 5½, and 11 inches high. Designer: F. Meydam. Made by NV Koninklijke Nederlandsche Glasfabriek 'Leerdam' (HOLLAND). ABOVE RIGHT: Vase in clear crystal with engraved decoration. Designer: Jindřich Tockstein. Made by Žel. Brod Glassworks (CZECHOSLOVAKIA)

Made by Zel. Brod Glassworks (Czechoslovakia)
LEFT: Engraved clear crystal vase, with inner holder suspended in the body of the glass; about 12 inches high. Designer: W. Heesen. Made by Ny Koninklijke Nederlandsche Glasfabriek 'Leerdam' (HOLLAND).
BELOW: Heavy crystal vase and bowl with deeply engraved decoration. Designer: Erik Höglund. Made by Boda Bruks AB (SWEDEN)

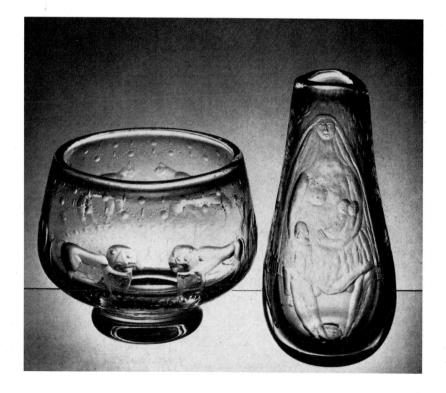

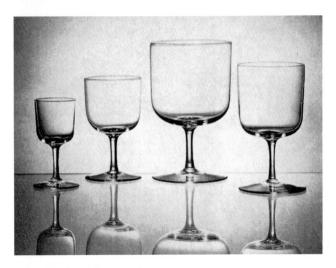

ABOVE: Connoisseur wine service in clear crystal. The straw-like stem is drawn from the finely blown bowl leaving a tapered depression in the bottom of the bowl. Designer: Sven Fogelberg. Made by Thos. Webb & Sons (GB)

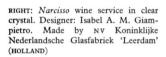

BELOW: Ravenhead Waterloo suite in flint glass. Designer: A. H. Williamson, ARCA. Made by automatic process by The United Glass Bottle Manufacturers Ltd. For Johnsen & Jorgensen Flint Glass Ltd (GB)

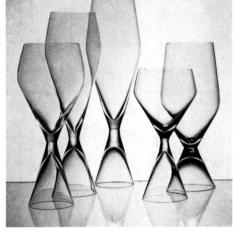

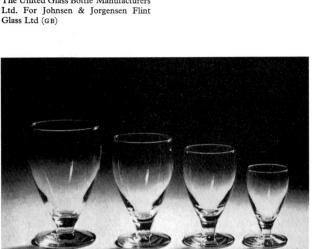

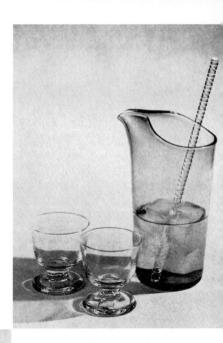

ABOVE: Cocktail mixer and glasses in c crystal. Designer: Monica Bratt. Made Reijmyre Glasbruk AB (SWEDEN)

BELOW: Sherdley flint glass beer mugs. signer: A. H. Williamson, ARCA. Made automatic process by The United Glass Be Manufacturers Ltd. For Johnsen & Jorge Flint Glass Ltd (GB)

BELOW: Blown crystal vase and tumb Designer: Ingeborg Lundin. Made by Orrefors Glasbruk (SWEDEN)

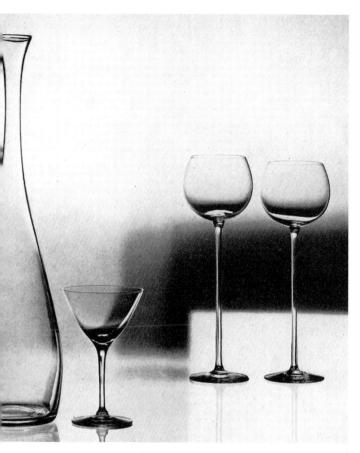

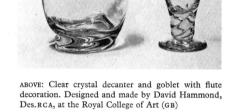

BELOW: Blown crystal Martini mixer and glasses, etched line decoration. Made in Sweden for Raymor (USA)

ABOVE: Decanter and long-stemmed wine glasses in clear crystal. Designer: Nils Landberg. Made by AB Orrefors Glasbruk (SWEDEN)

BELOW: Clear crystal cocktail set; stopper and glass base coloured green. Designers: Monica Bratt and Paul Kedelv. Made by Reijmyre Glasbruk AB (SWEDEN)

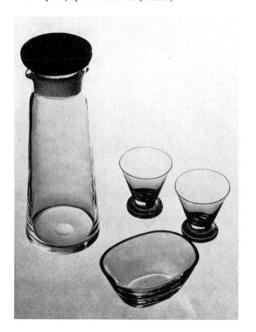

1958–59 · glass · **371**

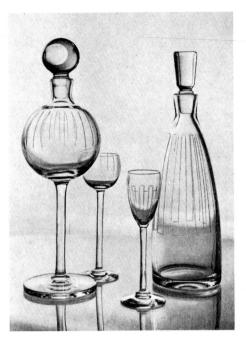

ABOVE: Liqueur set in clear crystal with cut decoration. Designer: Bengt Orup. Made by AB Johansfors Glasbruk (SWEDEN)

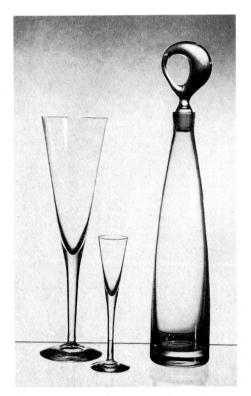

ABOVE: Aristocrat clear crystal decanter with sculptured stopper, and long-stemmed beer and schnaps glass. Designer: Per Lütken. Made by Holmegaards Glasværk A/S (DENMARK)

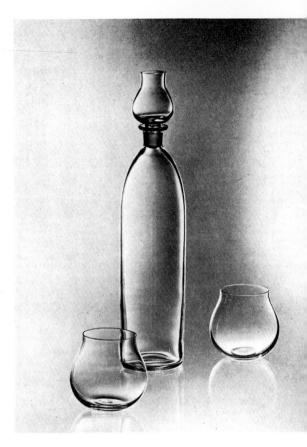

ABOVE: Blown crystal decanter and glasses. Designer: Ingeborg Lundin. Made AB Orrefors Glasbruk (SWEDEN). BELOW: Blown crystal small decanters moulded stoppers and decoration. Designer: Erik Höglund. Made by Boda Ba AB (SWEDEN)

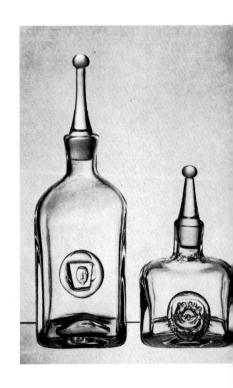

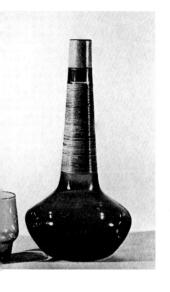

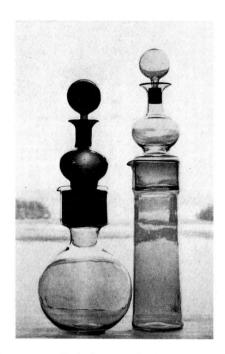

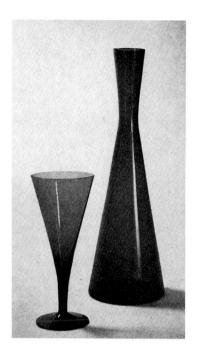

ABOVE LEFT: Bottles for water or fruit juice in white and in green glass with red and white moulded stoppers. Designer: Kaj Franck. Made by 0/4 Wärtsilä-concern Ab Nuutajärvi Glassworks (FINLAND). ABOVE RIGHT: Winston decanter and wineglass in pine-green glass. Designer: Per Lütken. Made by Holmegaards Glasværk A/S (DENMARK). LEFT: Cane-bound decanter, and tumbler in emerald-green or opaline glass. Designed and made by A/S Kastrup Glasværk (DENMARK)

BELOW LEFT: Whisky decanter in clear crystal with cut decoration. Designer: Vicke Lindstrand. Made by AB Kosta Glasbruk (SWEDEN). BELOW: Wicker-covered green glass water set with raffia stoppers to jug and carafe. Designed and made by Mancioli Natale & C. (ITALY)

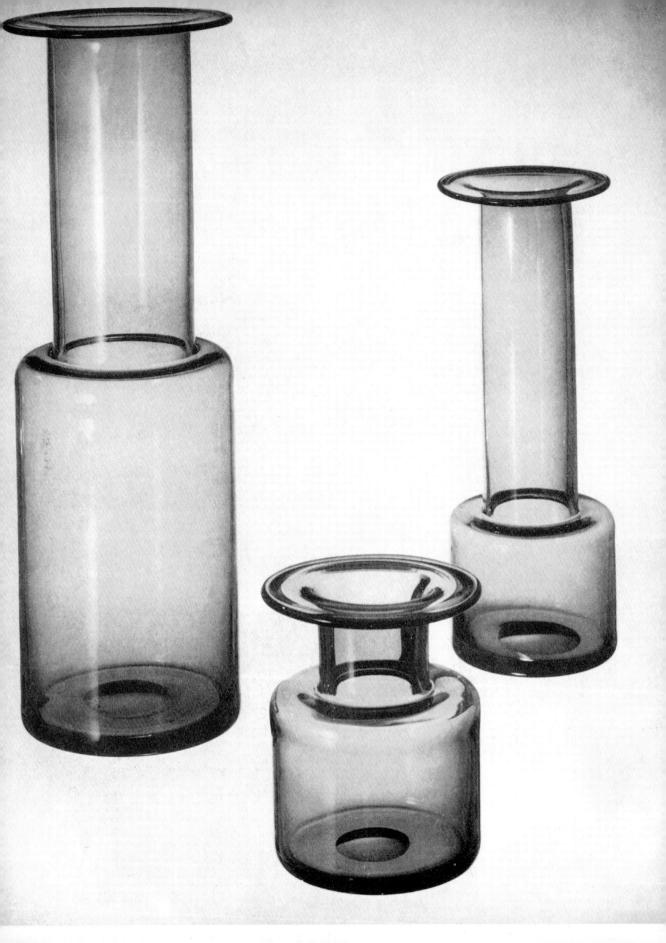

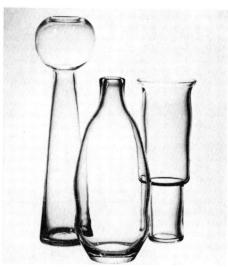

Vases in clear crystal. Designer: Victor Berndt. Makers: AB Flygsfors Glasbruk (SWEDEN)

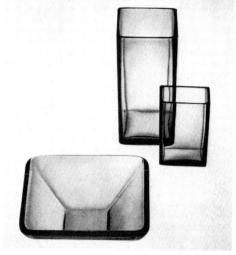

Bevel-edge coloured glass vases and 9-inch bowl. Designer: Sven Palmqvist. Makers: AB Orrefors Glasbruk (SWEDEN)

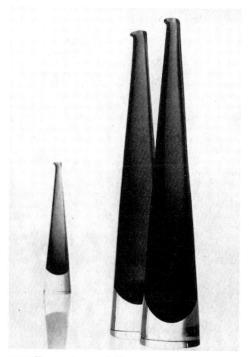

ABOVE: Vases or decanters in blue-grey glass; 8 and 12 inches. Designer: Timo Sarpaneva. Makers: Karhula-Iittala Glassworks (FINLAND). RIGHT: Maypole vases in blue/green or clear glass, red/black or green/purple 'pole'; 11½ inches. Designer: Nanny Still. Makers: 0/Y Riihimaki Glassworks (FINLAND)

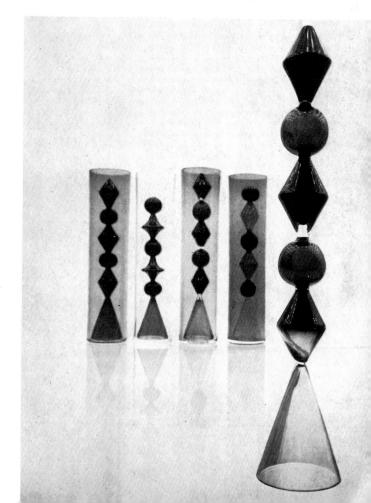

ttle vases in grey-blue glass; 15, 5 and 10 hes. Designer: Per Lütken. Makers: Imegaards Glasværk A/S (DENMARK)

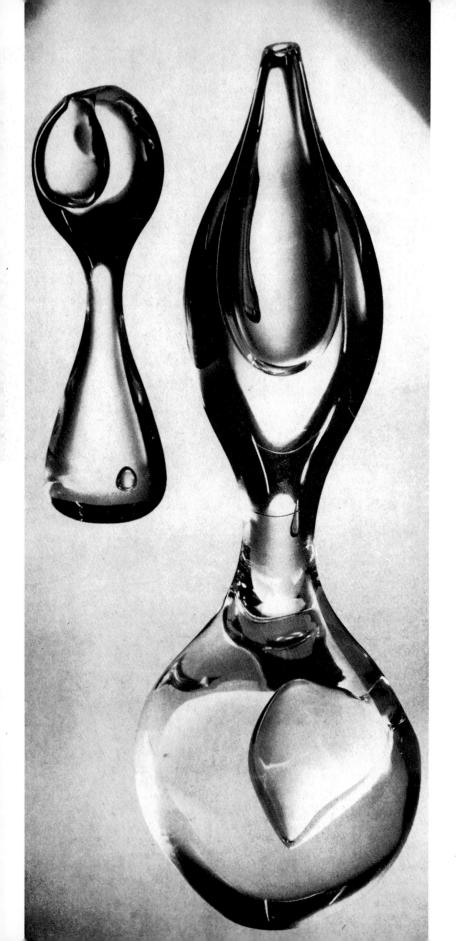

Thick crystal vase, engraved decoration and hand polished shaped top; 6½ inches. Designer: G. F. Baxter, Des.RCA. Makers: James Powell & Son (Whitefriars) Ltd (GB)

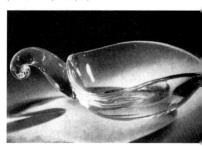

Crystal dish with curved edge and handle; length 8 inches. Designer: Lloyd Atkins. Makers: Steube Glass (USA)

Thick crystal bowl; diameter 8 inches. Designer Tapio Wirkkala. Makers: Karhula-Iittala Glass works (FINLAND)

 Free form thick crystal vases with trapped bubble 10 and 13 inches high. Designer: Vicke Lindstrand. Makers: AB Kosta Glasbruk (SWEDEN)

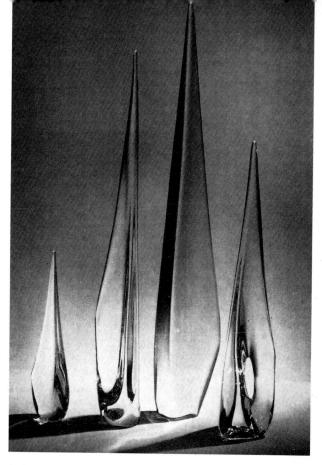

Sculptured shapes in thick crystal. Designer: Michel Daum. Makers: Daum Cristallerie de Nancy (FRANCE)

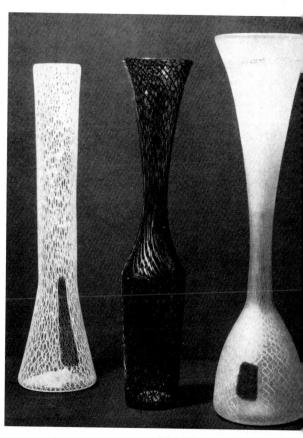

Blown Venetian glass vases in clear or opaline glass, white or coloured Zanfirico decoration; 20 to 22 inches high. Designer: Dino Martens. Makers: Rag. Vetreria Aureliano Toso (ITALY)

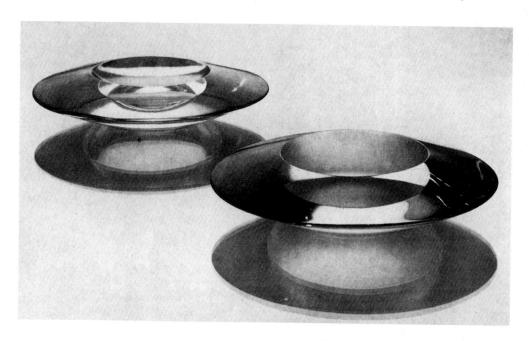

White crystal ashtrays, about 6 inches across. Designer: Aimo Okkolin. Makers: 0/Y Riihimaki Glassworks (FINLAND)

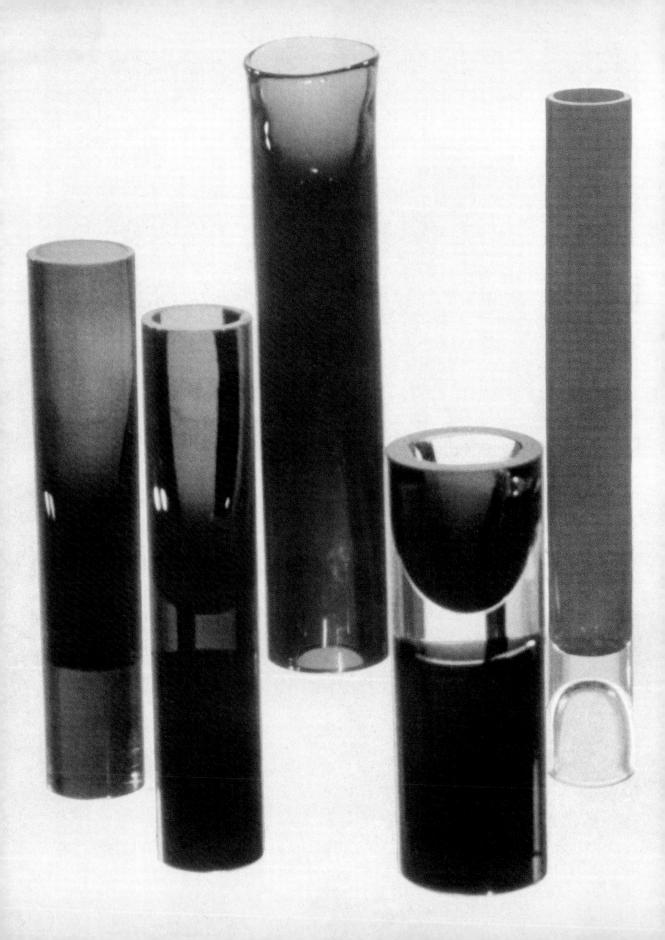

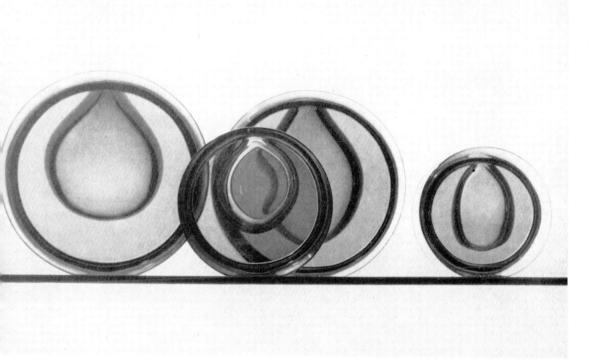

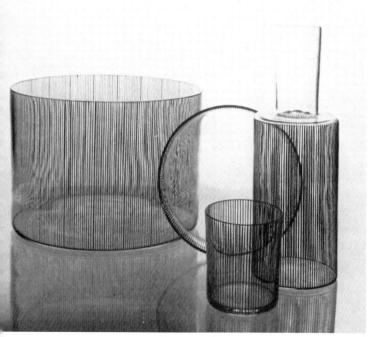

- r Crystal dense colour vases, 5 to 9½ inches high. Designer: Tappio Wirkkala. Made by Karhula-Iittala Glassworks (FINLAND)
- 2 Bloc thick crystal vases in green and purple; inner holder suspended in the body of the glass. Designer: Nanny Still. Made by O/Y Riihimaki Glassworks (FINLAND)
- 3 Blown glassware, painted 'Stripe' decoration. Large bowl 6 inches deep, diameter 8½ inches. Designer: Bengt Orup. Made by AB Johansfors Glasbruk (SWEDEN)

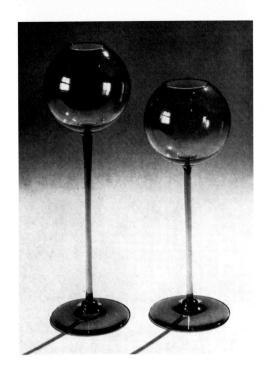

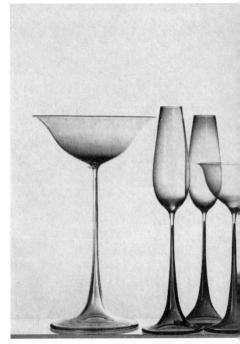

Thinly-blown pedestal vases in coloured crystal; 15 to 25 inches. Designer: Nils Landberg. Made by AB Orrefors Glasbruk (SWEDEN)

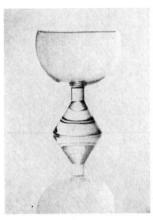

Cocktail glass in clear crystal, base decorated white spiral. Designer: Tapio Wirkkala. Made by Karhula-Iittala Glassworks (FINLAND)

Flamingo clear crystal wine glasses. Designer: Saara Hopea. Made by o/Y Wärtsilä-concern AB Nuutajarvi Glassworks (FINLAND)

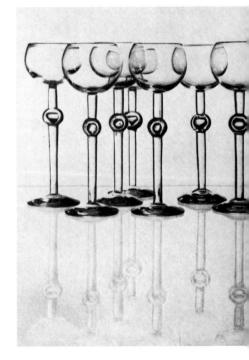

Clear crystal wine glasses from the *Saint-Rémy* service. Designer: Georges Chevalier. Made by Cie des Cristalleries de Baccarat (FRANCE)

Clear crystal wine service with handcut decoration. Designer: Nils Landberg. Made by AB Orrefors Glasbruk (SWEDEN)

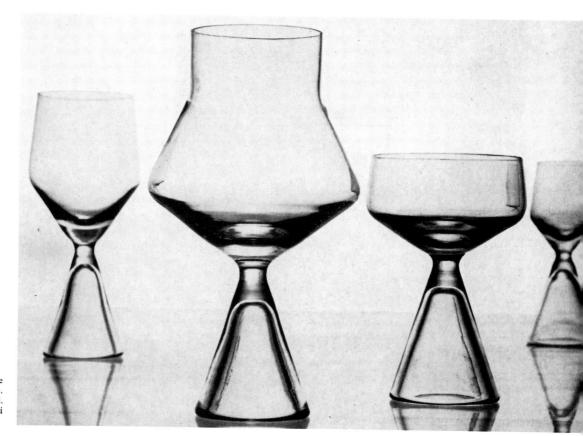

7hite crystal table asses on pedestal base. esigner: Nanny Still. (ade by 0/Y Riihimaki lassworks (FINLAND)

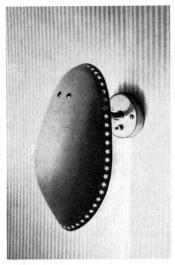

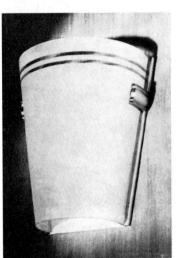

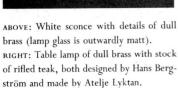

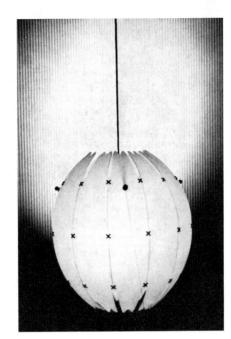

LEFT AND CENTRE: Flexible sconce with white quered shade of brass, and globe of matt plexig with details of dull brass, both designed by I Bergström and made by Atelje Lyktan. BELOW: White plastic lantern designed by Esben K and made by Le Klint.

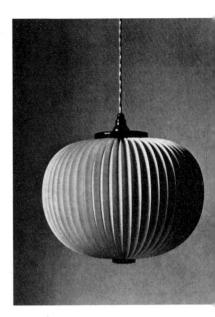

LEFT: Wall fixture of sandblasted glass with clear line decoration and gilt coloured cellulosed metal w designed by Loraine Read Tucker and made by Tucker and Edgar. BELOW, RIGHT: Fawn stoneware pottery lamp with brush decoration and shade of pale aquamarine bl Stoneware horse directly modelled in refractory clay. Both designed and made by Reginald Marlow.

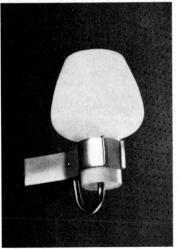

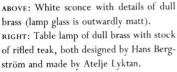

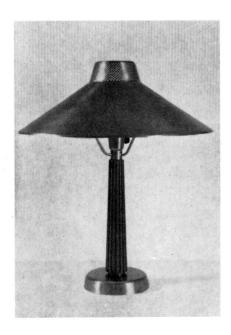

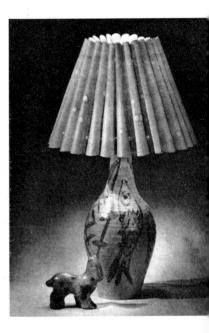

RE: Fitment designed by Johansson-Pape and made by Dohansson-Pape and made by Metal Factory for O.Y. kmann A.B. Outer shade is of glass engraved with stripes: r shade of opal-coloured RIGHT: Spotlight reflector, ned by J. A. C. Howard and e by Tucker & Edgar, cellulkingfisher blue, with chron-plated cap and universal

LEFT: Three-light semi-ceiling fitting, by Best & Lloyd Ltd, with obscured and tinted glasses and reflector finished in enamel. Other metalwork cast-brass and finished French old gold or Butler's silver.

BELOW: Three lamps designed by Bertil Brisborg and made by Nordiska Kompaniet: (1) Table lamp with foot and stand of polished ash, textile shade. (2) Table lamp of dull finished brass with shades of white lacquered wire, covered with textile. (3) Floor lamp with foot and stand of mahogany, metal parts of dull finished brass.

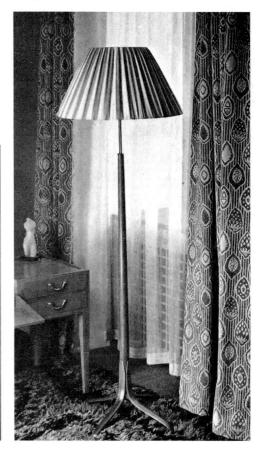

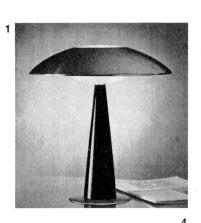

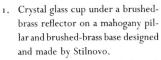

2. Brass base with glass shade and leather-covered pillar designed by Hans Bergström and made by Atelje Lyktan.

3. Black slipware base with sgraffito decoration and shade of pleated paper designed and made by Marianne de Trey.

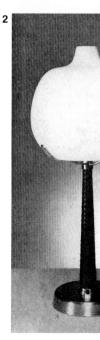

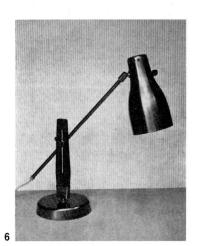

- 4. White rope-wound stem on polished timber base with white shade sprayed primrose nylon flock on top section and gold trimmings, designed by Beverley Pick, M S I A, and made by W. S. Chrysaline
- 5. Brass pillar with linen shade designed by Paavo Tynell and made by O/Y Taito A B.
- 6. Teak pillar with brass shade and base designed by Hans Bergström and made by Atelje Lyktan.
- 7. Aluminium reflector on steel tubing with fire-baked enamel finish in dusk grey, sage green, terra-cotta, desert gold or coral red designed and made by Kurt Versen Lamps Inc.

Cast-stone sculptured base and lacquered vellum shade designed and made by Kyle-Reed.

Lemon glazed earthenware base and opaque shade edged with lemon-coloured silk cord designed by G. L. de Snellman-Jaderholm and made by Wartsila Koncernen A B Arabia.

Pottery base with scratched primitive figures in orange outlined in black. Fibreglass shade sprayed warm grey and wound with thin green jute string designed and made by Berrier-Gnazzo.

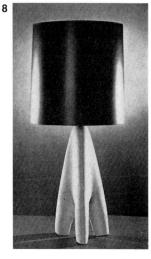

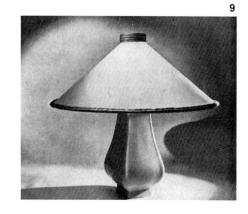

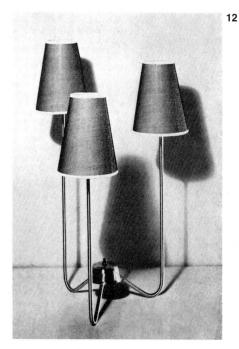

- Brass stand with neutral green silk screening on plastic shades by Kurt Versen Lamps Inc.
- 13. Rosewood stem on brass base with swirl Fibreglass shade. Arm movable to any one of seven stops, the shade and socket section remaining vertically in balance. Designed by Greta von Nessen and made by Nessen Studio Inc.

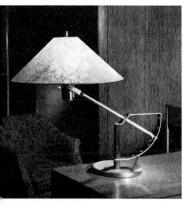

13

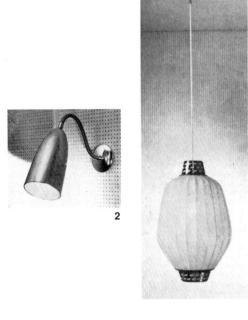

- 2. 15-in. adjustable flexible tube arm in chrome or silver designed by Paul Boissevain, Dip. Arch, M S I A, and made by Merchant Adventurers Ltd. Reflector and wall plate in contrasting colours, gold or copper anodized aluminium, or cream, red, yellow, blue/grey or Portland stone stove enamelled finishes.
- 3. White covering with gold stars and knob designed by Beverley Pick, MSIA, and made by W. S. Chrysaline Ltd. (Chrysaline shades are built on a wire frame cellulosed white and sprayed twice cocoon-wise with plastic while they are rotated. Shrinkage while drying produces the pleasant curves between the wires).
- Mondolite bracket, off-white metal-laced satin aluminium, varying lengths available, produced by Troughton & Young (Lighting) Ltd, and designed in their Design Department.

II

6

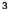

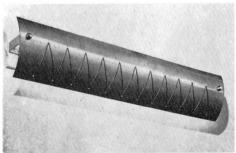

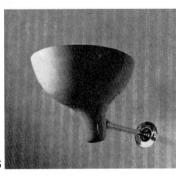

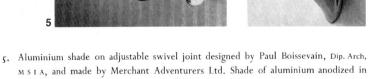

- various colours, or white stove-enamelled finish.

 6. Brass bracket with white lacquered cups designed and made by Stilnovo.
- Mondolite bracket, movable horizontally or vertically, metal in satin brass and offwhite finishes, and shade in off-white plastic by Troughton & Young (Lighting) Ltd.
- Wall bracket with Tellachrome metalwork and Sunray pleated shades trimmed with wine-coloured cord. Designed by Ian Henderson and produced by Tucker & Edgar.

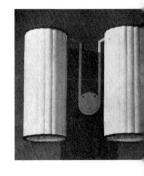

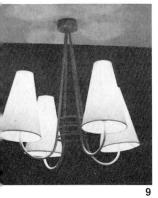

Orange lacquered metal fitment with cream paper shades designed by Jean Royère.

Five-branch brass fitment with white silk lampshades designed by Hans Bergström and made by Atelje Lyktan.

Brass and painted aluminium ceiling fitment designed by Paavo Tynell and made by ${\rm O/Y}$ Taito A B.

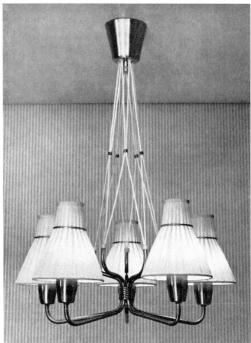

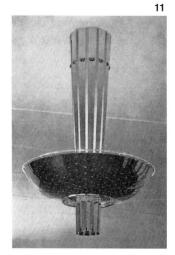

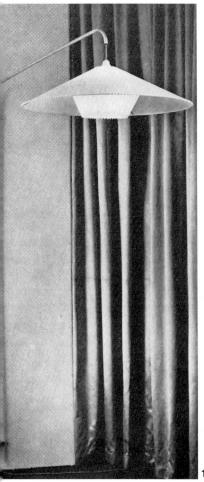

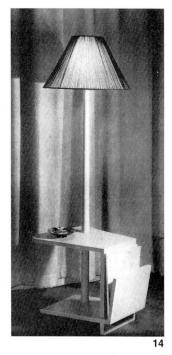

- 12. Mondolite wall standard with satin aluminium arm horizontally adjustable to any position. Large shade in ivory or peach rimpled plastic: inverted shade in off-white grained plastic. Produced by Troughton & Young (Lighting) Ltd, and designed in their Design Department.
- 13. Floor lamp 4 ft. 8 in. high on mahogany or beech base with paper shade designed by Nigel Walters and made by Primavera.
- 14. End table, floor lamp with reed shade, and magazine rack combination in light grey mahogany designed by Arthur A. Klepper and made by Wor-De-Klee Inc.

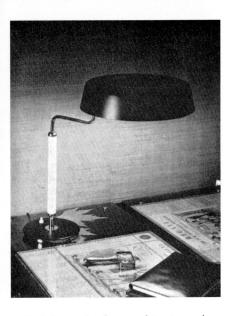

Black base and reflector, white tige, and polished brass adjustable arm. Designers and makers: Stilnovo (ITALY).

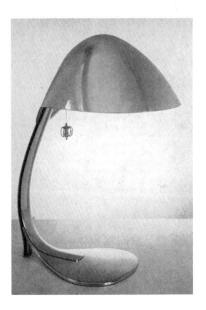

Brass reading lamp. Designer: Paavo Tynell. Makers: OY Taito AB (FINLAND).

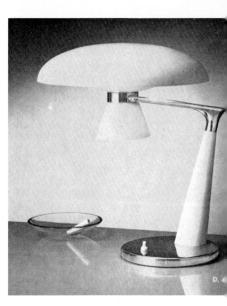

Polished brass base and arm, white lacquered reflectors and tige. Direct and indirect light. Designers and makers: Stilnovo (ITALY).

Steel tube and rod with spun aluminium shade stove enamelled black and white. Mahogany handgrip with push button switch. Designer: Robin Day, ARCA. Associate designer: John Reid, ARIBA. Makers: Thorn Electrical Industries Ltd (GB).

Brass arm and base with modern fabric shade. Designer and producer: Hans Bergström, Atelje Lyktan (sweden).

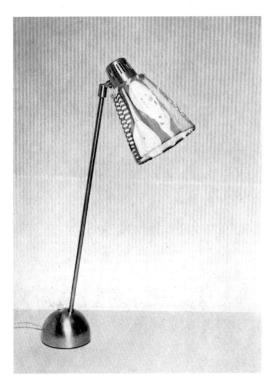

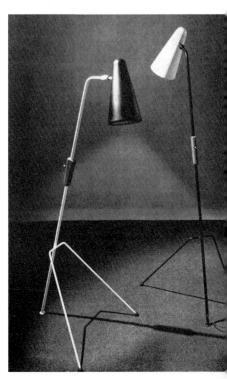

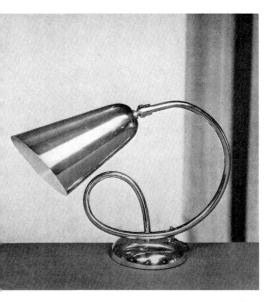

n brass table or wall lamp with swivel shade. er: Catherine Speyer. Makers: Laurel Lamp cturing Co Inc (USA).

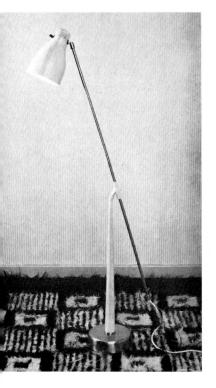

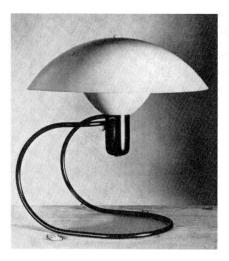

Bent black oxidized steel tubing with adjustable free-swivelling bulb cup. Fourteen-inch diameter shade finished baked parchment-toned enamel. Designer: Greta Von Nessen. Makers: Nessen Studio (USA).

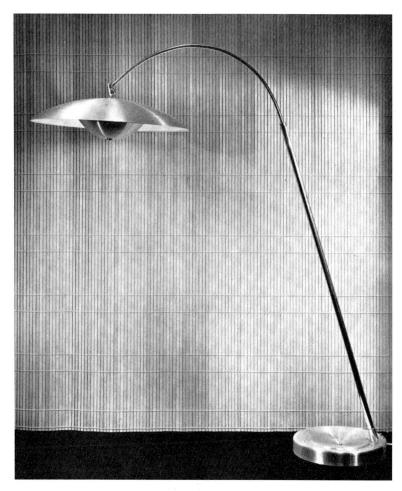

Aluminium and copper, with perforated adjustable metal shade. Designer: Paul Laszlo. Makers: Laszlo Inc (USA).

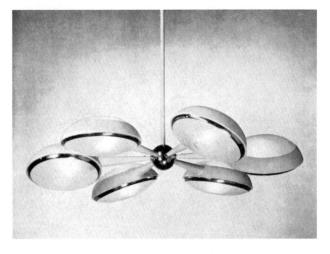

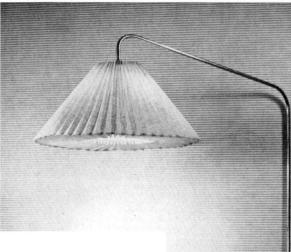

Crystal cups ringed with brass, white lacquered rod and arms. The cups can be rotated to any position. Designers and makers: Stilnovo (ITALY).

White reflector with adjustable green lacquered reflector on white arm. Polished brass swivel joint. Designers and makers: Stilnovo (ITALY).

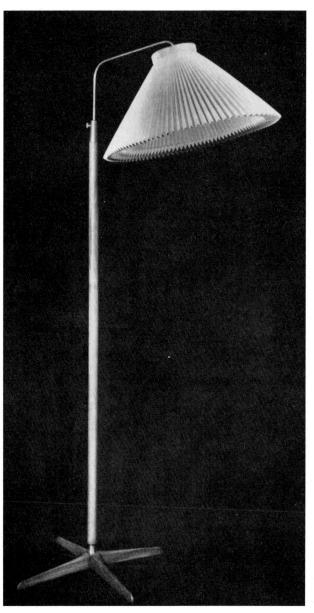

Bright lacquered brass arm shade of cream pleated buckram white-enamelled wall mound boss. Adjustable vertically horizontally. Makers: The General Electric Co Ltd, and designed in Design Office of their Fit Department (GB).

Natural wax finished mahogany adjustable stem and red Le I shade. Designer: Peter Br Makers: Peter Brunn Work (GB). (Photo: Elsam Mann & Cooper

E: Champagne-coloured Chrysaline g fitting with gilt metal end cap. rs: The General Electric Co Ltd. Dell in their Fittings Department (GB).

e: Perforated shade, spun brass finish. ner: Geoffrey Dunn. Makers: Dunn's omley (GB).

v: Natural cane screening supplied in s of different width, used here as hade and pot cover. From Dunn's mley (GB).

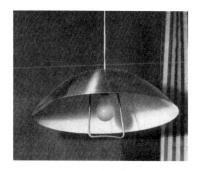

Perforated brass shades with inner shades of light yellow silk fabric. Designer and producer: Hans Bergström, Atelje Lyktan (sweden).

Hanging pendant with fabric shade. Designer and maker: Hans Bergström, Atelje Lyktan (SWEDEN).

BELOW: Stone base with Egyptian design in grey, brown and eggshell or matt black and white, mounted on a wood block, with burlap shade. Designer and maker: Raymor. From Modernage Furniture Corporation (USA).

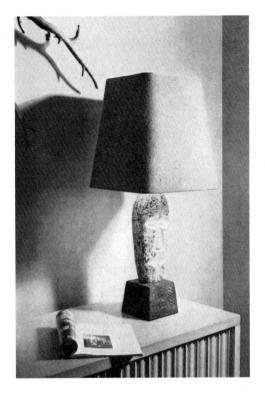

BELOW: The Puppy. Base of natural birch or silver-finished oak, set on a dark oak block, with fabric-over-parchment shade. Designer: Yasha Heifetz. Makers: The Heifetz Company. Small figure on left in copper or brass by Ben Fisher (USA).

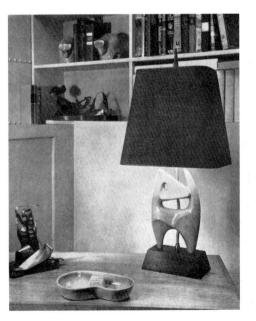

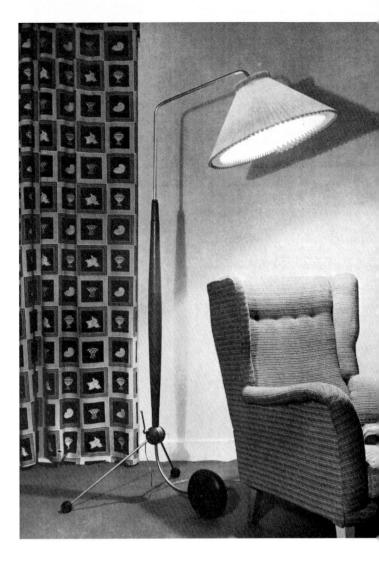

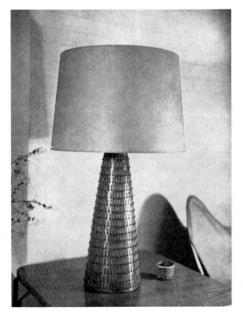

ABOVE: Unad adjustable walnut handgrip, feet counterweight, with bras and arm, and Le Klint Unad low wing easy cha Tile textile. Designers: Story Design Group. M Story & Co Ltd (GB).

LEFT: Pottery base with head design in terra colour and sprayed fib shade. Designers and m Berrier-Gnazzo (USA).

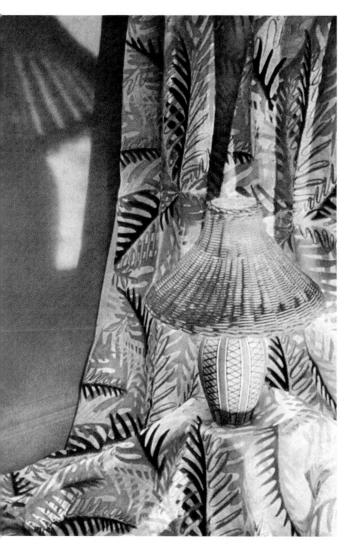

BELOW: Pottery caryatid lampbase in honey colour with beaded shade of woven and plaited raffia. Designer and maker: Rosemary D. Wren, ARCA, The Oxshott Pottery (GB). (Photo: Sir Isaac Pitman & Sons Ltd)

BELOW: Earthenware lampbase with coloured slip bands and turned centre decoration, finished with Crystal clear glaze. Available in celadon green and white or shell pink and white. Shade in ivory white Crinothene trimmed with beige cotton ruche. Makers: Carter Stabler & Adams Ltd (GB).

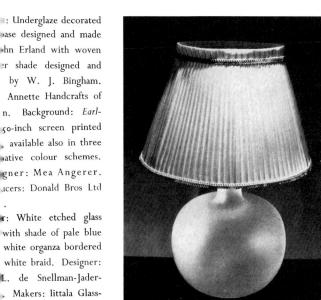

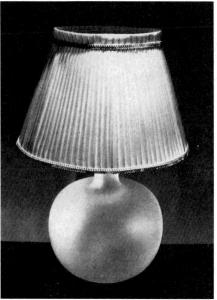

with shade of pale blue white organza bordered white braid. Designer: L. de Snellman-Jader-, Makers: Iittala Glasss (FINLAND).

Shelf, wall or table lamp, the two front legs movable along the main stem for various height adjustment. Steel stem finished dark grey with aluminium shade lacquered red, black, grey, yellow or white. Designer: Anthony Ingolia. Makers: The Heifetz Company (USA)

Table or wall lamps in wood and metal with fabric shades. Designer: Yki Nummi. Makers: O/Y Stockmann A/B (FINLAND)

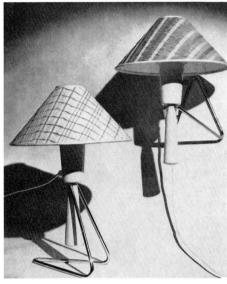

Hyacinth vases and lamp base with sgraffito decoration on the white earthenware body, and a bonbonnière in pale green and white earthenware. Designer: Endre Hevezi B.Arch. Makers: Booths & Colcloughs Ltd (GB)

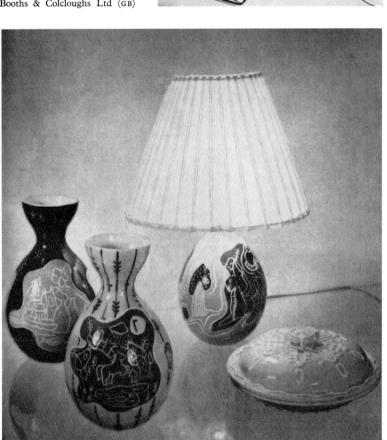

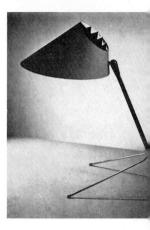

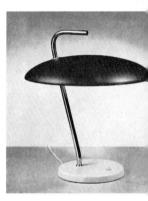

White marble base with polished by tige and black reflector. Designers makers: Stilnovo (ITALY)

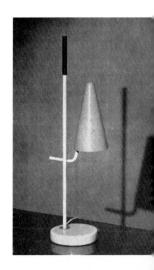

White marble base with white quered tige, black lacquered tern and red lacquered reflector. Desi and makers: Stilnovo (ITALY)

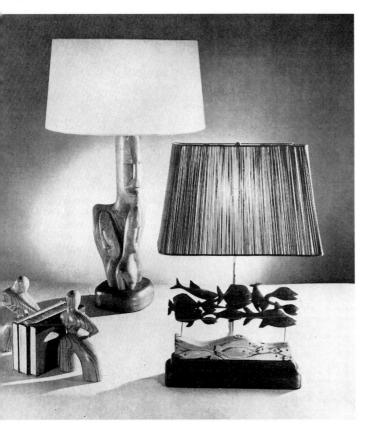

p on oak base with carved walnut , and 'fish' lamp on carved mahogany birch base. Designer: Nicholas harniuk. Carved oak bookends by es L. McCreery. Made for Rena enthal Inc (USA)

alt blue glass base with shade of white doid edged with white cord. Designer: L. de Snellman-Jaderholm. Makers: ala Glassworks (FINLAND)

Brass stand with oiled teak feet and sprayed white plastic shade. Designer and maker: Hans Bergström, Atelje Lyktan (SWEDEN)

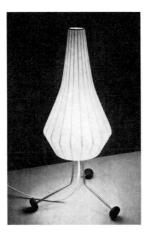

Pumpkin-shaped base in fine earthenware with hand-painted decoration in forest green and black or terra-cotta and black. Ivory Crinothene shade. Designer: Truda Carter ARCA. Makers: Carter Stabler & Adams Ltd (GB)

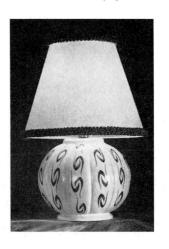

Sculptured walnut base, natural finish, and hand-woven shade, natural colour with cocoa and copper threads. Sculptor: F. F. Kern. Designer: Paul Laszlo. Makers: Laszlo Inc (USA)

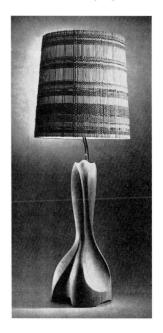

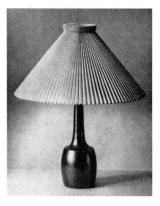

Lamp base designed by Esben Klint and made by Knabstrup Keramiske Industri. Pleated white paper shade designed and made by Le Klint (DENMARK)

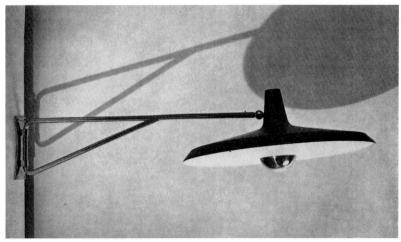

Polished brass arm with adjustable black lacquered reflector, white-lined. Designers and makers: Stilnovo (ITALY)

Wall bracket of perforated brass sprayed with plastic. Designer and maker: Hans Bergström, Atelje Lyktan (SWEDEN)

Shade stove-enamelled off-white on specially perforated metal, fitted with two lamps. Makers: Troughton & Young (Lighting) Ltd, and designed by their Design Staff for St Bartholomew's Students' Hostel (Easton & Robertson FFRIBA, Architects) (GB)

Gilt anodized spotlight reflector mounted on arm adjustable to any position. Designer: A. B. Read RDI, FSIA, in association with Dennis Lennon MC, FRIBA. Makers: Troughton & Young (Lighting) Ltd (GB)

Wall bracket of polished aluminium Designer: Paavo Tynell. Makers: O/Taito AB (FINLAND)

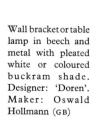

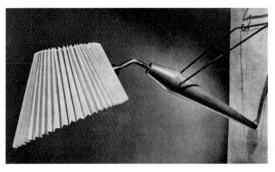

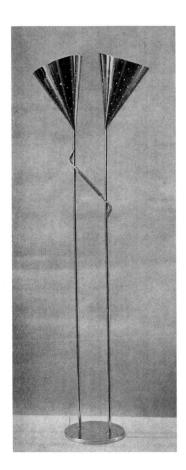

Brass floor lamp with perforated shades and centre handle covered in white leather. Designer: Paavo Tynell. Makers: O/Y Taito AB (FINLAND)

Brass ceiling fitment with perforated shade. Designer: Paavo Tynell. Makers: O/Y Taito AB (FINLAND)

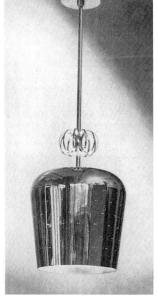

Opal glass shade and painted iron stem ringed with brass. Designer: Paavo Tynell. Makers: O/Y Taito AB (FINLAND)

Hanging lamp made from thin perforated slats of polished beech plywood. Designer: E. R. Aldhouse MSIA for Primavera (GB)

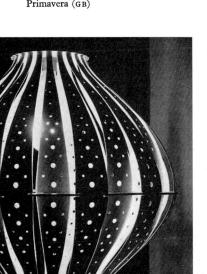

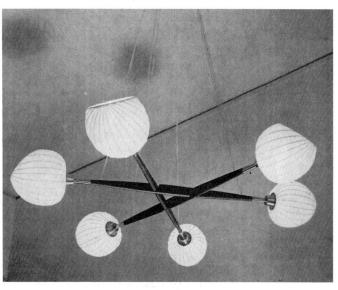

Oiled teak arms with brass details and sprayed plastic shades. Designer and maker: Hans Bergström, Atelje Lyktan (SWEDEN)

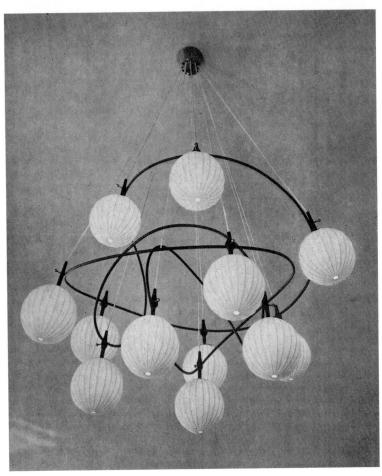

All-metal ceiling lamp, 18 inches diameter, with louvr in the base, finished two colours in plain enamel enamel combined with polychromatic copper, brass silver. Designers and makers: Best & Lloyd Ltd (GB)

ABOVE: Hanging fitment with plasticsprayed shades and details of blue lacquered iron and teak. Designer and maker: Hans Bergström, Ateljé Lyktan (SWEDEN)

Ceiling lamp with burnished copper base and shade. Designer and maker: Hans Bergström, Ateljé Lyktan (SWEDEN)

BELOW RIGHT: Pendant hung from teak bracket with white plastic-sprayed shades. Designer and maker: Hans Bergström, Ateljé Lyktan (SWEDEN)

Wooden wall bracket in oak, beech, walnut or mahogany with buckram shade finished in a choice of pastel colours. Designer: Rudolf Hollmann. Maker: Oswald Hollmann (GB)

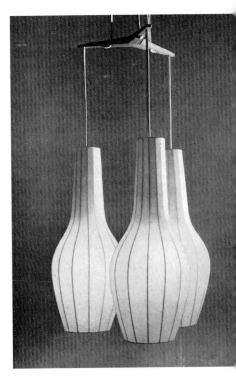

E: Wall lamp fixed on beech block mounted on two pins, with wire legs in various finishes and pleated ate shade in apricot, ivory or white. Designers: E. ke-Yarborough and Ronald Homes. Makers: Cone ngs Ltd (GB)

T: One of five decorative wall light panels featuring er motifs in beaten copper, finished verdigris, ed against an illuminated background of white ite glass. Designer: Gerald Lacoste, MBE, FRIBA. ers: Metalwork by Wm. Pickford Ltd. Glasswork Froughton & Young (Lighting) Ltd (GB)

W: Table lamps on glass bases with copper net and tic shades. Designer: Lisa Johansson-Pape. Makers: Orno A/B (FINLAND)

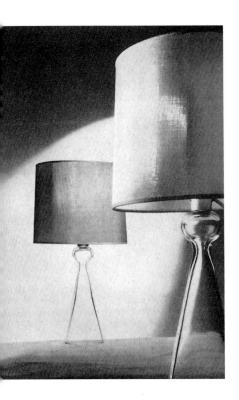

BELOW: Ceiling lamp with 14-inch reflector coloured outside and sprayed white inside; rise-and-fall unit case in polished brass with ceiling plate sprayed to match reflector. Diaboloshaped handgrip of beech, mahogany or walnut. Designer: Rudolf Hollmann. Maker: Oswald Hollmann (GB)

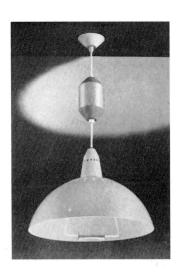

Table lamp of dyed cane on wooden base. Designer: Desmond Sawyer, LSIA. Makers: Desmond Sawyer Craftsmen in Cane (GB)

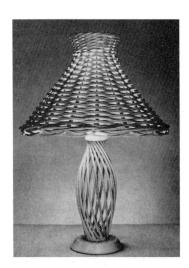

Table lamp on heavy crystal glass base with parchment shade. Designer: Michel Daum. Makers: Daum & Cie, Cristallerie de Nancy (FRANCE). FAR RIGHT: Desk lamp with shade mounted on swivel joint; finished satin silver, gold or copper anodized aluminium throughout, or with shade in stove-enamelled colour. Designer: Paul Boissevain, MSIA. Makers: The Merchant Adventurers Ltd (GB)

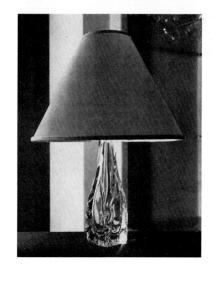

Table lamp, 17 inches high, on wood and metal base finished satin silver, brass or copper, with 15-inch diameter enamelled metal shade over 6-inch diameter glass cone. Designers and makers: Best & Lloyd Ltd (GB). FAR RIGHT: Lamp on black lacquered and white glass base with perforated metal shade lacquered red. Designers and makers: Stilnovo (ITALY)

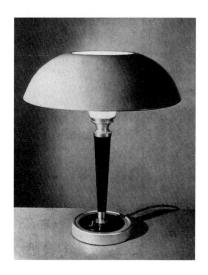

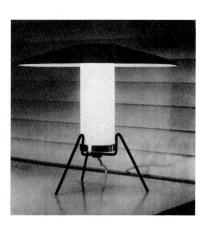

FAR LEFT: Table lamp on base of opaque glass in two tones of opalescent Rhodoid shade dec with gold stars and cord e Designer: Mrs G. L. de Snel Jaderholm. Makers: Iittala Glass (FINLAND). LEFT: Table lamp on lacquered tripod frame, white cylindrical diffuser and red-lace shade. Designers and makers: St (ITALY)

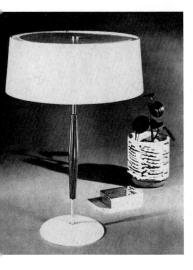

np on brass stand with walnut hand grip; n shade with baffle above and diffuser below. igner: Gerald Thurston. Makers: Lightolier (USA)

inch diameter ball-shaped desk lamps ting on a rubber-tipped, three-pronged base, mitting a wide range of adjustment. Avail-: in black or white for use with a 25-watt p. Designer: Harry Gitlin. For Stamford hting (USA)

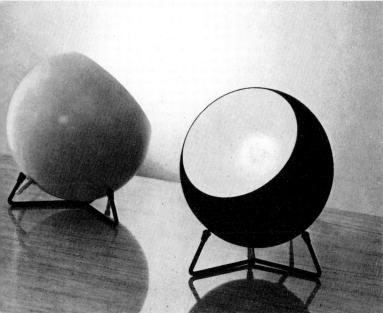

Table lamp on plastic-covered wire tripod base with pleated acetate shade in apricot, ivory or white, and grey switch lampholder. Designers: E. Cooke-Yarborough and Ronald Homes. Makers: Cone Fittings Ltd (GB)

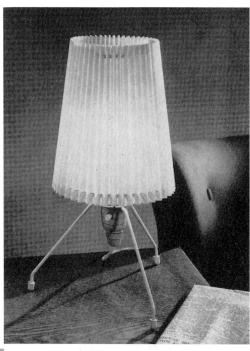

Table lamp with white etched glass base and shade of natural linen bordered with red cotton cord and decorated with red wooden beads. Designer: Mrs G. L. de Snellman-Jaderholm. Makers: Iittala Glassworks (FINLAND)

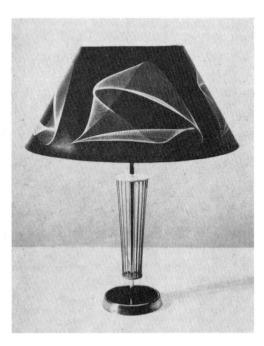

Table lamp with effective use of 'gravity curve' as a purely decorative feature. Polished brass base and stem, mustard stove enamelled wire cage. Designers: Beverley Pick Associates. Makers: Chrysaline Ltd (GB)

Polished brass table lamp designed for diffused lighting, with white-lacquered perforated reflector and coloured top reflector. Designer: Jacques Biny. Makers: Luminalite (FRANCE)

ABOVE: (left): Table lamp on wire base in satin brass or colours, Chrysaline sprayed shade. Designer: Beverley Pick, FSIA. Makers: Chrysaline Ltd (GB). (Right): Table lamp on Australian walnut and sycamore base, plastic shade. Designed and made by A. J. Eves, BA (GB). LEFT: Beech table lamp, with reverse pleated plastic shade. Designed and made by Troughton & Young (Lighting) Ltd (GB)

ow (*left*): Table lamp on cross-reeded rimu wood base. Designer:

Crichton. Makers: Mount Eden Turnery. Double espartre
te made by Max Robertson (New Zealand). Below (*right*): Lynx
: lamp on clear crystal base, raffia shade. Designed and made by
m Cristallerie d'Art (France). RIGHT: Table lamp on white
tue etched glass base; pleated white muslin shade with pale grey
ler. Designer: Mrs. G. L. de Snellman-Jaderholm. Base made
Carhula-Iittala Glassworks (FINLAND)

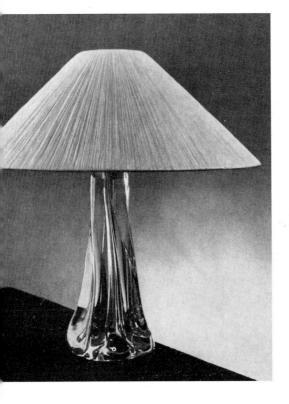

LEFT: Table lamp on clear crystal base, raffia shade. Designers and makers: Daum Cristallerie d'Art (FRANCE)

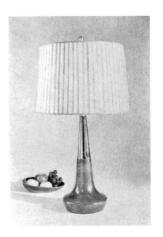

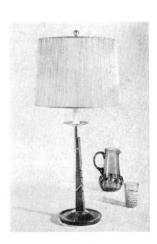

ABOVE: Table lamps on bases of walnut and polished brass; that on right is a ratchet design permitting adjustment in height from 29 to 33 inches. White translucent parchment shades mounted with light matchwood strips. Designer: Gerald Thurston. Makers: Lightolier Inc. (USA)

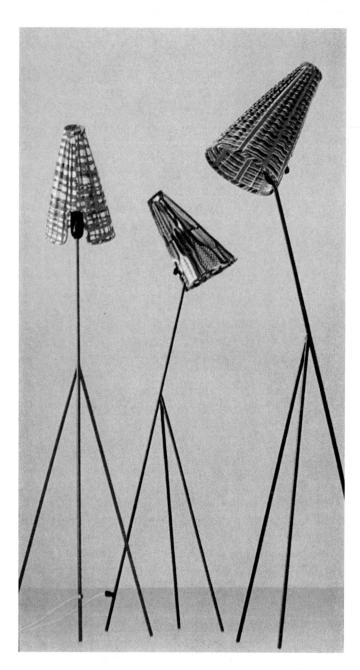

Standard lamps on metal stems lacquered in various colours. The gay textile shades are movable in any direction. Designer: Hans Bergström, SIR. Makers: Ateljé Lyktan (SWEDEN)

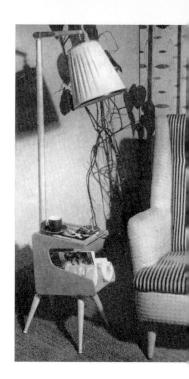

ABOVE: Combined birch standard lamp and small table; shade in shand on a brass frame. Designer: A. A. Patijn. Makers: De Kroon (HOLLAI BELOW (left): Indilux floor lamp on wrought-iron stem, white metal and reflector. Designer: Mathieu Matégot. Makers: Société Mate (FRANCE). BELOW (right): Floor-lamp on iron pedestal, sprayed black, polished brass support. Perforated metal screen, lacquered white; refle sprayed white inside, red, green, yellow or black outside. Design Ateliers Pierre Disderot (FRANCE). Makers: Geni Products (GB)

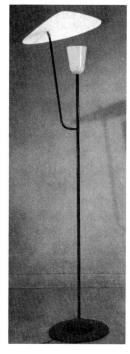

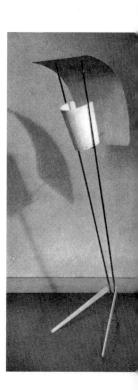

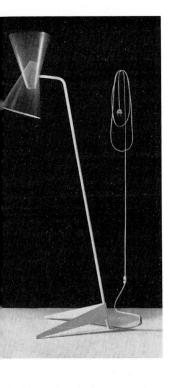

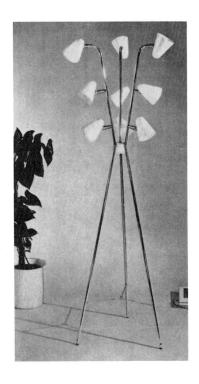

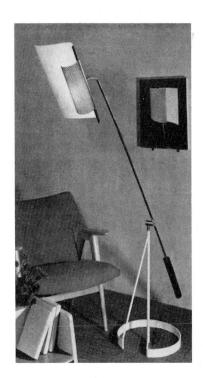

ndard lamp of steel tube construction, uered in various colours; rotating de. Designer: Alfred Altherr. Maker: nrich Kihm Stahlrohrmöbelfabrik ITZERLAND) (Photo: Hans Finsler)

DW: Reading and sewing lamp in n finished brass, pleated acetate shade. signer: J. M. Barnicot, MSIA. Makers: k, Stadelmann & Co. Ltd (GB)

Floor lamp on polished brass tubing double tripod frame, carrying nine individually flexible white-enamelled hoods pierced at the rim. BELOW: Combined floor lamp and table-height tray of walnut on cast brass base, with natural woven straw shade fitted with a plastic diffuser and baffle screen. Designer: Gerald Thurston. Makers: Lightolier Inc. (USA)

Floor lamp on wrought-iron base lacquered white, with pivoting brass arm balanced by a counterweight; the lacquered iron reflector is also adjustable. Designer: Jacques Biny. Makers: Luminalite (FRANCE). BELOW: Polished mahogany standard lamp with extendible satin brass tube. Designers and makers: Troughton & Young (Lighting) Ltd (GB)

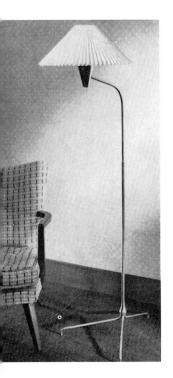

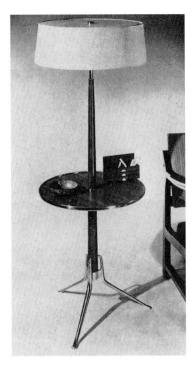

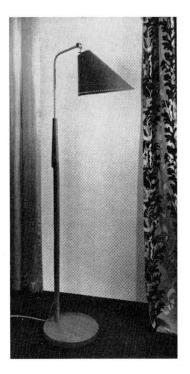

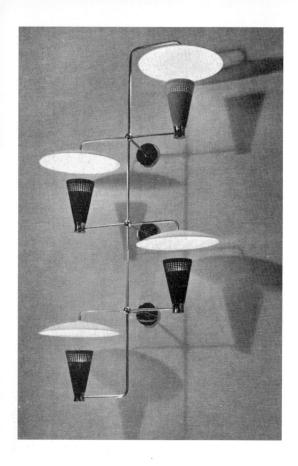

Polished satin brass bracket with brass cups, lacquered yellow, red, green and blue, under Perspex reflectors. Designer: J. M. Barnicot, MSIA. Makers: Falk, Stadelmann & Co. Ltd (GB)

BELOW: Clip-on adjustable wall light for positions where no wall point exists. Dove grey, red or off-white reflector, clip and stem chromium-plated brass. Designer: J. M. Barnicot, MSIA. Makers: Falk, Stadelmann & Co. Ltd (GB)

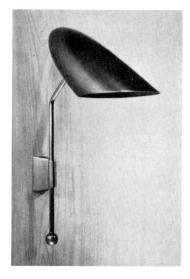

Wall bracket of stove-enamelled wire ing basket in House & Garden col Translucent silk-screened shade in re mustard with white decor. Desig Beverley Pick Associates. Makers: Ch line Ltd (GB)

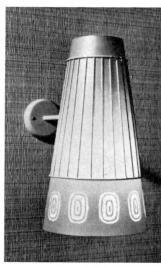

Combined wall lamp and telephone shelf in polished brass and walnut. The rectangular shade is in pleated aspenslat with an inset glass baffle screen. Designer: Gerald Thurston. Makers: Lightolier Inc. (USA)

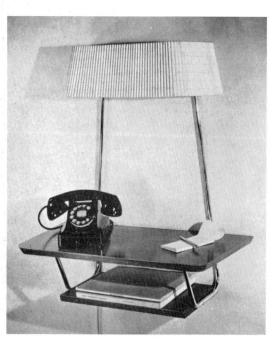

BELOW: Steel wall bracket with perforated brass cup. The curved back reflector, 15 inches wide, is in matt Perspex. Designers: Ateliers Pierre Disderot (FRANCE). Makers: Geni Products (GB)

ABOVE: Wall or table lamp in satin bre with counterweight. Shade in off-wh grained plastic material. Designers as makers: Troughton & Young (Lighting Ltd (GB)

Painted white metal wall bracket carrying twin lights fitted with pierced card shad in various colours. Designer: Fran-Mackmin. For Heal's of London (GB) equered metal ceiling fitting with globes of sprayed stic over a wire armature. Designer: Hans Berg-5m, SIR. Makers Ateljé Lyktan (SWEDEN)

.ow: Adjustable wall pendant on pivoting telescopic n controlled by a counterweight. Polished brass de. Designer: Gerald Thurston. Makers: Lightolier 3. (USA)

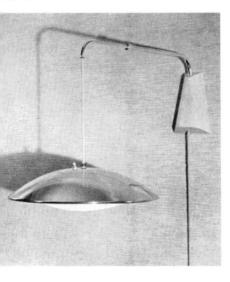

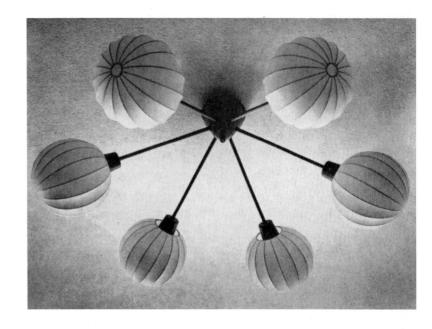

Wall lamp fitted with lacquered copper shade and reflector; olive green base and stem. Designer: John Crichton. Makers: J. E. West & Co. (NEW ZEALAND)

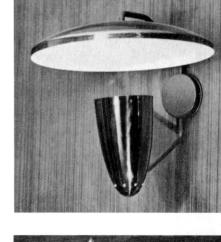

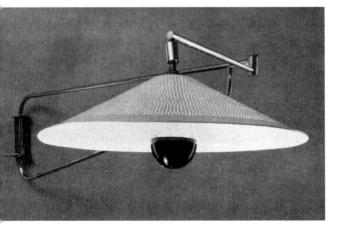

BOVE: Wall bracket operating on the ball-and-socket principle, ith metal perforated shade degned to give indirect patterned tiling illumination. Designers and makers: Solec (FRANCE)

GHT: Wall bracket in aluminium, the reflector surfaces painted hite, outer surfaces coloured or a anodised finish. Designer: udolf Hollman. Makers: Osald Hollman Ltd (GB)

Polished brass wall bracket with striped fabric shades in rust and white, turquoise and white, or other colours. Designer: Doren Leavey. Makers: Oswald Hollman Ltd (GB)

The design of light fittings, and particularly of the free-standing type, offers much scope for decorative treatment and every year sees a host of new creations in which the only standard component is the socket for the lamp. Apart from the light-giving properties of the shaded bulb there are few functional considerations that prevent the designer from doing almost anything he fancies, and considerable freedom in the use of imagination is found in all manner of shapes made up from several kinds of material.

The resulting sculptural exercises can, and often do, run to extremes of fantasy, and they introduce a note of gay nonsense which may give pleasure to the beholder while serving the needs of room lighting to a greater or lesser degree, depending on the design of the shade and the material used. While liberties in the design of the supporting standard or bracket do not impair the efficiency of the light, the shade may not always be the most suitable for giving the desired quality or intensity of light, and appearance alone is not a sufficiently reliable guide to the choice of a fitting.

This review illustrates designs for use in various applications which call for different types of shading. The efficiency of output necessarily varies as between one design and another, but since the type of light demanded of a reading lamp, for example, is different from that required for general room illumination, shade design and shade material vary accordingly. While exploiting the decorative possibilities, designers have not overlooked the respective functional requirements of the fittings under review.

Table lamps. Above left: Black Beauty on cast aluminium base lacquered black/white, with patterned plastic shade. Designer: C. I. A. Nilsson. Makers: A/B E. Hansson & Co. (SWEDEN). ABOVE RIGHT: Base of 'Verbano' ivory porcelain, pleated Perspex shade. Designer: Guido Andlowiz. Makers: Società Ceramica Italiana (ITALY). RIGHT: Black lacquered metal base with polished crystal centre. Designer: Max Ingrand (FRANCE). Makers: Fontana Arte (ITALY)

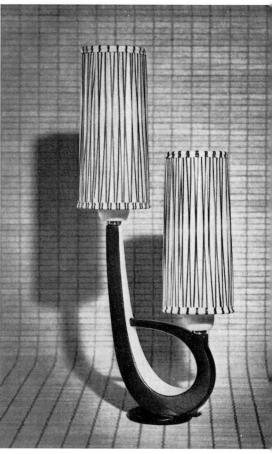

ABOVE: Two Silhouettes twin light fitting on c aluminium base lacquered dark brown and lig yellow; plastic shade. Designer: C. I. A. Nilss Makers: A/B E. Hansson & Co. (SWEDEN)

ble lamp on natural mahogany support with polished ss tube and legs. The reflector is enamelled. Designed I made by Best & Lloyd Ltd (GB)

OW: Reading lamp of cast aluminium, green mmer lac finish, polished brass arm balance, justable reflector. Designer: C. I. A. Nils-1. Makers: A/B E. Hansson & Co. (SWEDEN)

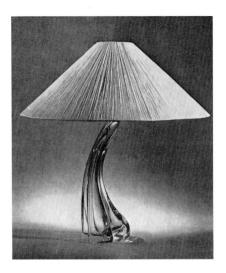

ABOVE: Table lamp on heavy crystal base; raffia shade. Designer: Michel Daum. Makers: Daum Cristallerie de Nancy (FRANCE)

RIGHT: Desk lamp on telescopic brass tube support. The shade and louvered diffuser are of ribbed styrene. Baked enamel finish in a choice of four colours. Designer: Gerald Thurston. Makers: Lightolier Inc. (USA)

ABOVE LEFT: Table lamp on teak rod support, Perspex shade. Designer: Hans Bergström. Makers: Ateljé Lyktan (SWEDEN). ABOVE RIGHT: Table lamp. Base, reflector and shade of polished brass or black aluminium, with white underside to top reflector. Designer: Svend Aage Holm Sørensen. Makers: Holm Sørensen & Co. (DENMARK)

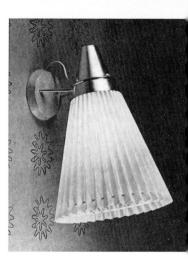

ABOVE LEFT: Wall light on beech mount. The arms are in polished brass, and the 13-in shade satin opal glass. Designed and made by Best & Lloyd Ltd (GB). ABOVE RIGI Wall light, type 'C.P.' Anodised aluminium cap and legs, polished beech mount, a pleated acetate shade, in white, ivory, or apricot; it is removable for washing. Design by Yarborough-Homes, MMSIA. Makers: Cone Fittings Ltd (GB)

ABOVE: Valencia Triple light bracket in satin brass. Designed for indirect lighting by Svend Aage Holm Sørensen. Makers: Holm Sørensen & Co. (DENMARK)

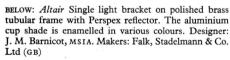

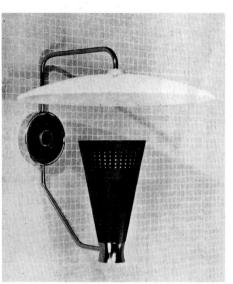

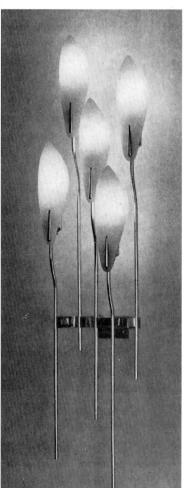

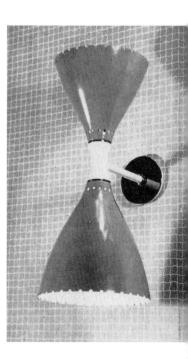

ABOVE: Diabolo wall bracket in ename aluminium and polished brass. Cherry blue grey, and off-white reflectors. Design J. M. Barnicot, MSIA. Makers: Falk, Stadmann & Co. Ltd (GB)

LEFT: Wall bracket for indirect lighting polished brass with opal glass shades in sidifferent colours. Designed and made Fontana Arte (ITALY)

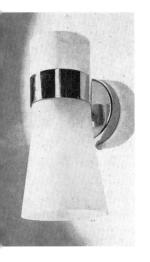

IVE LEFT: Wall light with matt opal shade, polished brass ring id. Designed and made by Paavo Tynell (FINLAND). ABOVE HT: Fluorescent tube wall fitting lacquered in various colours; last mount lacquered black. The tube can be rotated in the tical plane to a horizontal position. Designer: Gino Sarfatti. kers: Arteluce Soc. Acc. (ITALY)

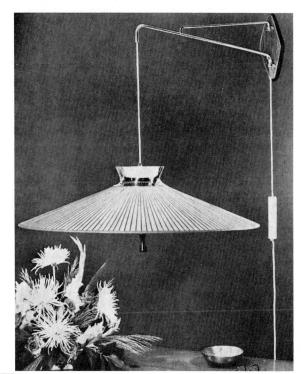

Free-swinging orientable wall lamps with up-and-down sliding movement. ABOVE: Walnut mount, polished brass arms. Walnut strips radiating from a pierced brass collar decorate the fibreglass shade. Designer: Gerald Thurston. Makers: Light-olier Inc. (USA). LEFT: Arm in polished brass; ball shade in Perspex. Designed and made by Stilnovo, s.r.l. (ITALY)

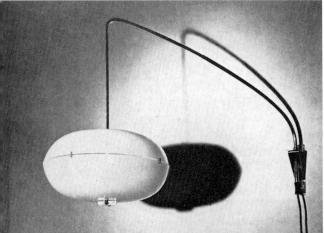

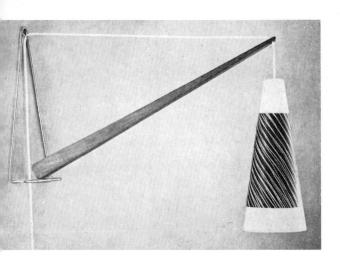

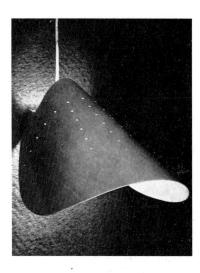

ABOVE: Airlie wall lamp with batten holder. The perforated reflector is in birch plywood, cellulosed in choice of colours; interior surface white. Designed and made by Alten Products (6B). LEFT: Wall bracket of polished brass tube with movable teak suspension arm. Satin opal glass shade with black-and-white plastic decoration. Designer: Svend Aage Holm Sørensen.Makers: Holm Sørensen & Co. (DENMARK)

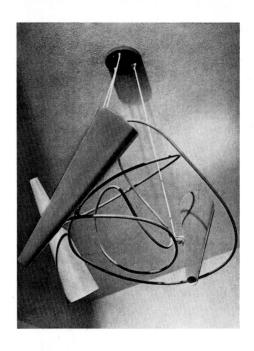

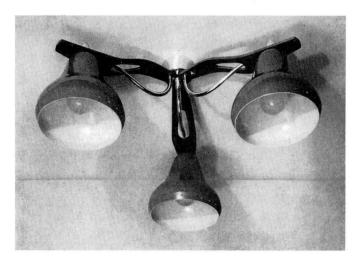

ABOVE: Ceiling pendant with enamelled reflectors on polished beech arms; tubes and ceiling plate are in polished brass. Designed and made by Best & Lloyd Ltd (GB)

ABOVE LEFT: Ceiling fitting in lacquered metal. Blue frame, shades in white, primrose, light green. Designer: Hans Bergström. Makers: Ateljé Lyktan (SWEDEN)

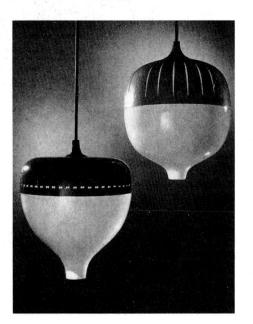

LEFT: Polished brass ceiling fitting with shade of moulded fibreglass, in rattan and various other finishes. Designed by H. Gottlieb and Erich Marx. Made by Modulite Inc. (CANADA)

ABOVE: Pendant with oiled suspension bracket; white glass shades with non-g satin finish. Designer: S Aage Holm Sørensen. Ma Holm Sørensen & Co. (MARK)

LEFT: Ceiling lamp with sprayed wire shade. Desi Hans Bergström. Makers: A Lyktan (SWEDEN)

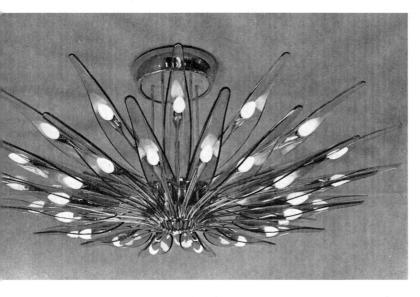

ABOVE: Ceiling pendant in polished brass with thirty-two lamps enfolded in clear and coloured crystal petal-shaped shades. Designed and made by Fontana Arte (ITALY)

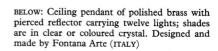

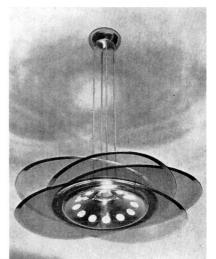

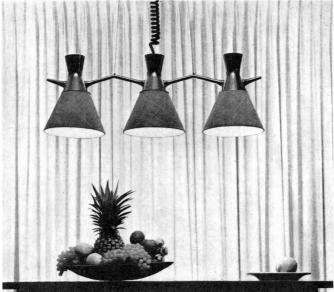

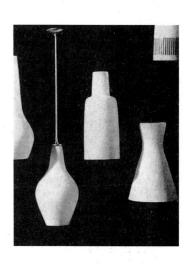

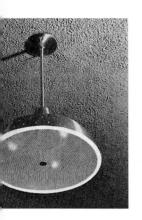

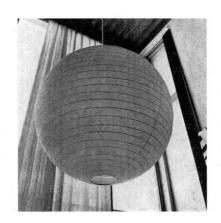

ABOVE LEFT: Three in Line adjustable ceiling fitting. Polished brass yoke, rubber covered coil suspension; textured cloth shades. Designer: Gerald Thurston. Makers: Lightolier Inc. (USA). ABOVE RIGHT: Shades in matt opal glass, plain or decorated. Designed by Uno Westerberg SIR. Metalwork in polished brass. Shades made in Sweden; fittings by Fredk. Thomas & Co. Ltd (GB)

FAR LEFT: Ceiling light in polished aluminium or brass with pierced baffle reflector. Available in natural finish or coloured lacquers. Designed and made by Modulite Inc. (CANADA)

LEFT: Ceiling lamp with plast-sprayed shade. Designer: Hans Bergström. Makers: Ateljé Lyktan (sweden)

The means used for lighting a room continue to play an important part in its decorative scheme. Table lamps still make good wedding presents, and, whereas there are some which cannot reasonably be selected without reference to the setting in which they will appear, most of them suit a wide range of circumstances.

Generally speaking, the purer and simpler the form, the more nearly absolute will be its ubiquity. Simplicity does not, however, call for characterless or negative design; in fact, as will be seen from the illustrations, there is strength and unity in the simplest of the lamps and fitments shown.

Fixtures are of a different category. Designed for permanent siting, they can be selected in the first place to give the required amount of light where it is needed and, secondly, to fit either unobtrusively or as decorative motifs into the surrounding detail. With the possible exception of some of the shades which may have become distractingly large or elaborate and are, in any case, often supplied as separate or interchangeable items, most of the fixtures have been designed with sufficient flexibility to allow of harmonious siting in a variety of contemporary settings.

Conventional materials; ceramics, glass, wood and metal; still offer sufficient scope to meet the structural needs of most designs, but there is occasional use for plastics and, particularly where soft or semi-rigid shades are concerned, for synthetic washable materials. They can either be sponged down in situ, or removed bodily and immersed in a detergent solution.

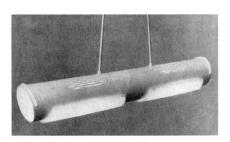

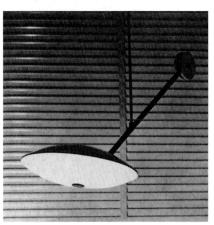

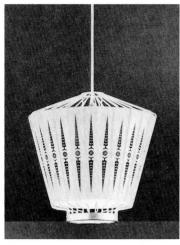

ABOVE: Wall lamps in (left) black-lacquere aluminium with decorative reflector; (right) with teak turned ornaments and textishade. Designers and makers: Hans-Agi Jakobsson AB (SWEDEN)

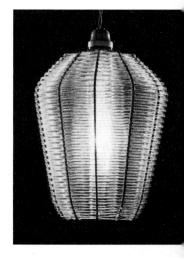

ABOVE: Pendant shade, hand-woven plastic monofilament on plastic coated wi frame. Colours: clear on red or yello frame; all red, all yellow. Designe Desmond Sawyer, LSIA. Makers: Desmor Sawyer Designs Ltd (GB)

FAR LEFT: Pendant of grouped aluminiu cylinders lacquered black or other colou (interior white). LEFT: Ceiling lamp with balanced reflector on oxidised brass mour The shade is in aluminium, lacquere black, with glass diffuser. Both are designed and made by Stilnovo, s.r.l. (ITALY)

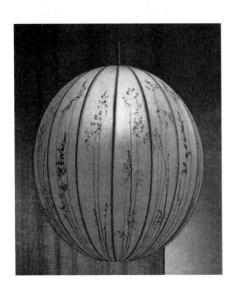

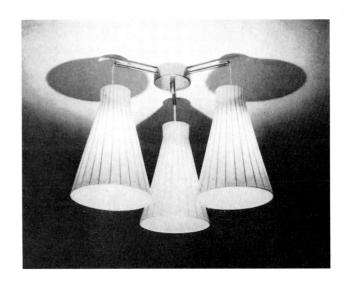

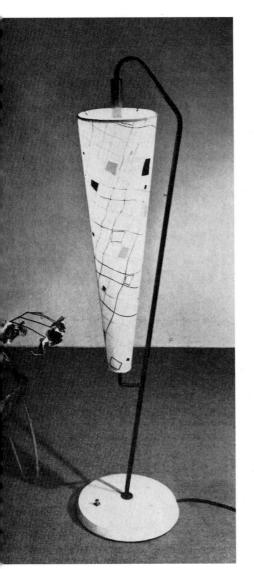

ABOVE LEFT: Pendant shade of layered parchment interleaved with pressed and dried grasses and leaves. Designed and made by Birgitta Sorbon-Malmsten (SWEDEN). ABOVE RIGHT: Ceiling pendant with plast-sprayed shades; copper suspension details. Designers and makers: Hans-Agne Jakobsson AB (SWEDEN). LEFT: Floor standard, 4 feet 4 inches high, on white terrazzo base with foot-operated switch. Black stem with polished brass sleeve; black and yellow patterned shade with Perspex top diffuser. Designers and makers: Troughton & Young (Lighting) Ltd (GB). BELOW LEFT: Pendant for direct or indirect lighting with aluminium shades lacquered black or other colours; polished brass waist. Designer: Sven Aage Holm Sørensen. Makers: Holm Sørensen & Co. (DENMARK). BELOW RIGHT: Pendant with matt black decorated opal glass shade; polished brass and gold-lacquered ceiling plate and gallery, matt black suspension. Designer: J. A. C. Howard. Makers: Tucker & Edgar (GB)

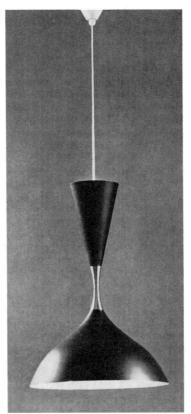

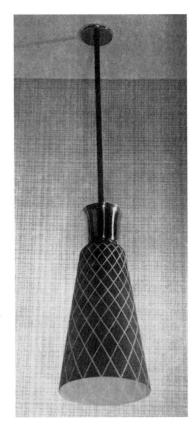

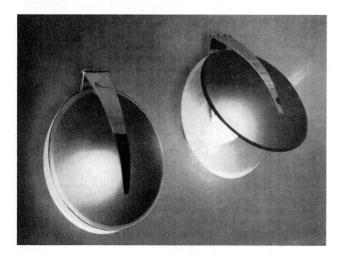

ABOVE: Small wall lamps with cupped shades in satin white and coloured crystal glass on hinged mount of polished brass. Designers and makers: Fontana Arte (ITALY)

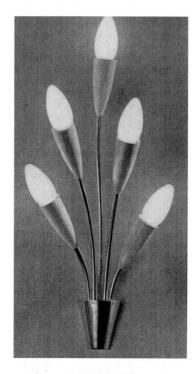

RIGHT: Polished brass wall bracket with white relief; fitted 'Silverlight' candle bulbs. Designers and makers: General Electric Co. Ltd (GB)

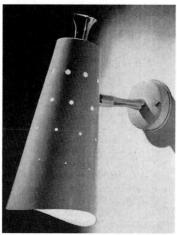

RIGHT: Wall lamp on adjustable brass mount; pierced shade in spun aluminium with pearl-grey baked enamel finish and brass finial. Designer: John Crichton. Makers: E. West & Co. (NEW ZEALAND)

BELOW: Double standard floor lamp on polished brass base with bla lacquered brass stem and rubber-covered carrying handle. The sha (larger in Plexiglass, smaller in aluminium lacquered black and white) carried on an extending swivel bracket and can be moved up and down rotated. Designers and makers: Stilnovo s.r.l. (ITALY)

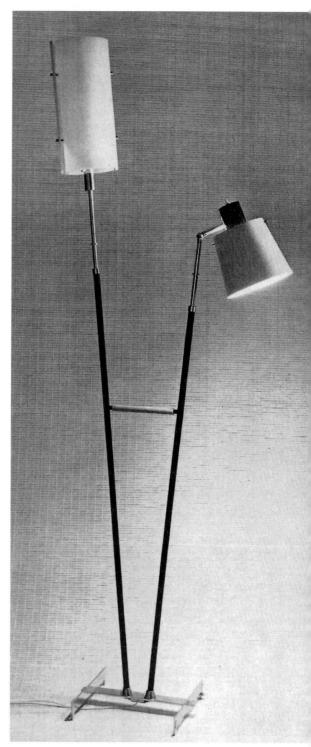

ve: Prisma ceiling pendant on ished brass mount; black-lacquered a with opal Plexiglass shades. Total gth: 3 feet 11 inches. Designer: degard Liertz. Makers: Hessenps (GERMANY)

HT: Gala floor standard on polished ss base with black-lacquered stems. two lower shades are in brass quered electric blue; the centre shade 1 polished brass. Total height: 5 feet nches. Designer: Hildegard Liertz. kers: Hesse-Lamps (GERMANY)

ABOVE: Satin brass wall bracket on white mount. Red silk-screened shade with white motif and gilt edge. Also available with glass shade. Designers: Beverley Pick Associates. Makers: General Electric Co. Ltd (GB)

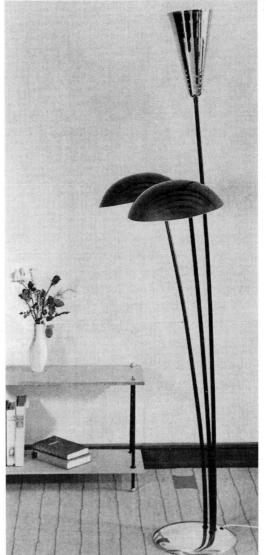

ABOVE: Wall bracket with large opal glass shade on fancy brass mount. Designer: J. Junek. Makers: Kamenicky-Senov Chandelier Works (CZECHOSLOVAKIA)

BELOW: Wall lamp with white-lacquered brass mount held in a bronze hand; satin glass globe. Height 18½ inches. Designers and makers: Fontana Arte (ITALY)

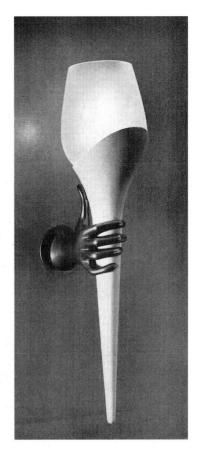

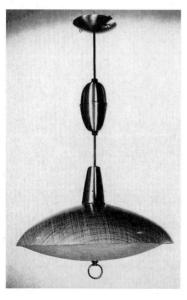

ABOVE: Pendant of moulded fibreglass on aluminium pulley fixture; rattan finish shade with brass or copper trimming. Designer: H. Gottlieb. Makers: Modulite Inc. (CANADA).

RIGHT: Table lamp on light ruby glass base; shade of white rhodoid with raised spots, and vieux-rose velvet ribbon binding. Designer: Mrs. G. L. de Snellman Jaderholm. Base made by Karhula-Iittala Glassworks (FINLAND)

BELOW: Table lamp on flexible brass stem; white Perspex base and shade. Designer: Yki Nummi. Makers: Stockmann-Orno (FINLAND)

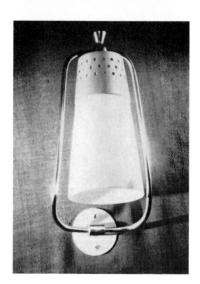

ABOVE: Wall bracket with polished brass and gold-lacquered arms and finial; perforated gallery in cherry or lemon chrome and white flashed opal glass shade. Designer: J. A. C. Howard. Makers: Tucker & Edgar (GB)

ABOVE: Pendant on metal suspension slacquered aluminium shades mounted teak cup. Designer: Sven Middell Makers: A/S Nordisk Solar (DENMARK)

LEFT: Table lamp on black terrazzo with satin brass stem and embossed lishade. Also available with a white razzo base and black bronze stem. signers and makers: Troughton & Yo (Lighting) Ltd (GB)

w: Table lamp on polished brass base white plast shade on 15-inch teak rod ort. Designer: Hans Bergström. ers: Ateljé Lyktan (SWEDEN)

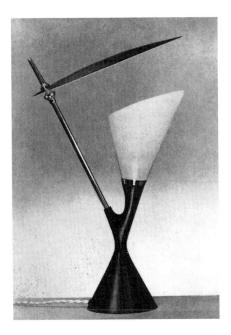

ABOVE LEFT: Table lamp on cast iron base, dull black finish; white plastic shade with adjustable aluminium reflector lacquered black (cream underside) on polished brass arm. Designer: Sven Aage Holm Sørensen. Makers: Fog & Mørup (DENMARK). ABOVE RIGHT: Table lamp in polished brass with shade of pressed butterflies and leaves under fibreglass. Height overall 27 inches. Designer: John Crichton. Base made by E. West & Co.; shade by Max Robertson (New ZEALAND)

BELOW LEFT: Table lamp in polished brass, or with black lacquer finish; white satin glass diffuser. Designers and makers: Fontana Arte (ITALY). BELOW RIGHT: Table lamps on teak base with hand-painted multi-colour decoration; matt white shade. Height 13½ inches. Designers and makers: Hans-Agne Jakobsson AB (SWEDEN)

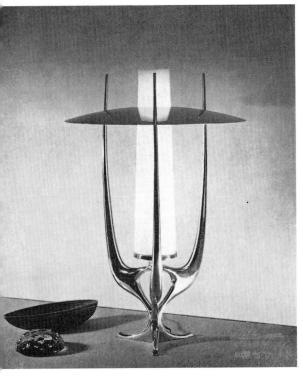

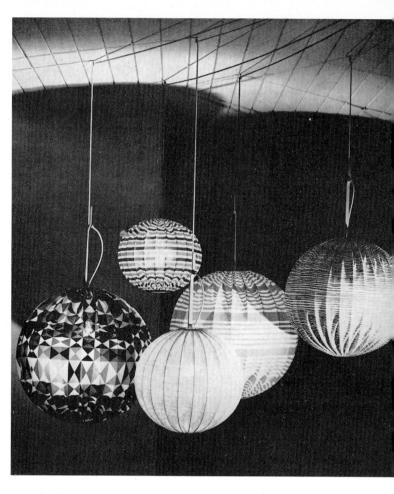

BELOW: Terrazze pendants in opal glass; single or tiered aluminium shades lacquered black, orange, or red. Designer: Jørn Utzon. Makers: A/s Nordisk Solar Co. (DENMARK)

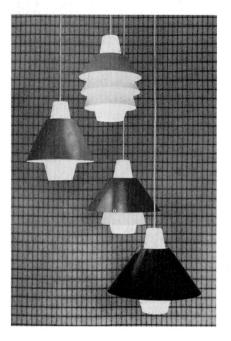

ABOVE: Wire frame globe pendants, 19½ to 27 inches diameter, printed textile shades; suspension de in maple. Designers and makers: Hans-Agne Jakobsson AB (SWEDEN). BELOW: Triple pendant of adjust multicolour art glass shades with brass accents; the white plastic suspension cord runs through a b divider with inner rods in correlated colours. Custom made in Denmark for Raymor (USA)

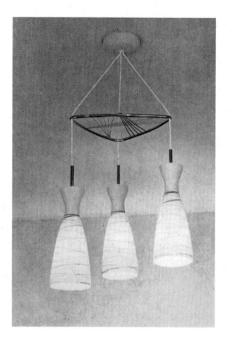

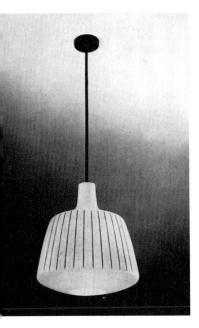

E: Mondolite pendant, white satin finish opal glass e, black and yellow line decoration; suspension, black finish, or polished brass. Designers and rs: Troughton & Young (Lighting) Ltd (GB)

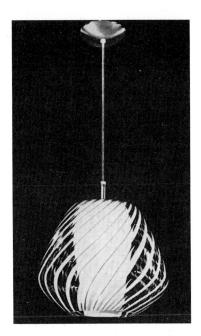

ABOVE: Glass-in-glass ceiling pendant, opal inner cylinder, clear glass outer shade with etched swirl and fine mauve line decoration. From the Capri collection by Lightolier Inc. (USA)

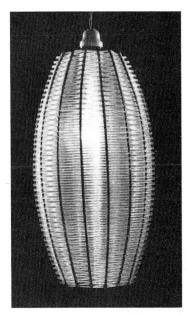

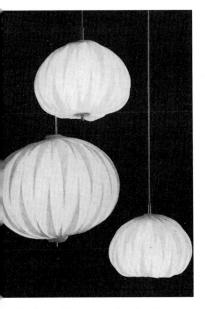

ve: Pendants with globe shades of white plastic ton. Designer: Antti Nurmesniemi. Made by ek (FINLAND)

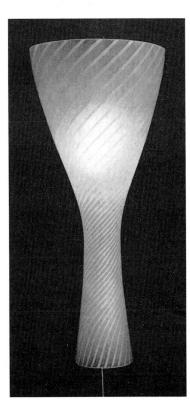

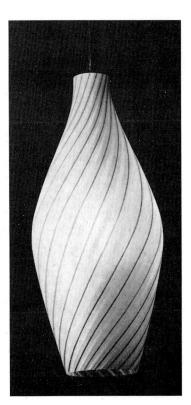

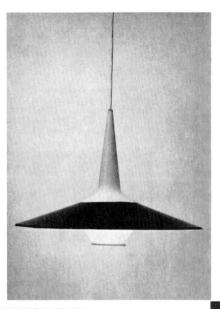

ABOVE: Pendant globe in plastic with lacquered metal shade. Designer: Bertil Roos. Made by Livoflex Gmbh (SWITZERLAND)

BELOW: Orno pendant for diffused lighting,

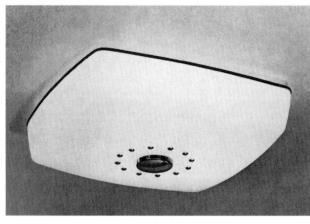

ABOVE: Ceiling fitting with white or champagne Perspex bowl and polished brass ornament. Designed and made by the General Electric Co. Ltd (GB)

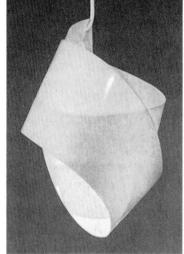

ABOVE: Pendant shade of twisted plast strip about 12 inches wide. Designer: Hans Bergström. Made by Ateljé Lyktan AB (SWEDEN)

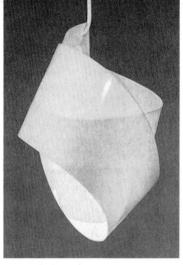

ABOVE: Pendants in satin brass with satin et opal glass diffuser; the bulb is adjustable change the light distribution. Designer: B Dahl. Made by Sønnico (NORWAY)

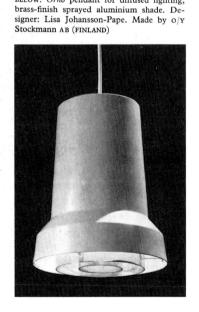

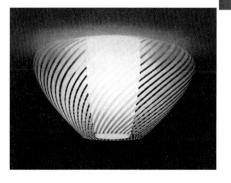

LEFT: Ceiling fitting Toledo: clear glass s with striped decoration embodied in the gopal glass inner diffuser. Designer: A Gangkofner. Made by Peill & Putzler G (GERMANY)

Wall lamp on extensible swivel arm in polished white and black lacquered aluminium reflector lley slide fitting. Designed and made by Stilnovo WTALY)

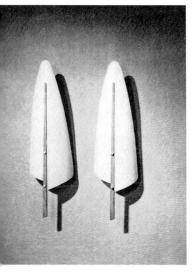

: Wall lamps for use with candelabra bulb; white flow Bonoplex glass shade, polished oak detail. ners and makers: Hans-Agne Jakobsson AB PEN)

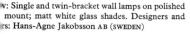

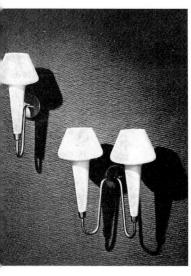

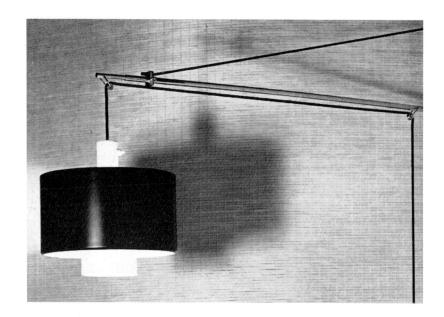

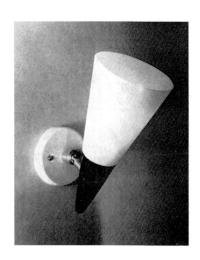

LEFT: White pinspot Perspex wall light. It is clipped to a metal mount and can be inverted. Designed and made by Troughton & Young (Lighting) Ltd (GB)

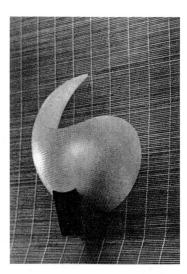

ABOVE: Wall bracket with cupped shade in white Plexiglass on bronze mount. Designed and made by Ilum (ARGENTINA)

Adjustable wall bracket from the Harlequin range. Satin finish white flashed opal glass shade; also available with metal reflector in black, white, or four colours; or decorated glass. Designed and made by Troughton & Young (Lighting) Ltd (GB)

BELOW: Wall lamp on oak or Oregon pine bracket, pleated plastic shade. Designer: Wilhelm Wohlert. Made by Le Klint (DENMARK)

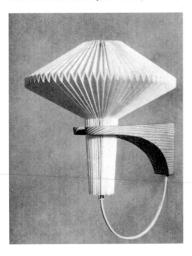

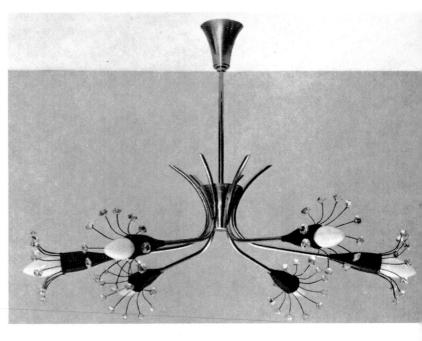

ABOVE: Pendant in polished brass with cut crystal bead decoration to the cupped candle bulbs. Designer: R Hollman. Made by Oswald Hollman Ltd (GB)

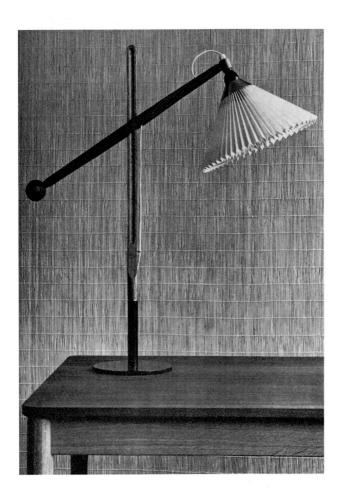

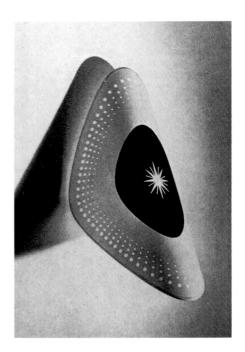

ABOVE: Wall fitting intended for use where a normal bracket is not avail shield shade in card, decorated in red and black. Designed and made by General Electric Co. Ltd (GB)

LEFT: Table lamp with adjustable bar mounted on smoked oak support black-lacquered metal base; pleated shade in plastic-coated paper. Desig Wilhelm Wohlert. Made by Le Klint (DENMARK)

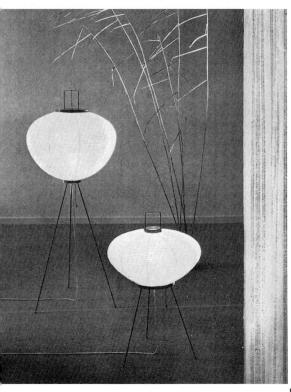

ABOVE: Table lamp in white glass with copper base and top. Designed and made by Solec (FRANCE)

LEFT: Floor lamps on black tubular steel tripod base with spun plastic globes over wire frame. Designed by Isamo Nouguchi (JAPAN). For Gösta Westerberg AB (SWEDEN)

r: Standard lamp with black perforated metal shade set on an iron ; white fibreglass inner diffuser. Designer: John Crichton. Made by Murray (NEW ZEALAND)

w: Table lamp in white and black Plexiglass mounted on black sed brass stand. Designed and made by Stilnovo, s.r.l. (ITALY)

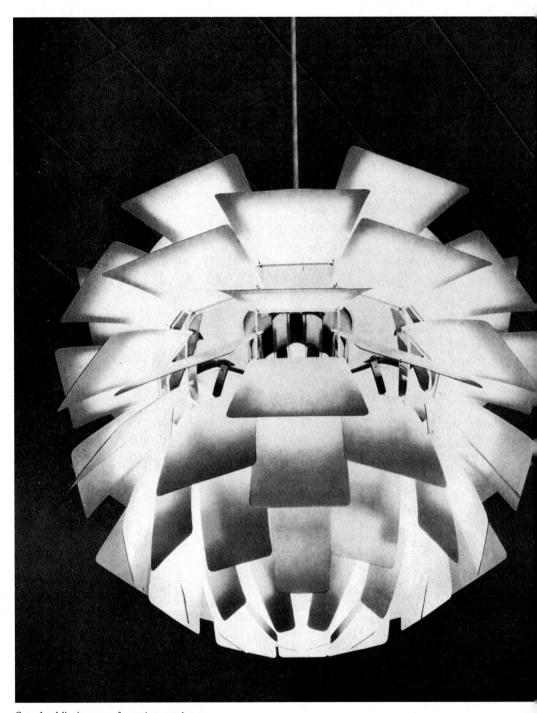

Cone chandelier in copper, for 300/400 watt lamp; outside matt-brushed, inside white. Diameter 28½ inches. Designer: Poul Henningsen. Makers: Louis Poulsen & Co. (DENMARK)

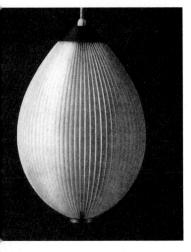

:ado pendant in pleated plastic, lacquered metal ls. Designed and made by Le Klint (DENMARK)

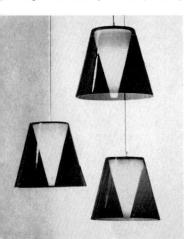

te opal cone pendants with outer shade of ured glass. Designer: Carl Fagerlund. Makers: Drrefors Glasbruk (SWEDEN)

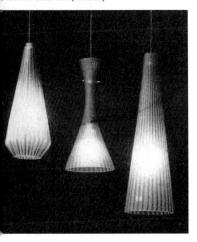

hed glass pendants in orange/yellow, amber/grey, blue/acquamarine. Designer: Dino Martens. kers: Vetreria Rag. Aureliano Toso (ITALY)

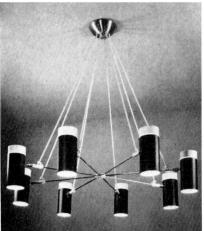

1 -

ABOVE: Multiple pendant on flexible suspension with brass arms; reflectors satin black or coloured. Made by Troughton & Young (Lighting) Ltd (GB). RIGHT: White Chrysaline pendant, card shade in red, citron, or black. Designer: Beverley Pick, FSIA. Makers: W. S. Chrysaline Ltd (GB)

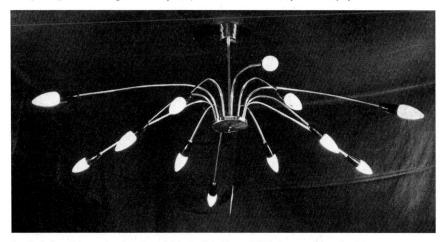

Candle-bulb multi-spray metal pendant, finished polished brass with black-sprayed spun aluminium lamp housings. Designer: W. E. Summers. Makers: Courtney Pope (Electrical) Ltd (GB)

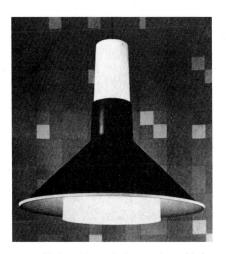

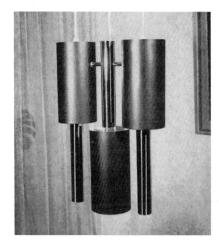

ABOVE: Yankee white opal glass pendant with lacquered aluminium shade. Designer: Sven Middelboe. Makers: A/s Nordisk Solar Co. (DENMARK)
RIGHT: Triple brass-rube pendant with spun aluminium shades sprayed black. Designed and made for fluorescent lighting by Svend Aage Holm Sørensen (DENMARK)

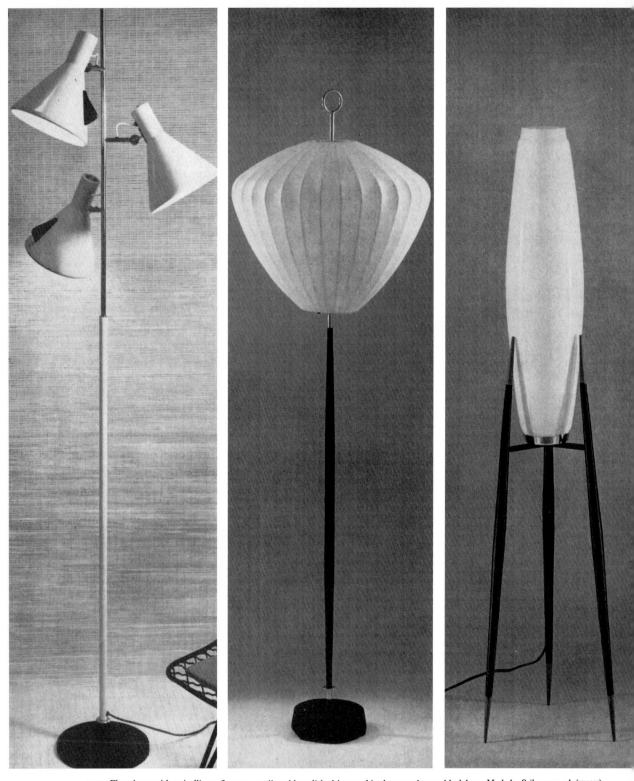

LEFT: Floor lamp with swivelling reflectors on adjustable polished brass white-lacquered stem; black base. Made by Stilnovo, s.r.l. (ITALY)
CENTRE: Floor lamp with plastic-coated cottonweave shade on wire frame; brass rod support on steel tube stem, cast base lacquered black
RIGHT: Floor lamp on conical steel legs with teak points; shade, opaline glass on spun brass ring. Both these designs are made by Svend
Aage Holm Sørensen (DENMARK)

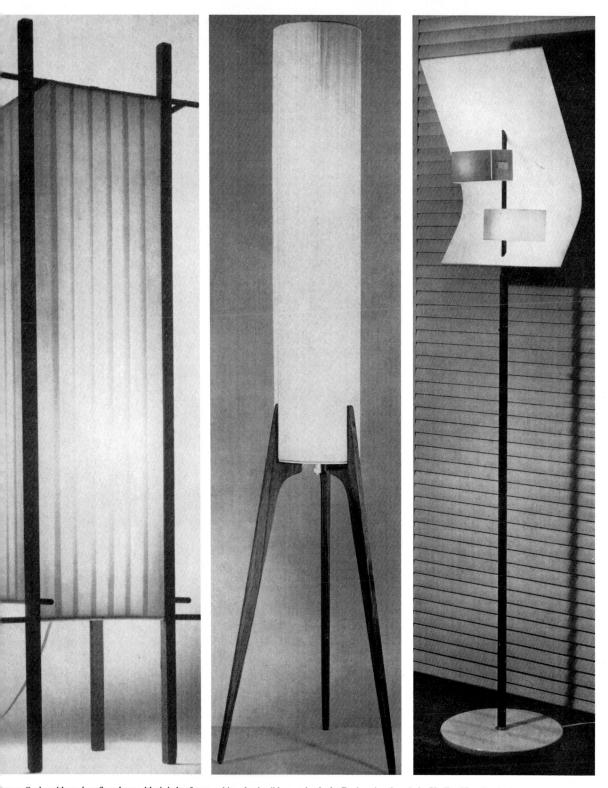

LEFT: Osaka table or low floor lamp; black balsa frame, white plastic ribbon-strip shade. Designed and made by Heal's of London (GB)
CENTRE: Teak tripod floor lamp with white nylon cylinder shade. Custom-made in Denmark for Raymor (USA)
RIGHT: Floor lamp with twin shades in red and light green plexiglass, and white-lacquered turnable reflector; black-lacquered stem and white marble base. Made by Stilnovo, s.r.l. (ITALY)

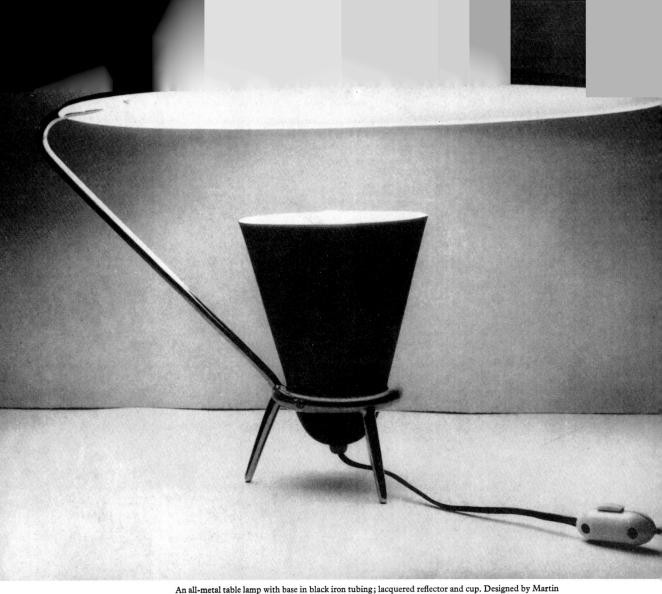

An all-metal table lamp with base in black iron tubing; lacquered reflector and cup. Designed by Martin Eisler in collaboration with Susy Aczel. Made by Ilum (ARGENTINA)

Table lamp on teak tripod base; white, red, or curry colour pleated plastic shade and brass details. Custom-made in Denmark for Raymor (USA)

Rimu wood table lamp on copper base, white fibreglass shade. Designer: John Crichton. Base by Mt. Eden Turnery; shade by Max Robertson (NEW ZEALAND)

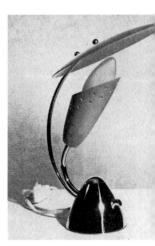

Table lamp on polished brass base black, green or yellow-lacquered met flector and matching candle-bulb & Made by Homeshade Company Ltd (6

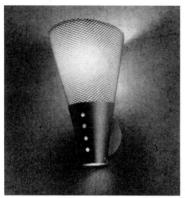

Metal wall bracket with expanded aluminium diffusing screen in lemon-chrome or cherry-red finish. Designed and made by Teeanee Ltd (GB)

◆ 'Pin-up' bracket with adjustable mahogany arm on matt black mount; washable Chrysaline shade, brass top cone. Designer: Beverley Pick, FSIA. Makers: W. S. Chrysaline Ltd (GB)

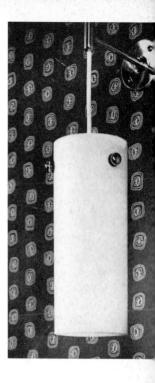

Wall bracket in satin opal glass on polished brass mount. Made by Hailwood & Ackroyd Ltd (GB)

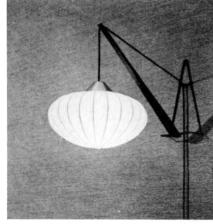

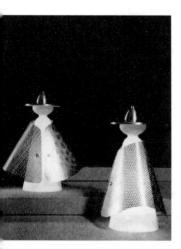

White frosted glass table lamps 14 and 16 nches high; perforated metal details in brass or copper. Designed and made by Hans-Agne Jakobsson AB (SWEDEN)

Box table lamp in Acririte, which is semi-opaque and gives a diffused light. Designed and made by Yasushiro Hiramatsu (JAPAN)

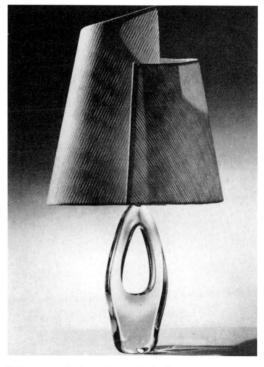

Table lamp on lead-crystal base; shade of figured fabric flashed onto parchment. Made by Daum Cristallerie de Nancy (FRANCE)

silver and tableware | Silber und Geschirr | Argenterie et arts de la table

ABOVE: Tea-set in 'polka dot' pattern produced by T. G. Green & Co Ltd, available in liberty green and maroon. Breakfast, dinner sets and jugs are also produced in this design. (Photo: Courtesy of *The Pottery Gazette*). RIGHT: *Magnolia* tea and coffee service printed in grey, with motif in pale yellow and white with green leaves. Background groundlaid in pale green with a fine green line on outer edge. Designed by S. C. Talbot and made by A. E. Gray & Co Ltd.

ABOVE: Ludlow dinner-ware designed by S. C. Talbot and made by A. E. Gray & Co Ltd. Decorative border is printed in green with a pale green groundlaid surround extending to the green off-edge line; centre motif handpainted in pink, lilac, blue, cerise, yellow, red and green. LEFT: Tea and coffee service made by Porzellanfabrik Langenthal A.G.

Part of a dinner service in fine earthenware called 'LA' designed by Stig Lindberg and made by AB Gustavsberg Fabriker.

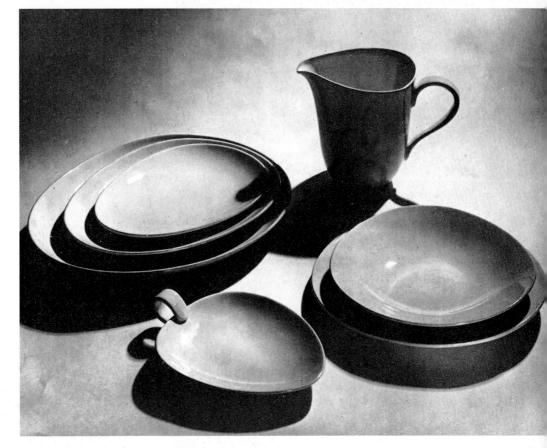

BELOW: Sherborne teaset with coloured slip facing in celadon green or shell pink designed by John Adams, ARCA, and produced by Carter Stabler and Adams Ltd, makers of Poole Pottery. The knobs and handles are ivory white.

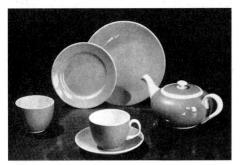

RIGHT: Dinner-ware designed by Susie V. Cooper, RDI, and made by The Susie Cooper Pottery Ltd. Plate on left has a wide mahogany-coloured band with a sgraffitto motif accentuated by black free-hand painting interspersed with small circles and finished with a narrow band of fern green in the well. Plate, soup bowl and saucer on right show the same motif freehand painted on a cream ground.

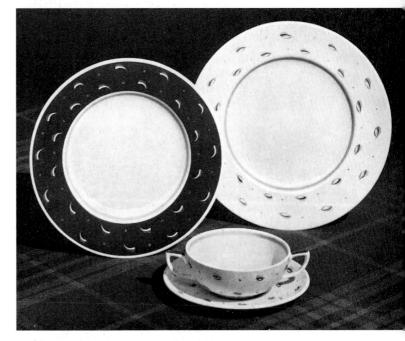

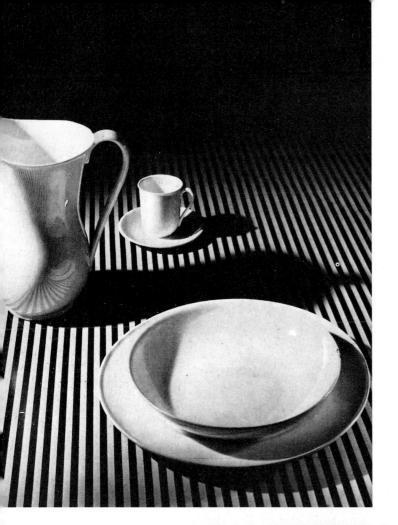

Part of a dinner service in bone china, known as 'LB' and designed by Stig Lindberg. Made by AB Gustavsberg Fabriker.

BELOW: Sherborne coffee-set to match tea-ware illustrated on the opposite page, designed by John Adams, ARCA, and produced by Carter Stabler and Adams Ltd.

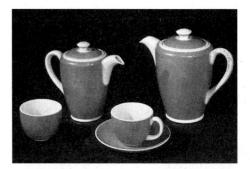

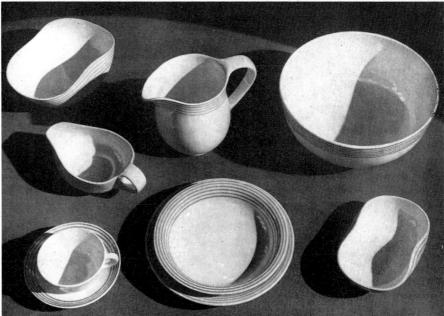

Gray Lines tableware in white earthenware designed by Wilhelm Kåge and made by AB Gustavsberg Fabriker. Stainless steel Gense tableware designed by Folke Ahrström.

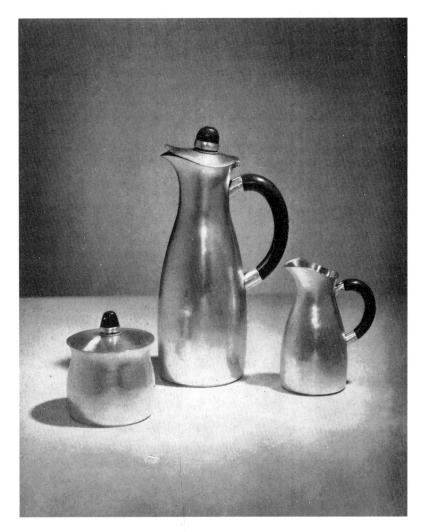

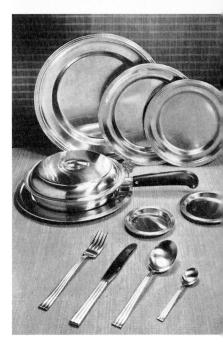

Silver coffee pot, hot-milk jug and sugar bowl with ebony knobs and handles designed by Sven-Arne Gillgren and made by Guldsmeds Aktiebolaget i Stockholm.

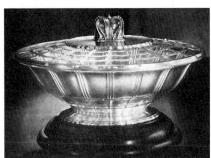

Silver rose bowl designed by A. G. Styles and made by S. J. Sparrow of R. E. Stone for The Goldsmiths & Silversmiths Co Ltd., and RIGHT, octagonal-shaped silver tea-set designed by F. Cobb and made by The Goldsmiths and Silversmiths Co Ltd.

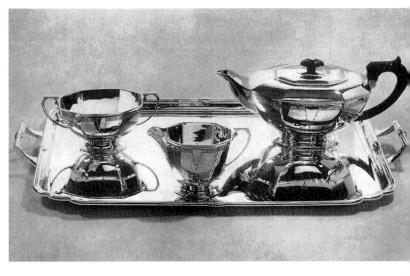

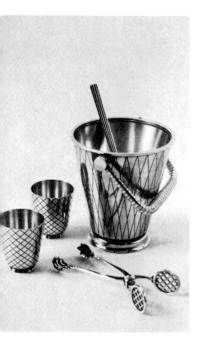

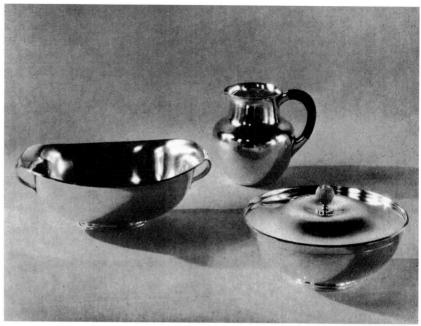

er Ice Pail, Spoon, Tongs and Cups igned by Sigvard Bernadotte made by Georg Jensen.

HT, ABOVE: Silver sugar bowls and jug gned by Karl Gustav Hansen made by Hans Hansen Solvsmedie A/S.

HT, BELOW: Silver coffee ware designed made by Frantz Hingelberg.

coffee pot has an ivory handle and ob, and its shape makes an interesting inparison with a similar set below.

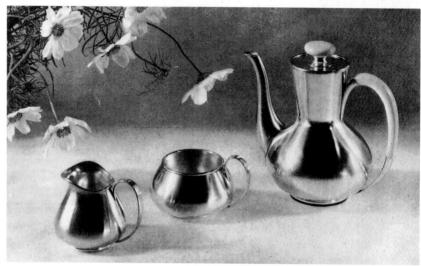

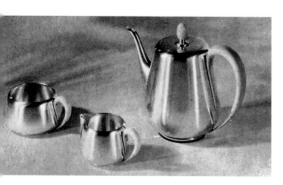

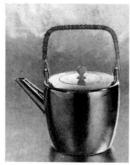

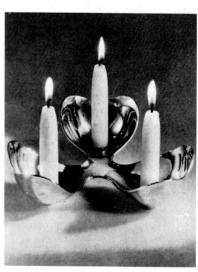

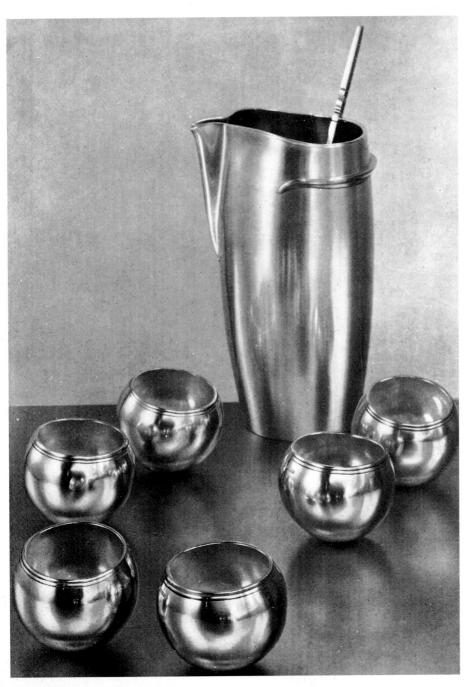

Cocktail set of spun silver designed by Erik Fleming and made by Atelier Borgila, AB. The handgrip is of gold, as is also the stirring spoon.

BELOW: Silver bowl designed and made by Margret Craver. (Purchased by Newark Museum for their permanent collection.)

BELOW: Silver tea-kettle designed and made by Karl Gustav Hansen.

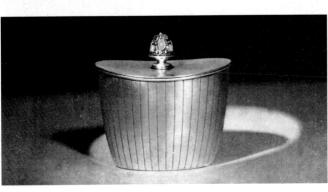

Chased silver bonbonnière. Knob set with agates, designed by Arne Erkers and made by Guldsmeds Aktiebolaget i Stockholm.

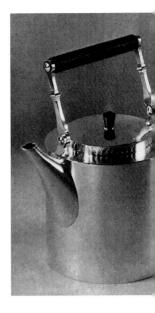

Pitcher in aluminium by a staff designer for The Aluminium Company of Canada Ltd.

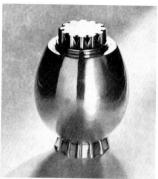

Hand-wrought sugar sifter designed and made by Margret Craver.

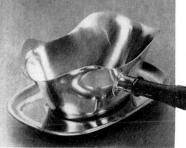

Bowl suitable for chocolates or cigarettes designed by Helge Lindgren, and made by K. Anderson

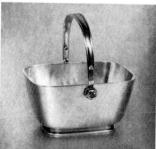

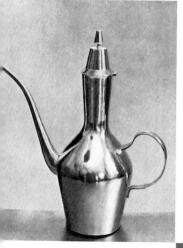

Hand-made silver wine jug designed and made by Sigurd Persson.

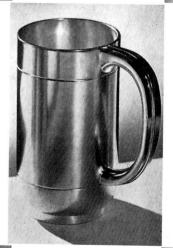

Prototype in silver of 1½-pint tankard to be made in pewter or stainless steel, matt finish, designed by Milner Gray, RDI, FSIA, of The Design Research Unit and made by A. Carter, of D. & J. Wellby Ltd.

Silver bowl and fluted flower vase designed by Sven-Arne Gillgren. Made by the designer and Guldsmeds Aktiebolaget i Stockholm.

Prototype of another silver tankard, one-quart size, designed by Milner Gray, RDI, FSIA, and made by A. Carter. (See illustration above for additional details.)

- Tulip pattern Streamline coffee ware, hand-painted in two shades of green on a pale celadon green ground, or in two shades of red on a shell-pink ground, both with 'crystal' colourless glaze.
 Designed by John Adams, ARCA, and produced by Carter Stabler & Adams Ltd. Knobs, handles and linings are in the ivory white body.
- Sandringham. Fine bone china tea-set printed in brown with flowers and ribbon in either blue, pink or yellow. Designed by Victor Skellern, ARCA, and produced by Josiah Wedgwood & Sons Ltd.
- Cockerel. Dinner and tea ware in black and gold on white, designed by Walter Dorwin Teague, and made by Taylor, Smith & Taylor Co. (Photo: Lucas & Monroe.)
- Cobalt pattern in Franciscan fine china with deep cobalt band, edged with burnished gold. Shape designed by Mary K. Grant. Produced by Gladding McBean & Co.

- 5. Early morning tea-set in highly-fired copper-red stoneware with matt celadon linings, designed by Donald Mills and produced by Donald Mills Pottery Ltd. (Photo: Ducrow.)
- 6. Tableware designed and made especially for a reception attended by H.R.H. The Princess Elizabeth given by the Royal Designers for Industry. Designer: Susie V. Cooper, RDI. Producers: Susie Cooper China Ltd. (Courtesy: Royal Society of Arts.) Wallpaper background produced by The Wall Paper Manufacturers Ltd.

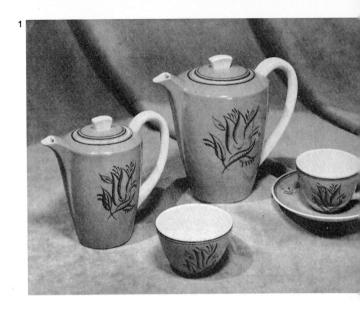

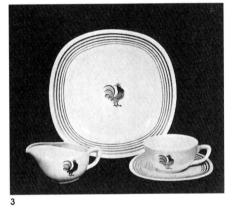

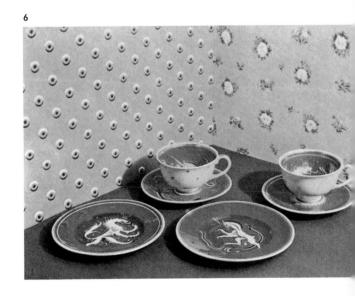

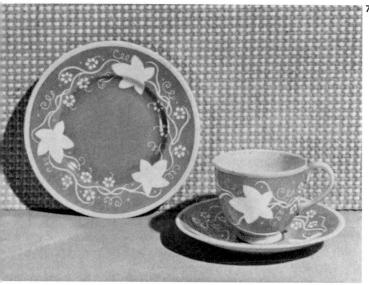

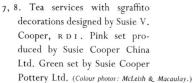

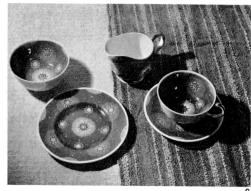

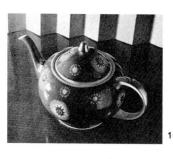

9, 10. Tea service with sea-anemone design in jade, fern or bright green, Indian red, Sèvres blue or grey-blue, with gold finish on handles. Designed by Susie V. Cooper, R D I, and made by Susie Cooper China Ltd. Fabrics in top illustration by Loom Art Ltd, see page 60.

11. Carnation. Jug and plate with hand-painted white 'resist' decoration on a sage green stippled lustre ground, designed by S. C. Talbot and produced by A. E. Gray & Sons Ltd.

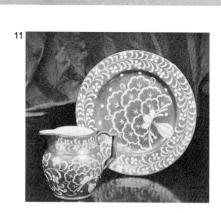

12. Tea ware in soft shell pink or Sèvres blue with gold white-circled stars, designed by Susie V. Cooper, RDI, and made by Susie Cooper China Ltd. Background: Mull printed linen designed by Marion Hoffer and produced by Donald Bros Ltd.

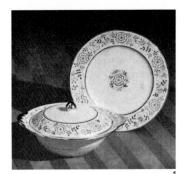

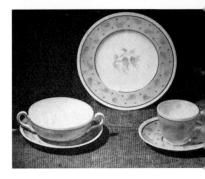

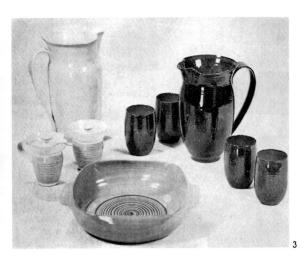

- Tudor. Ivory dinner ware, copper-plate engraved, printed in royal blue with blue inner line, silver edges and handles, designed by S. C. Talbot and produced by A. E. Gray & Co. Ltd.
- Westover. Fine bone china dinner, tea and coffee ware designed by Millicent Taplin and produced by Josiah Wedgwood & Sons Ltd. The design is in grey and robin's egg blue.
- 3. Earthenware in grey, brown and blue designed by Edwin and Mary Scheier.

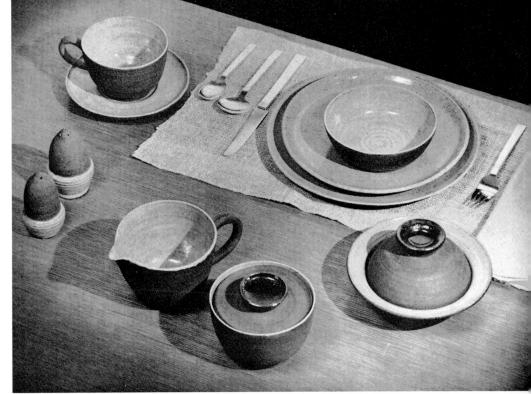

 Luncheon service of dark brown bisque stoneware with speckled tan glaze linings, and hand-wrought sterling silver flatware all designed and made by F. C. Ball.

(Photo: Stone & Steccati.)

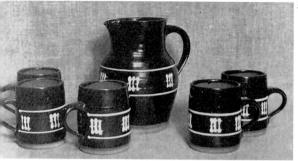

- Black and cream slipware jug and mugs designed and made by Marianne de Trey.
- Earthenware chocolate set, mottled brown, gold and grey glaze with subdued red, blue, green and violet reflections, designed and made by Herbert H. Sanders. (Photo: George E. Stone & H. W. Wichers.)
- 7. Beer mugs produced by Josiah Wedgwood & Sons Ltd. Shape designed by Keith Murray, RDI, and 'resist' decoration in gold or silver by Millicent Taplin.

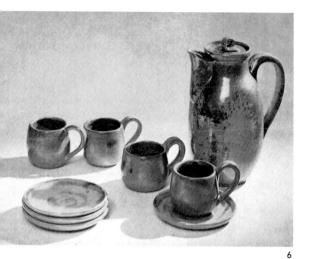

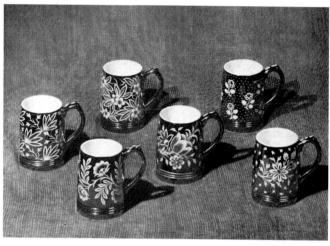

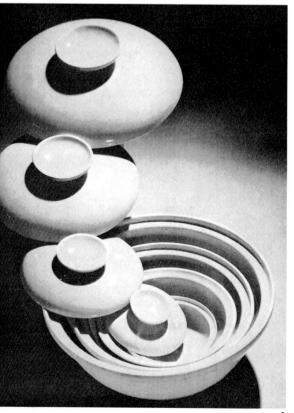

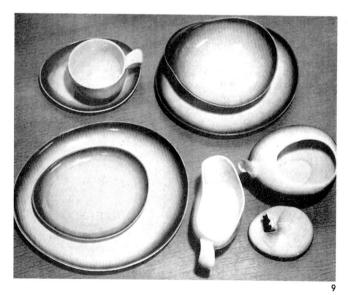

- 8. Earthenware bowls fitted with lids designed by Stig Lindberg and produced by Gustavsberg Fabriker A B .
- Tableware in sea green and oyster white designed by Simon Slobodkin and made by Senegal China Institute Inc.

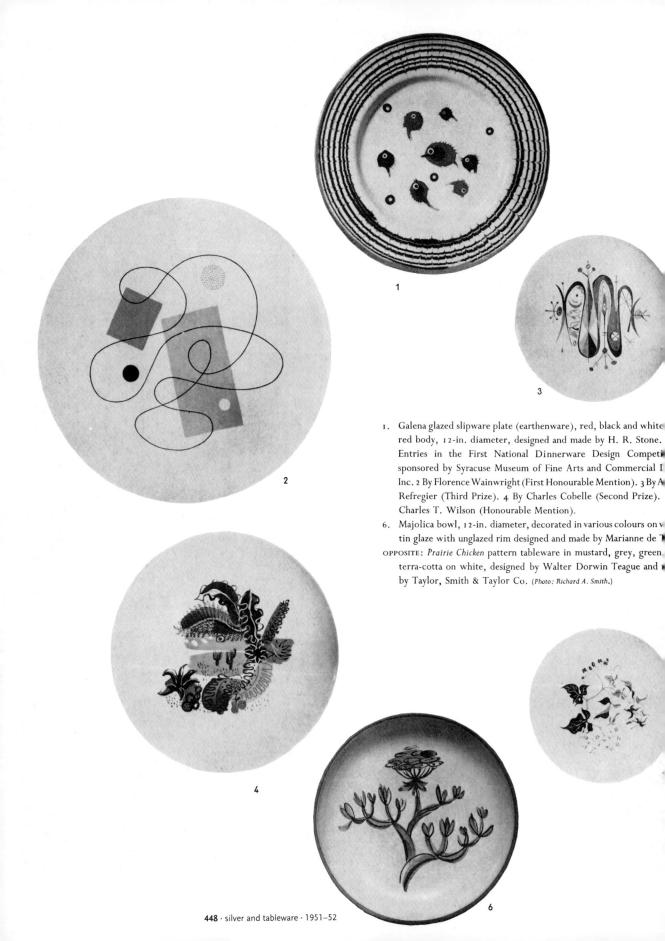

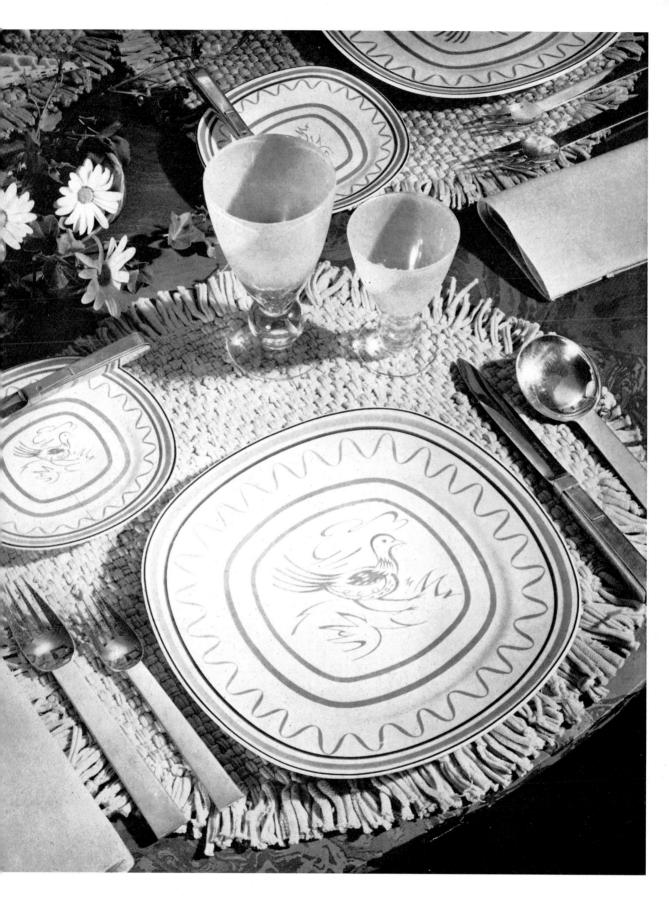

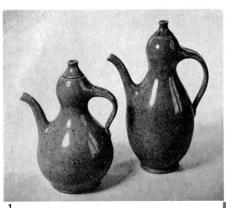

- Stoneware coffee jugs with celadon glaze designed and made by Gutt Eriksen.
- Majolica coffee-set decorated in pink and brown on an off-white glaw designed and made by Marianne de Trey.

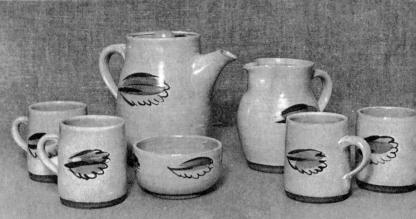

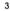

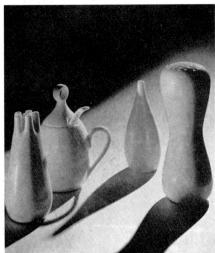

4

- Condiment set and sugar castor in bone china designed by Stig Lindberg and made by Gustavsberg Fabriker A B.
- 4. Highly-fired celadon stoneware condiment bottles with blue decoration designed by Donald Mills and made by Donald Mills Pottery Ltd. (Photo: Ducrow.)

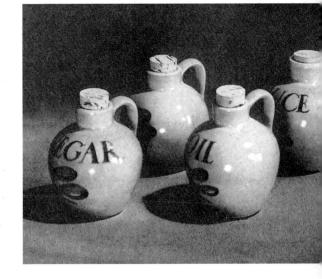

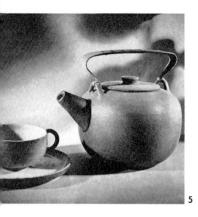

toneware tea-set glazed with white nside cups and pot, and brown matt nish outside. Designed and made y Laura Andreson.

toneware tea-set and matching vase lesigned and made by Laura Andreon. Large plate with pink matt laze: remainder white with red lay emphasizing texture.

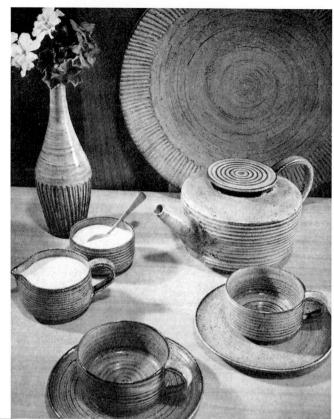

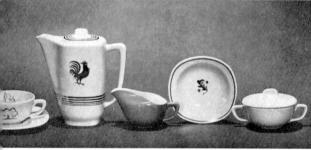

Meadow Tree cup and saucer; Cockerel coffee ot; Day Lily cream jug; Oak Leaf cereal lish; and Autumn Leaves sugar bowl all lesigned by Walter Dorwin Teague and nade by Taylor, Smith & Taylor Co.

Photo: Lucas and Monroe.)

Encanto pattern in fine bone china designed by Mary K. Grant and produced by Gladding McBean & Co.

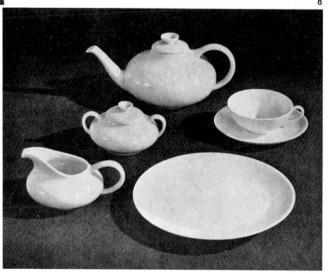

- Silver-plated candlesticks, approximately 11½ in. high, designed by Aage Helbig Hansen and made by Alfenide Ltd, Dansk Forsølvnings Anstalt.
- Silver-plated candle holders for candles of different thicknesses, or for use as flower bowls. Designed by Aage Helbig Hansen and made by Alfenide Ltd, Dansk Forsolvnings Anstalt.

- Silver candelabra designed by T. Trier Morch and made by A. Michelsen.
- Silver candelabra designed by Henning Koppel and made by Georg Jensen.

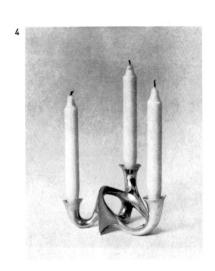

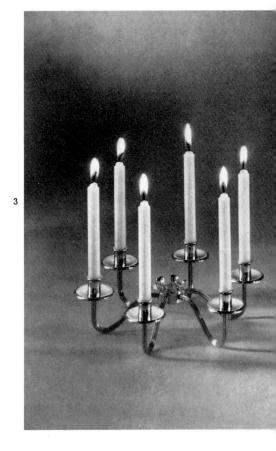

Brass candleholder, designed by Paavo Tynell and made by O/Y Taito A B.

Silver bread dish, candlestick and water pitcher with ivory handle designed by Svend Weihrauch and made by Frantz Hingelberg.

Silver candlesticks, chased and engraved, designed and made by R. E. Stone for The Goldsmiths & Silversmiths Company Ltd. (Courtesy: Design and Research Centre for the Gold, Silver and Jewellery Industries.)

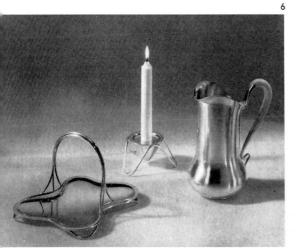

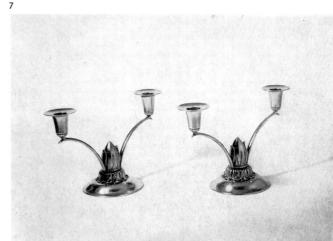

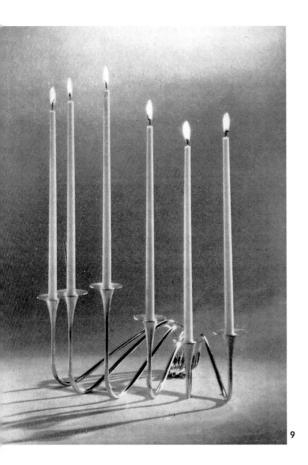

8. Silver condiment set designed by F. Piret and made by Adie Bros Ltd. Salt and mustard lined with blue glass. Ivory handle to mustard.

9. Silver candelabra designed by T. Trier Morch and made by A. Michelsen.

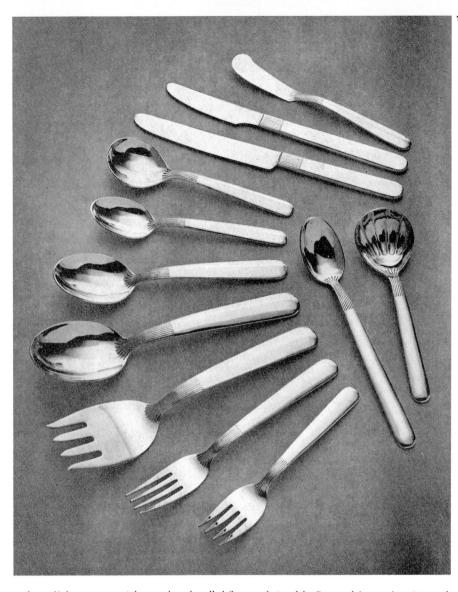

- Silver-plated combined corkscrew a bottle-opener designed by Napi Associates and made by The Napi Company.
- Silver tableware designed by Jac Prytz and made by Tostrup.

- 1. Loewy Modern pattern stainless steel grade-rolled flatware designed by Raymond Loewy Associates and made by Diamond Silversmiths Ltd, a subsidi of Ekco Products Company. (Photo: Allen, Gordon, Schroeppel & Redlich Inc.)
- 2, 3. Silver condiment set and sugar caster designed by Ib Bluitgen, and table silver designed by Harald Nielsen. Both made by Georg Jensen.
- 4. Silver-plated one-handed 'party servers,' each with a spoon for juices and either a flat side for serving sandwiches or a fork for straining liquing Designed by Napier Associates and made by The Napier Company.

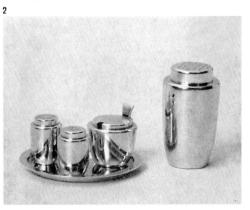

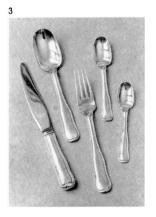

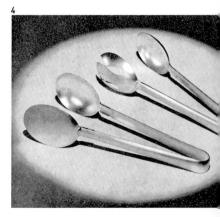

7. Lily of the Valley silver tableware, part of a large set in the same pattern, designed by H. Russell Price, and made by The Gorham Company. Grey Feather china with white motif, made by Glidden Pottery Inc.

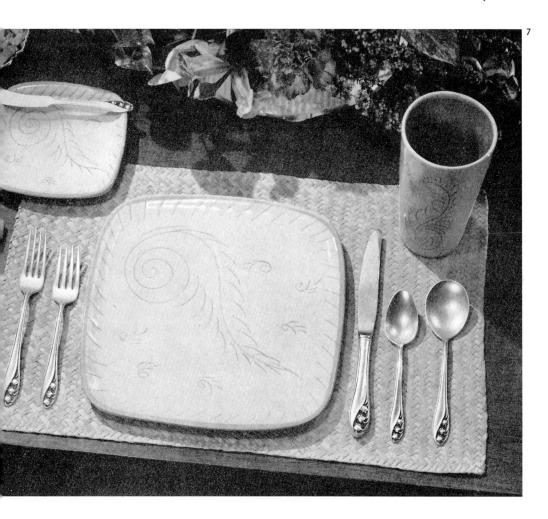

Hand-made silver tableware designed by Sigurd Persson.

Stainless steel tableware, part of a 50-piece set, designed by Aage Helbig Hansen and made by Alfenide Ltd, Dansk Forsølvnings Anstalt.

Silver table spoons and forks designed by Svend Weihrauch and made by Frantz Hingelberg.

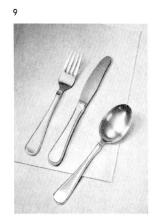

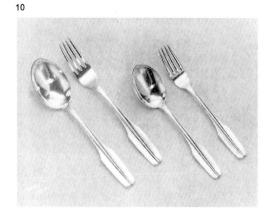

 Silver vegetable dish with ivory-knobbed lid designed and made by Inger Moller.

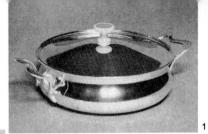

2

 Handwrought silver three-sided bowl designed and made by William De Hart.

 Stainless steel cake dish designed by Sigurd Persson and made by AB Silver & Stål.

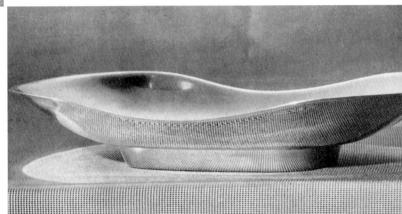

4

 Silver bowls designed by Sven-Arne Gillgren and made by Guldsmeds Aktiebolaget i Stockholm, G A B.

5. Silver bowl and bonbonnière with ivory-knobbed lid, both designed by Karl Gustav Hansen and made by Hans Hansen Sølvsmedie A/S.

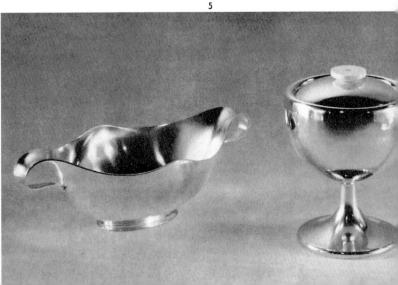

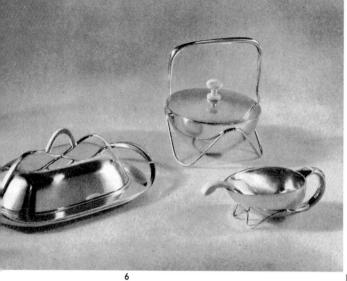

 Silver and ivory dish with cover, carrot dish, sauce pitcher and ladle designed by Svend Weihrauch and made by Frantz Hingelberg.

۰

 Free form handwrought silver bowl on ebony feet designed and made by Frederick Miller.

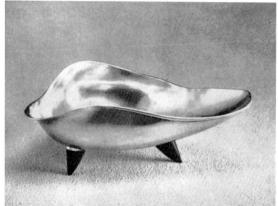

7

8

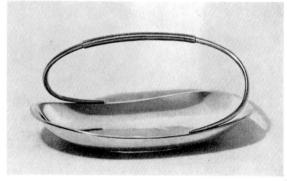

 Silver cake plate designed by H. P. Jacobsen and made by Carl M. Cohr's Sølvvarefabriker A/S.

 Silver dish designed by H. P. Jacobsen and made by Carl M. Cohr's Sølvvarefabriker A/S.

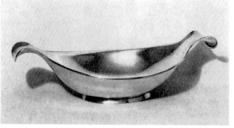

10

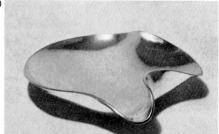

 Free form silver plate designed by H. P. Jacobsen and made by Carl M. Cohr's Sølvvarefabriker A/S.

- Silver water pitcher with ivory handle designed by C. J. Antonsen and made by C. Antonsen.
- Silverwater pitcher

 in. high with
 ivory handle
 designed by Sven
 Weihrauch and
 made by Frantz
 Hingelberg.
- Silver coffee pot with wooden handle designed by H. P. Jacobsen and made by Carl M. Cohr's Solvvarefabriker A/S.

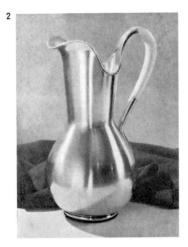

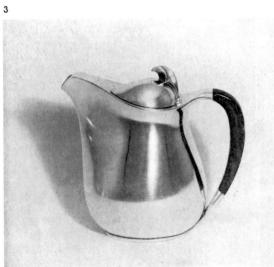

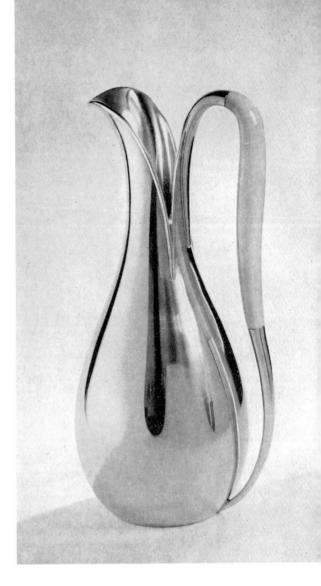

- 4. Hand-raised silver jug, natural grey finish, designed by W. P. Belk and made by Roberts & Belk Ltd. (Courtesy: Design and Research Centre for the Gold, Silver and Jewellery Industries.)
- Silver sauceboat with ivory handle designed by H. P. Jacobsen and made by Carl M. Cohr's Solvvarefabriker A/S.

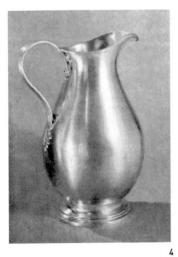

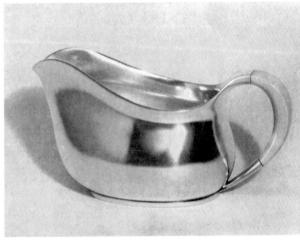

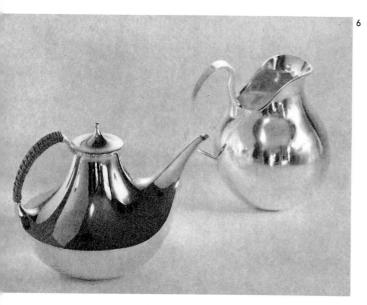

- 6. Silver teapot with wicker handle and silver water jug designed by Karl Gustav Hansen and made by Hans Hansen Solvsmedie A/S.
- Silver demitasse coffee set, the pot with an ebony handle, designed by Karl Gustav Hansen and made by Hans Hansen Sølvsmedie A/S.

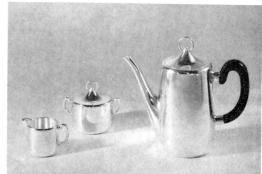

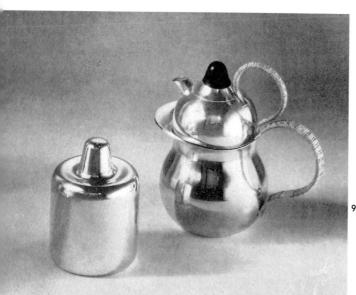

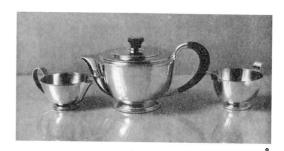

- 8. 1½-pint silver and ebony tea set designed by A. Edward Harvey, ARCA, LRIBA, and made by Hukin & Heath Ltd. (Photo: B. P. Arnold, RBSA.)
- Silver tea caddy and combined teapot and hot-water jug designed by M. L. Stephensen and made by Kay Boyesen.
- 10. Silver tea set, the pot with plastic handles, designed by Arne Korsmo and made by Tostrup.
- 11. Silver coffee set with ebony handles and feet designed by Åge Erhard and made by Folmer Dalum of A. Dragsted A/S.

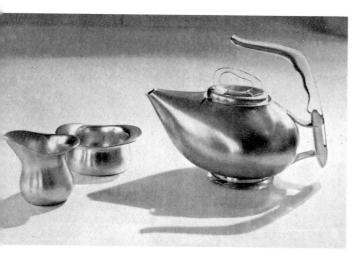

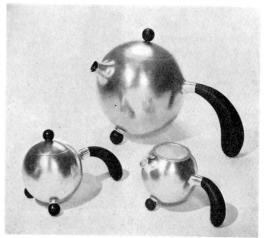

10

RIGHT: Polished brass centrepiece. Designer: Tommi Parzinger. Makers: Dorlyn (usa).

Below: Silver bowl, $15\frac{1}{2}$ in. diameter. Designer: Henning Koppel. Maker: Georg Jensen (Denmark).

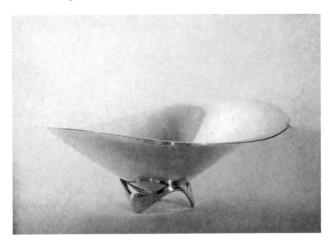

BELOW: Silver cigar and cigarette box engraved and engine-turned, with two cedar-lined compartments and ivory *Prometheus* figure. Designer and sculptor: A. Lucas. Makers: E. Silver (Bond Street) Ltd (GB).

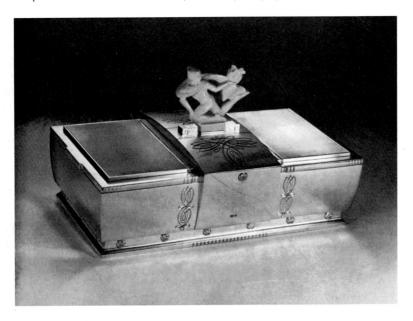

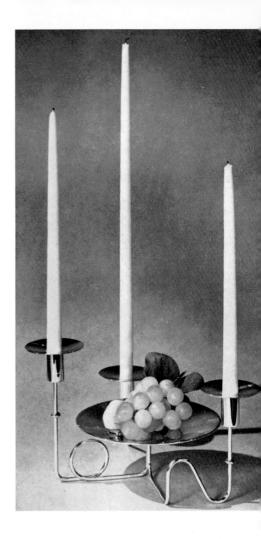

Hand-made silver vase. Designer and maker: Sigurd Persson (sweden).

Enamelled bowl decorated in transparent and opaque red. Designer and maker: Sigurd Persson (sweden).

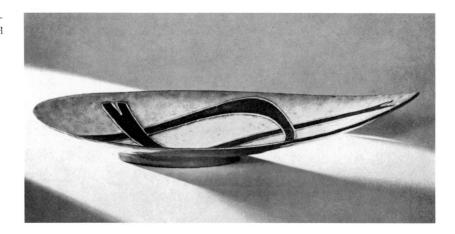

Enamelled bowl decorated in green and blue. Designer and maker: Sigurd Persson (SWEDEN).

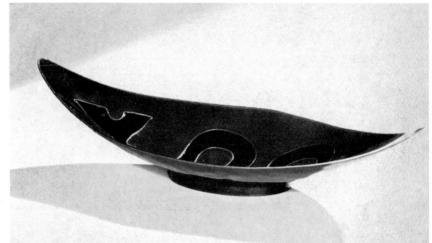

BELOW: Silver candelabrum. Designer: E. C. Clements. Makers: Padgett & Braham Ltd (GB). (Courtesy: Design and Research Centre for the Gold, Silver and Jewellery Industries.)

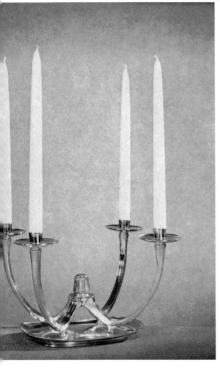

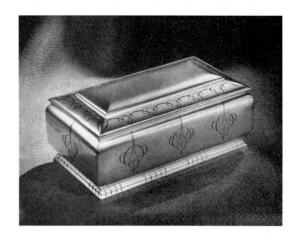

Hand-made silver cigarette casket with engraved decoration, lined inside with black macassar ebony. Designer and maker: Robert E. Stone (GB).

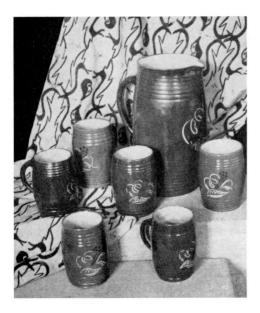

Earthenware beer set in brown, yellow and black, the design inlaid. Designer and maker: Rachel Warner. Fabric in background designed and printed by Susan Warner (GB).

RIGHT: Silver jug. Designer: Henning Koppel. Maker: Georg Jensen (DENMARK).

BELOW: Glazed stoneware beer set, black, rust and oatmeal. Designer: Bernard Leach. Makers: The Leach Pottery team (GB).

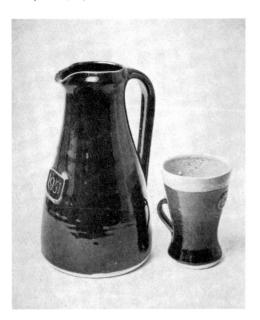

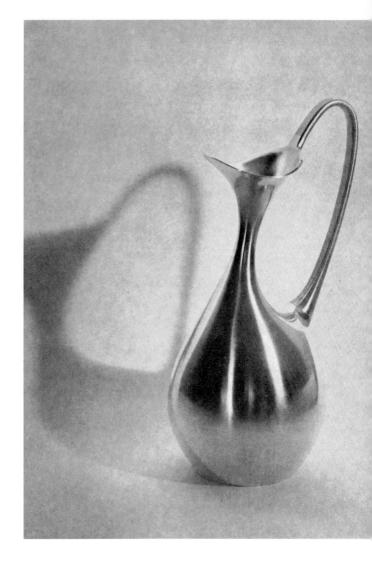

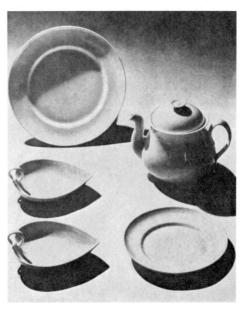

White porcelain Columb ware. Designer: Arthu Percy. Makers: Upsala Ekeby AB, Karlskron Factory (SWEDEN).

iscuit box, wine pitcher with ebony handle, and cups with blue enamel linings, I in sterling silver. Designer: Sven Weihrauch. Maker: Frantz Hingelberg DENMARK).

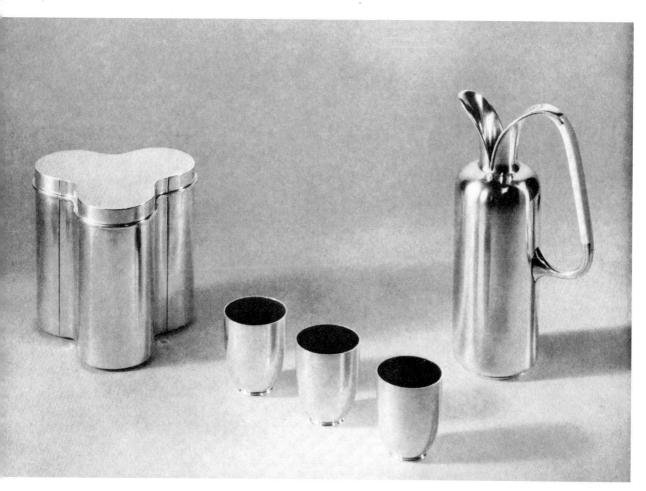

LEFT: Sugar castor, whisky flagon and flower vase in highly-fired tin-glazed stoneware with blue, rust, yellow and green decoration. Designers: Donald and Jacqueline Mills. Makers: Donald Mills Pottery Ltd ($_{\rm GB}$).

BELOW: Silver cream and sugar set. Designer: A. Edward Harvey, ARCA, LRIBA. Prototype made by Mrs Maughan Harvey (GB). (Photo: B. P. Arnold, RBSA.)

Silver candelabrum designed by Karl Gustav Hansen. Makers:Hans Hansen Sølvsmedie A/S (DENMARK)

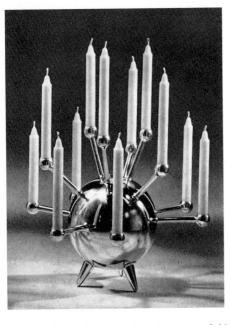

Silver ice bucket. Designer: Sigvard Bernadotte. Makers: Georg Jensen Silversmiths Ltd (Denmark)

BELOW: Golden melon colour *Interplay* ovenproof china, *Arabesque* pattern, made by Iroquois China Company combined with *Etiquette* glass by Imperial Glass Corporation, *Bamboo* silver by Langbein & Co., and nasturtium orange napkins by John Matouk on a redwood table by Van-Kepple Green. Chairs by Fulbright Industries (USA)

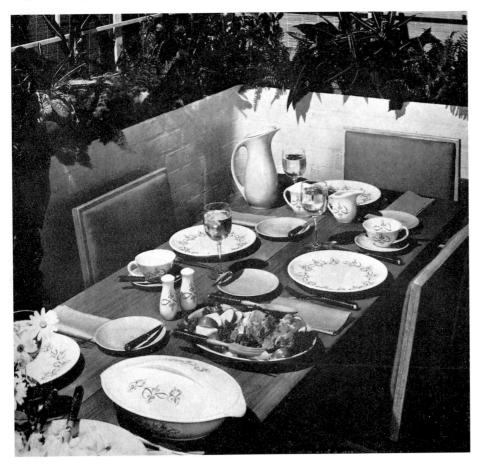

Hand-made silver candlesticks. Designe and maker: Sigurd Persson (SWEDEN)

Trend sterling silver candlesticks usab singly or mounted one upon anothe Designed by Gorham Designers. Maker The Gorham Company (USA)

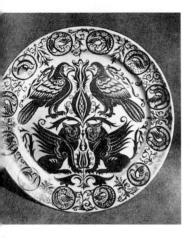

que painted in gold and purple lustre with glaze. Designed and painted by Doris ton MSIA (GB)

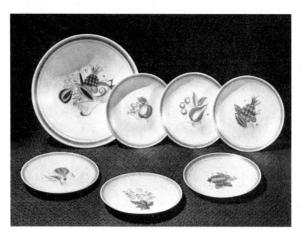

Dessert set in fine earthenware with hand-painted motif in copper, green and grey or fawn and grey. Designer: Truda Carter ARCA. Makers: Carter Stabler & Adams Ltd (GB)

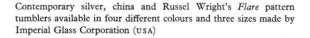

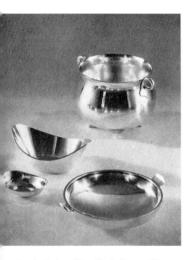

ver bowls designed by Karl Gustav Hansen. kers: Hans Hansen Sølvsmedie A/S (DENMARK)

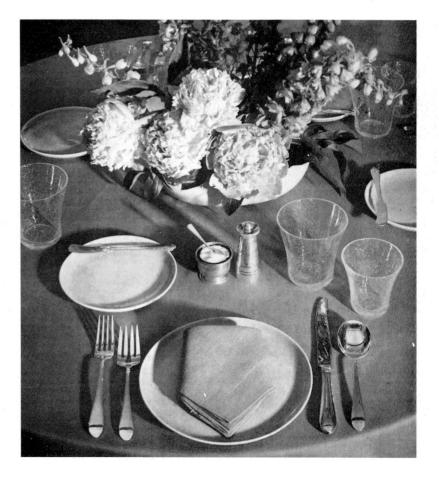

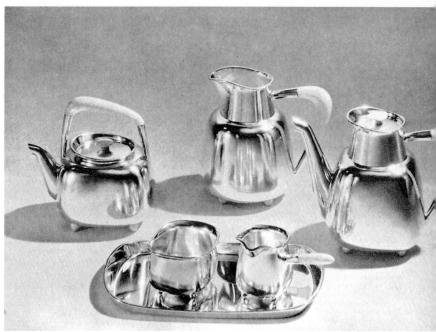

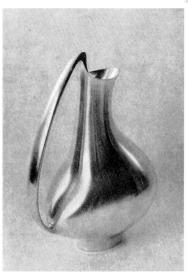

Silver and ivory tea and coffee set. Designer: Ibi Trier Morch. Maker: A. Michelsen (DENMARK)

ABOVE AND BELOW:
Silver Jugs. Designer: Henning Koppel.
Makers: Georg Jensen Silversmiths Ltd
(DINMARK)

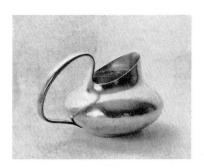

Silver and ebony tea and coffee set. Designer: Karl Gustav Hansen. Makers: Hans Hansen Sølvsmedie A/S (DENMARK)

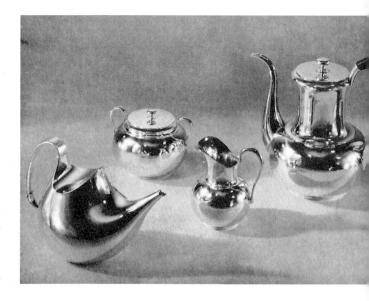

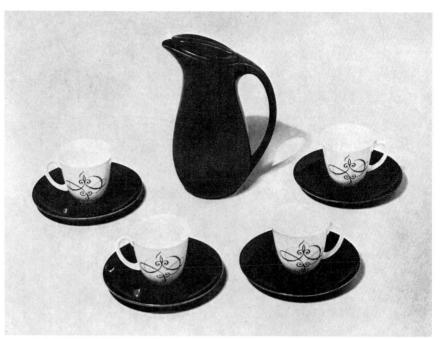

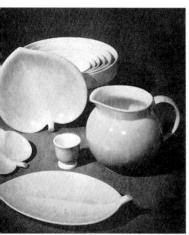

Interplay coffee set in fine china, available in two solid colours and three different patterns.

ABOVE: Charcoal jug and saucers used with Arabesque cups. Makers: Iroquois China Company (USA)

LEFT: Faience tableware for everyday use, yellow on cream glaze. Designer: Nils Thorsson. Makers: The Royal Copenhagen Porcelain Factory (DENMARK)

BELOW: Heat-resistant *Princess* tableware of thin lightweight opal glass. Makers: Corning Glass Works (USA)

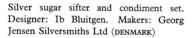

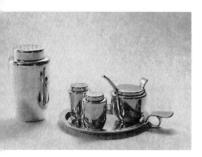

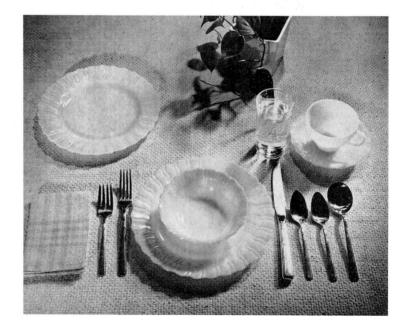

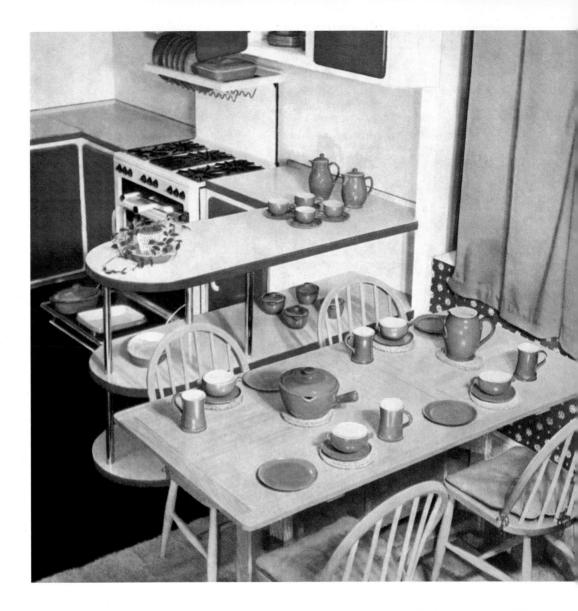

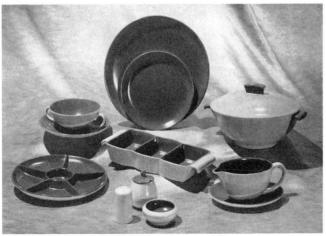

ABOVE: Denby ovenware available in meadow green with cream glazed interior, cottage blue with yellow glaze, and mahogany brown with pale lavender glaze. The complete set of eighty-six pieces (all sold singly) covers a wide range from casseroles and serving dishes to plates, cups and saucers, all usable from oven to table. Makers: Joseph Bourne & Son Ltd (GB)

(Photo: Courtesy of Harrods Ltd.)

Streamline tableware in fine earthenware finished Twintone two-colour eggshell glaze, available in various colour combinations. Plates in background designed by Poole Design Unit. Other pieces by John Adams ARCA. Makers: Carter Stabler & Adams Ltd (GB)

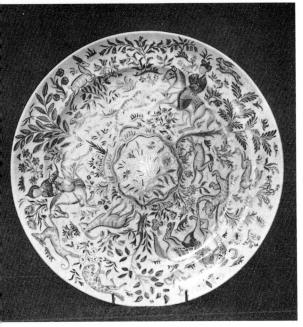

Toast rack in gilding metal designed and made by M. B. A. Yehia, Royal College of Art, and used as a prototype for production by Liberty & Co. Ltd (GB)

n-glazed plaque painted in 1es, green and orange with 1d outline, motif based on rsian paintings. Designer: oris Parton MSIA. Makers: G. Green & Co. Ltd (GB)

Low: Sienna dinnerware, anslucent white tin glaze eer red-brown clay body tentionally left exposed on e rims. Makers: Keramik lanufaktur Kupfermuehle. ERMANY) U.S.: Frasers Inc.

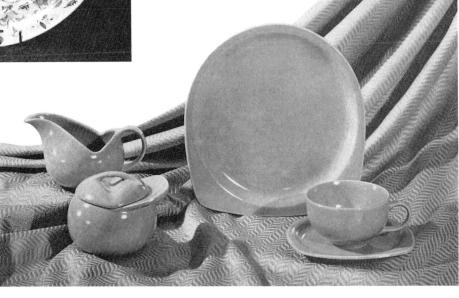

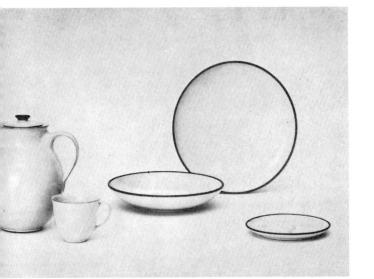

ABOVE: Vogue pattern earthenware with coffee brown or mist green glaze. Designer: Alf Rosen. Makers: Universal Potteries (USA)

Silver tureen with bound white plastic handles. Designer: Arne Erkers. Makers: Just Andersen A/S (DENMARK)

BELOW: Twin Oaks dinner and tea service. White china with the motif in two shades of green, pink and brown. Makers: The Edwin M. Knowles China Company (USA)

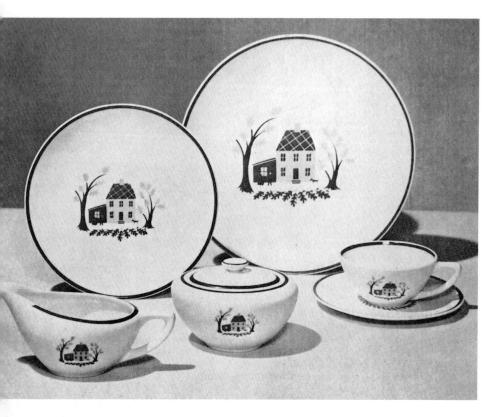

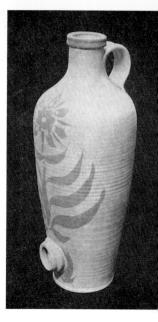

Cider jar, 14 inches high, buff body wi iron brush decoration, inside glaze Designer and maker: F. G. Cooper (G

BELOW: Coffee pot, cup and saucer, flasided vase and small dish in fine earther ware with copper carbonate glaze (green breaking to metallic black). Designaturay Fieldhouse. Makers: Pendi Pottery (GB)

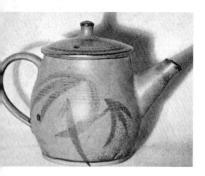

Stoneware teapot with wood ash glaze. Designer and maker: H. R. Stone (GB)

Photo: F. Hague

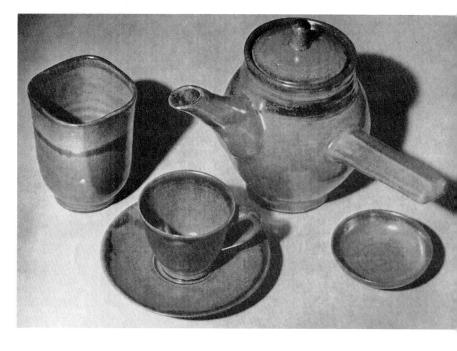

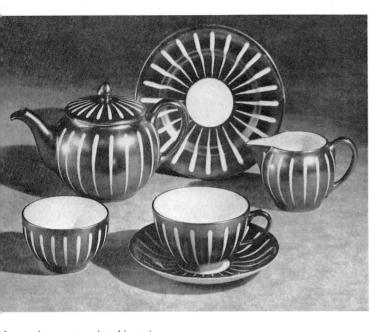

Pewter jug designed by Ellen Schlanbusch. Makers: Just Andersen A/S (DENMARK)

rly morning teaset, resist white stripe on ad bronze ground. Designer: S. C. Talbot. akers: A. E. Gray & Co Ltd (GB)

rthenware teapot, cream glaze with iron p-trailed decoration. Designer and maker: G. Cooper (GB)

ABOVE: Pewter tea and coffee service. Designer: Ellen Schlanbusch. Makers: Just Andersen a/s (DENMARK)

LEFT: Sauce and salt boats, sterling silver exteriors and gilt interiors. Designer and maker: E. G. Clements, Royal College of Art (GB)

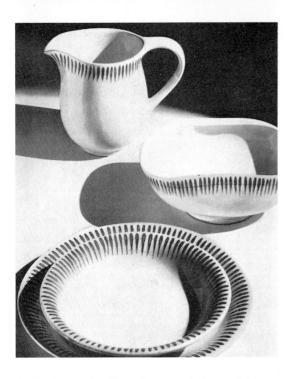

Amulett dinner set in white earthenware with blue or red decoration. Designer: William Kåge. Makers: AB Gustavsberg Fabriker (SWEDEN)

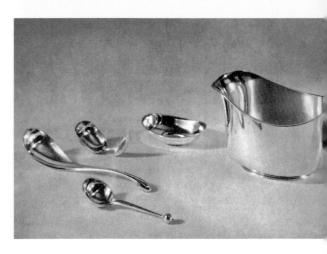

Sterling silver ladles, sweet dish and sauce boat with insulated cane handle. Designer: Karl Gustav Hansen. Makers: Hans Hansen Sølvsmedie A/S (DENMARK)

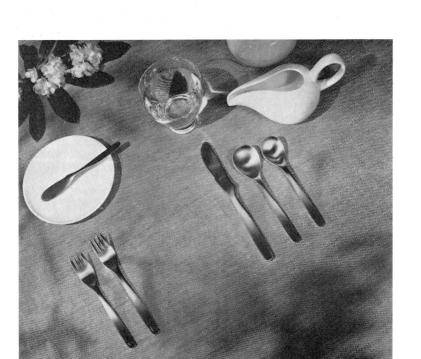

Dana stainless steel child's spoon, fork and pusher.
Designer: Aage Helbig Hansen. Makers: A/S
Alfenide, Dansk Forsølvnings Anstalt (DENMARK)

American Modern stainless steel flatware, white pottery cream jug and plate and handblown glass tumbler. The dinnerware is available in several colours, including chartreuse curry and black chutney. Designer: Russel Wright. Makers: John Hull Cutlers Corporation, The Steubenville Pottery Co. and Morgantown Glassware Guild respectively (USA)

Stoneware oil or vinegar bottle with ground stopper. In celadon, black or grey-blue glazes. Designers: Harry and May Davis. Makers: Crowan Pottery (GB)

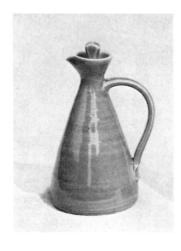

BELOW: White porcelain plates, hand-decorated by Leone Plard on a white muslin tablecloth. Stainless steel cutlery with Plexiglass handles. Gilded copper candle holders, green metal centrepiece and green glassware. Setting arranged by Colette Gueden for Primavera (FRANCE)

Stainless steel fork, knife and spoon, also made in silver or electroplate. Their size is unusual—between dinner and dessert length. Designer: Voss. Maker: C. Hugo Pott (GERMANY)

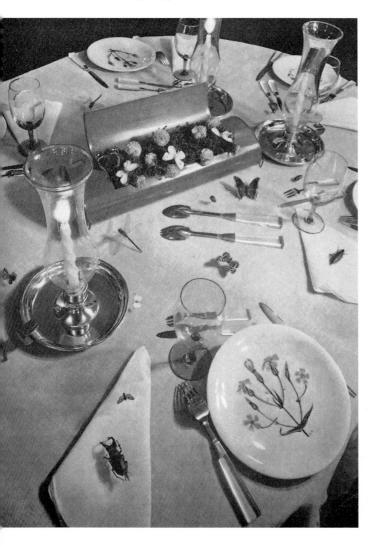

Silver spoons, knife and fork. Designer: Ole Hagen. Makers: A. Michelsen (DENMARK)

Stainless steel flatware. Designer: Sigurd Persson. Makers: Silver & Stål (SWEDEN)

Brass candlesticks with foliage decoration. White porcelain doves. White porcelain dinner service by Gustavsberg Fabriker and glasses by Strömbergshyttan. Silver cutlery with ebony handles; rush mat table cover. Table decorations and cutlery designed and made by Svenskt Tenn AB (SWEDEN)

Silver condiment set. Designer: Ib Bluitgen. Makers: Georg Jensen Silversmiths Ltd (Denmark)

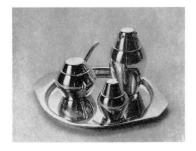

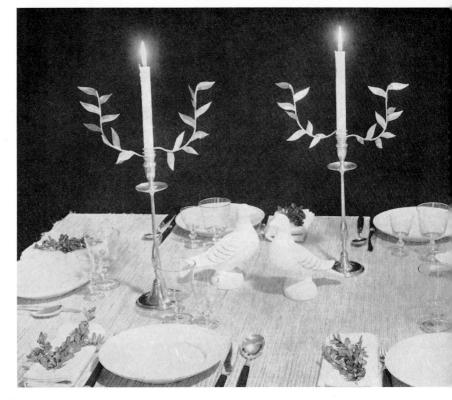

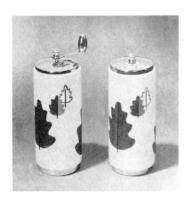

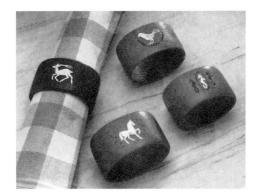

Gold-tooled leather napkin rings on met bases. Designer and maker: James S. Taylo ARCA (GB)

ABOVE: The *Holiday* ceramic pepper mill and salt shakers, hand-painted in dark green, chartreuse or burgundy on a cream ground, tops of stainless steel. Designer: Olde Thompson. Makers: George S. Thompson Corporation (USA)

Bread trays carved in light maple, available with movable or fixed handles. Designer and maker: Laur. Jensen (DENMARK)

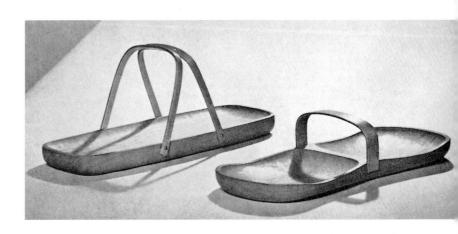

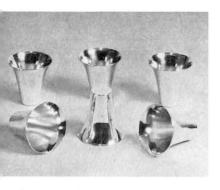

LEFT: Spun silver wine goblets and silver condiment set with fluted covers. Designer and maker: Robert G. Clark, Des. RCA, MSIA (GB) (Courtesy: Mr. and Mrs. George Clark)

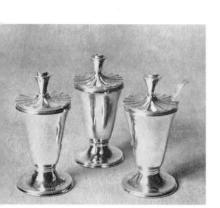

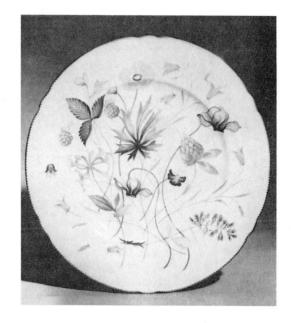

Plate from the Forest Glade dinner, tea or coffee set in fine bone china with slightly conventionalized flower design in natural colours. Designer: Eric W. Slater. Makers: Shelley Potteries Ltd (GB)

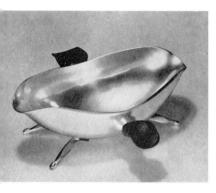

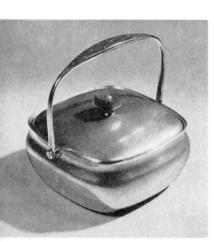

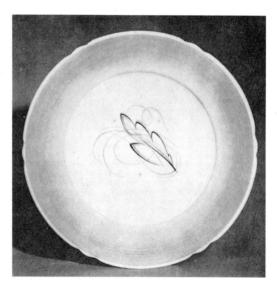

Leaf pattern plate available in dinner, tea or coffee ware in pastel shades of grey-green, chrome-green or pink, the surround hand done on the wheel in grey-green, and the outline of the leaf accentuated in the same colour. Designer: Eric W. Slater. Makers: Shelley Potteries Ltd (GB)

LEFT: Prototype muffin dish in gilding metal with rosewood insulated handle incorporating decorative use of rivets, and above it a silver sauceboat with carved rosewood handles. Designers and makers: Eric G. Clements, Des. RCA, MSIA, T. J. Boucher and H. A. Lock (GB) (Photo: Peter Parkinson)

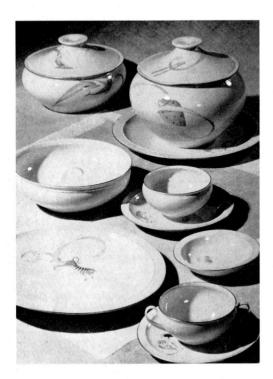

Salier china dinner service handdecorated in gold, turquoise and grey-violet by Sigrid von Unruh. Shape designed by Siegmund Schütz. Makers: Staatliche Porzellan-Manufaktur Berlin (GERMANY)

ABOVE: Melamine plastic Maplex or Evermaid serving platter in chartreuse and vegetable bowl in dark green. Both available in other colours. Designers and makers: Maple Leaf Plastics Ltd (CANADA).

BELOW: Silver flower or fruit bowl with candle-holders. Designer: Arne Erkers. Makers: Just Andersen A/S (DENMARK)

Gratina ovenware designed by Gunnar Nylund and made by AB Rörstrands Porslinsfabriker (SWEDEN) Background fabric is an all-cotton screen print, Hedgerow, with nigger brown motif on piece-dyed grounds in colour shown, or on green, mulberry or grey. Designer: Mary Beard. Makers: Scatchard's Fabrics Ltd (GB)

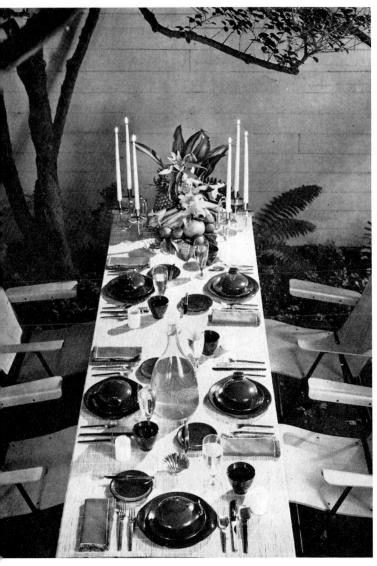

Residential dinner service of Melmac plastic in a copper penny shade and American Modern pilsner glasses. Samsonite folding armchairs of birch, natural finish, on black enamelled tubular steel legs. Designer: Russel Wright. Makers: Northern Industrial Chemical Co., Morgantown Glassware Guild and Shwayder Brothers Inc. respectively (USA). BELOW: Silver fruit bowl. Designer: Arne Erkers. Makers: Just Andersen A/S (DENMARK)

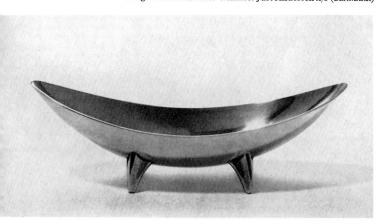

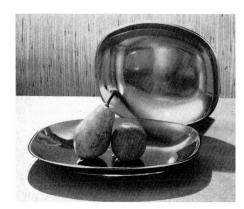

Stainless steel fruit or bread servers. Designer: Folke Arström. Makers: A/B Gense (SWEDEN)

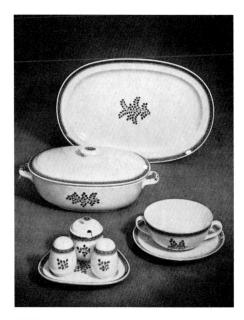

Gabriella faience dinner, coffee and tea ware with blue outer band and centre motif. Designer: Nils Thorsson. Makers: The Royal Copenhagen Porcelain Factory (DENMARK). BELOW: Vases in sterling silver with engraved lineal designs. Designed and made by Barbro Littmarck for W. A. Bolin (SWEDEN)

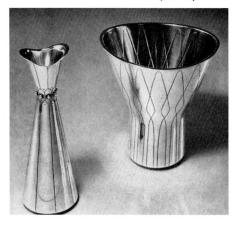

Gold-rimmed Vintage china on Acc shape in burgundy and grey w sepia tracing. Designed and made The Edwin M. Knowles China Co pany (USA)

Dana stainless steel candelabra. Designer: Aage Helbig Hansen. Makers: A/S Alfenide, Dansk Forsølvnings Anstalt (DENMARK)

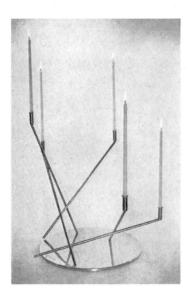

Stoneware sweetmeat dishes with p blue ash glazes. Designer and mak Eleanor Whittall (GB)

Salt and pepper set in sterling silver, the handle tops inset with moonstones and topaz. Designer and maker: Birger Haglund (SWEDEN)

Circular footed bowl and dessert plates finished in *Alpine* semi-matt off-white glaze. Hand-painted decorations in the Delft technique. Half of the set in green and grey, remainder in coral pink and grey. Designer: Truda Carter, ARCA. Makers: Carter, Stabler & Adams Ltd (GB)

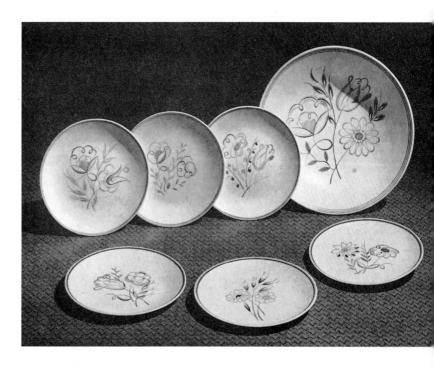

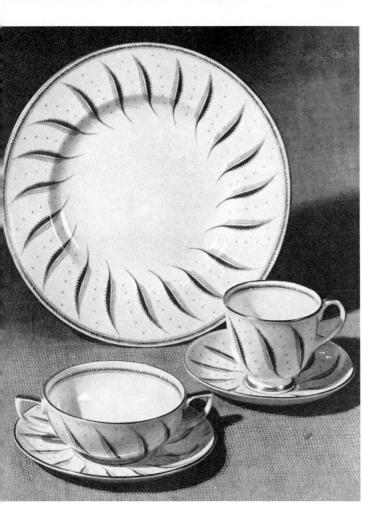

Shelley china tankard and ashtray with sgraffito design on various coloured grounds and burnished gold tracing on handle and foot of tankard. Designer: Eric W. Slater. Makers: Shelley Potteries Ltd (GB)

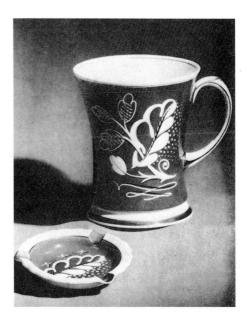

piral fern leaf decoration in avocado green on tea and inner ware. Designer: Susan V. Cooper, RDI. Makers: he Susie Cooper Pottery Ltd (GB)

ana stainless steel dish with teak handles. The lid can also e used as a dish. Designer: Aage Helbig Hansen. Makers: /s Alfenide, Dansk Forsølvnings Anstalt (DENMARK)

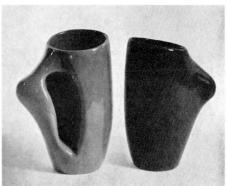

Pottery beer mugs available in black, dark brown, light brown, green or blue. Designer: G. Beaudin. Makers: Decor Pottery Reg'd (CANADA)

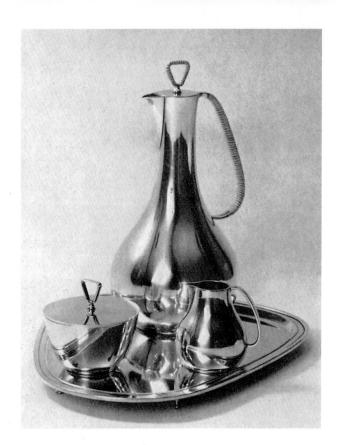

Sterling silver coffee set, the handles of the copot bound with plastic. Designer: Sigvard Berdotte. Makers: Georg Jensen Silversmiths I (DENMARK)

Stainless steel pitcher. Designer: Folke Arströ Makers: A/B Gense (SWEDEN)

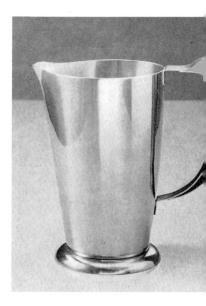

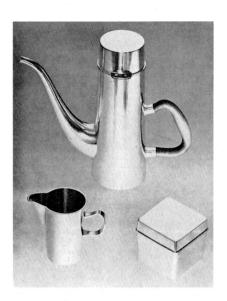

Hand-made silver coffee service, including a square sugar box. The handle of the pot is mahogany. Designed and made by Sigurd Persson (SWEDEN)

Dana stainless steel coffee set with teak handles. Designer: Aage Helbig Hansen. Makers: A/S Alfenide, Dansk Forsølvnings Anstalt (DENMARK)

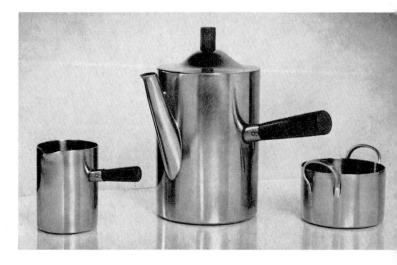

ntour silver candlesticks, sugar bowl, cream cher and beverage server with black polyrene handle. Designer: John Van Koert. akers: The Towle Silversmiths (USA)

Low: Silver iced-water jug with ebony handle. esigner: Sigvard Bernadotte. Makers: Georg usen Silversmiths Ltd (DENMARK)

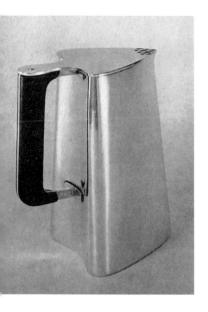

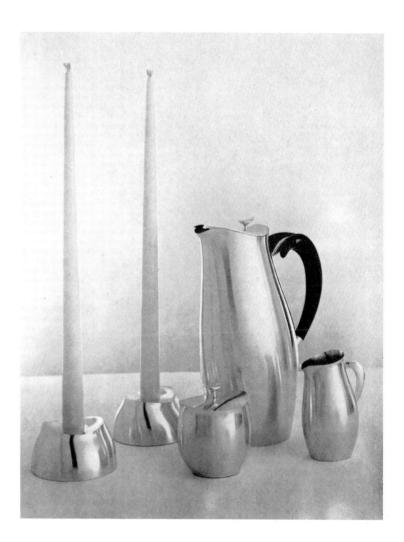

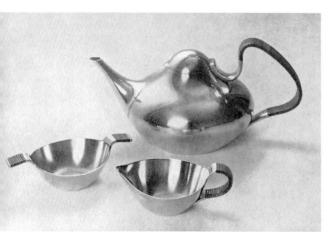

terling silver tea set with handles of wicker. esigner: Henning Koppel. Makers: Georg nsen Silversmiths Ltd (DENMARK). RIGHT: One f a pair of silver coffee pots with handle bound leather. Designer and maker: Eric G. Clements, es. RCA, MSIA (GB) (Photo: Peter Parkinson)

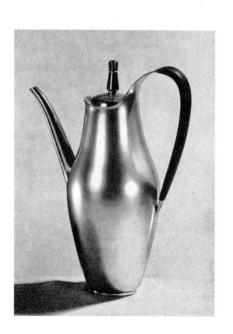

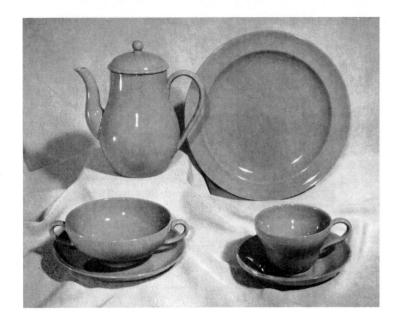

LEFT: Plain shapes in celadon, lavender, or Windsor grey self-coloured fine earthenware. Makers: Josiah Wedgwood & Sons Ltd (GB). BELOW: Pastella fine domestic earthenware in blue, green or yellow glazes. Designer: Stig Lindberg. Makers: AB Gustavsberg Fabriker (SWEDEN)

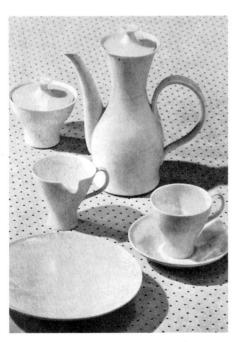

ABOVE: Krokus coffee service in white porcelain rimmed with gold or purple. Designer: Hubert Griemert. Makers: Staatliche Porzellan-Manufaktur Berlin (GERMANY). RIGHT: Script tea and dinner plates from the new range of Continental porcelain tableware made in four harmonious and interchangeable designs. Designers: Raymond Loewy Associates. Makers: Rosenthal-Porzellan AG (GERMANY) for the Block China Corporation of New York (USA)

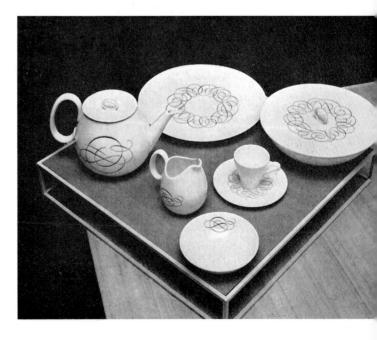

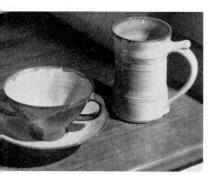

LEFT: Soup cup and saucer, and pint beer mug in fine earthenware with mushroom and white glazes breaking to red body combination. Designer: Murray Fieldhouse. Makers: Pendley Pottery (GB) (Photo: Pottery Quarterly)

BELOW: Residential dinnerware, sea mist colour, made of Melmac plastic by Northern Industrial Chemical Co; Flare glasses made by Imperial Glass Corporation; and American Modern stainless steel flatware made by John Hull Cutlers Corporation. All designed by Russel Wright (USA)

Walnut salad bowl, 12 inches wide, on brass stand 7 inches high. Designer: Tommi Parzinger. Makers: Dorlyn Silversmiths (USA). BELOW: Hand-decorated salad service caddy, chrome details, white enamelled iron rack. Designer: Olde Thompson. Makers: George S. Thompson Corporation (USA)

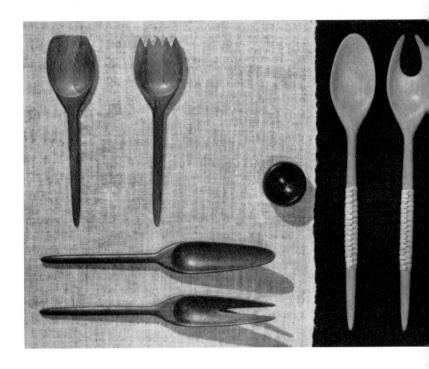

Serving spoons and forks in teak and beech. Designed and made by Nanny Still (FINLAND)

Silver salt and pepper shakers. Designer: Hans Henriksen. Makers: Georg Jensen Silversmiths Ltd (DENMARK)

Silver condiment set. Designed and made by K. W. Lessons at the Royal College of Art (GB). (Courtesy: The Worshipful Company of Goldsmiths)

Silver-topped condiment set in blue crystal glass. Designed and made by Robert Welch at the Royal College of Art (GB) (Courtesy: The Worshipful Company of Goldsmiths)

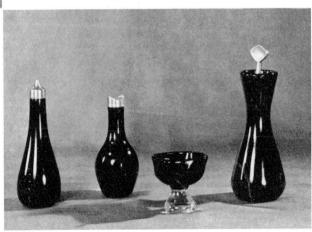

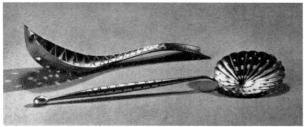

Beaten silver engraved sugar sifter spoons. Designed and made by Robert Welch (GB) (Courtesy: The Worshipful Company of Goldsmiths)

Prototype stainless steel knife, fork and spoon, with black plastic handles. Designed by H. Batelaan (HOLLAND)

RIGHT: Silver hors d'oeuvre set designed by Magnus Stephensen. Makers: Georg Jensen Silversmiths Ltd (DENMARK)

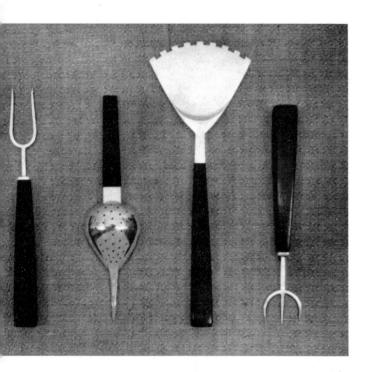

Table silver with palissander handles. Designer: Bertel Gardberg (FINLAND)

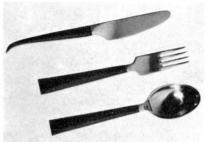

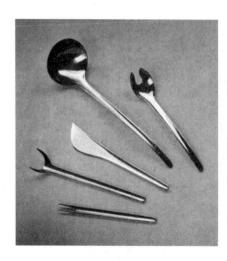

Stainless steel flatware. Designer: Acton Bjørn. Makers: Dansk Knivfabrik (DENMARK)

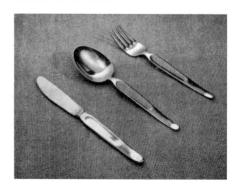

Double tea jugs in faience, decorated in black, grey and blue. Designer: Stig Lindberg. Makers: AB Gustavsbergs Fabriker (SWEDEN)

BELOW: Earthenware jugs and small mug in green, yellow and blue glazes; hand decorated white jug. Designer John Andersson. Makers: Andersson & Johansson (SWEDEN)

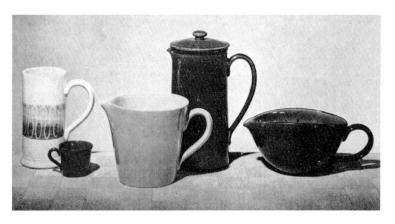

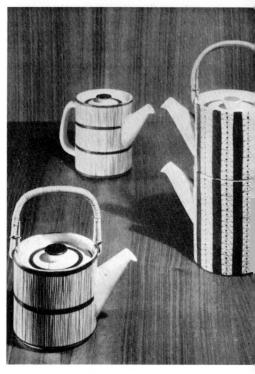

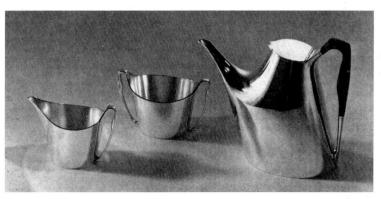

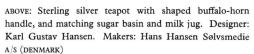

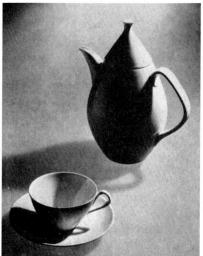

ABOVE: 'LF' coffee set in white bone china. Designer: Stig Lindberg. Makers: AB Gustavsbergs Fabriker (SWEDEN)

LEFT: Stainless steel coffee set with ebony handles. Designer: Magnus Stephensen. Makers: Georg Jensen Silversmiths Ltd (DENMARK)

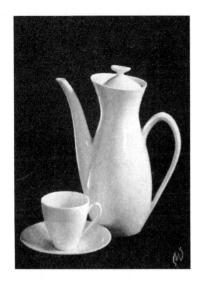

BELOW: Porcelain tea- and coffee-ware in ivory or celadon green. Designers and makers: Porzellanfabrik Langethal AG in collaboration with the Schweizer Werkbund (SWITZERLAND) (Photo: Hans Finsler)

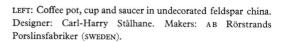

Earthenware teapot, black glaze, with twin jampot and 'television' cup, saucer and plate combination in white and yellow. Designed and made by Axel Brüel (DENMARK)

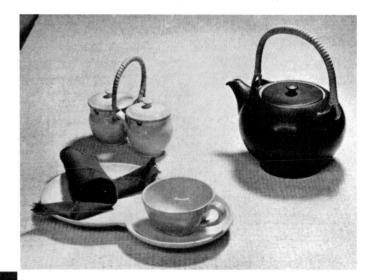

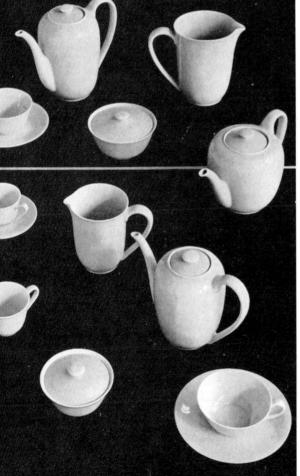

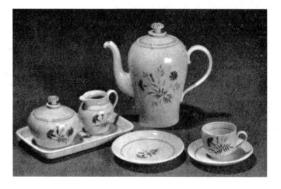

White porcelain coffee set with underglaze Cornflower decoration in blue and black. Designer: Ebbe Sadolin. Makers: Bing & Grøndahls Porcellænfabrik A/S (DENMARK). BELOW: Silver and ivory coffee set designed by Svend Weihrauch. Makers: Frantz Hingelberg (DENMARK)

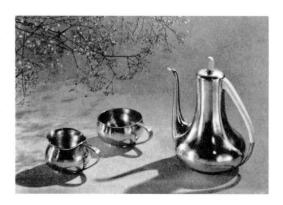

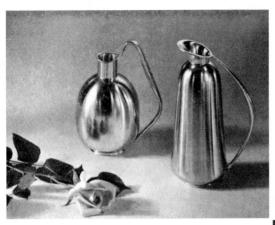

Sterling silver wine pitchers. Designer: Svend Weihrauch. Makers: Frantz Hingelberg (DENMARK). RIGHT: Fine bone china coupe shape rimless plate. Grey onglaze print and freehand platinum decoration Wild Oats; available in tea, dinner or coffeeware. Designer: Victor Skellern. Makers: Josiah Wedgwood & Sons Ltd (GB)

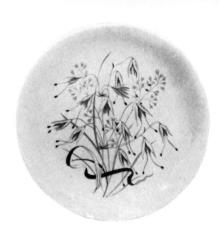

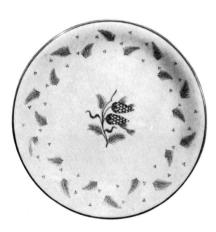

Gold-rimmed fine bone china coupe-shaped dinner plate from the *Pinehurst* service, decorated grey on-glaze print and free-hand gold painting. Designer: Millicent Taplin, MSIA. Makers: Josiah Wedgwood & Sons Ltd (GB)

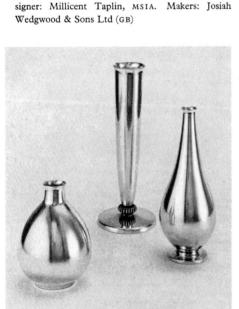

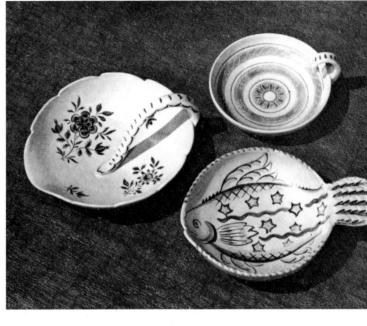

ABOVE: Decorated earthenware dishes in blue and white: fish dish with majolica decoration in brown, yellow and green. Designed and made by Audrey Samuel (GB)

Sterling silver vases and/or candleholder. Designed by Arne Erkers—those at FAR LEFT in collaboration with Ellen Schlanbusch. Makers: Just Andersen A/S (DENMARK)

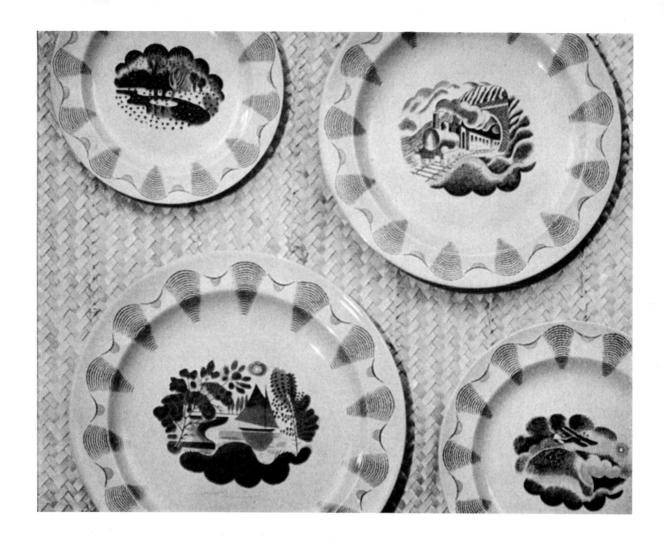

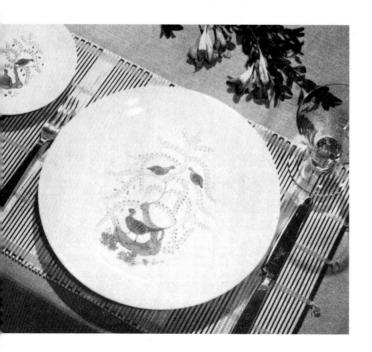

Queensware *Travel* dinner service decorated black print and hand enamelling. Designer: Eric Ravilious. LEFT: *Partridge in a Pear Tree*. On-glaze litho print and gold hand enamelling on white coupe shape. Both sets are made by Josiah Wedgwood & Sons Ltd (GB). BELOW: White earthenware *Moderne* shape, black print and hand-painted decoration. Designer: S. C. Talbot. Makers: A. E. Gray & Co. Ltd (GB)

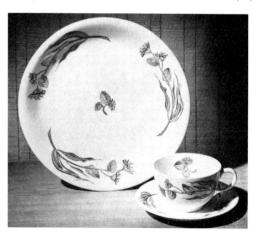

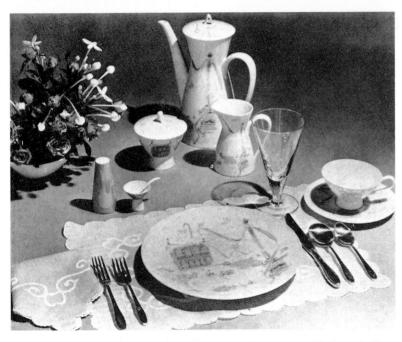

ABOVE: Classic Modern china-porcelain tableware decorated in various motifs; shown is Plaza. Designers: Raymond Loewy Associates. Makers: The Rosenthal-Block China Corporation (USA)

BELOW: Spisa-Terma coffee pot in flame-pro earthenware. Designer: Stig Lindberg. Makes AB Gustavsbergs Fabriker (SWEDEN)

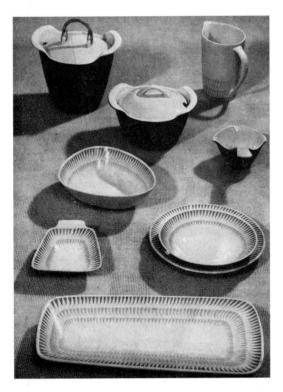

ABOVE: Earthenware tableware in plain black and green, or with yellow/grey pattern on a white body. Designer: Carl-Harry Stålhane. Makers: AB Rörstrands Porslinsfabriker (SWEDEN)

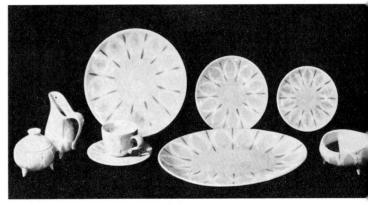

ABOVE: Contemporary Hand-decorated ovenproof kitchenware. Colours: Bluish-green egrey with white. Designer: Charles Murphy. Makers: Red Wing Potteries (USA)

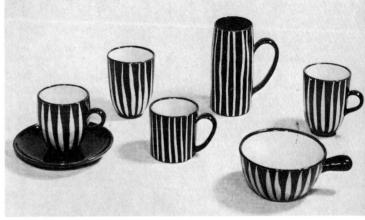

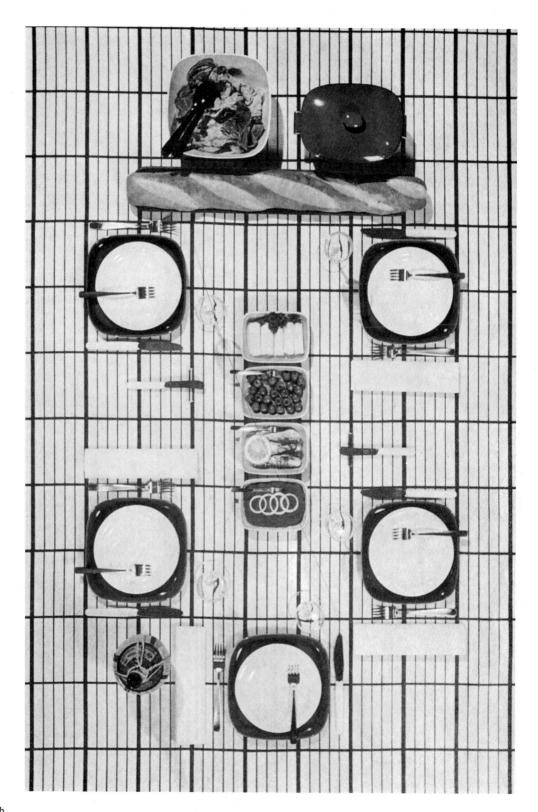

(GHT: Luncheon table set with ratina, Arena and Dala fine arthenware plates and dishes. esigner: Gunnar Nylund. lakers: AB Rörstrands Porsnsfabriker (SWEDEN)

Stylecraft salad ware in semiporcelain Staffordshire china, underglaze decoration. Shapes designed by Roy Midwinter; decoration by Terence Conran. Makers: W. R. Midwinter Ltd (GB)

BELOW: 'Hen' casserole in earthenware, brown glaze with raised yellow spots. Designer: Kaarina Aho. Makers: O/Y Wärtsiläconcern AB Arabia (FINLAND)

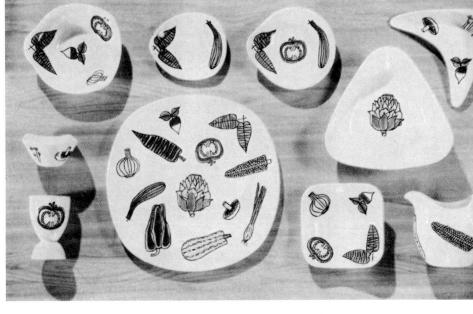

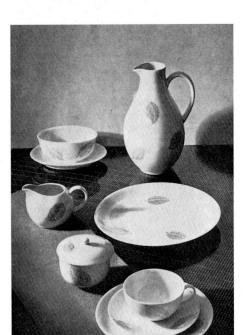

ABOVE: White porcelain tableware, on glaze decoration in matt gold. Shape designed by Dr. H. Gretsch (GERMANY); decoration by Jean Luce (FRANCE). Makers: Porzellanfabrik Arzberg (GERMANY). RIGHT: Hard-fired kitchenware, yellow or manganese brown glazes. Designer: John Andersson. Makers: Andersson & Johansson AB (SWEDEN)

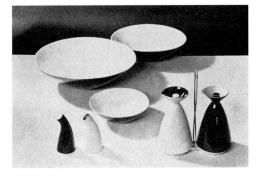

LEFT: Fine china salad service black and white glaze. De signer: Trude Petri-Raben Makers: Staatliche Porzellan Manufaktur Berlin (GERMANY

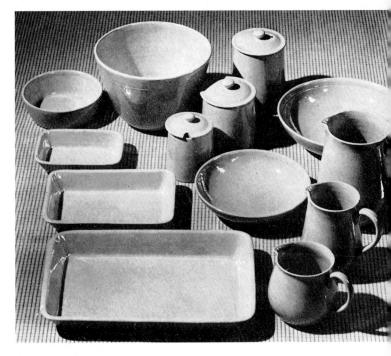

BOVE: White china soup tureen, gold line ecoration. Designer: Giovanni Gariboldi. Aakers: Società Ceramica Richard Ginori TALY). BELOW: Coupe shape fine bone hina dinner plate. *Honeysuckle* sepia print ecoration, hand enamelled in yellow, reen and gold, on glaze, designed by eter Wall, ARCA. Makers: Josiah Vedgwood & Sons Ltd (GB)

Fanfare On-glaze enamel transfer decoration in red/black and muted mauve on white earthenware; red enamel border. Transfers designed and made by Johnson, Matthey & Co. Ltd (GB)

IGHT: Undecorated white porcelain dinnervare, shape 411. Designer: Heinz Löffelhardt. Makers: Porzellanfabrik Schönwald (GERANY). BELOW: Starlight tea and dinner ware and-decorated in midnight blue on Flemish reen Spode earthenware. Makers: W. T. Lopeland & Sons Ltd (GB)

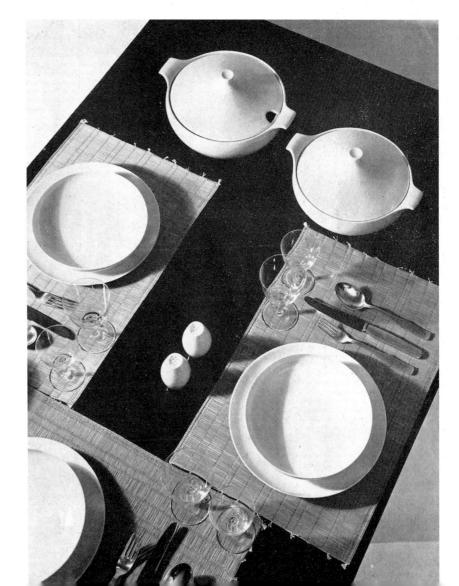

A table is laid with a mixture of breakables and unbreakables. The breakables need periodical replacement, either piecemeal or in sets, whereas the steel and silver pieces are far more likely to survive as eventual heirlooms. This need not imply that cutlery is immune to design changes whereas china is not, but it does point to inevitable differences in design outlook. Knives, forks and spoons must be given long-term consideration if they are to harmonise with whatever the future may bring to the design of the breakable pieces destined to accompany them.

Because of the more rapid turnover in chinaware, it would appear that greater scope exists for changes in design than with cullery, and yet the silver of today has moved a long way from the traditional outlook which has characterised so much of the recent output, particularly in Britain. Nevertheless in Britain, too, there appears to be a growing realisation that the heirlooms of tomorrow will be the designs of today and not the rehashed legacies of yesterday. Several young designers are showing considerably more enterprise than in the immediate past, but they still have some way to go before they are likely to challenge the supremacy of a country like Denmark.

Virility in design should not ignore tradition but, by pursuing it, it will cease to be virile. The receptiveness of the eye changes with time and environment, but the design, even of traditionally based crafts such as tableware, must feed the eye with what it needs. There is always scope at least for subtle variations of shape conditioned by environment while allied to the infinite possibilities of surface treatment, and these are the designers' main weapons for enhancing the pleasures of dining.

ABOVE RIGHT: Summer Sky fine earthenware (Queen's Ware) pale blue and white dinner service in the Barlaston shape. The pieces are made from two-colour clays permanently fused in the firing. Designers and makers: Josiah Wedgwood & Sons Ltd (GB)

RIGHT: Milk glass tableware, ashtray and sweet dish with heart pattern border. Designer: Gunnar Ander. Makers: AB Lindshammars Glasbruk (SWEDEN)

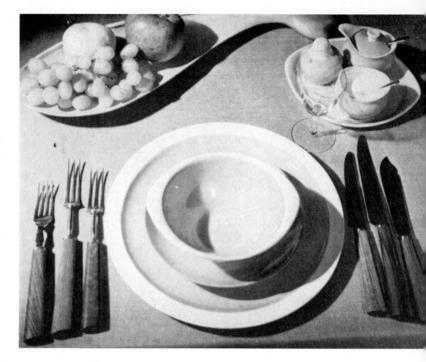

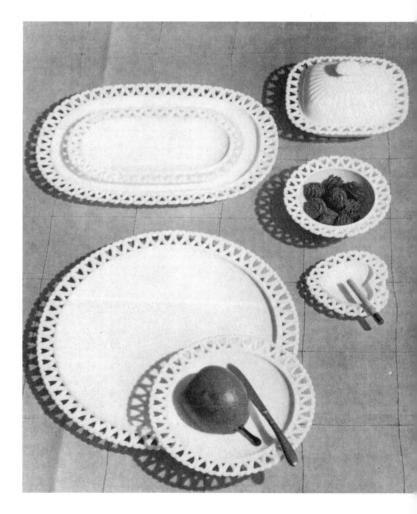

WE: Salad servers in black Melamine. signer: Herbert Krenchel. Makers: rben Ørskov & Co. (DENMARK)

VE: Stainless steel knife and teaon; enamel inlay to handles. Dener: Arne Korsmo, Arch. MNAL. kers: Cathrineholms Emaljefabrik

VE: Silverplated tableware with lowed-out handles. Designer: Arne rsmo, Arch. MNAL. Makers: Tostrup RWAY)

ow: Hand-carved scoops and mixing on in holly. Designer and maker: bert J. Martin (GB)

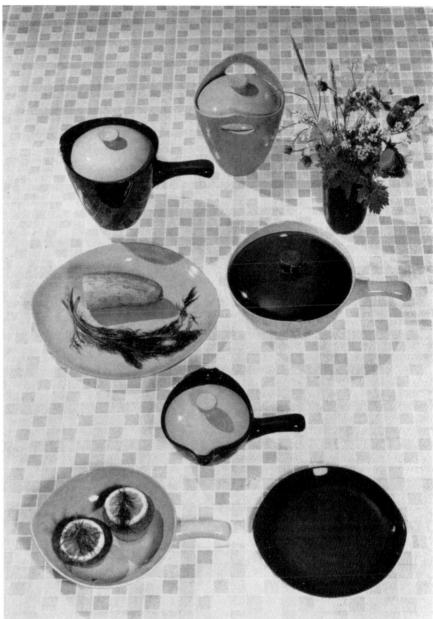

ABOVE: Ovenproof earthenware dishes and casseroles in dark red and yellow glazes. Designer: Sven Erik Skawonius. Makers: The Upsala-Ekeby Group, Ekebybruk (SWEDEN)

Salt and pepper shakers and mustard pot; tin glazed, with majolica decoration in soft olive-green and fine black stripes. Designed and made by Powell & Wells Studio Pottery (GB)

ABOVE: Sterling silver deep vegetable dish on silve frame. Designer: Magnus Stephensen. Maker Georg Jensen Silversmiths Ltd (DENMARK)

LEFT: Screen-printed linen table mats with matching napkins in black/green/lime; black/chocolate mauve. Designed and printed by Mary W Duncan (GB)

One-and-a-quarter and two-quart jugs in aluminium, bakelite handles. Designer: Erik Herløw, Arch. m.a.a. Makers: Dansk Aluminium Industri A/S (DENMARK)

ABOVE: Black Princess dinner service in stoneware, black/white glaze. Designer: F. Meydam. Makers: Kunstaardewerkfabriek 'Regina' (HOLLAND)

Taverna fine earthenware dinner service with onglaze printed decoration, and matt green casserole. The coffee cup and saucer are from the *Inca* service in feldspar china. Designer: Carl-Harry Stålhane. Makers: AB Rörstrands Porslinsfabriker (SWEDEN)

OVE: Blanca undecorated dinnerware in white feldspar china. Dener: Carl-Harry Stålhane. Makers: AB Rörstrands Porslinsfabriker VEDEN). BELOW: Fine bone china teaware decorated black print elude on Sapphire shape, with matt black saucer. White sculptural m vase with black decoration. Designers and makers: Ridgway Poties Ltd (GB)

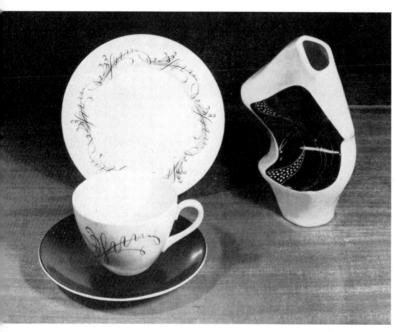

ABOVE: Ivory porcelain dinner service with fine gold rim and gold monogram. The square-based Bandol glasses are in clear crystal. Designers and makers: Maison Rouard (FRANCE)

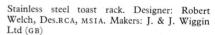

RIGHT: Salad servers, potato spoon, and forks for cold meats, in stainless steel. Designer: Magnus Stephensen. Makers: Georg Jensen Silversmiths Ltd (GB)

BELOW: Hand-wrought sterling silver engraved wine bowl and serving spoon; the lower part of the bowl is gilded and burnished. Designer and maker: Birger Haglund (SWEDEN)

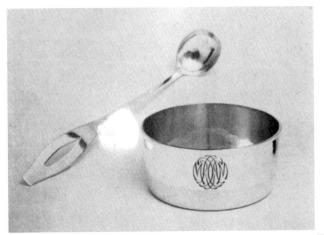

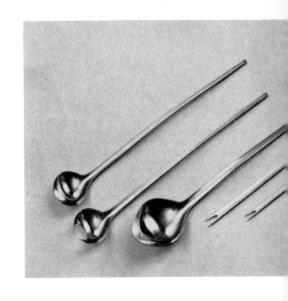

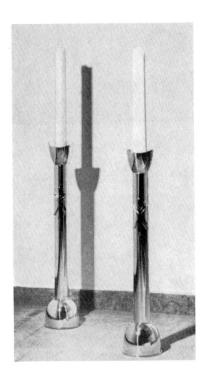

ABOVE: Floor candlesticks of smooth-ground brass. Designer: Arne Nilsson. Makers: Hans-Agne Jakobsson AB (SWEDEN)

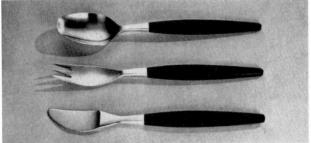

ABOVE: Stainless steel flatware with black nylon handles. Designer: Folke Arström. Makers: AB Gense (SWEDEN). RIGHT: Hors-d'œuvre fork in silver and rosewood. Below Left: Fish knife and fork in silver. Designer and maker: Bertel Gardberg (FINLAND). BELOW RIGHT: Flatware in stainless steel. Designer: Magnus Stephensen. Makers: Georg Jensen Silversmiths Ltd (DENMARK)

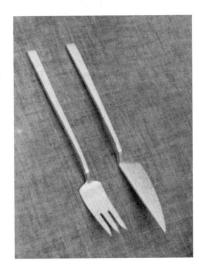

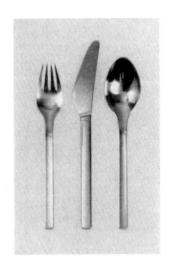

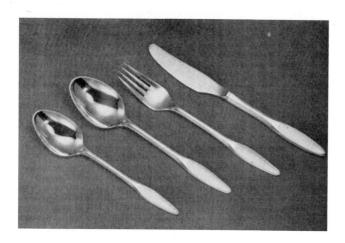

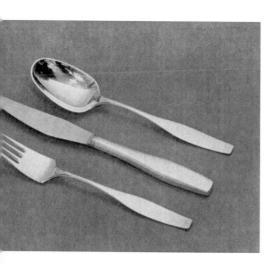

ABOVE: Kongelys silverplated cutlery with engraved tapered handle ends. Designer: Henning Seidelin. Makers: A/S P. C. L. Frigast Sølvvarefabrik (DENMARK)

LEFT: Charlotte cutlery in sterling silver. Designer: Karl Gustav Hansen. Makers: Hans Hansen Sølvsmedie (DENMARK)

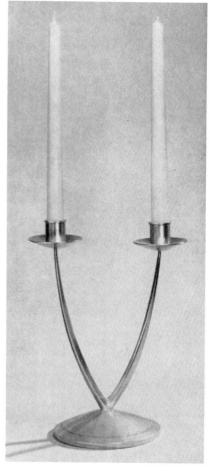

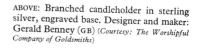

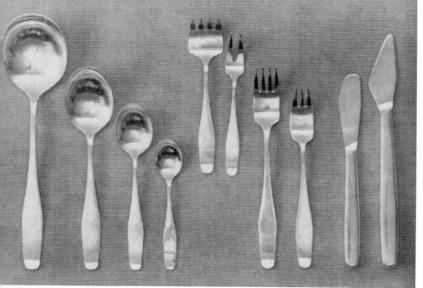

Ultra flatware in sterling silver. Designer and maker: Sigurd Persson (sweden)

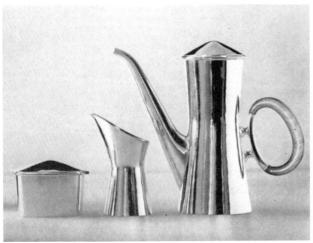

ABOVE: Hand-wrought coffee set in sterling silver; handle in rosewood. Designer and maker: Sigurd Persson (SWEDEN)

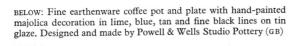

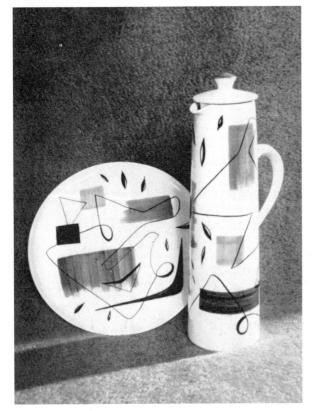

Black-glazed earthenware coffee jug, with television set in grey tin glaze. Designed and made by Axel Brüel (DENMARK)

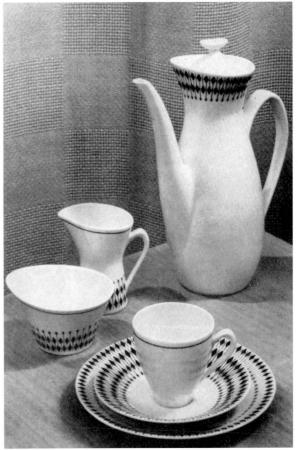

Inca coffee service in white feldspar china with dark green—almost black—decoration. Designer: Carl-Harry Stålhane. Makers: AB Rörstrands Porslinsfabriker (SWEDEN)

RIGHT: Select undecorated white feldspar china coffee service. Designer: Sylvia Leuchowius. Makers: AB Rörstrands Porslinsfabriker (SWEDEN)

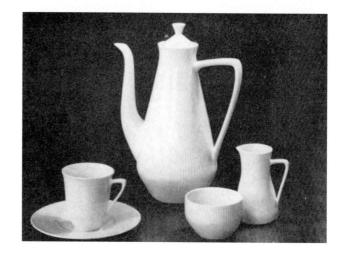

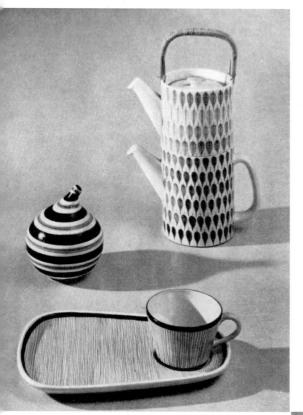

ABOVE: Television set, sugar bowl, and stacking teapots in multi-coloured faience. Designer: Stig Lindberg. Makers: AB Gustavsbergs Fabriker (SWEDEN)

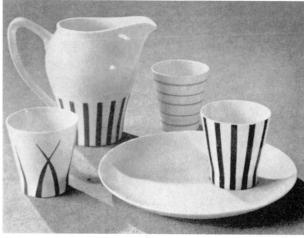

White porcelain jug and beaker/plate combination, hand-decorated in black, green, blue and other colours. Shape designed by Sven Erik Skawonius; decoration by Eva Bland. Makers: The Upsala-Ekeby Group, Karlskrona Factory (SWEDEN)

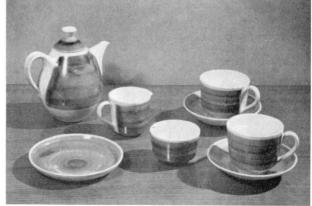

RIGHT: Hand-thrown earthenware early morning tea set; white tin glaze, turquoise decoration. Designed by Brigitta Appleby. Made by Briglin Pottery Ltd (GB)

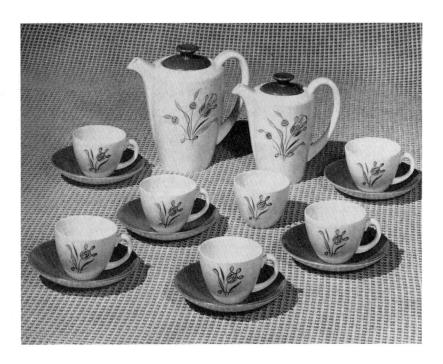

ABOVE: Teaware in white porcelain with slight fl decoration. Designer: Sigvard Bernadotte. Make A/S Bing & Grøndahls Porcellænsfabrik (DENMARK

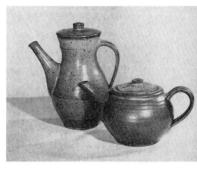

ABOVE: Hand-thrown stoneware coffee and teapot greenish russet and brick red/russet ash glazes on d body. Designed and made by Dorothy Kemp (GB)

ABOVE: Fine earthenware coffee service, offwhite semi-matt glaze, sepia contrast; *Blue Tulip* in-glaze decoration in blue, grey and brown designed by Truda Carter, ARCA and Ruth Pavely. Makers: Carter, Stabler & Adams Ltd (GB)

Hand-thrown early morning teaset; white tin glaze with black oxide contrast. Designer: Brigitta Appleby. Made by Briglin Pottery Ltd (GB)

BELOW: Coffee or tea service in polished brass or pewtertone finish, with metal-lined lids in 'Wengee' wood to match tray. Custom made in Denmark for Raymor (USA)

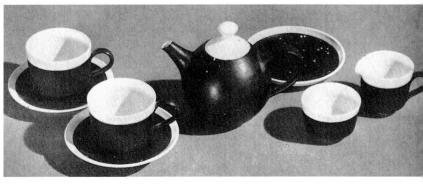

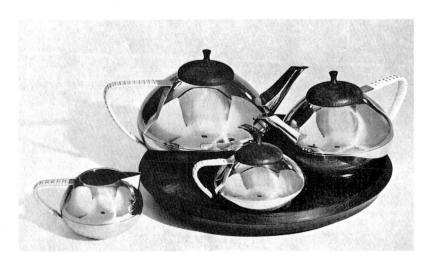

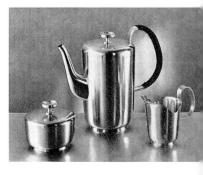

ABOVE: Coffee service in silver plate with plastic bou handle to pot. Designer: Heinz Decker. Makers: C. Hallbergs Guldsmeds AB (SWEDEN)

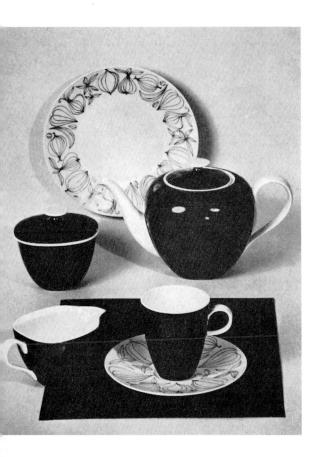

LEFT: Porcelain teaware from the Fortuna tableware range in deep 'Irish Green' and white with onion pattern border. Shape designed by Else Fischer-Treyden; decoration by Otto Hoffmann. Makers: Rosenthal-Porzellan AG (GERMANY)

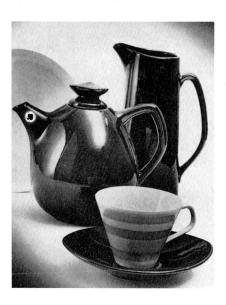

ABOVE: Siam tea service in red clay ware; cup glazed white with yellow band decoration. Designer: Carl-Harry Stålhane. BELOW: Rosmarin tea service in earthenware; pink exterior glaze, white inside. Designer: Hertha Bengtson. Both designs are made by AB Rörstrands Porslinsfabriker (SWEDEN)

LEFT: Porcelain teaware, colourless glaze, hand-decorated onglaze in black and white with orange cup. Designed and made by D. Duszniak, Warsaw Institute of Industrial Design (POLAND)

HT: Stoneware teapot, celan glaze. Designer: Jørgen ogensen. Makers: The Royal penhagen Porcelain Manutory A/S (DENMARK)

LEFT: Stoneware teapot. White glaze with onglaze red iron brush decoration. Designed and made by F. G. Cooper, MSIA (GB)

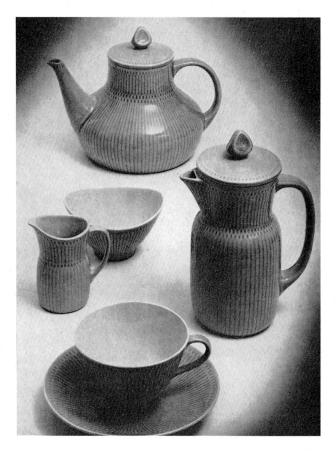

BELOW: Gourmet ovenproof earthenware; white, with 'grill' decoration in green, yellow or brown. Designers: Stig Lindberg and Bibi Breger. Made by AB Gustavsbergs Fabriker (SWEDEN)

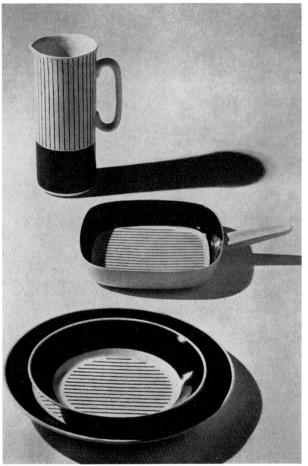

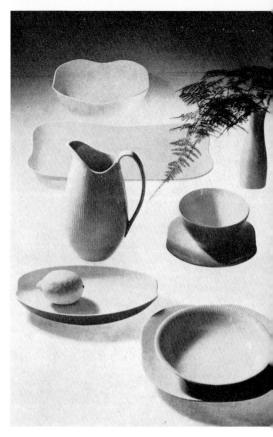

ABOVE: Dinner service in white feldspar china, 'ripple' decoration. Designer: Sven Erik Skawonius. Makers: The Upsala-Ekeby Group, Ekebybruk (SWEDEN)

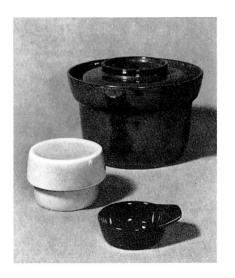

ABOVE: Krenit steel enamelled frying pan with detachable Bakelite handle. Made in three sizes: 6, 8 and 10-inch diameter, and in different colour combinations for each size. Designed and made by Herbert Krenchel (DENMARK). LEFT: Patella ovenproof porcelain in yellow, rusty brown and speckled brown glazes. Designer: Magnus Stephensen, MAA. Makers: The Royal Copenhagen Porcelain Manufactory A/S (DENMARK)

Left: Aluminium saucepan with black-anodised lid; lid knob in white bakelite, handle in black. Designer: Erik Herlow, MAA. Makers: Dansk Aluminium Industri a/s (Denmark). Below Left: Hand-made stainless steel fruit dish, $7\frac{1}{2} \times 9$ inches. Designed and made by John Grenville (GB). (Courtesy: The Worshipful Company of Goldsmiths). Below Centre: Flatware in stainless steel. Designer: Arne Jacobsen, MAA. Makers: A. Michelsen (Denmark)

Candlestick in silver or in polished brass, on teak base. Designer: Sven Aage Holm Sørensen. Made by Holm Sørensen & Co. (DENMARK)

Hand-thrown salad bowl, 14 inches diameter; quart soup flagon, with matching soup cup and saucer. Designed and made by Susan Lane at Ways Ware Pottery (GB)

LEFT: Lobster fork in stainless steel. Also made in sterling or plated silver. Designer: Sigurd Persson (sweden). Makers: Württembergische Metallwarenfabrik (GERMANY)

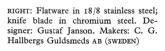

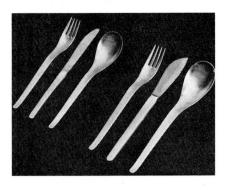

LEFT: Flatware design No. 2722 in 18/8 stainless steel. Designer: Carl Pott. Makers: C. Hugo Pott (GERMANY)

RIGHT: Silver-plated dessert and table spoons. Designed by Bertel Gardberg. For Hackmann & Co. (FINLAND)

LEFT: Pilét kitchen knives: mirrorpolished stainless steel, serrated edge; rosewood handles assembled by expansion rivets to an inseparable unity with blade. In three sizes and, alternatively, for left-hand use. Designer: Henning Nørgaard. Makers: Raadvad Cutlery Works Ltd (DENMARK)

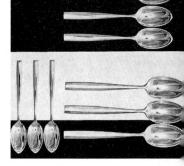

LEFT: Eton flatware in 18/8 stainless steel, knife in chromium steel; celluloid handles in ivory or other colours, or in imitation mother-of-pearl, or pallisander wood. Designer: Henning Nørgaard. Makers: Raadvad Cutlery Works Ltd (DENMARK)

RIGHT: Engraved punch ladle in sterling silver and whalebone. Designed and made by K. W. Lessons at the Royal College of Art (GB)

LEFT: Flatware design No. 111 in sterling silver. Designer: Henning Koppel. Makers: Georg Jensen Sølvsmedie A/S (DENMARK)

RIGHT: Silver-plated flatware. Designed by Bertel Gardberg. For Hackmann & Co. (FINLAND)

LEFT: Condiment set in stainless steel. Designer: Robert Welch, Des.RCA, MSIA. Made by J. & J. Wiggin Ltd (GB)
(Photo: C.o.I.D.)

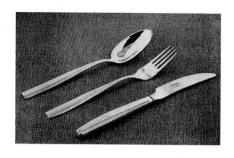

RIGHT: Serving set in sterling silver with black lignum vitae handles. Designer: Mauno Honkanen. Made by Koruteollisuus Tillander (FINLAND)

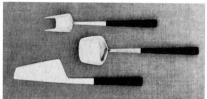

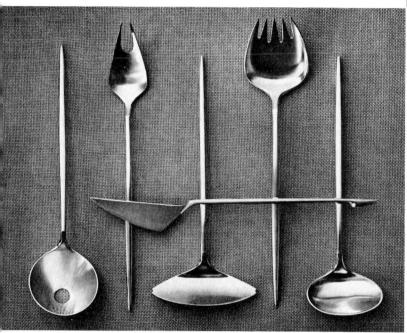

LEFT: Hors d'oeuvres set in sterling silver, including mayonnaise spoon, herring fork, sardine server, salmon fork, olive spoon and tomato knife. Designer: Vagn Åge Hemmingsen. Made by Franz Hingelberg (DENMARK)

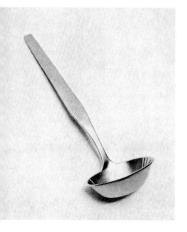

Robert Welch, Des.RCA, MSIA (GB)

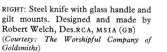

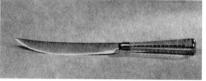

LEFT: Soup serving spoon in stainless steel. Designed by Bertel Gardberg. For Hackmann & Co. (FINLAND)

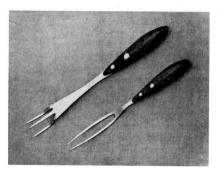

RIGHT: Pilét kitchen forks in mirrorpolished stainless steel with rosewood handles; of similar construction to knives shown opposite. Designer: Henning Nørgaard. Makers: Raadvad Cutlery Works Ltd (DENMARK)

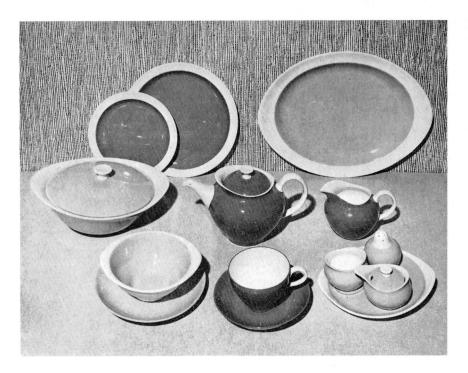

ABOVE: Stainless steel casserole with copper bottom and ebony handle; capacity 4 pints. Designer: Magnus Stephensen. Makers: Georg Jensen Sølvsmedie A/S (DENMARK)

Fiesta moulded Melmex tableware in 'House & Garden' colours. Designed with heavy sections and tapered edges, it is of pleasant weight and good appearance. Designer: Ronald E. Brookes, MSIA. Makers: Brookes & Adams Ltd (GB)

ABOVE: Queen's Ware permanently fused two-colour tableware, Summer Sky (blue and white) and Havana (lilac brown and white) in the Barlaston shape. Designer: Norman Wilson. Makers: Josiah Wedgwood & Sons Ltd (GB)

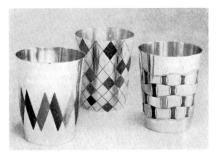

Handmade sterling silver beakers, height 5½ inches, chased decoration filled with multicoloured enamels. Designer: Barbro Littmarck. Makers: W. A. Bolin (SWEDEN)

Oven-proof individual soup bowl in stoneware; unglazed exterior with iron decoration, interior white or grey-green glaze. Designed and made by Harry and May Davis at Crowan Pottery (GB)

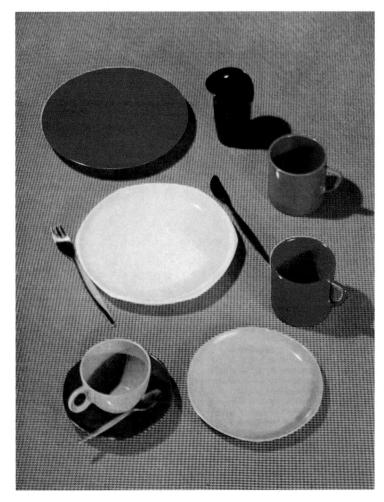

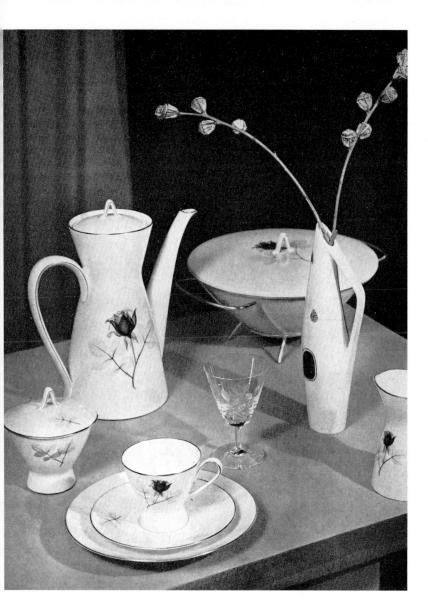

ABOVE: Engraved sauceboat in sterling silver. Designer: E. G. Clements, Des.RCA, MSIA. Made by L. W. Burt (GB). (Courtesy: The Worshipful Company of Goldsmith)

Vegetable dish in stainless steel, 9-inch diameter. It is made in eight different sizes. Designer and maker: S. A. Sartel (BELGIUM)

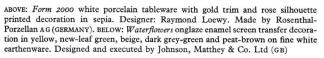

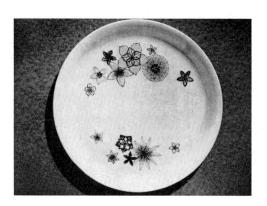

BELOW: Mottled green/white hand-thrown beaker; oxide decoration under white tin glaze. Height: 5 inches. Designer: Brigitta Appleby. Made by Briglin Pottery Ltd (GB)

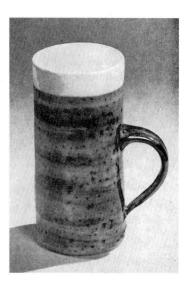

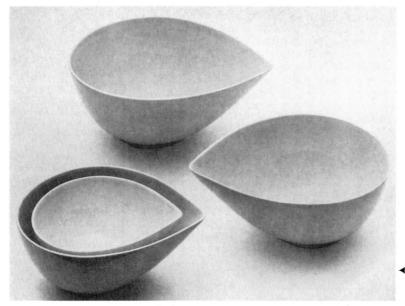

Yellow-glazed earthenware curry bowls designed by Hertha Bengtson. Makers: AB Rörstrands Porslinsfabriker (SWEDEN)

Wärtsilä-concern Arabia (FINLAND)

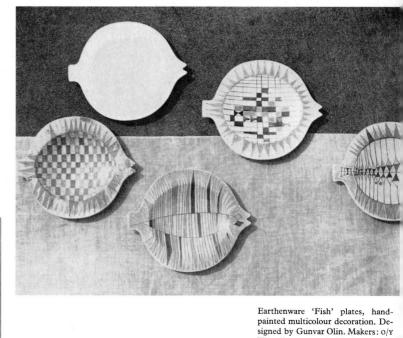

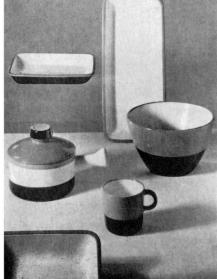

Cayenne red clay ovenware; reddishbrown and black exterior glaze, bone-white interior glaze. Designer: Hertha Bengtson. Makers: AB Rörstrands Porslinsfabriker (SWEDEN)

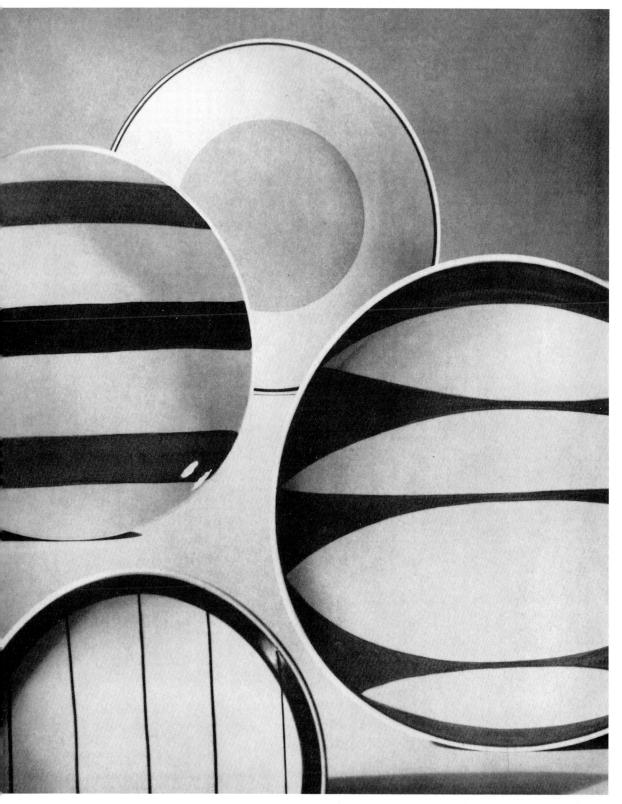

Fine earthenware plates with hand-painted underglaze decoration; centre plate, yellow; those at left, lilac-brown and brown-black; right-hand plate, blue-white. Designed by Stig Lindberg. Makers: AB Gustavsbergs Fabriker (SWEDEN)

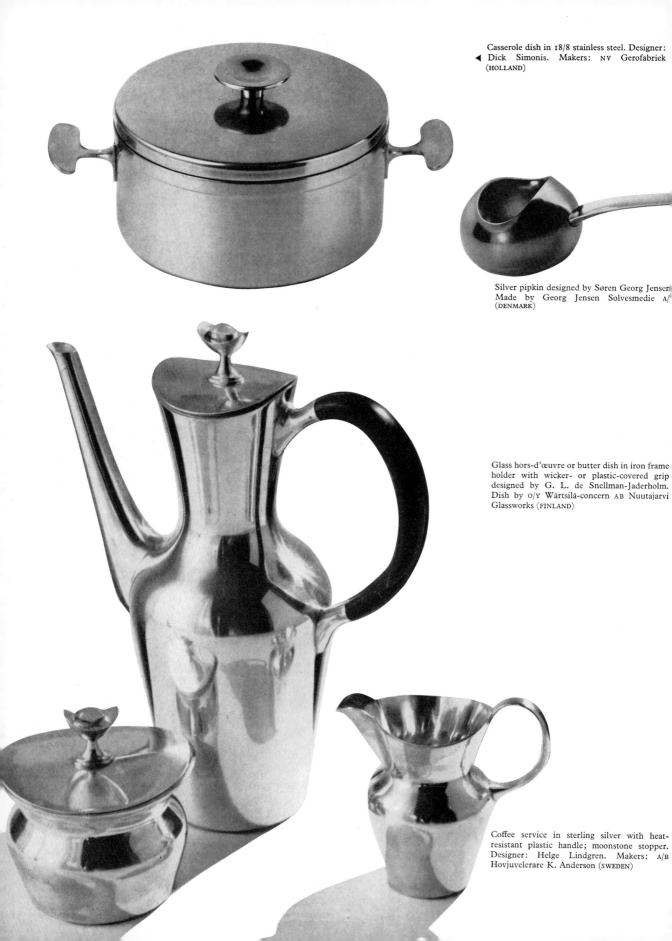

Hand-carved salad servers in acajou. Designed and made by A. Van Itterbeeck (BELGIUM)

Columbia anodised aluminium coffee maker with nylon handle. Designer: Kås Claesson. Makers: Peter Bodum a/s (DENMARK)

Cane core bread basket designed and made by Lauris Lønborg (DENMARK)

Sugar, salt and pepper pourers in 18/8 stainless steel, plastic base. Designer: Pierre Forssell. ▶ Makers: AB Gense (SWEDEN)

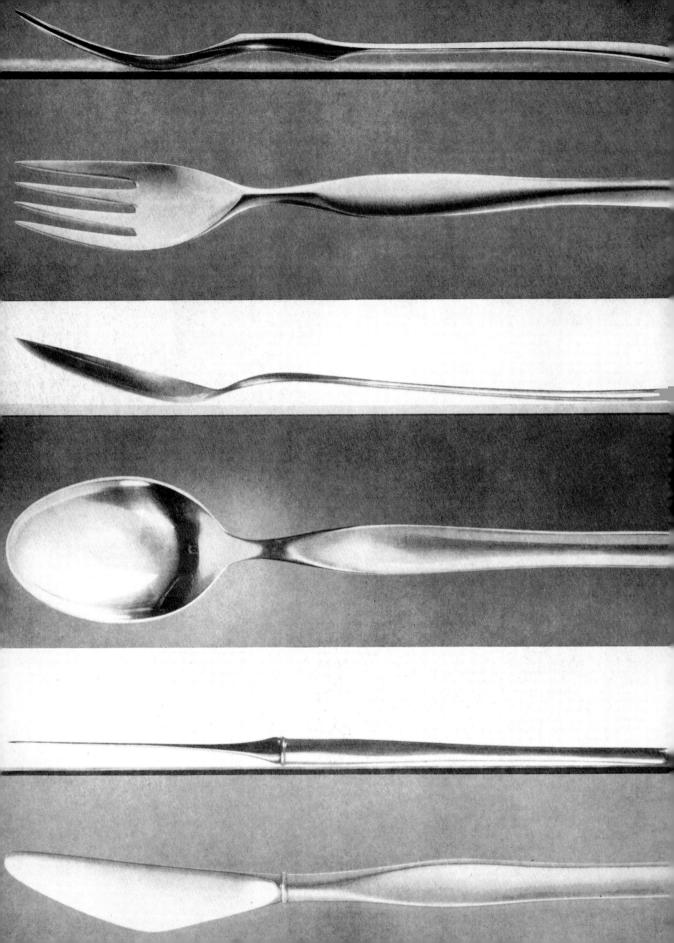

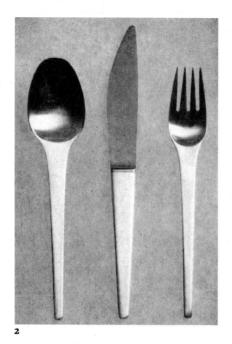

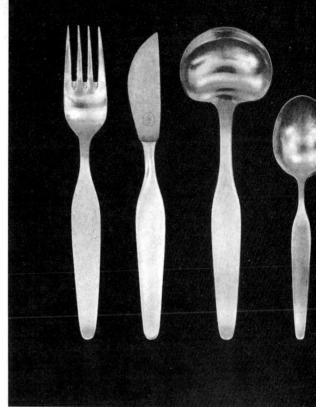

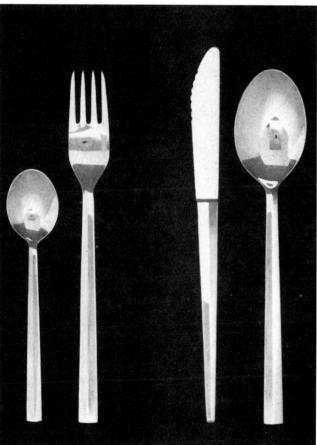

- I Flatware in silver. The fork is from the Hopea Siipi (Silver Wing) service, the knife and spoon from Tapio. Both are designed by Tapio Wirkkala and made by Kultakeskus o/y (FINLAND)
- 2 Caravel flatware service in silver. Designer: Henning Koppel. Makers: Georg Jensen Solvsmedie A/S (DENMARK)
- 3 Flatware in sterling silver, serrated knife blade. Designer: Marco Lugherra. Made by Sola Besteckfabrik AG (SWITZERLAND)
- 4 Flatware design No. 2723 in 18/8 chrome nickel steel, with stainless steel knife blade. It is made in a size between the usual dinner and luncheon sizes. Designed by Dr. Josef Hoffman of Vienna. Made by C. Hugo Pott (GERMANY)

RIGHT: Red earthenware plate, $12\frac{1}{2}$ -in. diameter, decorated by feather combing in red and cream slip on a black slip ground and glazed with a transparent galena glaze. Designed and made by H. R. Stone.

BELOW: Unglazed stoneware inlaid with chamotte clay in different colours designed by Axel Salto and made by The Royal Copenhagen Porcelain Factory.

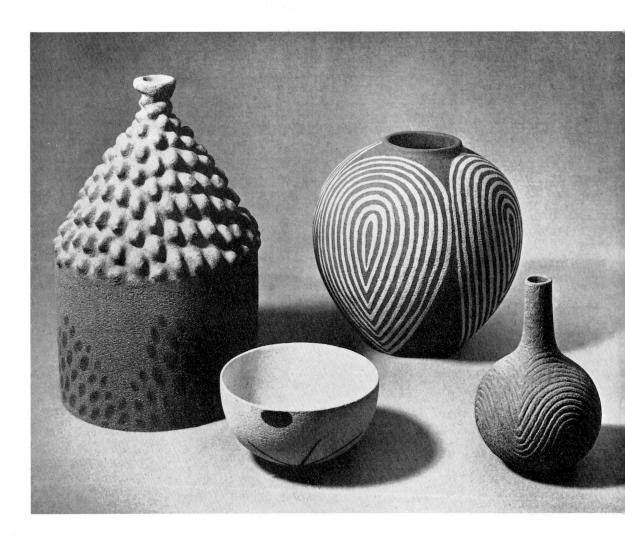

Cream stoneware bulb bowl with blue underglaze decoration and cream stoneware dish with black slip decoration, both designed and made by Eleanor Whittall.

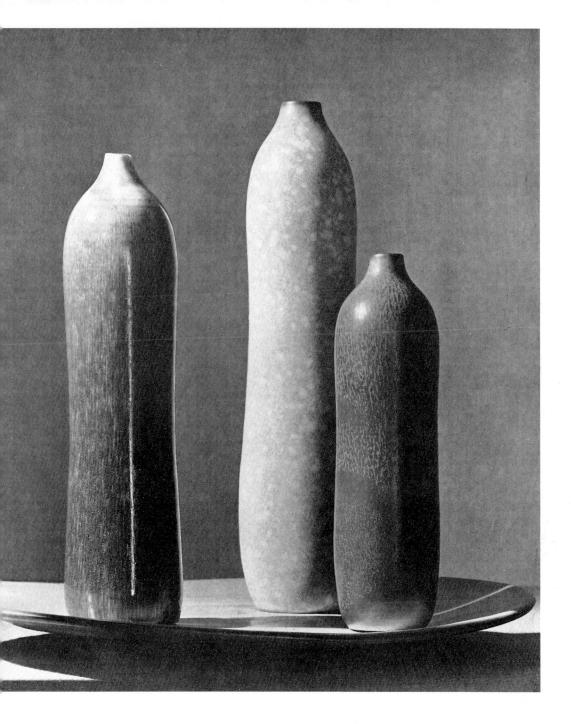

nic stoneware vases in *sang de boeuf*, yellow-green and black-brown glaze esigned by Carl Harry Stahlhane and made by

в Rorstrand Porslinsfabriker.

ıбнт: Galena glazed plate, 12½ in. diameter,

esigned and made by H. R. Stone.

ed earthenware clay, decorated by feather combing in red and ack slip on a cream slip ground.

KTREME RIGHT: Earthenware plate, one of a series of biblical subjects, 6 in. diameter, in black, brown and grey, designed and made by dwin and Mary Scheier.

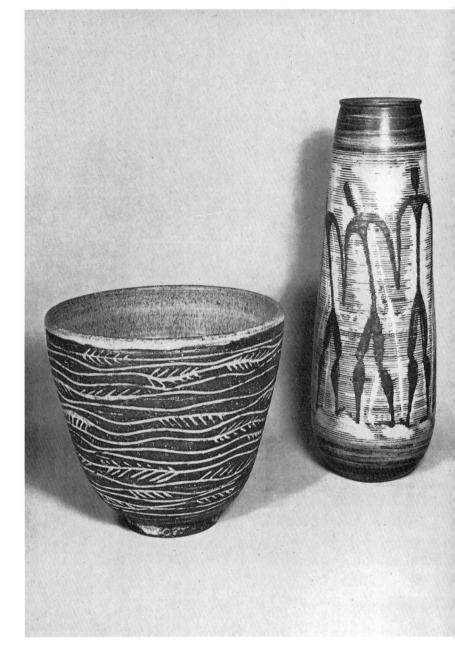

Handthrown flower-pot, 8 in. high, earth-pink matt glaze on brown body, and vase, 16 in. high, with figures in mulberry brown against grey matt glaze, both designed and made by Nancy Wickham; prizewinners in competition sponsored by The Syracuse Museum of Fine Arts and The Onondaga Pottery Co. (Photo: Syracuse Museum of Fine Arts

sgraffito technique, designed and made by Marguerite Wildenhain.

2: oval pinched footed bowl, velvet-yellow matt glaze vase, and blue Pompeian lava glaze vase, grey reduction glaze with melt craquelé.

3: bowl, dove-grey reduction glaze with melt craquelé, and bottle-shaped vase, tiger-eye reduction gla 4: cylindrical vase, grey reduction glaze with melt craquelé; plate, eggshell matt glaze with mineral deposits and square pinched bowl, flame-red matt glaze.

2, 3 and 4 designed and made by Gertrud and Otto Natzler.

TOP LEFT: Grey-green stoneware bowl with brush drawing in iron oxide designed and made by H. F. Hammond.

CENTRE: Fighting Cock earthenware bowl in sgraffitto on iron slip: designed and made by Rachel Warner. (Photo: J. G. Restall)

ABOVE: Earthenware tray with underglaze decoration in blue and purple, designed by Birger Kaipiainen and made by Arabia Porcelain and Earthenware Factory.

BELOW: Vase in cream colour and celadon slip with hand-turned 'runner' bead decoration designed by Keith Murray, RDI, and made by Josiah Wedgwood & Sons Ltd.

LEFT: Vase of the Evangelists, reminiscent of Byzantine and early-Christian bas-reliefs in ivory yet modern in colour and form.

Designed by Endre Hévézi and Dr Gyula Bajo and made by Booths & Colcloughs Ltd, Hanley. Background: Ormiston 50-in. printed linen designed by Marion Mahler and made by Donald Bros Ltd. Four other colour schemes on white grounds available: duckegg, cyclamen or jade, each with dark and light grey; yellow, cinnamon and chocolate.

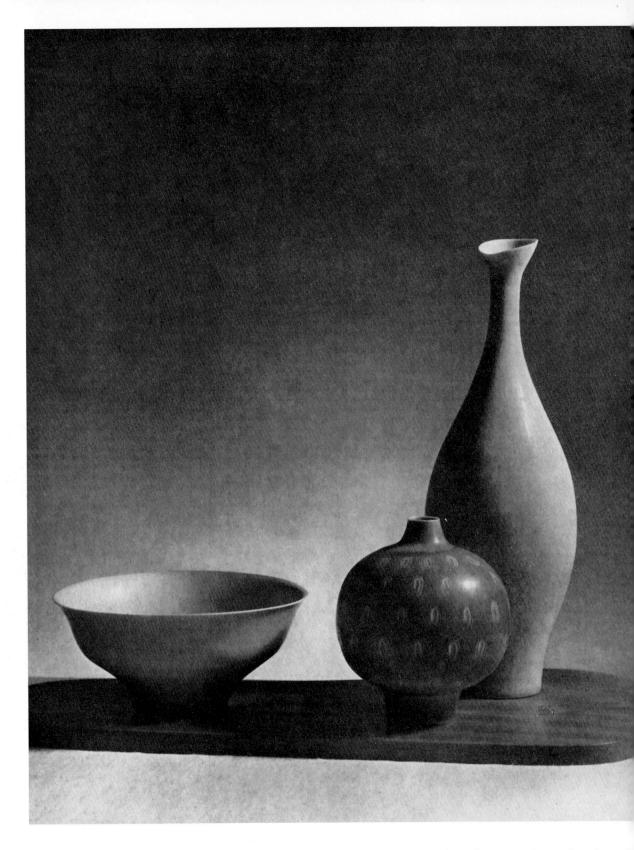

Unic stoneware in grey-white, olive-green and ivory glaze, designed by Carl Harry Stahlhane and made by AB Rorstrand Porslinsfabriker.

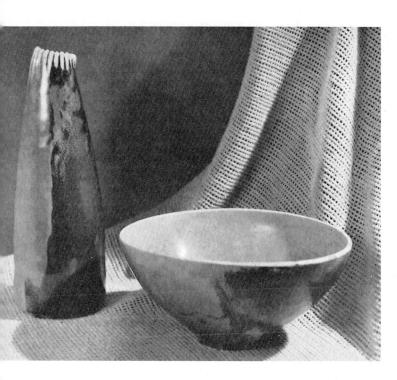

Vase and bowl of stoneware with sang de bouf glaze designed by Toini Muona and made by Arabia Porcelain and Earthenware Factory.

BELOW, RIGHT: Cream glaze stoneware vase with golden yellow brush decoration, designed and made by Constance Dunn, ARCA.

LOWER: Group of Unic stoneware miniatures, with white, brown and blue flame glaze, designed by Gunnar Nylund and made by AB Rorstrand Porslinsfabriker.

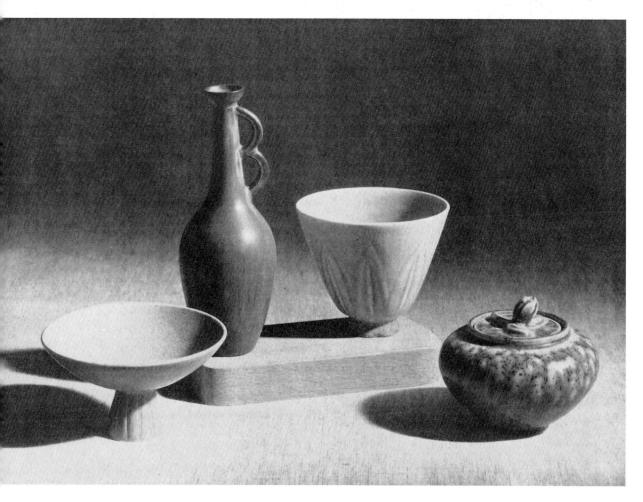

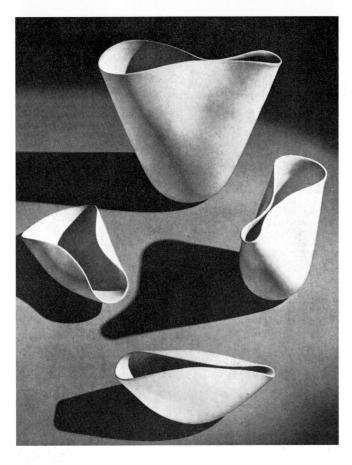

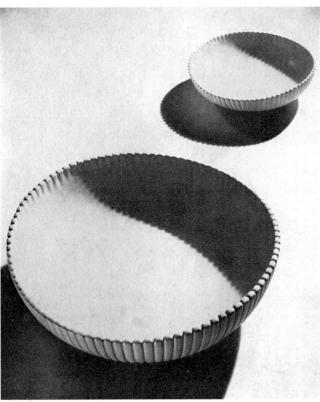

- Veckla. White stoneware designed by Stig Lindberg and made by A B Gustavsbergs Fabriker. 'Pinching' the soft clay before firing has enhanced the characteristics of the material.
- Vinda. White stoneware designed by Stig Lindberg and made by A B Gustavsbergs Fabriker.
- 3. Translucent pale pink bowl and white vase of unfired thin china clay designed by Aune Siimes and made by Wartsila-Koncernen A B Arabia. The pattern is introduced by varying the thickness and thus changing the opacity.
- OPPOSITE: Våga. White stoneware designed by Wilhelm Kåge and made by A B Gustavsbergs Fabriker. The wavy edges are reminiscent of underwater forms.

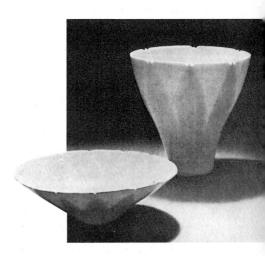

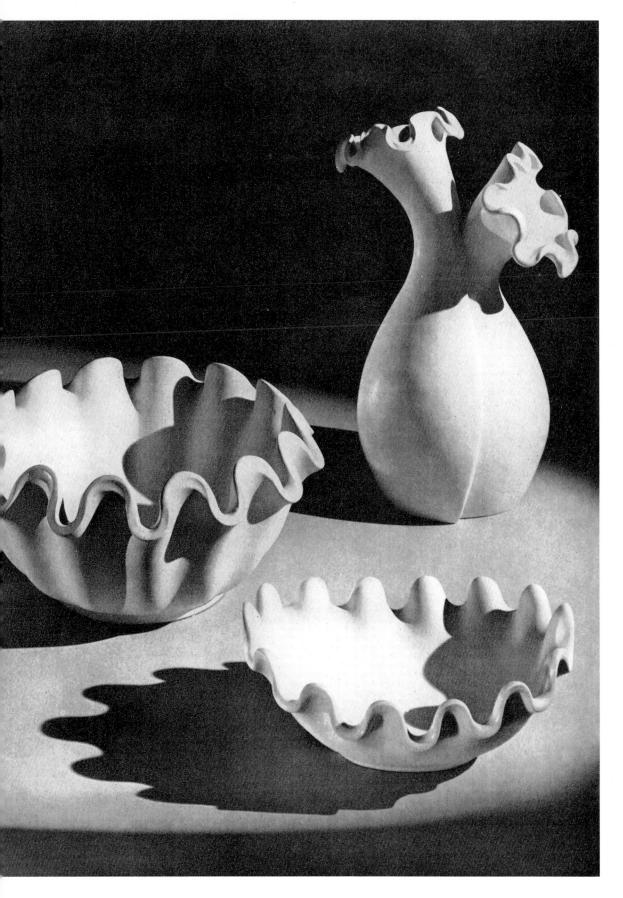

- Unic stoneware vases with turquoise and brown glazes designed by Stig Lindberg and made by A B Gustavsbergs Fabriker.
- Frozen Music. Vases of highly-fired stoneware with contrasting matt glazes designed by Carl Harry Stålhane and made by A B Rörstrands Porslinsfabriker.

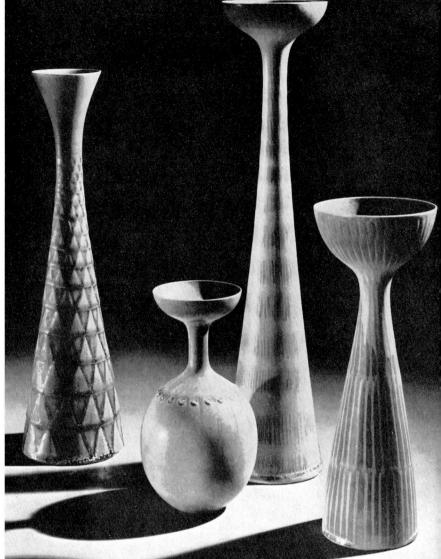

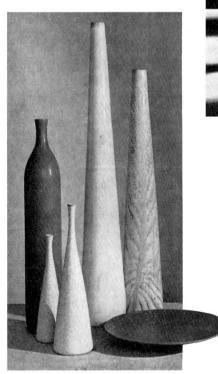

- 3. Faiences designed by Stig Lindberg and made by A B Gustavsbergs Fabriker.
- Handmade stoneware vases, 7 in. and 16 in. high, designed by Meindert Zaalberg and made by Potterij Zaalberg. (Photo: A. Dingjan.)
- Stoneware vases with white and green glazes, and bowl with white glaze, designed by Kyllikki Salmenhaara and made by Wartsila-Koncernen A B Arabia.
- Vases of highly-fired stoneware with various matt glazes designed by Carl Harry Stålhane and made by A B Rörstrands Porslinsfabriker.
- Stoneware vases and bowl with sang de bouf glaze designed by Toini Muona and made by Wartsila-Koncernen A B Arabia.

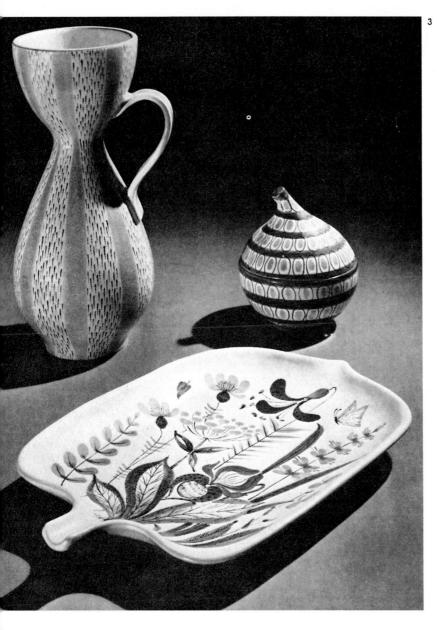

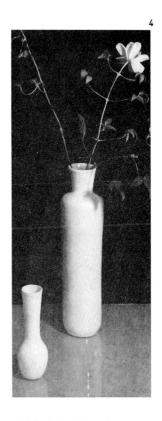

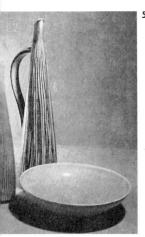

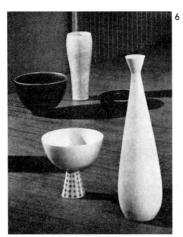

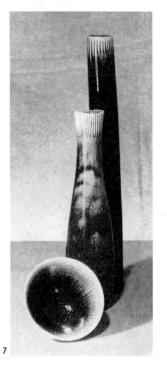

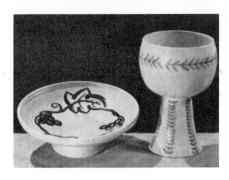

- White stoneware designed and made b Eleanor Whittall. Dish with decoration is black slip, and stemmed cup with blu decoration.
- Vase of stoneware-chamotte with decorations in grey, black and white, designed b
 Carl Harry Stålhane and made by A I Rörstrands Porslinsfabriker.
- Stoneware bowl with sang de bœuf glaze and vase with white and eau-de-nil glaze designed by Friedl Kjellberg and made b Wartsila-Koncernen A B Arabia.
- 4. White china miniatures with gold-painted decorations designed by Maria Hackman and made by A B Rörstrands Porslinsfabriker

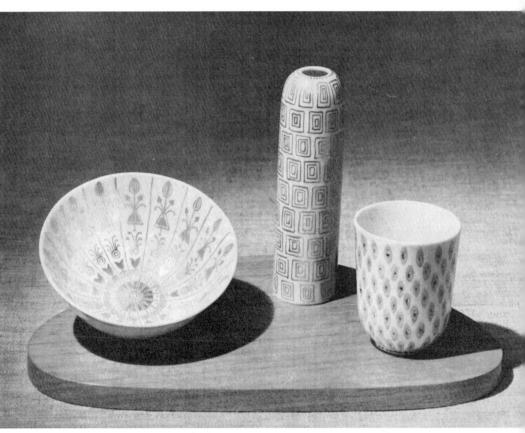

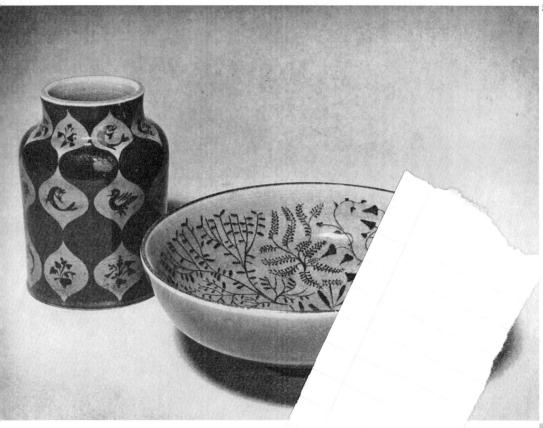

- Stoneware vase and bowl with black decoration on turquoise glaze designed by Nils Thorsson and made by The Royal Copenhagen Porcelain Factory.
- Vase with multi-coloured decoration on grey and white glaze designed by Poldi Wöjtek and made by A/S Michael Andersen & Son.
- Dish of stoneware with black decoration on turquoise glaze designed by Nils Thorsson and made by The Royal Copenhagen Porcelain Factory.
- 8. Handmade pottery with rich creamcoloured slip decoration and amber glaze on red clay designed by Peter Holdsworth and made by Holdsworth Pottery.

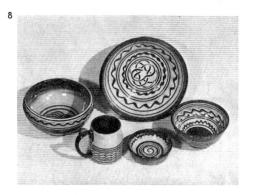

ABOVE: Dull earthenware plate decorated in grey and black. Designer and maker: Marciano A. Longarini (ARGENTINA).

BELOW: Black and white slipware dish, diameter 18 in. Designer and maker: William Newland (GB). (Collection: Arthur Lane).

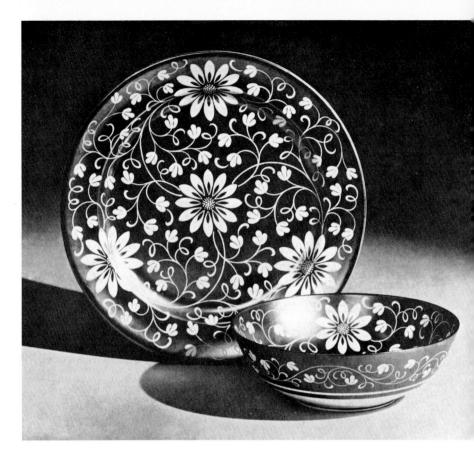

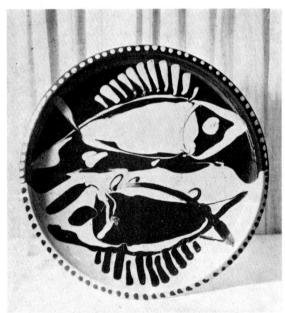

RIGHT: Underglaze plate with black, grey and citron yellow decoration on ivory coloured clay, diameter 24 in. Designer and maker: Margaret D. Hine (GB).

Plate and bowl with hand-painted 'resist' design in broom or silver lustre on ivory ground. Designer: S. C. Talb Makers: A. E. Gray & Co Ltd (GB).

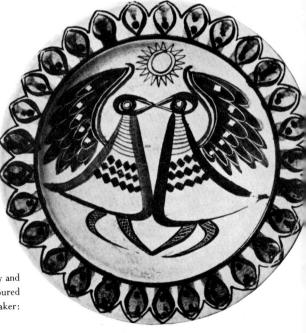

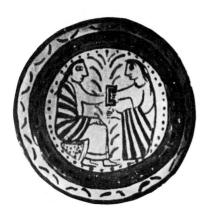

ABOVE: Glazed plate, the figures in blue on a white ground. Designer and maker: Marciano A. Longarini (ARGENTINA).

RIGHT: Faience plate decorated in red, blue, green, yellow and mulberry, and vase in black and grey. Designed and painted by Stig Lindberg. Makers: AB Gustavsbergs Fabriker (SWEDEN).

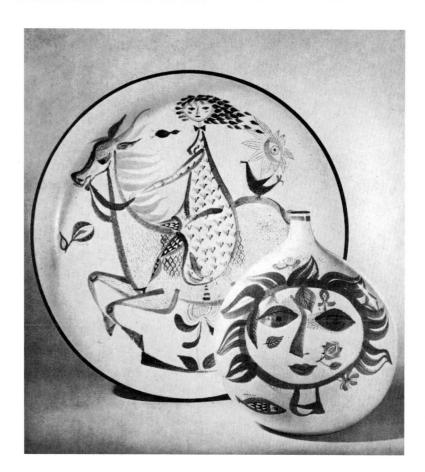

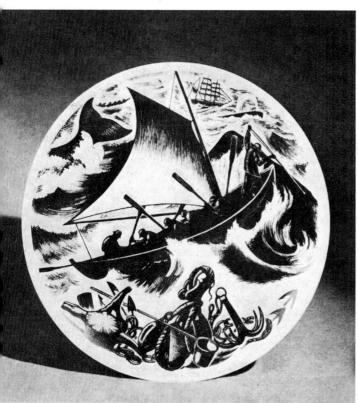

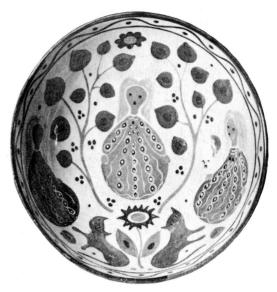

ABOVE: Three Girls. Earthenware plate painted in oxides of cobalt, iron, nickel and chrome. Designer and maker: Henry Clante (DENMARK).

LEFT: One of a series of twelve plates depicting New England industries, printed in sepia on Wedgwood cream colour *Queensware*. Designer: Clare Leighton. Makers: Josiah Wedgwood & Sons Ltd (GB).

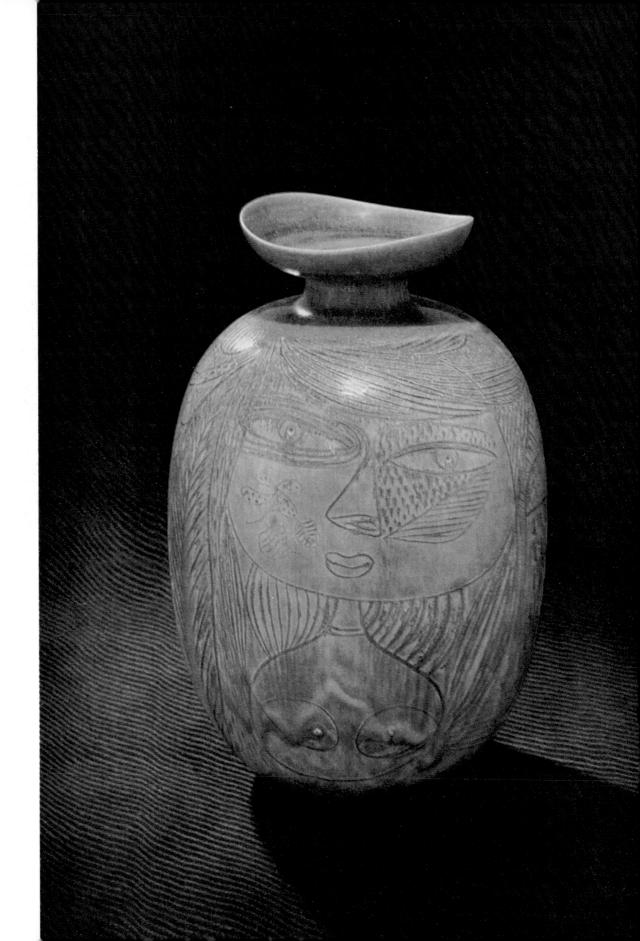

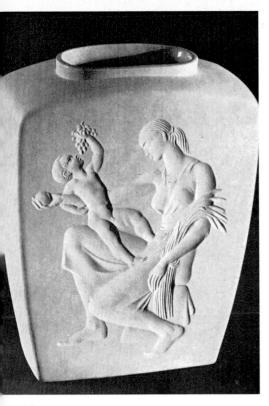

eres vase. Celadon green porcelain with relief decoration, xterior unglazed. Designer: Siegmund Schütz. Makers: taatliche Porzellan-Manufaktur Berlin, Werk Selb (GERMANY).

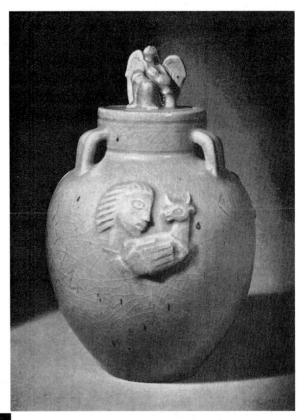

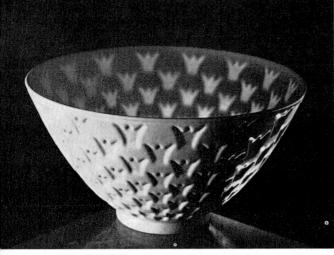

PPPOSITE: Stoneware vase. Designer and maker: Stig Lindberg, B Gustavsbergs Fabriker (sweden). Now in the Trondheim Museum, Norway.

ABOVE: Mathaeus vase. Stoneware, celadon glaze with relief decoration. Designer: Jais Nielsen. Makers: The Royal Copenhagen Porcelain Factory (DENMARK).

LEFT: Crown bowl, white matt-glazed porcelain. Designer: Gunnar Nylund. Makers: A B Rörstrands Porslinsfabriker (SWEDEN).

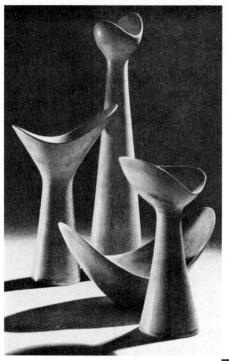

Stoneware vases with bone yellow glaze, signed 'Stig L'. Designer: Stig Lindberg. Makers: A B Gustavsbergs Fabriker (SWEDEN).

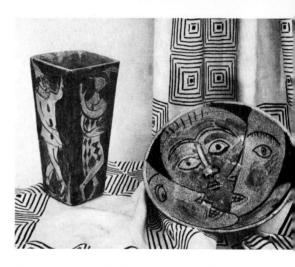

Terra-cotta vase with black, brown and white decoration, and terr cotta bowl decorated in turquoise, cobalt, black and white. Design and maker: Emanuel Romano. Background of handwoven pure si Honan designed by Hugo Dreyfuss and printed in brown on natural ground by Kagan-Dreyfuss Inc (usa).

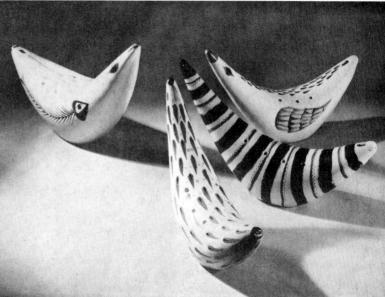

Toy Ocarinas. Faience with polychrome decorations. Designer: St Lindberg. Makers: A B Gustavsbergs Fabriker (sweden).

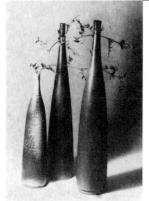

LEFT: Stoneware bottles with green and brown glazes. Designer Kyllikki Salmenhaara. Makers: Wärtsilä-koncernen a.b. Arabi (FINLAND).

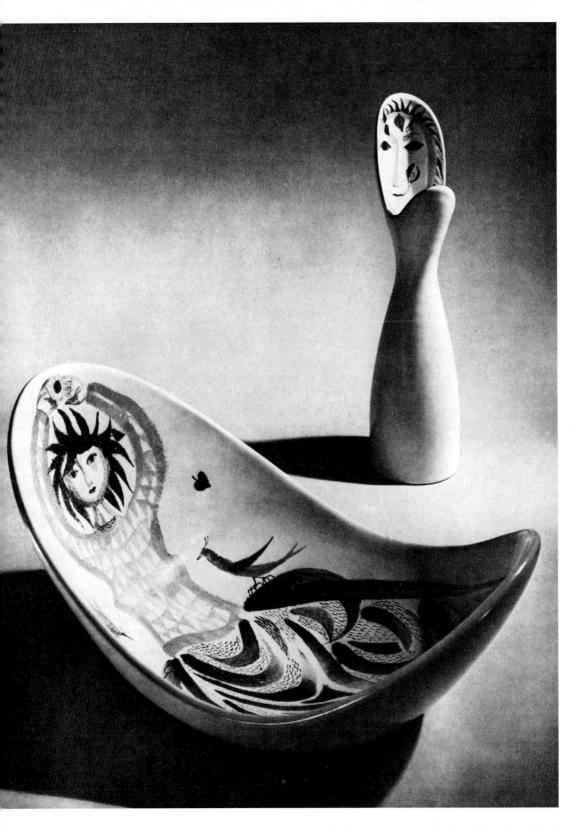

Faience with decorations in green, yellow, blue, red and black on white glaze. Designed and painted by Stig Lindberg. Makers: AB Gustavsbergs Fabriker (SWEDEN)

RIGHT: Grey stoneware with the decoration incised through the glaze. Designers and makers: Edwin and Mary Scheier (USA)

BELOW: The Nest. High relief wall plaque. Designer: Gunnar Nylund. Makers: AB Rörstrands Porslinsfabriker (SWEDEN)

RIGHT: Unique high-fired stoneware. Tall vases of blanc de chine, and small vase with black-brown iron glaze. Designer: Carl Harry Stålhane. Makers: AB Rörstrands Porslinsfabriker (SWEDEN)

Small green and grey pottery vases designed to hold orchids. Designer and maker: Käte Weinreis (GERMANY)

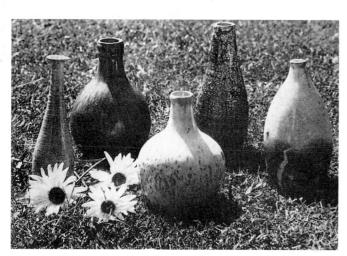

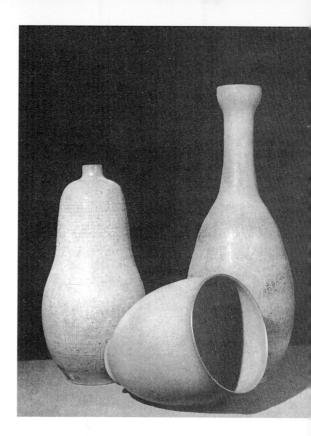

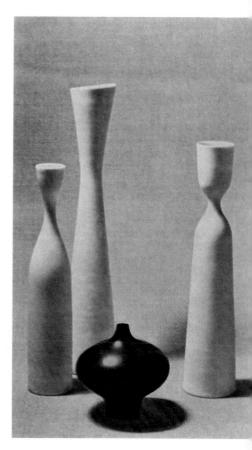

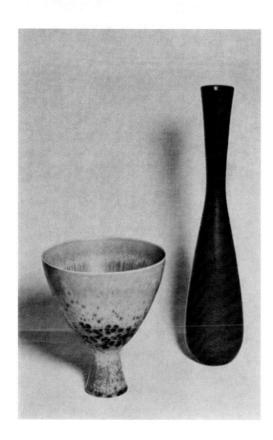

LEFT: Unique high-fired stoneware. Bowl with uranium yellow glaze and black crystals; vase with black-brown iron glaze. Designer: Carl Harry Stålhane. Makers: AB Rörstrands Porslinsfabriker (SWEDEN)

BELOW: Stoneware bottles, six inches high. Left: black glaze on buff body; right: cobalt blue glaze breaking to black. Designer and maker: Christopher Russell at the Purbeck Pottery (GB)

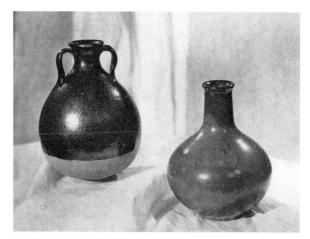

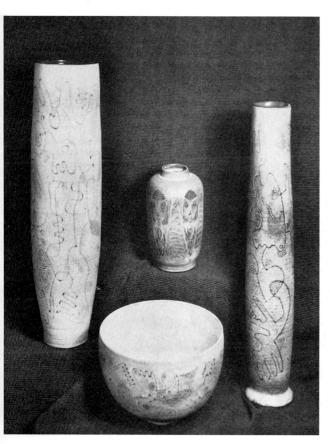

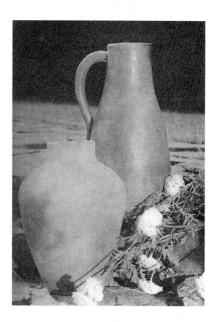

Blue-green and grey floor vases. Designer and maker: Käte Weinreis (GERMANY)

LEFT: Grey earthenware vases and bowl, and blue lamp base, all with the design incised through the glaze. Designers and makers: Edwin and Mary Scheier (USA)

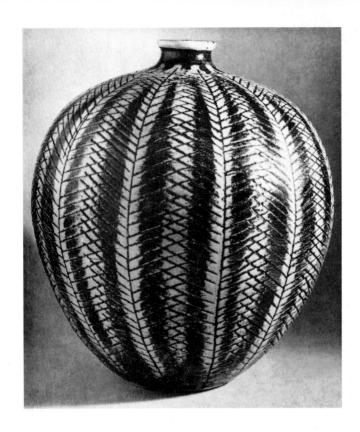

Grey stoneware vase with black decoration. Designer and maker: Anders Liljefors of AB Gustavsberg Fabriker (SWEDEN)

Sagoland. Plate from a nursery set in earthenware with blue underglaze decoration. Designer: Stig Lindberg. Makers: AB Gustavsberg Fabriker (SWEDEN)

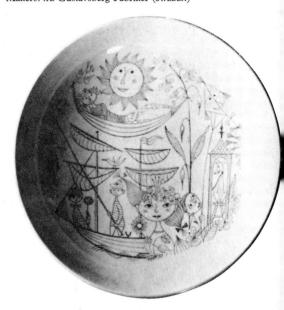

Bowl of white feldspar porcelain decorated in the filigree technique. Designer: Maria Hackman-Dahlén. Makers: AB Rörstrands Porslinsfabriker (SWEDEN)

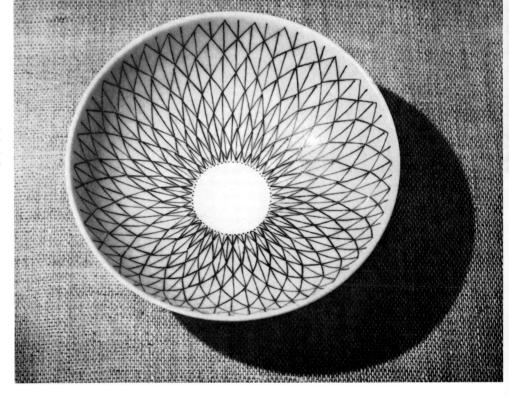

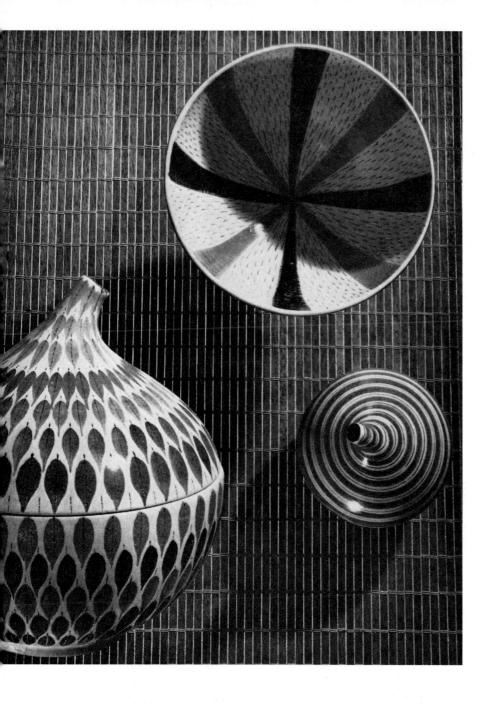

Faience bowl and vases with polychrome decoration. Designer: Stig Lindberg. Makers: AB Gustavsberg Fabriker (SWEDEN)

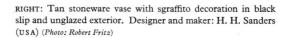

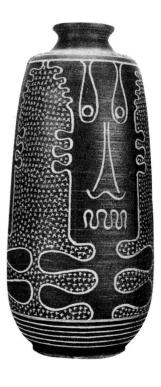

Unique stoneware. Group of three miniatures designed by Gunnar Nylund. Coral vase with red iron glaze, and Ciel Noir vase, 'uranium' with silver spots, by Carl Harry Stålhane. Bowl with onion decoration by Hertha Bengtson. Makers: AB Rörstrands Porslinsfabriker (SWEDEN) (Courtesy: Svenska Hem)

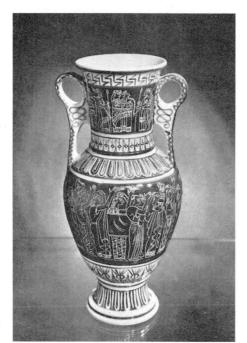

Stoneware vase with celadon glaze. Designer and maker: Christopher Russell at the Purbeck Pottery (GB)

Grecian style vase with sgraffito lecoration through olive-green to he cream body, 15 inches high. Designer and maker: Christopher tussell at the Purbeck Pottery (GB)

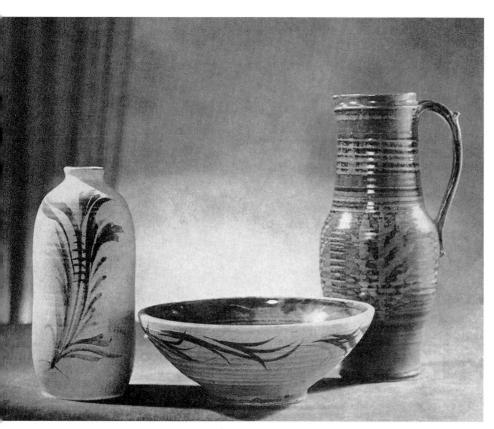

Matt white pot, bowl with rust brown glaze inside, and jug with dark celadon glaze, all with iron brushwork decoration. Stoneware designed and made by William Ruscoe (GB)

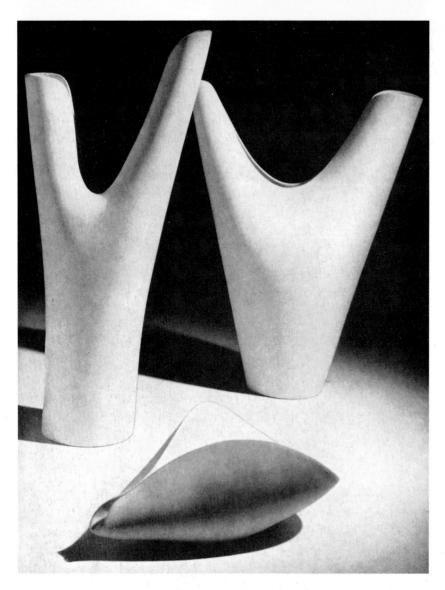

Veckla. White stoneware in which the basically symmetrical form is given a free shape by cutting and turning in the top edges. The tall vases are suitable for pouring through either 'branch' while offering a comfortable hold. Designer: Stig Lindberg. Makers: AB Gustavsberg Fabriker (SWEDEN)

BELOW: Thrown and cut earthenware bowls with grey-green opaque glaze. Designer and maker: K. I. C. Clark (GB)

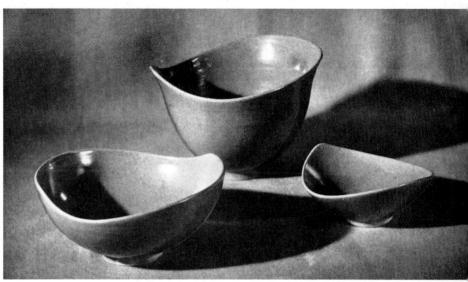

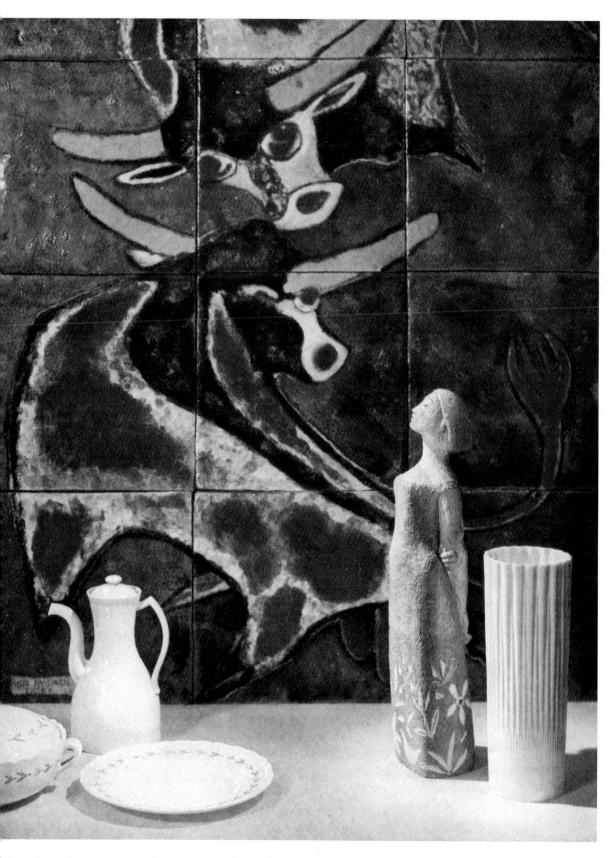

White china coffee pot, and part of an earthenware dinner service designed by Arthur Percy; ceramic figure by Mari Simmulson; and white china vase by S. E. Skawonius backed by ceramic tiles by T. Kaasinen. All made by Upsala Ekeby AB (SWEDEN) (Courtesy: Svenska Hem)

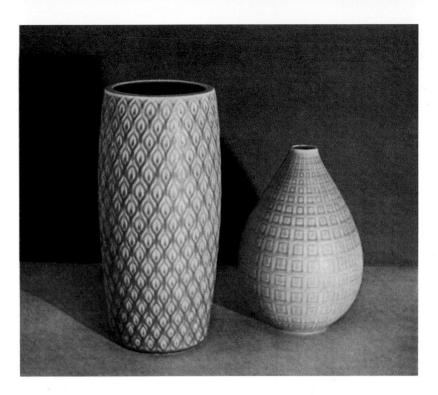

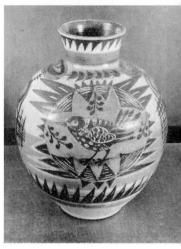

ABOVE: Hard earthenware pot, ochre groundecorated in black-and-white slip and coppe and iron oxides. Designer and makes Honorah M. French (GB)

ABOVE: Earthenware vases from the new Marselis range made in a variety of different coloured glazes with incised decoration. Designer: Nils Thorsson. Makers: The Royal Copenhagen Porcelain Factory (DENMARK)

RIGHT: Earthenware vase and shallow bowl; grey, black and white, with sgraffito decoration. Designer and maker: Marianne de Trey (GB)

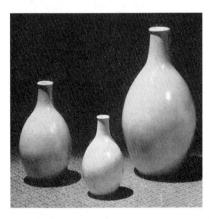

ABOVE: Carafes in fine earthenware, hand thrown and finished with semi-matt egg-shell glazes. Colours include mushroom, sepia, magnolia white, ice green, mist blue. Shapes designed by Poole Design Unit. Makers: Carter, Stabler & Adams Ltd (GB)

High-fired hand-thrown porcelain bowl, 14 inches diameter and pitcher 20 inches high, finished grey-white matt and reduction glazes. Small brown stoneware bowl in centre. Designer: Meindert Zaalberg. Makers: Potterij Zaalberg (HOLLAND) (Photo: A. Dingjan)

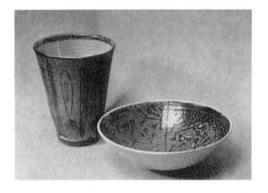

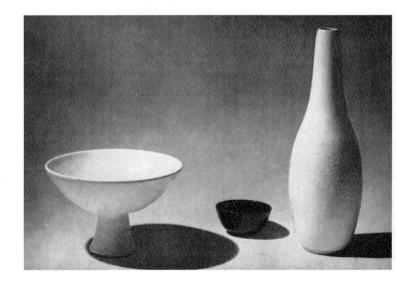

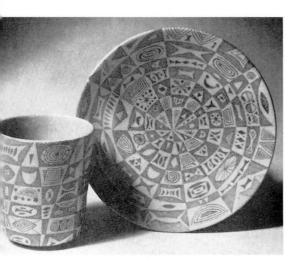

Fantasia. 2½-inch diameter cigarette cup and 4¾-inch diameter ashtray decorated copper - plate printing on light grey body in red and green. Designer of shape: Jacob E. Bang. Decoration: Paul Hoyrup. Makers: Nymolle Ceramic Works, a/s Rafa (DENMARK)

RIGHT: Black and silver lacquered vase, 9 inches high. Designer and maker: Mitsusuke Tsuji (JAPAN)

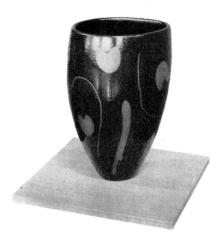

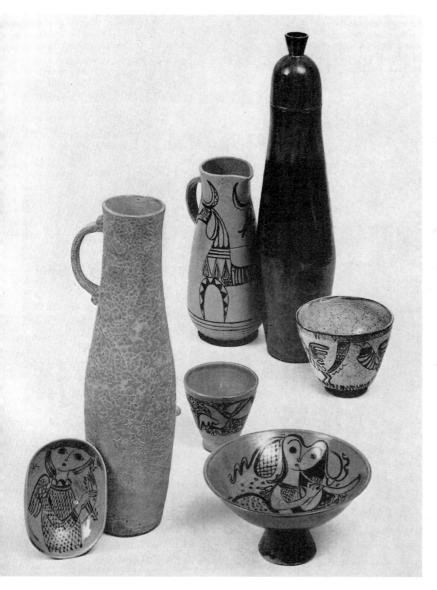

LEFT: Hand-thrown glazed stoneware pitchers and bowls. Red or white body decorated majolica or tin glaze painting or underglaze painting. Designers and makers: Krystyna Sadowska and Konrad Sadowski (CANADA)

BELOW: Italia. Vase 9¼ inches high decorated with copper-plate printing on light grey body in red, green or brown. Designer of shape: Jacob E. Bang. Decoration: Paul Høyrup. Makers: Nymolle Ceramic Works, A/S Rafa (DENMARK)

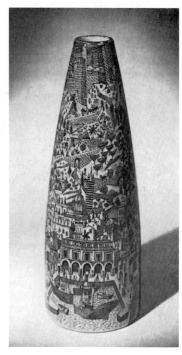

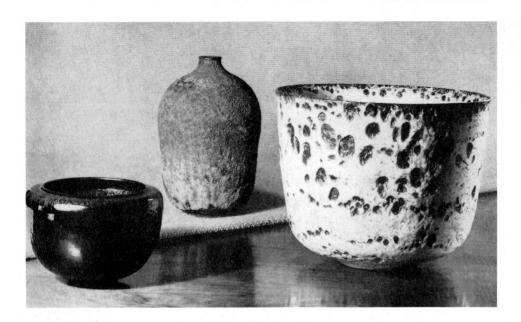

Hand-thrown ceramics (left) iron glaze, (centre) with sulf lava glaze, and (right) with bl and-white crater glaze. Desig and makers: Gertrud and (Natzler (USA) (Courtesy: Dalzell field Galleries)

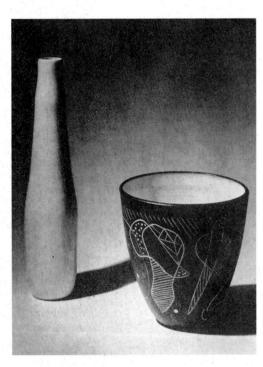

ABOVE: High-fired hand-thrown porcelain vase, 20 inches high, with grey-white ash finish; unglazed black stone-ware vase, 10 inches high, with white sgraffito decoration. Designer: Meindert Zaalberg. Makers: Potterij Zaalberg (HOLLAND) (Photo: A. Dingjan)

RIGHT: Hand-thrown clay vases baked to 1,000°C resulting in a grey bark-like effect. Three are glazed with a transparent syrup-brown glaze, while the fourth is covered with a transparent glaze over a light blue angobe. Designer and maker: Grete Möller (SWEDEN)

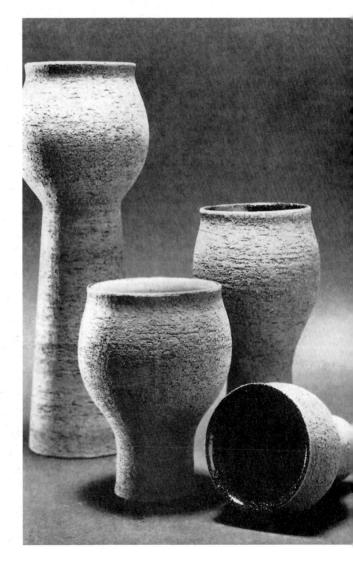

DVE: Pottery vase, approximately 10½ hes high, lacquered yellow, with coration in black lacquer. Designer d maker: Mitsusuke Tsuji (JAPAN)

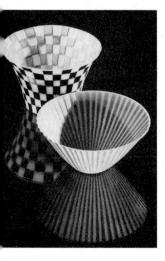

gg-shell-thin' china bowls in white d white-and-dark-blue chequer-board sign. Designer: Anne Sümes. Makers: 'ärtsilä-koncernen AB Arabia (FIN-ND)

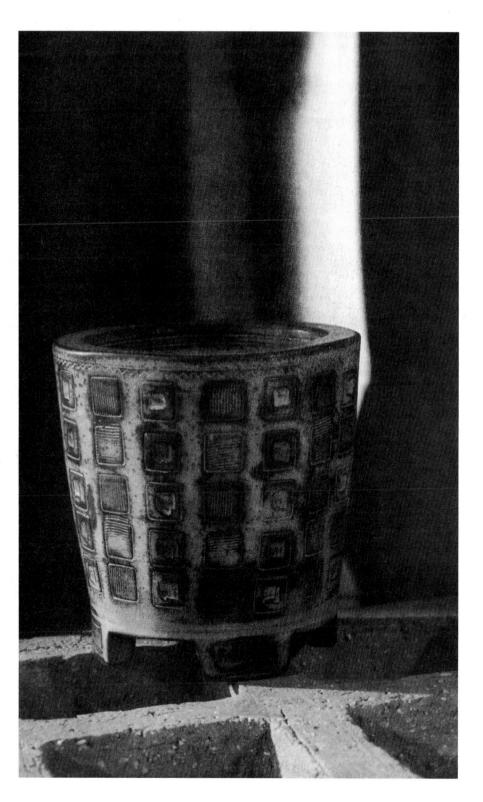

Unique multicoloured stoneware bowls, hand-painted decoration under transparent lead glaze. Round bowls 6–7 inches diameter, fishbowl 12 inches long. Designer: Hertha Bengtson. Makers: AB Rörstrands Porslinsfabriker (SWEDEN)

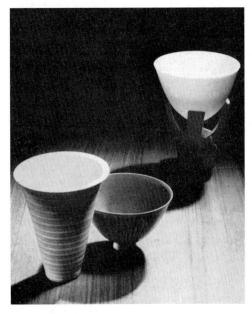

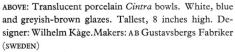

RIGHT: Black clay vase and bottle-vase, decorated bluegreen angobe; light blue slipware plate, hand-painted decoration in black. All fired to 1000°C; transparent lead glaze. Designer and maker: Tom Möller (SWEDEN)

Beaten gold lacquerware. Makers: Technical Division, Industrial Arts Institute, Tokyo (JAPAN)

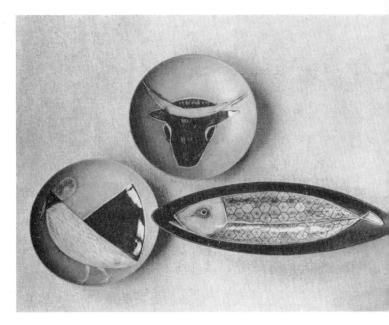

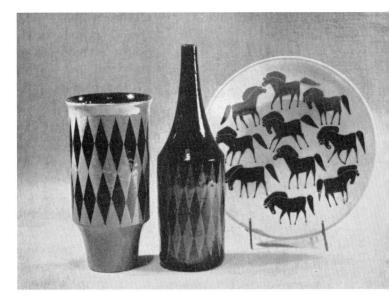

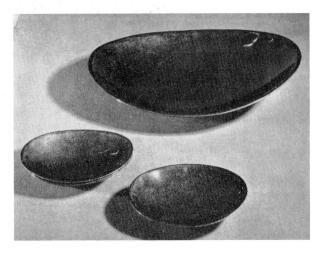

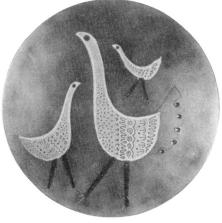

10-inch plate, enamel copper. Birds pale op blue decorated black gold, on golden-bitransparent base. Desi and maker: Fran Desrochers - Dre (CANADA) (Photo: Omer Pl.)

ow: Pottery jug and mugs in green, stone-black and blue glazes, and white-glazed combined fruit dish and dle-holder with on-glaze dull green decoration. Designer maker: Marciano A. Longarini (ARGENTINA)

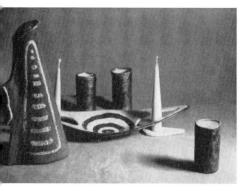

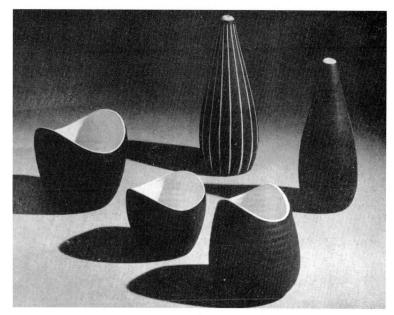

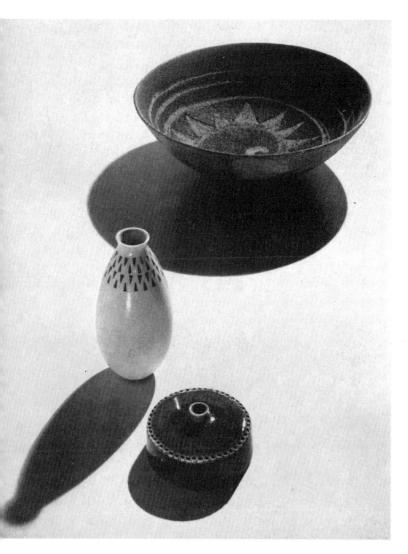

ABOVE: Tigo Ware in black/white. Transparent glaze, slip decorated with matt finish. Background: Tok (Marrow), Retek (Radish); Foreground: Harcsa (Carp), Csuka (Bream), Fogas (Whiting). Designer: Tibor Reich, FSIA. Prototypes developed in cooperation with Gordon Burley at Alderminster Pottery (GB) (Photo: Council of Industrial Design)

Stoneware in brown, blue and white glazes, with incised decoration. Designer: Karin Bjorqvist. Makers: AB Gustavsbergs Fabriker (SWEDEN)

BELOW: Vases in grey grogg-clay, fired to 1000°C, transparent glaze. Interior decorated blue and brown angobe. Designer and maker: Grete Möller (SWEDEN)

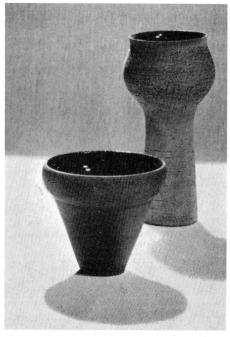

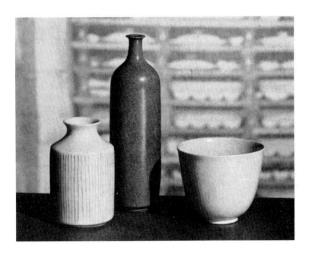

Stoneware wine pitcher, celad glaze. Height 18 inche Designer: Hans H. Hanse Makers: The Royal Copenhag Porcelain Co. Ltd (DENMARK)

ABOVE: Stoneware vases in greybrown and grey-white glazes. Designer: John Andersson. Makers: Andersson & Johansson AB (SWEDEN)

Stoneware vase, $7\frac{1}{2}$ inches high, 'rabbit pelt' glaze, and miniatures (one-of-a-kind), in charcoal black, matt white, and blue, green and brown glazes. Designer: Gunnar Nylund. Makers: AB Rörstrands Porslinsfabriker (SWEDEN)

Stoneware covered jar, and bowl, redbrown glaze, with design scratched through slip. Designed and made by Edwin and Mary Scheier (USA)

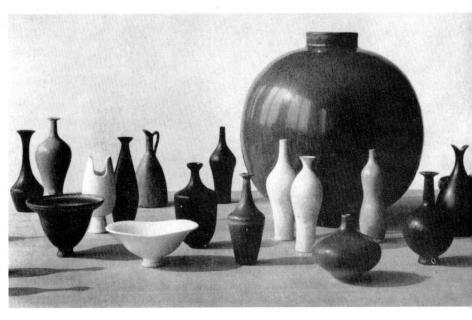

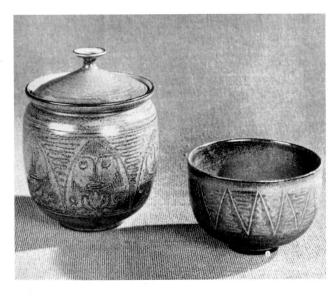

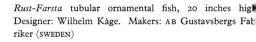

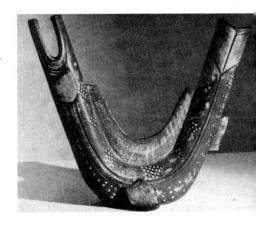

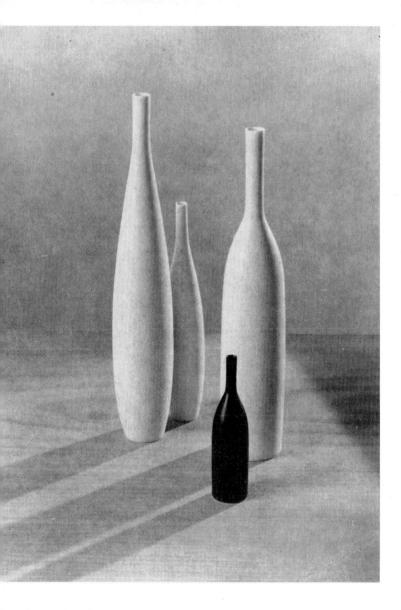

Stoneware vases in charcoal black and matt white glazes (one-of-a-kind). The tallest is 16 inches high. Designer: Carl-Harry Stålhane. Makers: AB Rörstrands Porslinsfabriker (SWEDEN)

Unique stoneware in turquoise, brown, and yellow glazes. Designed and made by Stig Lindberg (SWEDEN)

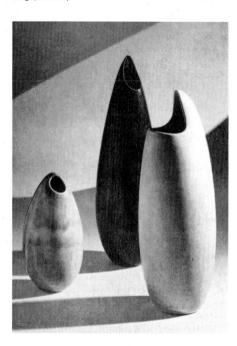

Low: Grey earthenware bowls with exterior decoration scratched through the ze to the body. Designed and made by Edwin and Mary Scheier (USA). HT: Clay vase 12 or 16 inches. Grey/white, turquoise or black. Designer: uno Platten. Makers: Tonwarenfabrik-Aedermannsdorf AG (SWITZERLAND)

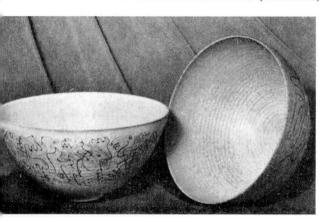

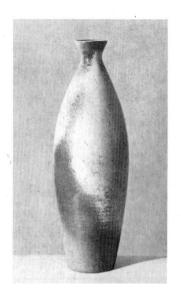

In addition to the balance and harmony of their shapes, ceramics derive so much of their beauty from the combined effects of glaze, decoration and texture that the ceramic artist enjoys an immense field of research and a reward proportionate to the manner in which he makes use of it.

That research should never lose sight of the tradition from which the craft grows is, however, an axiom particularly of ceramic art, which maintains closer contact between hand and material, during the making, than any other craft and is therefore one of the most satisfying.

And yet the many exquisite pieces shown here are not only of the past, in the sense of exhibiting the best traditions of a centuries-old medium, but are at the same time vital expressions of our age in which new techniques and new conceptions add their contributions to the perpetual growth of ceramic art.

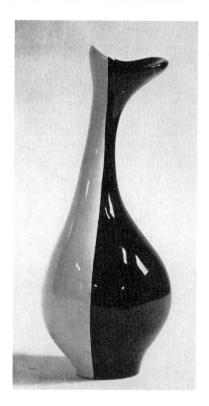

ABOVE: Earthenware vase in two colours designed by Maria Campi. For Società Ceramica Italiana (Italy). BELOW: Vases and candlesticks in matt black glaze, and in white glaze with dark blue decoration. Vases range in size from $6\frac{1}{2}$ to 10 inches. Designer: John Andersson. Makers: Andersson & Johansson AB (SWEDEN)

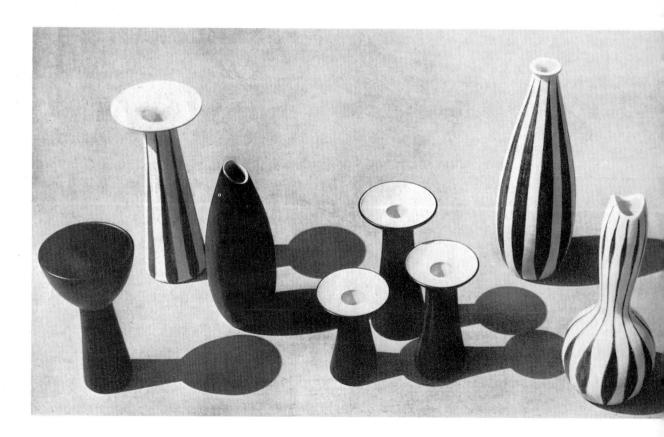

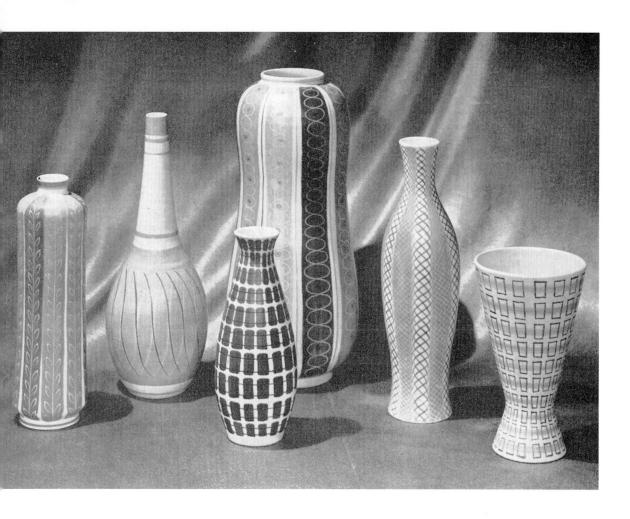

ABOVE: Earthenware Vases. In-glaze decoration on matt white glaze. Black/white motifs on Purbeck grey/lupin blue/bracken brown, or charcoal/tropic turquoise/grey stripes. Others grey/yellow or charcoal/terra-cotta bands. $5\frac{1}{2}$ –17 inches high. Shapes designed by A. B. Read, Lucien Myers and Guy Sydenham. Decorations by A. B. Read, RDI, ARCA. Makers: Carter, Stabler & Adams Ltd (GB). RIGHT: Black/white glazes. Vases $19\frac{1}{2}$ and 13 inches, dish $16\frac{3}{4}$ inches long. Designer: Arthur Percy. Makers: Upsala-Ekeby Group (SWEDEN). BELOW: Ivory body, black underglaze decoration. 7 and 11 inches. Designer and maker: Z. D. Kujundzic (SCOTLAND)

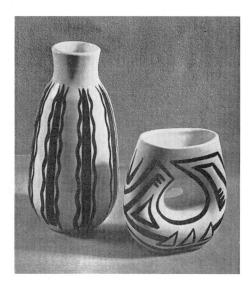

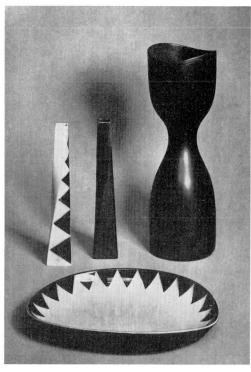

Earthenware vases. RIGHT: White glaze, decoration in black/violet and black/pink; height 22 inches. Designed and decorated by Antonia Campi. For Società Ceramica Italiana (ITALY). BeLow: Decoration in dark blue on white glaze; tallest vase 23 inches. Designed by John Andersson. Made by Andersson & Johansson AB (SWEDEN)

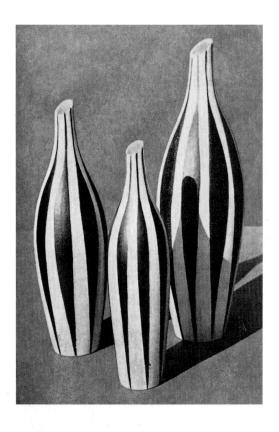

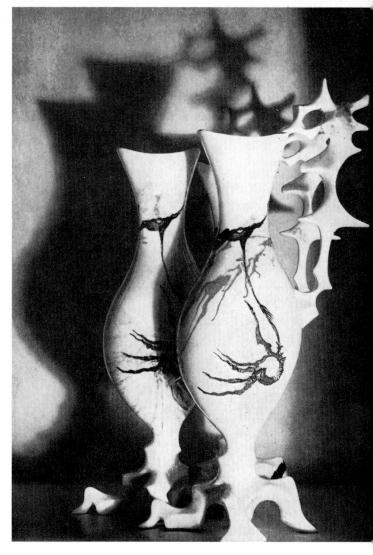

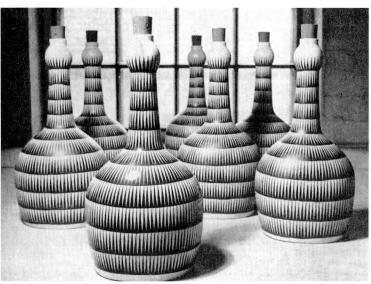

LEFT: Black-and-white striped earthenware bottles, 14 inches high, with red-lacquered cork stoppers. Designe by Orvokki Laine. Made by Kupittaan Saviosakeytic Turku (FINLAND). BELOW: White porcelain vase wit bluish-black decoration under transparent glaze; heigh 9 inches. Designed by Erik Reiff. Made by Bing 4 Grøndahls Porcellænsfabrik (DENMARK)

Earthenware lamp base, grey crystalline glaze; 21 inches high. Designed and made by Guido Andlowiz. For Società Ceramica Italiana (ITALY)

Terra-cotta water jugs, bottle, vase and pitcher, hand decorated, in copper, manganese, cobalt oxides, and raw umber glazes on tin glaze base. 12 to $16\frac{1}{2}$ inches high. Designed and made by Krystyna and Konrad Sadowski (CANADA)

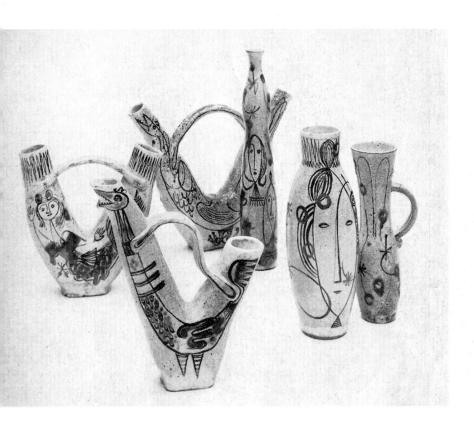

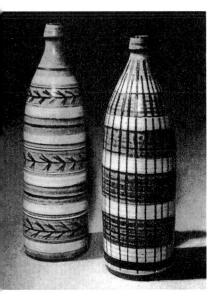

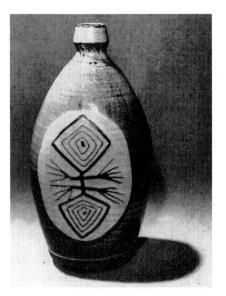

ABOVE: Stoneware bottle, with brushwork decoration in brown pigment on an oatmeal ground. Height: 15 inches. Designed and made by Bernard Leach (GB)

FAR LEFT: Earthenware bottles, 12 inches high; black, grey and white sgraffito through black slip and white glaze. LEFT: 9-inch bottle flattened both sides, pattern scratched through glaze; grey, white and brown. All designed and made by Marianne de Trey (GB)

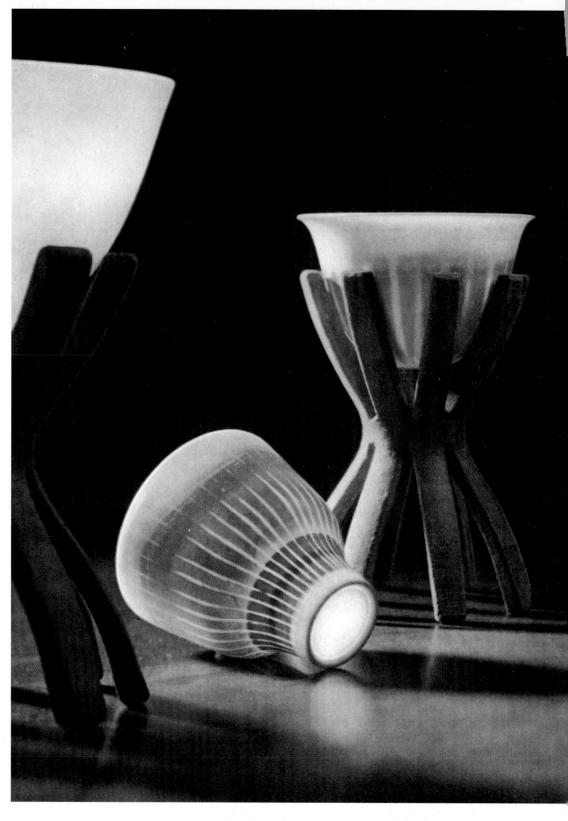

Translucent porcelain *Cintra* bowls on chamotte mount. Designed and made b Wilhelm Kåge. For AB Gustavsbergs Fabriker (SWEDEN)

BOVE: Stoneware salad bowl with white feldspathic glaze and sgraffito ecoration. White on mottled brown ground. Diameter 11 $\frac{3}{4}$ inches. esigned and made by Irwin Hoyland (GB) (Photo: David Galloway)

GHT: High-fired stoneware vases, *Solfatara* uranium yellow glaze. 8 and 7 inches high. Designed by Axel Salto. Made by The Royal Copenhagen orcelain Factory (DENMARK)

ELOW (left and right): High-fired stoneware vases, Solfatara uranium ellow glaze. Height 15 inches; (centre) oxidised-fired vase, iron oxide rystal glaze. Height 14 inches. Designed by Axel Salto. Made by The oyal Copenhagen Porcelain Factory (DENMARK)

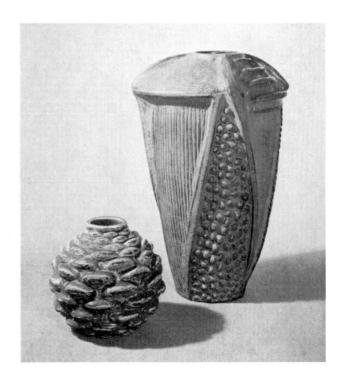

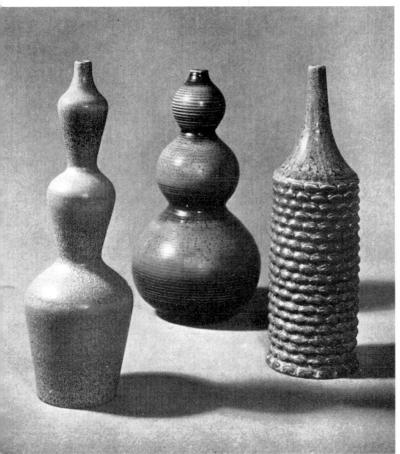

BELOW: Stoneware vase, Sung glaze. Height 17 inches. Designed by Axel Salto. Made by The Royal Copenhagen Porcelain Factory (DENMARK)

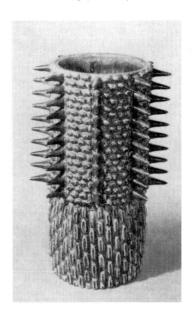

As in the case of glass, the ceramic artist needs to be something of a chemist; probably more so, for the shaping of a bowl, however pleasurable an exercise, is merely a preliminary to the firing and glazing which transforms it from meekness to magnificence.

It is said that organic chemistry knows no boundaries, whereas inorganic, which is the potter's chemistry, has definite limitations. Nevertheless, its applications to ceramic art are proved each year to be capable of extension, and the potter's repertoire continues to grow as his experiments with glazing and firing enlarge the scope of his knowledge and experience.

Within the framework of decorated eramics two schools of thought and practice emerge; the one which seeks absolute control of decorative effect and the other which grants a certain licence to the forces of nature and evokes results which are not entirely predictable. It is not feasible to set one against the other. Both have their respective merits and there is no compulsion, other than personal preference and a sense of appropriateness, to be persuaded either way. Examples of both schools are illustrated as well as those exhibiting a preponderance for form in which the eloquence of the glaze is used to underline shape rather than as supplementary decoration.

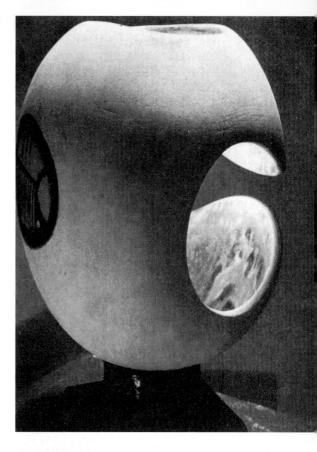

ABOVE: White earthenware table lamp clay-brown angobe decoration, interio turquoise enamel. Designed and madby José Maria Lanús (ARGENTINA)

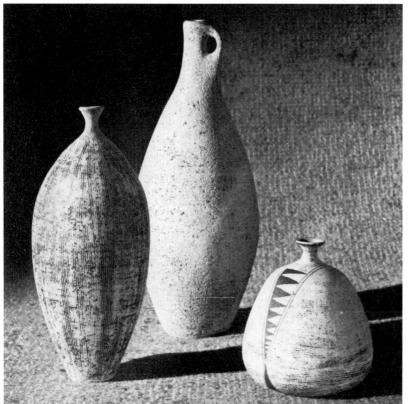

ABOVE: Stoneware bowl, 8-inches dia meter. Exterior unglazed with incruste white slip decoration; interior dark brown glaze. Designed and made by Edgar Böckman (SWEDEN)

LEFT: Unglazed stoneware vases; sgraffito, and iron oxide decoration. Centre vase 15 inches high. Designed and made by Waistel Cooper. For Heal's o London (GB)

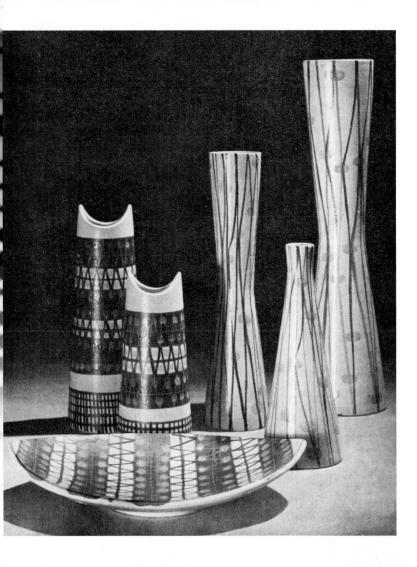

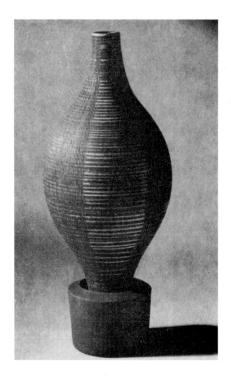

ABOVE: Unglazed red-brown *Terra-Farsta* stoneware vase. Height 13½ inches. Designed and made by Wilhelm Kåge. For AB Gustavsbergs Fabriker (SWEDEN)

ABOVE: Earthenware group. White glaze, banded decoration in blue, grey and yellow; linear in grey and turquoise. Vases from $7\frac{5}{8}$ to 16 inches high; dish 11½ inches. Designer: Mari Simmulson. Makers: The Upsala-Ekeby Group, Ekebybruk (SWEDEN). RIGHT: Stoneware vase, $7\frac{3}{4}$ inches diameter. Outside unglazed, inside green glaze. Designed and made by Lisa Larson. For AB Gustavsbergs Fabriker (SWEDEN). BELOW: Earthenware bowl and 8-inch modelled vase with copper oxide green decoration on oatmeal semi-matt glaze. Designed and made by Z. D. Kujundzic (GB)

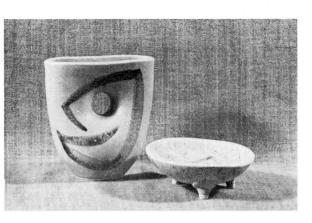

ABOVE: Earthenware vase, scored decoration on fused manganese and turquoise blue ground; height 16 inches. Designed and made by G. F. Cook (GB)

ABOVE: Earthenware fruit bowl, wax-resist decoration in blue, green, yellow and brown under white tin glaze; diameter 11 inches. Designed by Eileen Lewenstein. Made at Briglin Pottery Ltd (GB)

ABOVE: One-of-a-kind stoneware vases and bowl from the *Magnific* series designed by Carl-Harry Stålhane. Made by AB Rörstrands Porslinsfabriker (sweden)

Below: Stoneware bowls, rich brown mottled glaze; diameter $9\frac{1}{2}$ inches. Designer: Francesca Lindh. Made by o/y Wärtsilä-concern ab Arabia (FINLAND)

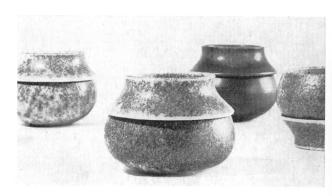

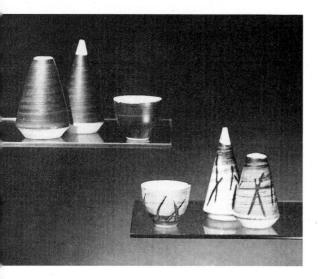

LEFT: Condiment sets in earthenware, wax-resist decoration combined with tin glaze. Designed by George Dear. Made at Briglin Pottery Ltd (GB)

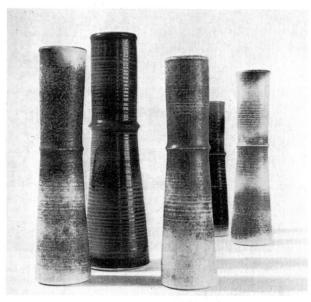

ABOVE: Stoneware vases, dark brown mottled glaze; height 12 inches. Designer: Richard Lindh. Made by 0/Y Wärtsilä-concern AB Arabia (FINLAND)

BELOW: Earthenware bottle vase, applied and scratched decoration on a grey matt glaze; height 37 inches. Small stoneware pot, yellow and brown matt glaze. Designed and made by Edwin and Mary Scheier (USA)

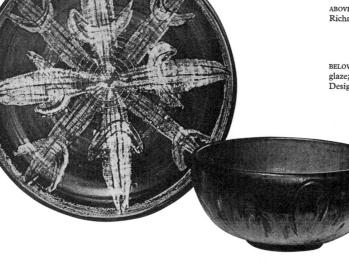

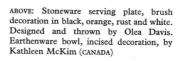

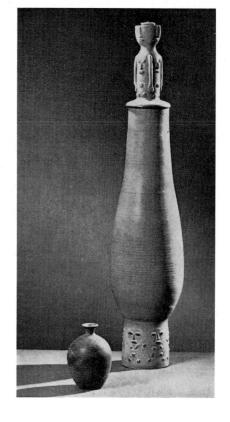

LEFT: White porcelain branch vase with fine scalloped rim; height 9 inches. Designer: Tapio Wirkkala (FINLAND). Made by Rosenthal-Porzellan AG (GERMANY)

Dark brown stoneware bowl, scratched exterior decoration, inside turquoise blue glaze. Diameter 19 inches. Designer: Nils Kähler. Made by A/S Herman A. Kähler (DENMARK)

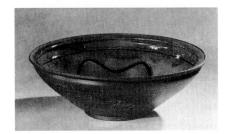

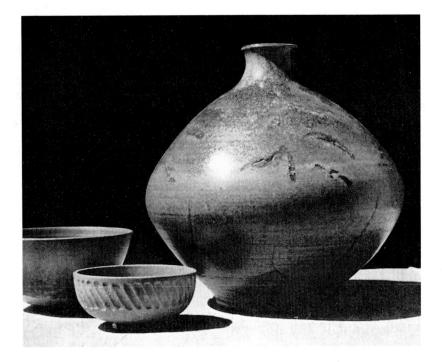

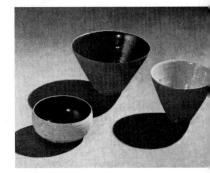

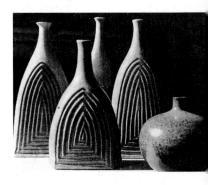

TOP: Stoneware, one-of-a-kind; unglazed wholem outside. Beakers, rich sienna temmoku and cre Bristol glaze inside; dish, black temmoku. 4, 6, 4 4j-inch diameter. Designed and made by Mun Fieldhouse at Pendley Pottery (GB). ABOVE: Stonew bottle jars, about 12 inches high, blue, green a uranium glazes, cut decoration; pot, yellow-brow Designed and made by Finn Lynggaard (DENMAR)

ABOVE: Stoneware group. Jar, 11 inches high, waxresist decoration under green-brown glaze; centre bowl, yellow-green uranium glaze; left-hand bowl, black-red ironglaze. Designed and made by Finn Lynggaard (DENMARK)

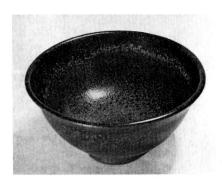

ABOVE: Stoneware bowl, olive-green and silver-grey speckled glaze. Diameter 6 inches. Designed and made by F. G. Cooper, MSIA (GB)

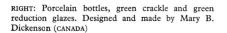

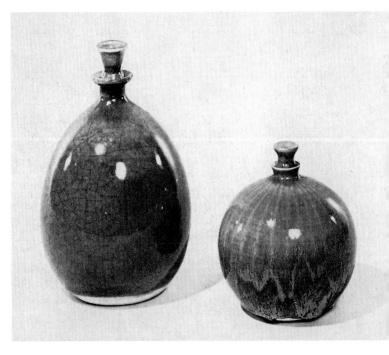

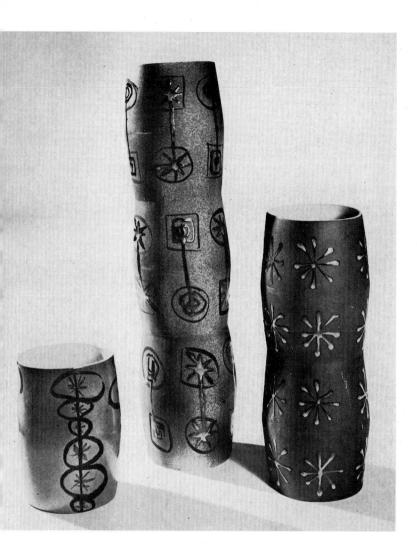

BELOW: Hand-thrown earthenware vase, green crystalline glaze. 14 inches. Designed and made by Gertrud and Otto Natzler (USA)

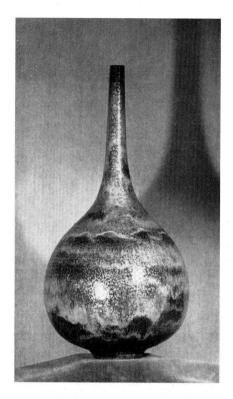

LEFT: High-fired stoneware barrel vases, decorated black slip with white snowflake pattern, or deep turquoise with figure '88'; interior white. 8½, 26, and 16½ inches. Designed by David Gil. Made at Bennington Pottery. For Raymor (USA)

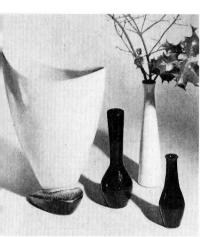

OVE: Denby Asphodel earthenware vases; oyster, endip brown, lime-green and glossy black glazes. to 12 inches. Designer: Kenneth Clark. Makers: seph Bourne & Son, Ltd (GB)
GHT (left to right): Stoneware bottle, green glaze, by

(B) (GHT (left to right): Stoneware bottle, green glaze, by bil Laubenthal; earthenware branch vase, iron stome pebble glaze, by Alma and Ernst Lorenzen; neware vase, salt glaze, by Dorothy Dodman (ANADA)

Coventry University

ABOVE: Earthenware vase, white feldspathic glaze inside, sgraffito exterior decoration through black to white; about $8\frac{1}{2}$ inches. Below: Cylindrical plant container, sgraffito exterior decoration in mushroom and deep brown; about $6\frac{1}{2}$ inches. Both are designed and made by Irwin Hoyland (GB)

BELOW: Earthenware bottles and deep bowl, oxide exterior decoration on the raw body, interior white tin glaze; centre bottle 11 inches high, bowl $6\frac{1}{2}$ inches. Designed by Eileen Lewenstein. Made at Briglin Pottery Ltd (GB)

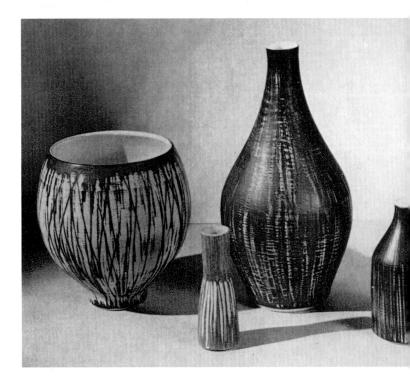

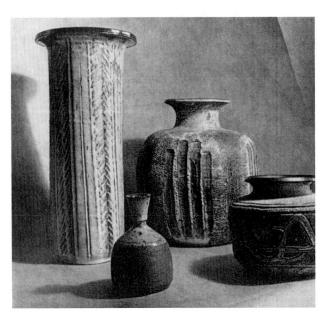

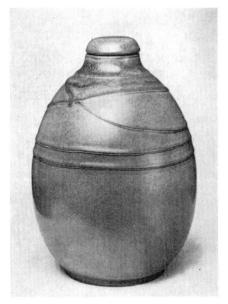

ABOVE: Stoneware vase, brownish glaze and haut-relief decoration; about 12 inches. Designer: Ebbe Sadolin. Made by A/S Bing & Grøndahls Porcelænsfabrik (DENMARK). LEFT: Stoneware, incised and sgraffito decoration: tall vase (22 inches), red and white glaze; bottle, pale blue neck, unglazed dark clay base; large pot, dark grey/blue; small pot, unglazed dark clay, grey glazed decoration. Designed and made by M. Wildenhain (USA)

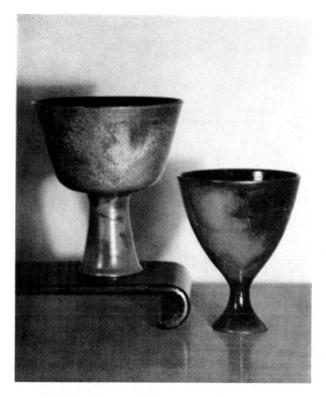

ABOVE: Earthenware chalices, copper reduction glazes. 6 and 5½ inches high. Designed and thrown by Gertrud and Otto Natzler (USA) (Courtesy: Dalzell Hatfield Galleries)

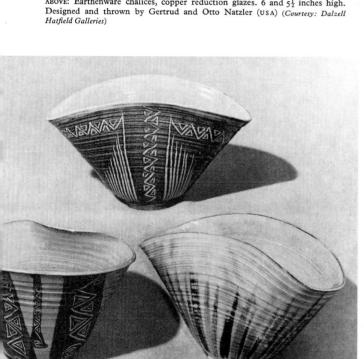

ABOVE: Red clay fan-shaped vases, transparent tin glaze, black slip and sgraffito, or oxide brush decoration. Made in various sizes, centre vase $12 \times 7\frac{1}{2}$ inches. Designed and made by Mary Gibson-Horrocks (GB)

BELOW: Thrown stoneware bowl, applied and scratched decoration in deep blue and brown; height 17 inches. Designed and made by Edwin and Mary Scheier (USA)

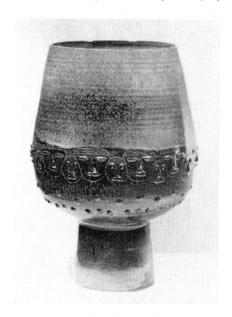

BELOW: Earthenware vases, incised decoration hand-painted in green, orange, yellow and black on mustardbiege body; 11 and 8 inches. Custom-made in Italy for Raymor (USA)

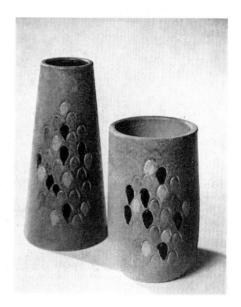

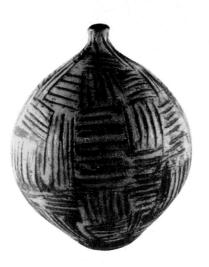

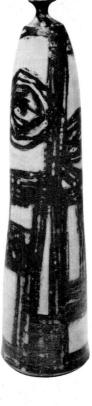

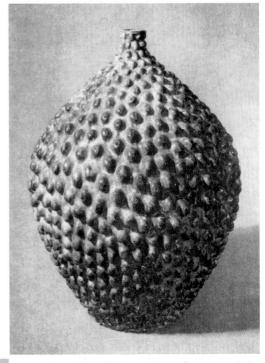

Stoneware vase, *Rutil* blue glaze; 20 inches high. Designed and made by Axel Salto at The Royal Copenhagen Porcelain Manufactory A/S (DENMARK). RIGHT: High-fired raw clay vase, 44 inches high. Designed and made by Meindert Zaalberg at Potterij Zaalberg (HOLLAND)

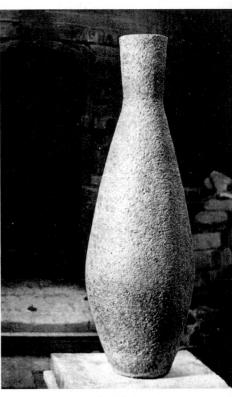

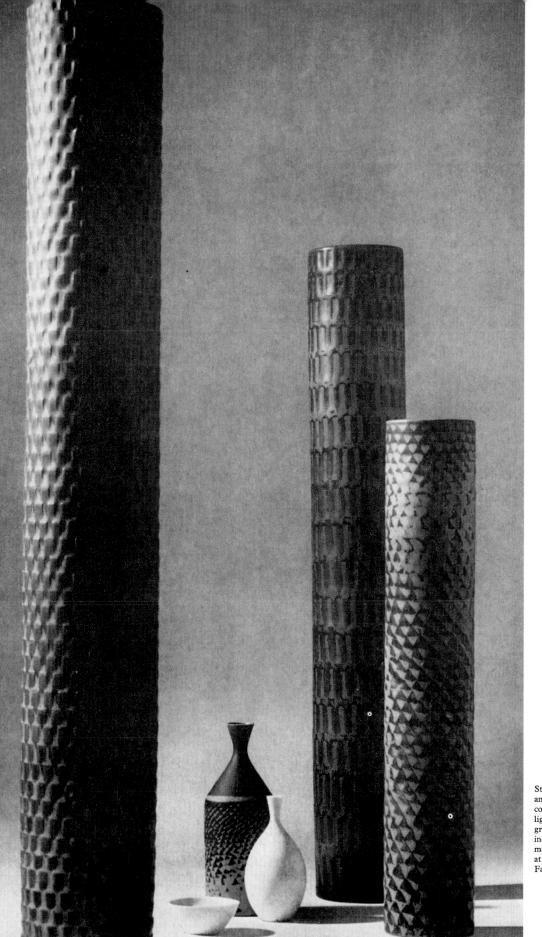

Stoneware miniatures, and tall vases in green copper glazes—from light turquoise to blackgreen; heights, up to 20 inches. Designed and made by Stig Lindberg at AB Gustavsbergs Fabriker (SWEDEN)

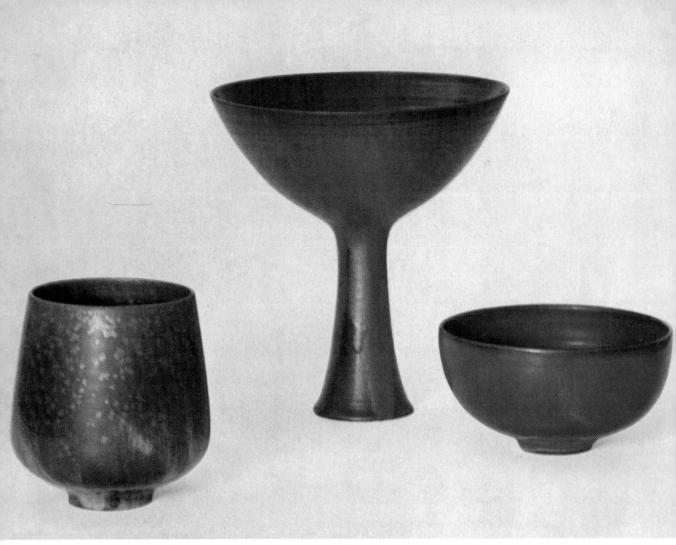

ABOVE: Earthenware vase, green crystal glaze; pedestal bowl, deep red glaze; small bowl, mystic blue glaze. Designed and thrown by Gertrud and Otto Natzler (USA)

(Courtesy: Dalzell Hatfield Galleries)

Earthenware. Wine Jar, matt grey glaze over red body, inside bluish-white tin glaze: height 15 inches; tin-glazed bowl, sgraffito decoration through copper pigment: width 16 inches; storage jar, tin glaze inside with manganese decoration on unglazed body: height 7 inches. All hand-thrown and decorated by P. F. Rushforth, Sydney School of Art (AUSTRALIA)

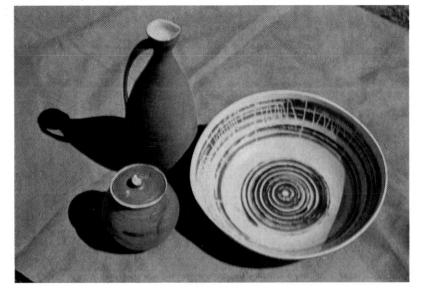

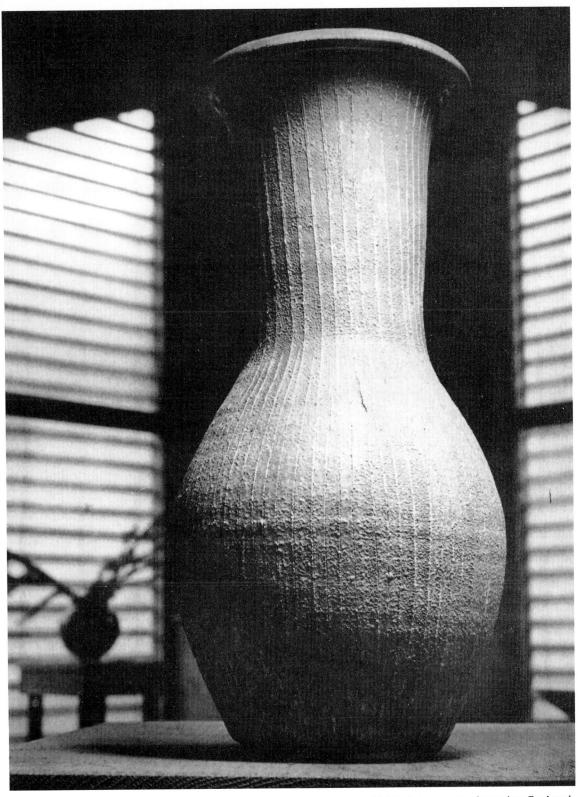

High-fired stoneware vase, decorated sgraffito through dark matt glaze; height 20 inches. Hand-thrown by M. Wildenhain (USA)

INDEX Designers and architects Designer und Architekten Designers et architectes

Abraham, Janine 219, 232 Acking, Carl-Axel 202 Aczel, Susy 432 Adams 158, 234 Adams, John 438, 439, 444, 468 Addison, C. 90 Adler, Ruth 277, 287, 292, 296, 301 Adnet, Jacques 99, 155 Adolfson, Karl-Axel 226 Advance Design Inc. 114, 231 Ahola, Hilkka Liisa 355 Ahrström, Folke 440, 477, 480, 498 Aldhouse, E. R. 399 Altherr, Alfred 179, 212, 407 Ander, Gunnar 361, 380, 494 Andersen, Gunnar Aagaard 171 Andersen, Erik 259 Andersson, John 486, 492, 550, 552, 554 Andlowiz, Guido 410, 555 Andreson, Laura 451 Angerer, Mea 395 Antonsen, C. J. 458 Appleby, Brigitta 501, 502, 509 Arnheim, Lucie 273 Arthur, F. B. 124 Asscher, S. 150 Ateliers Pierre Disderot 406, 408 Atkins, Lloyd 376 Audsley, Ian 125 Augenfeld, Felix 80, 81, 83, 125, 192 Augusztiny, Arpad 105 Austin, Frank 92, 105 Awashima, Masakichi 358, 359, 360

B
Bajo, Dr. Gyula 521
Baliero, H. 172
Ball, F. C. 446
Baly, Edward 230, 242
Bang, Jacob E. 350, 361, 365, 545
Barker, J. Granville 323
Barnicot, J. M. 407, 408, 412
Barnsley, Edward 105
Barovier, Angelo 362
Barovier, Ercole 358, 359, 362
Bartlett, Ivan 280, 281
Bartos, Harold 141
Batelaan, H. 485
Bath Cabinet Makers 184
Baugniet, M. 235

Baumgarten, Paul G. R. 128 Baxter, G. P. 376 Baxter, Geoffrey 357 Beard, Mary 476 Beaudin, G. 479 Belgiojoso, Peressutti & Rogers 225 Belk, W. P. 458 Bellmann, Hans 214, 220, 242 Bender-Madsen, A. 166, 170, 226 Bengtson, Hertha 503, 510, 548 Benham, Mollie 117 Bennett, Noreen F. 268, 270, 279 Bennett, Ward 258 Benney, Gerald 499 Bergh, Elis 315 Berglund, Erik 213 Bergström, Hans 384, 386, 388, 389, 390, 391, 393, 397, 398, 399, 400, 406, 409, 411, 414, 415, 416, 421, 424 Bernadotte, Sigvard 162, 169, 441, 464, 480, 481, 502 Bernard, A. 250 Berndt, Viktor 358, 366, 375 Berrier-Gnazzo 387, 394 Bertoia, Harry 145 Best & Lloyd Ltd. 400, 411, 414 Best, Grace 272 Beverley Pick Associates 404, 408, 416, 419 Bingham, W. J. 395 Biny, Jacques 404, 407 Birnbaum, David 105 Biørn, Acton 485 Bjorquist, Karin 549 Black, Misha 414 Bland, Eva 501 Blomberg, Kjell 352 Bloomfield, Diana 292 Bluitgen, Ib 454, 467, 474 Böckman, Edgar 558 Boissevain, Paul 388, 402 Bolley, John S. (Mrs) 278 Boman, Carl-Johan 87, 105, 116 Boman, Marianne 147, 160 Bongard, Herman 318 Booth & Ledeboer 98, 102, 120, 123 Borg, Olli 220, 222 Boucher, T. J. 475 Boyd, F. W. 138

Bradbery, Ian 187, 196 Bratt, Monica 330, 354, 370, 371 Breger, Bibi 504 Breger, Carl-Arne 284 Brendon, Dorothy 284 Breuer, Marcel 51 **Brice of Auerbach Associates 108** Brisborg, Bertil 385 Brodie, Fred 125 Brook, John 299 Brookes, Ronald E. 508 Brown, Edward Daly 290 Browning, Irene 296 Brüel, Axel 487, 500 Brummer, Arttu 319 Brunn, Peter 100, 110, 133, 140, 392 Brussel, E. J. 134 Buck, Erik 149 Bulow, Karen 295 Bülow-Hübe, Sigrun 208 Burr, Graham 566 Bush, Robin 125 Butterworth, Michael 242

Caillette, René Jean 130, 137, 152, 161, 165, 202, 204 Callwood, R. H. 282 Cameron, Donald 114, 121 Campi, Maria 552, 554 Carter, Truda 397, 465, 478, 502 Carter, W. M. 149 Casson, Hugh 90 Cecil & Presbury 102 Chevalier, Georges 353, 381 Chomentowska, M. 235, 237, 242 Claesson, Kås 513 Clante, Henry 531 Clark, Dorothy 286 Clark, F. G. 195, 475 Clark, Kenneth I. C. 542, 563 Clark, Robert G. 475 Clegg, Christine 288 Clements, Eric G. 202, 461, 471, 475, 481, Clinch, E. L. 94, 115, 123 Close, Helen 176 Cobb, F. 440

Conran, Terence 186, 192, 289, 290, 492

Cobelle, Charles 448

Cohn, Erna 273

Braakman & Dekker 252

Braakman, C. 190, 264

Conran & Company 261 Cook, G. F. 560 Cooke-Yarborough, E. 401, 403 Cooper, Dan 111 Cooper, F. G. 470, 471, 503, 562 Cooper, Susie V. 438, 444, 445, 479 Cooper, Waistel 558 Copier, A. D. 314, 316, 332, 333, 355, 367 Cotton, Peter 147 Craig, J. 286 Craver, Margret 442, 443 Crichton, John 147, 190, 201, 214, 242, 247, 265, 405, 409, 411, 418, 421, 427, 432 Cross, Mellville 283 D'Angelo Reggiori, Sergio 306 Dahl, Birger 424 Dahlén, Märta Maria 280 Dalby, Helen 311 Daum Cristallerie d'Art 405 Daum, Michel 351, 357, 367, 377, 402, 411 Davenport, David 221 David Joel Ltd. 160 Davis, Harry 473, 508 Davis, May 473, 508 Davis, Olea 561 Day, Lucienne 8, 276, 290, 292, 294, 295 Day, Robin 117, 133, 142, 159, 176, 207, 209, 223, 234, 390 De Hart, William 456 De Mey, Jos. 221, 225, 245, 246, 264 De Parcevaux, Yves 247 De Roover, Jul 207, 216 De Snellman-Jaderholm, G. L. 316, 320, 387, 395, 397, 505, 512 De Tonnancour, Jacques 109 De Trey, Marianne 386, 447, 448, 450, 544, 555 Dean, Ethel 293 Dear, George 561 Decker, Heinz 502 Deskey, Donald 97 Desrochers-Drol, Françoise 548 Desville 311 Dickenson, Mary B. 562 Ditzel, Jørgen 156, 157, 219, 221, 222 Ditzel, Nanna 156, 157, 219, 221, 222 Dodman, Dorothy 563 Döhler, P. 95 Dollemore, Brian 256 Dorosz, C. 154 Downie, L. McDonald 66 Draper, Peter 490 **Drew**, Jane 116, 128 Dreyfuss, Hugo 135, 169, 170, 173, 224, 534 Duckworth, Aidron 219 **Dumond**, Jacques 97, 100, 122, 144, 191, 206, 217 Duncan, Mary W. 496 Dunn, Constance 523 Dunn, Geoffrey 94, 115, 117, 167, 393 **Durkin**, Hilda 297, 299 Durussel, Bernard 88, 96

Ε E. Gomme Ltd. 192 E. Khan & Co. 175 Eames, Charles 16, 17, 53, 106, 135, 151, 157, 191 Eberle, G. 199 Edson Crafts 222, 223 Edwards, Arthur 131 Eisler, Martin 55, 100, 257, 432 Ekselius, Karl Erik 173, 205 Ekström, Yngve 146, 156, 157, 173, 185, 200, 203, 251 Elnegaard, Poul 171 Engö, Björn 256, 260 Engström, Sven 148, 182 Enström, Nils 99, 105, 116 Ercolani, L. R. 184, 192, 226 Erhard, Åge 459 Erickson, Carl E. 346 Eriksen, Gutte 450 Erkers, Arne 442, 469, 476, 477, 488 Erland, John 395 Ers. Vanderborght Frères 249 Evans, Bill 113

Duszniak, D. 503

Dybowska, D. 309

Eves, A. J. 154, 404 Fabry, Erno 117 Fagerlund, Carl 429 Falk, Lars-Erik 287 Fazakas, Donelda 43 Fieldhouse, Murray 470, 483, 562 Fini, Leonor 100 Fischer-Treyden, Else 503 Fisker, Marianne 283 Fitton, Roger 213, 228 Fleming, Erik 442 Fogelberg, Sven 370 Fontana Arte 210, 412, 415, 418, 419 Fornasetti, Piero 23 Forsberg, Ann-Mari 303 Forssell, Pierre 513 France & Daverkosen 164 Franck, Kaj 350, 373 Frank, Josef 130, 191, 196, 206, 268, 274, 280 Frankl, Paul T. 95, 100, 101, 105, 127 Frattini, Gianfranco 198, 199, 250 Fredin-Fredholm, Maud 269, 273 Freedgood, Martin 100 French, Honorah M. 544 Frey, W. 210 Fridhagen, Bertil 105, 116, 139, 162, 174, 199, 238, 245 Fry, Maxwell 116, 128 Fryklund, Erik 213 Funk, Geraldine 118

G Gangkofner, A. F. 423, 424 Gardberg, Bertel 485, 498, 506, 507 Gariboldi, Giovanni 493 Gascoin, Marcel 134 Gate, Simon 317 Gauberti, Paul 173, 190 Gautier-Delaye 165, 178, 263 Gay, Bernard 220 Gazagnaire, Hellen 280 Gazagnaire, Jean 280 Gebrüder Rohrer 190 Gehlin, Hugo 314, 342 General Electric 418, 424, 426 Genisset, Jean-Pierre 89 Giampietro, Isabel A. M. 370 Gibbs, Herbert E. 178 Gibbs, T. 127 Gibson, Colin 221 Gibson, Frank R. 278, 281 Gibson-Horrocks, Mary 565 Gil, David 563 Gillgren, Sven-Arne 440, 443, 456 Girard, Alexander 32, 53, 81, 82, 91, 106, 298 Gispen, W. H. 172, 175, 261 Gitlin, Harry 403 Glenzer, Jacobo 130 Gooday, Leslie 48 Goodfellow, Philip F. 197 Gooværts-Kruithof, R. &. E. 256 Gordon, lan 357 Gorham Designers 464 Gottlieb, H. 414, 420 Gould, Allan 96, 135, 137 Grant, Duncan 279 Grant, Mary K. 444, 451 Gray, Milner 443 Greaves & Thomas 172 Greenwood, A. 107, 123 Grenville, John 505 Gretsch, Dr. H. 492 Griemert, Hubert 482 Grierson, Martin 127, 175, 222 Grierson, Ronald 166, 291 Grieve, H. W. 67, 133 Groag, Jacqueline 285, 289, 296, 298, 301 Groag, Jacques 92, 112, 115 Gröndal, Susan 269 Gross, F. M. 209, 245 Grunsven 237 Guariche, Pierre 171, 234 Gullberg, Elsa 87 Gullion, Jacques S. 159 Gussin, Lawrence 282

Gardiner & Thornton 39

H
Hackman-Dahlén, Maria 528, 538
Hagen, Ole 441, 473
Haggstrom, Pian 177
Haglund, Birger 478, 498
Hainke, A. 203
Hald, Edward 317, 319, 330, 337, 344, 353
Haller, Dagmar 284, 285
Hammond, David 368, 371
Hammond, H. F. 521

Hanninen, Olavi 141, 251 Hansen, Aage Helbig 452, 455, 472, 479, 480 Hansen, Hans H. 550 Hansen, Karl Gustav 441, 442, 456, 459, 464, 465, 466, 472, 486, 499 Harcourt, Roger 163 Harford, Ronald 101 Harlis, E. 201 Harris, M. 357 Harrison, Anthony 311 Harvey, A. Edward 459, 463 Hauner, Carlo 257 Hayward, Peter 163, 200, 207, 212 Heal, Christopher 90, 190, 240 Heal's 431 Hebert, Julien 156 Heesen, W. 364, 369 Heidrich, Stephen 131, 192, 203 Heifetz, Yasha 394 Height, Frank 212 Hellman-Knafve, Ingrid 99 Helweg-Möller, B. 155 Hemmingsen, Vagn Åge 507 Henderson, lan 388 Henningsen, Poul 19, 428 Henriksen, Hans 484 Henrion, F. H. K. 94 Henry, Hélène 235 Herbert, James 183, 203, 227 Herbert, John 227 Heritage, Robert 215, 244, 250 Herløw, Erik 228, 496 Hertzberger, W. 302 Hévézi, Endre 396, 521 Hill, J. 297 Hine, Margaret D. 530 Hinz, D. 194, 200, 201 Hiort af Ornäs 231, 251 Hiramatsu, Yasuhiro 263, 433 Hoffer, Marina 311 Hoffer, Marion 445 Hoffmann, Dr. Josef 515 Hoffmann, Kim 131, 192, 204 Hoffmann, Otto 503 Höglund, Erik 366, 369, 372 Holdsworth, Peter 529 Hollingsworth, Bruce 282 Hollmann, Rudolf 400, 401, 409, 426 Homes, Ronald 401, 403 Honkanen, Mauno 507 Hopea, Saara 353, 362, 380 Hörlin-Holmqvist, Kerstin 259 Houghton, J. R. 208, 219 Howard, J. A. C. 385, 417, 420 Howell, James A. 201, 222, 223, 234, 237, 263 Howell, Marie 222, 223, 234, 237, 263 Hoyland, Irwin 557, 564 Høyrup, Paul 545 Hubbard, Brian 211 Hurd, Alison 300 Hvidt, Peter 105, 136, 169, 239, 240, 261

le, Kho Liang 260 Ihnatowicz, E. 264 Illum 425 425, 433

Inchbald, Michael 231 Ingelög, Kristin 284 Ingolia, Anthony 396 Ingrand, Max 235, 410 Iversen, Henrik 73 J. H. Hunt & Co. 176, 178 Jackson, Doreen 727 Jacobsen, Arne 13, 23, 25, 134, 198, 207, 235, 254, 290, 291, 505 Jacobsen, H. P. 457, 458 Jakobsson, Hans-Agne 416, 421, 422, Janson, Gustaf 506 Jaraczewska, J. 264 Jensen, Hans 219 Jensen, L. 474 Jensen, Søren Georg 512 Johansson, Ejvind A. 224, 226 Johansson-Pape, Lisa 161, 385, 401, 424 Johnstone, J. Y. 175, 183 Jones, Hugh 197 Jonklaas, J. 147, 154 Jørgensen, Erik Ole 143 Jouve, G. 96 Juhl, Finn 24, 96, 204, 232, 248, 258 Junek, Jaruslak 419 Jung, Dora 303 Juul-Hansen, Knud 139, 147, 149, 191, 204 Kaasinen, T. 543 Kagan, Vladimir 69, 100, 101, 110, 113, 121, 126, 131, 135, 169, 170, 173, 183, 206, 210, 224, 230, 237 Kåge, Wilhelm 439, 472, 534, 547, 548, 550, 556, 559 Kähler, Nils 562 Kaipiainen, Birger 521 Kaiser, Robert 225, 243 Kandya Ltd. 209 Karlby, Bent 291 Karlsen, Arne 242 Kavanaugh, Gere 308 Kedelv, Paul 346, 360, 371 Keith, Howard B. 84, 92, 94, 113, 115, 116, 139, 142, 152, 162, 170, 176, 194, 200, 231, 258 Kemp, Dorothy 502 Kempe, T. 239 Kempkes Jr., H. 173 Kenmochi, Isamu 174 Kindt-Larsen, Edvard 229, 243 Kindt-Larsen, Tove 229, 243 King, A. 58 King, Raymond 45 Kipp, Maria 95 Kjaerholm, Poul 73, 141 Kjellberg, Friedl 528

Klepper, Arthur A. 101, 109, 389 Klepper, Irina A. 106, 108, 111 Klint, Esben 384, 397 Knaff, Micheline 304 Knoll, Florence 145, 247 Koller, Reinhold 218, 227 Koppel, Henning 460, 462, 466, 481, 506, 515 Kørbing, Kay 226 Korsmo, Arne 459, 494 Kramer, Walter 294, 306 Krenchel, Herbert 494, 504 Kujundzic, Z. D. 553, 559 Kuypers, Jan 235 Kyle-Reed 387

Lacoste, Gerald 401 Laine, Orvokki 554 Lake, John-Orwar 349 Lalique, Marc 366 Lampard, Kenneth D. 155 Lampl, Fritz 320, 338 Landberg, Nils 20, 316, 331, 337, 341, 345, 346, 347, 371, 380, 381 Landman, J. A. 72 Lane, Susan 505 Lanús, José Maria 558 Lappalainen, Ilmari 198, 206, 240 Larsen, Ejner 166, 170, 226 Larson, Lisa 559 Larsson, Axel 87, 105, 163, 191, 199, 202 Lászlò, Paul 37, 41, 117, 127, 132, 187, 190, 208, 391, 397 Laubenthal, Sybil 563 Laverne, Erwin & Estelle 12, 21 Laverne Inc. 301 Laverrière, Janette 197, 204 Le Grest & Co. 160 Le Klingt 429 Le Mare, Kathleen 309 Leach, Bernard 462, 555 Leavey, Doren 409 Lebetkin, Jarvis 203 Leconte, Pierre 133 Leighton, Clare 531 Lemesre, Eric 265 Lennon, Dennis 92, 117, 123, 141, 159, 398 Lerner, Nathan 105 Lessons, K. W. 484, 506 Leuchowius, Sylvia 501 Levin, Richard 133 Levy-Ravier, Jacques 34 Lewenstein, Eileen 560, 564 Lewis, A. M. 101, 110, 185 Libensky, Stanislav 357 Libert Dessins 299

Liebes, Dorothy 95, 98

Liertz, Hilegard 419

Liljefors, Anders 438

551, 567

Lindberg, Stig 274, 276, 438, 439, 447,

450, 482, 486, 490, 501, 504, 511, 524,

526, 531, 533, 534, 535, 538, 539, 542,

Lindgren, Helge 443, 512 Lindh, Francesca 560, 561 Lindstrand, Vicke 324, 325, 326, 330, 331, 332, 336, 338, 339, 345, 347, 349, 364, 368, 373, 376 Liskova 350 Littmarck, Barbro 477, 508 Lock, H. A. 475 Loewy, Raymond 509 Löffelhardt, Heinz 493 Lohmeyer, Hartmut 201 Lønborg, Lauris 513 Long, Henry E. 101, 191 Long, Ronald A. 166, 170, 195, 198, 220, 223, 224, 225 Longarini, Marciano A. 530, 531, 549 Loos, Walter 60 Lord, S. A. 85 Lorenzen, Alma 563 Lorenzen, Ernst 563 Lucas, A. 460 Luce, Jean 492 Lugherra, Marco 515 Lundgren, Tyra 277 Lundin, Ingeborg 15, 325, 330, 338, 342, 344, 352, 370, 372 Lurçat, Jean 97 Lütken, Per 317, 321, 331, 332, 333, 368, 372, 373, 375 Lynggaard, Finn 562 Lyons, Eric 40 М Mabon, Robert 149 MacGregor, Norman Fox 223, 225 Mackmin, Francis 408 Mahler, Marion 84, 122, 284, 288, 295, 297, 521 Mancioli Natale & C. 373 Manning, Frederick 107, 144 Markelius, Sven 11 Marlow, Reginald 384 Marrot, Paule 61, 250 Marsh, Roff 117 Martens, Dino 352, 353, 377, 429 Martin, Edna 268, 269, 271 Martin, Hubert J. 494 Marx, Erich 414 Matégot, Mathieu 179, 182, 185, 406 Mauler, René 88 McAvoy, Kelvin 110, 130, 158, 166 McCobb, Paul 152 McCreery, James L. 43 McKee, Robert R. 50 McKim, Kathleen 561 Meiling, Eila 150 Meredew Design Group 174, 179 Meroni, Italo 219 Meydam, F. 330, 331, 351, 364, 365, 367,

369, 496

Middelboe, Sven 420, 429 Middleton-Stanford, Betty 307

Midwinter, Roy 492

Miller, Frederick 457

Mills, Donald 444, 450, 463 Mills, Edward D. 56 Mills, Jacqueline 463 Milne, A. J. 107, 112, 120, 143, 162, 166, 178, 225, 231 Mocharniuk, Nicholas 397 Mogensen, Børge 105, 129, 238 Mogensen, Jørgen 503 Molander, Hans-Harald 156 Mølgard-Nielsen, Orla 105, 136, 169, 240 Möller, Grete 546, 549 Moller, Hans 43 Moller, Inger 456 Möller, Tom 548 Mollino, Carlo 4-5 Mørch, Ibi Trier 452, 453, 466 Morris, Neil 128, 155, 172, 174, 239 Morrison, Earle A. 125, 141, 194 Morrison-Bush Associates 151 Mortier, M. 234 Motley, Joan 290 Motte, J. A. 234 Moyano, Lucrecia 314, 331, 333, 349, 354 Mullen, Joseph 83 Munckton, D. W. 211 Muona, Toini 523, 526 Murphy, Charles 490 Murray, Keith 447, 521 Myer, Ewart 133, 183 Myers, Lucien 553 Myrstrand, Gunnar 148, 182

Nance, Robin 246 Napier Associates 454 Nash, John 340 Natzler, Gertrude 520, 546, 563, 565, 568 Natzler, Otto 520, 546, 563, 565, 568 Nelson, George 9, 10, 81, 106, 174, 191, 205, 255 Neutra, Richard J. 29, 30, 38, 49, 52, 63, 68, 74 Nevalinna, Lea 150, 163, 238 Newland, William 532 Newton, Derek 196 Nicholson, Robert 120, 288, 387 Nicholson, Roger 306, 307, 387 Nielsen, Harald 454 Nielsen, Jais 533 Nilsson, Alf 198 Nilsson, Arne 218 Nilsson, C. I. A. 410, 411, 433 Noguchi, Isamu 427 133, 135

Nilsson, C. I. A. 410, 411, 433
Noguchi, Isamu 427
Nordiska Kompaniet Design Studios
133, 135
Nørgaard, Henning 506, 507
North, Bernard 242
Nothhelfer, Karl 90
Noxon, C. S. 256
Nummi, Yki 396, 420
Nurmesniemi, Antti 423
Nylund, Gunnar 476, 491, 523, 533, 536, 540, 550
Nyman, Gunnel (Mrs) 314, 315

Ohchi, Hiroshi 185 Ohlsson, Folke 213 Öhrström, Edvin 316, 321, 324, 339, 340, 341, 344, 349, 356, 367 Okkolin, Aimo 377 Old, Maxime 215 Olin, Gunvar 510 Oliver, Mary 270, 274, 281 Olsen, Åage Herman 239 Olsen, Hans 211, 254 Olsen, Kurt 171, 173, 199, 205 Olson, Lars 226 Orrghen-Lundgren, Gudrun 298, 299, 304, 305 Orup, Bengt 341, 344, 345, 348, 355, 362, 367, 372, 379 Ossian, John 105 Östberg, Olof 119 Østervig, Kurt 172, 174 Ottelin, Olof 117, 161, 220

Paatela, Eero 150 Pagani, Carlo 204 Pahlmann, William 118, 119 Palmqvist, Sven 314, 321, 326, 338, 346, 350, 354, 375 Pålsson, Folke 143 Paltial Ltd. 208 Panton, Verner 19, 24 Parisi, Ico 224 Parker, Margot Portela 158 Parton, Doris 465, 469 Parzinger, Tommi 177, 210, 214, 217, 460, 484 Patijn, A. A. 72, 144, 162, 165, 172, 176, 199, 228, 234, 250, 406 Paulin, Pierre 12 Pavely, Ruth 502 Payer, Ernst 101 Peabody, Lawrence 174 Peake, Brian 46, 47, 71 Penaat, William 145 Penraat, J. 57 Percy, Arthur 344, 351, 462, 543 Perkins, H. J. 146 Persson, Sigurd 443, 455, 456, 461, 464, 473, 480, 499, 500, 506 Petri-Raben, Trude 492 Pick, Beverley 386, 388, 429, 433 Pile, Barbara 290 Pilley, A. V. 85, 116, 117, 122 Pinto, Edward H. 91 Pippal, Robert 167 Pira, Olof 175 Piret, F. 453 Platt, William 83 Platten, Bruno 551 Plums, Harald 73 Poli, Flavio 351, 364 Pollak, Ernst 217

Pompa, Philip 283

Pons, Geneviève 165

Ponti, Gio 250, 307 Poole Design Unit 469, 544 Pott, Carl 506 Poulsen, K. Stonor 236 Price, Alan 493 Price, H. Russell 455 Priestley, Sylvia 291 Prizek, Mario 151 Probber, Harvey 121, 230 Prytz, Jacob 454 Pulitzer, G. 199 Pye, David W. 134

Race, Ernest 85, 135, 139, 156, 158, 159, 195 Ramos 184 Raphaël 187 Rastaad og Relling 235 Ravilious, Eric 489 Ravillious, John 218 Raymond Loewy Associates 454, 482, 490 Raymor 394 Read, A. B. 398, 553 Read, Winning 279, 285, 298 Reason, Laurence A. 163, 227, 230 Refregier, Anton 448 Reich, Tibor 171, 177, 197, 216, 293, 297, 306, 549 Reid, John 390 Reiff, Erik 554 Renou, André 89 Rewell, Viljo 75 Reynolds, A. B. 94 Rice, Eryl 284 Richards, Charles 357, 361 Riedel, Oskar 86, 211 Risley, John 157 Risom, Jens 82, 127, 138

173, 174 Rodker, E. 233 Romano, Emanuel 534 Roos, Bertil 424

Robertson, T. R. L. 105, 131

Robinson, Joan 105

Rose, Ben 271, 276, 277, 286, 294, 298

Rosen, Alf 469

Rosén, David 146 Rowley, Laurence A. J. 84, 91

Royère, Jean 35, 61, 89, 96, 97, 100, 125, 134, 152, 154, 161, 167, 173, 175, 179, 190,

Robsjohn-Gibbings, T. H. 100, 101, 105,

116, 126, 127, 130, 138, 139, 140, 150, 162,

247, 250, 389

Ruda, Bengt 163, 169, 173, 223, 227

Rudofsky, Bernard 286 Ruf, Fred 214 Ruscoe, William 541

Rushforth, P. F. 568 Russell, Christopher 540, 541

Russell, W. H. 98, 105, 246 Ruth, Theo 135, 143, 168, 195, 223,

232, 248

S. N. Cooke & Partners 65 Sadolin, Ebbe 487 Sadowska, Krystyna 545, 555 Sadowski, Konrad 545, 555 Salerno, Joseph 94, 98 Sallamaa, Stig 163 Salmenhaara, Kyllikki 526, 534 Salto, Axel 518, 557, 566

Sampe, Astrid 292, 305

Samuel, Audrey 488

Sanders, Herbert H. 447, 539

Sandnes, Oysten 363 Sarfatti, Gino 413

Sarpaneva, Timo 287, 344, 361, 375

Sartel, S. A. 509 Satink 205, 207

Satoh, Jyunshiro 339, 343, 344, 345

Satoh, Nobutoshi 185 Satow, T. 100

Sawyer, Desmond 401, 416, 423 Scheier, Edwin 446, 519, 536, 537, 550,

551, 561, 565 Scheier, Mary 446, 519, 536, 537, 550, 551, 561, 565

Schlanbusch, Ellen 471 Schneider-Esleben, Paul 135 Schotz, Cherna 203

Schrader, Åse Voss 318, 319

Schütz, Siegmund 476, 533 Scott, J. A. 218

Scott, William 311 Seidelin, Henning 499 **Selbing**, John 338, 366

Selig of Leominster 167

Semmens-Simpson 97 Shadbolt, Douglas 107

Shaw, Robert 300, 302

Shinjo, Akira 174 Shuttleworth, Peter 282

Siimes, Aune 524

Simeon, Margaret 271, 283, 296 Simmulson, Mari 543, 559

Simonis, Dick 512

Skawonius, Sven Erik 494, 501, 504, 543

Skellern, Victor 444, 488

Skogh, Svante 116, 142, 168, 195, 216, 238

Slater, Eric W. 475, 479 Slobodkin, Simon 447 Smith, Elsie 306 Snaith, William T. 102

Société Matégot 234

Solec 427

Sølvsten, Harbo 87

Sorbon-Malmsten, Birgitta 417 Sørensen, Svend Aaga Holm 412, 413,

414, 417, 421, 429, 430, 505

Speight, Sadie 272

Spender, Humphrey 278, 294 Speyer, Catherine 80, 100, 391

Staaf, Sven 226

Stålhane, Carl-Harry 487, 490, 497, 500, 503, 519, 522, 526, 528, 536, 537, 540, 551, 560

Standish-Taylor (Designs) 213

Stennett-Willson, R. 344, 345, 352 Stephensen, Magnus 441, 459, 485, 486,

496, 498, 504, 508 Stephenson, H. 209

Sternfeldt, Sven 133 Stevens, Irene 318, 321, 352

Stewart, Robert A. 176, 287

Stiff, A. J. 146

Still, Nanny 345, 353, 375, 379, 381, 484 Stilnovo 390, 292, 396, 398, 402, 416,

418, 425, 427 Stockford, Philip 296

Stone, Edward D. 134, 140 Stone, H. R. 448, 470, 518, 519

Stone, Robert E. 453, 461 Story Design Group 92, 98, 99, 394

Strange, John 221, 235 Straub, Marianne 113, 140

Strauch, H. W. E. 59 Stricker, Daisy 184 Styne, A. F. 105 Sümes, Anne 547 **Summers**, W. E. 429

Svedberg, Elias 120 Svensson, Alf 162, 171, 194, 213, 261

Swalén, Uno 211 Sydenham, Guy 553

T. Baumritter & Co. 149 Tabraham, J. H. 95, 124, 178, 246 Talbot, S. C. 436, 437, 445, 446, 471, 489, 530 Tapiovaara, Ilmari 238, 254

Taplin, Millicent 446, 447, 488

Tayler & Green 44 Taylor, James S. 474

Teague, Walter Dorwin 145, 444, 448, 451

Teeanee Ltd. 433 Tempestini, Maurizio 182 Theisen, Josef 236

Thomas, Robin 289 Thomas, Ronnie 311 Thompson, Olde 474, 484

Thorkildsen, Else Marie 285

Thorne, Ross 62

Thorsson, Nils 467, 477, 529, 544

Thurstan, Violetta 272

Thurston, Gerald 403, 405, 407, 408,

409, 411, 413, 415 Thygesen, Axel 251

Tisdall, Hans 281, 294

Titus Blatter & Co. 182

Tockstein, Jindrich 369 Tomlinson 231

Tourre, Steve 116

Tower, Meriel 291

Townsend, G. Paulson 40 Troughton & Young 408, 423, 425

Trower, Thomas F. 45 Tsuji, Mitsusuke 545, 547

Tucker, John 227 Tucker, Loraine Read 384 Twitchell & Rudolph 97 Tybulewicz, O. 230 Tynell, Helena 322, 348, 355 Tynell, Paavo 386, 389, 390, 398, 399, 413, 453

U Udsen, Bertel 64 Unika-Væv 309 Utzon, Jørn 422

Valkema, lep 351 Van Den Berghe-Pauvers 245 Van Itterbeeck, A. 513 Van Kasteel, Bart 72 Van Koert, John 481 Van Sliedregt, Dirk 108, 116, 117, 131, 141, 166 Varral, J. R. 183 Vedel, Kristian 211 Venini, Paolo 339 Venini Glassworks 363 Vestergaard Jensen, H. 252 Volther, Poul M. 131, 143, 158, 172, 175, 198, 220 von der Lippe, Eduard 86, 87 von Nessen, Greta 387, 391 von Paleske, Christa 200, 222 von Unruh, Sigrid 476 Vorster, D. S. 124, 172

W
Wainwright, Florence 448
Wall, Peter 493
Walters, Nigel 117, 179, 244, 389
Wanscher, Ole 237, 255
Ward, Neville 92, 105
Warner, Barry 229, 232, 245, 265
Warner, Rachel 462, 521
Warren, Mary 294

Wason, M. S. 244 Watkins, Frank 201, 252 Webster, Jane 361 Wegner, Hans J. 14, 138, 171, 175, 226, 229, 243, 244 Wehmanen-Tennberg, Lea 87 Weihrauch, Svend 453, 455, 457, 458, 463, 487, 488 Weinreis, Käte 536, 537 Welch, Robert 361, 484, 485, 497, 507 Wermer, Federico 54 Westerberg, Uno 415 Westerberg-Levander, Evy 251 Whalen, Alyne 103 Whicheloe, Norman A. P. 117 White, Mary 294 Whitehead, David 48 Whittall, Eleanor 478, 518, 528 Wichard, Frits 297 Wickham, Michael 191 Wickham, Nancy 520 Wier, Don 316, 340 Wildenhain, Marguerite 520, 564, 569 Wilhelm Renz KG 191, 203, 263 William Pahlmann Associates 129, 190 Williams, J. A. 134 Williamson, A. H. 370 Willis, George 276 Wilson, Charles T. 448 Wilson, Norman 508

Wilson, W. J. 320, 324 Windeleff, Aage 105 Winter, Edward 307

376, 379, 380, 515, 561

Wohlert, Vilhelm 254, 426

Wolkowski, Wladyslaw 218

Wormann, Hans N. 190

Witty, James C. 175

Wöjtek, Poldi 529 Wor-De-Klee Inc. 43, 153

Wirkkala, Tapio 265, 331, 339, 345, 355,

Wormley, Edward J. 95, 101, 119, 150, 281 Wörrlein Werkstätten 194, 205, 211, 224, 251, 257 Wren, Rosemary D. 395 Wright, Russel 134, 472, 477, 483 Wrøblewski, Zdizislaw 256

Y
Yabsley, P. 138
Yarborough-Homes 412
Yates, Herbert 237
Yehia, M. B. A. 469
Yoshida, Isoya 42, 76
Yoshitake, Mosuke 263
Young, Dennis 112, 113, 126, 138, 177
Young, Marjorie 280

Z Zaalberg, Meindert 526, 544, 546, 566 Zanuso, Marco 198 Zeisel, Eva 105

Credits Bildnachweis Crédits

Bonhams, London: 24 Christie's Images, London: 11, 24 Christina & Bruno Bischofsberger Collection, Zürich: 4–5 Fiell International Ltd., London: (photos: Paul Chave): 8, 21, 22, 23 left; 9 right, 14, 23 right (Ross & Miska Lovegrove Collection); 16, 17 (Mithra Neuman Collection) (photos: Paul Hodsoll): 10, 12 Fritz Hansen, Copenhagen: 13, 25 Louis Poulsen, Copenhagen: 19 left Sotheby's, London: 15, 20

DECORATIVE ART SERIES

More titles on architecture & design from TASCHEN

Decorative Art – 1950s Ed. Charlotte & Peter Fiell 576 pages 3–8228–6619–9 [ENGLISH/GERMAN/FRENCH]

Decorative Art – 1960s Ed. Charlotte & Peter Fiell 576 pages 3–8228–6405–6 [ENGLISH/GERMAN/FRENCH]

Decorative Art – 1970s Ed. Charlotte & Peter Fiell 576 pages 3–8228–6406–4 [ENGLISH/GERMAN/FRENCH]

Design of the 20th Century Charlotte & Peter Fiell 768 pages 3–8228–7039–0 [ENGLISH] 3–8228–0813–X [GERMAN] 3–8228–6348–3 [FRENCH]

sixties design Philippe Garner 176 pages 3–8228–8934–2 [ENGLISH/GERMAN/FRENCH]

Furniture Design
Sembach/Leuthäuser/Gössel
256 pages
3–8228–0276–X [ENGLISH]
3–8228–0097–X [GERMAN]
3–8228–0163–1 [FRENCH]

1000 Chairs Charlotte & Peter Fiell 768 pages 3–8228–7965–7 [ENGLISH/GERMAN/FRENCH]

The Rudi Gernreich Book
Peggy Moffitt, William Claxton
256 pages
3-8228-7197-4
[ENGLISH/GERMAN/FRENCH]

Julius Shulman Architecture and its Photography Ed. Peter Gössel 300 pages 3–8228–7204–0 [ENGLISH] 3–8228–7335–5 [GERMAN] 3–8228–7334–9 [FRENCH]